JIMMY PAGE

BY JIMMY PAGE

ISBN: 978-1-905-662-32-6

Genesis Publications Ltd
Genesis House
2 Jenner Road, Guildford
Surrey, England, GU1 3PL

www.genesis-publications.com

www.jimmypage.com

St Barnabas Church, Epsom: this photograph was taken by the choirmaster, Mr Coffin.

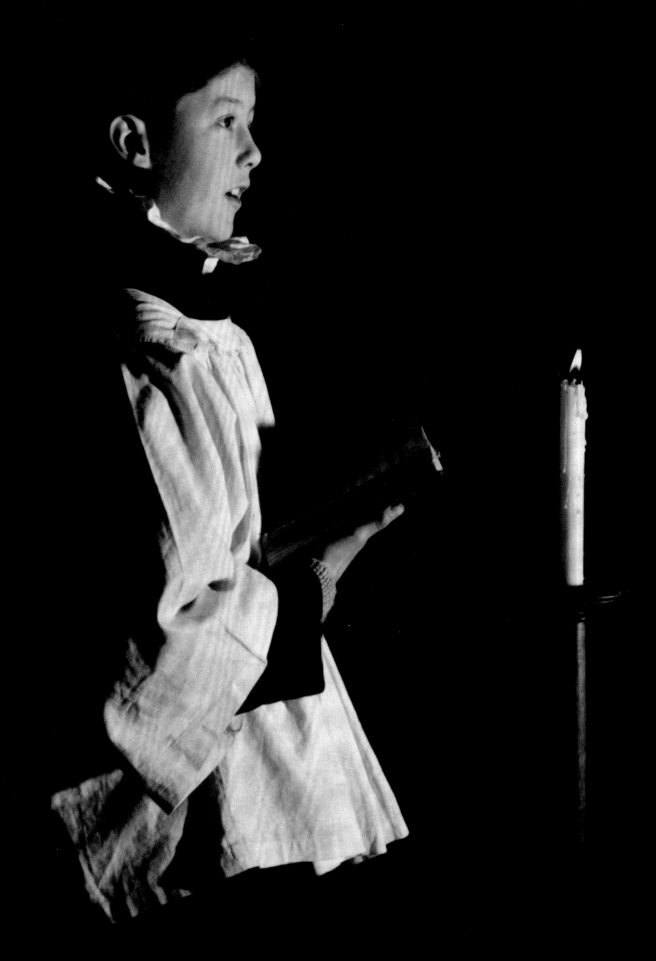

It might get loud…

This book is a visual documentary to reflect my contribution to music.

I was born on 9th January 1944, near Heston, Middlesex, to my father James and my mother Patricia, hence James Patrick.

We moved to three locations in that area before relocating to Epsom, Surrey, where a guitar had been left at the house by a previous owner. That intervention didn't mean too much at the time as no family members played the guitar and rock'n'roll was yet to emerge on British airwaves. Later on, I made the visual connection between the guitar and the music that was erupting on the TV and radio.

One day at school, a guy called Rod Wyatt was playing and singing a Lonnie Donegan song – a record that I had at home and had seen performed on television. This was a pivotal point as I said, 'I have a guitar at home.' And he said, 'Well, bring it to school and I'll show you how to tune it and play a few chords.'

Then the adventure begins…

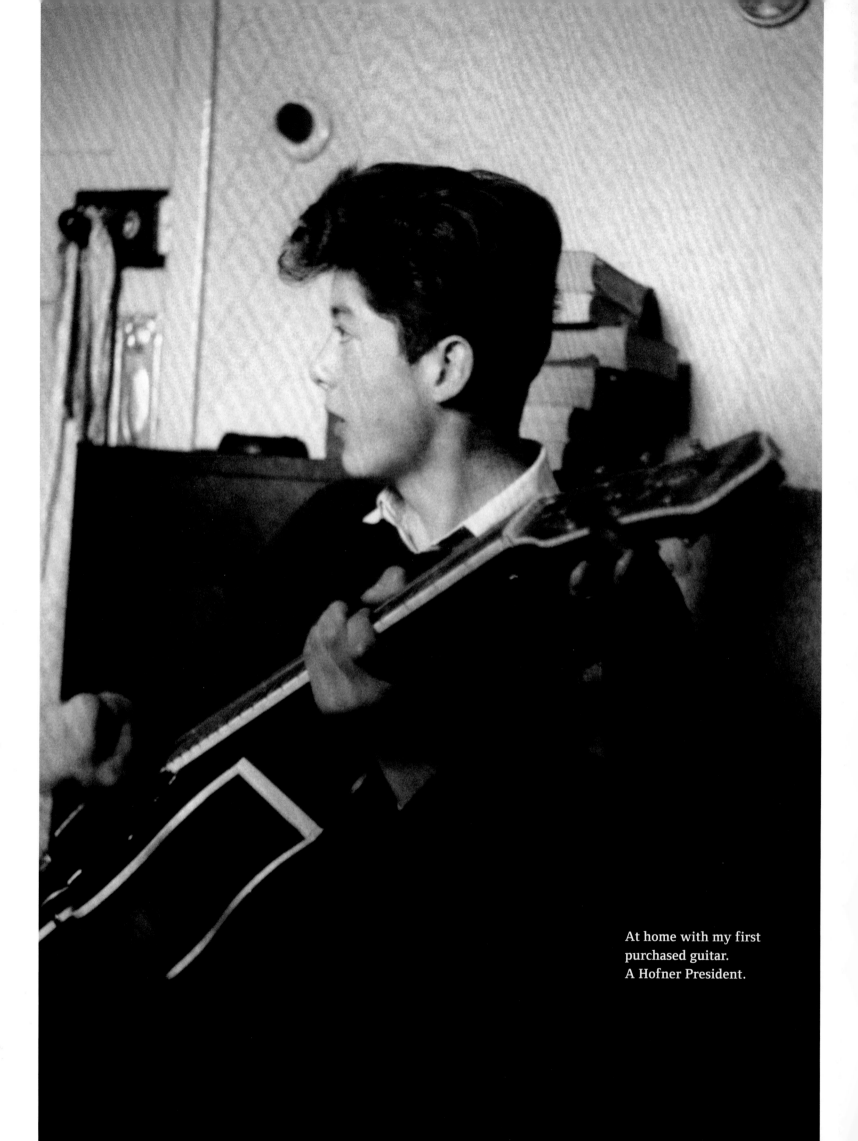

At home with my first
purchased guitar.
A Hofner President.

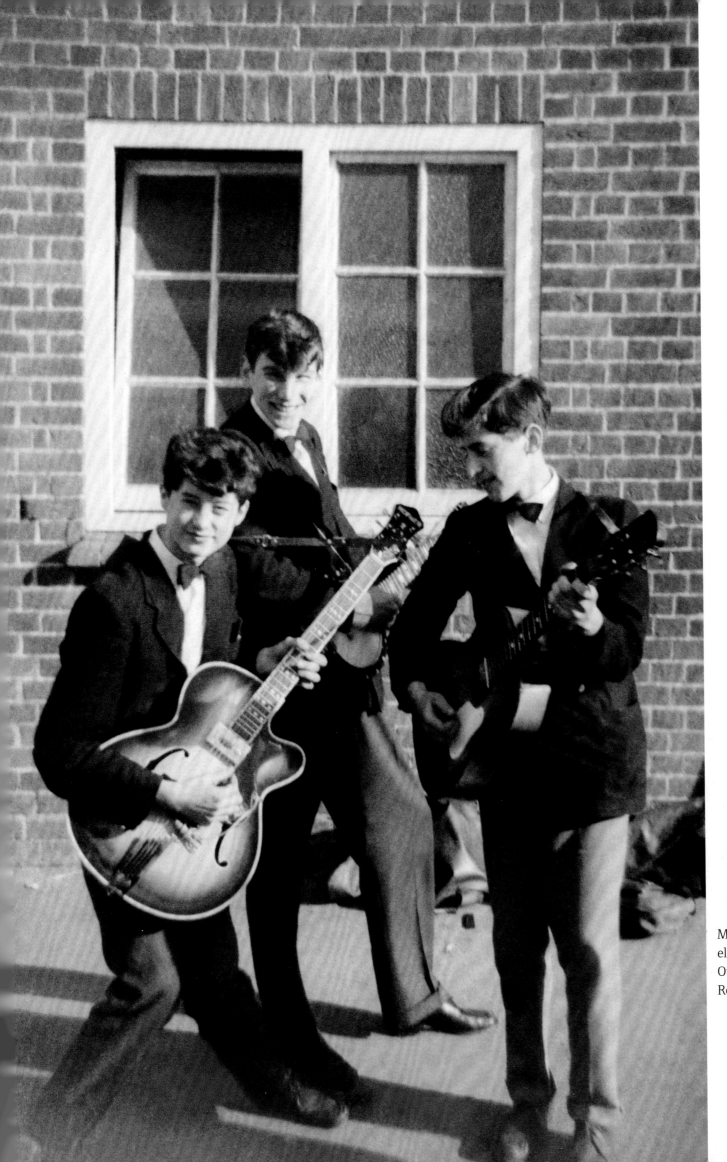

My first attempt at
electrifying the guitar.
Outside school with
Rod Wyatt (on the right).

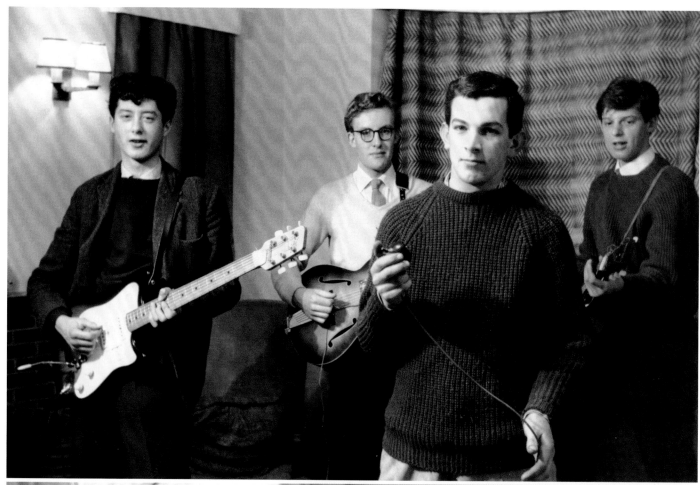

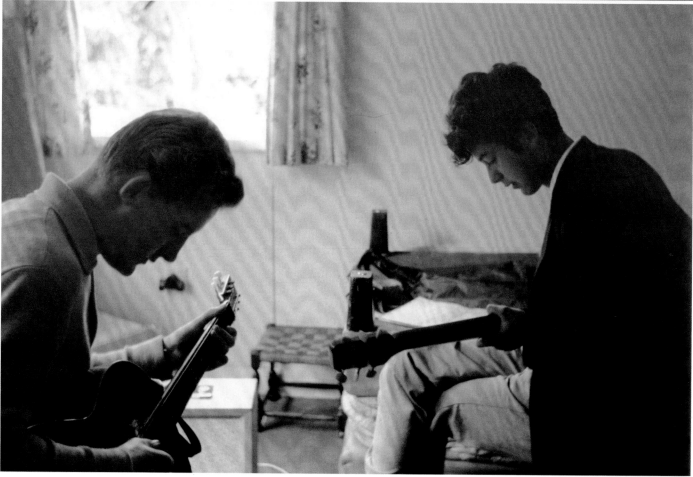

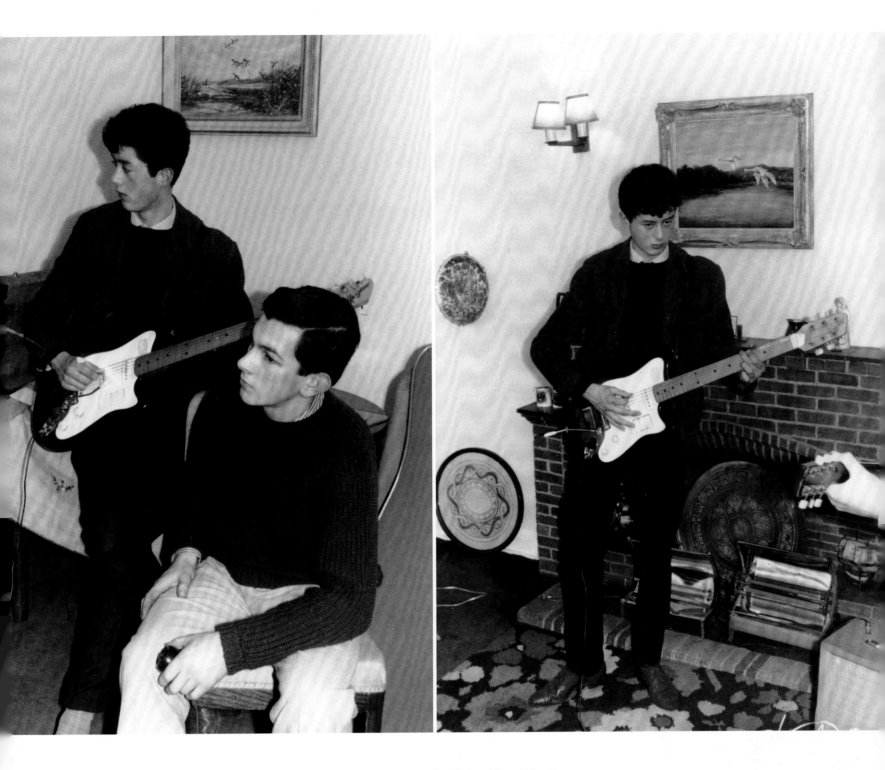

Here with my first electric guitar and with local band The Paramounts.

I had been playing in various groups in Epsom when Chris Tidmarsh asked me if I would like to play in a London band. I could only play on the weekends as I was still in school. That band was Red E Lewis & The Redcaps (shown overleaf).

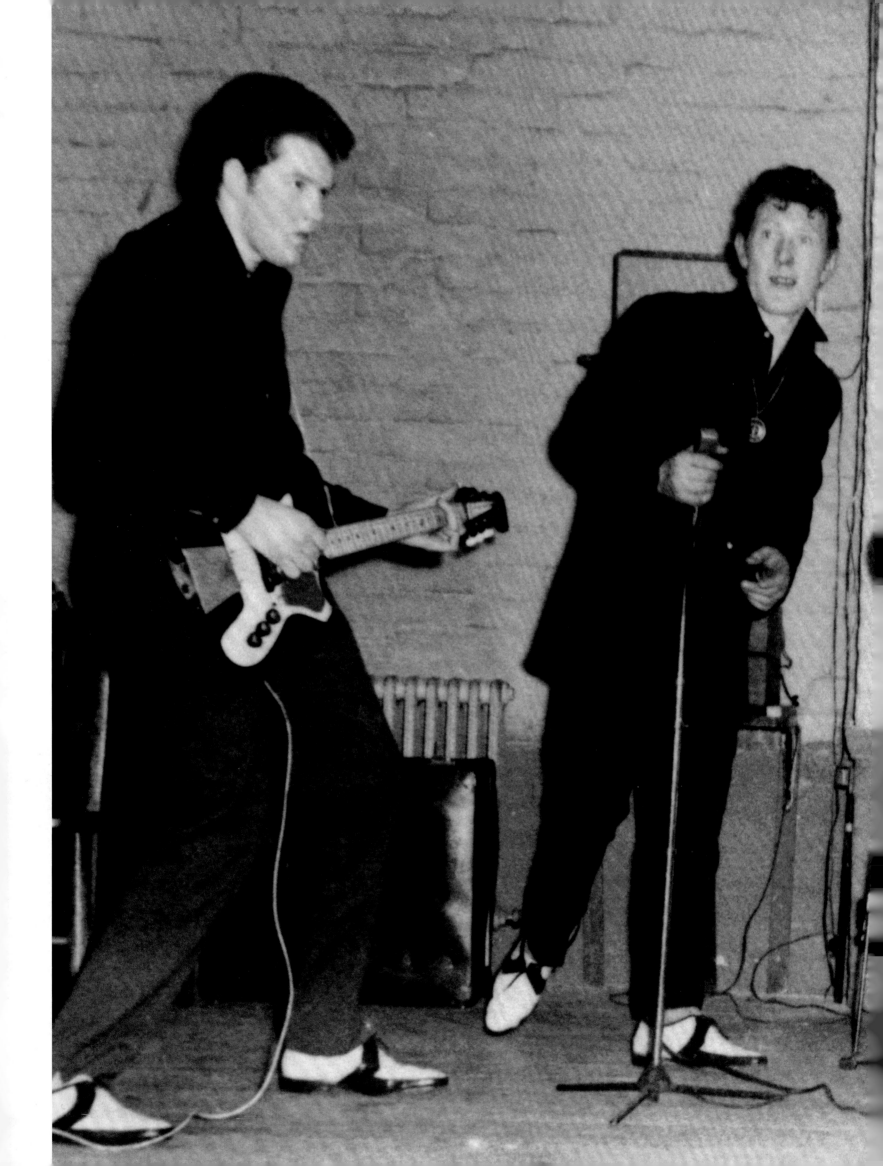

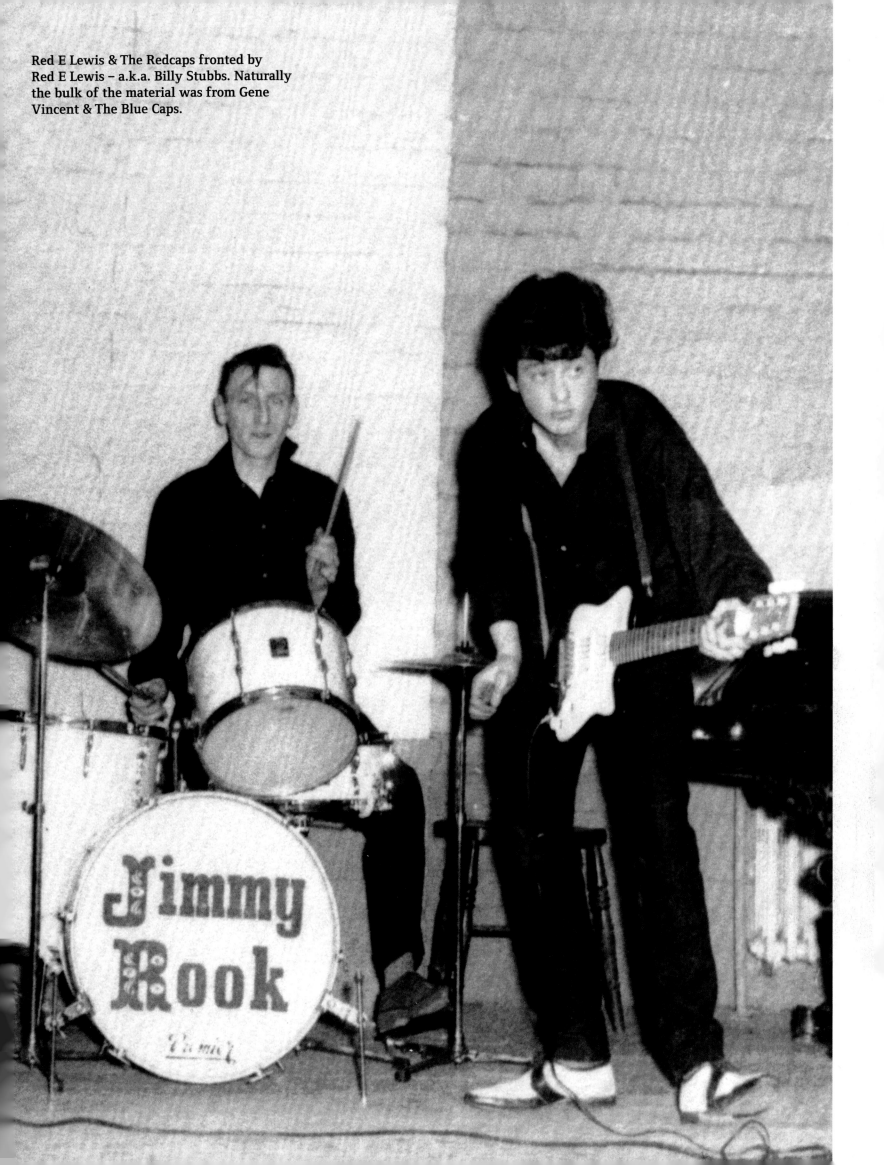

Red E Lewis & The Redcaps fronted by
Red E Lewis – a.k.a. Billy Stubbs. Naturally
the bulk of the material was from Gene
Vincent & The Blue Caps.

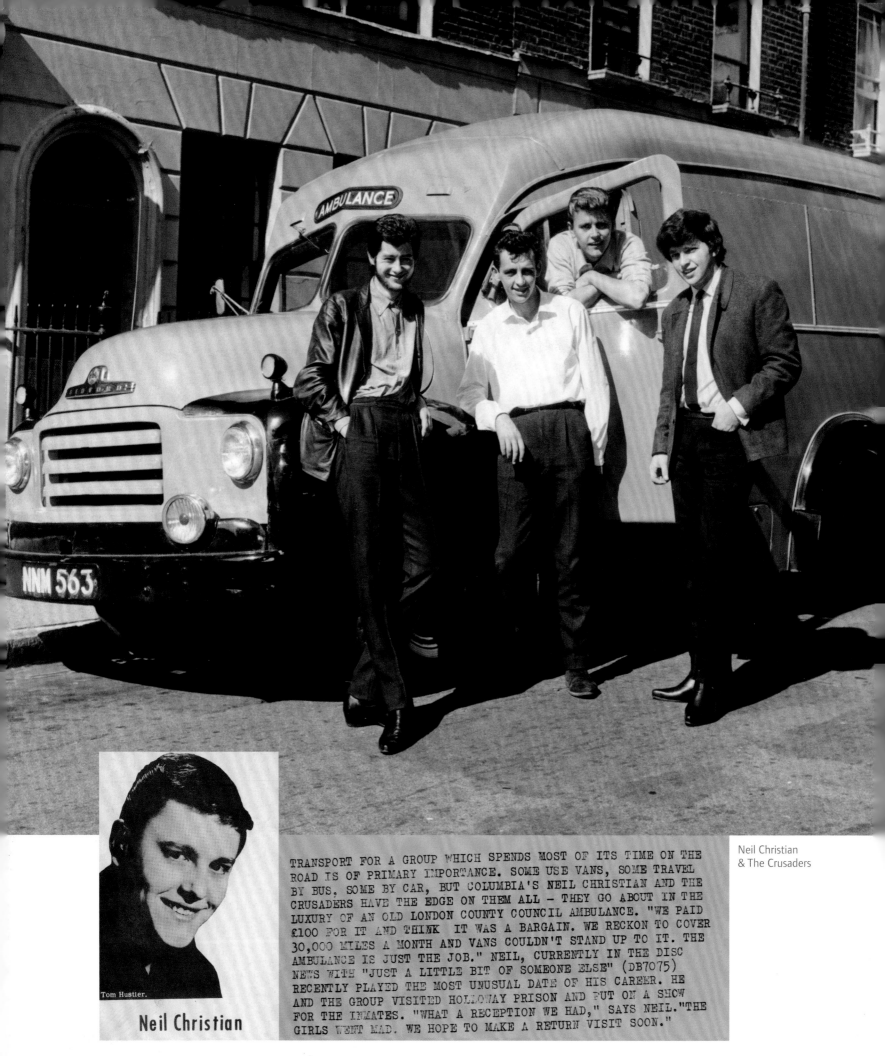

Neil Christian

Tom Hustier.

Neil Christian
& The Crusaders

TRANSPORT FOR A GROUP WHICH SPENDS MOST OF ITS TIME ON THE
ROAD IS OF PRIMARY IMPORTANCE. SOME USE VANS, SOME TRAVEL
BY BUS, SOME BY CAR, BUT COLUMBIA'S NEIL CHRISTIAN AND THE
CRUSADERS HAVE THE EDGE ON THEM ALL — THEY GO ABOUT IN THE
LUXURY OF AN OLD LONDON COUNTY COUNCIL AMBULANCE. "WE PAID
£100 FOR IT AND THINK IT WAS A BARGAIN. WE RECKON TO COVER
30,000 MILES A MONTH AND VANS COULDN'T STAND UP TO IT. THE
AMBULANCE IS JUST THE JOB." NEIL, CURRENTLY IN THE DISC
NEWS WITH "JUST A LITTLE BIT OF SOMEONE ELSE" (DB7075)
RECENTLY PLAYED THE MOST UNUSUAL DATE OF HIS CAREER. HE
AND THE GROUP VISITED HOLLOWAY PRISON AND PUT ON A SHOW
FOR THE INMATES. "WHAT A RECEPTION WE HAD," SAYS NEIL."THE
GIRLS WENT MAD. WE HOPE TO MAKE A RETURN VISIT SOON."

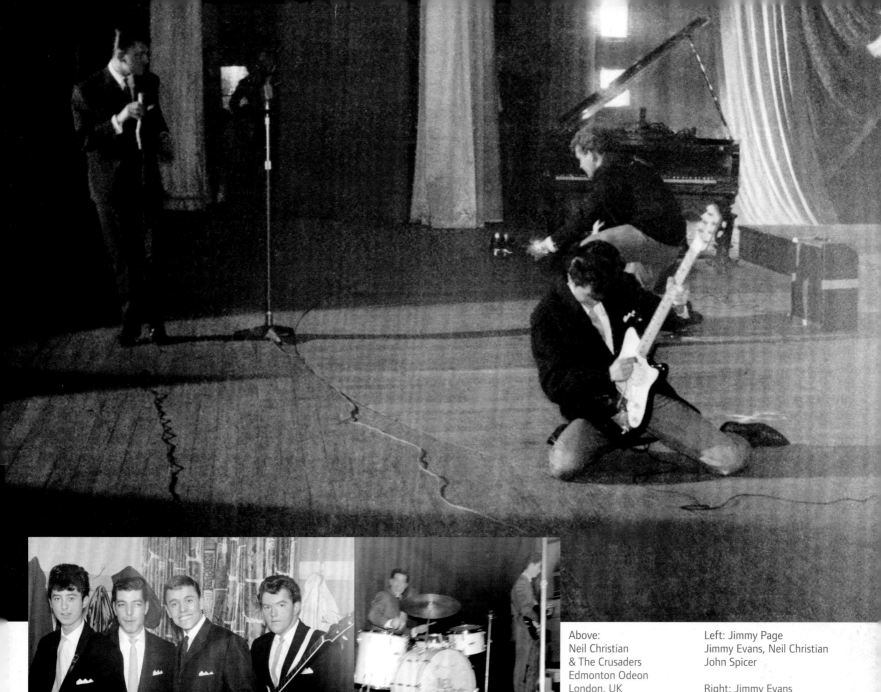

Above:
Neil Christian
& The Crusaders
Edmonton Odeon
London, UK
Supporting Cliff Richard
& The Shadows

Left: Jimmy Page
Jimmy Evans, Neil Christian
John Spicer

Right: Jimmy Evans

Below: Sutton School of Art
London, UK

Later there was a personnel change to Red E Lewis & The Redcaps as Chris Tidmarsh became Neil Christian and we became The Crusaders. We had a drummer named Jimmy Evans who'd been a drum major in the army. He was without doubt one of the best drummers to feature in local bands in England at that time.

The material that we played ranged from Johnny Burnette & The Rock'n'Roll Trio's 'Train Kept A Rollin' and 'Honey Hush', to Chuck Berry's 'I'm Talking About You' and 'No Money Down'. However, at this time there was a huge demand for Top 20 hits to be played by touring bands.

In late 1962 I was invited to play on a recording involving two of the most prominent musicians in England, Jet Harris and Tony Meehan of Cliff Richard & The Shadows fame. The track was called 'Diamonds' and it reached Number One in the charts in January 1963. On their record I played acoustic guitar.

Even with all this activity I made the decision to go to art college and study fine arts. I didn't stop playing and over the next few months kept my hand in by occasionally jamming at clubs. One night at the Marquee I was approached to play a session and things developed from there.

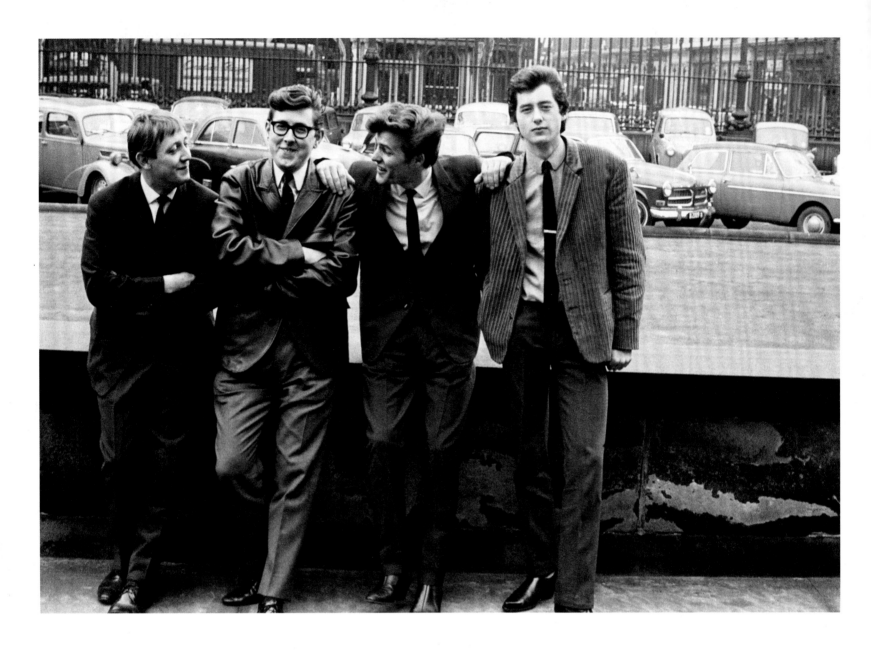

My early session work involved, amongst others, playing guitar with Carter-Lewis & The Southerners and harmonica and guitar with Mickey Finn & The Bluemen. These are promo shots with the bands, although I never played live shows with them.

During this time the increasing volume of recording dates began to demand a decision: was I a better artist or a better musician? It became an easy decision.

Some of the artists that I worked with included: The Kinks, The Who, The Rolling Stones, Joe Cocker, Lulu, Petula Clark, Donovan, Al Stewart, Marianne Faithfull, Van Morrison & Them, Billy Fury (harmonica), Cliff Richard (harmonica), Kathy Kirby, Chris Farlowe, Dave Berry, Dusty Springfield, PJ Proby, Tony Christie, The Pretty Things, Tom Jones, Screaming Lord Sutch, David Bowie and Benny Hill; American artists such as Roy Orbison, Otis Spann, Brenda Lee, Jackie DeShannon, Burt Bacharach and The Everly Brothers; and French artists like Françoise Hardy, Johnny Hallyday, Michel Polnareff and Sylvie Vartan, but unfortunately not Brigitte Bardot.

I was also on Shirley Bassey's 'Goldfinger' Bond theme, the soundtrack to *Casino Royale* and the album of *A Hard Day's Night*.

Then I went on as an arranger and producer for Andrew Oldham's Immediate record label working, for example, on the John Mayall and Eric Clapton tracks: 'I'm Your Witch Doctor', 'Telephone Blues' and 'Sitting On Top Of The World'. I wrote and produced 'The Last Mile' for Nico who was later to surface in The Velvet Underground.

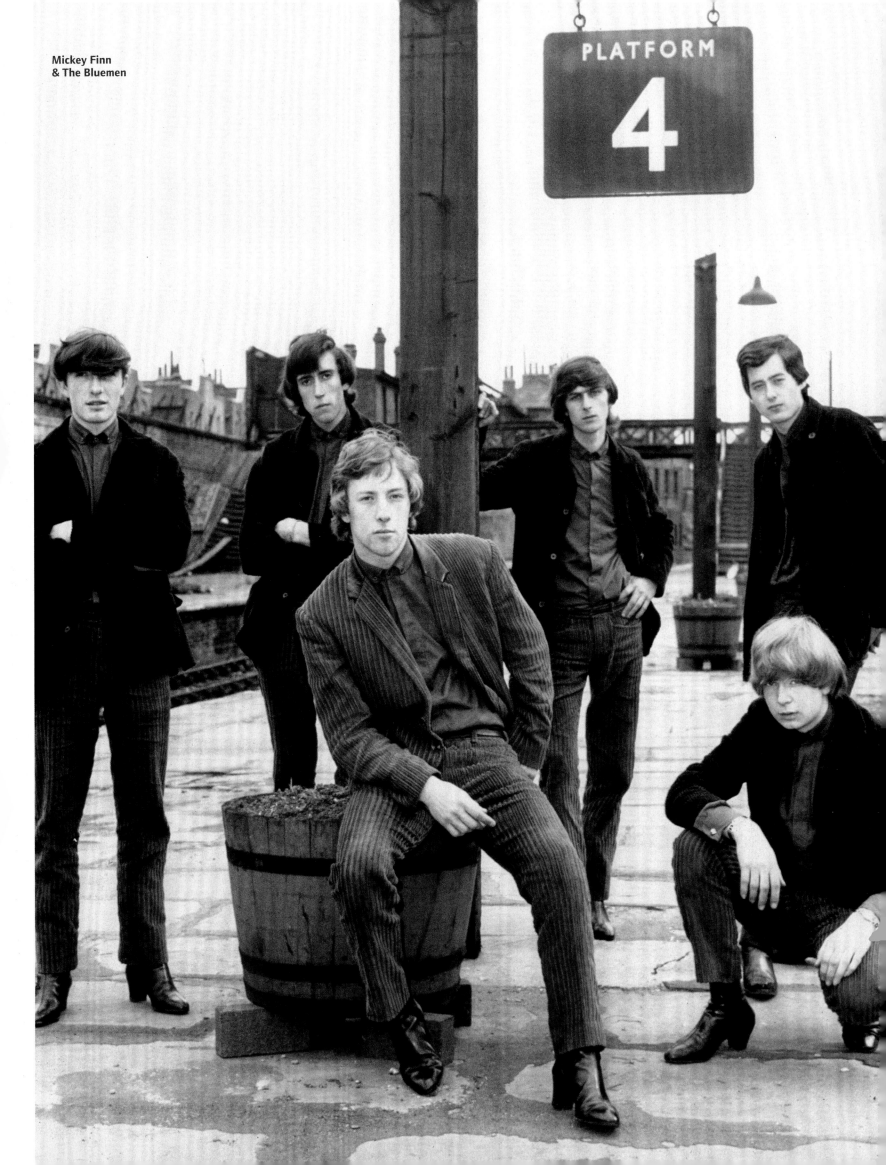

Mickey Finn
& The Bluemen

PLATFORM 4

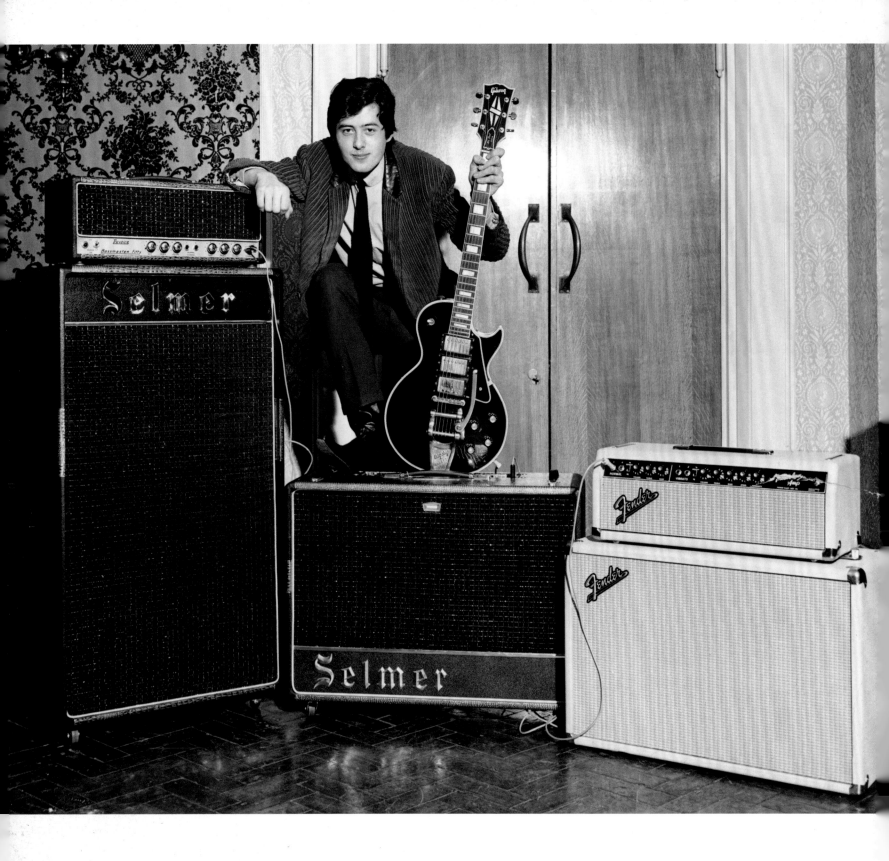

Selmer Showroom – the largest guitar store in London, on Charing Cross Road. I also bought my Danelectro from here.

During this period in the studio I introduced a distortion 'fuzz' box to the recording sessions, and it soon became a must-have accessory for guitarists in and out of the session world.

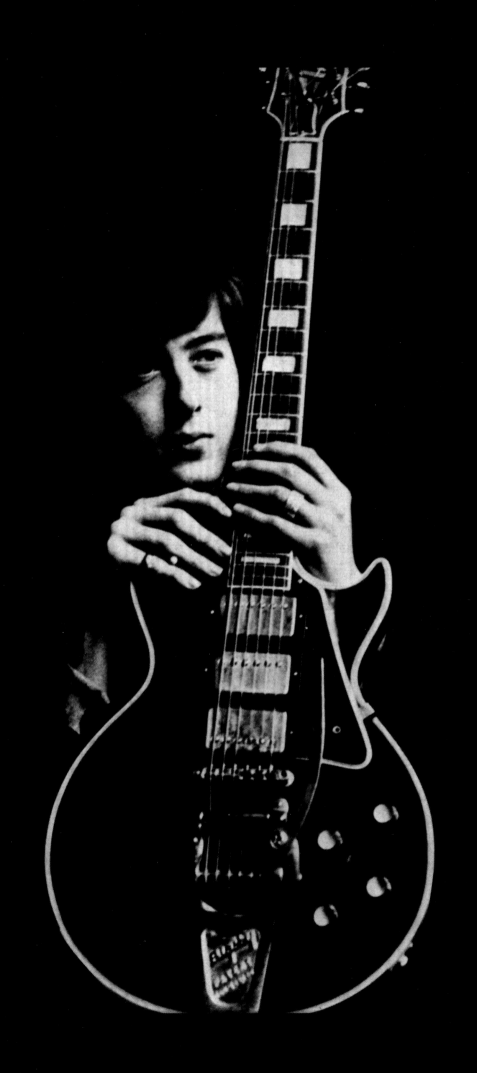

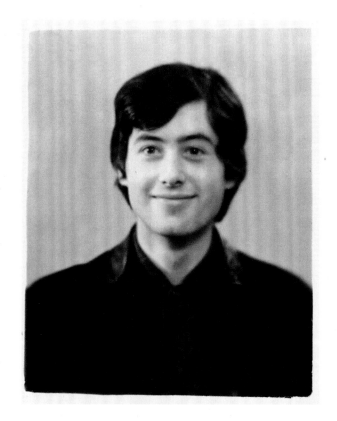

I had been called to do a session in Berlin with Caterina Valente.
This is my first passport.

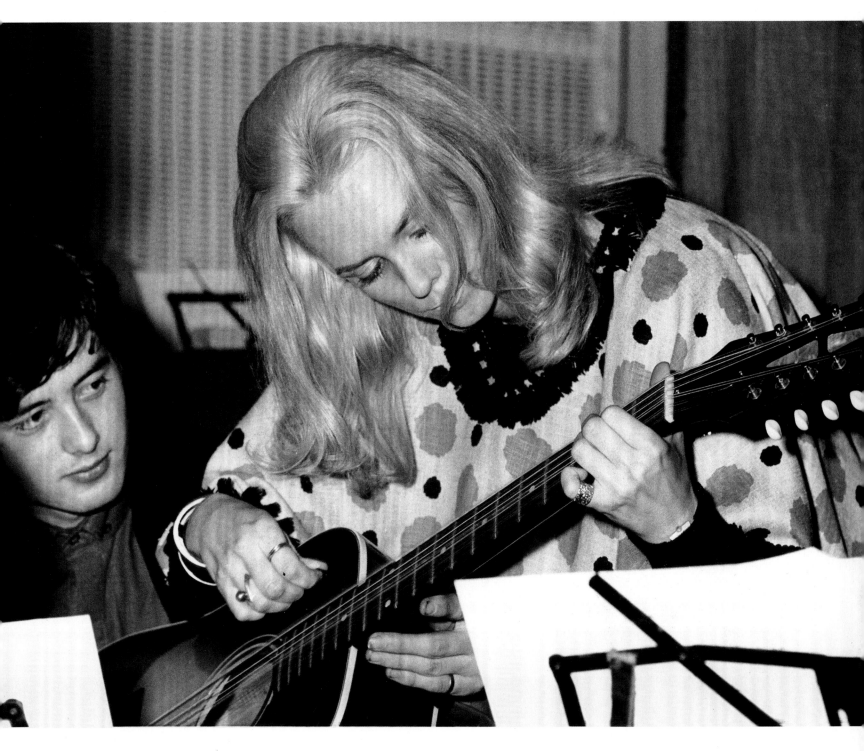

Here at EMI, on a Jackie DeShannon session. I had a chord sheet but she asked if she could show me her version, so here is a time-snap of that moment.

We wrote songs together, some to be recorded by Marianne Faithfull. And Jackie sang backing vocals on my only solo single.

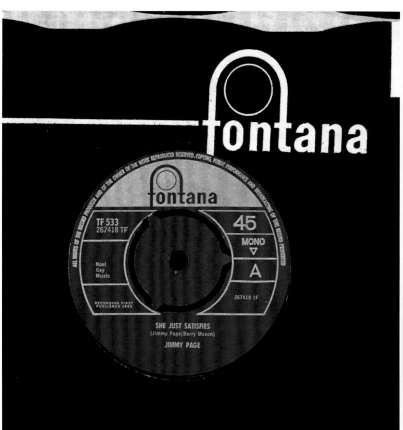

Introducing Jimmy Page

SESSION musicians are a notoriously tough lot. Usually cynical about young musicians, their respect is not easily gained. One young musician who—at the age of 19—has not only earned their respect but also their admiration is Jimmy Page.

Born in Heston, Middlesex, Jimmy concentrated his scholastic studies on art and had no ideas in becoming a musician until two years ago. Since then, he has built up a terrific reputation amongst musicians—many of whom are twice his age—as an ace guitarist.

But Jimmy is not only a talented guitarist—he also plays Dobro, harmonica and percussion instruments—and on his first disc for Fontana, sings ! The number is titled ' She Just Satisfies ' and was written by Jimmy with composer Barry Mason.

His radio debut was on ' Saturday Club,' and he made his television bow on ' Beat Room.' He recently returned from his first trip to the U.S.A., where he worked with Jackie de Shannon —they had met when Jackie visited this country late last year.

Together they wrote 8 or 9 new numbers, one of which will be the next Marianne Faithfull single in the States. Jimmy tried his hand at producing, too, while in the United States, and did many sessions in Los Angeles.

His favourite composer—which must help to make him popular with many teenagers at the moment—is Bob Dylan.

' She Just Satisfies ' backed with ' Keep Movin'' is on Fontana TF 533.

THE RELEASE OF
'SHE JUST SATISFIES'
FEBRUARY 26

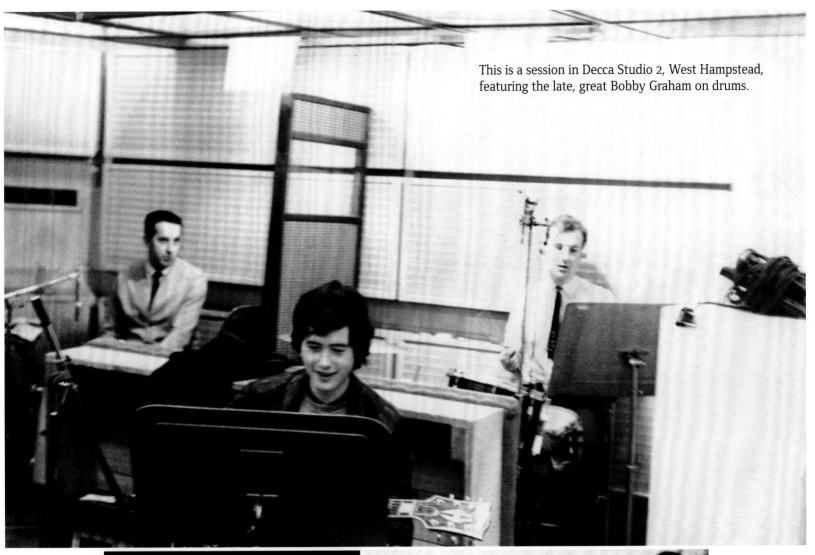

This is a session in Decca Studio 2, West Hampstead, featuring the late, great Bobby Graham on drums.

I believe this photograph (right) to be from a session at Decca Studio 1. It was a project of Mike Leander – one of the most successful arrangers of his day – where he attempted a full orchestral version using guitar players to replicate the strings of a well-known piece of classical music. There were so many guitarists, some had not been seen for years but were known by reputation. I am playing my Danelectro here with some of the more current guitarists, in particular (on the right) Joe Moretti who had made some outstanding contributions during the late Fifties, early Sixties.

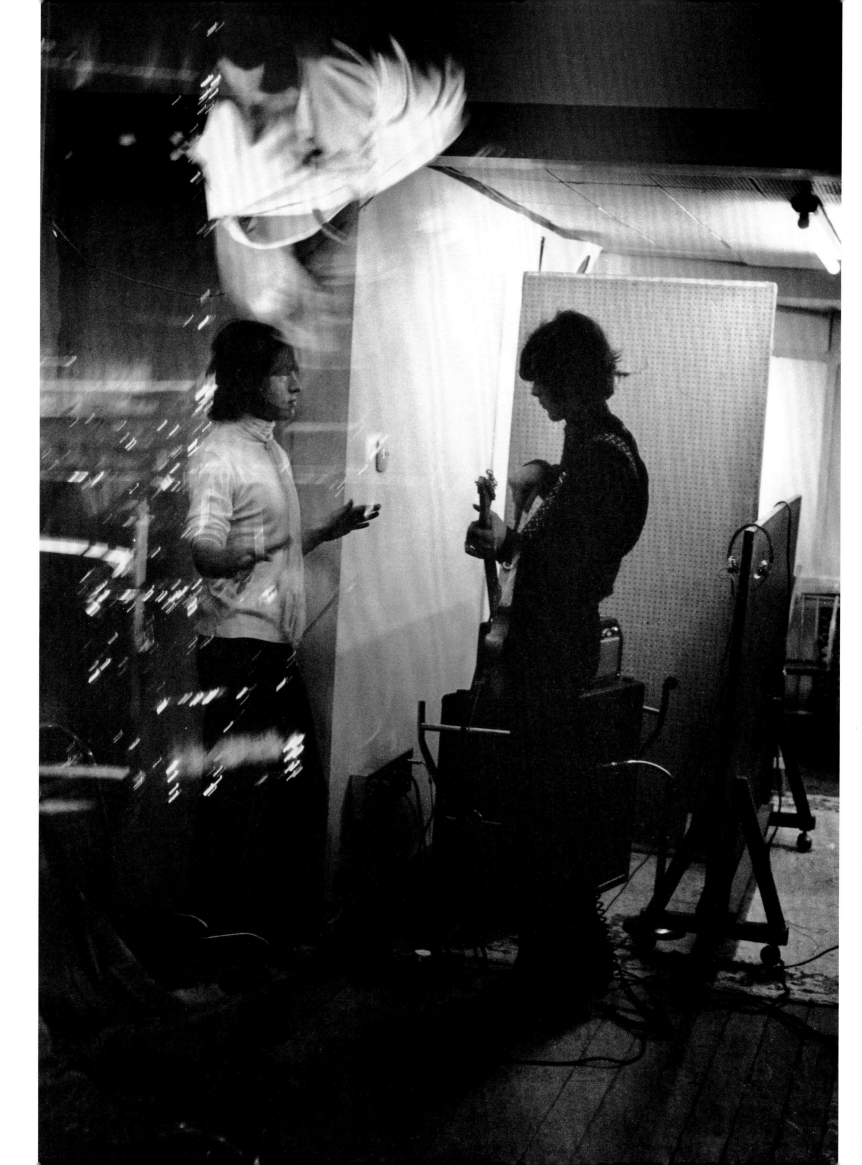

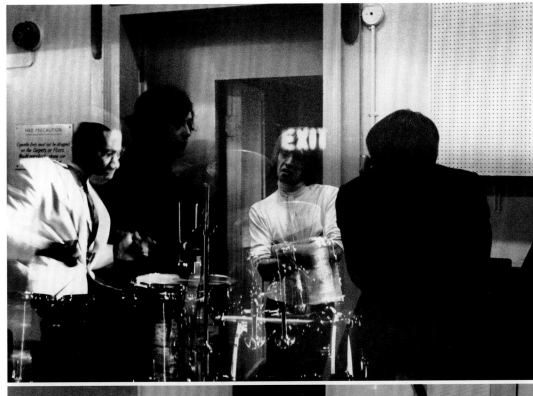

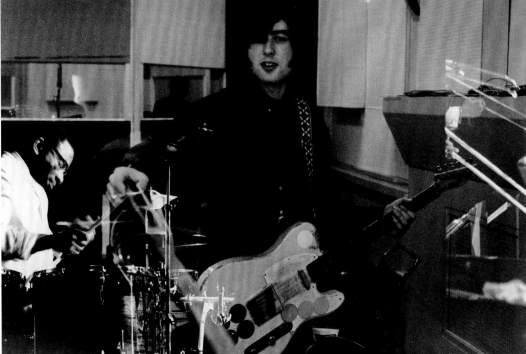

In late 1966 I did some sessions with the talented Brian Jones who was working on a soundtrack for the film *A Degree of Murder* that starred his girlfriend, Anita Pallenberg. It was featured at the Cannes Film Festival in April 1967. Key-man of The Rolling Stones, Ian 'Stu' Stewart, took these remarkable photographs whilst I was working with Brian at IBC Studio.

Stu was to appear on The Yardbirds' album *Little Games*, on the track 'Drinking Muddy Water', as well as two Zeppelin tracks: 'Rock'n'Roll' and 'Boogie With Stu'. He was without doubt one of the finest, if not the best, blues pianist in England.

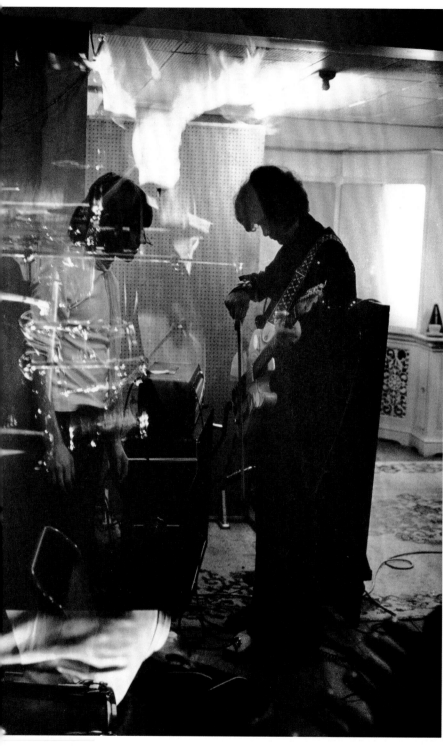

IBC Studios
London, UK

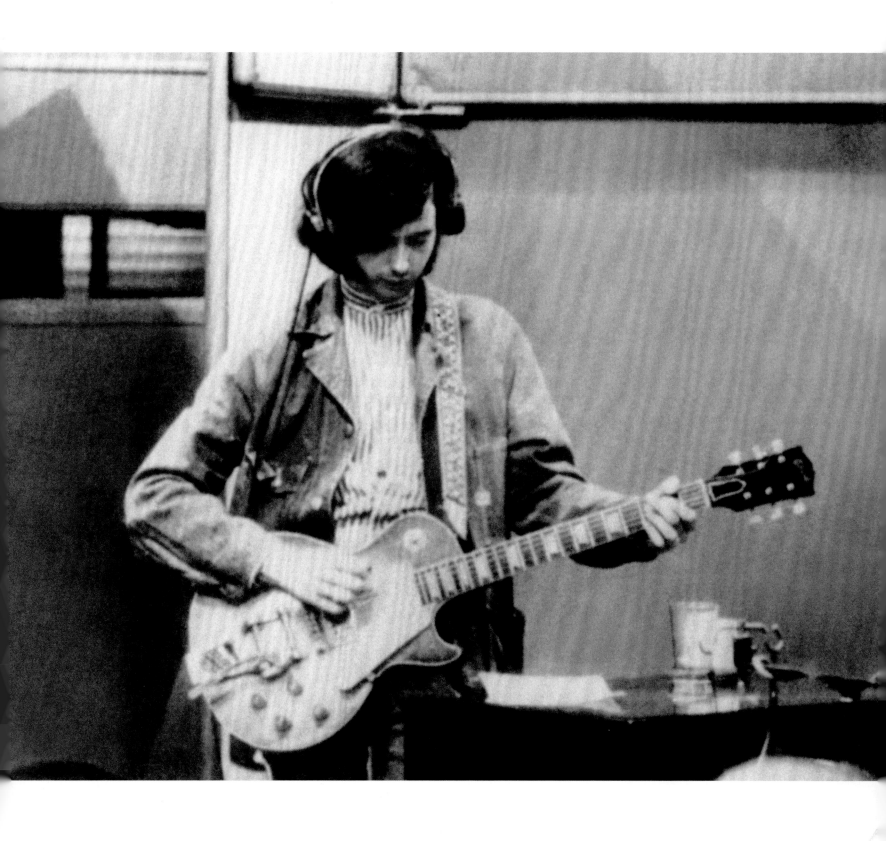

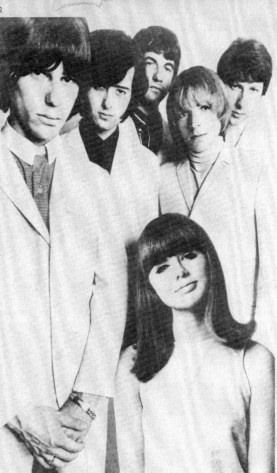

I went to a Yardbirds show at Oxford University as Jeff's guest. I believe Keith Relf really shone that night with a pre-punk ethic that was not appreciated by some of the group members. Unfortunately Paul Samwell-Smith, bass player and producer of the group, decided to quit that night. This left a vacancy for a bass player in the band who had a number of outstanding show commitments. So I joined on bass, temporarily, as Chris Dreja was going to take over the bass mantle and I would move into the front line with Jeff on guitars.

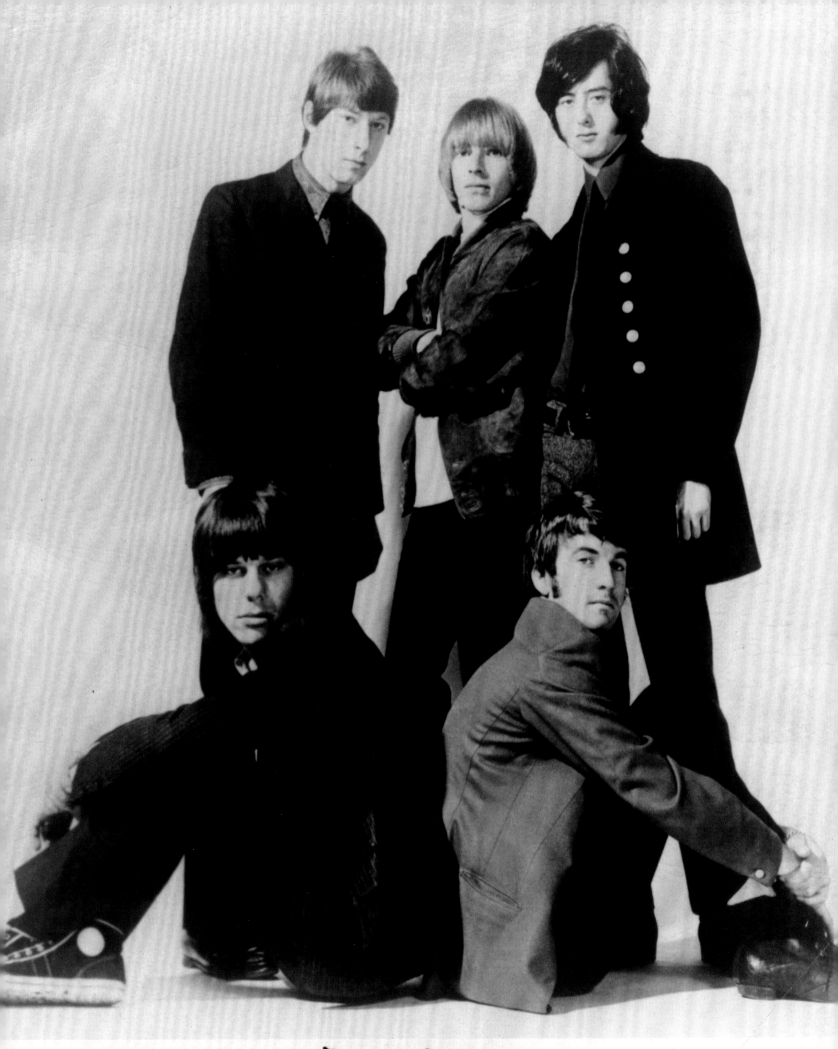

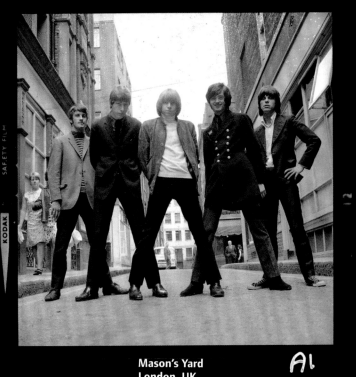

Mason's Yard
London, UK

A1

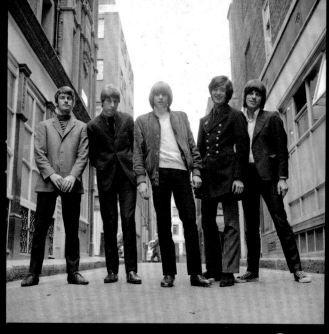

A4

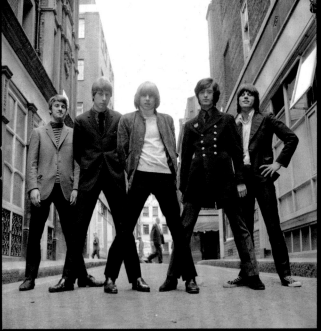

A2

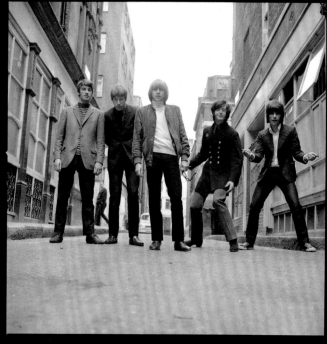

A5

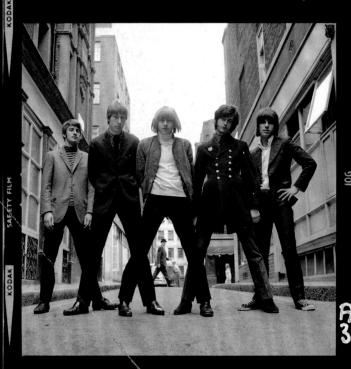

A3

A6

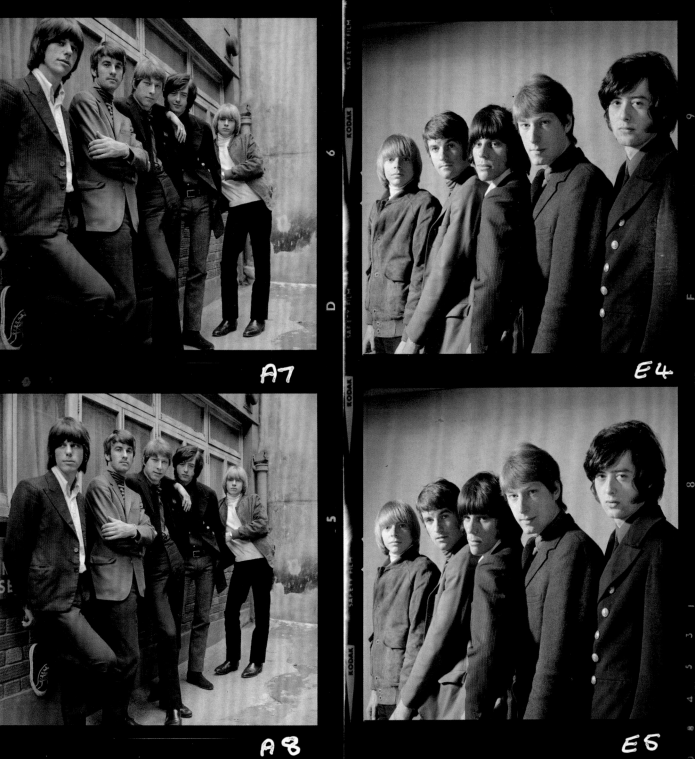

A7

E4

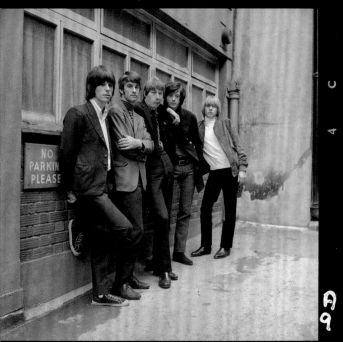

A8

E5

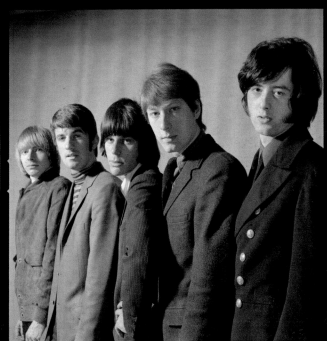

A9

E6

NO
PARKING
PLEASE

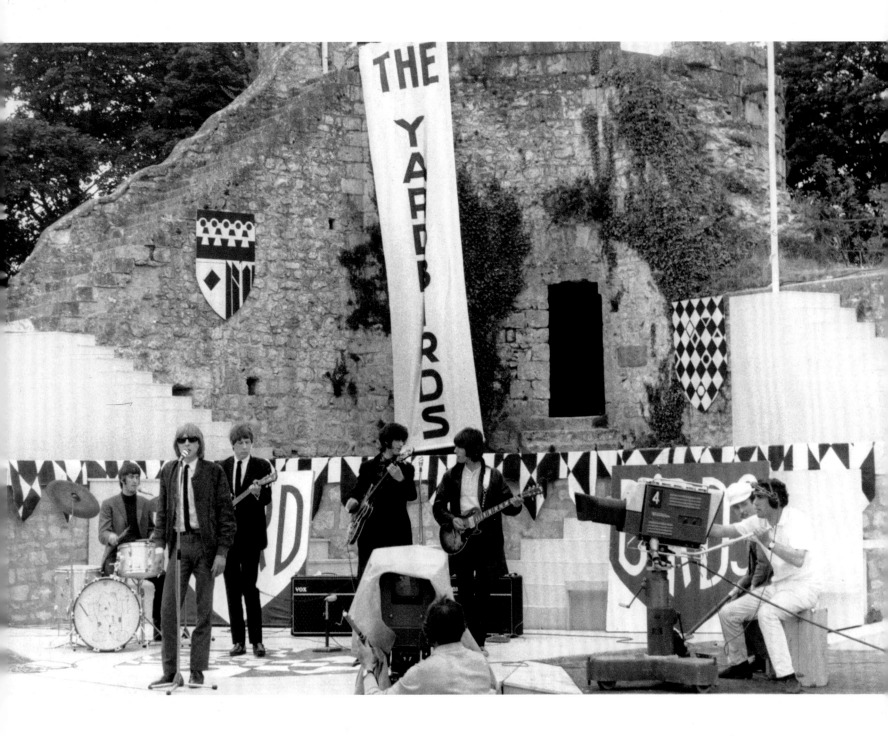

June 27
Provins Rock Festival
Provins, France

Opposite:
July 22
Ready Steady Go!
Wembley
London, UK

August 10
Green's Pavilion
Manitou Beach
Detroit, USA

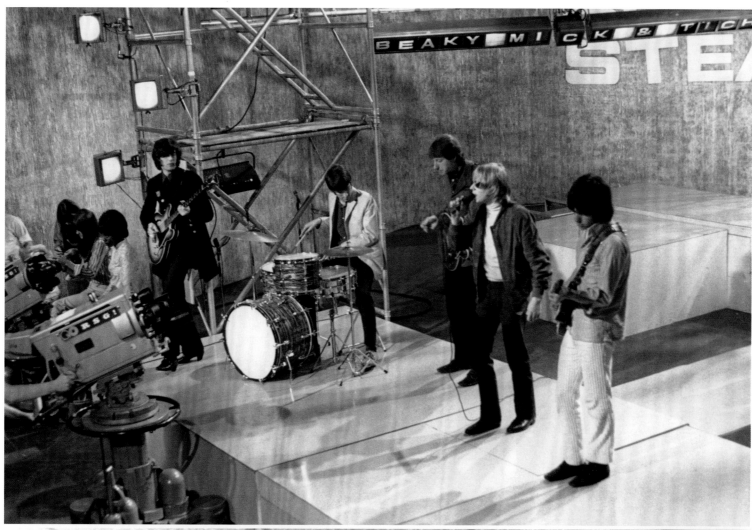
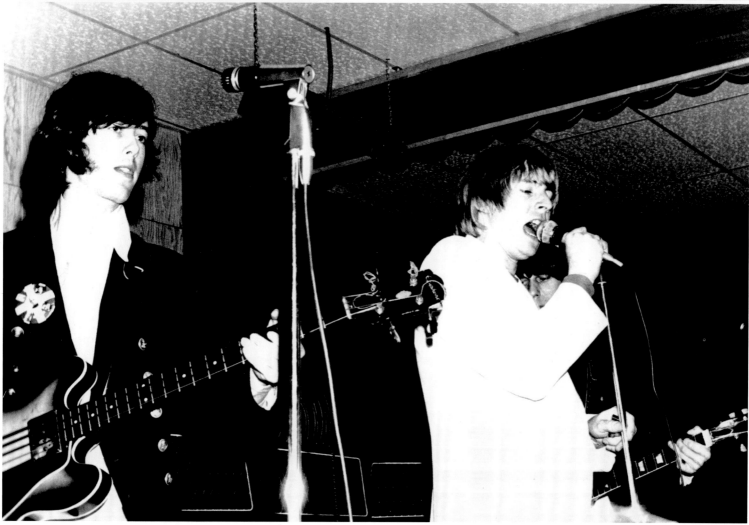

35 THE YARDBIRDS 1966

Arriving by sea plane.

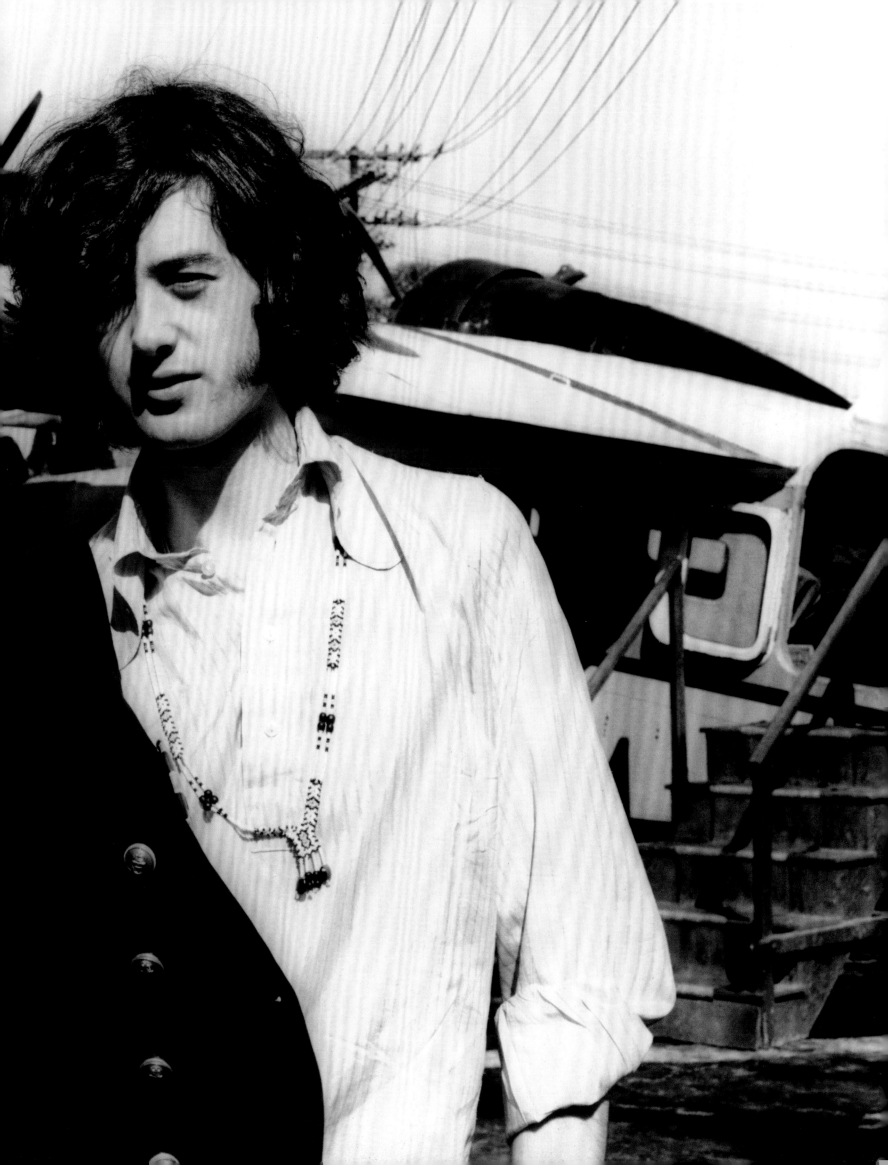

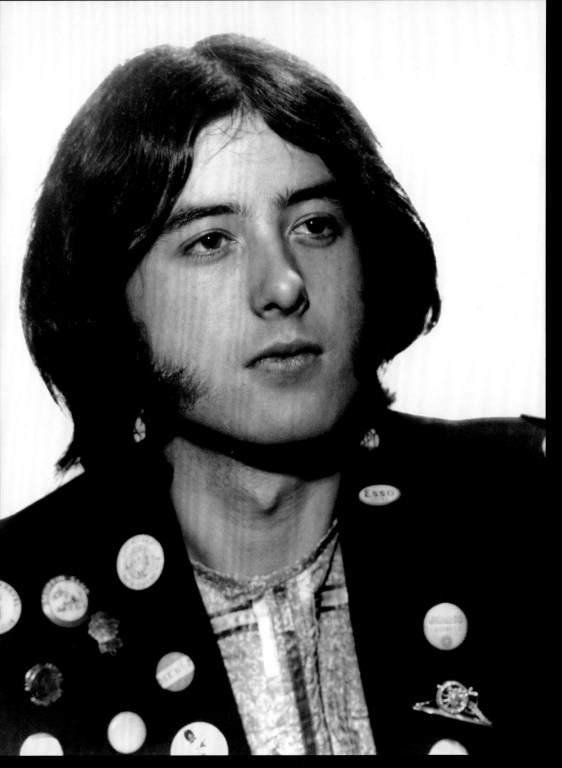

October 19
BBC TV Centre
London, UK

'Happenings Ten
Years Time Ago'
on *Top Of The Pops*

**THE RELEASE OF
'HAPPENINGS TEN YEARS
TIME AGO', OCTOBER 14**

August 10
Before the show,
Green's Pavilion
Lakeview Park
Manitou Beach
Detroit, USA

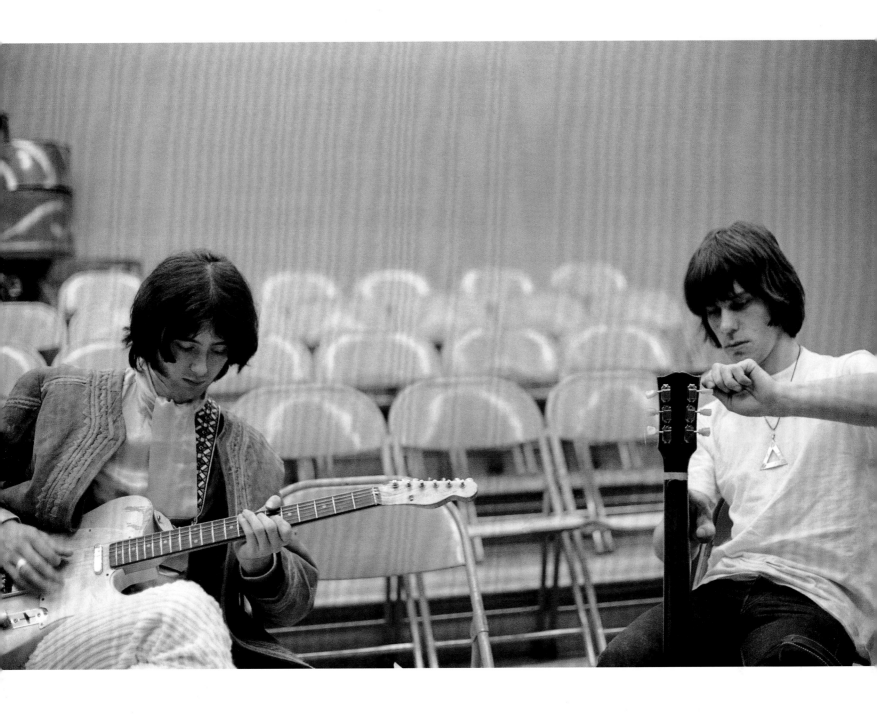

October 22
Tune-up before sound-check
Staples High School
Auditorium
Westport, USA

1966

Start of European summer tour
June 21: Marquee Club, London, UK
June 23: Mecca Palais, Ashton-under-Lyne, UK
June 24: University of Durham, Durham, UK
June 25: Palais de Danse, Bury, UK
June 26: Le Weekend Club, Paris, France
June 27: Provins Rock Festival, Provins, France
June 29: Bromley Court Hotel, Bromley, UK

July 1: Chiselhurst Caves, Chiselhurst, UK
July 2: RamJam Club, Brixton, London, UK
July 3: North Pier Pavilion, Blackpool, UK
July 5: Winter Gardens, Malvern, UK
July 7: Town Hall, Elgin, UK
July 8: Raith Ballroom, Kirkcaldy, UK
July 9: Bass Recreation Grounds, Derby, UK
July 10: Pier Pavilion, Hastings, UK
July 14: Town Hall, Kidderminster, UK
July 15: Palais de Danse, Cowdenbeath, UK
July 15: City Hall, Perth, UK
July 16: Ice Rink, Ayr, UK
July 17: Victoria Ballroom, Dunbar, UK
July 20: Town Hall, Stourbridge, UK
July 21: Assembly Rooms, Worthing, UK
July 22: *Ready Steady Go!*, Wembley, London, UK
July 23: Co-op Hall, Gravesend, UK
July 25: Bath Pavilion, Bath, UK
End of European summer tour

Start of first American tour
August 5: Dayton's Auditorium, Minneapolis, USA
[2 shows]
August 6: Civic Opera House, Chicago, USA
August 7: Maple Lake Pavilion, Mentor, USA
August 8: Detroit Lake Pavilion, Detroit Lakes, USA
August 9: Roof Garden Ballroom, Arnolds Park, USA
August 10: Green's Pavilion, Manitou Beach, USA
August 12: Indiana Beach Ballroom, Monticello, USA
[2 shows]
August 12: Cold Spring Resort, Hamilton, USA
August 13: Checkmate Young Adult Club, Amarillo, USA
August 14: State Fairgrounds, Great Falls, USA
August 16: Hal-Baby's, Denver, USA
August 17: JP's Palace, Sante Fe, USA
August 18: Tulsa Assembly Center Exhibit Hall, Tulsa, USA
August 19: Wedgewood Amusement Park,
Oklahoma City, USA
August 20: Wedgewood Amusement Park,
Oklahoma City, USA
August 21: Thrift City on Speedway, Tucson, USA
August 23: Casino Ballroom, Avalon, Catalina Island, USA
August 25: Carousel Ballroom, San Francisco, USA
[*without Jeff Beck*]
August 26: Rollarena, San Leandro, USA
[*without Jeff Beck*]
August 27: Earl Warren Showgrounds, Santa Barbara, USA
[*without Jeff Beck*]
August 27: Ventura High School Auditorium, Santa
Barbara, USA
[*without Jeff Beck*]
August 28 & 29: Whisky a Go Go, Los Angeles, USA
[Unconfirmed]
August 30: San Jose Civic Auditorium, San Jose, USA
[*without Jeff Beck*]
August 31: Rose Garden Ballroom, Pismo Beach, USA
[*without Jeff Beck*]

September 1: Civic Auditorium, Stockton, USA
[*without Jeff Beck*]
September 2: Potters Hut, Ruidoso, New Mexico
[*without Jeff Beck*]
September 3: Salem Armory Auditorium, Salem, USA
[*without Jeff Beck*]
September 4: HIC Exhibition Hall, Honolulu, Hawaii, USA
[*without Jeff Beck*]
September 7: Civic Auditorium, Santa Monica, USA
[*without Jeff Beck*]
September 9: Alexandria Roller Rink, Alexandria, USA
[*without Jeff Beck*]
September 10: Baltimore Civic Center, Baltimore, USA
[*without Jeff Beck*]
End of first American tour

Start of UK autumn tour
September 23: Royal Albert Hall, London, UK [2 shows]
September 24: Odeon Theatre, Leeds, UK [2 shows]
September 25: Empire Theatre, Liverpool, UK [2 shows]
September 28: ABC Theatre, Manchester, UK [2 shows]
September 29: ABC Theatre, Stockton, UK [2 shows]
September 30: Odeon Theatre, Glasgow, UK [2 shows]

October 1: City Hall, Newcastle, UK [2 shows]
October 2: Gaumont Theatre, Ipswich, UK [2 shows]
October 6: Odeon Theatre, Birmingham, UK [2 shows]
October 7: Colston Hall, Bristol, UK [2 shows]
October 8: Capitol Theatre, Cardiff, UK [2 shows]
October 9: Gaumont Theatre, Southampton, UK [2 shows]
End of UK autumn tour

October 14: Elstree Film Studios, Borehamwood, UK
[wrap party for *Blow Up*]
October 19: *Top Of The Pops*, BBC TV Centre, London, UK
October 21: The Comic Strip, Worcester, USA
October 22: Staples High School Auditorium,
Westport, USA
October 23: Fillmore West, San Francisco, USA

Start of second American tour: Dick Clark Caravan of Stars
October 29: Memorial Auditorium, Dallas, USA
October 30: Harlingen Civic Auditorium, Harlingen, USA
October 30: Memorial Coliseum, Corpus Christi, USA
[Jeff Beck leaves after this show]
October 31: Municipal Auditorium, Beaumont, USA
[2 shows]

November 1: Rapides Parish Coliseum, Louisiana State
University, Alexandria, USA
November 2: Southern State College Field House,
Magnolia, USA
November 3: Decatur High School Auditorium,
Decatur, USA
November 5: Memorial Building Auditorium,
Kansas City, USA
November 6: Bartlesville Civic Center, Bartlesville, USA
November 6: Tulsa Assembly Center Arena, Tulsa, USA
November 7: Chanute Auditorium, Chanute, USA
November 8: RKO Orpheum Theater, Davenport, USA
November 9: Memorial Field House, Indiana State
University, Terre Haute, USA
November 10: Kiel Auditorium, St Louis, USA
November 11: Coliseum, Indianapolis, USA
November 12: Akron Civic Center, Akron, USA
November 12: Grover Center, Ohio University, Athens, USA
November 13: Baltimore Civic Center Arena,
Baltimore, USA
November 14: Paintsville High School, Paintsville, USA
November 15: Diddle Arena, University of Western
Kentucky, Bowling Green, USA
November 16: Memorial Gymnasium, Tennessee
Technological University, Cookeville, USA
November 17: Field House, University of Tennessee,
Martin, USA
November 18: Michigan State Fair Coliseum, Detroit, USA
[2 shows]
November 19: Michigan State Fair Coliseum, Detroit, USA
[2 shows]
November 20: Michigan State Fair Coliseum, Detroit, USA
[2 shows]
November 21: Richmond Civic Hall, Richmond, USA
November 22: Pittsburgh Civic Arena, Pittsburgh, USA
November 23: Pittsburgh Civic Arena, Pittsburgh, USA
November 26: Washington Coliseum, Washington, USA
[2 shows]
November 27: Veterans Memorial Field House,
Huntingdon, USA
End of second American tour: Dick Clark Caravan of Stars

December 2: Baldwin-Wallace College, Berea, USA
December 4: Springbrook Gardens Teen Club, Lima, USA
[2 shows]
December 10: Bristol University, Bristol, UK
December 13: Aberystwyth University, UK
December 15: Hull University, Hull, UK
December 23: Wembley Studios, London, UK

Start of third American tour
December 27: The Fifth Dimension, Ann Arbor, USA
[2 shows]
December 28: Expo Gardens Youth Building, Peoria, USA
[2 shows]
December 29-January 2: USA [Unconfirmed dates and
venues]
End of third American tour

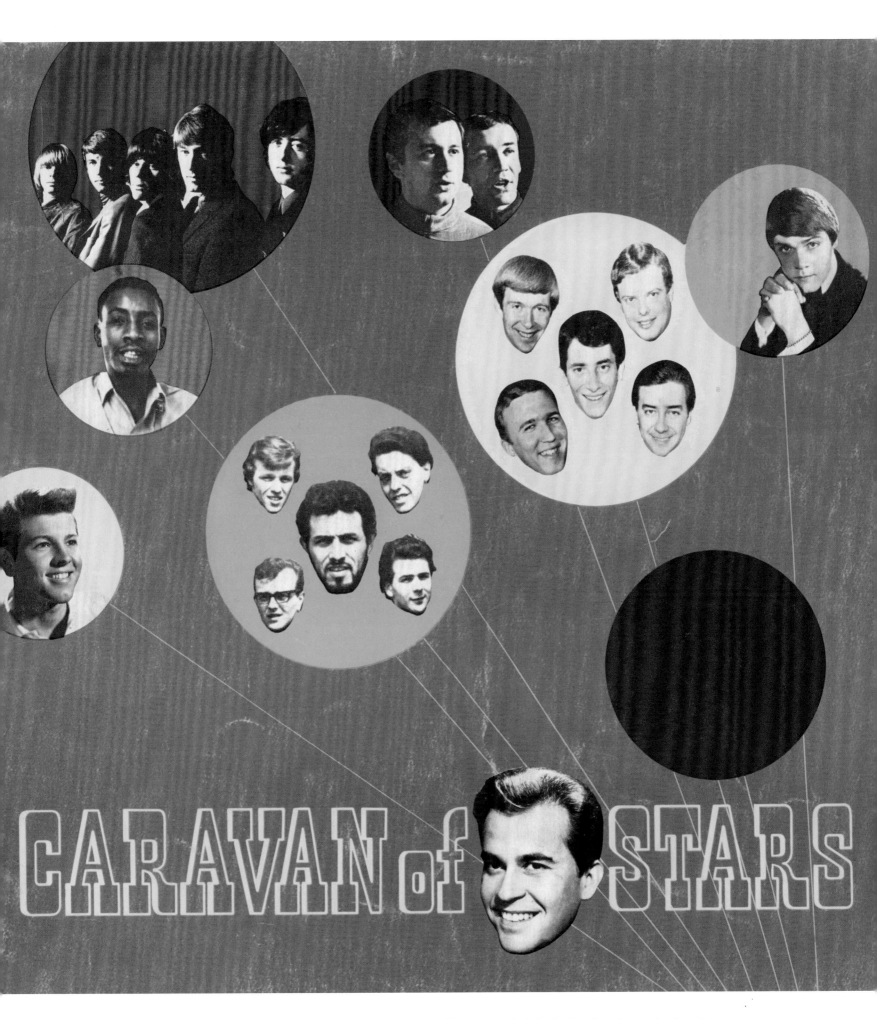

It was after a few days into the Dick Clark tour that Jeff temporarily left the band and went back to LA.

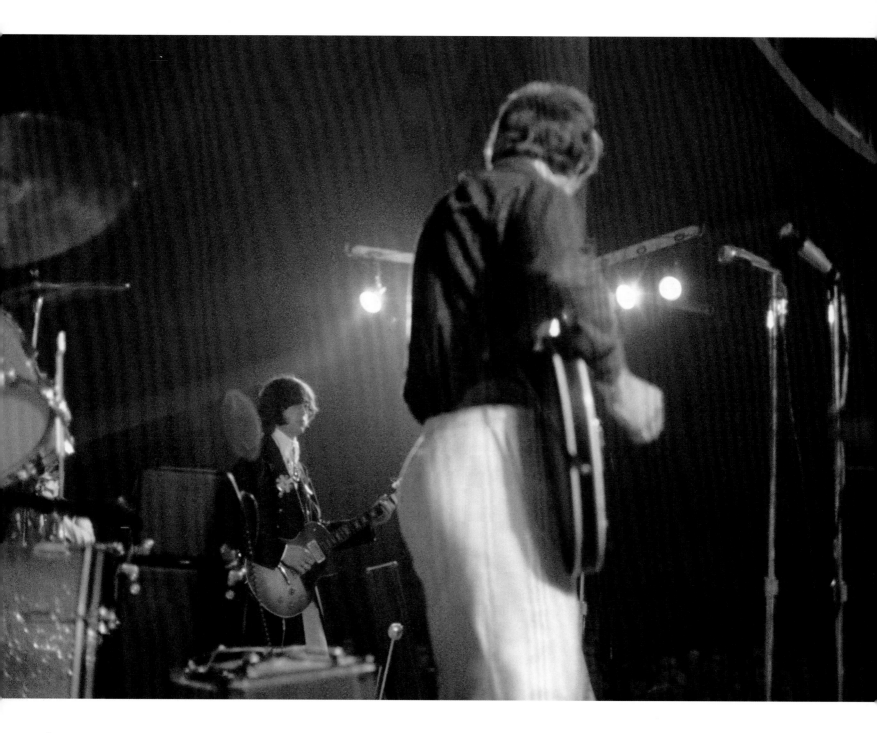

August 27
Earl Warren Showgrounds
Santa Barbara, USA

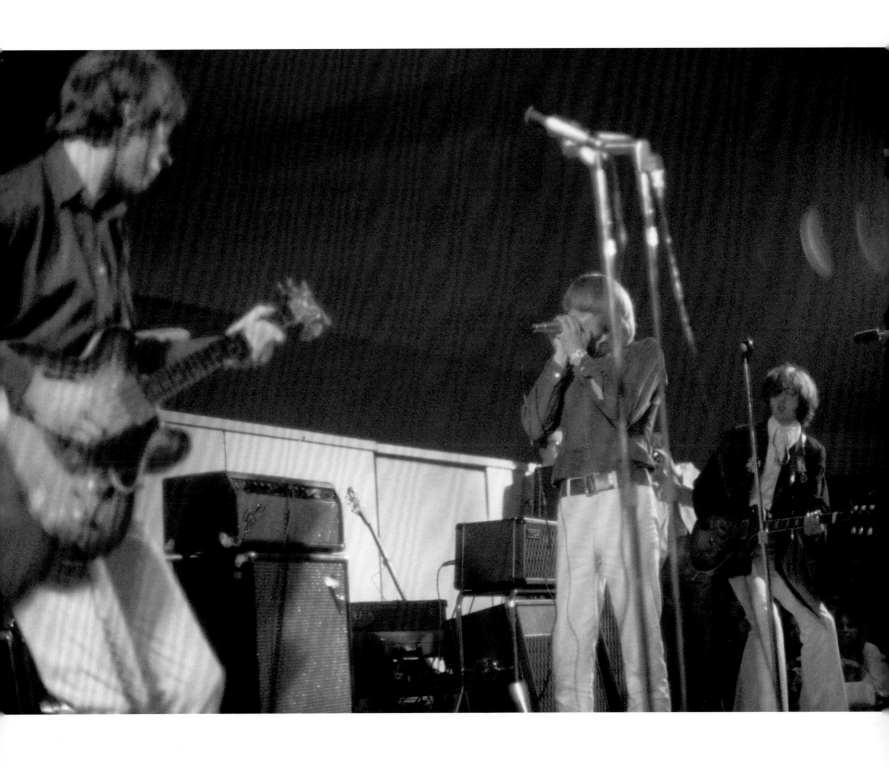

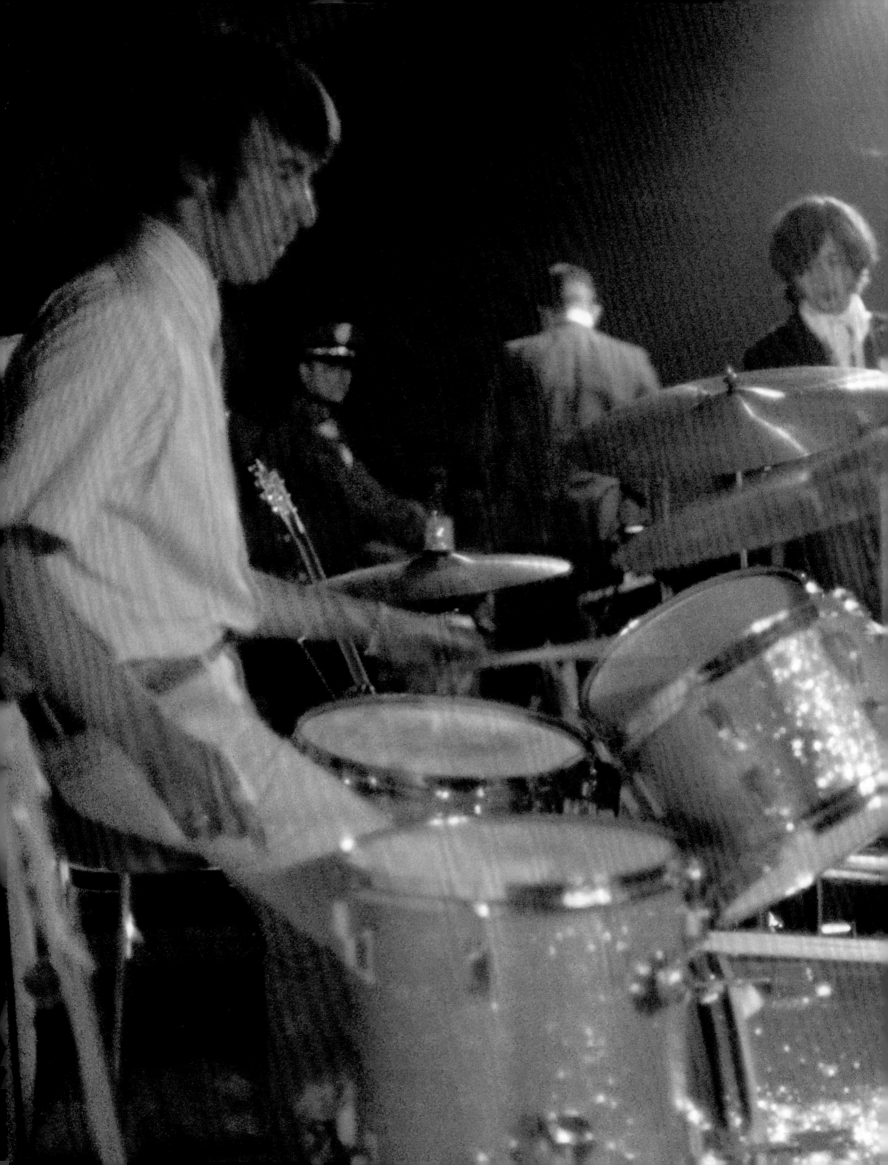

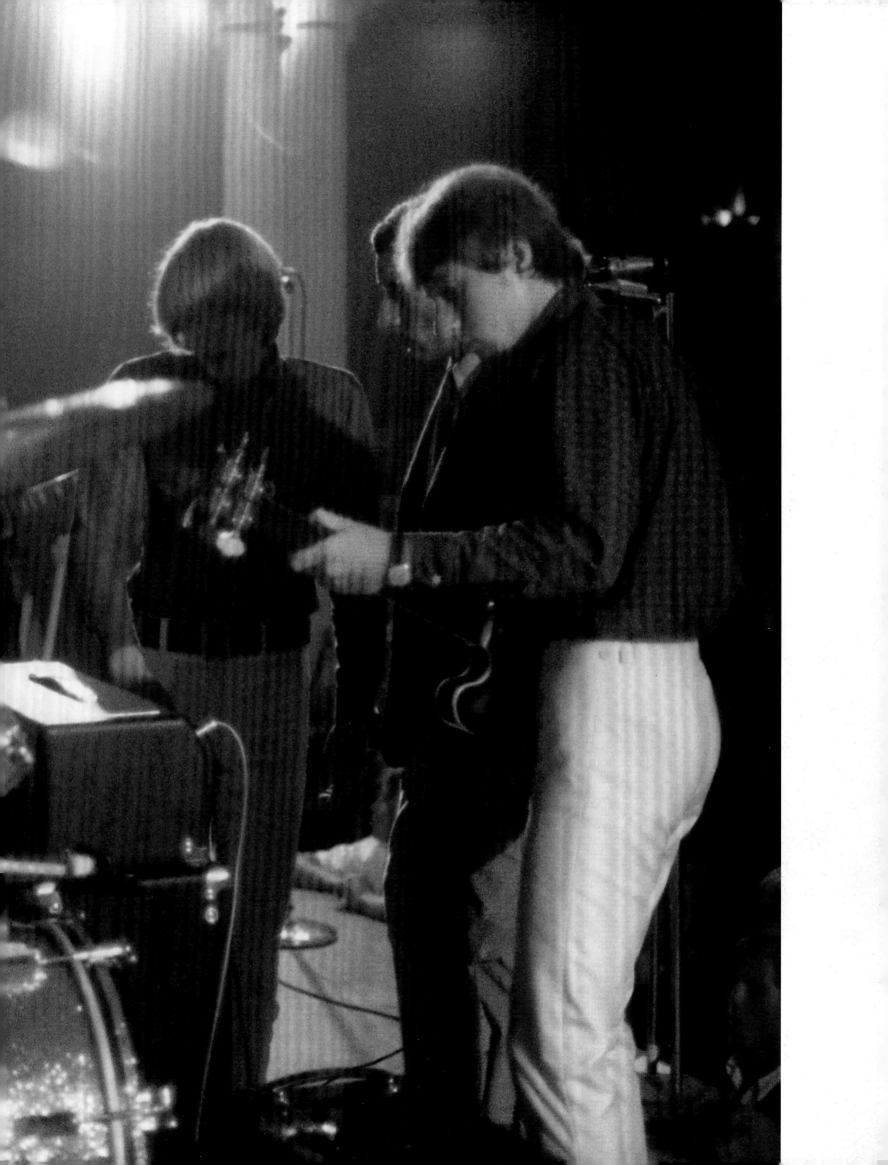

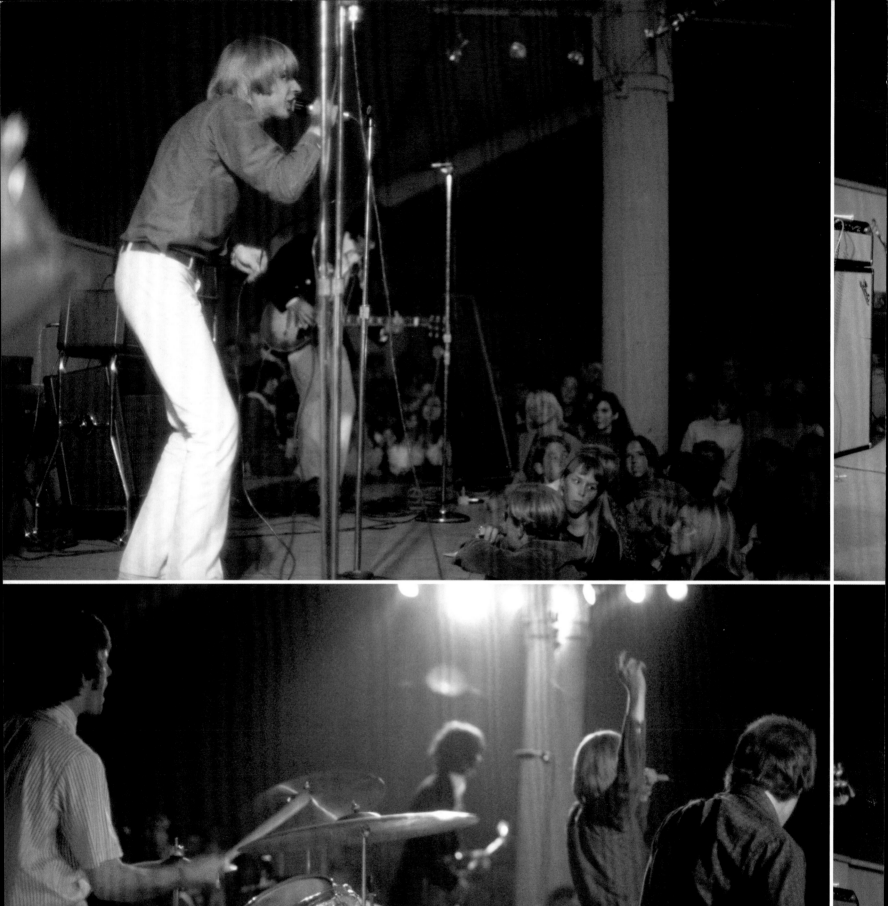

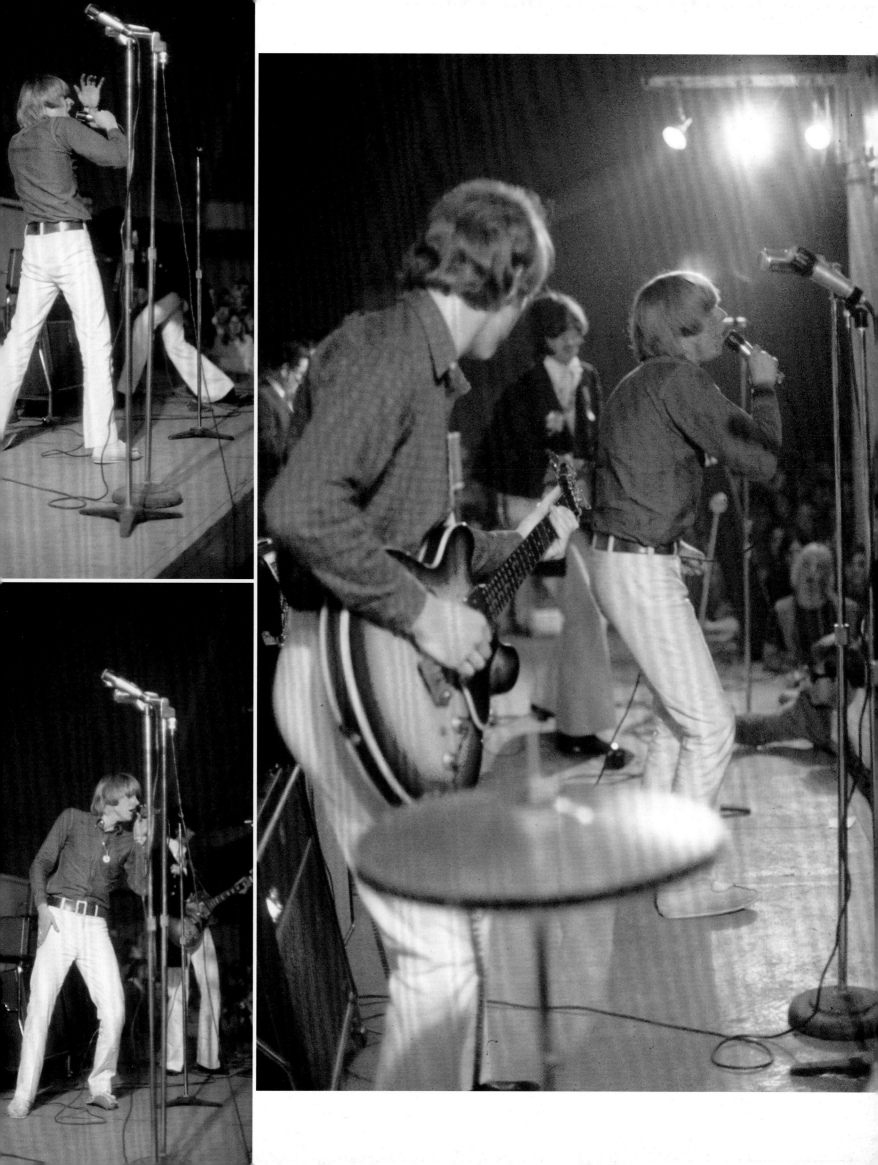

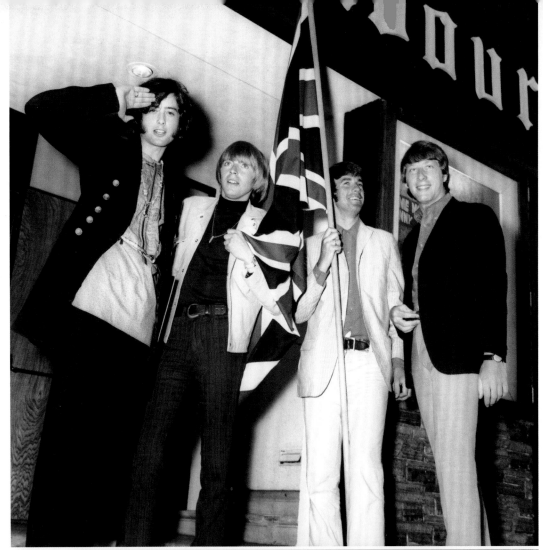

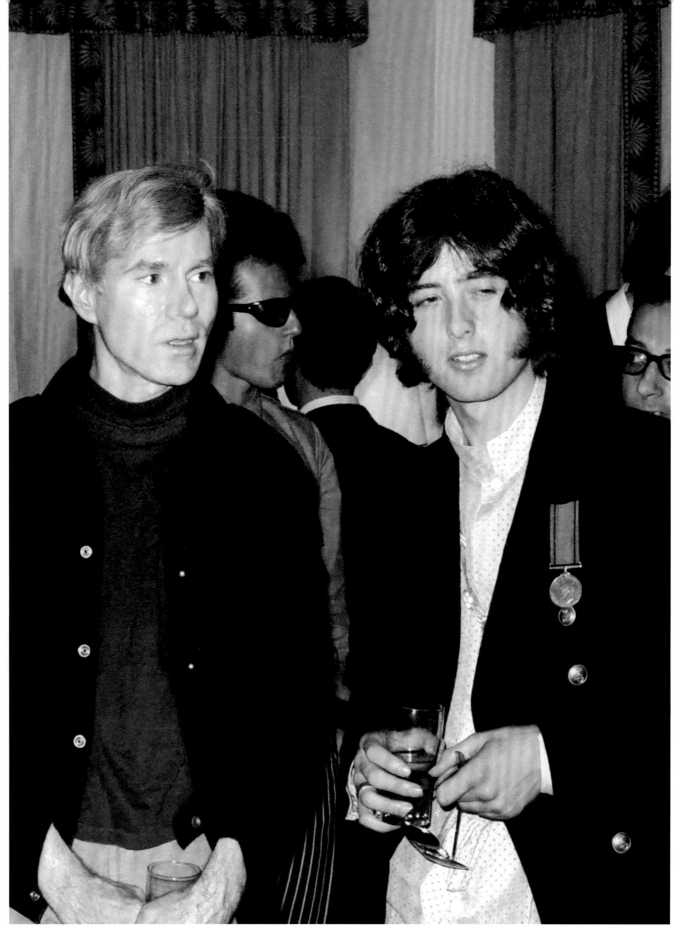

I met Andy Warhol in New York and he invited me for a screen test at
The Factory. We met again in Detroit at an aftershow following one of
the last dates of the Dick Clark tour. He had travelled to Detroit with
The Velvet Underground.

1967

January 6: Denmark
January 7: Denmark
January 8: Denmark

Start of Australasian tour
January 17: National Theatre, Singapore
January 21: Sydney Stadium, Sydney, Australia [2 shows]
January 22: Sydney Stadium, Sydney, Australia [2 shows]
January 25: Centennial Hall, Adelaide, Australia [2 shows]
January 26: Festival Hall, Melbourne, Australia [2 shows]
January 27: Festival Hall, Melbourne, Australia [2 shows]
January 28: Festival Hall, Brisbane, Australia [2 shows]
January 30: Theatre Royal, Christchurch, New Zealand [2 shows]
January 31: Town Hall, Wellington, New Zealand [2 shows]

February 1: Founders Theatre, Hamilton, New Zealand [2 shows]
February 2: Town Hall, Auckland, New Zealand [2 shows]
End of Australasian tour

Start of European tour
March 9: Radio Caroline Club, Paris, France
March 15: Stadthalle, Offenbach, Germany

April 13: Boom, Arhus, Denmark
April 14: Teatersalen, Fredericia, Denmark
April 14: Vesterhavshallen, Ringkjobing, Denmark
April 15: Holte Hallen, Holte, Denmark
April 15: Brondby Pop-Club, Brondby, Denmark
April 15: Balleruphallen, Ballerup, Denmark
April 16: Reventlowparken, Lolland, Denmark
April 30: Grand Spectacle de Jeunes, Chaville, France

May 7: *NME* Poll Winners Concert, Wembley, London, UK
May 8: Cannes Film Festival, Cannes, France
May 20: HEC Business School, Jouy en Josas, France
May 26: Tiles Club, London, UK
May 29: City Football Club, Cambridge, UK

June 2: University of Kent, Canterbury, UK
June 5: Bath Pavilion, Bath, UK
June 17: Raven Club, RAF Waddington, UK
June 18: Saville Theatre, London, UK

July 1: Roundhouse, London, UK
End of European tour

Start of fourth American tour
July 7: Garden Auditorium/Kerrisdale Arena, Vancouver, Canada [2 shows]
July 8: Garden Auditorium/Kerrisdale Arena, Vancouver, Canada [2 shows]
July 10: Teensville, Theinsville, USA
July 11: New Place, Algonquin, USA
July 12: Crimson Cougar, Aurora, USA
July 19: Lakeside Amusement Park, Colorado Springs, USA
July 21: Santa Rosa Fairgrounds, Santa Rosa, USA
July 22: Santa Monica Civic Auditorium, Santa Monica, USA
July 25: Fillmore West, San Francisco, USA
July 26: Fillmore West, San Francisco, USA
July 27: Fillmore West, San Francisco, USA
July 28: Governors Hall, Sacramento, USA
July 29: Concord Fairgrounds, Concord, USA
July 29: San Ramon High School Stadium, Danville, USA
July 31: Kerrisdale Arena, Vancouver, Canada

August 1: The Garden Auditorium, Vancouver, Canada
August 9: Tippy Ballroom, Lake Tippecanoe, USA
End of fourth American tour

Start of fifth American tour
August 24: Surf Nantasket, Hull, USA
August 25: Village Theater, New York, USA [2 shows]
August 26: Hidden Valley Ski Resort, Huntsville, Canada
August 27: Rocky Point Park, Rhode Island, USA
End of fifth American tour

Start of sixth American tour
October: Orlando Coliseum, Orlando, USA [Unconfirmed]
October 7: Mountain Park, Holyoke, USA
October 28: Washington University Fieldhouse, St. Louis, USA

November 3: Village Theater, New York, USA [2 shows]
November 4: Village Theater, New York, USA [Unconfirmed]
November 5: Village Theater, New York, USA [Unconfirmed]
November 6: Village Theater, New York, USA [Unconfirmed]
November 7: Village Theater, New York, USA [Unconfirmed]
November 8: Village Theater, New York, USA [Unconfirmed]
End of sixth American tour

1968

January 3: Corn Exchange, Chelmsford, UK
January 19: Middle Earth Club, London, UK

March 2: Southampton University, Southampton, UK
March 8: Aston, Birmingham, UK
March 9: Faculté d'Assas, Paris, France
March 10: Olympia, Paris, France
March 16: Luton, UK
March 23: Retford, UK

Start of seventh American tour
March 28: The Aerodome, Schenectady, USA
March 29: Clarkson University, Potsdam, USA
March 30: Anderson Theater, New York, USA

April 8: Thee Image, Miami Beach, USA
April 9: Thee Image, Miami Beach, USA
April 10: Thee Image, Miami Beach, USA
April 12: Action House, Island Park, USA
April 13: Action House, Island Park, USA
April 14: Action House, Island Park, USA
April 25: Allen Theater, Cleveland, USA
April 26: Cincinnati Convention Center, Cincinnati, USA
April 28: Brown University, Providence, USA
April 29: University of Massachusetts, Amherst, USA

May 3: The Grande Ballroom, Detroit, USA
May 4: The Grande Ballroom, Detroit, USA
May 5: Hullabaloo, Mentor, USA
May 10: Earl Warren Showgrounds, Santa Barbara, USA
May 11: Melodyland Theatre, Anaheim, USA
May 23: Fillmore West, San Francisco, USA
May 24: Fillmore West, San Francisco, USA
May 25: Fillmore West, San Francisco, USA
May 31: Shrine Exposition Hall, Los Angeles, USA

June 1: Shrine Exposition Hall, Los Angeles, USA
June 4: Montgomery International Speedway, Montgomery, USA
June 5: Montgomery International Speedway, Montgomery, USA
End of seventh American tour

July 7: Luton Technical College, Luton, UK [Unconfirmed]

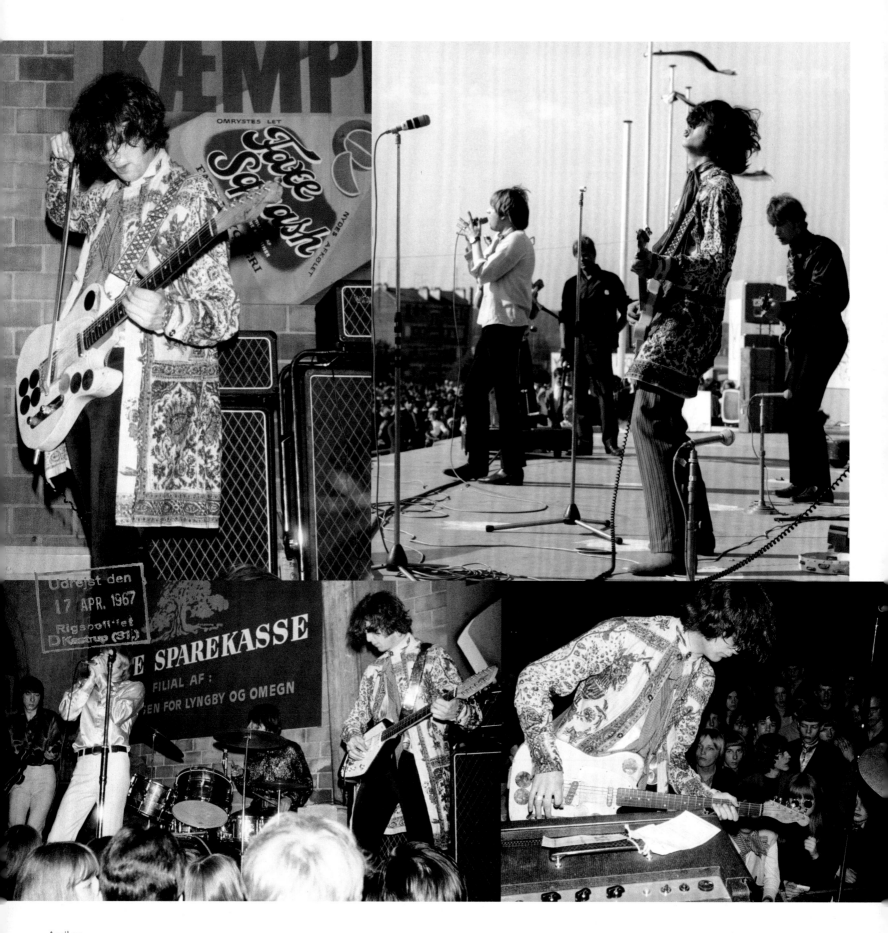

April 15
Holte Hallen
Holte, Denmark

Top right & opposite:
April 30
Grand Spectacle de Jeunes
Chaville, France

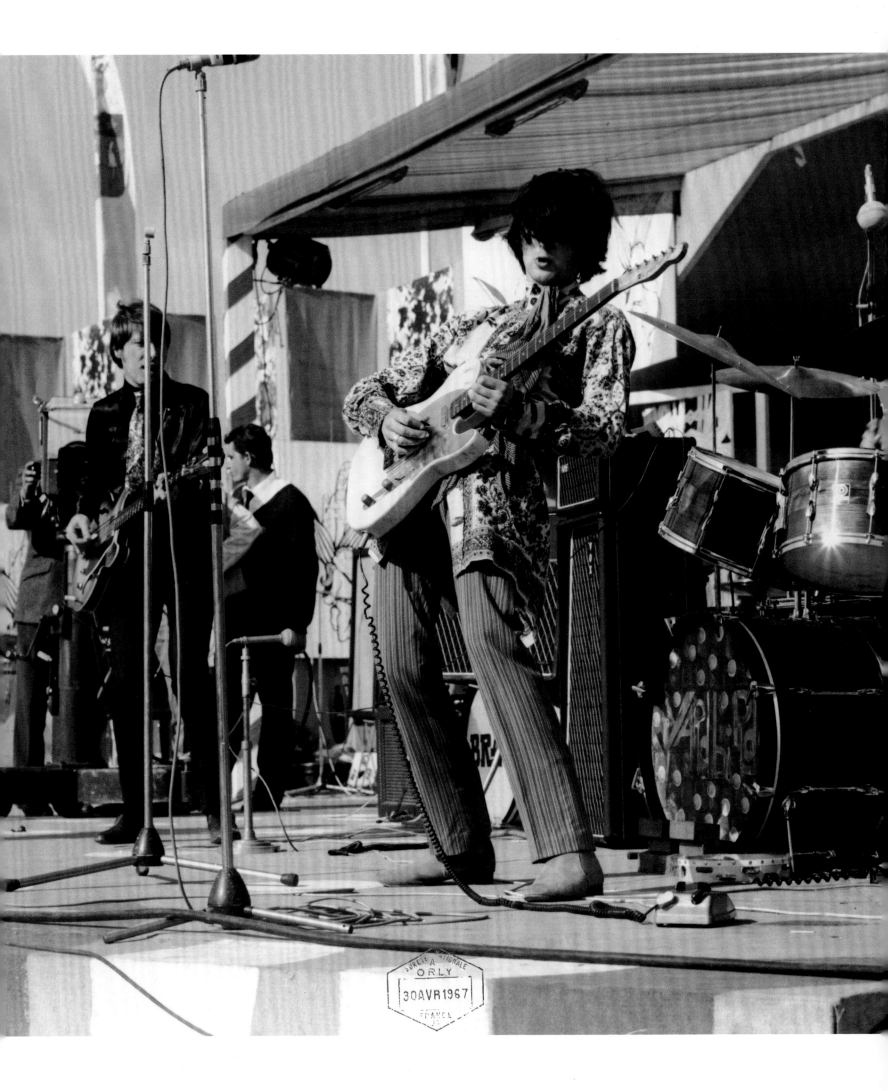

55 THE YARDBIRDS 1967

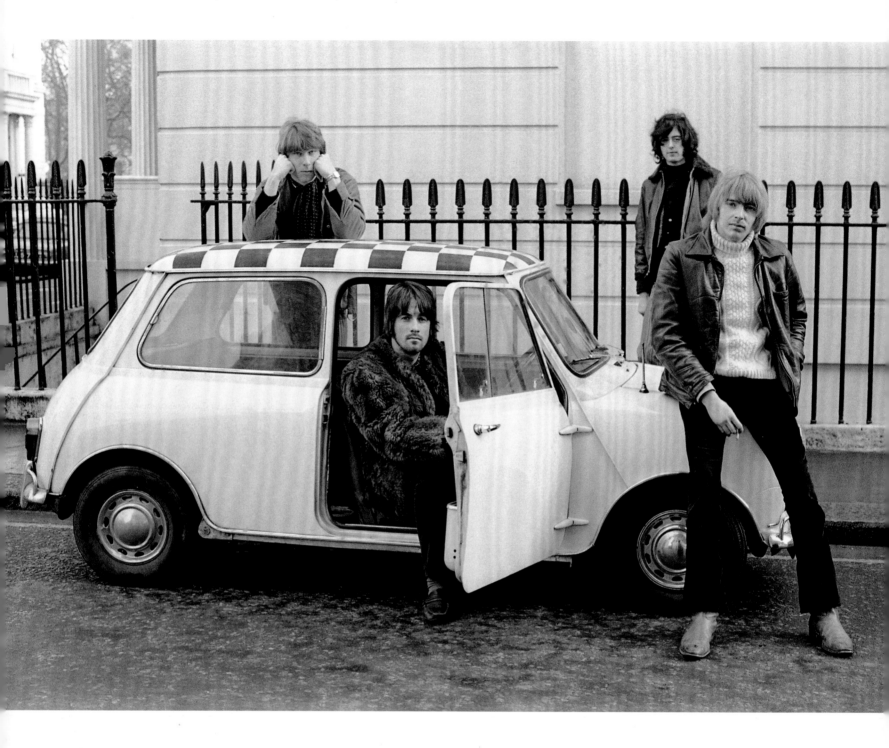

It's Jim McCarty's Mini. These photographs were taken
near his flat in Hollywood Road, and standing outside the
infamous Baghdad House, a café on Fulham Road.

THE RELEASE OF
LITTLE GAMES, JULY 24

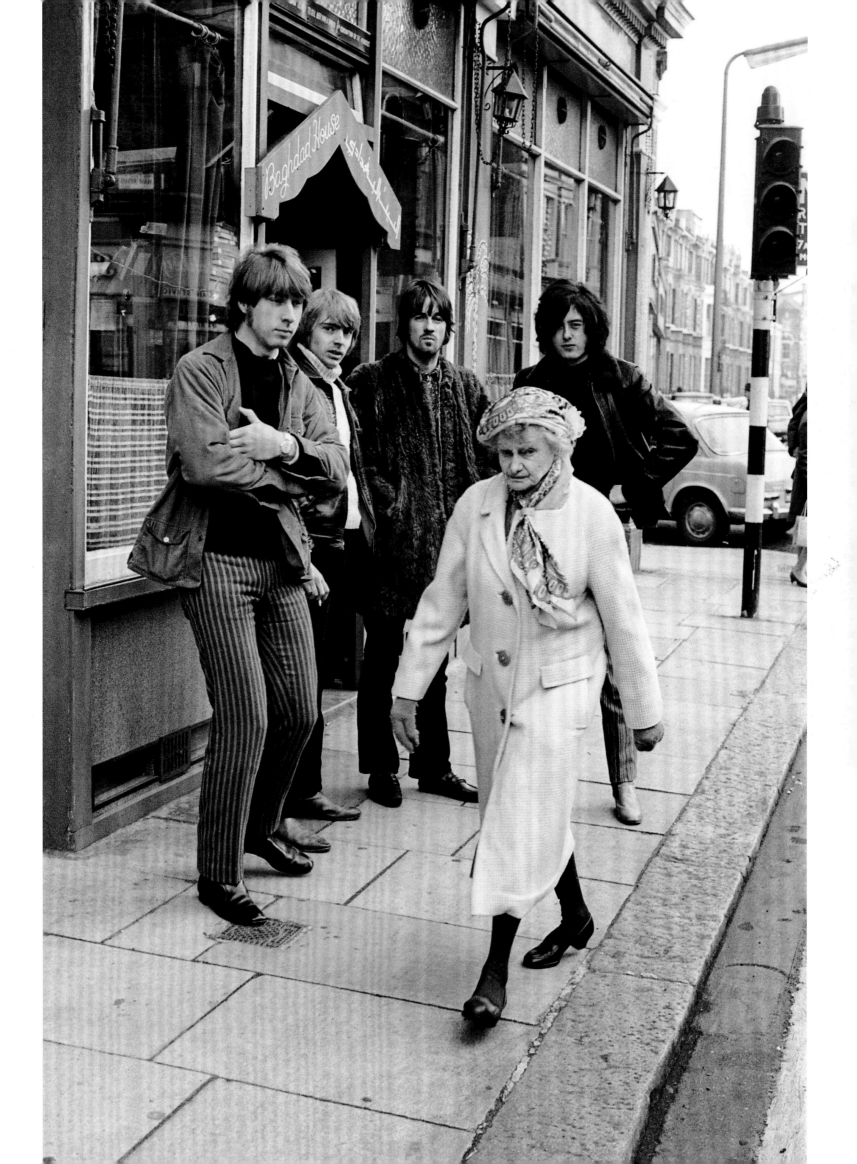

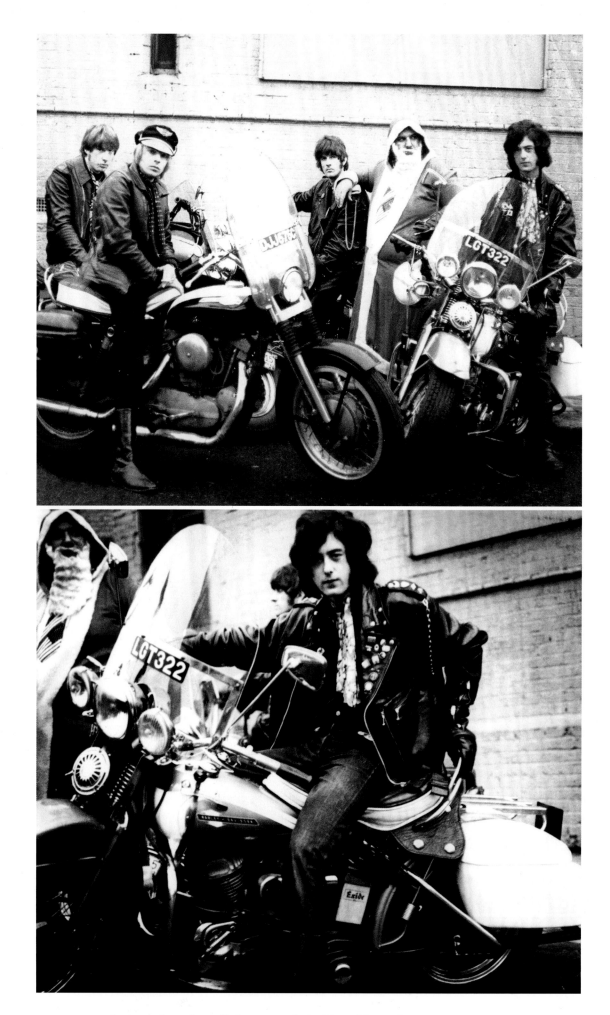

A photo shoot for a Christmas card. An idea of Peter Grant's:
the photographs were taken but the card never materialised.

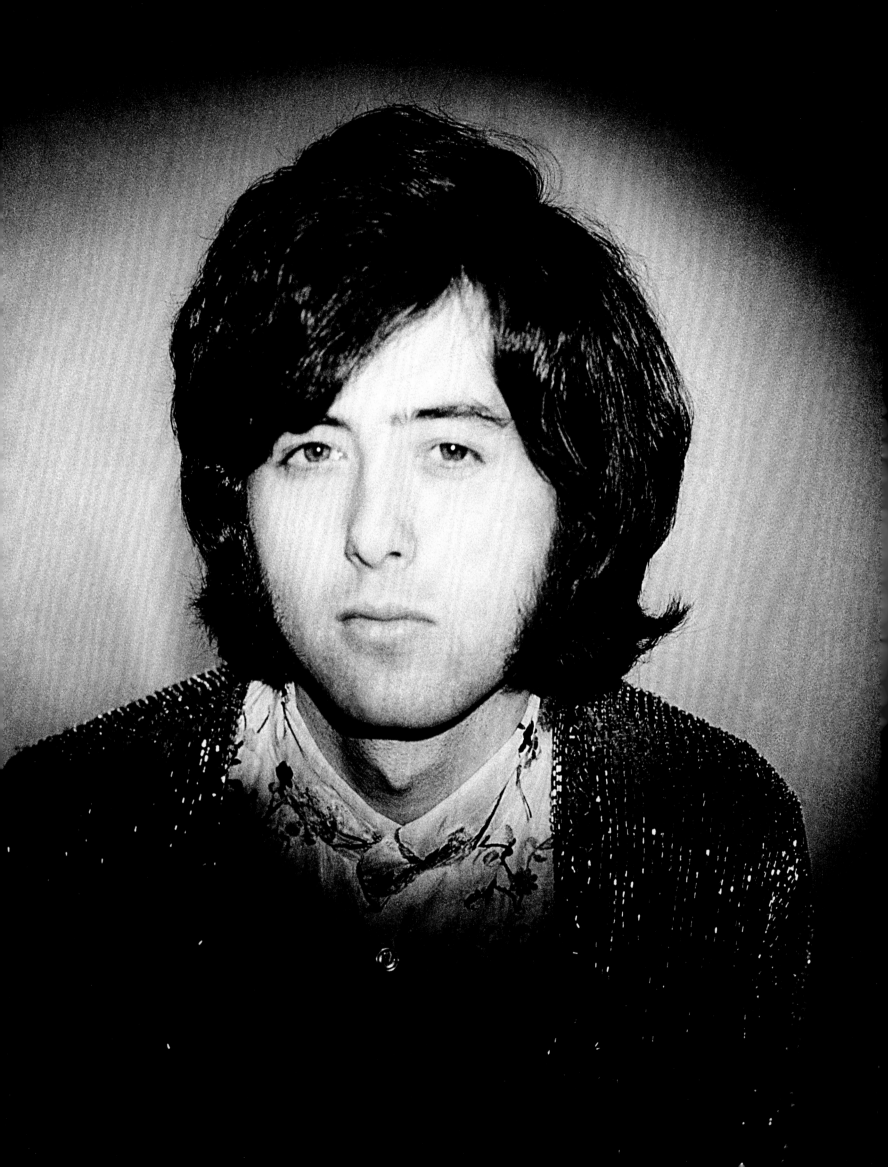

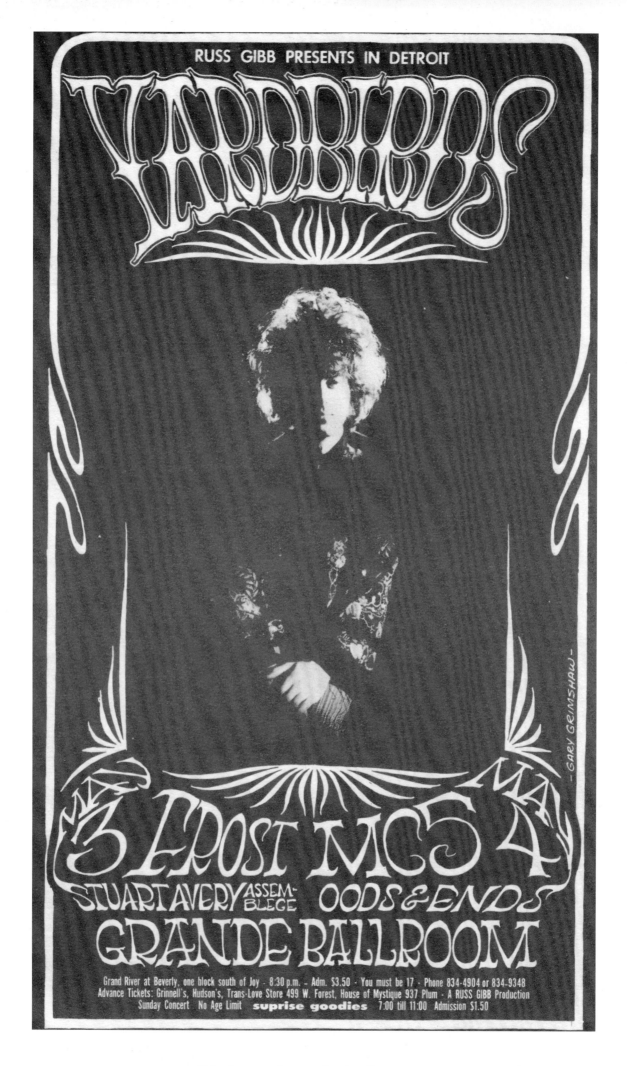

This photograph was taken by Chris Dreja.

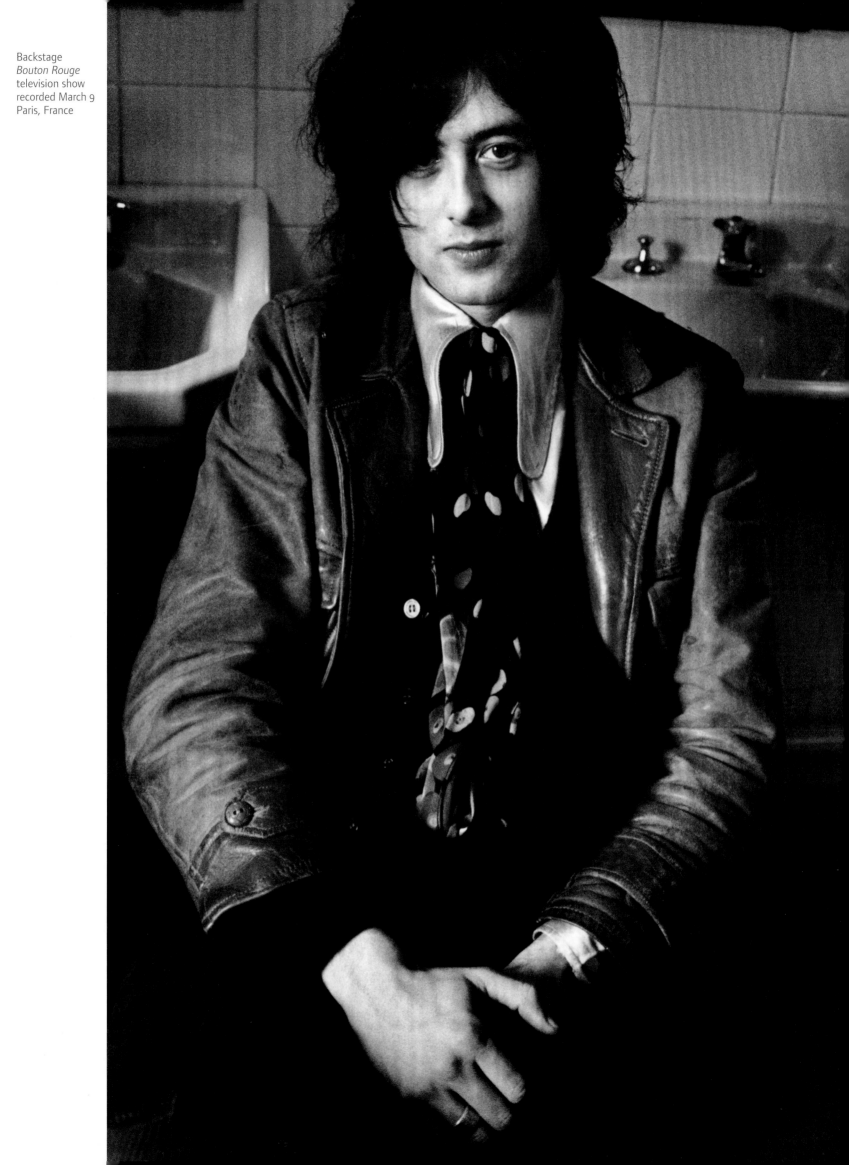

Backstage
Bouton Rouge
television show
recorded March 9
Paris, France

The four Yardbirds were bravely soldiering on and this section is a photographic document of the recording of a television show, *Bouton Rouge*, in Paris. From the initial shots in the dressing room there is a sound-check, then full dress rehearsals. It shows us in the world of 'hurry up and wait'. The final double page photograph in this sequence is us at the Faculté d'Assas in Paris later that day.

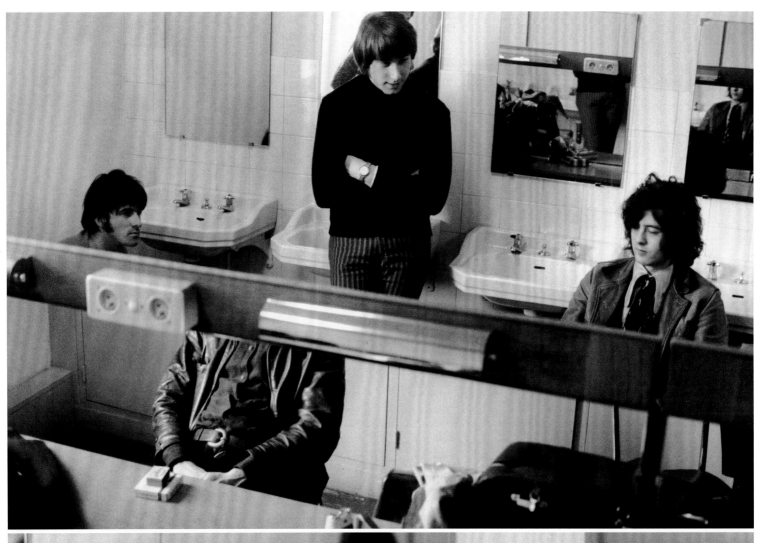

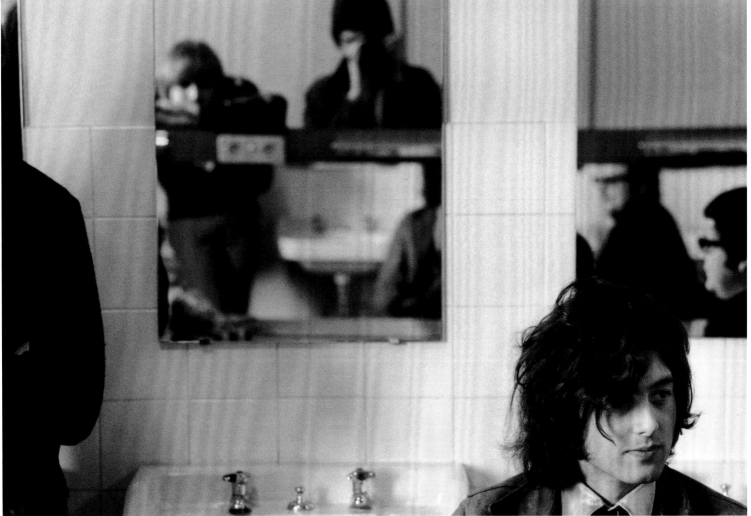

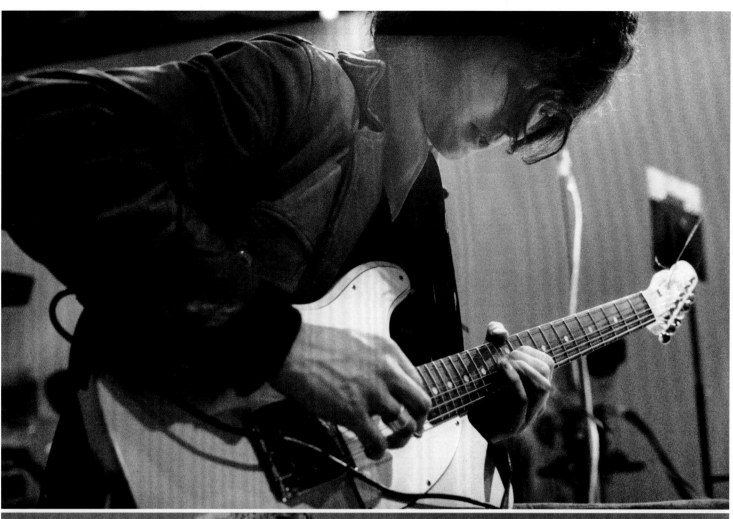

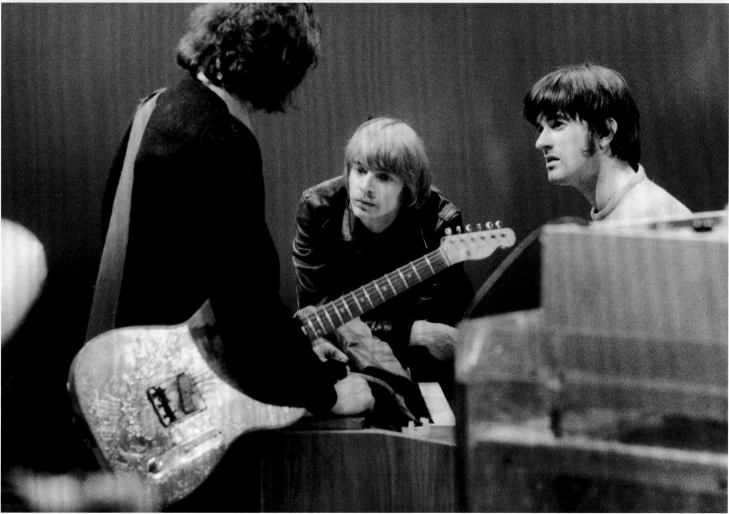

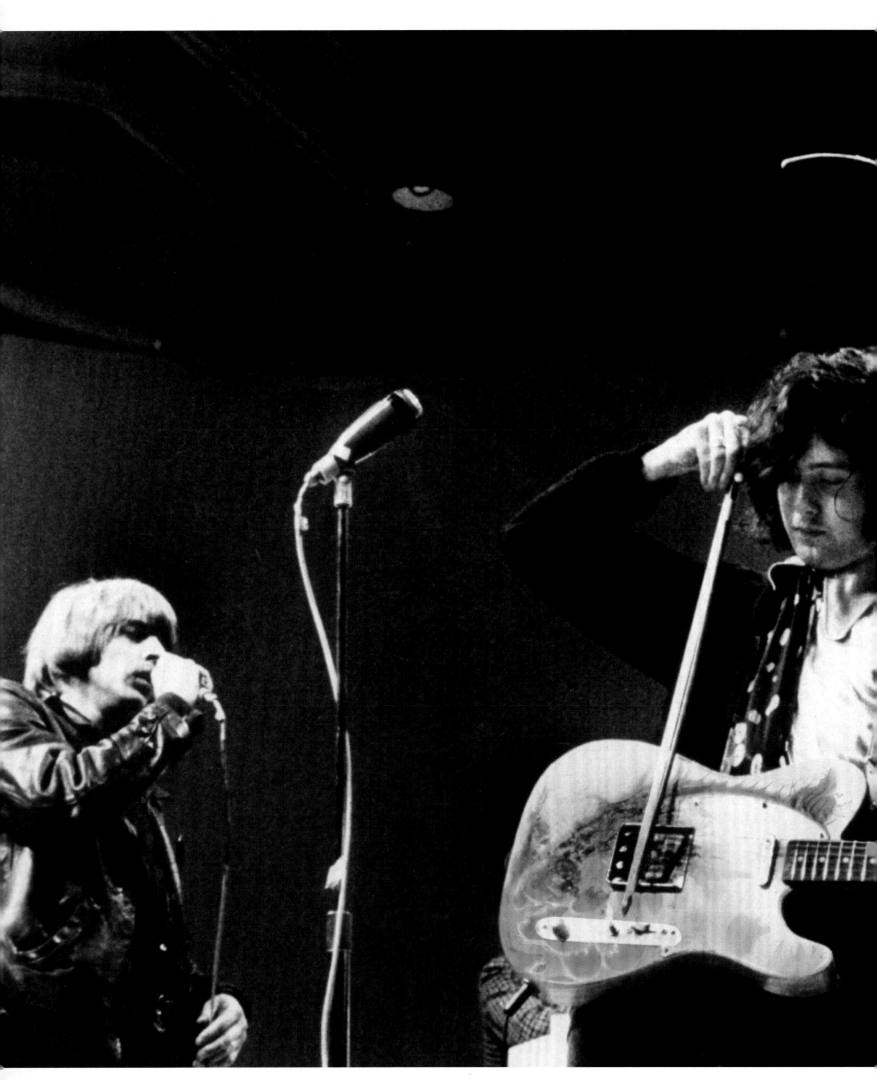

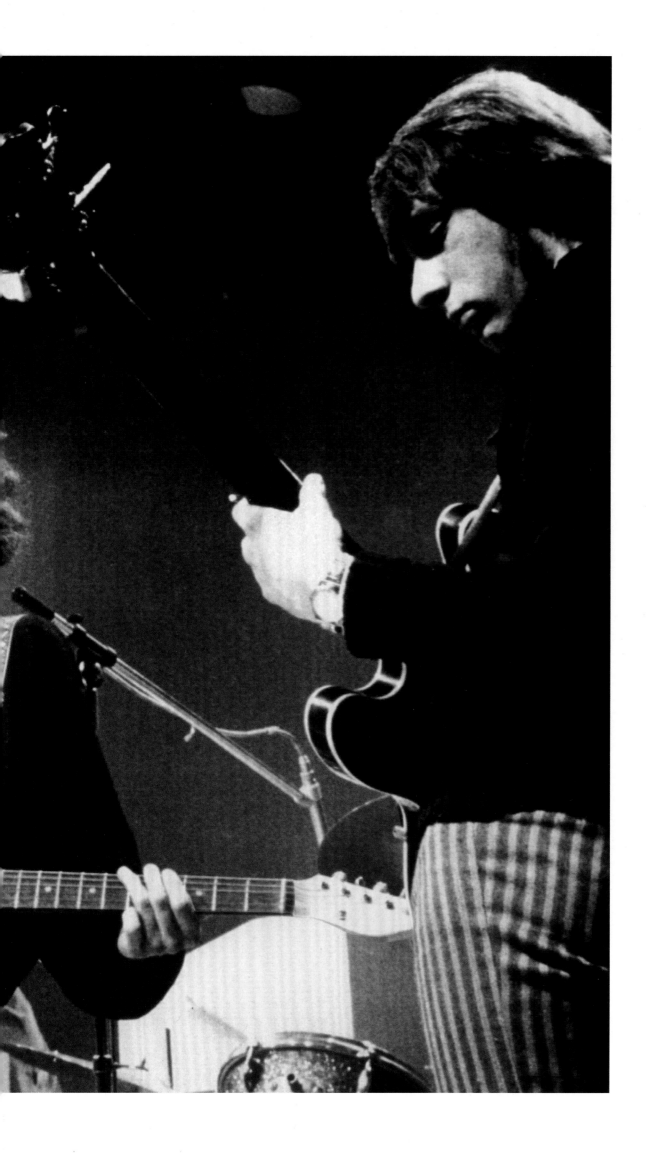

The sound-check
Bouton Rouge television show
recorded March 9
Paris, France

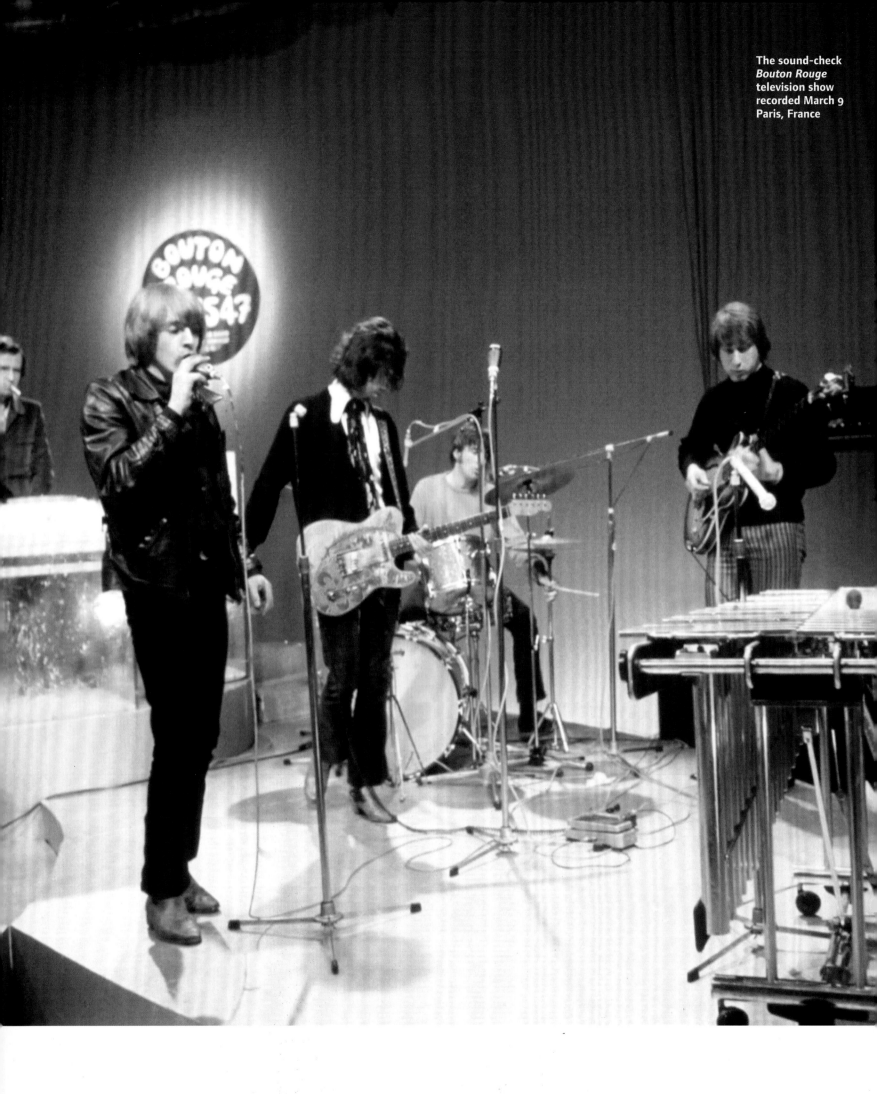

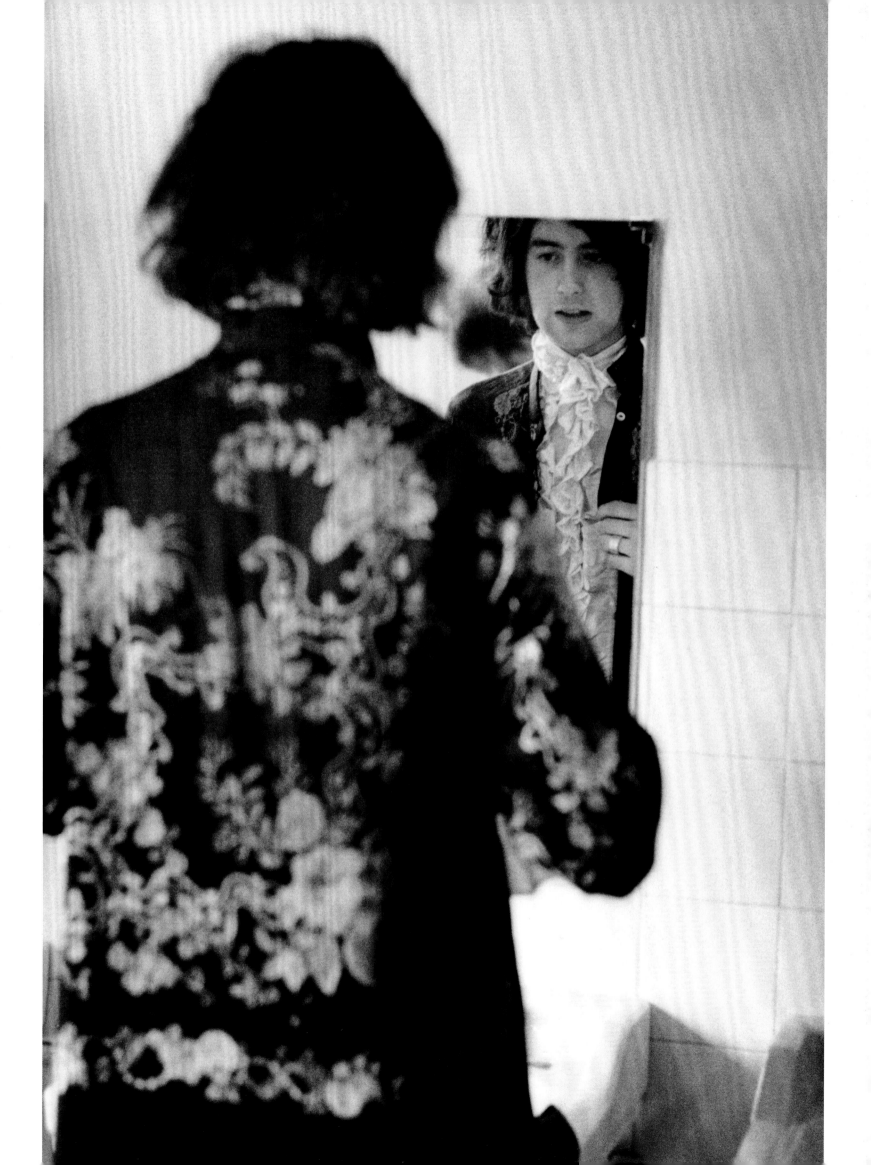

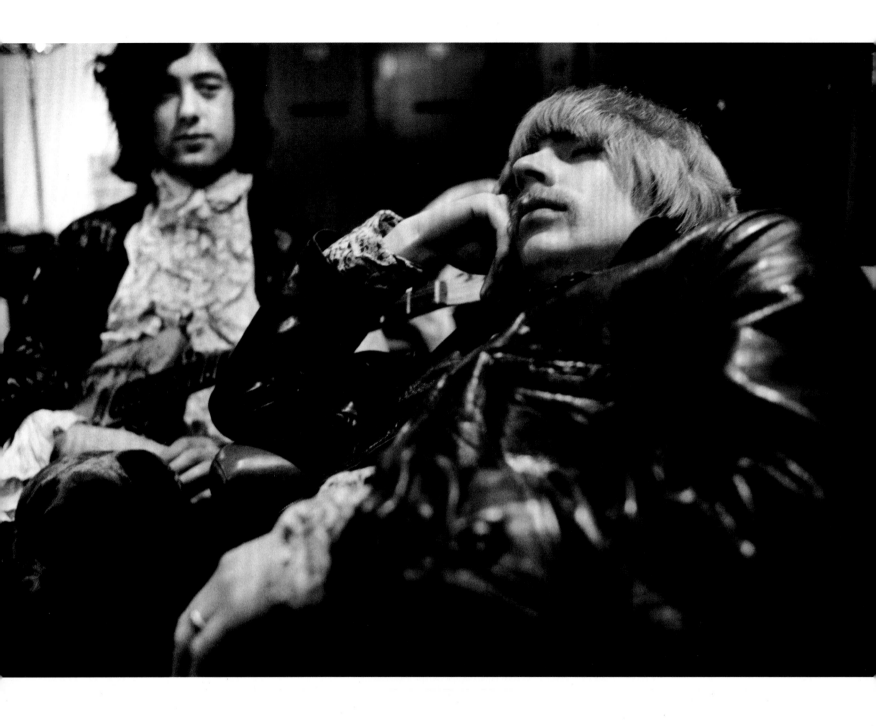

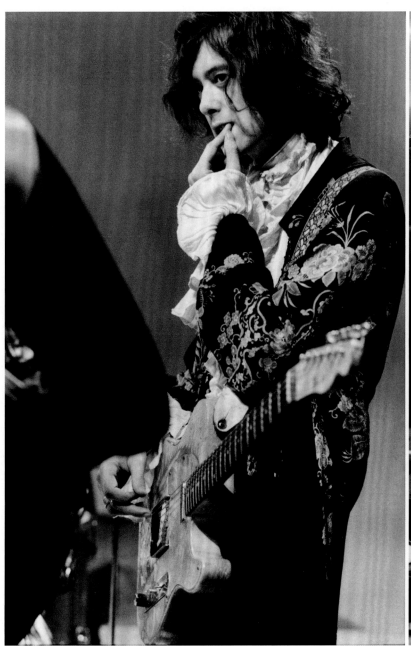
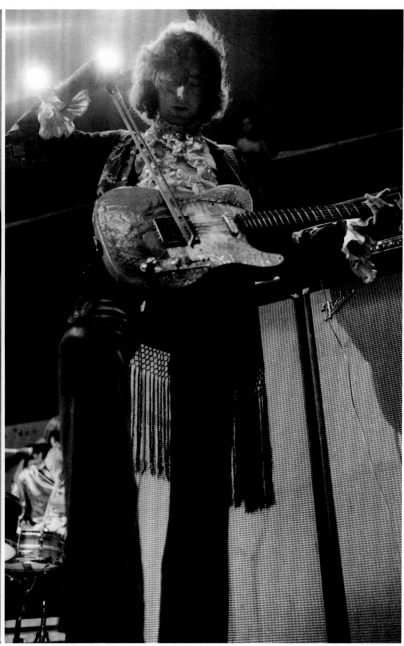

Full dress rehearsal
Bouton Rouge television show
recorded March 9
Paris, France

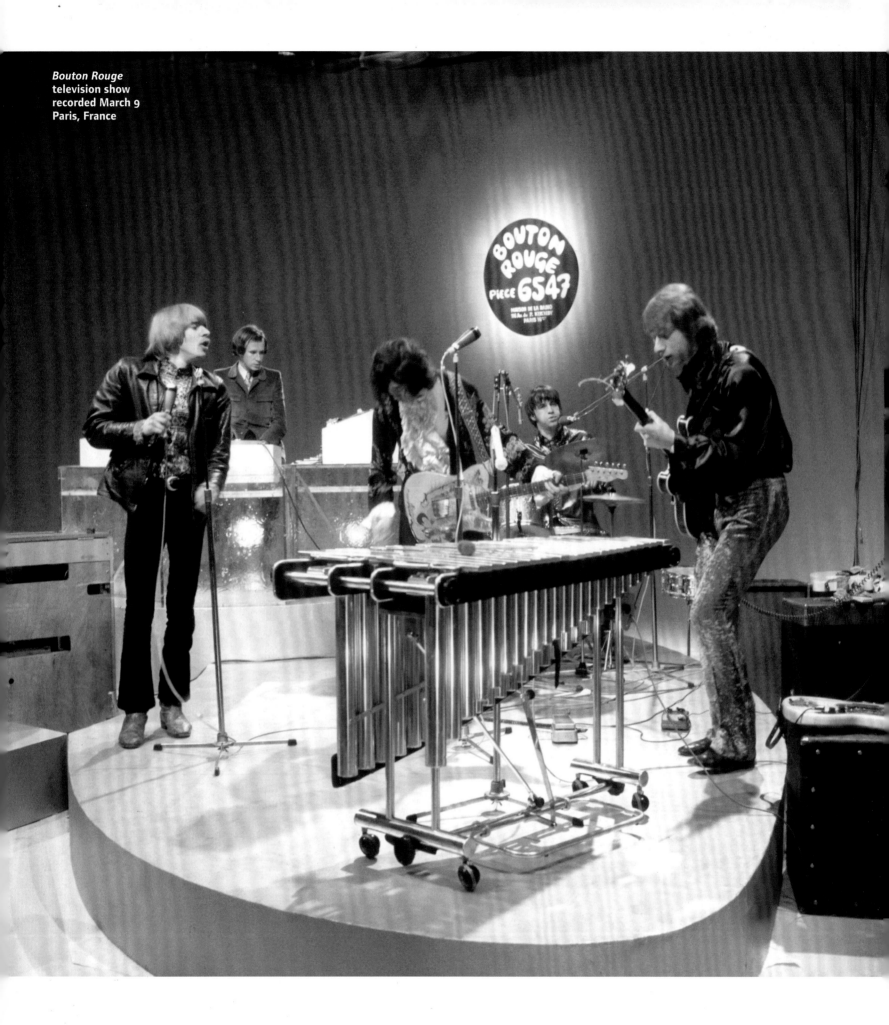

BOUTON
ROUGE
PIECE 6547

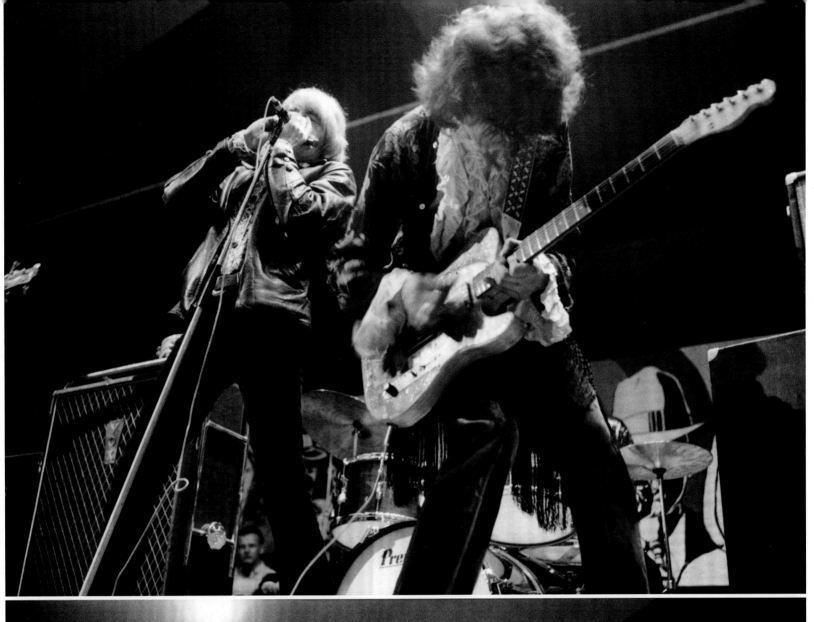

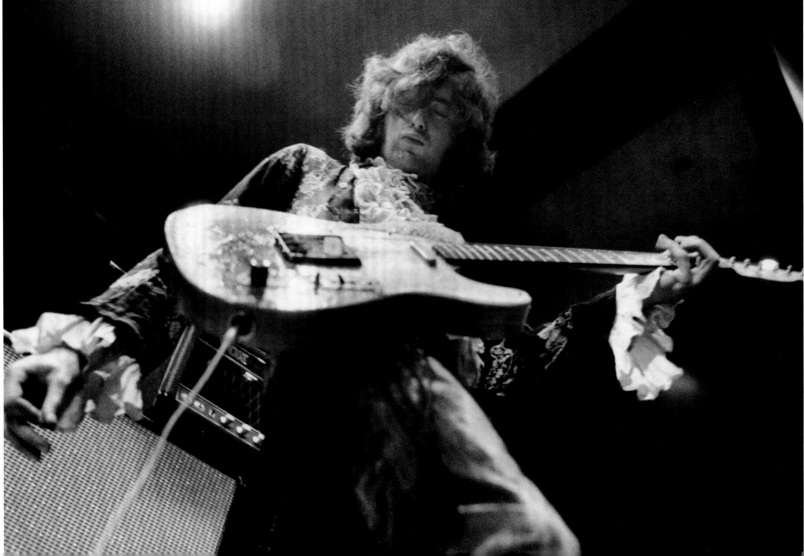

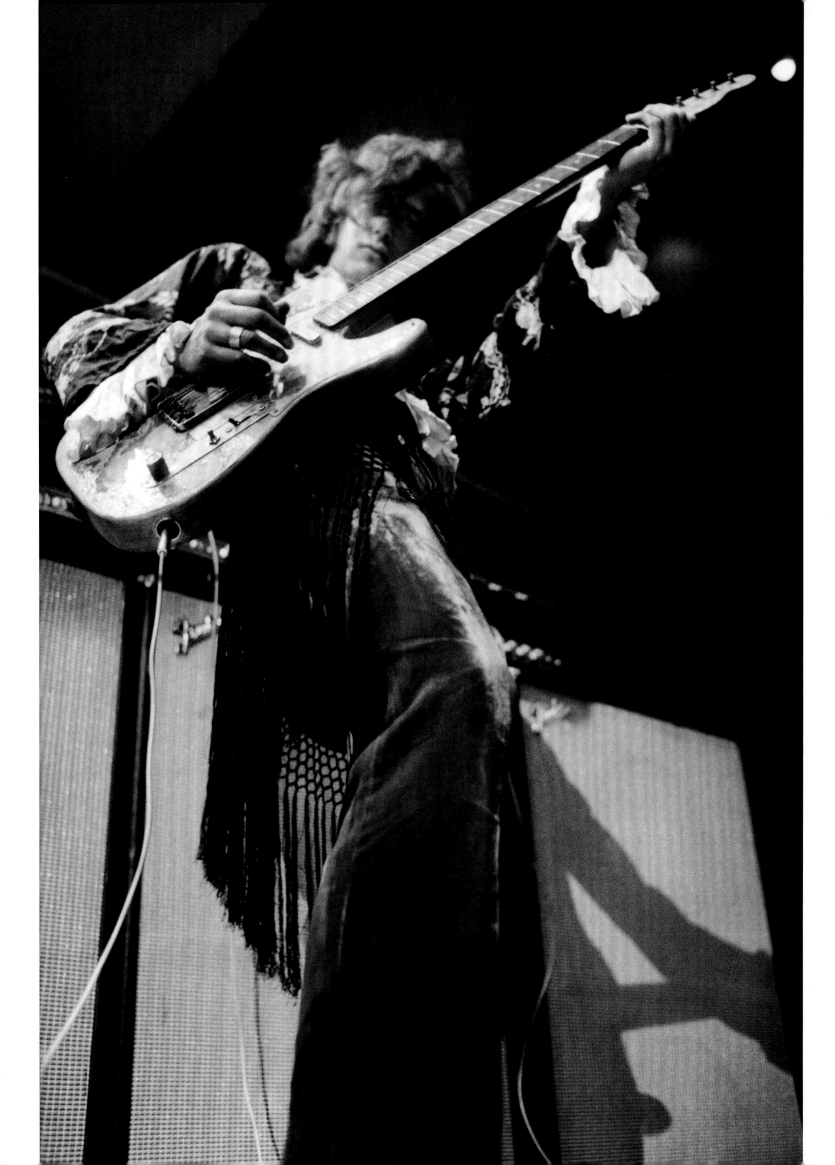

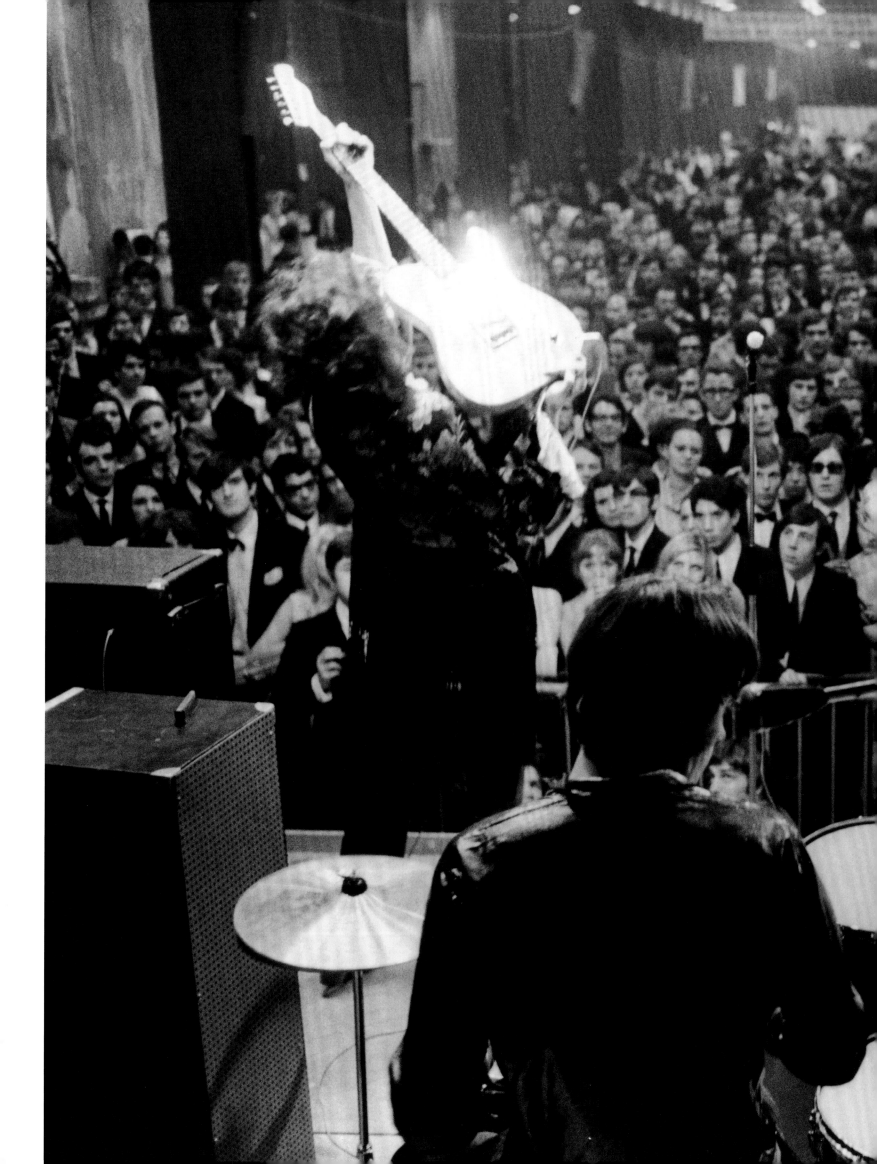

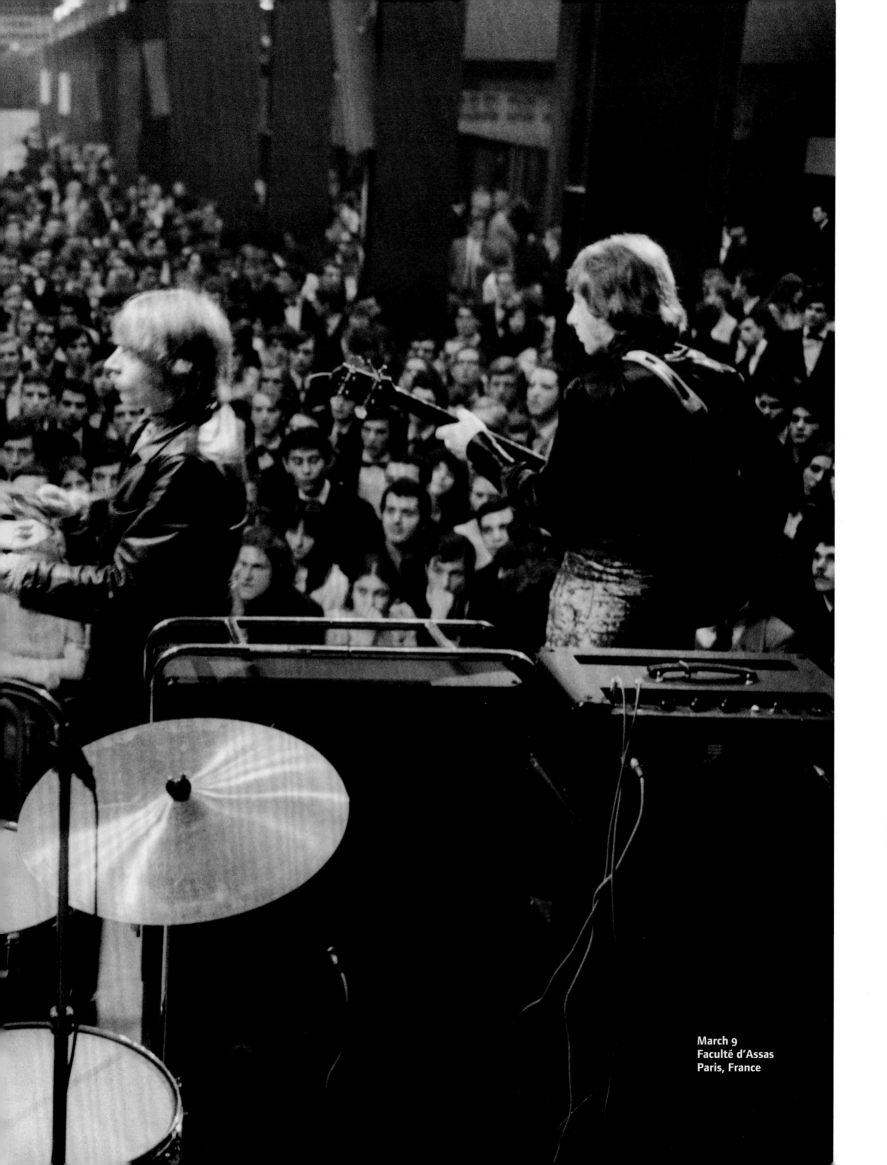

March 9
Faculté d'Assas
Paris, France

Around this time I did some sessions with The Staple Singers, Donovan's
'Sunshine Superman' (above and right), Al Stewart's *Love Chronicles*,
Mike Heron of The Incredible String Band, and Joe Cocker's
'With A Little Help From My Friends', the single and the album (left).

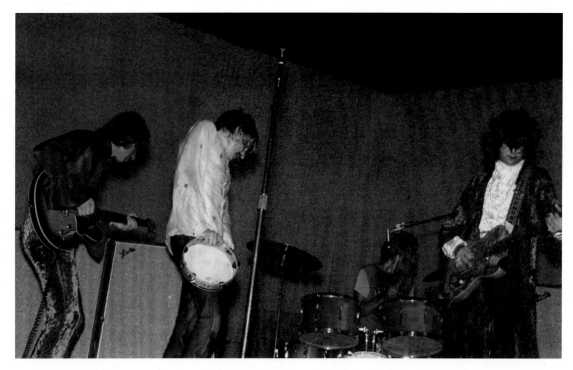

It was in Los Angeles that The Yardbirds – Jim and Keith – decided to call it a day and pursue a new musical direction. The day before their announcement I visited a palmist who told me that I was soon to make a decision that would change my life.

Along with the character guitar playing I had established improvising blues and rock, the musical climate was clear to me – with FM radio now playing complete albums to challenge the AM singles chart stations, and with the listening audience open to an eclectic mix, I wanted to expand and develop the acoustic, electric and experimental themes that I had explored in The Yardbirds. In order to channel these ideas I decided to form and produce my own group. I knew I had established a large and enthusiastic following in the States and it was time for expansion and to make my own musical statement.

I attempted to contact Terry Reid, a vocalist I had heard during a Yardbirds UK tour. He had, surprisingly, just signed with (ex-Yardbirds) producer Mickie Most, but he did recommend Robert Plant, who was unknown to me. I went to hear him, liked him and got him to Pangbourne to outline my musical ideas and routine some of the related material I had, 'Babe I'm Gonna Leave You' is a good example.

Initially, I thought about a drummer who had played on 'With A Little Help From My Friends' but when John Bonham was suggested, again unknown to me, he was soon to tour with Tim Rose. I went to see him play in London, then I knew immediately there was no-one else.

John Paul Jones – who I had seen in the latter stages of my session days and who had played bass on 'Beck's Bolero' and some Yardbirds singles – called me and asked if he could join.

We rehearsed the set at my home in Pangbourne for some remaining Yardbirds dates in September in Scandinavia and this gave us the ideal opportunity to routine the new material for an album that would be recorded in London when we returned.

The early promo shots on pages 87 and 89 are taken from around that period.

In early October 1968 the band began recording at Olympic Studios with Glyn Johns engineering and after 30 hours recorded time *Led Zeppelin I* was completed with a mix of acoustic, electric, rock, blues, *avant-garde* and experimental music, performed with vision, improvisation, attitude, and a bullet-proof blueprint.

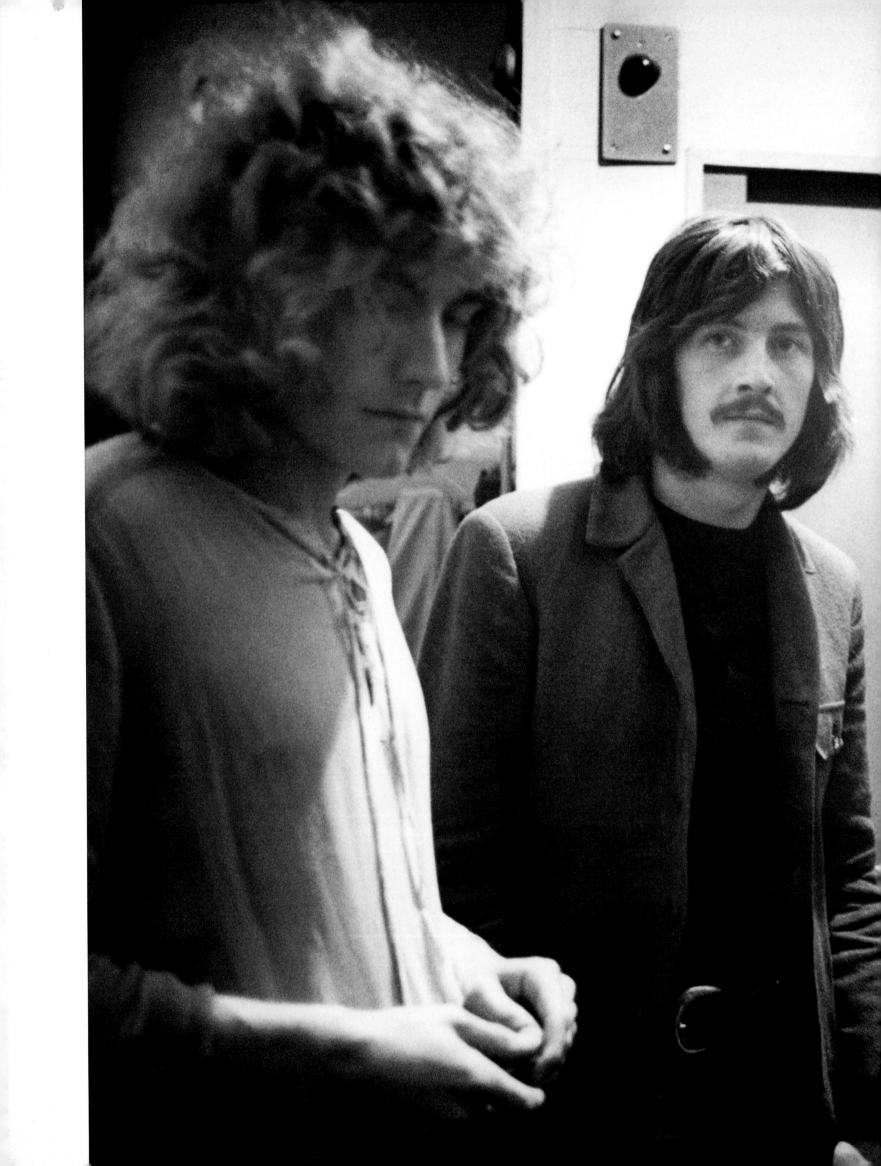

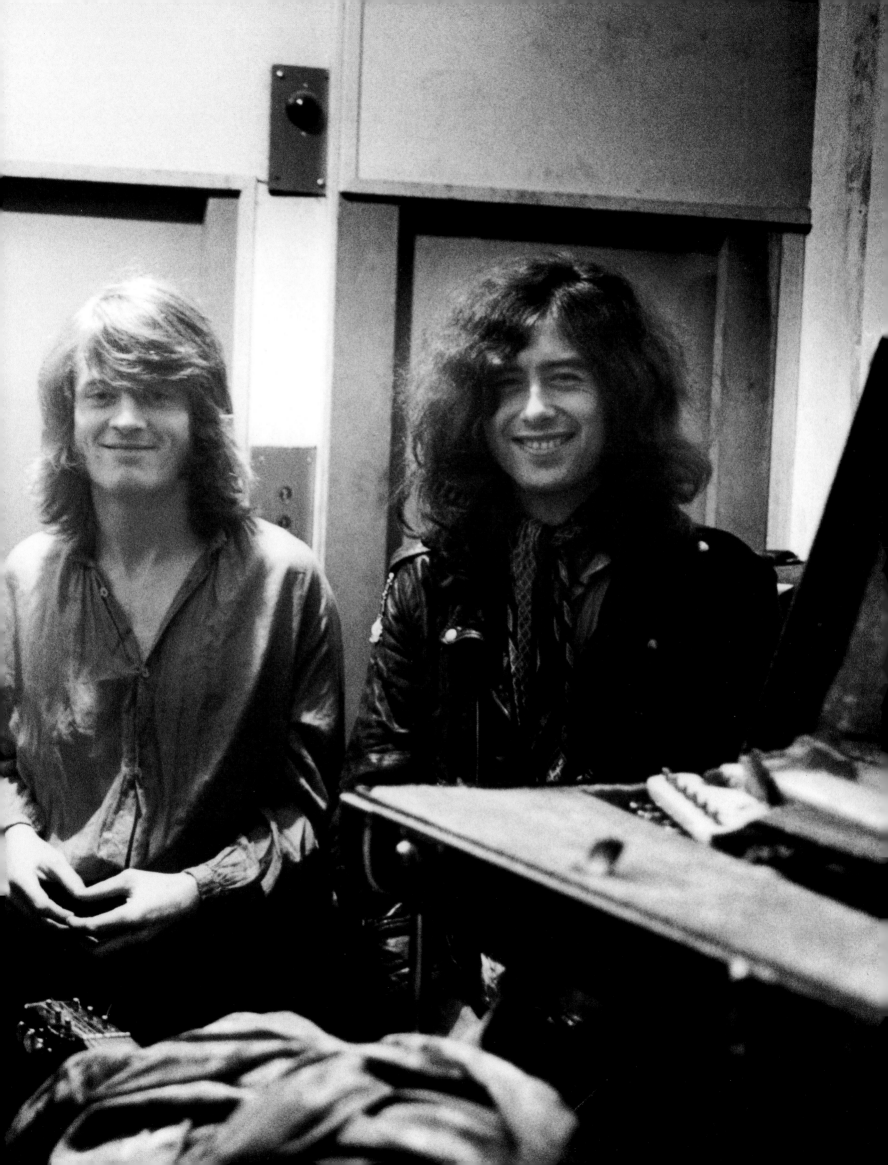

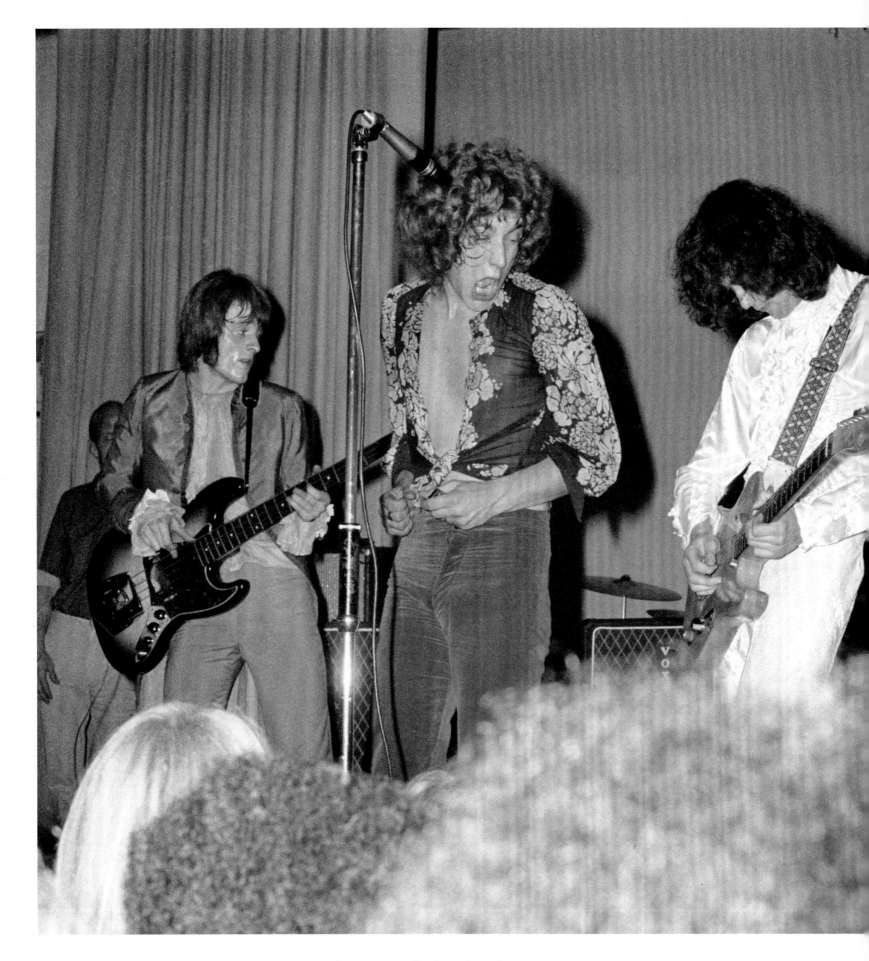

The New Yardbirds in Scandinavia.

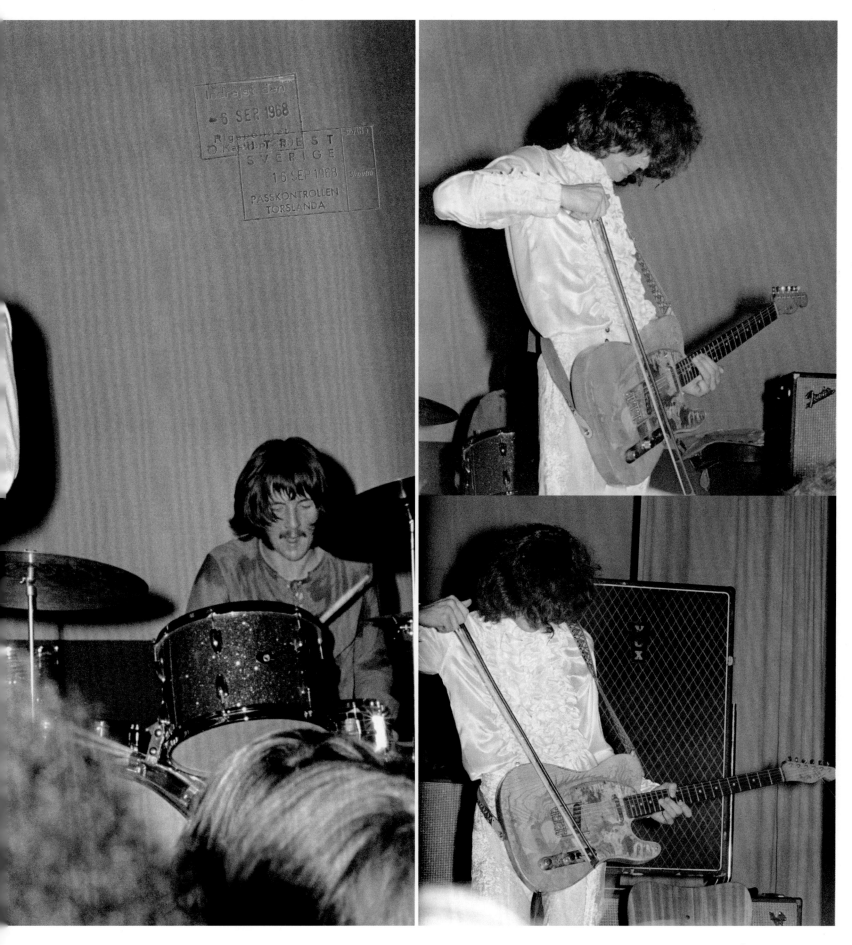

September 7
Teen-Clubs
Gladsaxe, Denmark
Debut show, first
of Scandinavian
tour dates

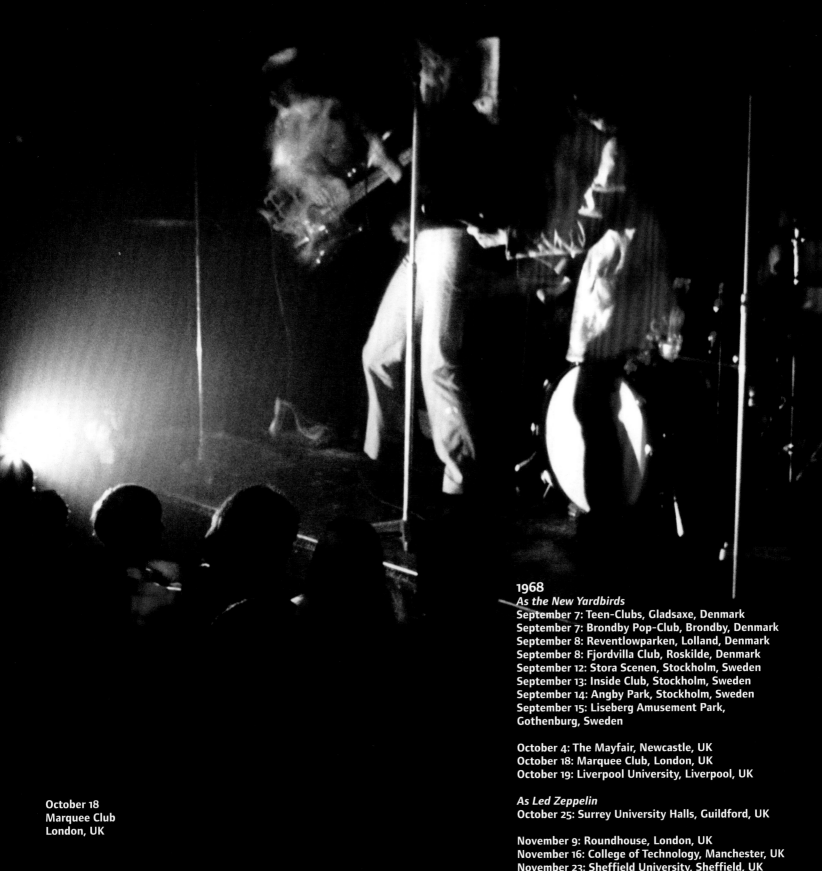

October 18
Marquee Club
London, UK

1968
As the New Yardbirds
September 7: Teen-Clubs, Gladsaxe, Denmark
September 7: Brondby Pop-Club, Brondby, Denmark
September 8: Reventlowparken, Lolland, Denmark
September 8: Fjordvilla Club, Roskilde, Denmark
September 12: Stora Scenen, Stockholm, Sweden
September 13: Inside Club, Stockholm, Sweden
September 14: Angby Park, Stockholm, Sweden
September 15: Liseberg Amusement Park,
Gothenburg, Sweden

October 4: The Mayfair, Newcastle, UK
October 18: Marquee Club, London, UK
October 19: Liverpool University, Liverpool, UK

As Led Zeppelin
October 25: Surrey University Halls, Guildford, UK

November 9: Roundhouse, London, UK
November 16: College of Technology, Manchester, UK
November 23: Sheffield University, Sheffield, UK
November 29: Crawdaddy Club, Richmond, UK

December 10: Marquee Club, London, UK
December 13: Bridge Place Country Club, Canterbury, UK
December 16: Bath Pavilion, Bath, UK
December 19: Civic Hall, Exeter, UK
December 20: Wood Green Fishmongers Hall, London, UK

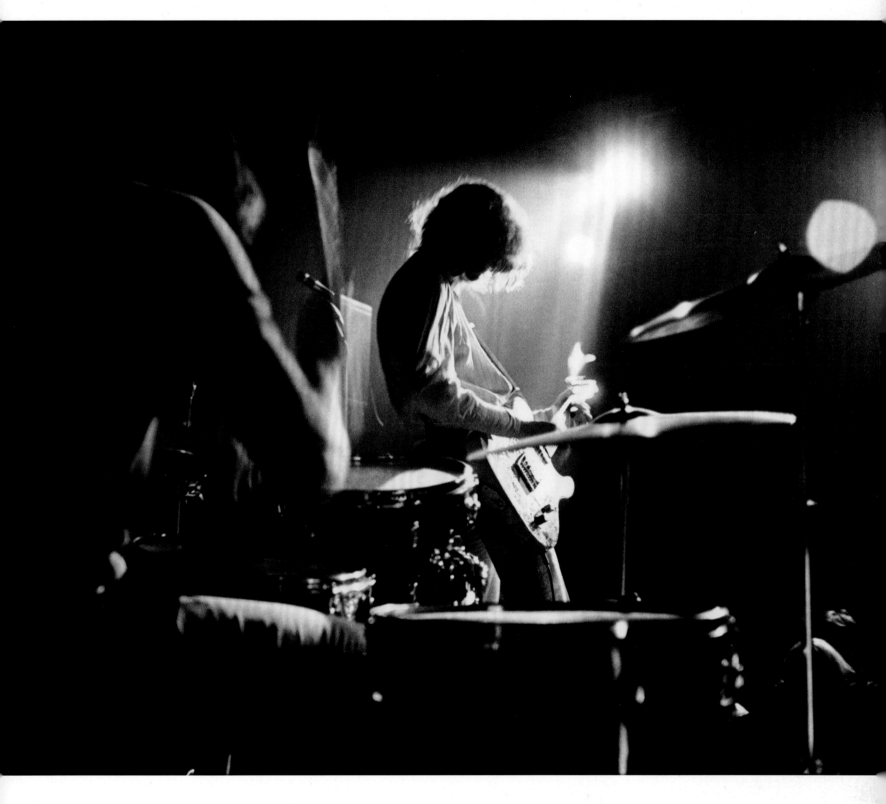

December 10
Marquee Club
London, UK

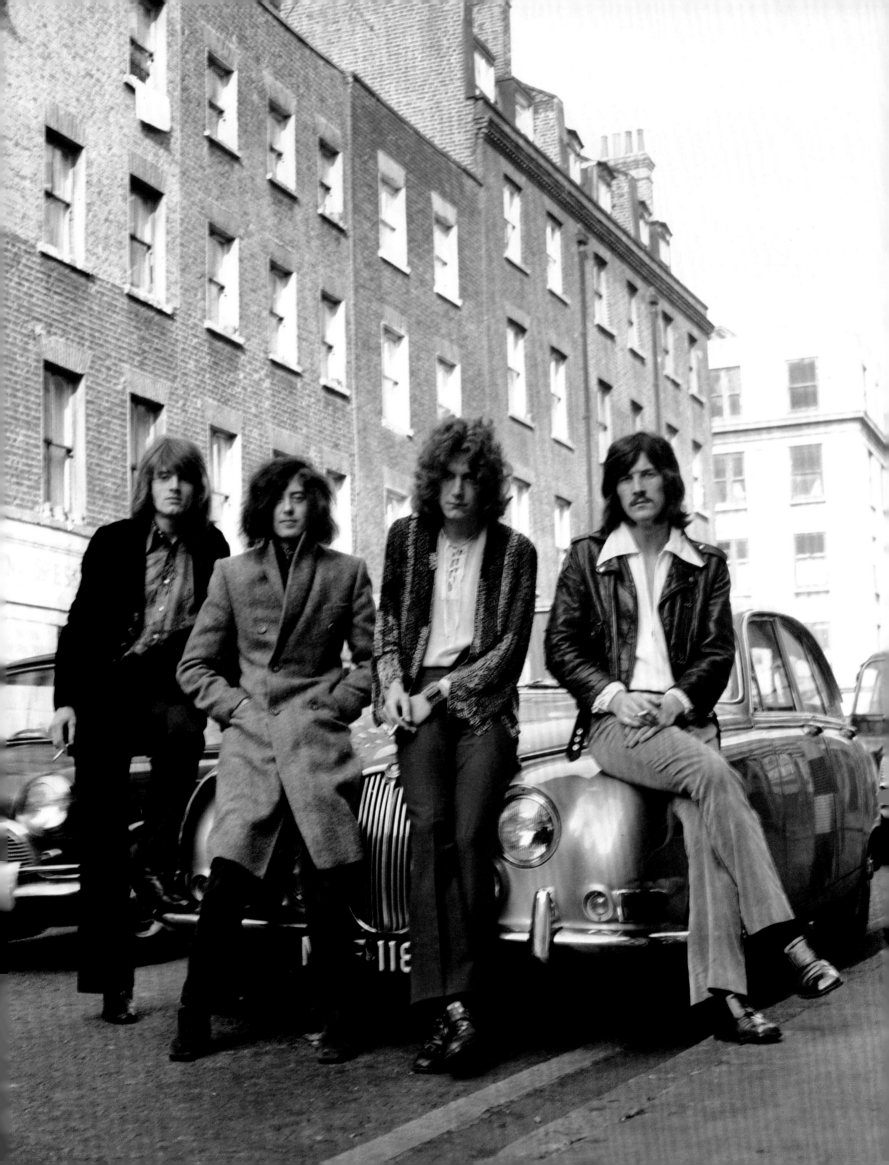

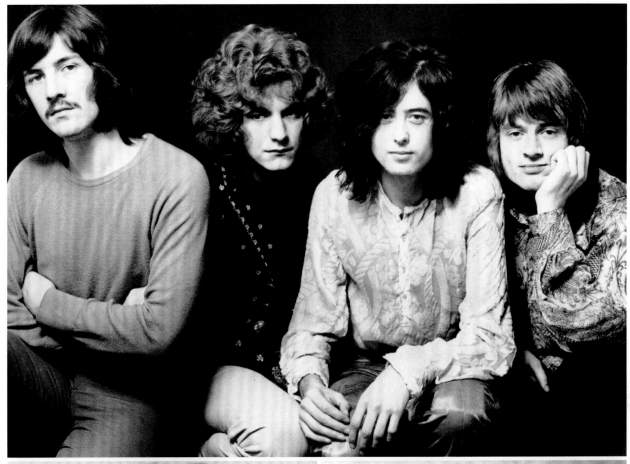

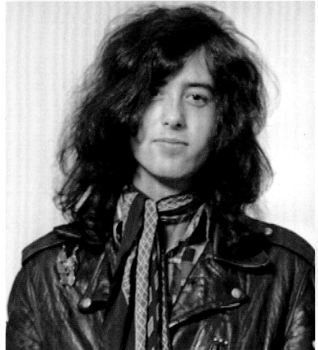

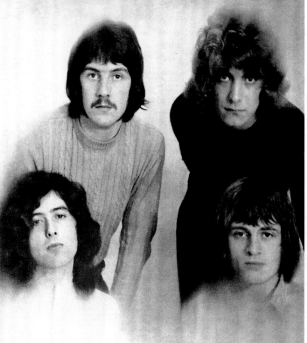

Early promotional shots
of the band and back
of the first album cover
(bottom right).

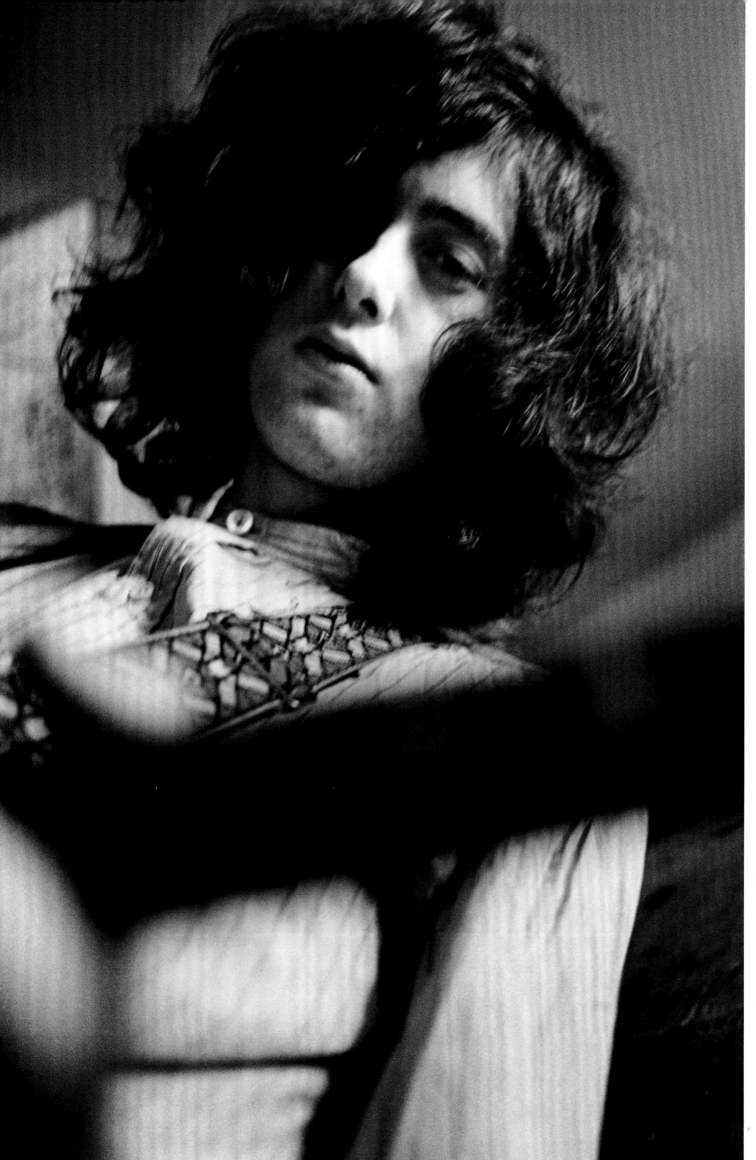

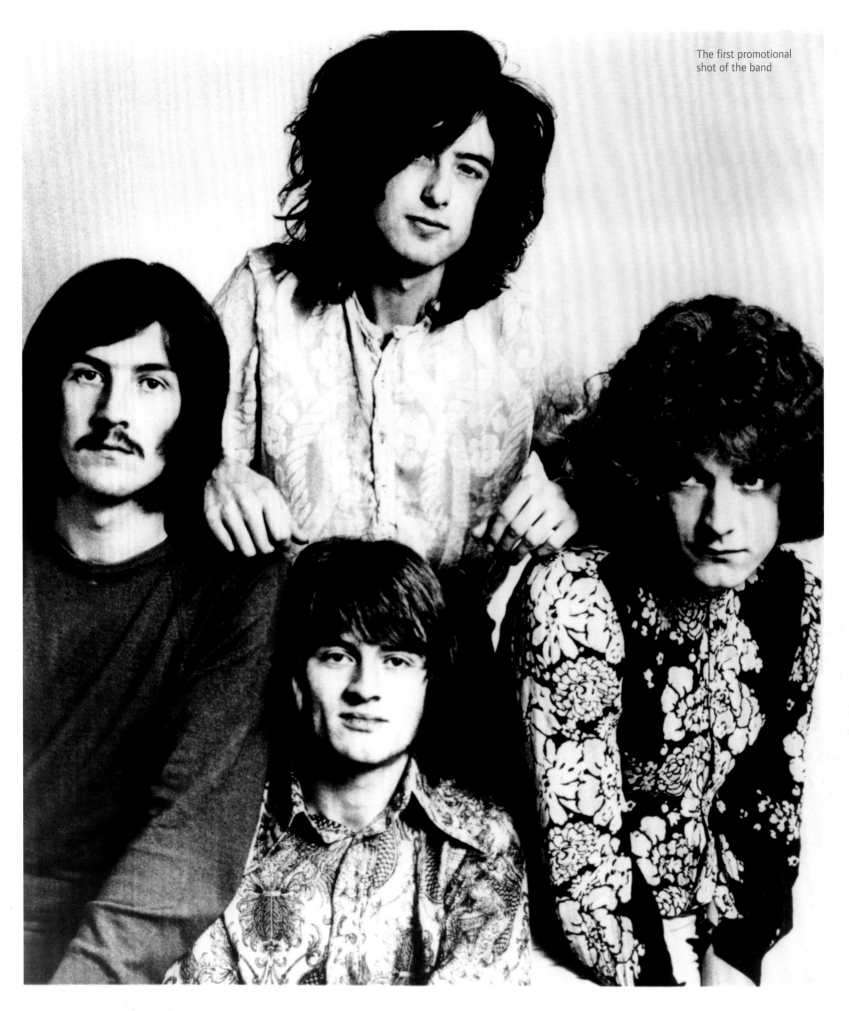

LED ZEPPELIN

ATLANTIC RECORDS

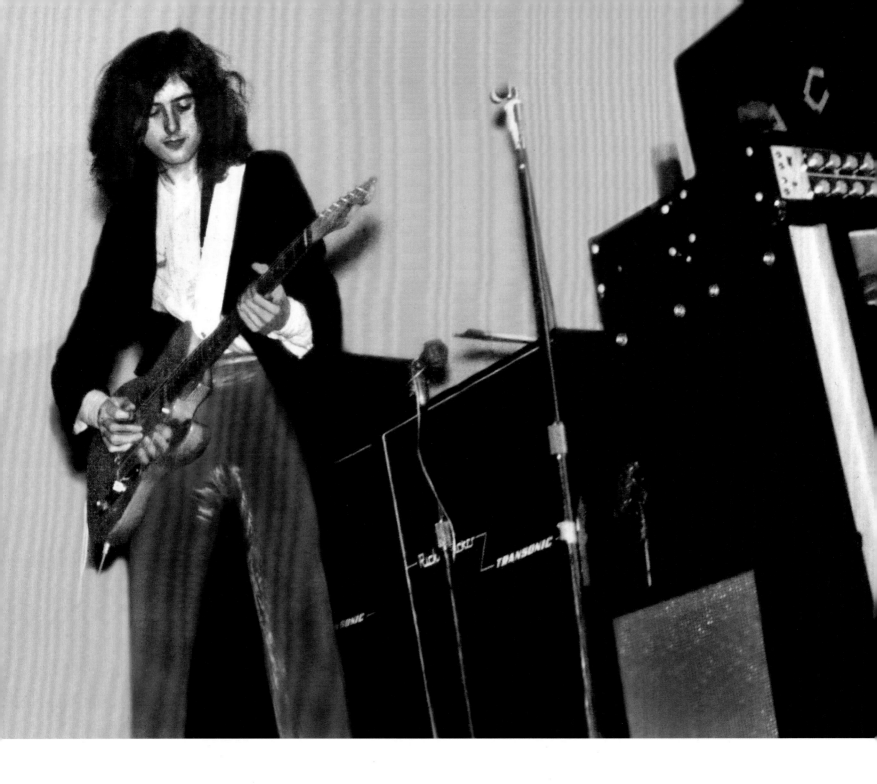

On the first US tour after a handful of shows supporting Vanilla Fudge, we headlined at the Whisky a Go Go, Hollywood.

January 2, 4 & 5
Whisky a Go Go
Los Angeles, USA

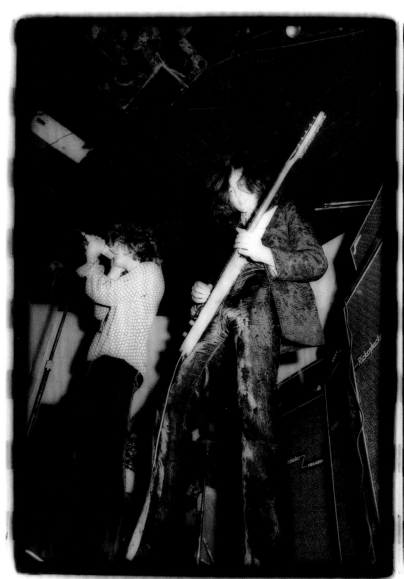

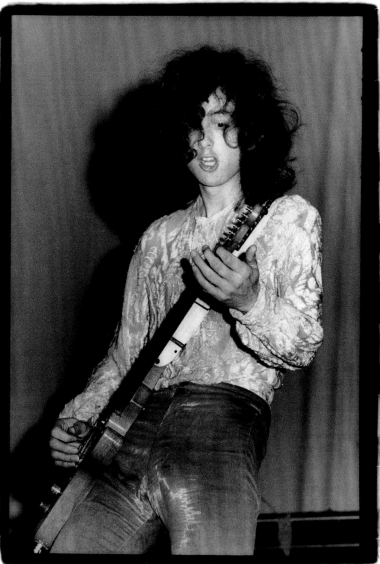

January 2
Whisky a Go Go
Los Angeles, USA

January 9
Fillmore West
San Francisco, USA

THE RELEASE OF *LED ZEPPELIN*
JANUARY 12 (US)
MARCH 28 (UK)

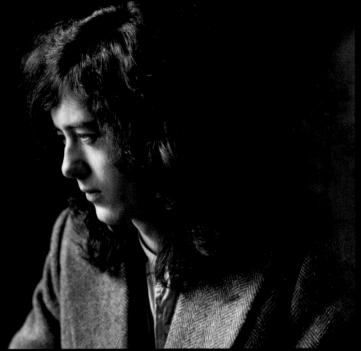

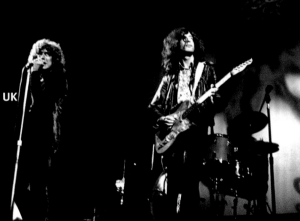

1968
Start of first American tour
December 26: Denver Auditorium Arena, Denver, USA
December 27: Seattle Center Coliseum, Seattle, USA
December 28: Pacific Coliseum, Vancouver, Canada
December 29: Civic Auditorium, Portland, USA
December 30: Gonzaga University, Spokane, USA

1969
January 2: Whisky a Go Go, Los Angeles, USA
January 4: Whisky a Go Go, Los Angeles, USA
January 5: Whisky a Go Go, Los Angeles, USA
January 9: Fillmore West, San Francisco, USA
January 10: Fillmore West, San Francisco, USA
January 11: Fillmore West, San Francisco, USA
January 12: Fillmore West, San Francisco, USA
January 15: University of Iowa Memorial Union, Iowa City, USA
January 17: The Grande Ballroom, Detroit, USA
January 18: The Grande Ballroom, Detroit, USA
January 19: The Grande Ballroom, Detroit, USA
January 20: Wheaton Youth Center, Wheaton, USA
January 23: Boston Tea Party, Boston, USA
January 24: Boston Tea Party, Boston, USA
January 25: Boston Tea Party, Boston, USA
January 26: Boston Tea Party, Boston, USA
January 31: Fillmore East, New York, USA [2 shows]

February 1: Fillmore East, New York, USA [2 shows]
February 2: The Rock Pile, Toronto, Canada
February 7: Kinetic Playground, Chicago, USA
February 8: Kinetic Playground, Chicago, USA
February 10: State University, Memphis, USA
February 14: Thee Image Club, Miami, USA
February 15: Thee Image Club, Miami, USA
End of first American tour

Start of first European tour
February 24: Lafayette Club, Wolverhampton, UK

March 1: Van Dike Club, Plymouth, UK
March 3: Playhouse Theatre, London, UK
March 5: Top Rank Suite Club, Cardiff, UK
March 7: Hornsey Wood Tavern, London, UK
March 10: Cooks Ferry Inn, London, UK
March 13: De Montfort Hall, Leicester, UK

March 14: Konserthuset, Stockholm, Sweden
March 14: Uppsala University Hall, Uppsala, Sweden
March 15: Brondby Pop-Club, Brondby, Denmark
March 15: Teen-Clubs, Gladsaxe, Denmark
March 16: Tivolis Koncertsal, Copenhagen, Denmark [2 shows]
March 17: TV Byen/Danmarks Radio, Gladsaxe, Denmark

March 19: BBC Studios, Maida Vale, London, UK
March 21: BBC Lime Grove Studios, London, UK
March 22: Mother's Club, Birmingham, UK
March 23: The Argus Butterfly, Peterlee, UK
March 24: Cooks Ferry Inn, London, UK
March 25: Supershow, Staines, UK
March 28: Marquee Club, London, UK
March 29: Bromley College of Technology, Bromley, UK
March 30: Farx Club, Northcote Arms, Southall, UK

April 1: Klooks Kleek, Hampstead, UK
April 2: Top Rank Suite Club, Cardiff, UK
April 5: Dagenham Roundhouse, London, UK
April 6: Boat Club, Nottingham, UK
April 8: The Cherry Tree, Welwyn Garden City, UK
April 9: Toby Jug, Tolworth, UK
April 13: Kimbells, Southsea, UK
April 14: The Place, Stoke, UK [Unconfirmed]
April 17: Club Lafayette, Wolverhampton, UK
End of first European tour

Start of second American tour
April 18: NY University Jazz Festival, New York, USA
April 24: Fillmore West, San Francisco, USA
April 25: Winterland Ballroom, San Francisco, USA
April 26: Winterland Ballroom, San Francisco, USA
April 27: Fillmore West, San Francisco, USA

Top left:
Herb Greene's studio
San Francisco, USA

Above:
February 1
Fillmore East
New York, USA

Opposite:
February 14 & 15
Thee Image Club
Miami, USA

San Francisco was a renowned muso capital and, having played there on several occasions with The Yardbirds, there was a real buzz about what I had put together in a new group. We were due to play with Taj Mahal and Country Joe & The Fish. Over the four days at the Fillmore the audience got a mass injection of what we were about. It is safe to say the reputation of the group travelled like wildfire across the States from this moment and these San Francisco dates were a pivotal point in the band's career.

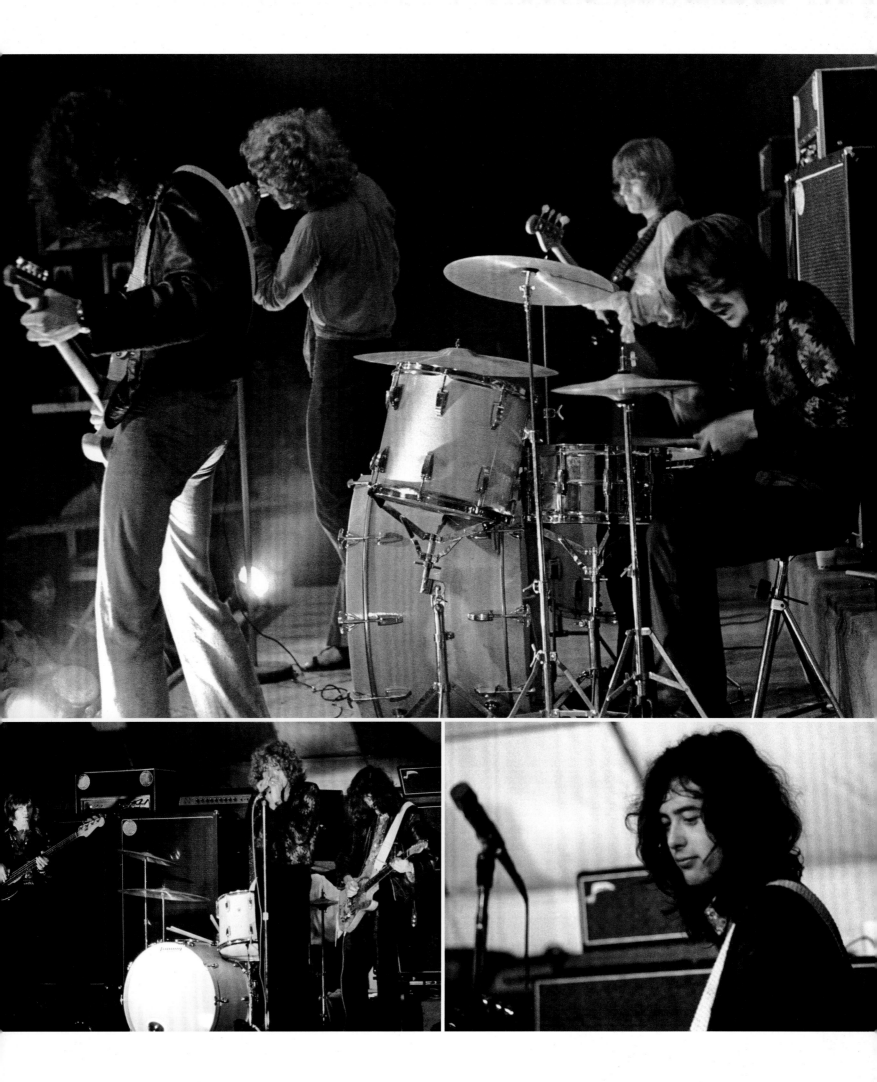

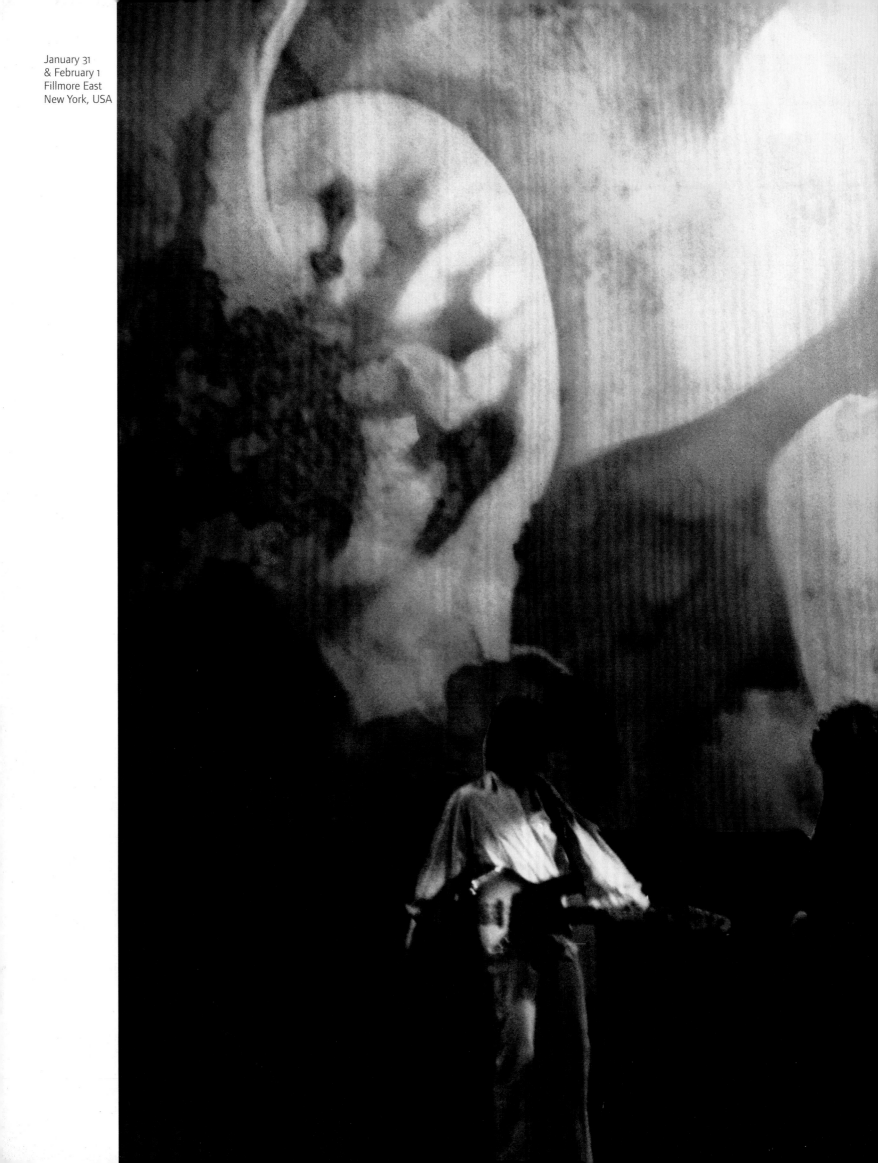

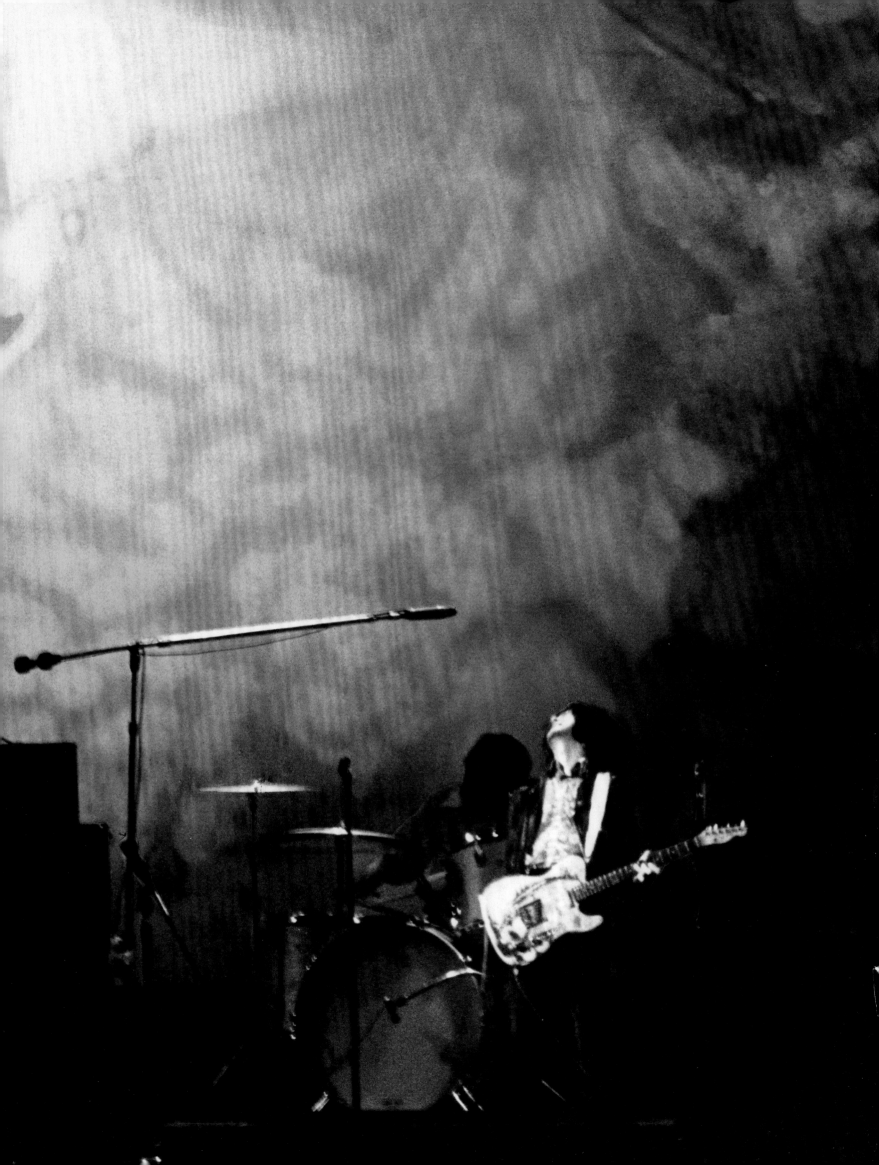

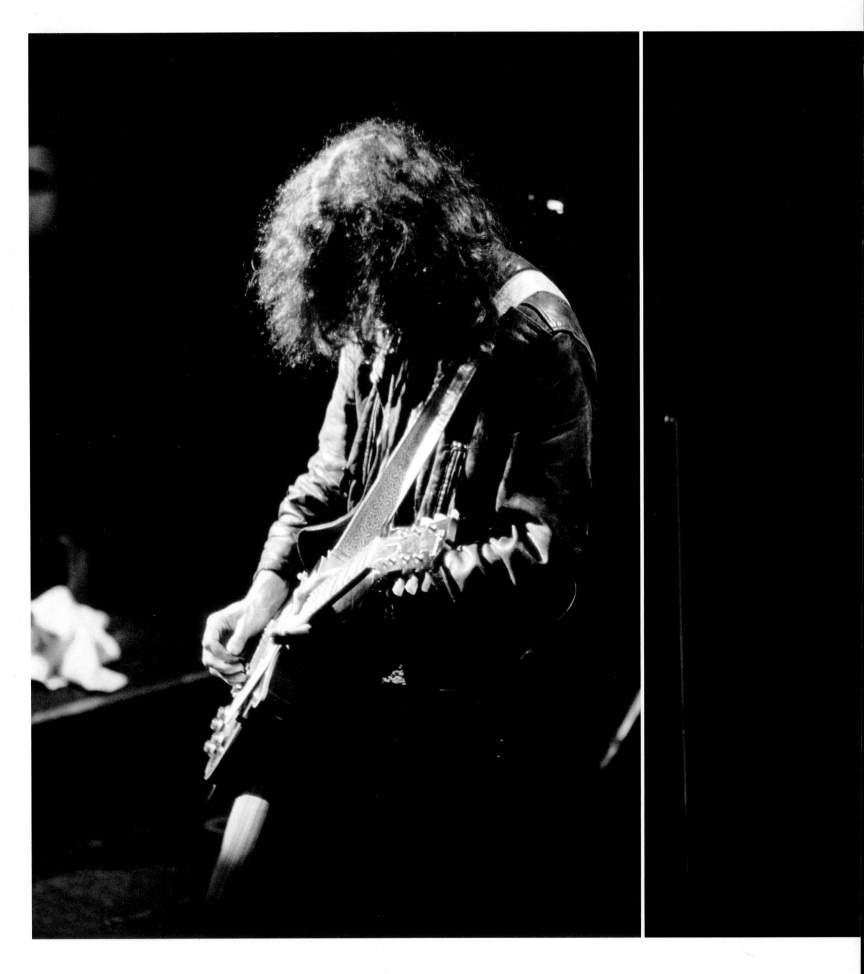

January 31
& February 1
Fillmore East
New York, USA

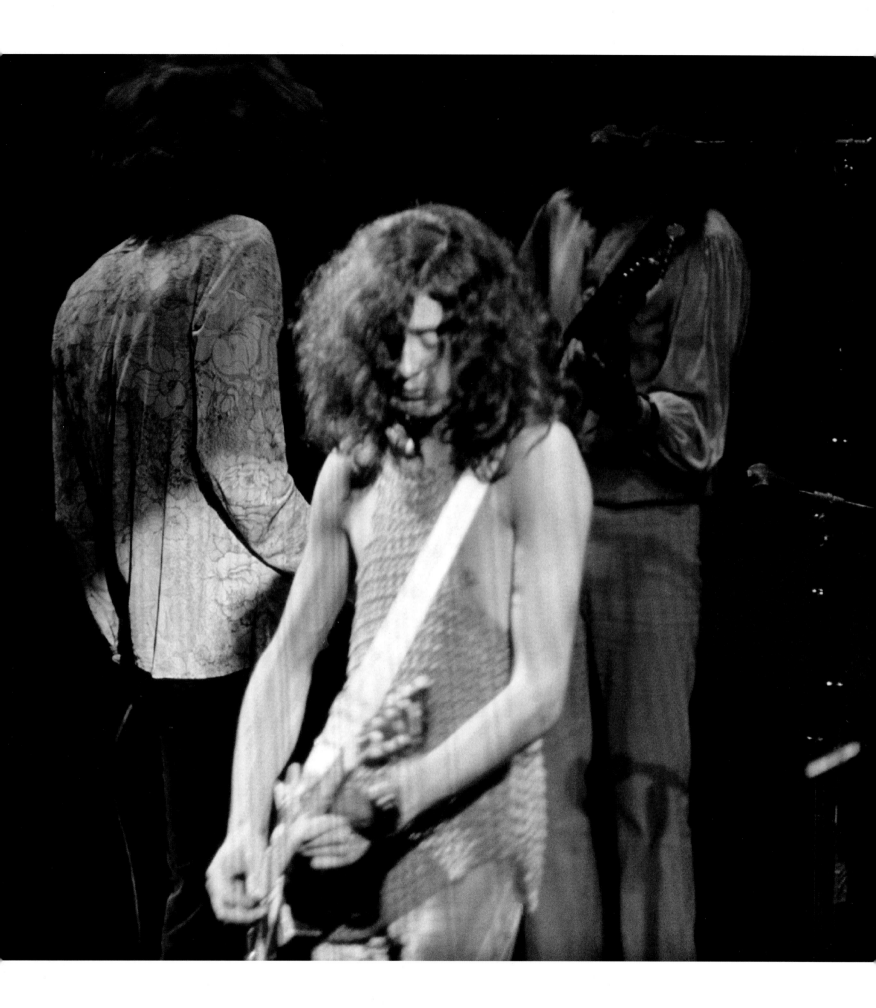

March 15
Teens-Club
Gladsaxe, Denmark

January 31
& February 1
Fillmore East
New York, USA

Opposite:
March 17
TV Byen/Danmarks Radio
Gladsaxe, Denmark

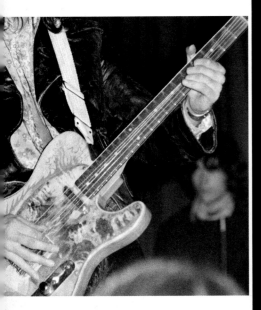

During my time with The Yardbirds,
I had taken the decision to
consecrate my guitar by painting
it in psychedelic colour opposites
and employing diffraction
grating beneath the clear Perspex
scratch plate.

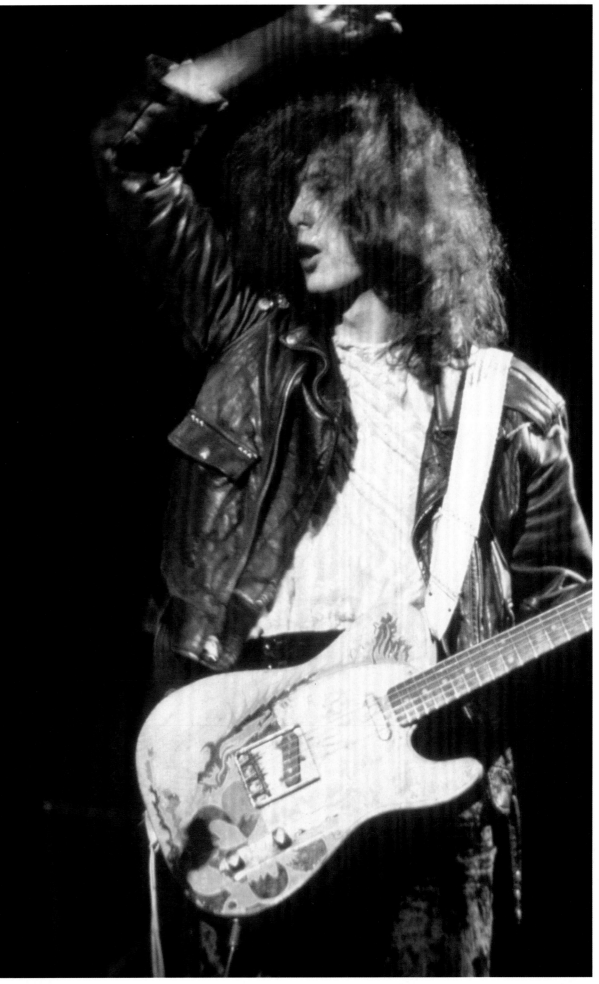

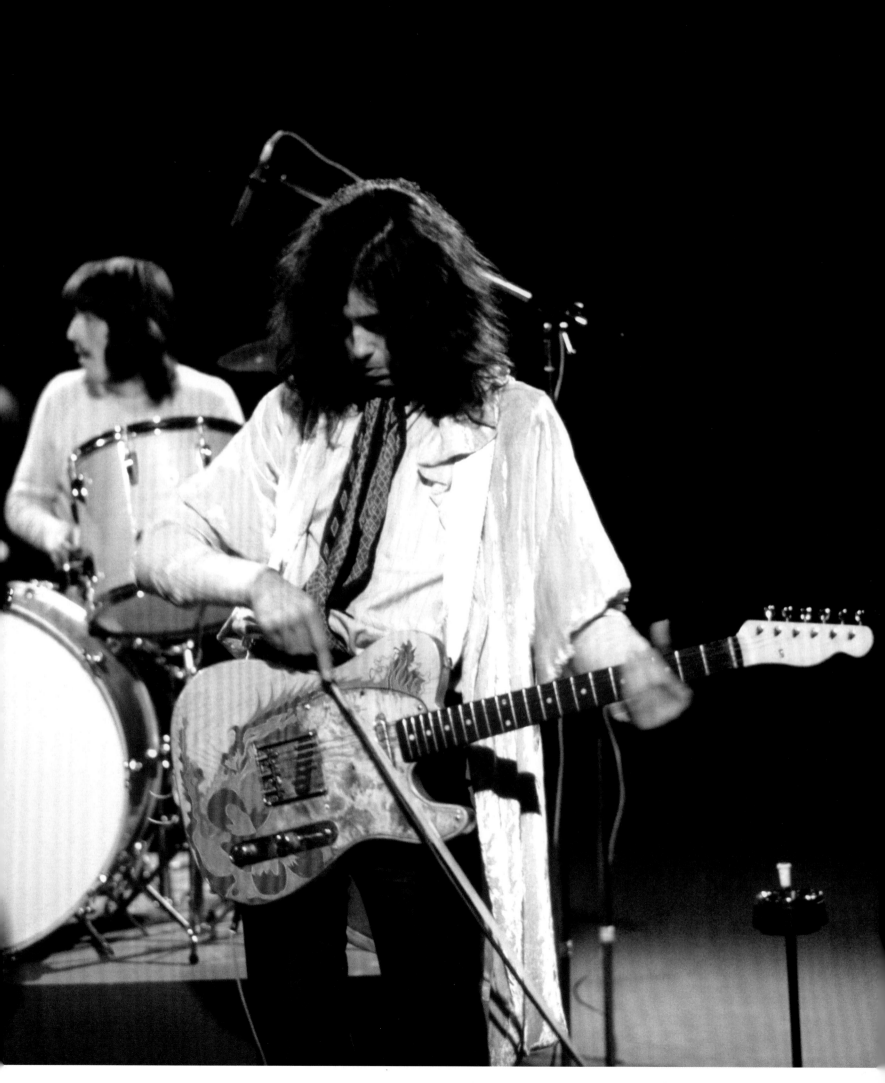

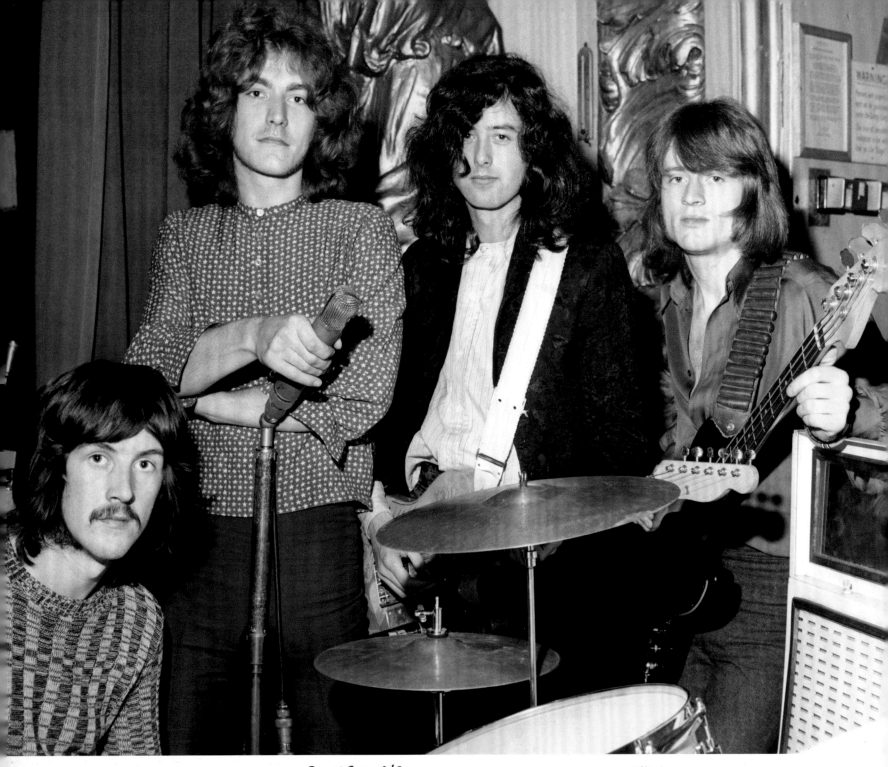

March 3
John Peel's
Top Gear
Playhouse Theatre,
London, UK

Recording Date ...3..MARCH..1969...........
Items Performed ② COMMUNICATION BREAKDOWN ③ DAZED AND CONFUSED ④⑤
 ① I CAN'T QUIT YOU BABY..........

2. Professional name of ~~Artist~~ or Group ...LED ZEPPELIN...........

3. Real name of ~~Artist~~ (or group leader) ...JIMMY PAGE...........

3a. Permanent Home Address (of Artist or Leader) ...4. SHOOTERS HILL,...
 ...PANGBOURNE, BERKS... Phone: ~~Pangbourne~~ .3273....

4. All correspondence will be sent to you/the Leader unless otherwise stated:
 Agent's/~~Manager's~~ name ...HAROLD DAVISON LTD...........
 Address ...4 ~~SHOOTERS HILL~~....PANGBOURNE, BERKS..
 Phone: ~~Pangbourne~~ 3273....

5. Solo Artist's classification
 (i.e. vocal/guitarist; vocalist; instrumentalist etc. ...)

We were invited to be filmed for
Supershow (opposite) which was
showcasing a number of artists and
we played 'Dazed And Confused'.
I suggested to the director that we
also do an additional number but
he felt that it wasn't necessary.

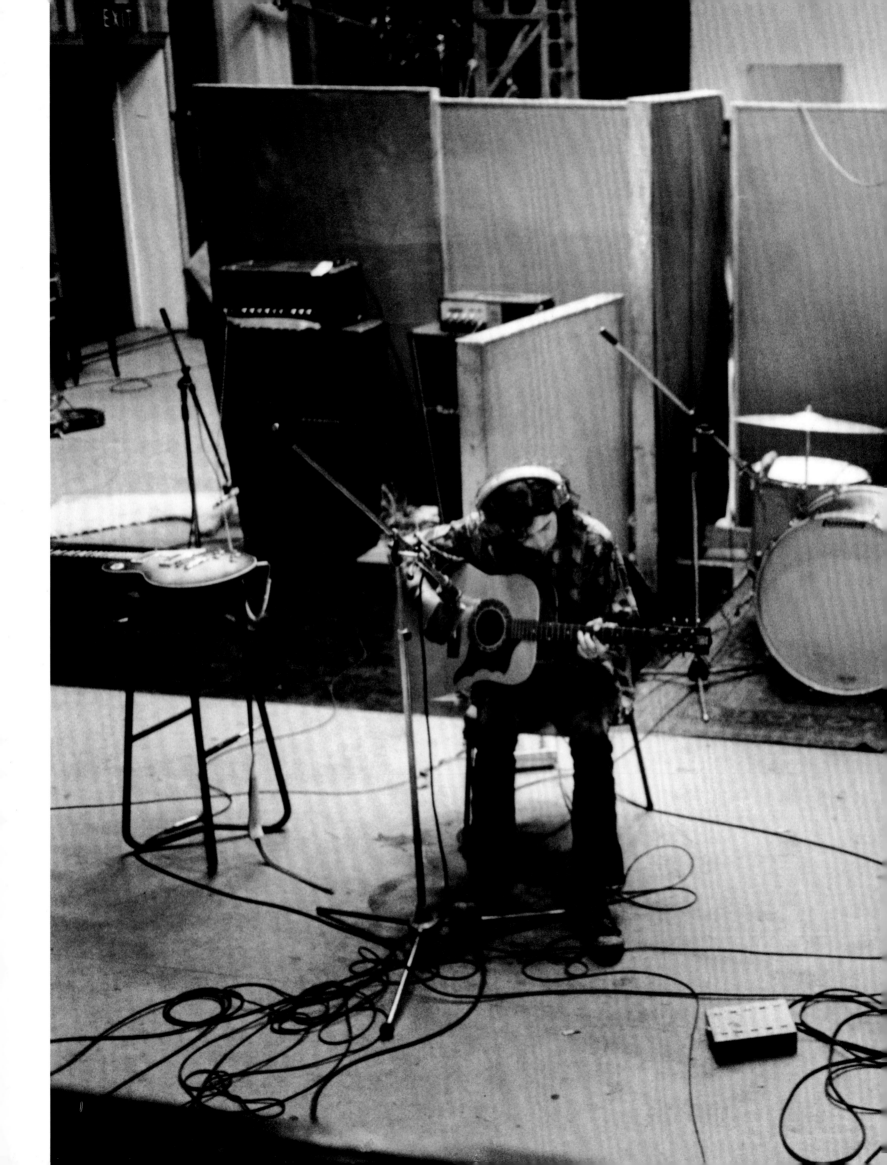

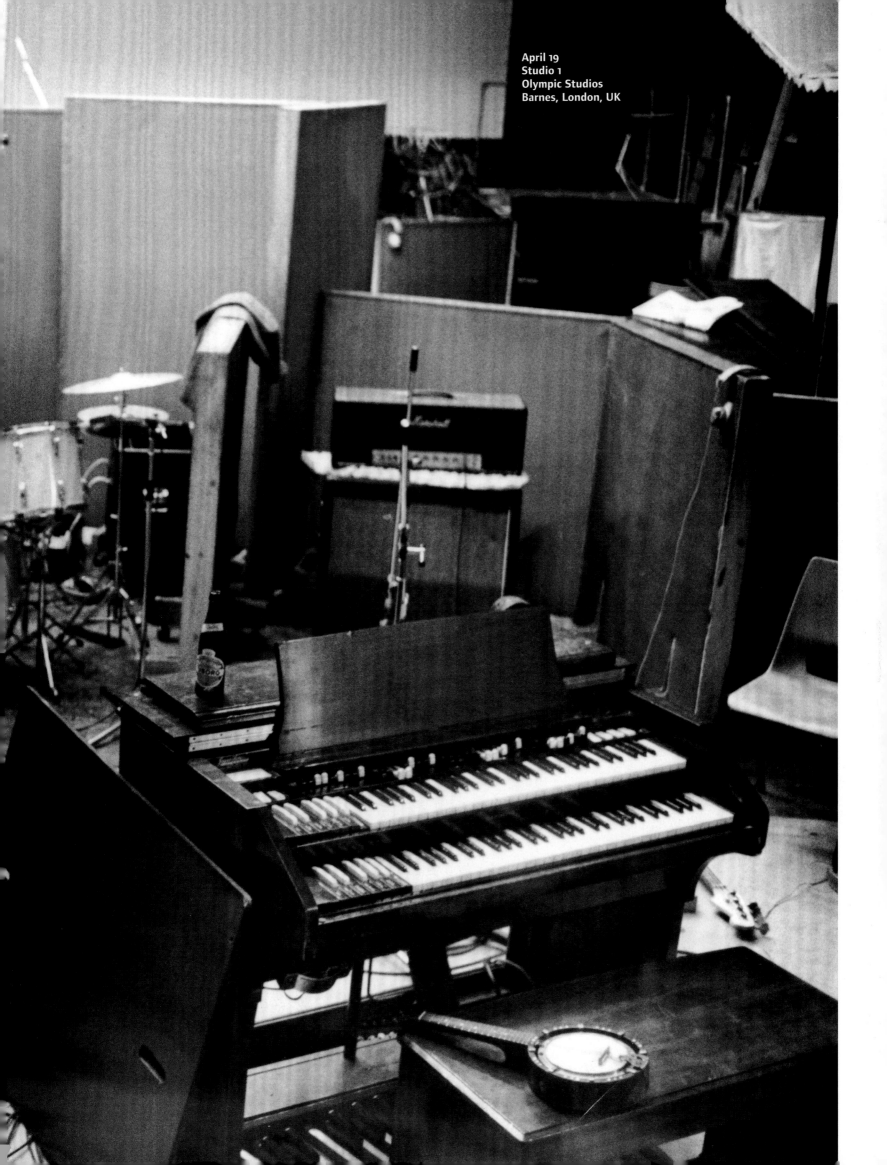

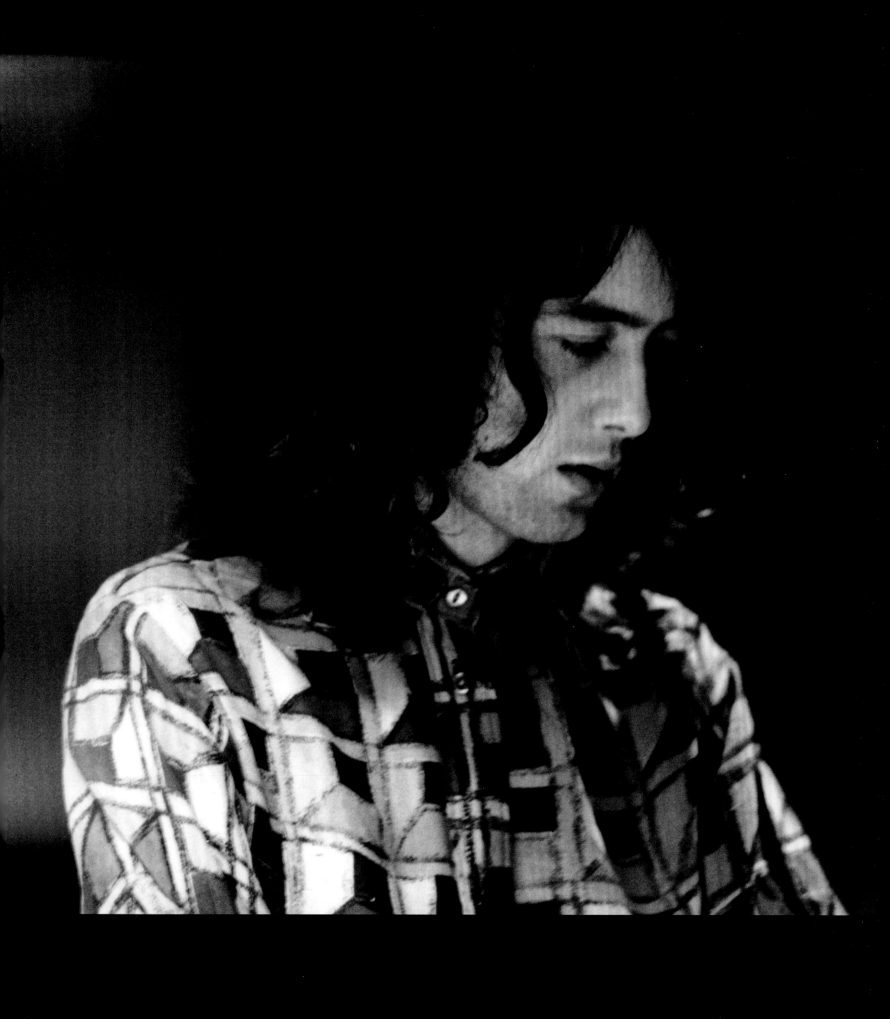

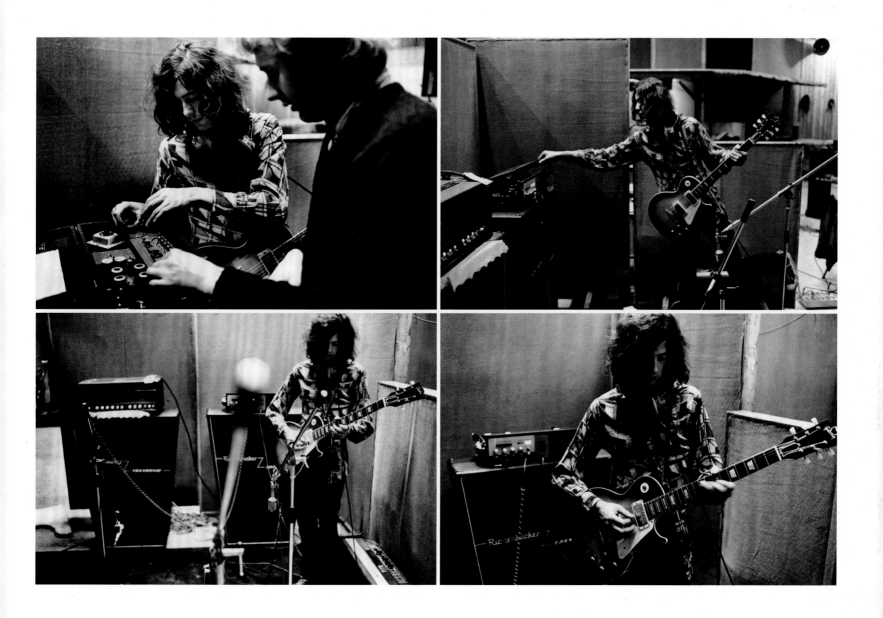

We began recording the second album at Olympic Studios with George Chkiantz. We recorded 'Whole Lotta Love' at this time. These photographs are during the recording of 'What Is And What Should Never Be'.

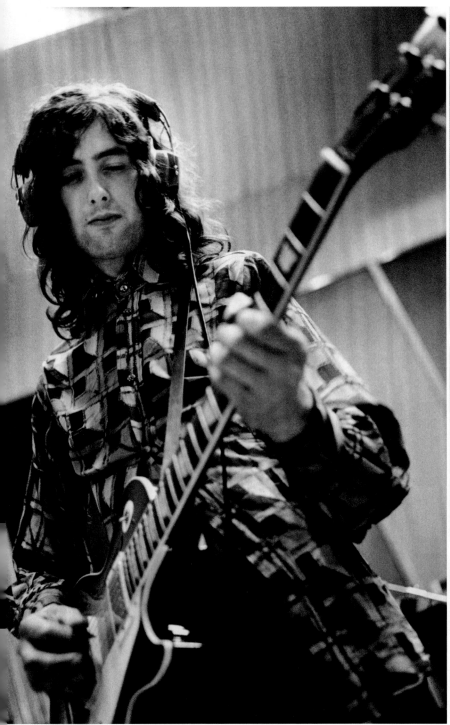

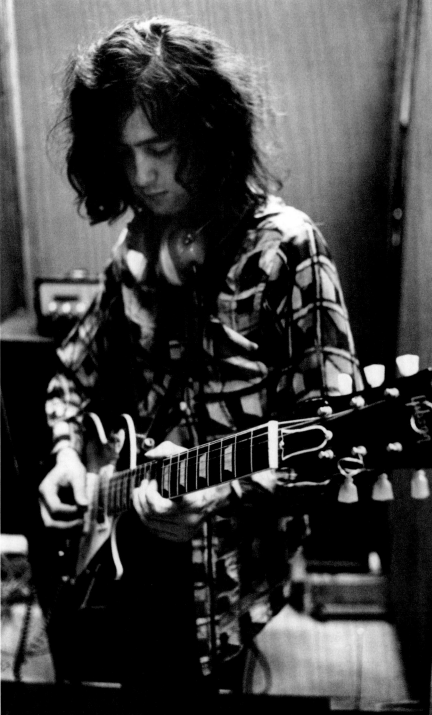

April 19
Studio 1
Olympic Studios
Barnes, London, UK

We began the recording of the second album in London with the idea to continue at different locations in America while absorbing the energy of life on the road.

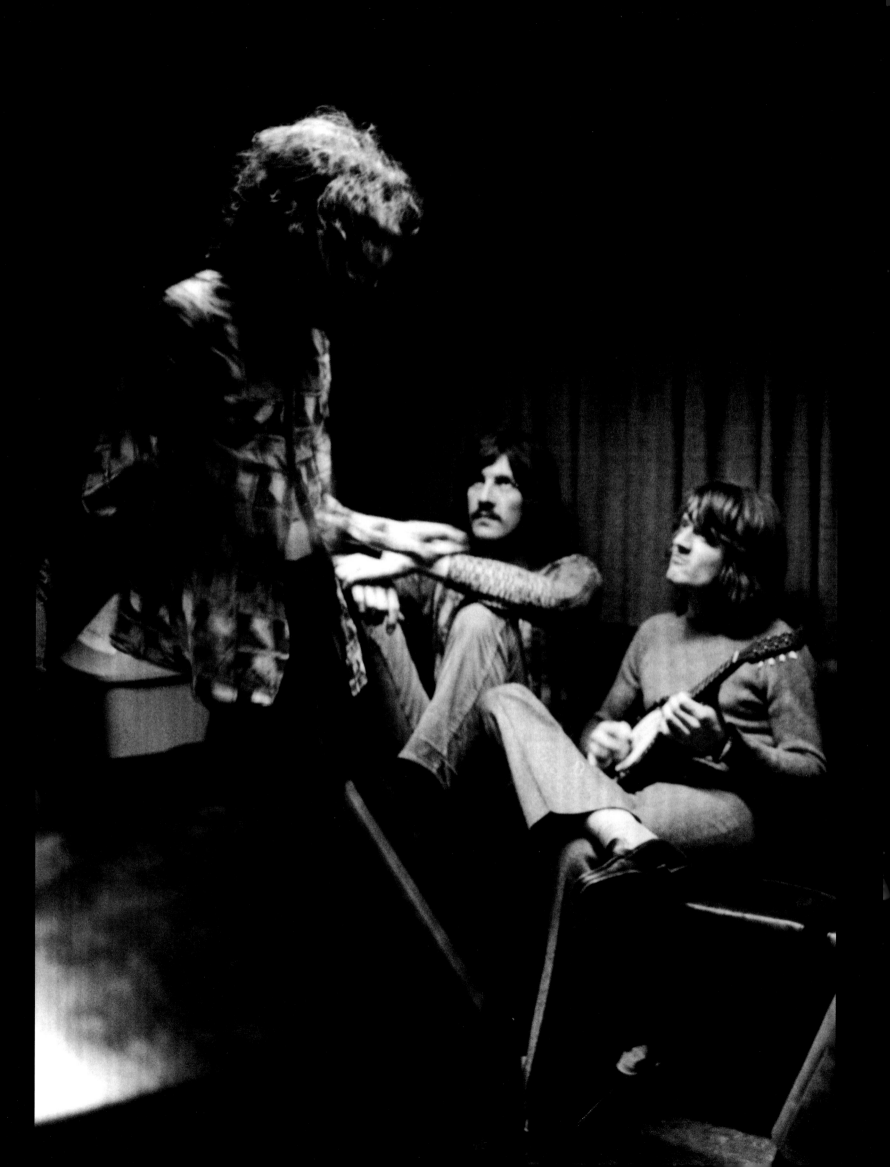

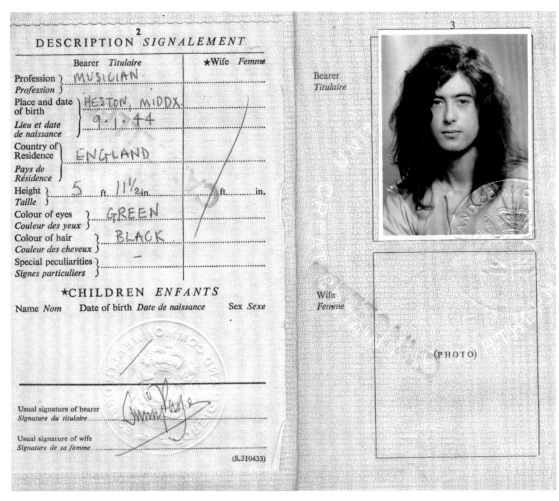

DESCRIPTION SIGNALEMENT

	Bearer *Titulaire*	★Wife *Femme*
Profession *Profession*	MUSICIAN	
Place and date of birth *Lieu et date de naissance*	HESTON, MIDDX. 9.1.44	
Country of Residence *Pays de Résidence*	ENGLAND	
Height *Taille*	5 ft 11½ in	ft. in.
Colour of eyes *Couleur des yeux*	GREEN	
Colour of hair *Couleur des cheveux*	BLACK —	
Special peculiarities *Signes particuliers*		

★CHILDREN ENFANTS

Name *Nom*	Date of birth *Date de naissance*	Sex *Sexe*

Usual signature of bearer
Signature du titulaire.

Usual signature of wife
Signature de sa femme.

(S.310433)

Bearer
Titulaire

Wife
Femme

(PHOTO)

Nº 326553

LND

EMBASSY
OF THE UNITED STATES
OF AMERICA
LONDON

NONIMMIGRANT VISA

H-2 21 APR 1969

CLASSIFICATION DATE

VALID IF PRESENTED BEFORE

26 May 1969 FOR

Multiple APPLICATIONS FOR

ADMISSION INTO THE UNITED STATES

ISSUED TO

James P.
PAGE

GRATIS [signature]

CONSULAR OFFICER

Bth-H-1084
Premier Talent
Assoc. Inc
N.Y. N.Y.

CANADA
IMMIGRATION
AUG 18 1969
TORONTO INTERNATIONAL AIRPORT
MALTON. ONT.

NON-IMMIGRANT "ENTERED"
NON IMMIGRANT "ENTRÉ"

1969

May 1: Crawford Hall, Irvine, USA
May 2: Rose Palace, Pasadena, USA
May 3: Rose Palace, Pasadena, USA
May 4: Santa Monica Civic Center, Santa Monica, USA
May 5: Santa Monica Civic Center, Santa Monica, USA
May 9: Edmonton Gardens, Edmonton, Canada
May 10: PNE Agrodome, Vancouver, Canada
May 11: Greenlake Aquatheater, Seattle, USA
May 13: Civic Auditorium, Honolulu, Hawaii, USA
May 16: The Grande Ballroom, Detroit, USA [2 shows]
May 17: Ohio University Convocation Center, Athens, USA
May 18: Guthrie Theater, Minneapolis, USA
May 23: Santa Clara Pop Festival, San Jose, USA [Unconfirmed]
May 23: Kinetic Playground, Chicago, USA
May 24: Kinetic Playground, Chicago, USA
May 25: Merriweather Post Pavilion, Columbia, USA
May 27: Boston Tea Party, Boston, USA
May 28: Boston Tea Party, Boston, USA
May 29: Boston Tea Party, Boston, USA
May 30: Fillmore East, New York, USA [2 shows]
May 31: Fillmore East, New York, USA [2 shows]
End of second American tour

Start of first UK tour
June 13: Town Hall, Birmingham, UK
June 15: Free Trade Hall, Manchester, UK
June 19: Antenne Culturelle du Kremlin-Bicêtre, Paris, France
June 20: City Hall, Newcastle, UK
June 21: Colston Hall, Bristol, UK
June 26: Guildhall, Portsmouth, UK
June 27: Playhouse Theatre, London, UK
June 28: Bath Festival of Blues, Bath Recreation Ground, Bath, UK
June 29: Pop Proms, Royal Albert Hall, London, UK [2 shows]
End of first UK tour

Start of third American tour
July 5: Atlanta International Pop Festival, Atlanta International Raceway, Hampton, USA
July 6: Newport Jazz Festival, Newport, USA
July 11: Laurel Jazz & Pop Festival, Laurel, USA
July 12: Spectrum Pop Festival, Philadelphia, USA
July 18: Kinetic Playground, Chicago, USA
July 19: Kinetic Playground, Chicago, USA
July 20: Musicarnival, Cleveland, USA
July 21: Schaefer Music Festival, Wollman Skating Rink Theater, New York, USA [2 shows]
July 25: Mid-West Rock Festival, State Fair Park, Milwaukee, USA
July 26: PNE Agrodome, Vancouver, Canada
July 27: Seattle Pop Festival, Gold Creek Park, Woodinville, USA
July 29: Kinsmen Field House, Edmonton, Canada
July 30: Terrace Ballroom, Salt Lake City, USA

August 1: Fairgrounds Arena, Santa Barbara, USA
August 2: Civic Auditorium, Albuquerque, USA [Unconfirmed]
August 3: Houston Music Hall, Houston, USA
August 4: State Fair Coliseum, Dallas, USA [Unconfirmed]
August 6: Memorial Auditorium, Sacramento, USA
August 7: Berkeley Community Theatre, Berkeley, USA
August 8: Swing Auditorium, San Bernardino, USA
August 9: Anaheim Convention Center, Anaheim, USA
August 10: Sports Arena, San Diego, USA
August 11: Ice Palace, Las Vegas, USA [Unconfirmed]
August 14: Austin Municipal Auditorium, Austin, USA [Unconfirmed]
August 15: HemisFair Arena, San Antonio, USA
August 16: Convention Hall, Asbury Park, USA [2 shows]
August 17: Oakdale Musical Theatre, Wallingford, USA
August 18: The Rock Pile, Toronto, Canada [2 shows]
August 20: Aerodrome, Schenectady, USA
August 21: Carousel Theatre, Framingham, USA
August 22: Pirates World, Dania, USA
August 23: Pirates World, Dania, USA
August 24: Veterans Memorial Coliseum, Jacksonville, USA
August 27: Casino Ballroom, Hampton Beach, USA [2 shows]
August 30: Singer Bowl Music Festival, Flushing Meadow Park, USA
August 31: Texas International Pop Festival, Lewisville, USA
End of third American tour

CANADA
IMMIGRATION
MAY 9 1969
VANCOUVER INT'L AIRPORT

NON-IMMIGRANT "ENTERED"
NON-IMMIGRANT "ENTRÉ"

CANADA
IMMIGRATION
JUL 26 1969
VANCOUVER INT'L AIRPORT

7

U. S. IMMIGRATION
NEW YORK, N. Y. 574

JUL 3 1969

ADMITTED UNTIL Nº 337484

EMBASSY
OF THE UNITED STATES
OF AMERICA
LONDON

NONIMMIGRANT VISA

H-1 30 JUN 1969

CLASSIFICATION DATE

Aug. 30-1969

MULTIPLE ADMISSION INTO THE UNITED STATES

ISSUED TO

James P.
Page

GRATIS [signature]

CONSULAR OFFICER

ATL-N-1074
Premiere Talent
Ass. Inc.
M.Y.

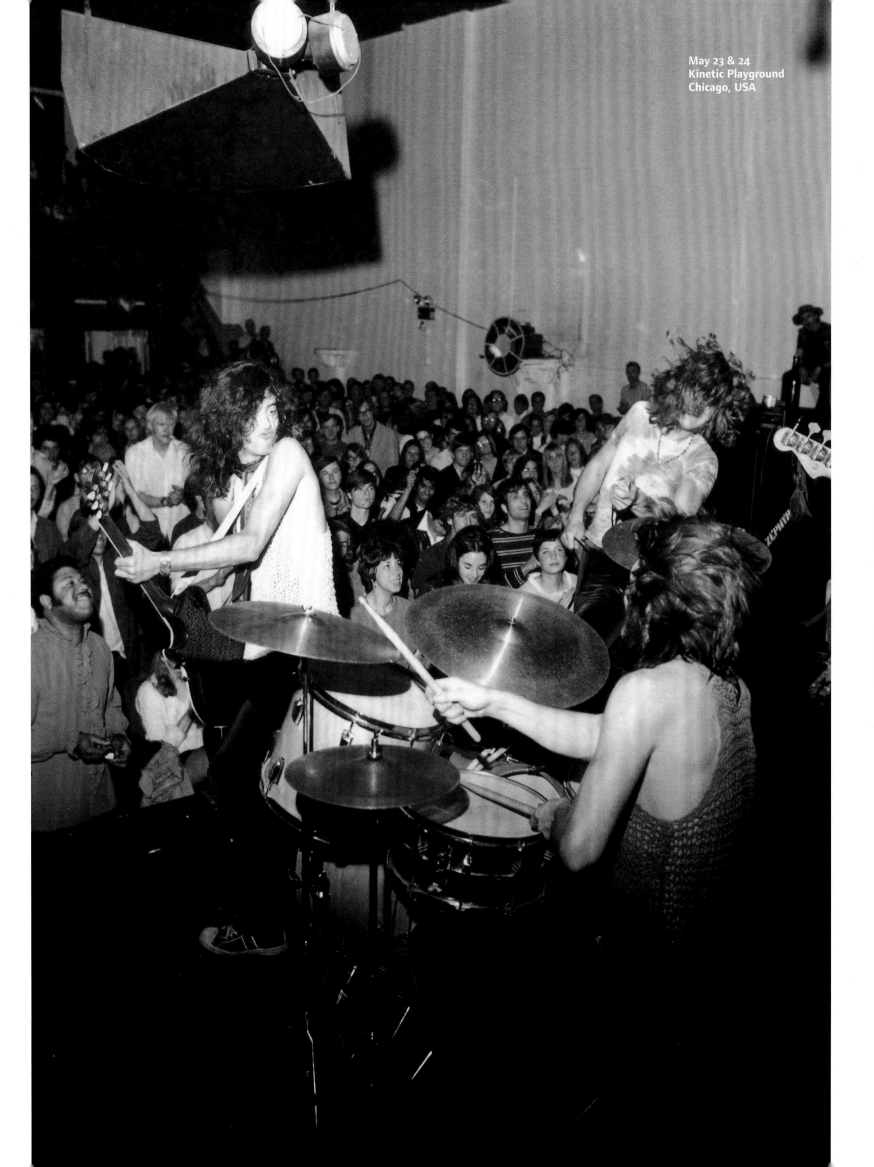

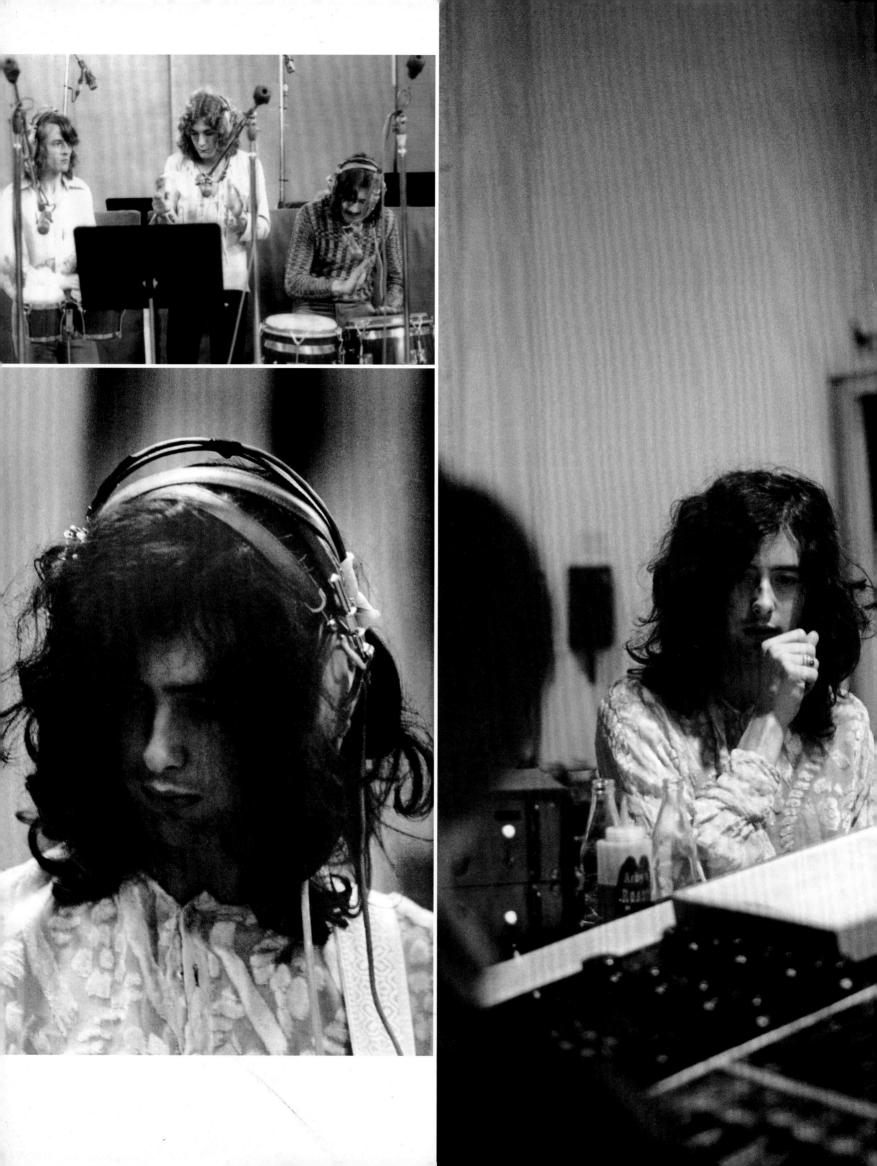

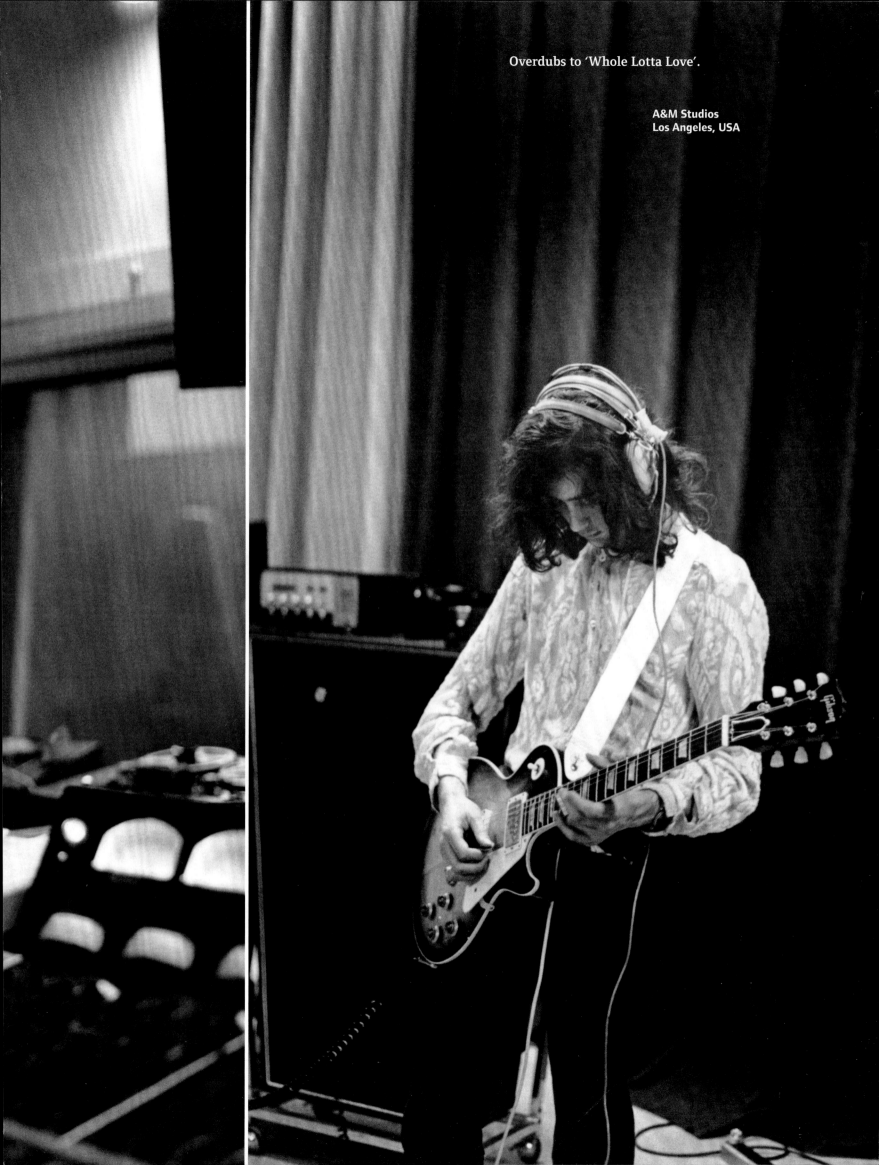

Overdubs to 'Whole Lotta Love'.

A&M Studios
Los Angeles, USA

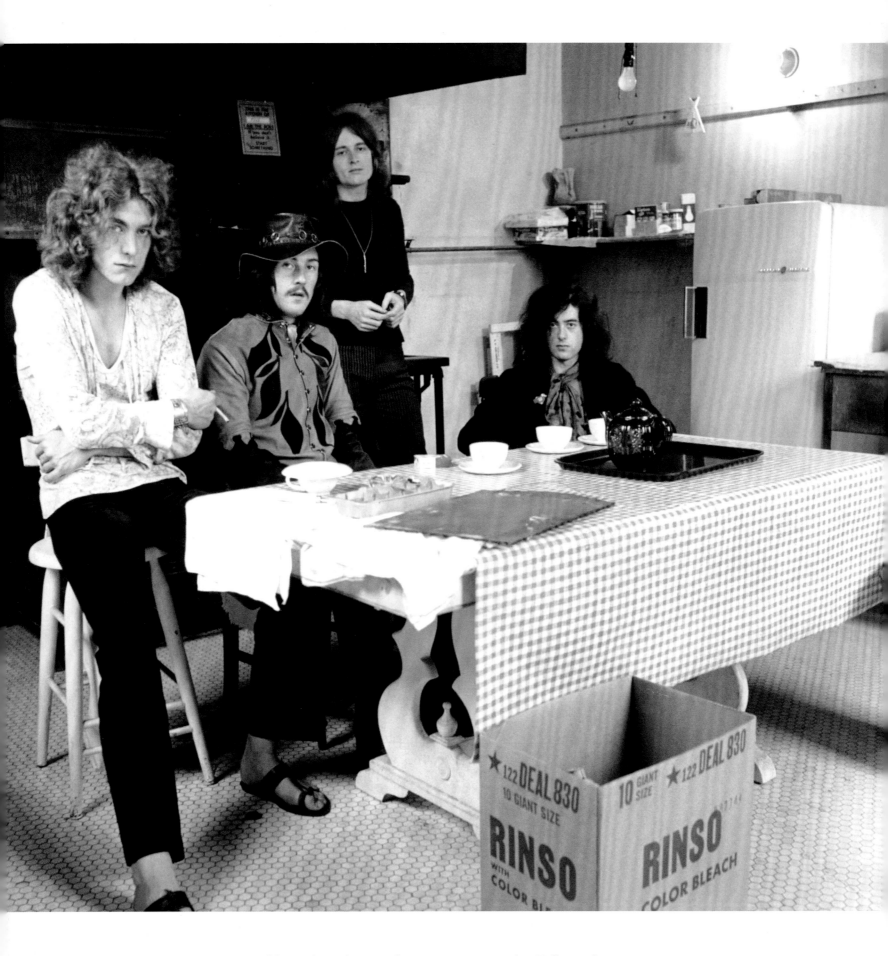

Publicity photo shoot at Chateau Marmont Hotel in Hollywood.

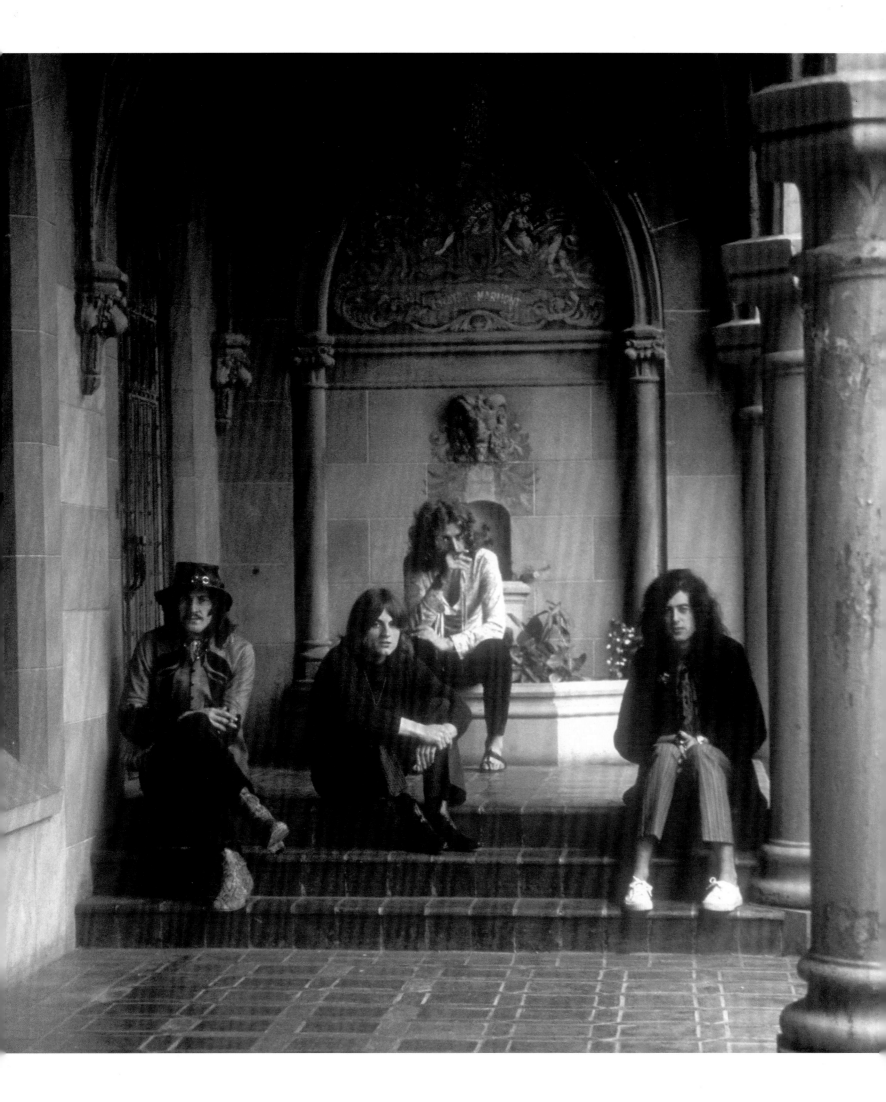

We'd recorded at Mirror Sound in Los Angeles. At the old Del-Fi studio, said to be where Ritchie Valens had recorded, we laid down the tracks 'Moby Dick' and 'Lemon Song'.

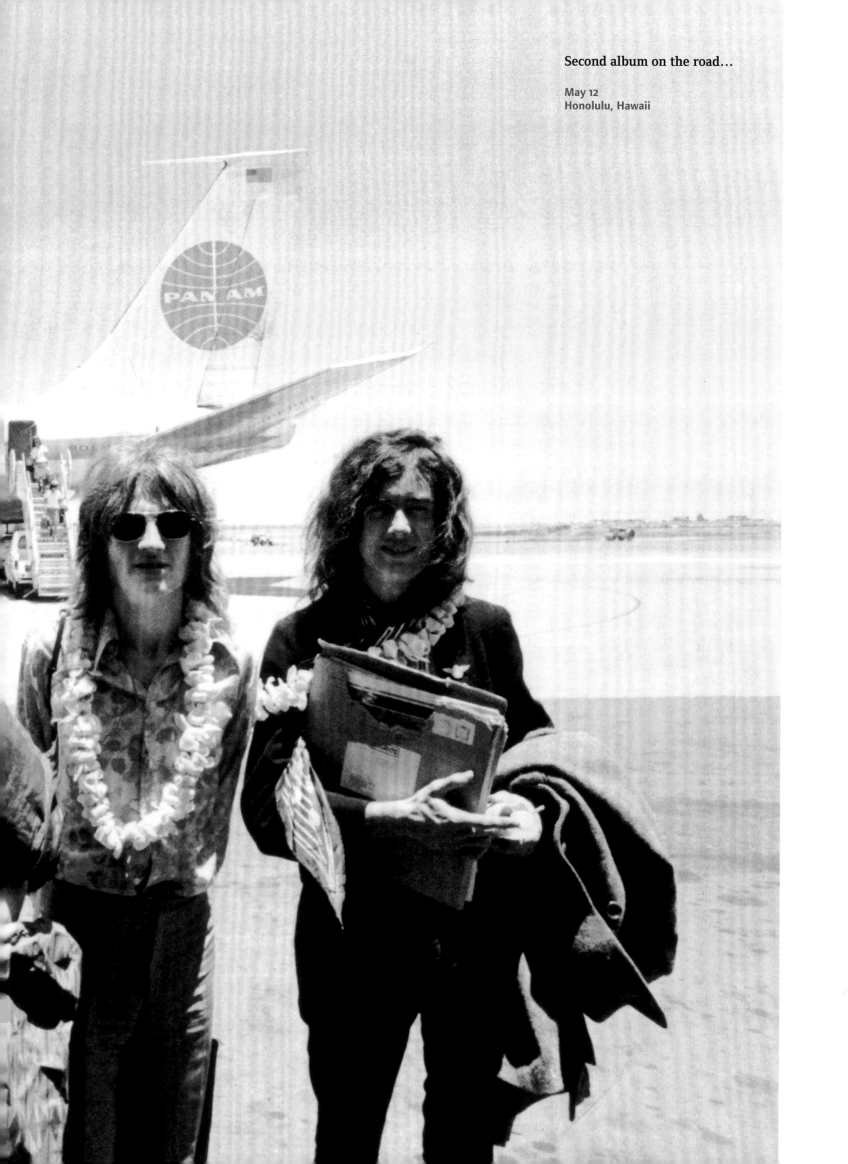

Second album on the road…

May 12
Honolulu, Hawaii

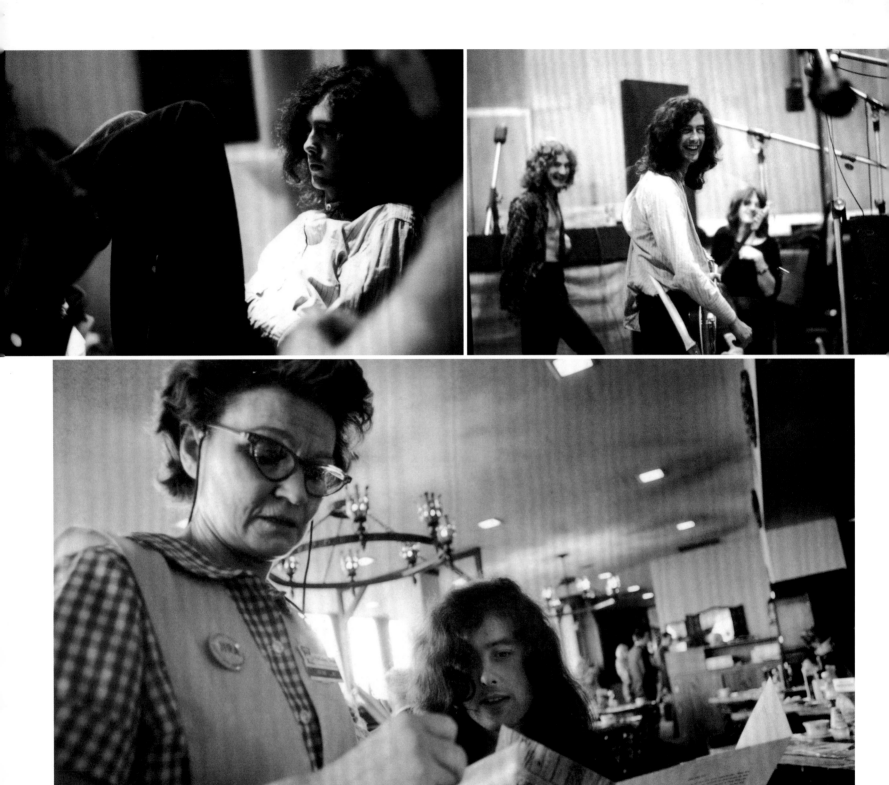

We'd recorded 'Bring It On Home' in Atlantic Studios where
Bonzo used double bass drums, but the vocal overdub was
done in Canada. The above photographs were taken during
the recording of 'Ramble On' at Groove Sound, New York.

Breakfast at The Barn.
May 26
The Barn
Boston, USA

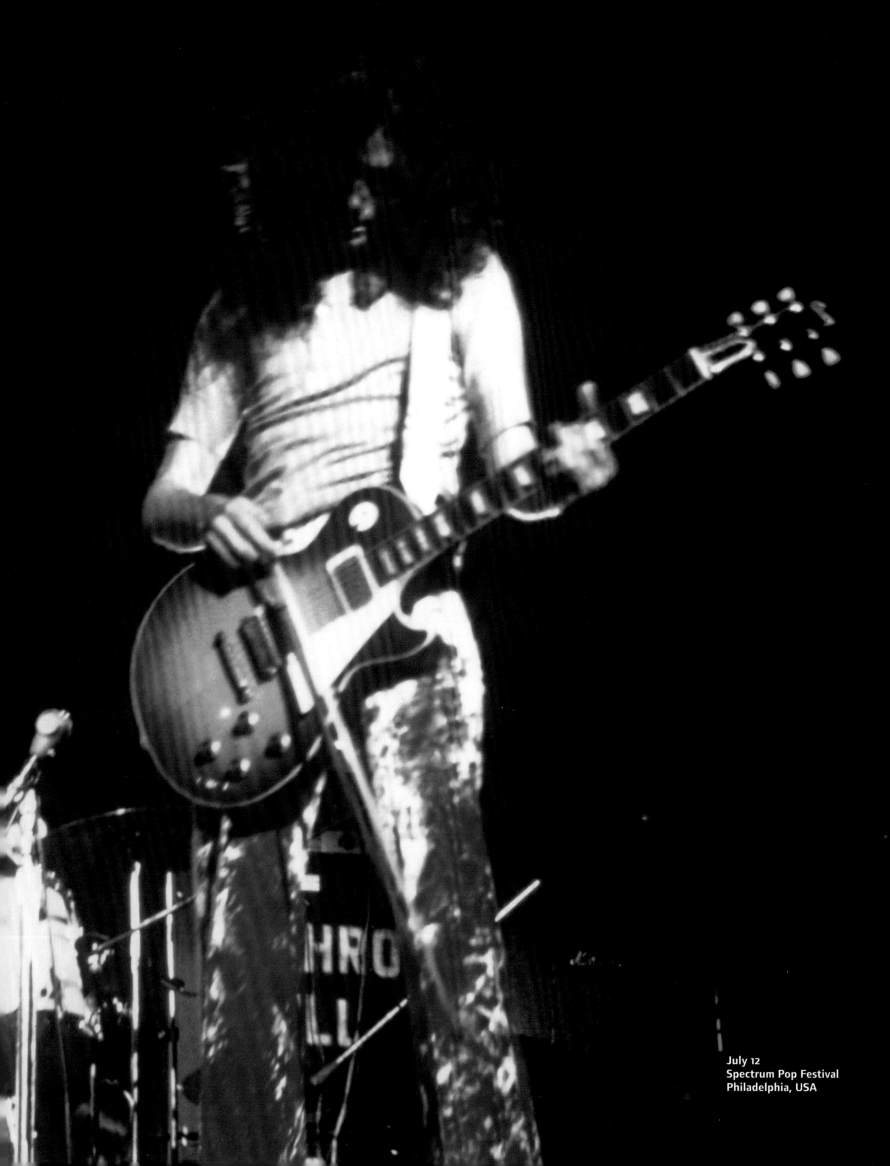

July 12
Spectrum Pop Festival
Philadelphia, USA

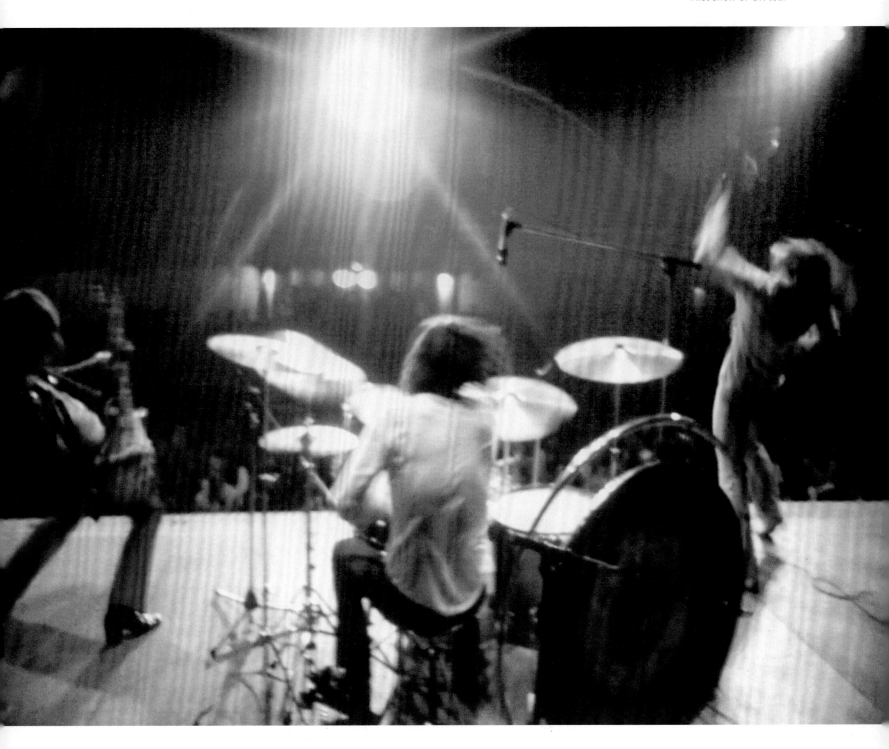

'Living Loving Maid' and 'Thank You' were done at Morgan Studios on 25th June.

It had become quite a work in progress with multiple locations, and then in New York I went in with Eddie Kramer to mix what was to become the classic *Led Zeppelin II*.

June 19
Tous en Scene
French television show
Antenne Culturelle
du Kremlin-Bicêtre
Paris, France

Bath Festival Of Blues '69

PROGRAMME TWO SHILLINGS

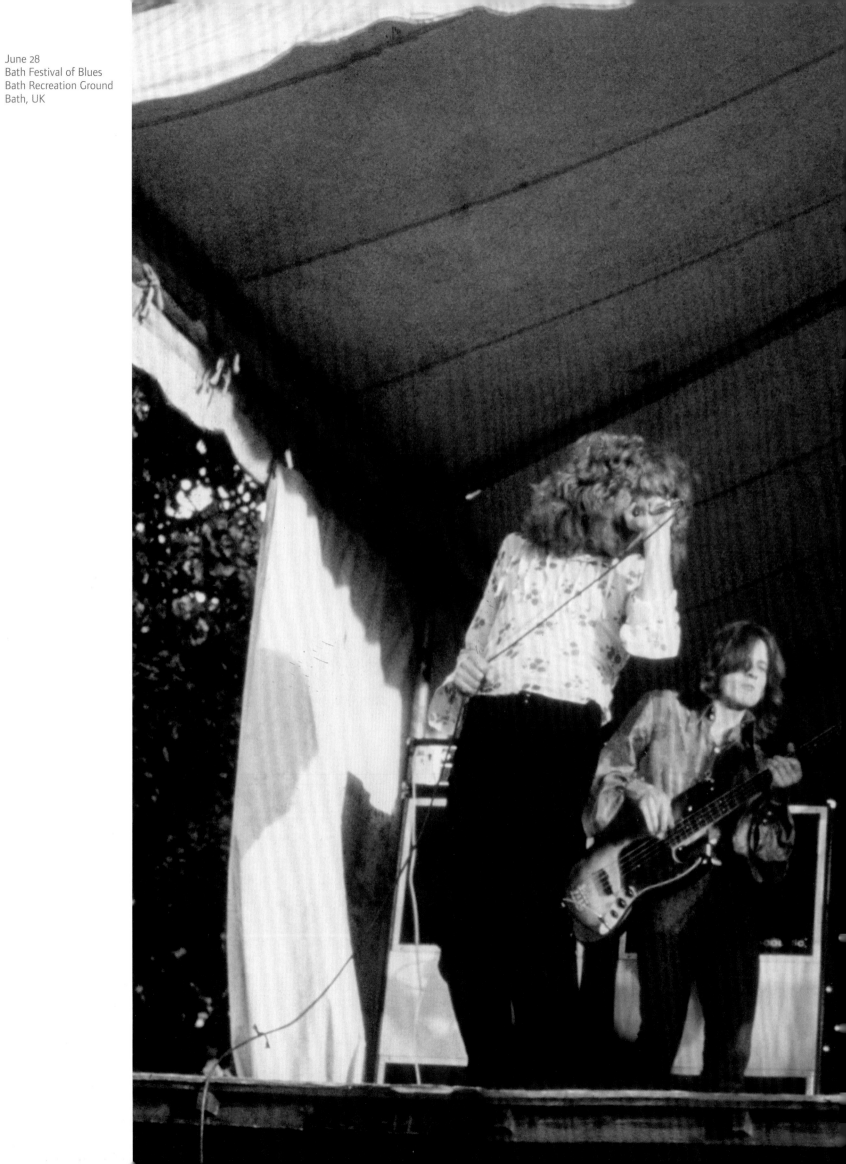

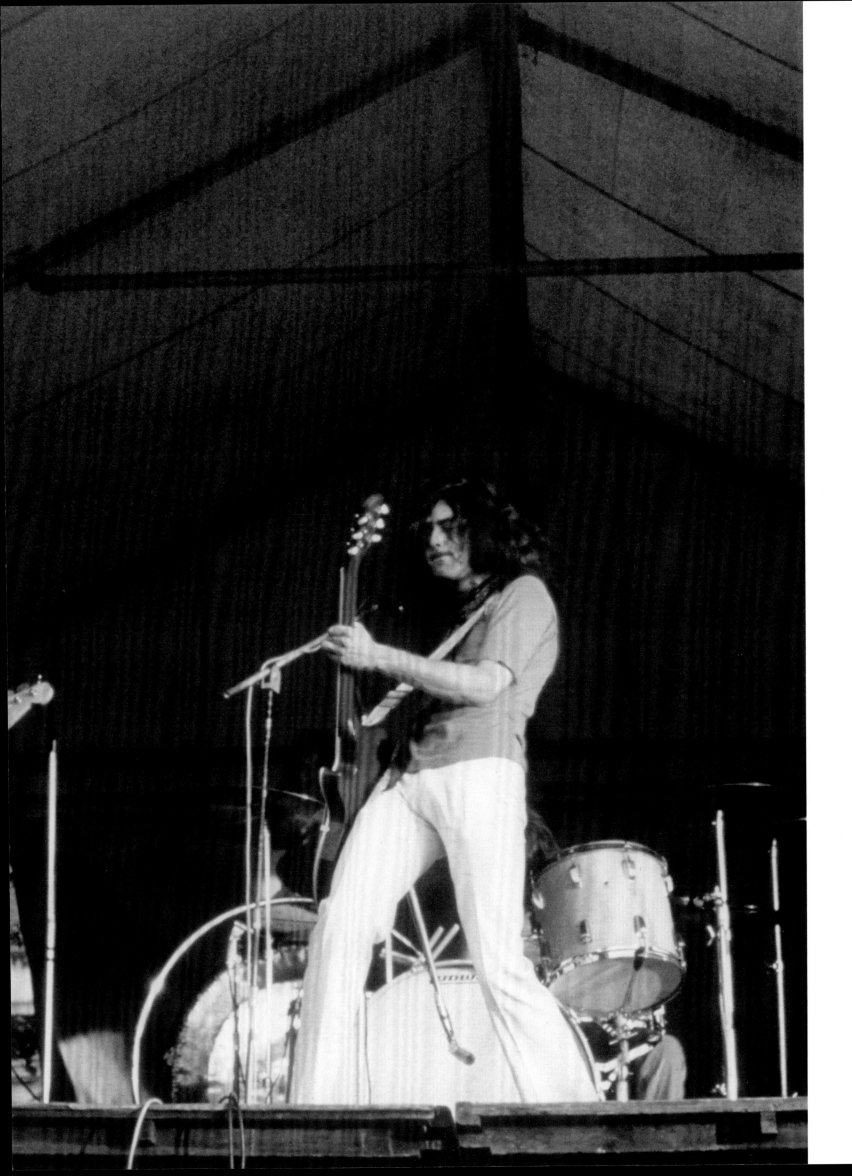

June 29
Pop Proms
Royal Albert Hall
London, UK

Final show of the
UK tour

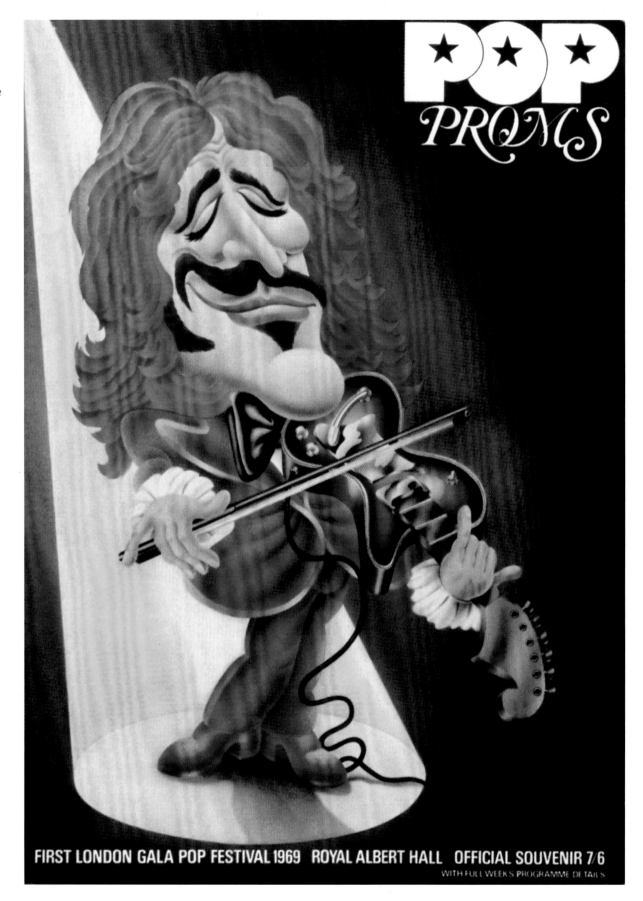

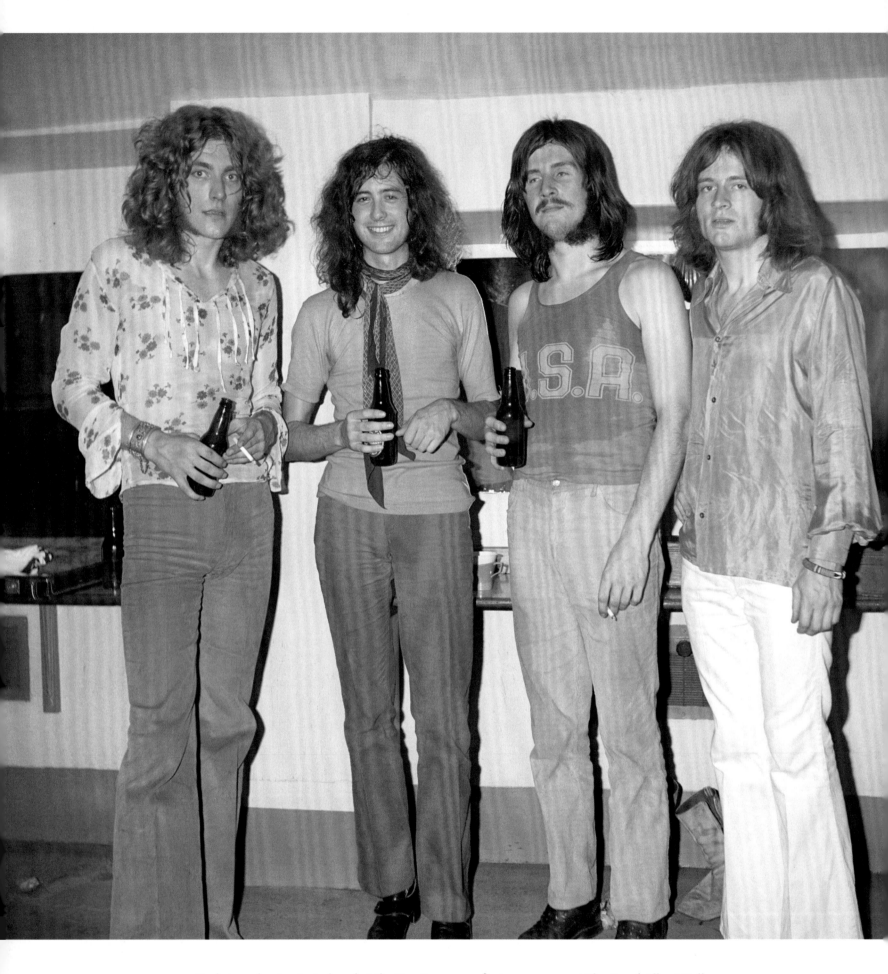

Backstage, having just played at the Pop Proms, our first appearance at The Royal Albert Hall.

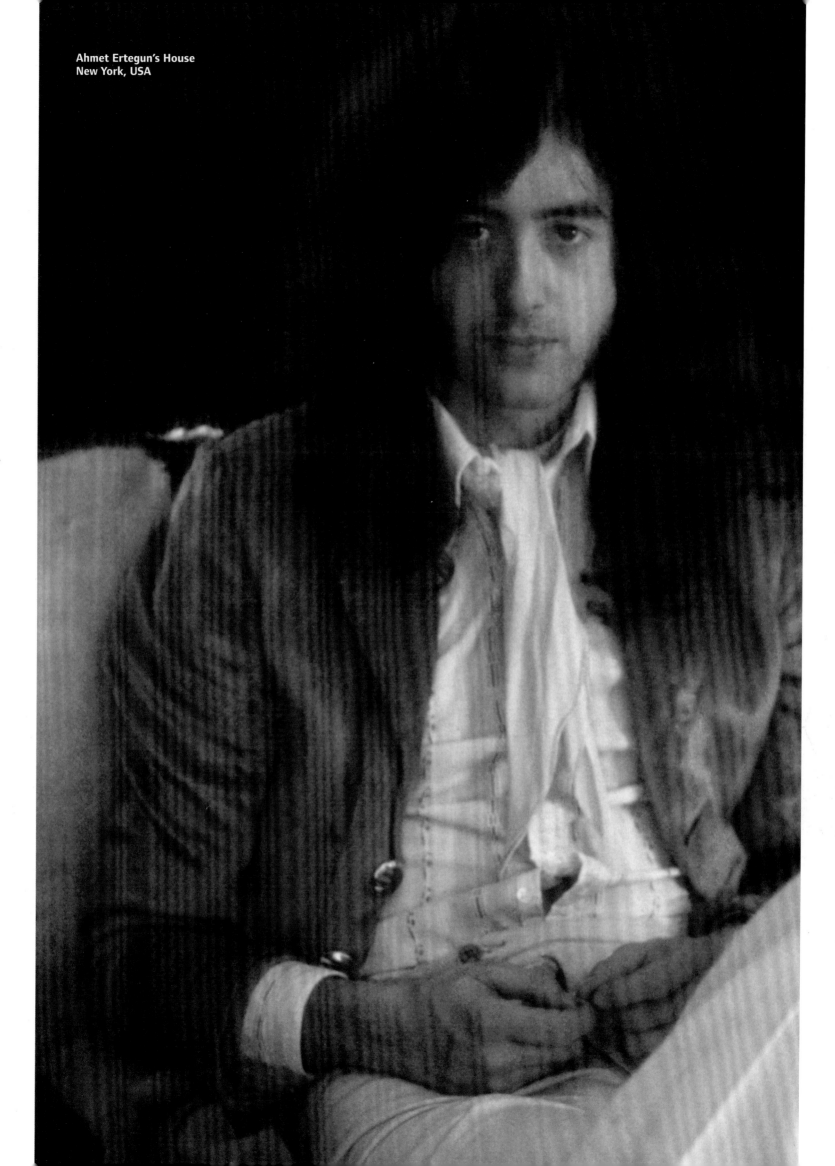

Ahmet Ertegun's House
New York, USA

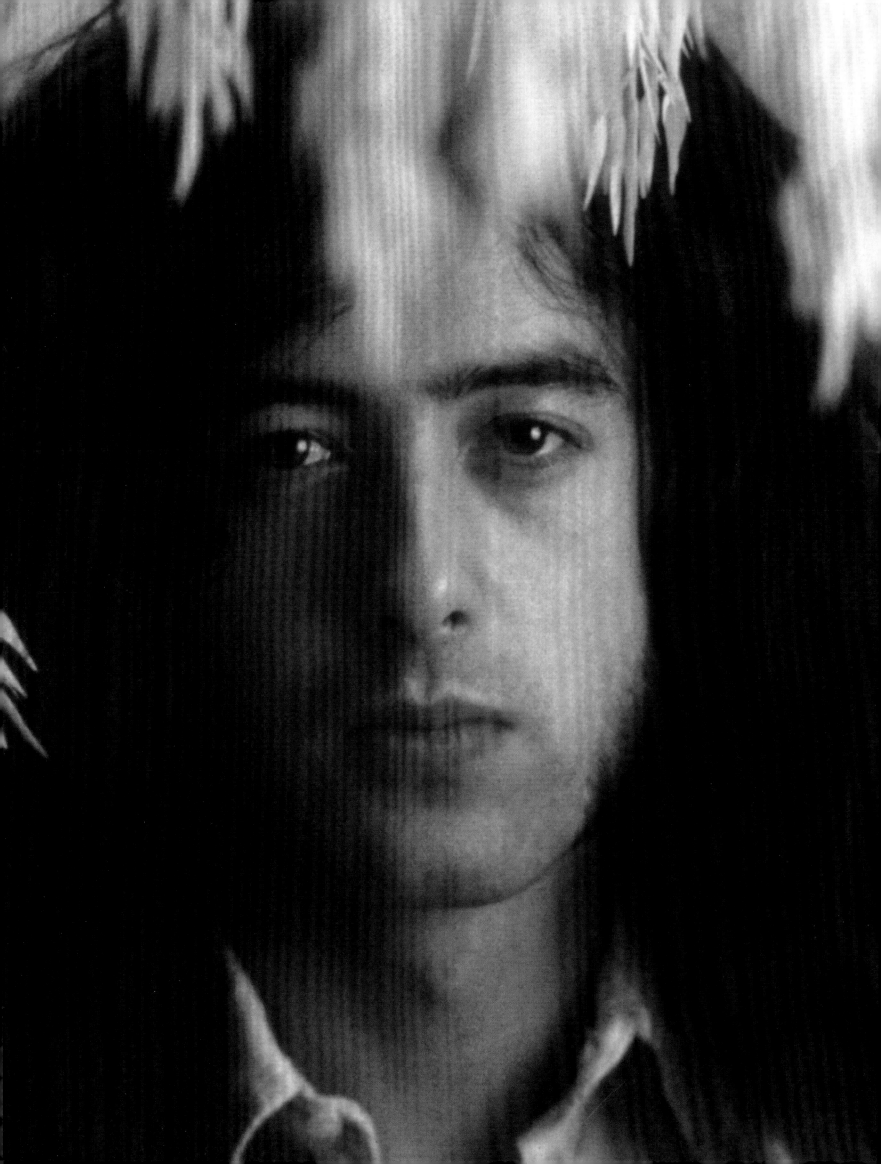

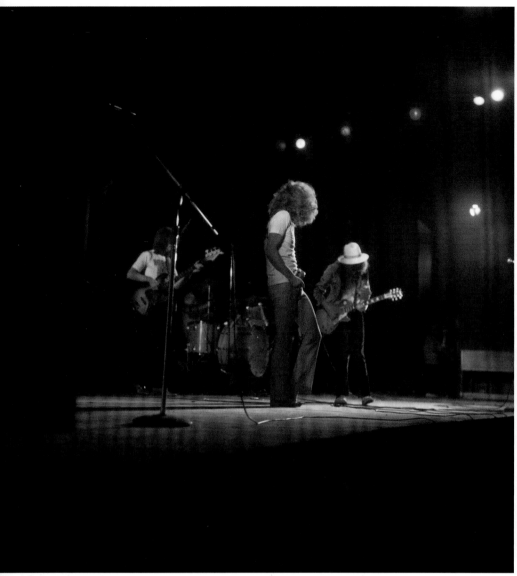

July 6
Newport Jazz Festival
Newport, USA

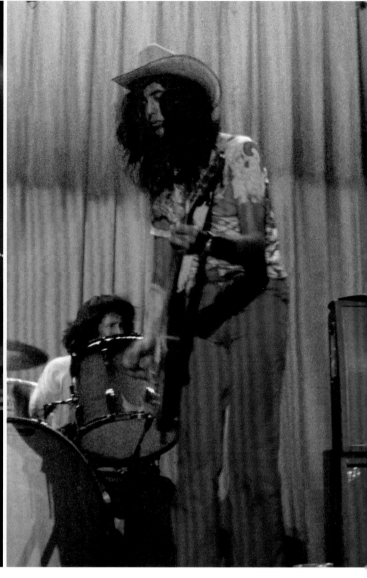

August 16
Convention Hall
Asbury Park
New Jersey, USA

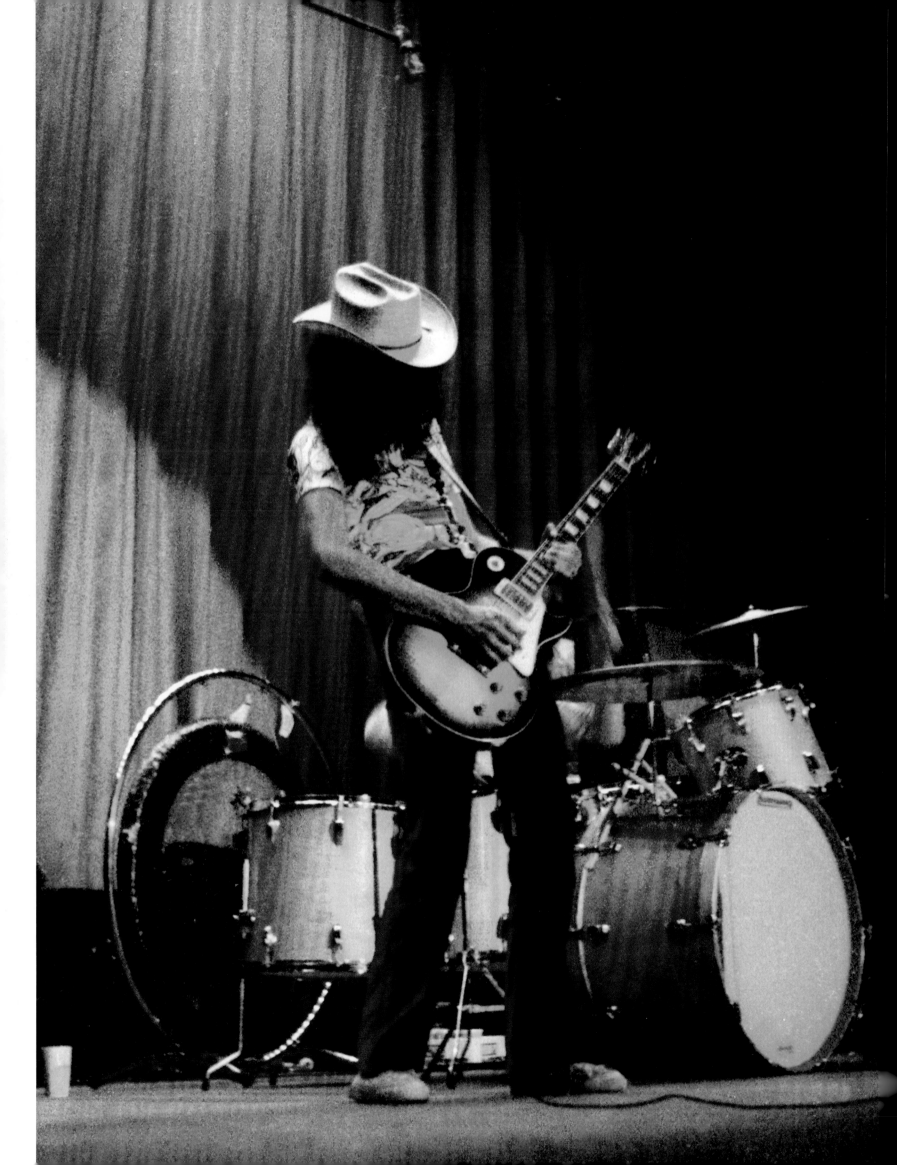

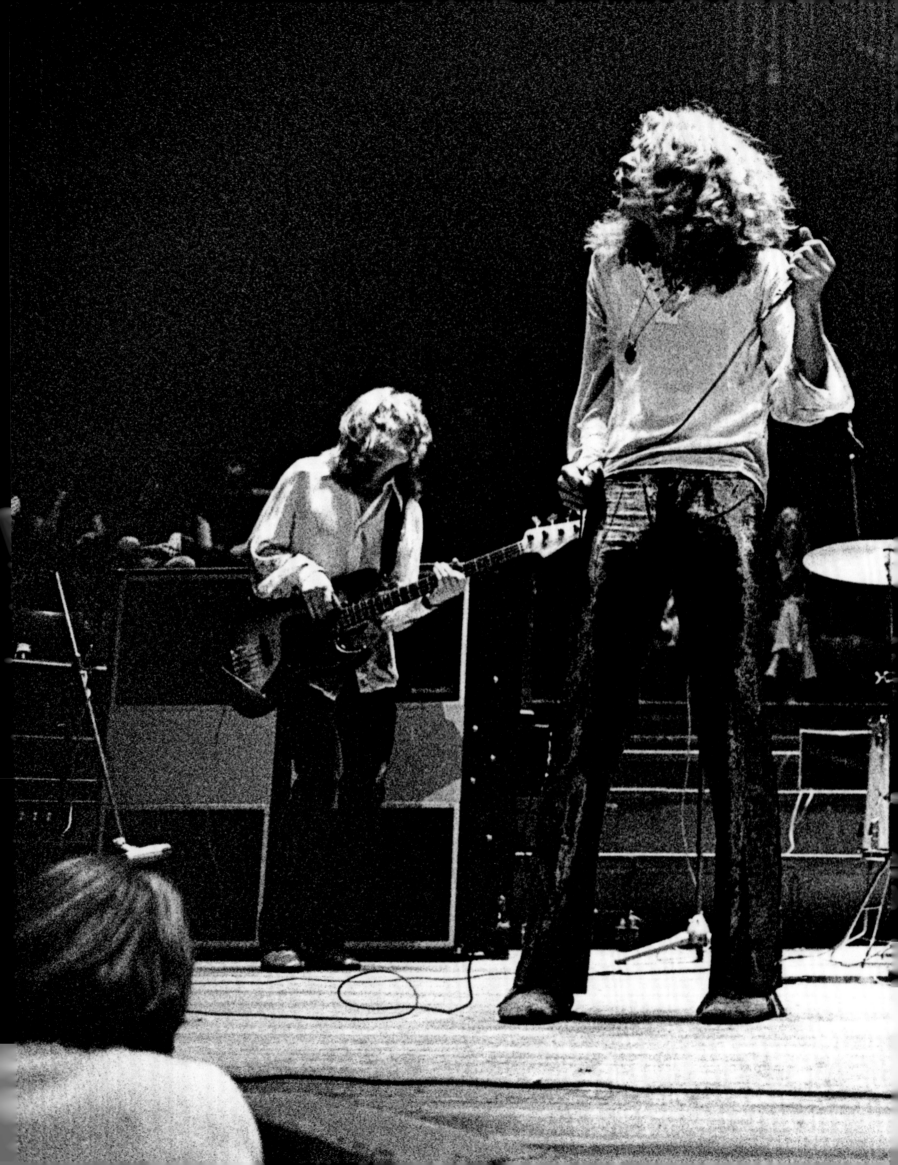

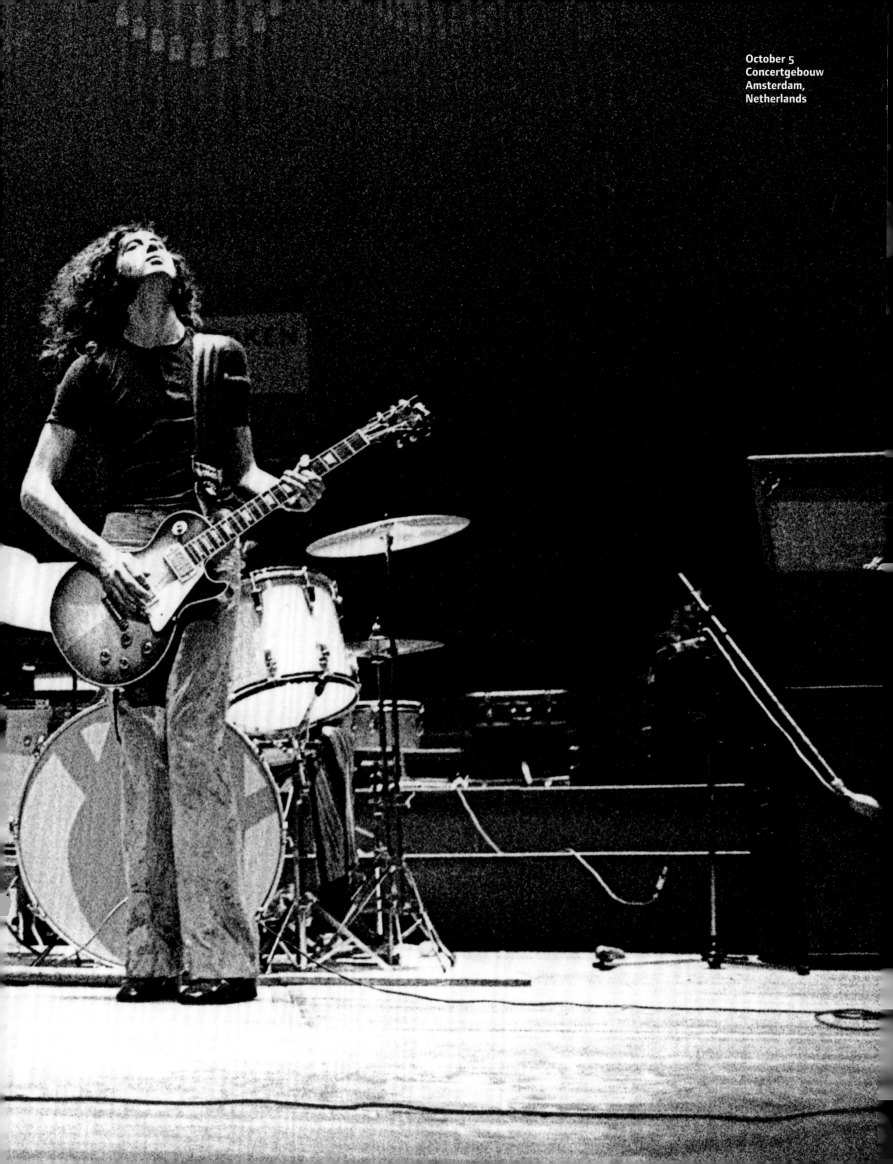

October 5
Concertgebouw
Amsterdam,
Netherlands

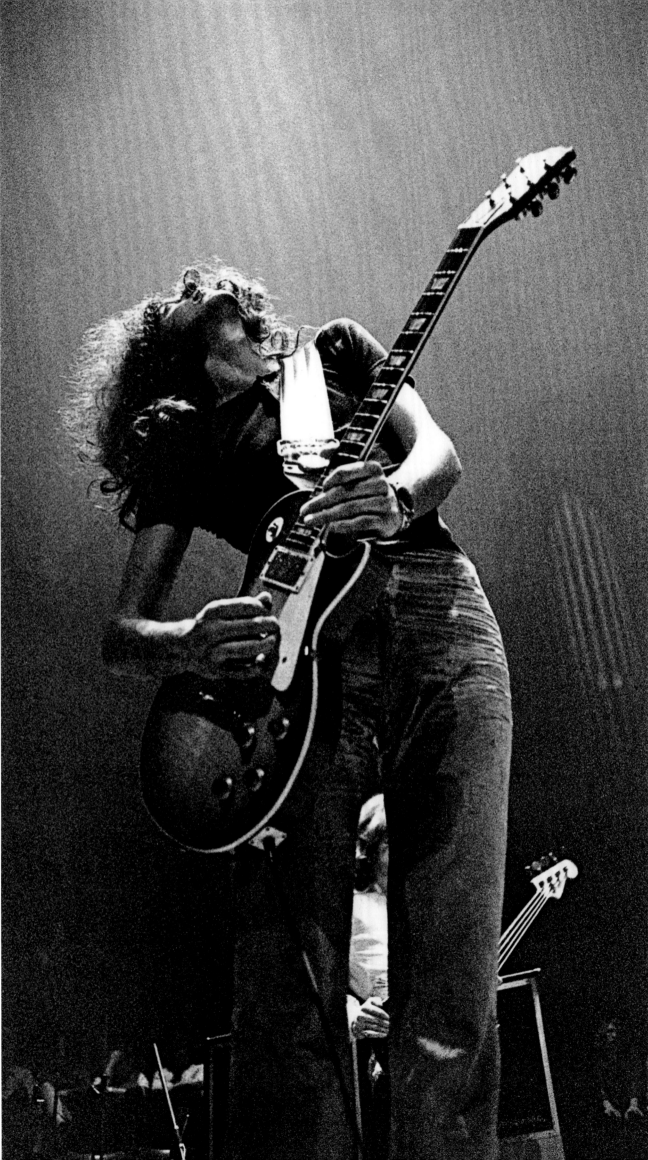

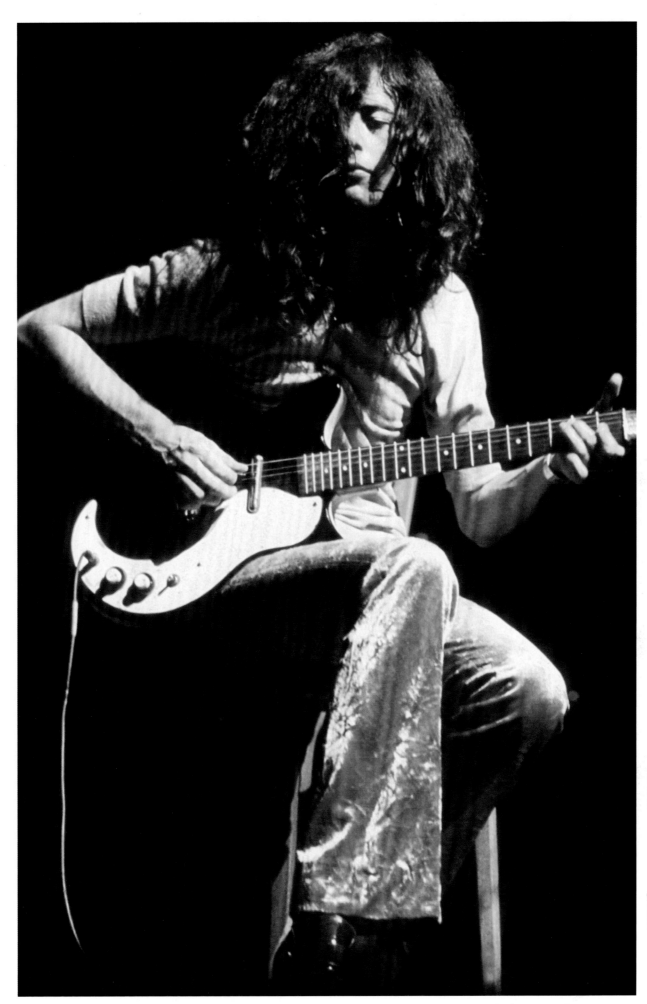

October 10
Olympia
Paris, France

October 10
Olympia
Paris, France

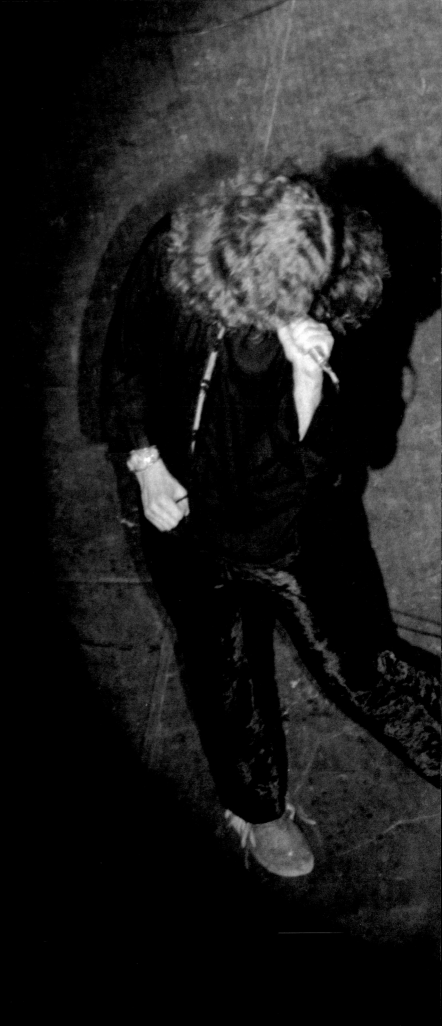

1969
October 3: Circus Theatre, Scheveningen, Netherlands
October 4: De Doelen, Rotterdam, Netherlands
October 5: Concertgebouw, Amsterdam, Netherlands
October 9: Concertgebouw, Harleem, Netherlands
[Unconfirmed]
October 10: Olympia, Paris, France
October 12: The Lyceum Theatre, London, UK

Start of fourth American tour
October 17: Carnegie Hall, New York, USA [2 shows]
October 18: Olympia Stadium, Detroit, USA
October 19: Kinetic Playground, Chicago, USA [2 shows]
October 20: Paramount Theatre, Seattle, USA
October 21: Electric Factory, Philadelphia, USA
[Unconfirmed]
October 24: Public Auditorium, Cleveland, USA
October 25: The Gansett Tribal Rock Festival, Boston Garden,
Boston, USA
October 30: Kleinhans Music Hall, Buffalo, USA
October 31: The Gansett Tribal Rock Festival, Rhode Island
Auditorium, Providence, USA
October 31: Springfield Municipal Auditorium,
Springfield, USA

November 1: Onondaga War Memorial Auditorium,
Syracuse, USA
November 2: O'Keefe Centre, Toronto, Canada [2 shows]
November 4: Kitchener Memorial Auditorium,
Kitchener, Canada
November 5: Memorial Hall, Kansas City, USA [2 shows]
November 6: Winterland Ballroom, San Francisco, USA
November 7: Winterland Ballroom, San Francisco, USA
November 8: Winterland Ballroom, San Francisco, USA
End of fourth American tour

December 6: L'École Centrale, Chatenay Malabry,
Paris, France

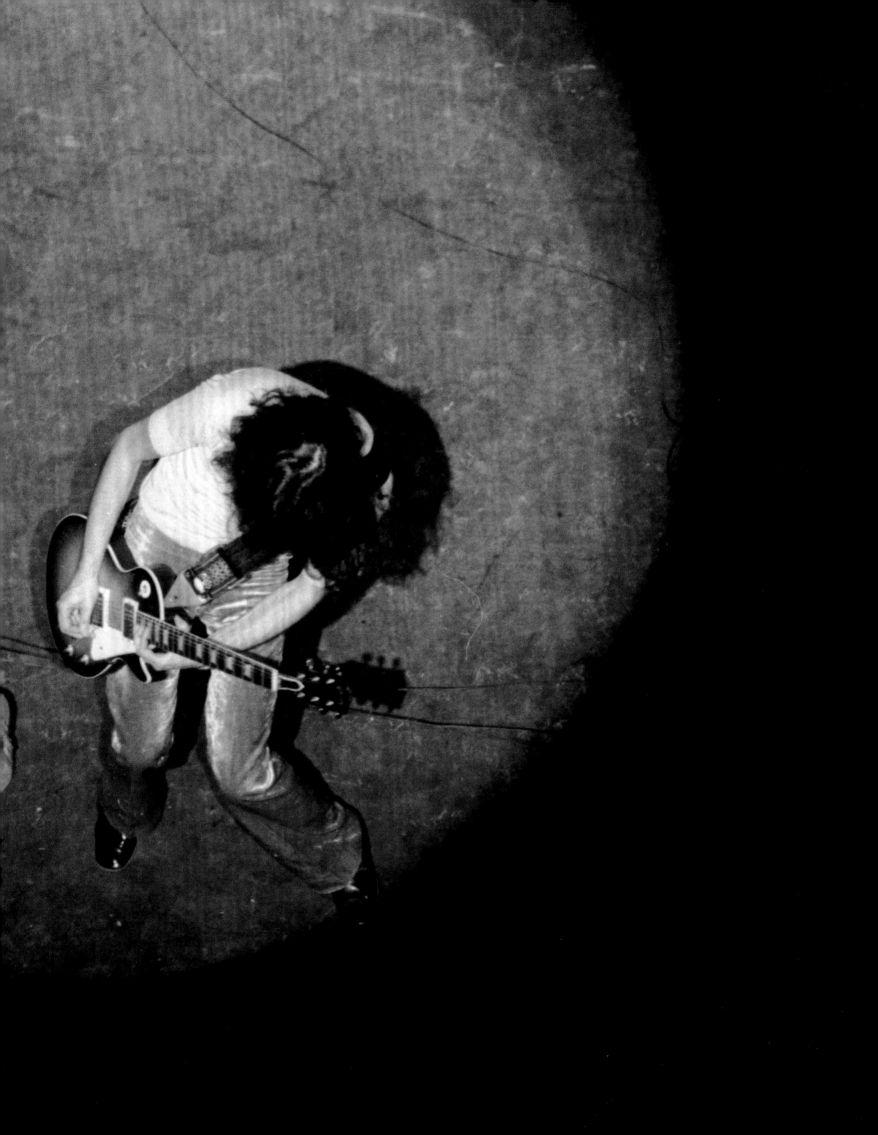

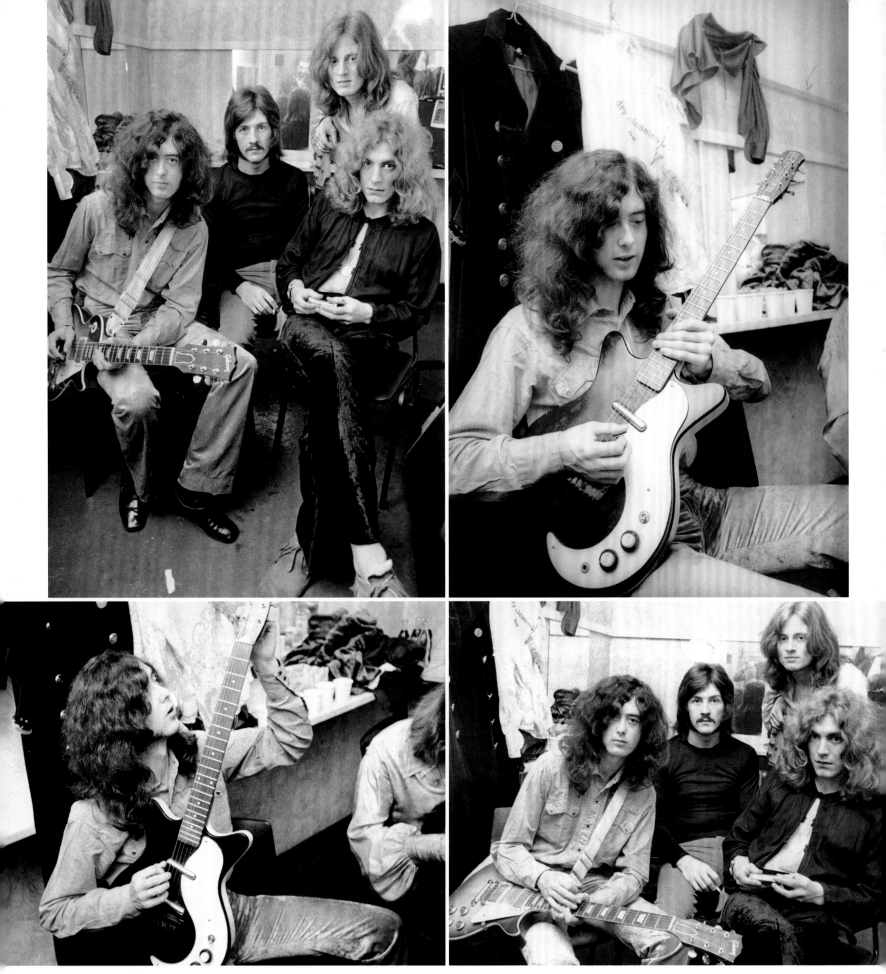

October 12
The Lyceum Theatre
London, UK

Final show of European
Autumn tour

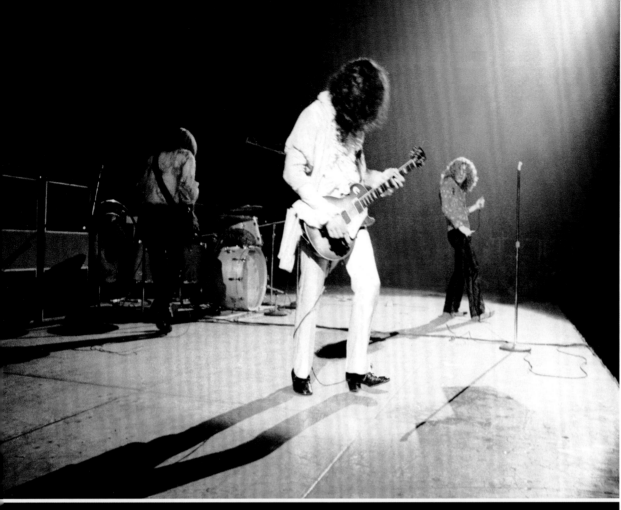

Led Zeppelin got to play the auspicious Carnegie Hall on one occasion. Unfortunately we managed to miss our flight and had to catch the plane out of London the same day as we were to play. However, it was still a remarkable show. With its classical heritage I could equate Carnegie Hall in New York with the Albert Hall in London – both standing with a serious musical imprint in their walls.

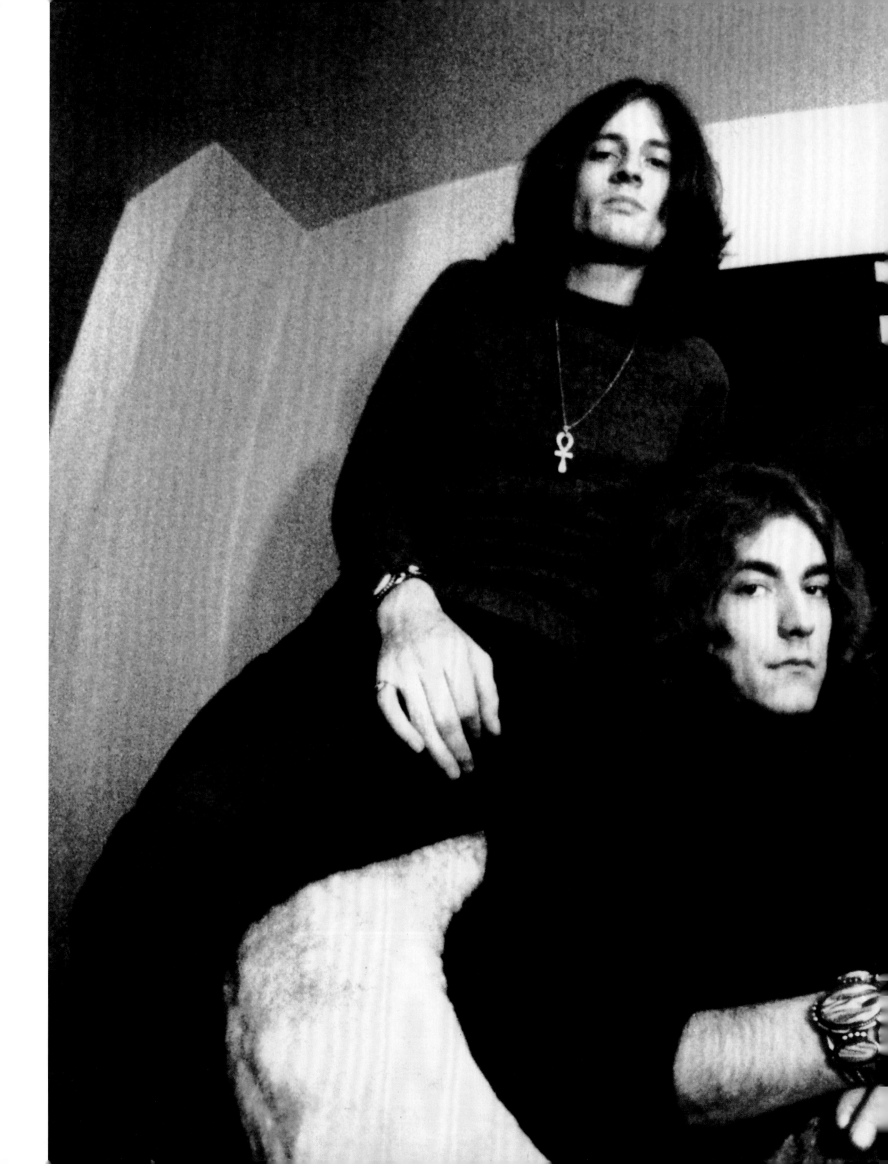

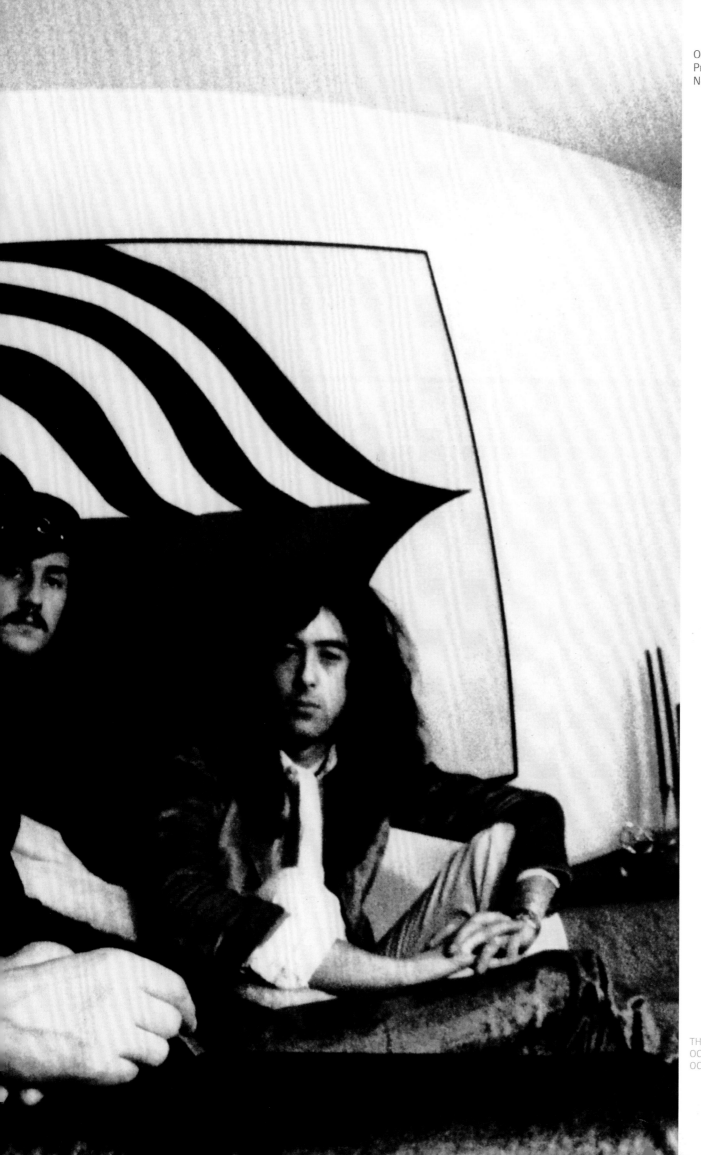

October
Promo shot
New York, USA

THE RELEASE OF *LED ZEPPELIN II*
OCTOBER 22 (US)
OCTOBER 31 (UK)

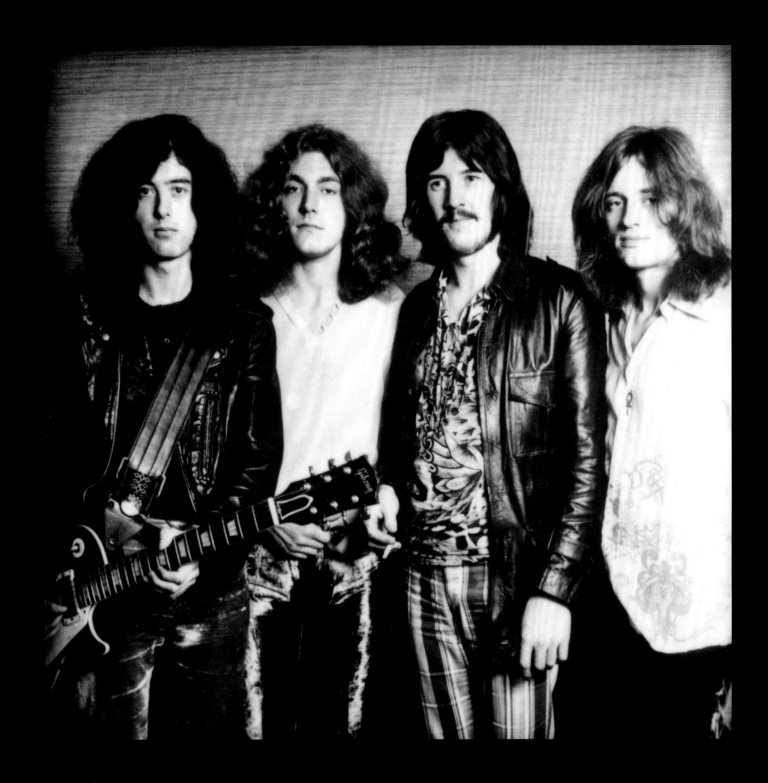

Early October
The Netherlands

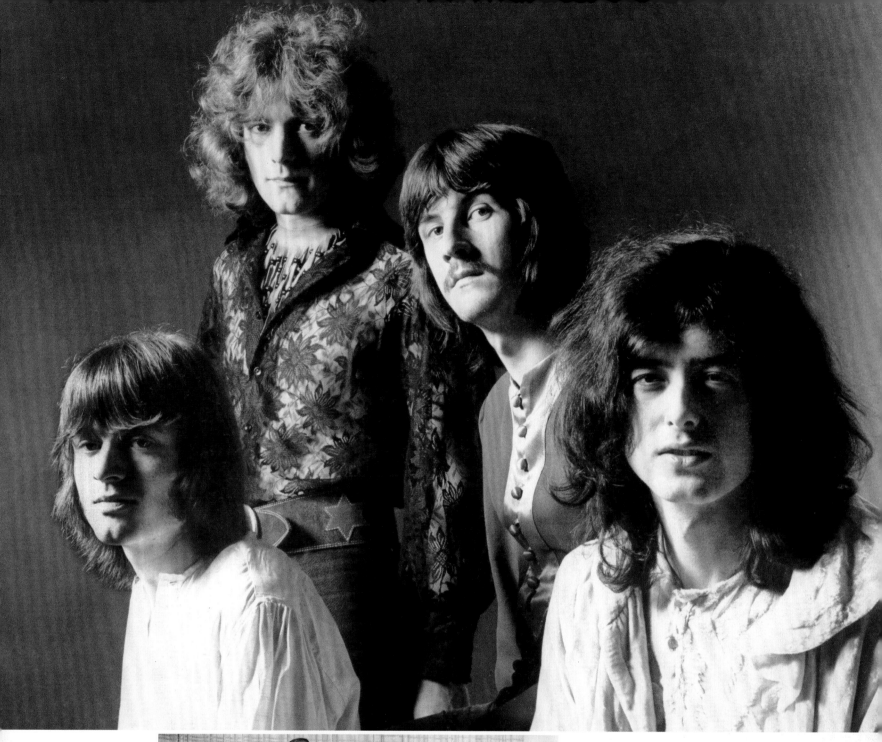

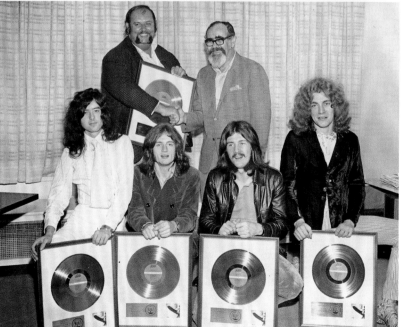

Led Zeppelin with Peter Grant and the man responsible for signing Led Zeppelin, Atlantic Records executive Jerry Wexler, presenting us with gold discs for $1 million sales of the first album. That first gold disc will always remain the most precious to me.

July 22
The Plaza Hotel
New York, USA

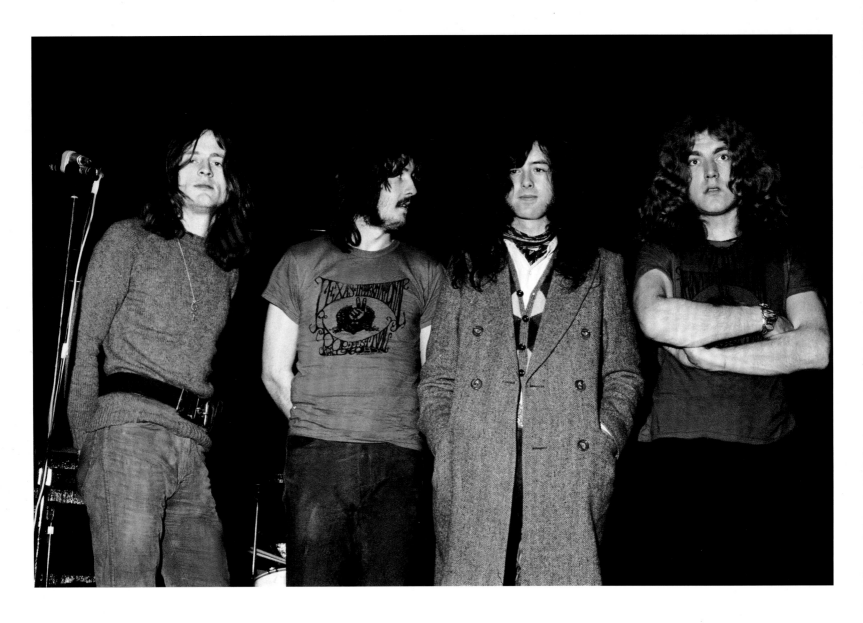

January 9
Royal Albert Hall
London, UK

This performance was filmed at the time and was
to be released years later on the *Led Zeppelin* DVD.

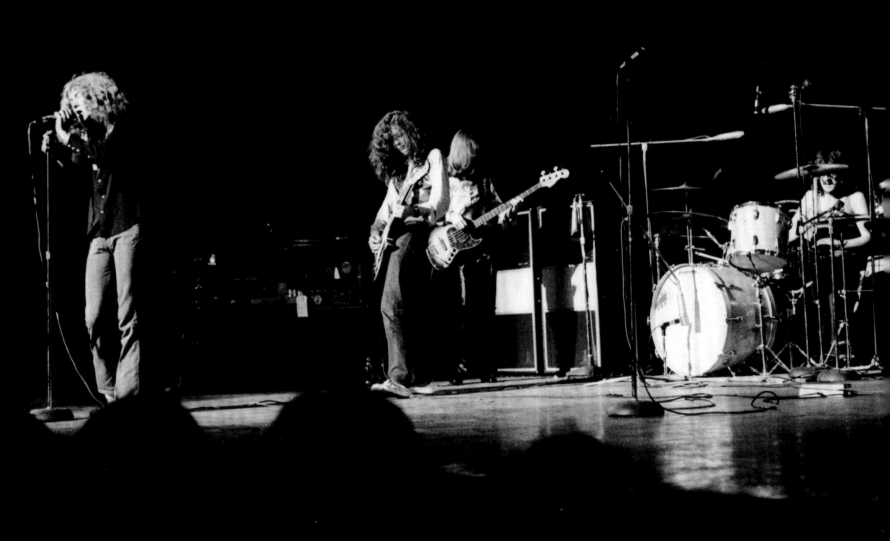

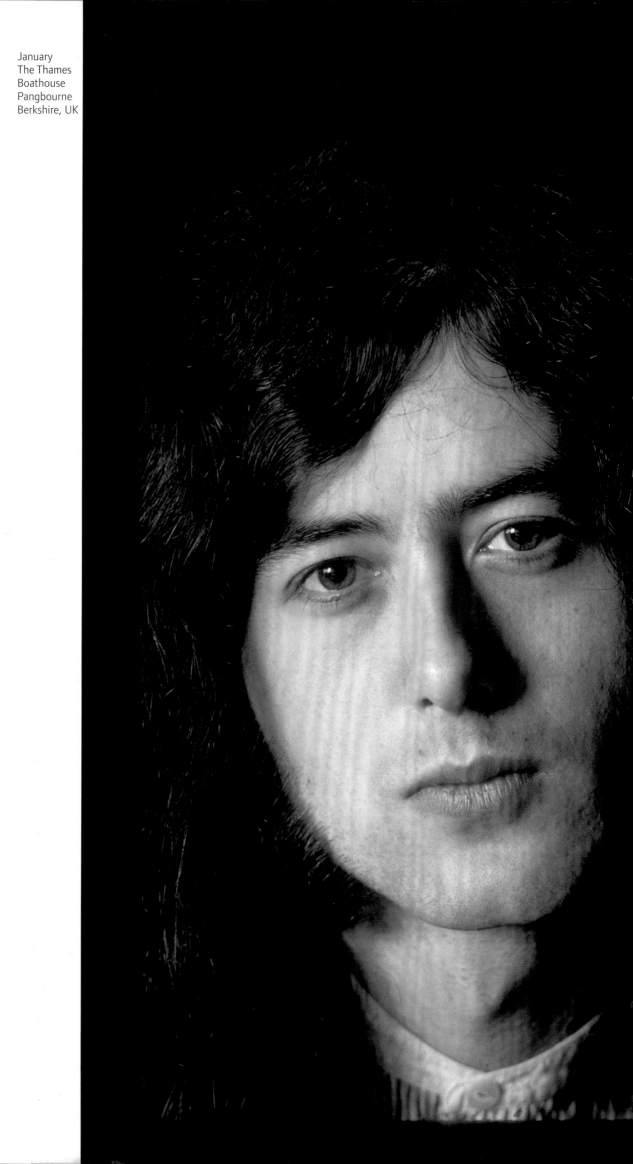

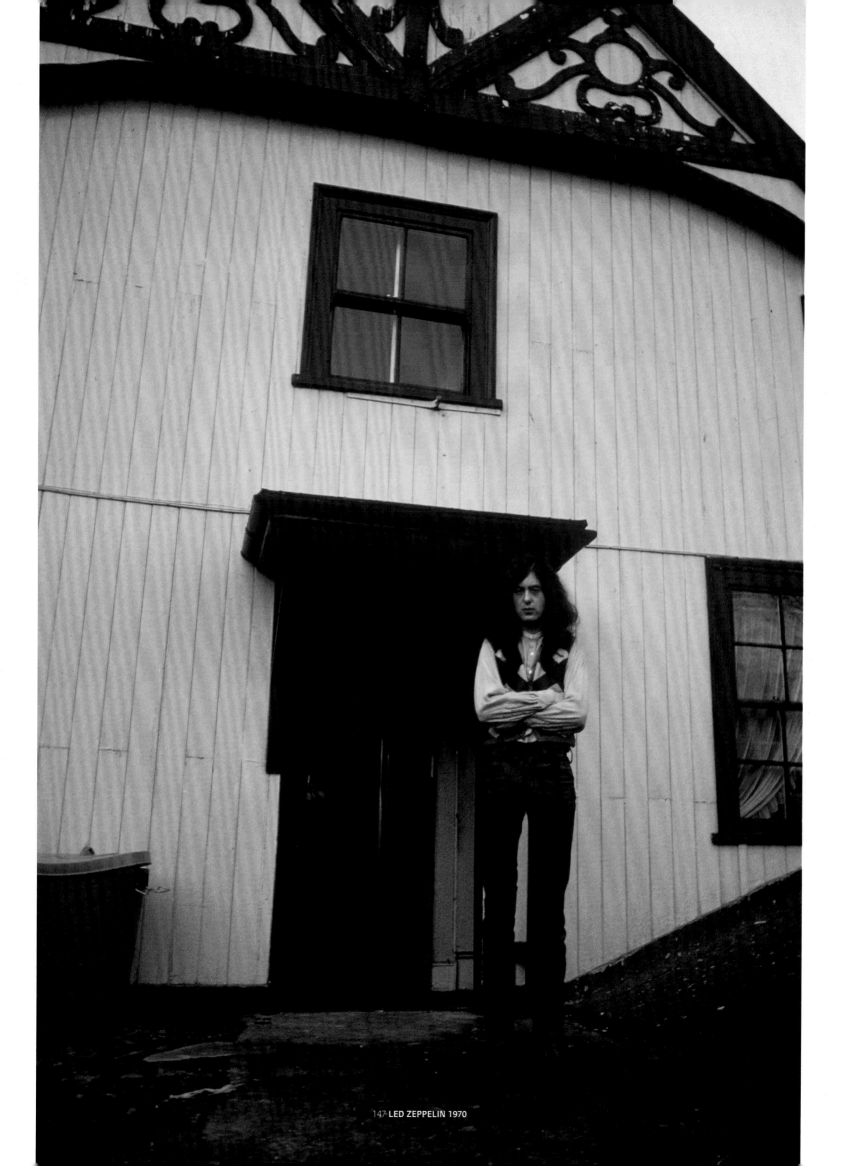

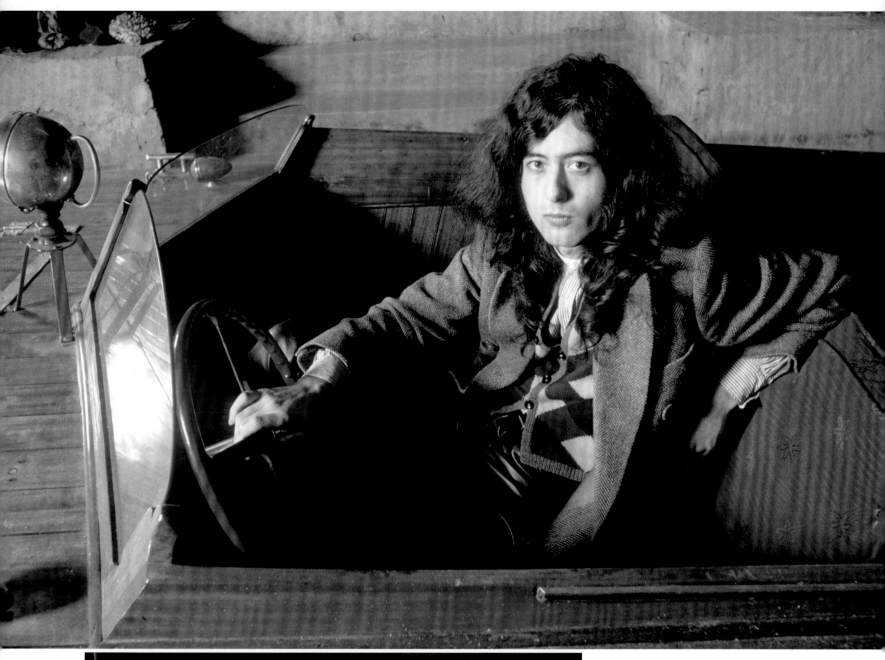

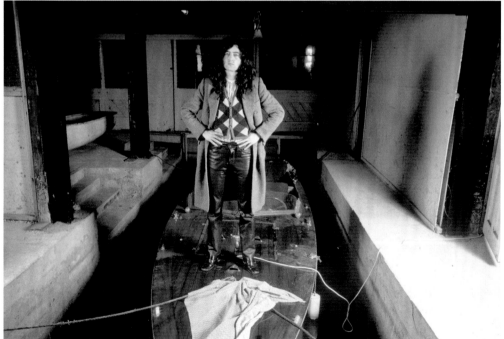

These are pictures of my first home in Pangbourne, that I acquired when I was in The Yardbirds. And it was here that Led Zeppelin were to rehearse for that first tour of Scandinavia, first album and beyond.

We also began our preparations for the second album, for example 'Whole Lotta Love' being routined here before the recording.

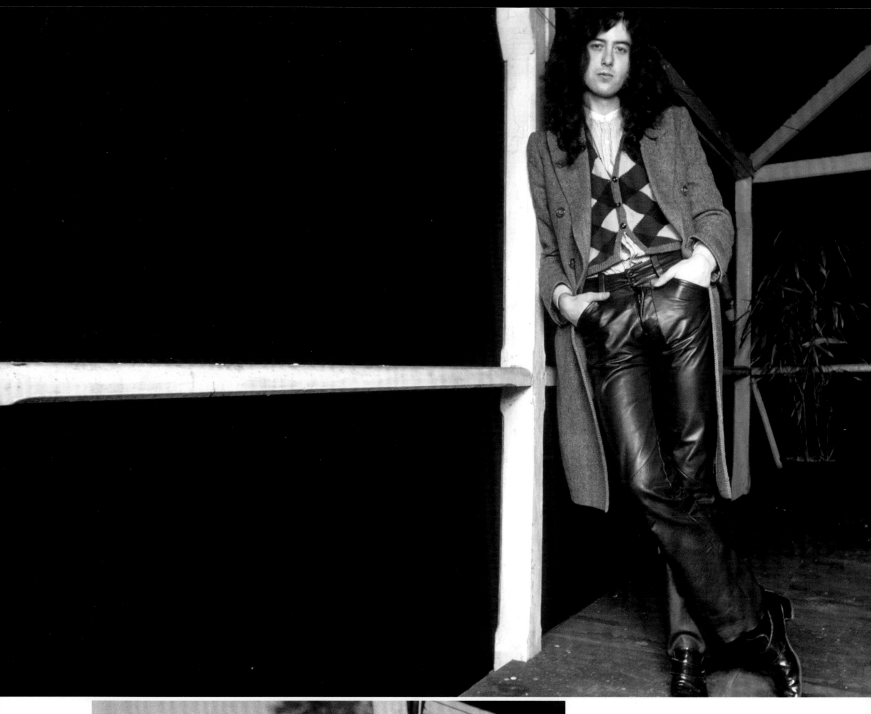

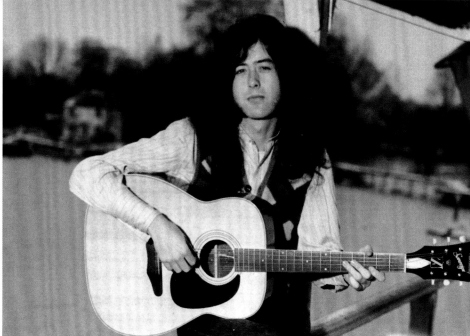

I wrote the first track to the third album, 'Friends', on this balcony.

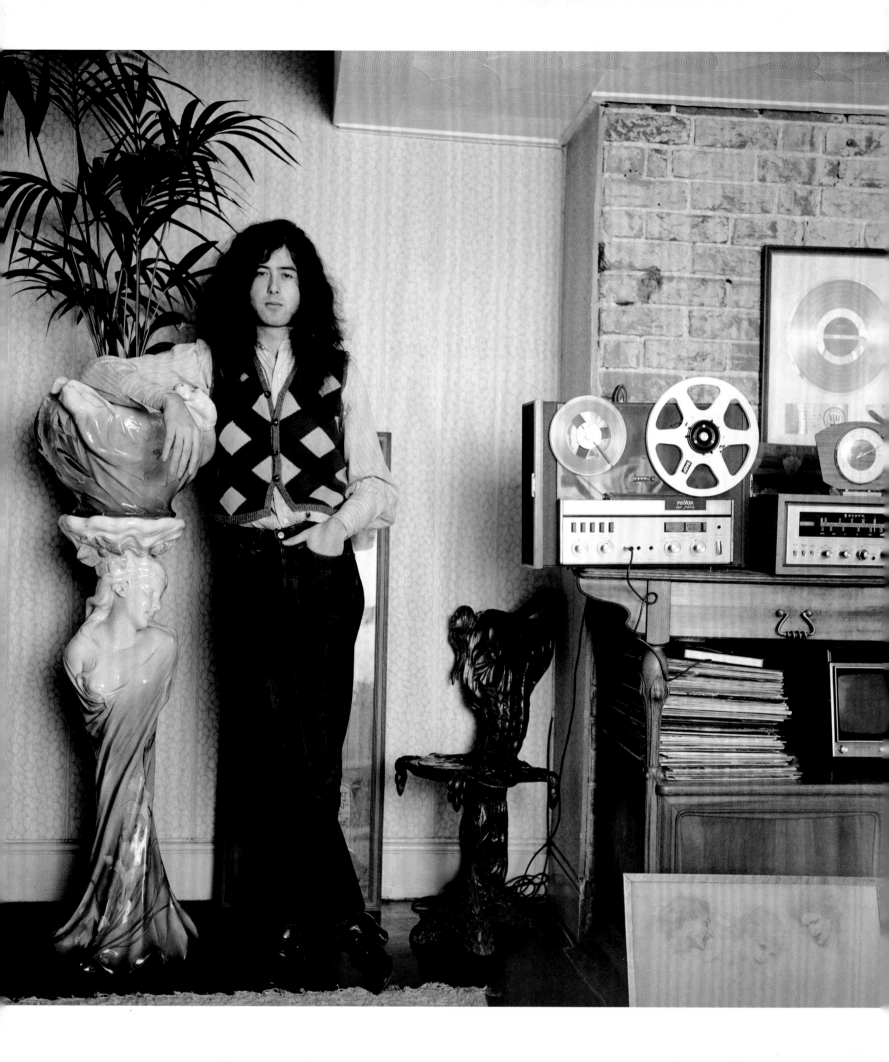

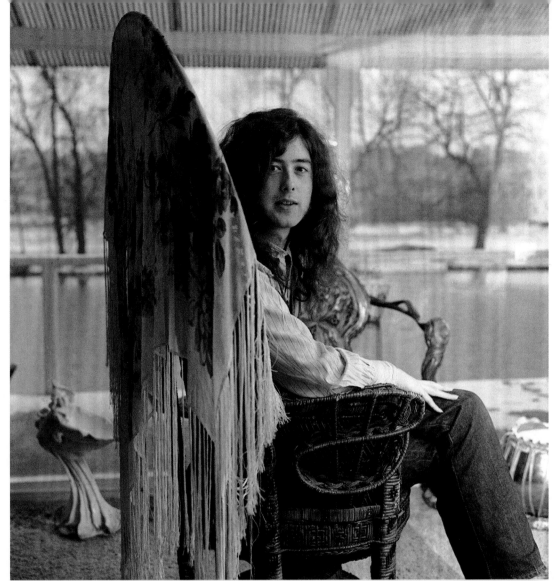

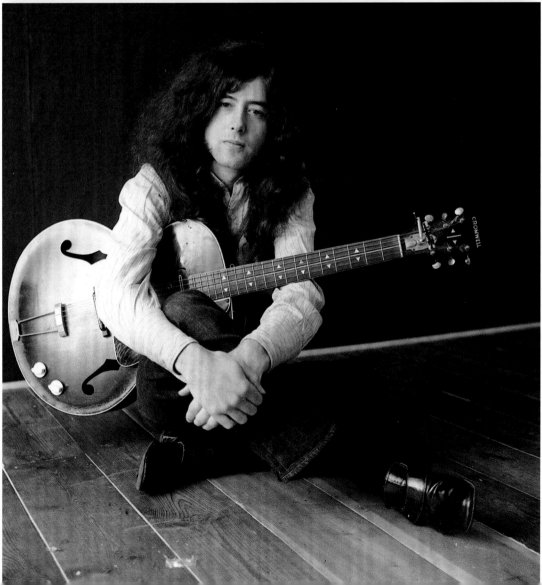

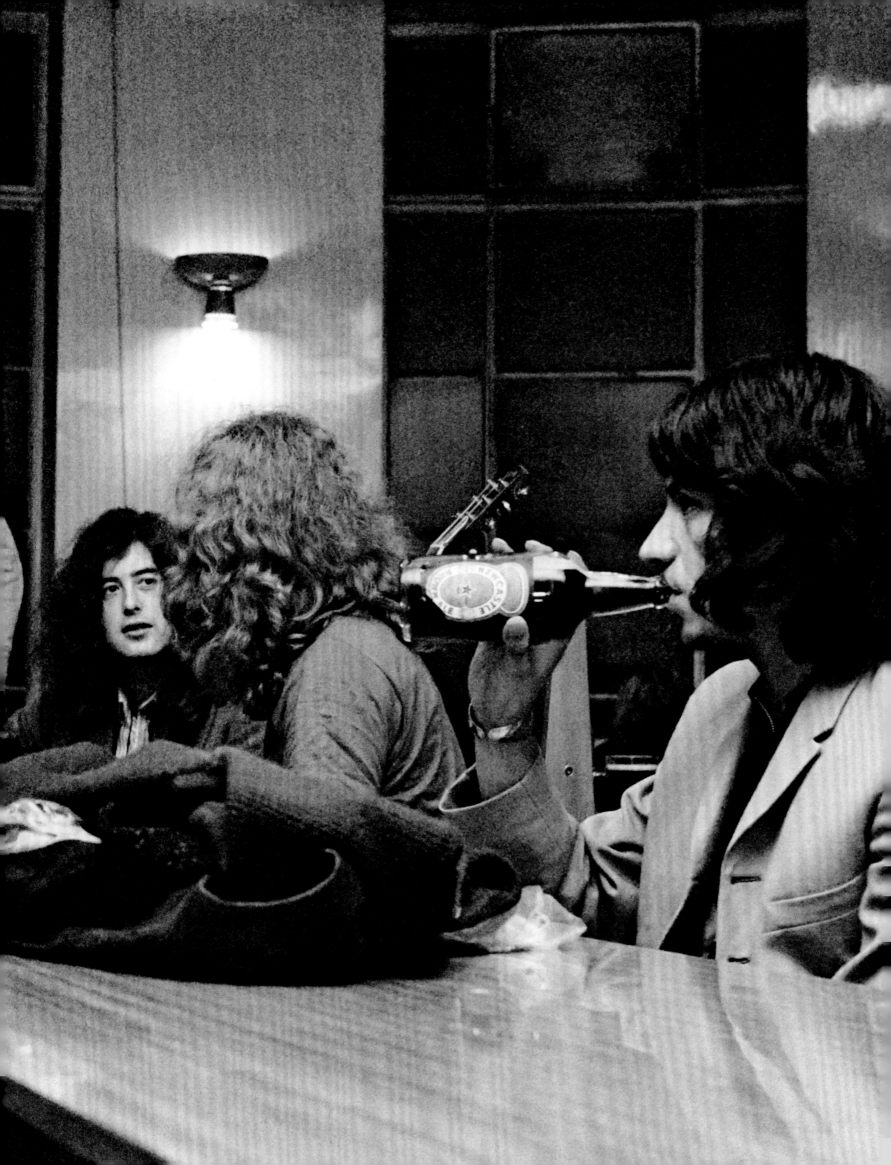

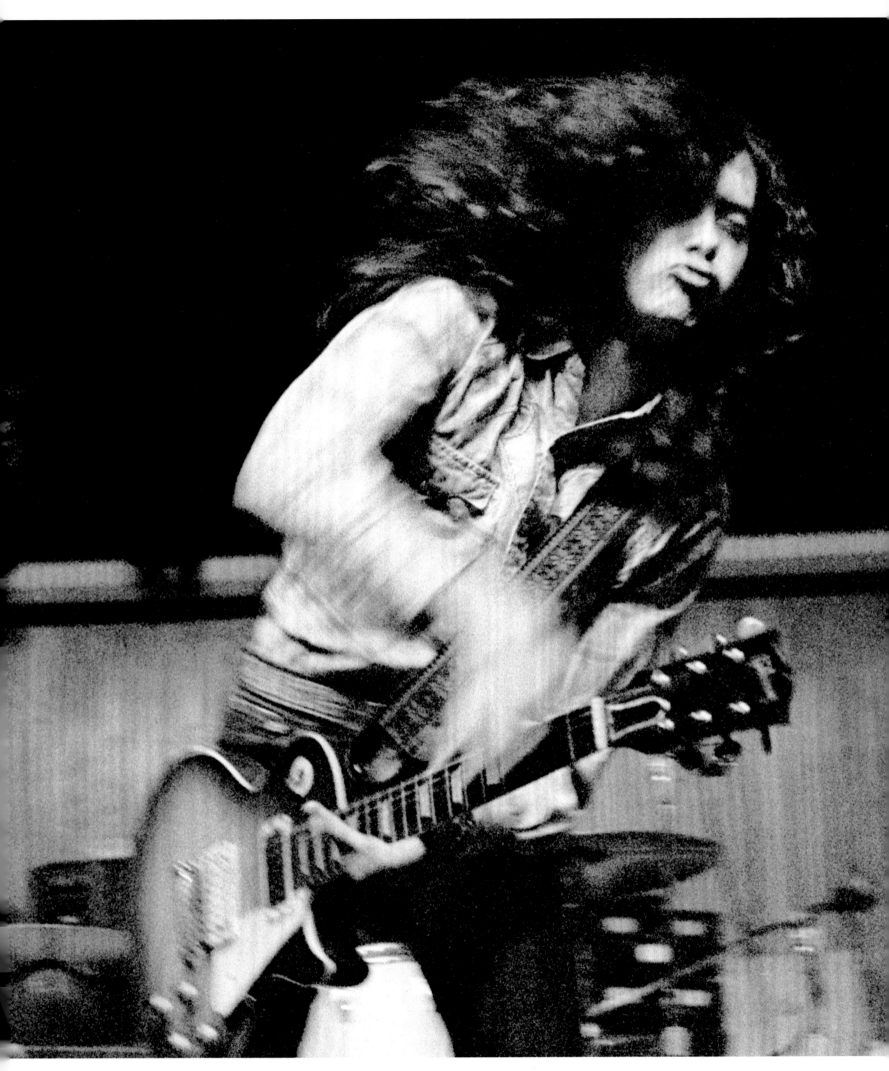

February 28
KB Hallen
Copenhagen, Denmark

March 7
Montreux Casino
Montreux, Switzerland

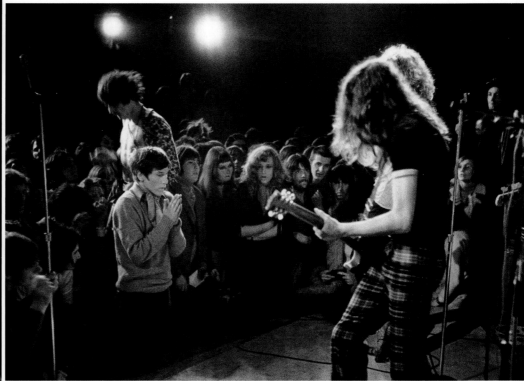

1970
Start of second UK tour
January 7: Town Hall, Birmingham, UK
January 8: Colston Hall, Bristol, UK
January 9: Royal Albert Hall, London, UK
January 13: Guildhall, Portsmouth, UK
January 15: City Hall, Newcastle, UK
January 16: City Hall, Sheffield, UK
January 24: Town Hall, Leeds, UK

February 17: Usher Hall, Edinburgh, UK
End of second UK tour

Start of second European tour
February 23: Kulttuuritalo, Helsinki, Finland
February 25: Konserthuset, Goteborg, Sweden
February 26: Konserthuset, Stockholm, Sweden
February 28: KB Hallen, Copenhagen, Denmark

March 7: Montreux Casino, Montreux, Switzerland
March 8: Circus Krone Bau, Munich, Germany
March 9: Konzerthaus, Vienna, Austria
March 10: Musikhalle, Hamburg, Germany
March 11: Musikhalle, Hamburg, Germany
March 12: Rheinhalle, Dusseldorf, Germany
End of second European tour

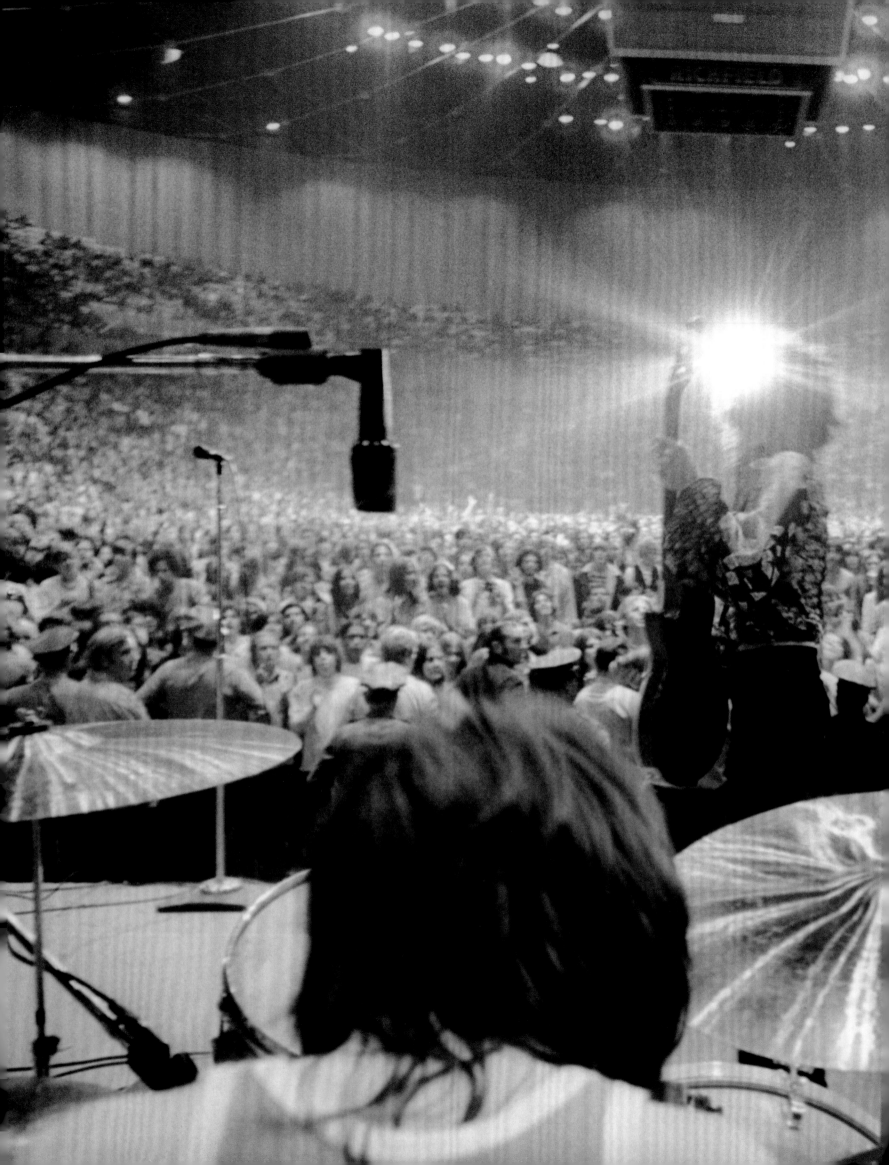

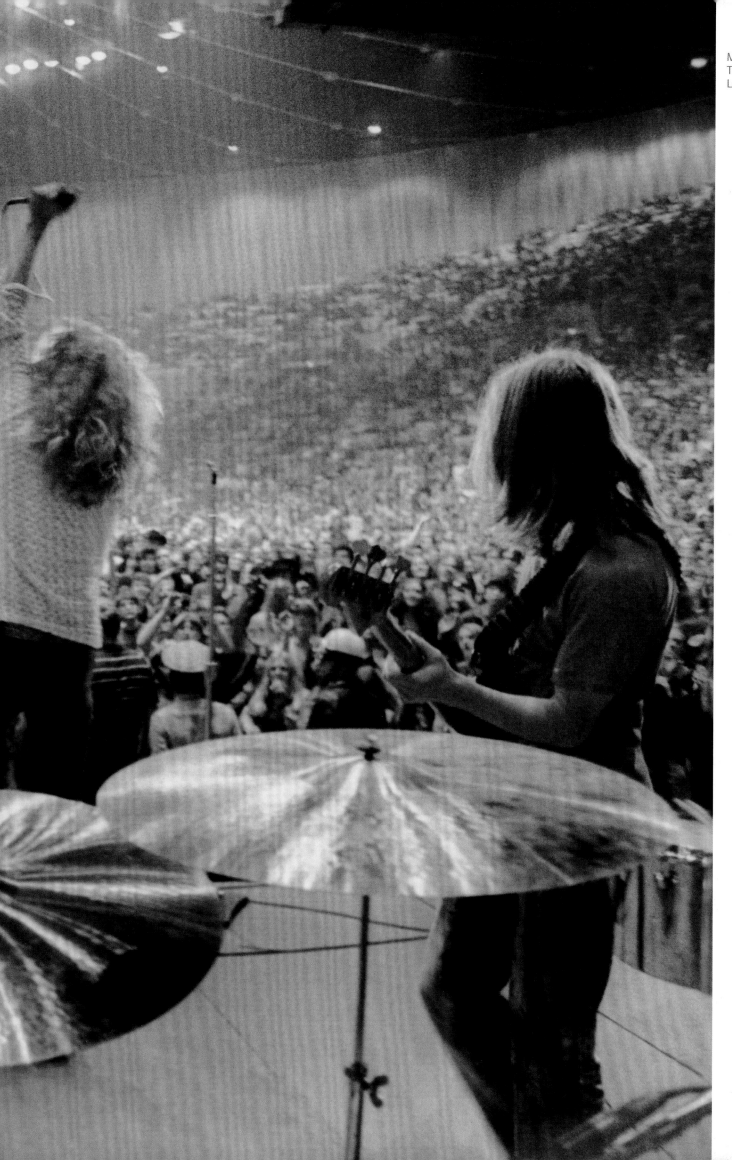

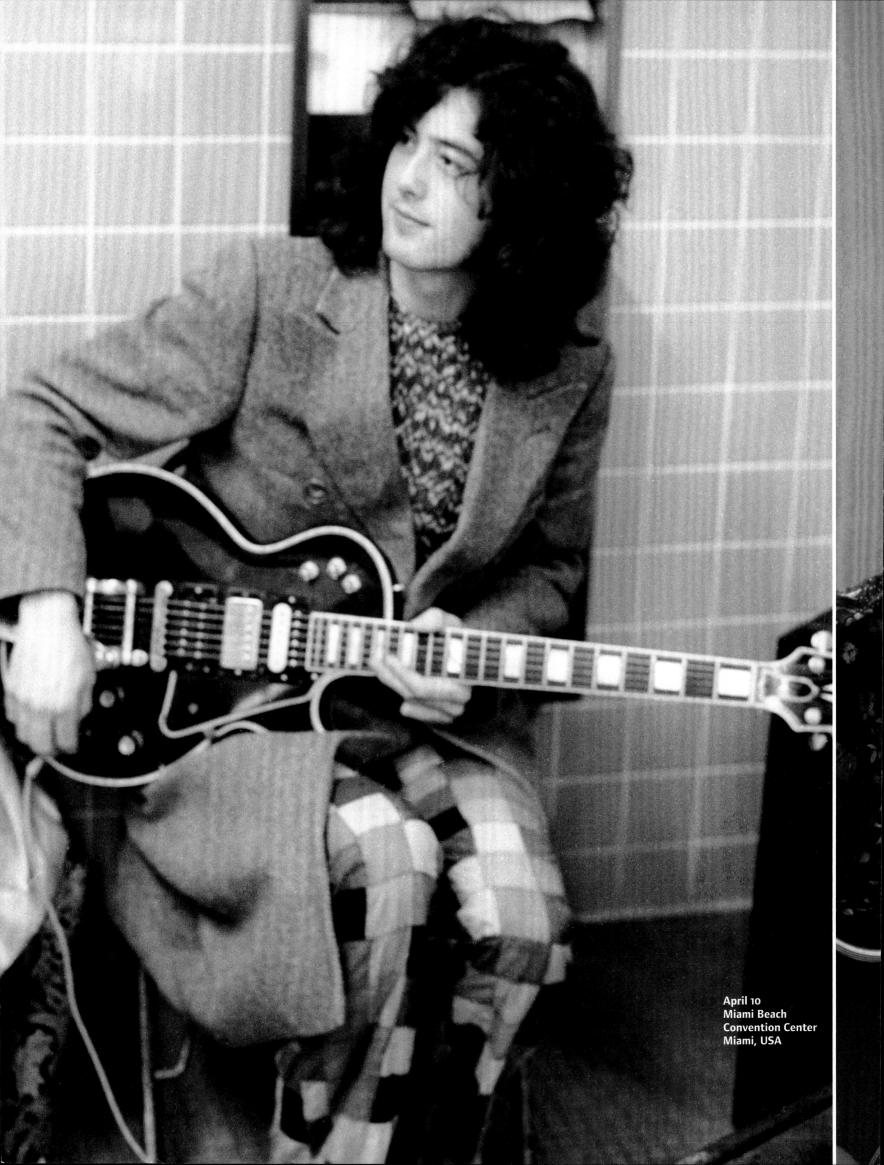

April 10
Miami Beach
Convention Center
Miami, USA

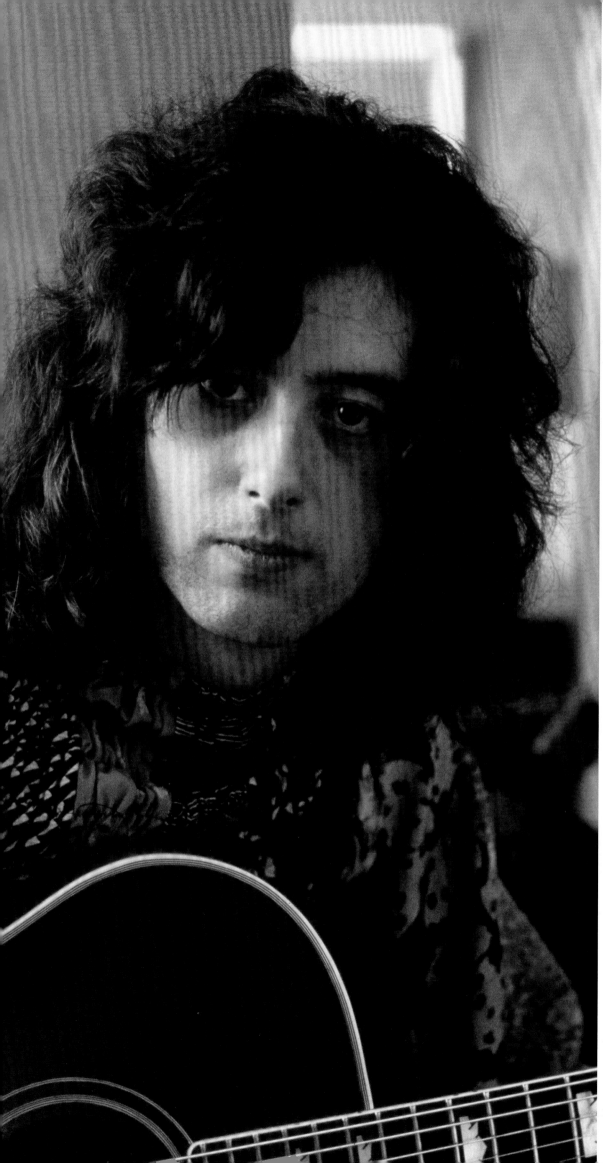

1970
Start of fifth American tour
March 21: Pacific Coliseum, Vancouver, Canada
March 22: Seattle Center Coliseum, Seattle, USA
March 23: Memorial Coliseum, Portland, USA
March 25: Denver Coliseum, Denver, USA
March 26: Salt Palace, Salt Lake City, USA
March 27: The Forum, Los Angeles, USA
March 28: Memorial Auditorium, Dallas, USA
March 29: Hofheinz Pavilion, University of Houston, Houston, USA
March 30: Civic Arena, Pittsburgh, USA
March 31: Spectrum, Philadelphia, USA

April 2: Civic Center, Charleston, USA
April 3: Macon Coliseum, Macon, USA
April 4: Coliseum, Indianapolis, USA
April 5: Civic Center, Baltimore, USA
April 7: Charlotte Coliseum, Charlotte, USA
April 8: JS Dorton Auditorium, Raleigh, USA
April 9: Curtis Hixon Hall, Tampa, USA
April 10: Miami Beach Convention Center, Miami, USA
April 11: Kiel Auditorium, St Louis, USA
April 12: Met Center, Minneapolis, USA
April 13: Montreal Forum, Montreal, Canada
April 14: Civic Centre, Ottawa, Canada
April 16: Roberts Stadium, Evansville, USA
April 17: Mid-South Coliseum, Memphis, USA
April 18: Veterans Memorial Coliseum, Phoenix, USA
End of fifth American tour

April 23: Lime Grove Studios, BBC TV, London, UK

June 22: Laugardalsholl Sports Center, Reykjavik, Iceland
June 28: Bath Festival of Blues, Bath & West Showground, Shepton Mallet, UK

April 23
Lime Grove Studios
BBC TV
London, UK
BBC 2's *Julie Felix Show*
Jimmy played
'White Summer'
'Black Mountainside'

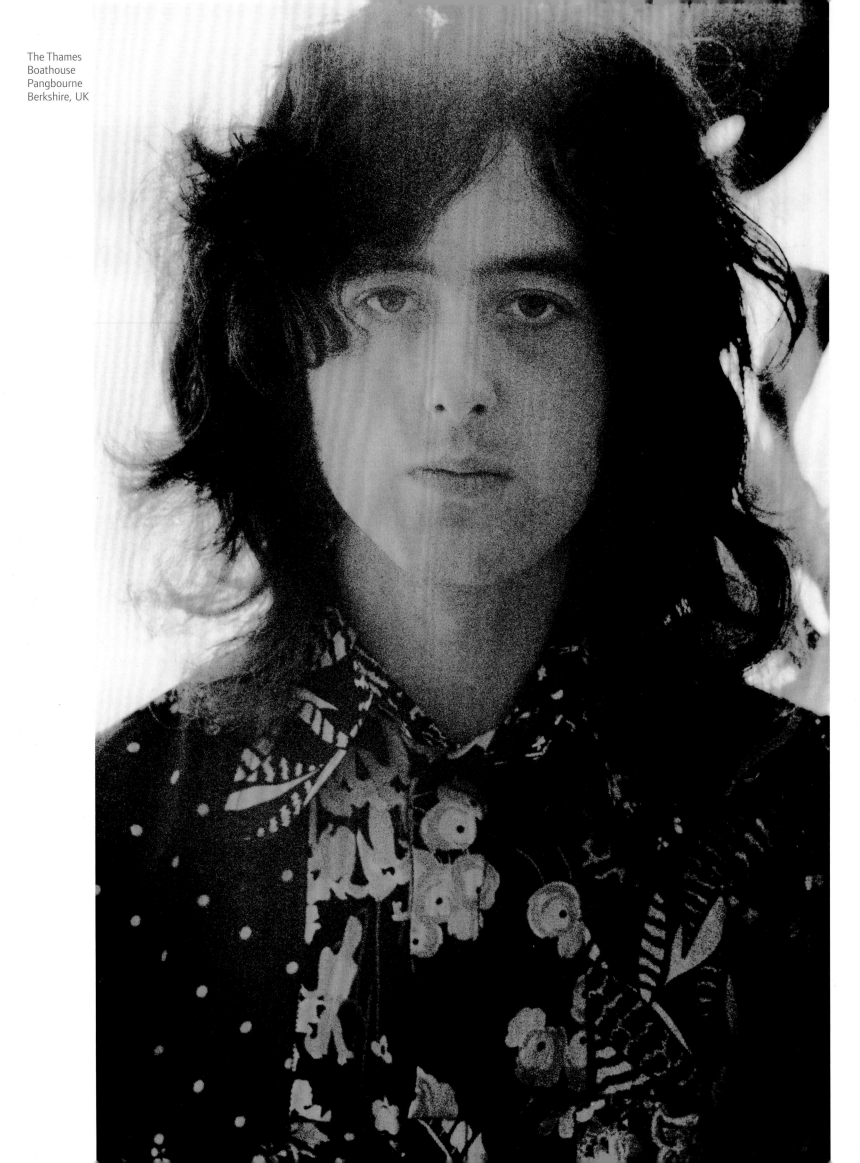

The Thames
Boathouse
Pangbourne
Berkshire, UK

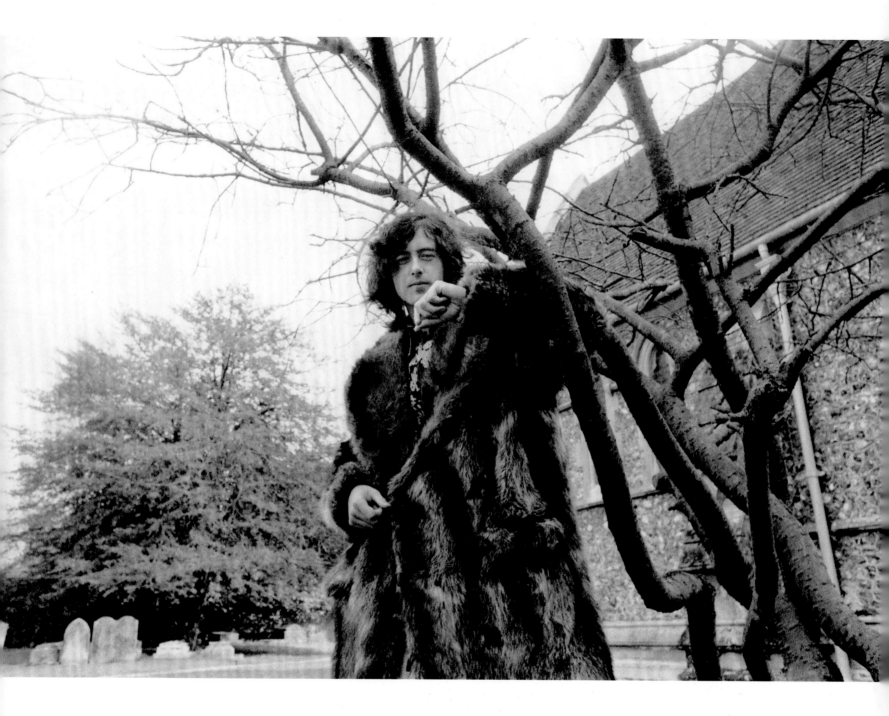

Shot in Pangbourne churchyard with allusions to Oscar Wilde.

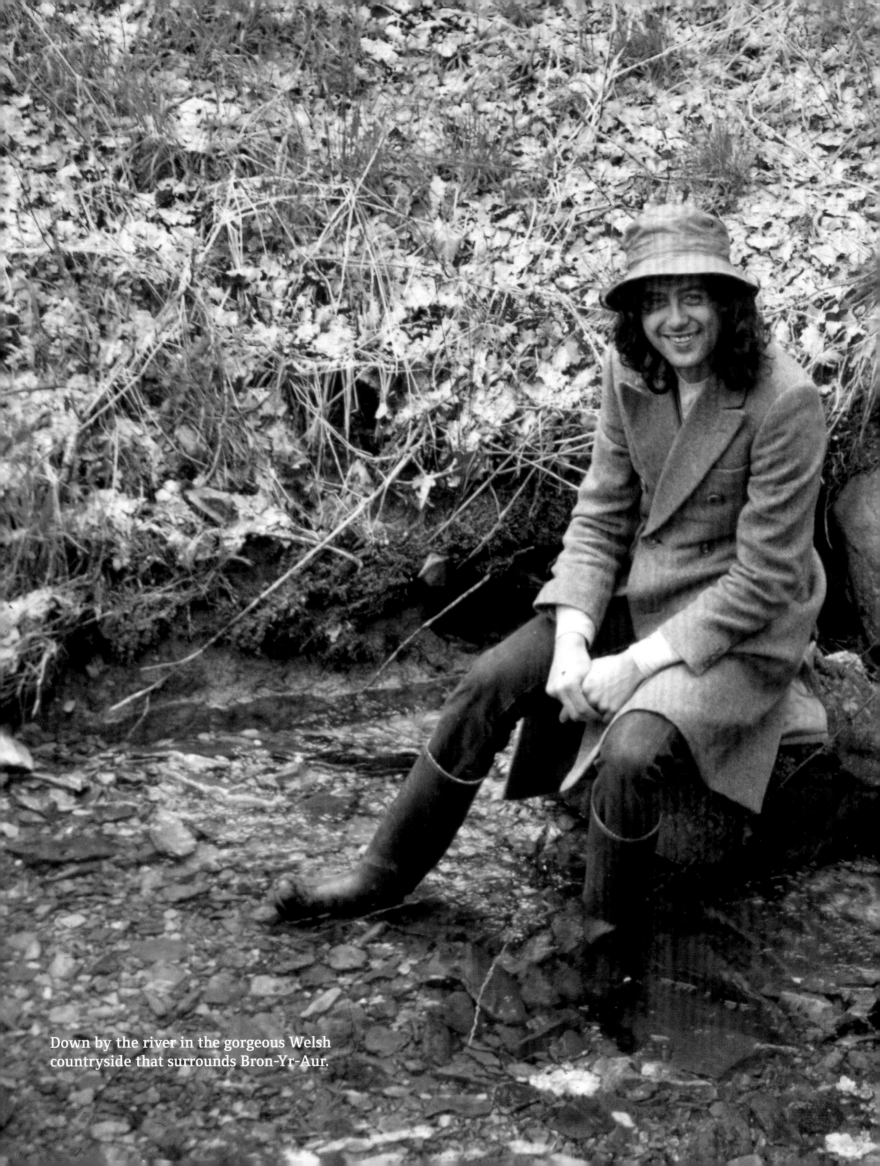

Down by the river in the gorgeous Welsh
countryside that surrounds Bron-Yr-Aur.

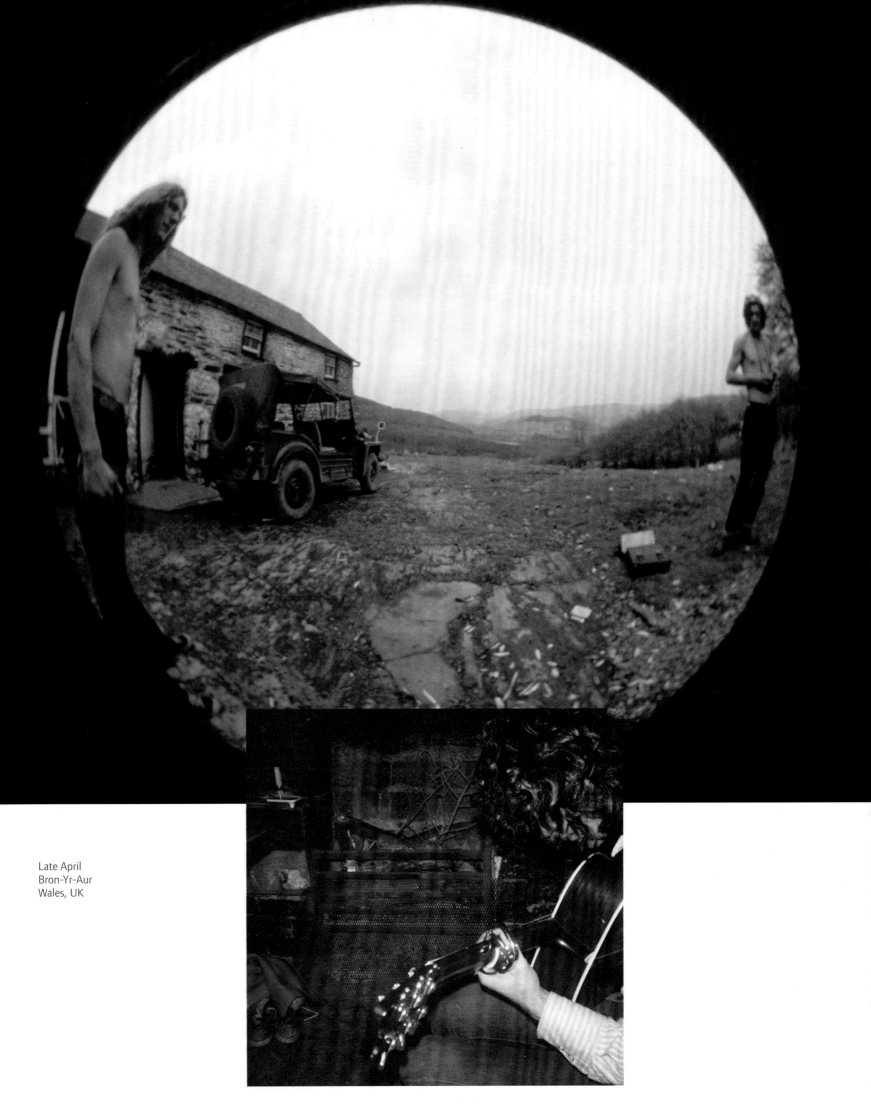

Late April
Bron-Yr-Aur
Wales, UK

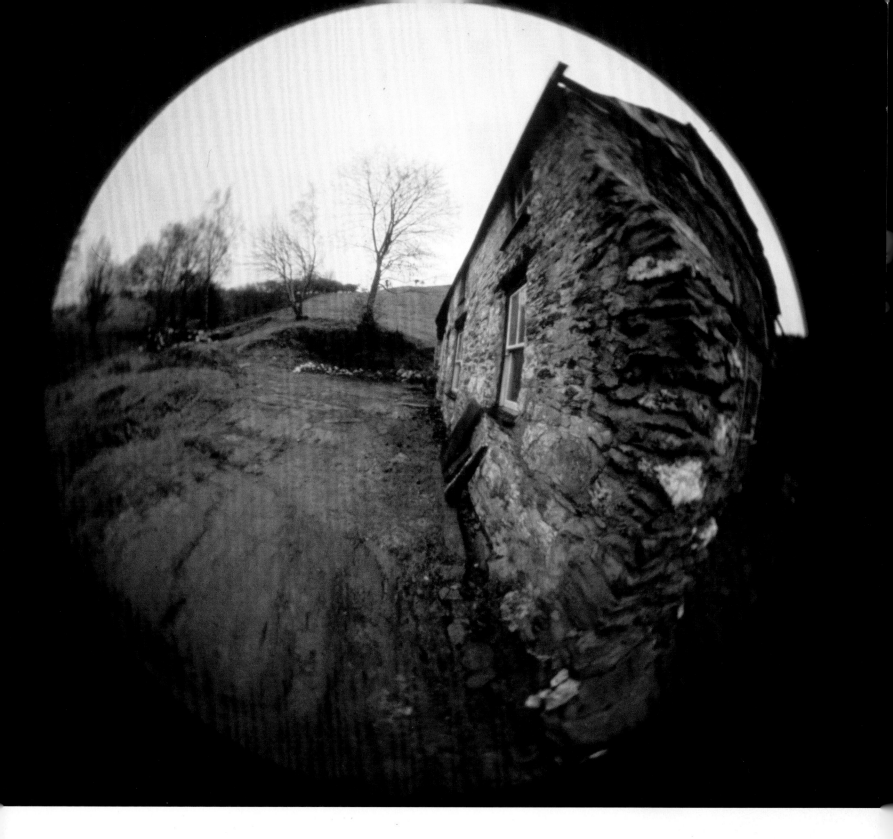

Bron-Yr-Aur
With only a short break after the US tour, Robert had suggested a holiday location in Wales. We took our families and wrote, among other things, 'That's The Way' during a highly creative time at this cottage.

We started recording our third album in early June 1970 in London.

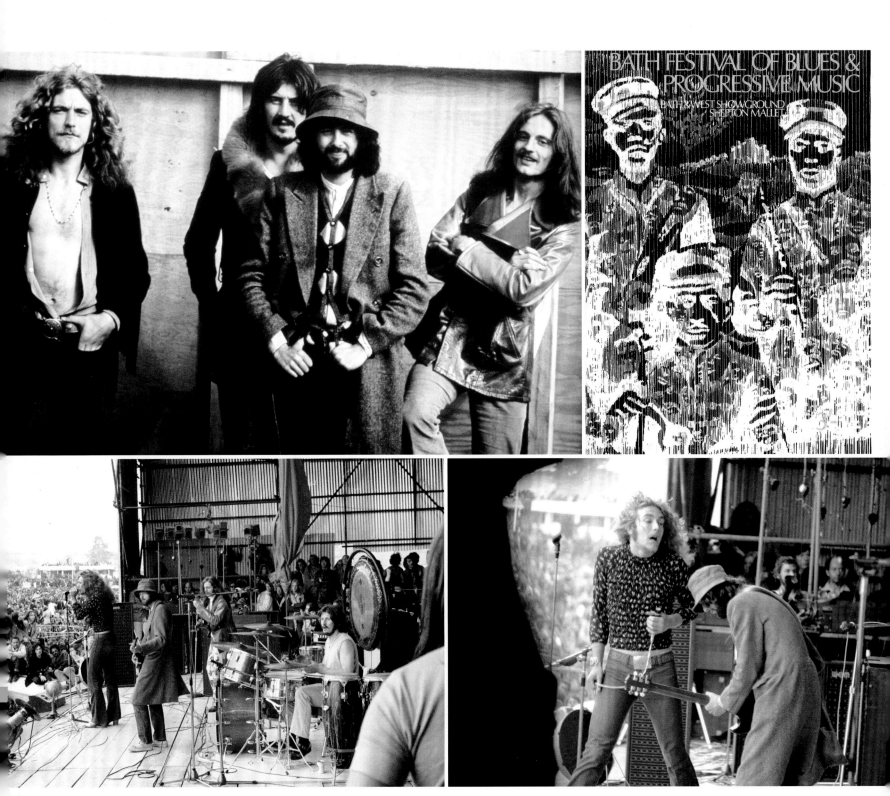

June 28
Bath Festival of Blues
Bath & West Showground
Shepton Mallet, UK

Bron-Yr-Aur to Bath with the addition of various degrees of stubble, we hit them hard with 'The Immigrant Song' to open our set. This was a new song to their ears but I'm sure they never forgot it. It was really cold that day, you could see some of the audience nestling under their sleeping bags, and I played as I arrived – in my coat.

1970

July 16: Sporthalle, Cologne, Germany
July 17: Grugahalle, Essen, Germany
July 18: Festhalle, Frankfurt, Germany
July 19: Deutschlandhalle, Berlin, Germany

Start of sixth American tour
August 15: Yale Bowl, New Haven, USA
August 17: Hampton Roads Coliseum, Hampton, USA
August 19: Municipal Auditorium, Kansas City, USA
August 20: City Fairgrounds Coliseum, Oklahoma City, USA
August 21: Assembly Center, Tulsa, USA
August 22: Tarrant County Convention Center, Fort Worth, USA
August 25: Municipal Auditorium, Nashville, USA
August 26: Public Auditorium, Cleveland, USA
August 28; Olympia Stadium, Detroit, USA
August 29: Man-Pop Festival, Winnipeg Arena, Winnipeg, Canada
August 31: Milwaukee Arena, Milwaukee, USA

September 1: Seattle Center Coliseum, Seattle, USA
September 2: Coliseum, Oakland, USA
September 3: Sports Arena, San Diego, USA
September 4: The Forum, Los Angeles, USA
September 4: Troubadour Club, Los Angeles, USA
[jam with Fairport Convention]
September 6: International Center Arena, Honolulu, Hawaii, USA
[2 shows]
September 9: Boston Garden, Boston, USA
September 19: Madison Square Garden, New York, USA [2 shows]
End of sixth American tour

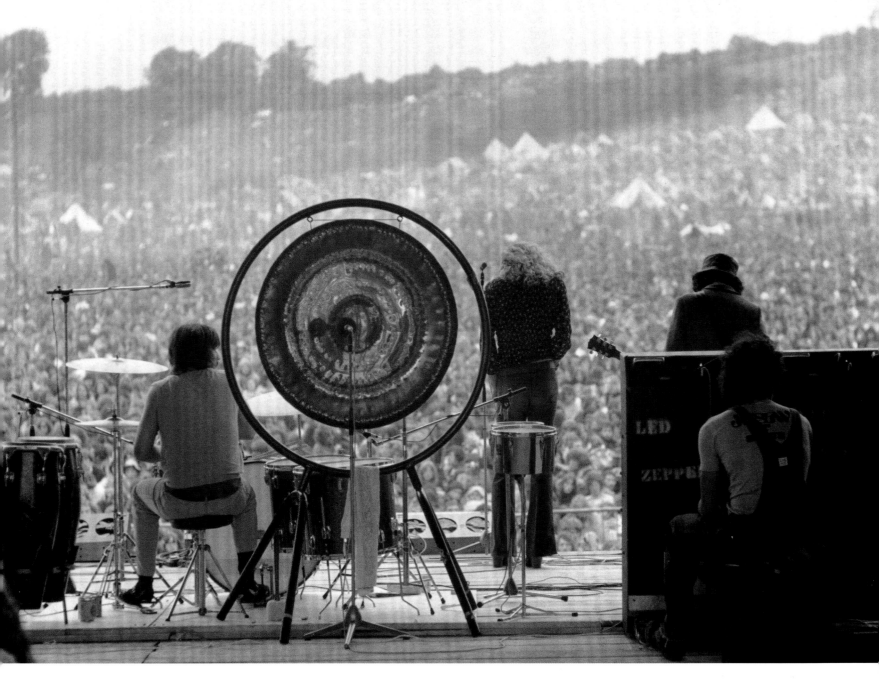

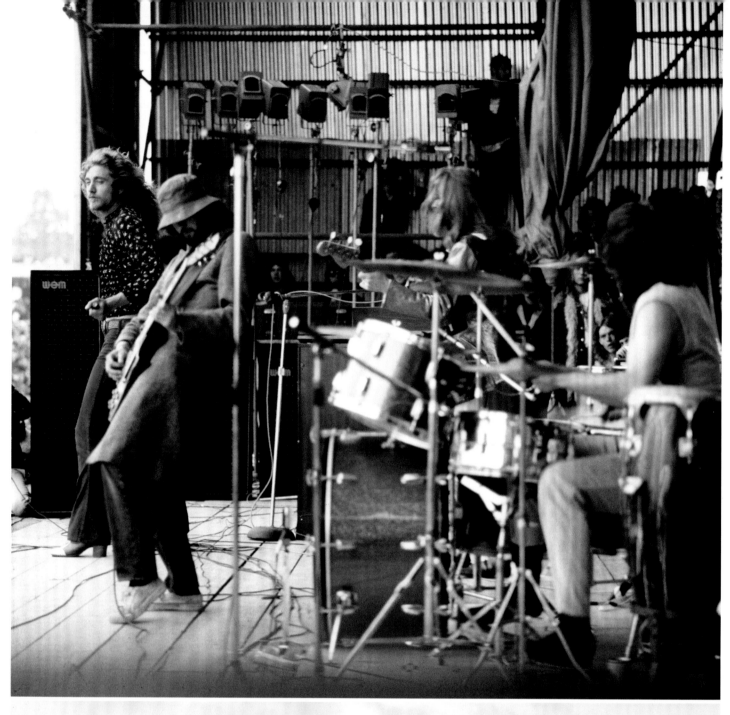
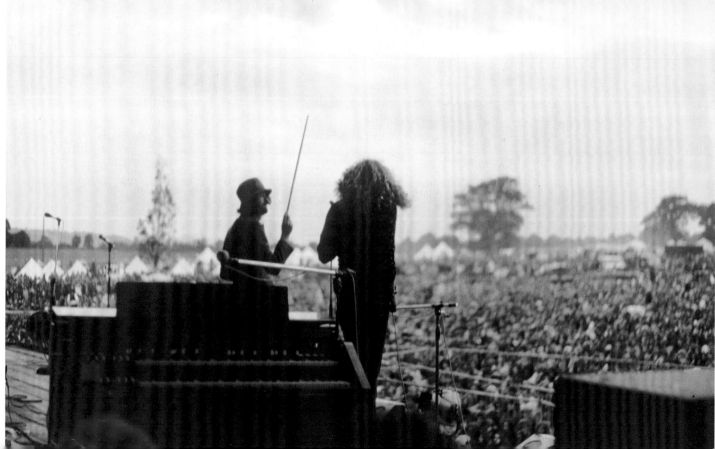

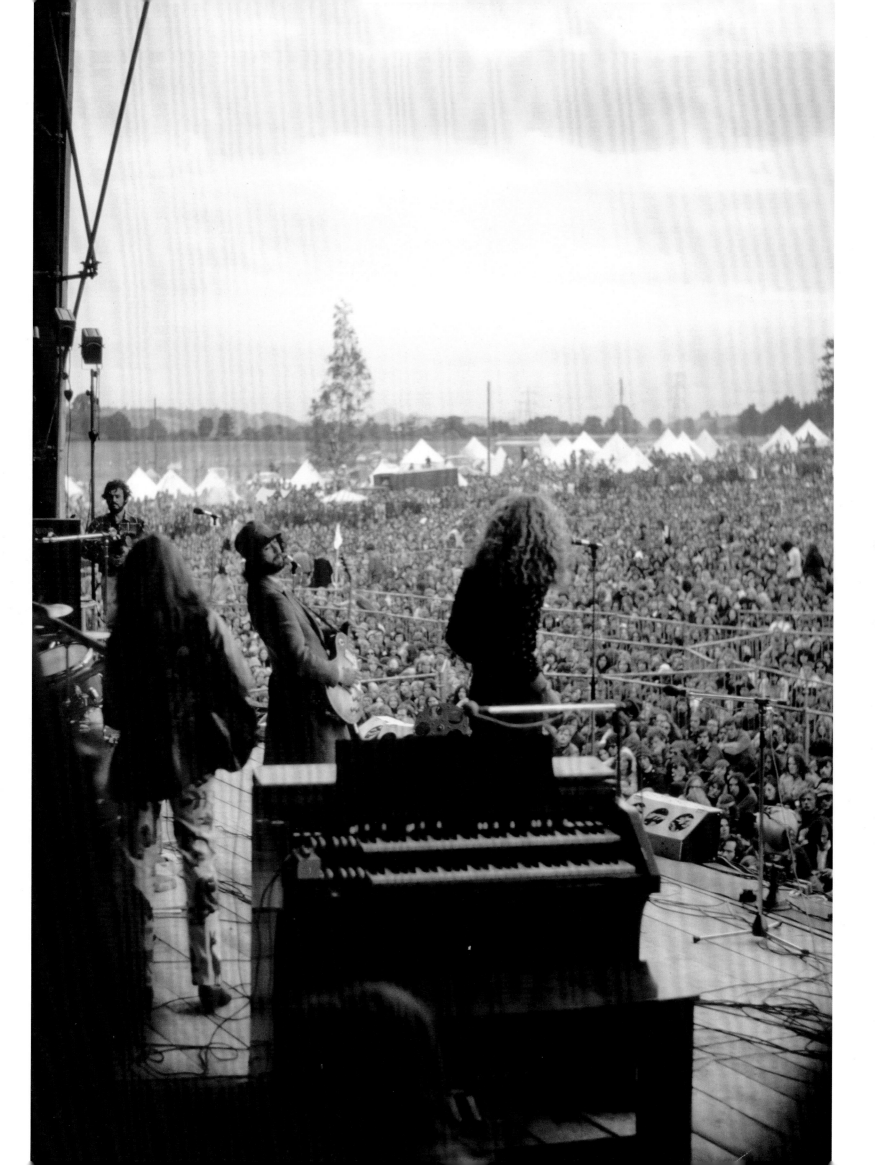

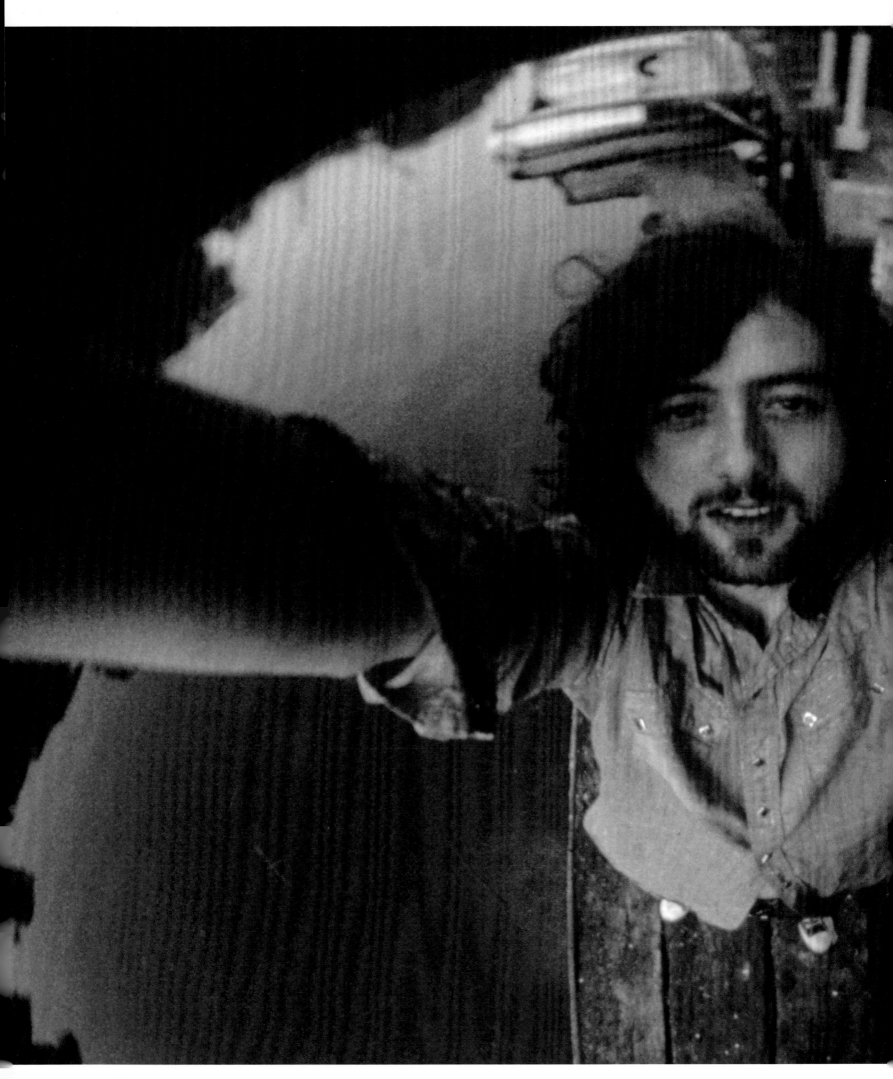

THE RELEASE OF
LED ZEPPELIN III
OCTOBER 4 (US)
OCTOBER 23 (UK)

January/February
Rolling Stones' Mobile Studio
Headley Grange
Headley
Hampshire, UK

Above and opposite shots are
taken from original 16mm film

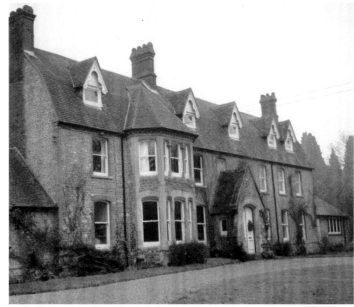

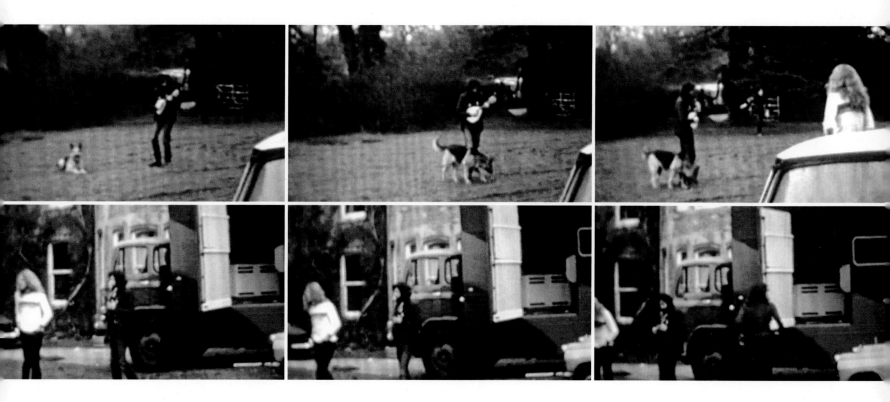

I thought it would be worth trying a radical approach to the next album with an isolated location to reside, write and record in. To lock in and condense the creative energy.

Headley Grange was available and fitted the bill – it would have no noise problems and it had been a Victorian workhouse – what could be more appropriate?

I brought in The Rolling Stones' Mobile Studio with Andy Johns engineering. By the time we had finished at Headley we had the fourth album.

The drums, recorded in the natural ambience of the entrance hall, were to define the sound of 'When The Levee Breaks', 'Misty Mountain Hop' and, on a later occasion, 'Kashmir'.

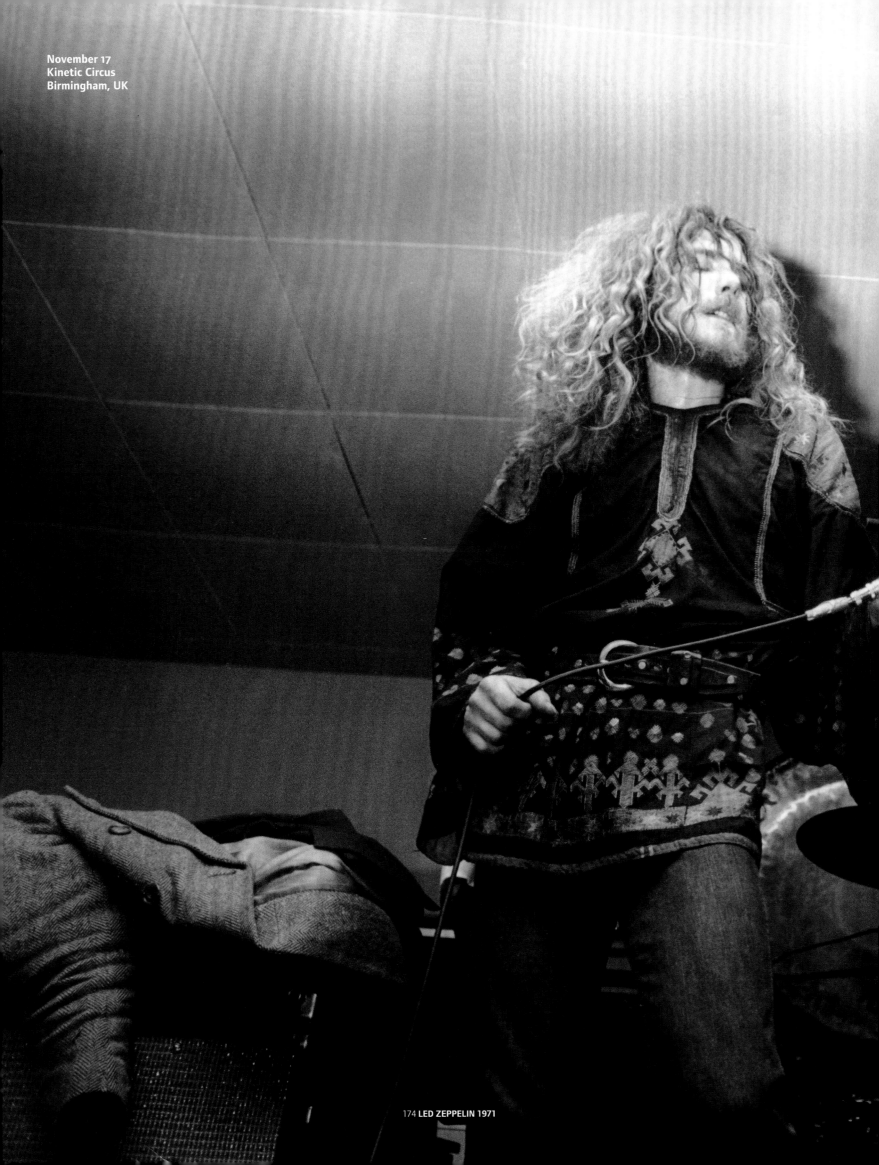

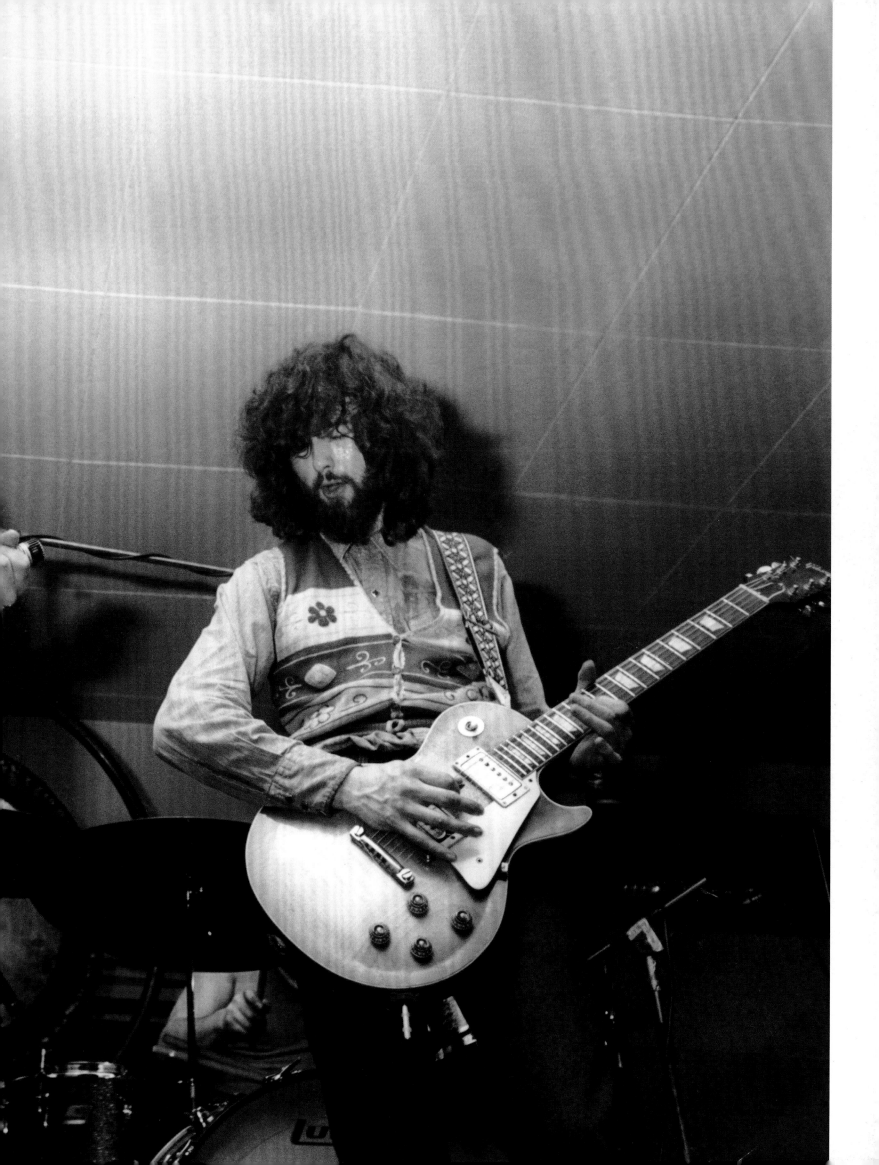

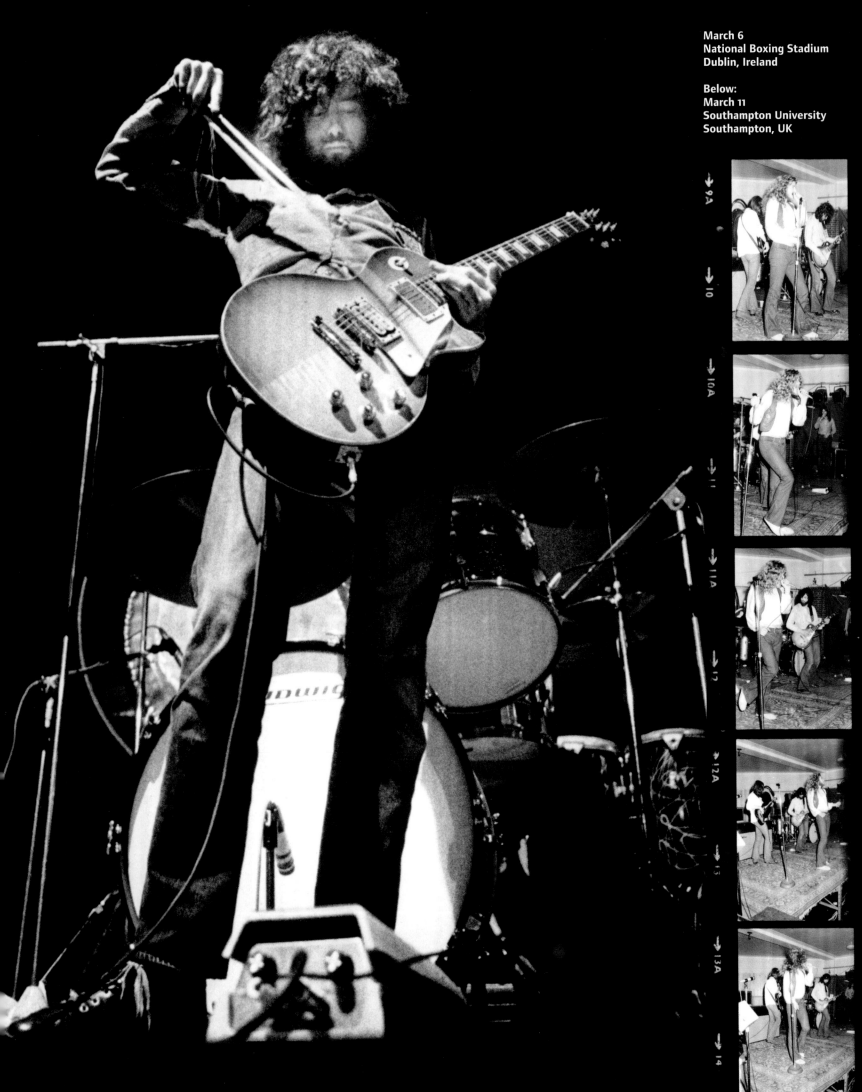

March 6
National Boxing Stadium
Dublin, Ireland

Below:
March 11
Southampton University
Southampton, UK

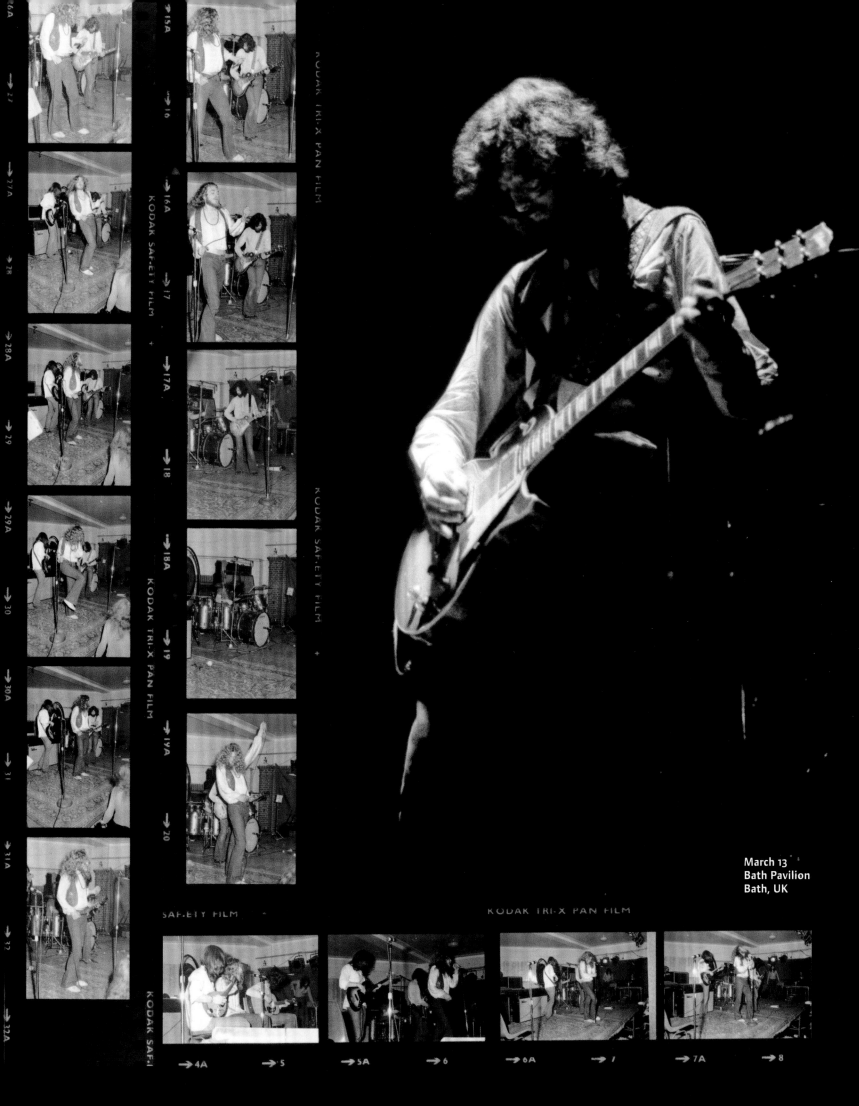

March 13
Bath Pavilion
Bath, UK

March 13
Bath Pavilion
Bath, UK

March 19
Manchester University
Manchester, UK

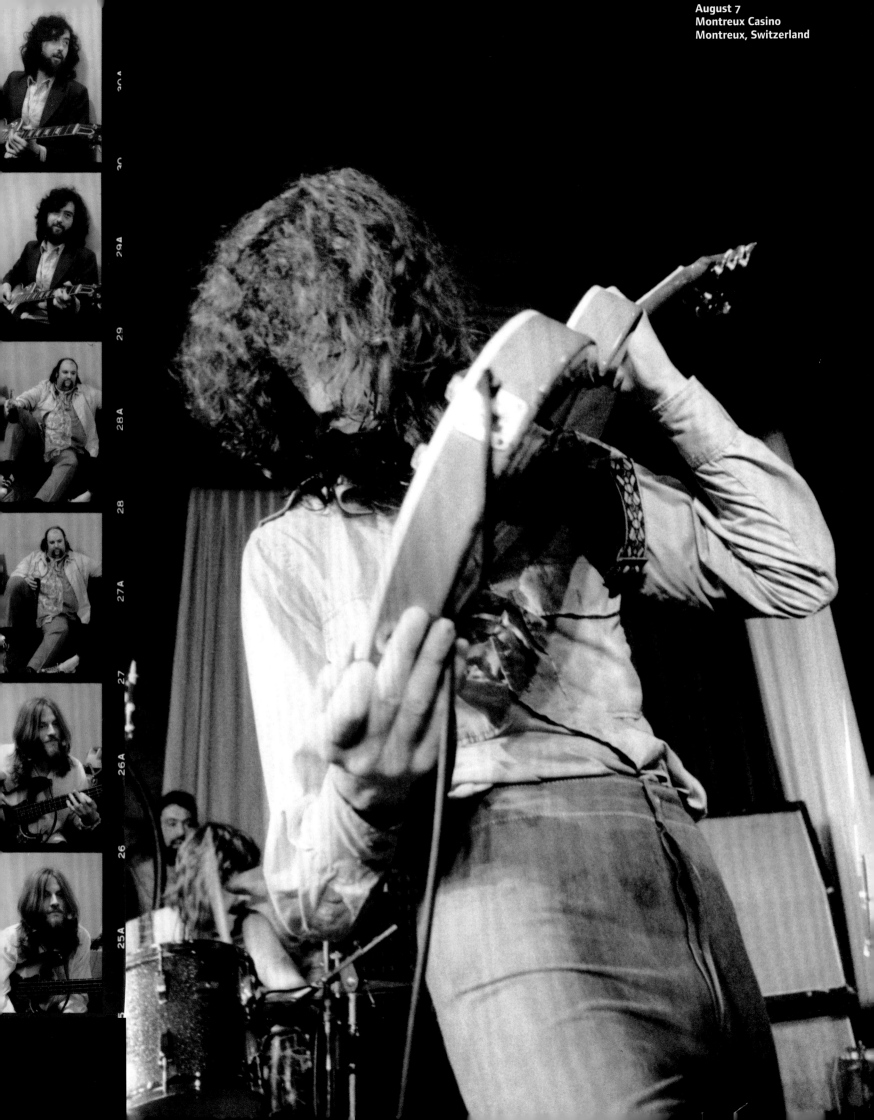

The 1971 European tour gave us the opportunity to play in Italy. During the concert in Milan the authorities, who were lined up along the top tier of the Vigorelli Velodromo stadium, discharged tear gas into the audience. No area was immune to the gas and even though we managed to save our guitars, other equipment went missing that evening. This was to become our first and final show in Italy.

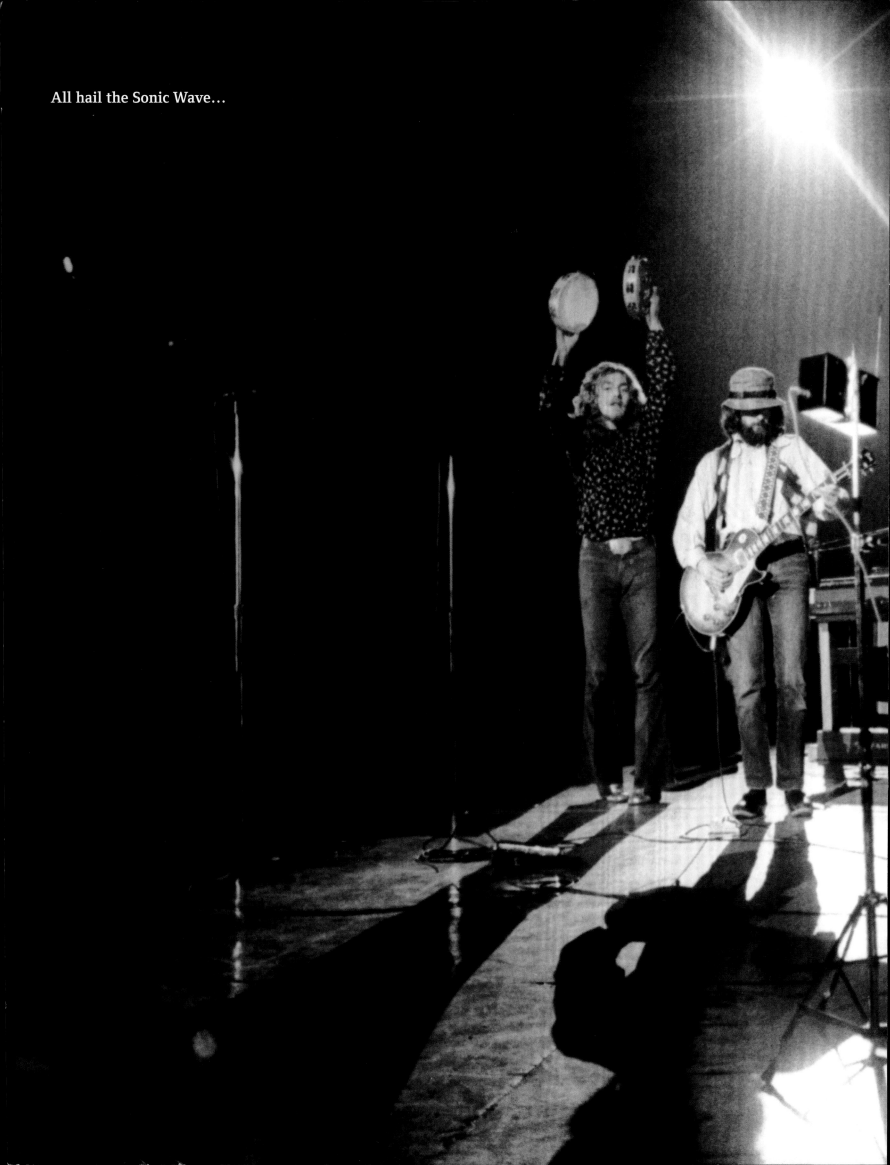

All hail the Sonic Wave…

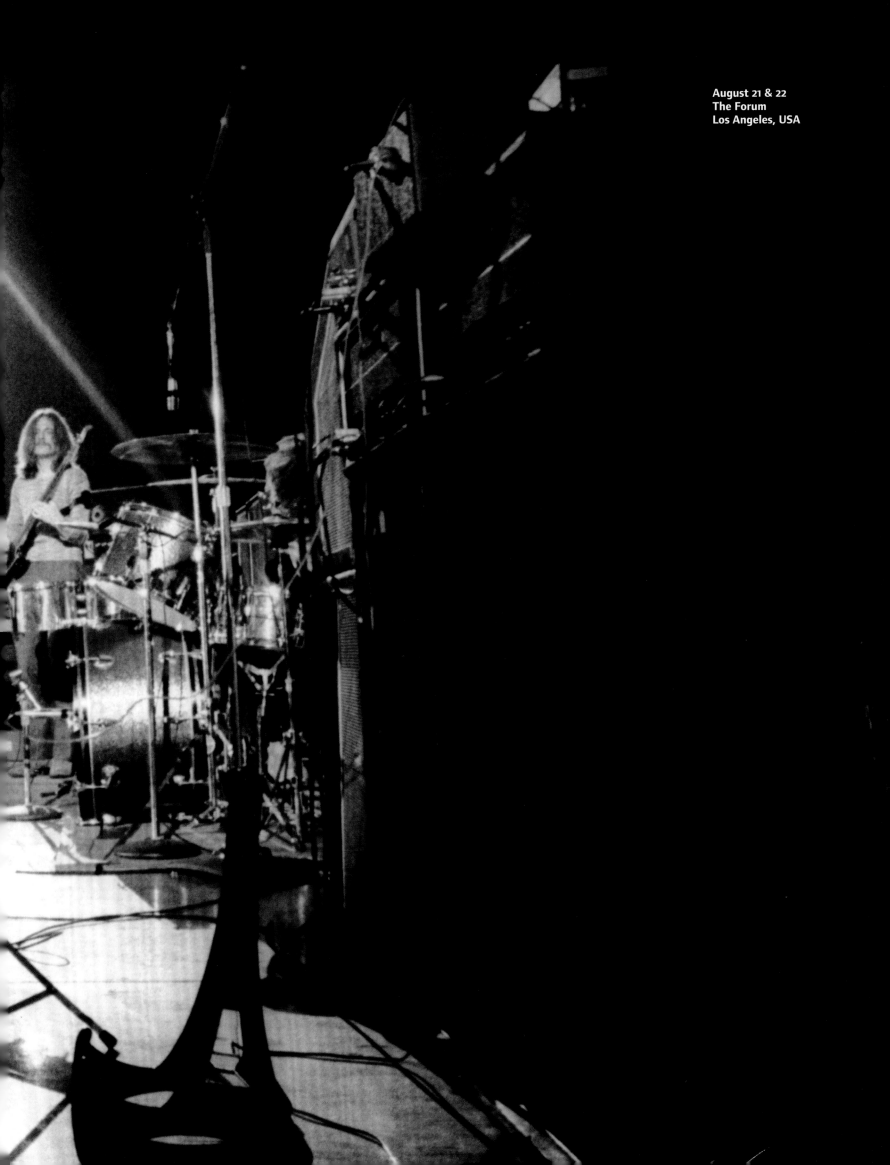

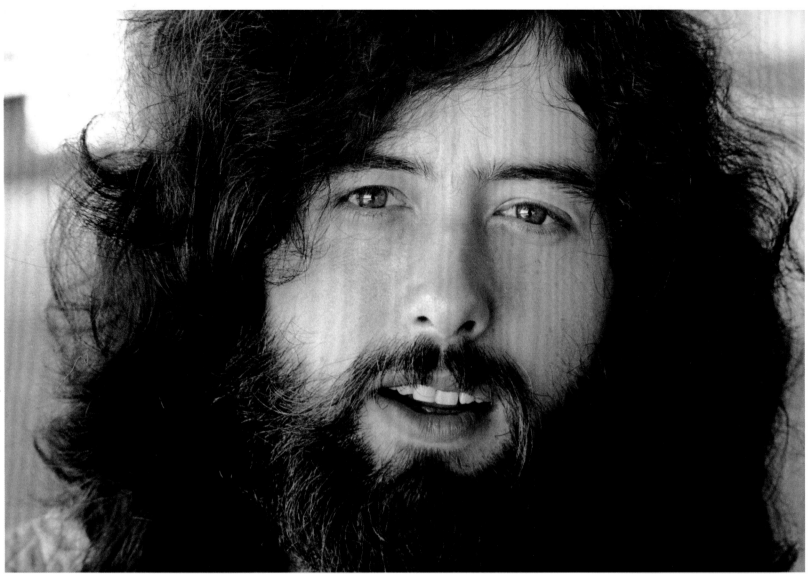

September 27
Hiroshima, Japan
Led Zeppelin receive peace
medals and the Civil Charter
from the Mayor of Hiroshima
after performing a charity
concert in the city

1971

Start of third UK tour – Back To The Clubs
March 5: Ulster Hall, Belfast, UK
March 6: National Boxing Stadium, Dublin, Ireland
March 9: Leeds University, Leeds, UK
March 10: University of Kent, Canterbury, UK
March 11: Southampton University, Southampton, UK
March 13: Bath Pavilion, Bath, UK
March 14: Trentham Gardens, Stoke, UK
March 18: The Mayfair, Newcastle, UK
March 19: Manchester University, Manchester, UK
March 20: The Belfry, Sutton Coldfield, UK
March 21: Boat Club, Nottingham, UK
March 23: Marquee Club, London, UK

April 1: Paris Cinema, London, UK
End of third UK tour – Back To The Clubs

May 3: KB Hallen, Copenhagen, Denmark
May 4: Fyns Forum, Odensen, Denmark
May 10: Liverpool University, Liverpool, UK

July 5: Vigorelli Velodrome, Milan, Italy

August 7: Montreux Casino, Montreux, Switzerland
August 8: Montreux Casino, Montreux, Switzerland

Start of seventh American tour
August 19: Pacific Coliseum, Vancouver, Canada
August 21: The Forum, Los Angeles, USA
August 22: The Forum, Los Angeles, USA
August 23: Tarrant County Convention Center, Fort Worth, USA
August 24: Memorial Auditorium, Dallas, USA
August 26: Sam Houston Coliseum, Houston, USA
August 27: Convention Center Arena, San Antonio, USA
August 28: St Louis Arena, St Louis, USA
August 29: Municipal Auditorium, New Orleans, USA
August 31: Sports Stadium, Orlando, USA

September 1: Hollywood Sportatorium, Hollywood (FL), USA
September 3: Madison Square Garden, New York, USA
September 4: Maple Leaf Gardens, Toronto, Canada
September 5: Chicago International Amphitheatre, Chicago, USA
September 7: Boston Garden, Boston, USA
September 9: Hampton Roads Coliseum, Hampton, USA
September 10: Onondaga War Memorial Auditorium, Syracuse, USA
September 11: War Memorial Auditorium, Rochester, USA
September 13: Berkeley Community Theatre, Berkeley, USA
September 14: Berkeley Community Theatre, Berkeley, USA
September 16: Civic Auditorium, Honolulu, Hawaii, USA
September 17: Civic Auditorium, Honolulu, Hawaii, USA
End of seventh American tour

Start of first Japanese tour
September 23: Budokan Hall, Tokyo, Japan
September 24: Budokan Hall, Tokyo, Japan
September 27: Shiei Taikukan Hall, Hiroshima, Japan
September 28: Festival Hall, Osaka, Japan
September 29: Festival Hall, Osaka, Japan
End of first Japanese tour

Start of fourth UK tour
November 11: City Hall, Newcastle, UK
November 12: Mecca Ballroom, Newcastle, UK
November 13: Caird Hall, Dundee, UK
November 16: St. Matthew's Baths Hall, Ipswich, UK
November 17: Kinetic Circus, Birmingham, UK
November 18: Sheffield University, Sheffield, UK
November 20: Electric Magic, Wembley Empire Pool, London, UK
November 21: Electric Magic, Wembley Empire Pool, London, UK
November 23: Public Hall, Preston, UK
November 24: Free Trade Hall, Manchester, UK
November 25: Leicester University, Leicester, UK
November 29: Liverpool Stadium, Liverpool, UK
November 30: King's Hall Belle Vue, Manchester, UK

December 2: Starkers Royal Ballroom, Bournemouth, UK
December 9: Locarno Ballroom, Coventry, UK
December 21: City Hall, Salisbury, UK
End of fourth UK tour

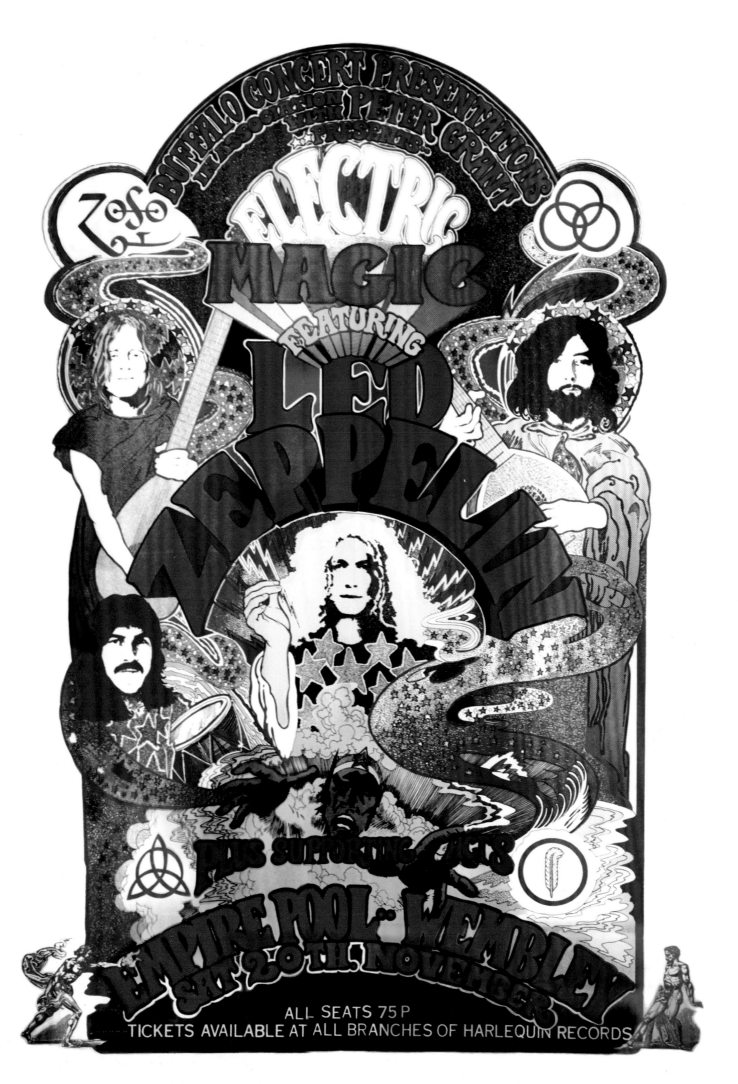

BUFFALO CONCERT PRESENTATIONS
IN ASSOCIATION WITH PETER GRANT
PRESENTS
ELECTRIC
MAGIC
FEATURING
LED
ZEPPELIN
PLUS SUPPORTING ACTS
EMPIRE POOL · WEMBLEY
SAT 20TH NOVEMBER
ALL SEATS 75P
TICKETS AVAILABLE AT ALL BRANCHES OF HARLEQUIN RECORDS

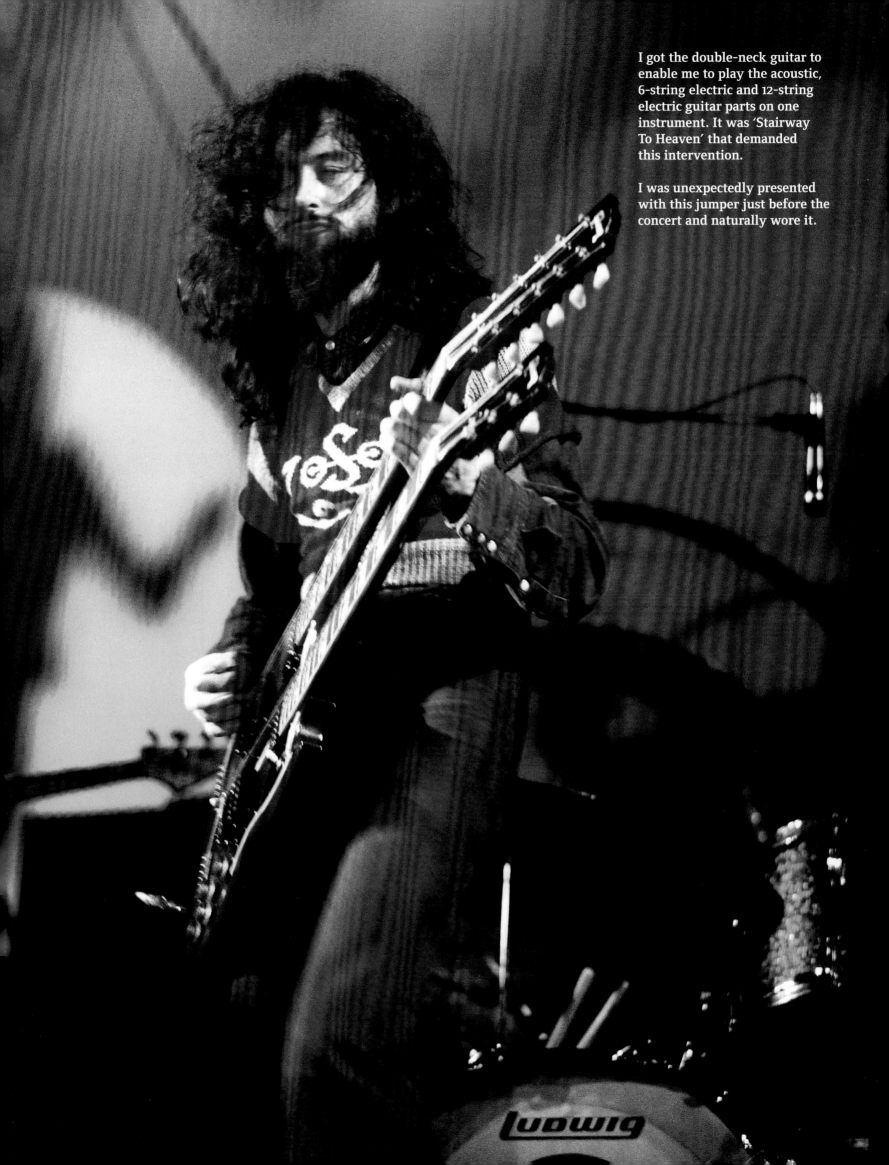

I got the double-neck guitar to enable me to play the acoustic, 6-string electric and 12-string electric guitar parts on one instrument. It was 'Stairway To Heaven' that demanded this intervention.

I was unexpectedly presented with this jumper just before the concert and naturally wore it.

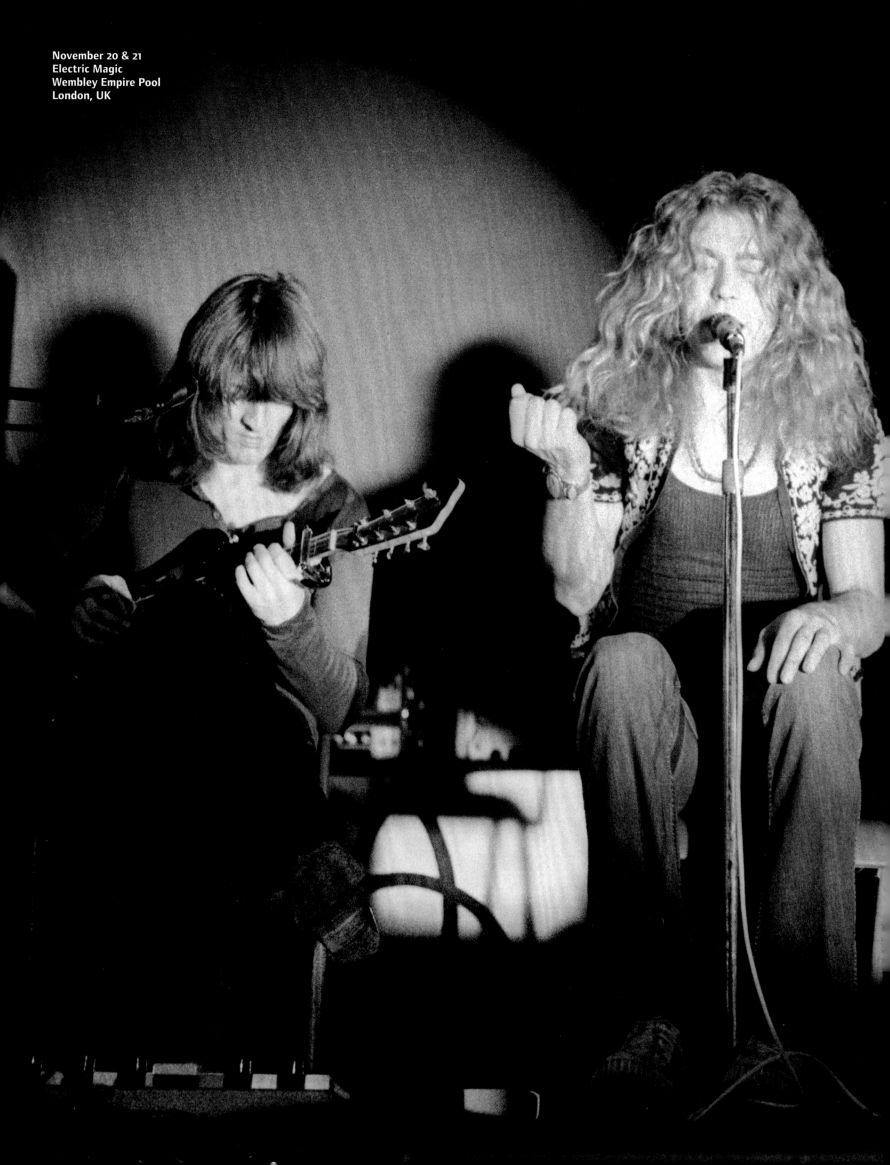

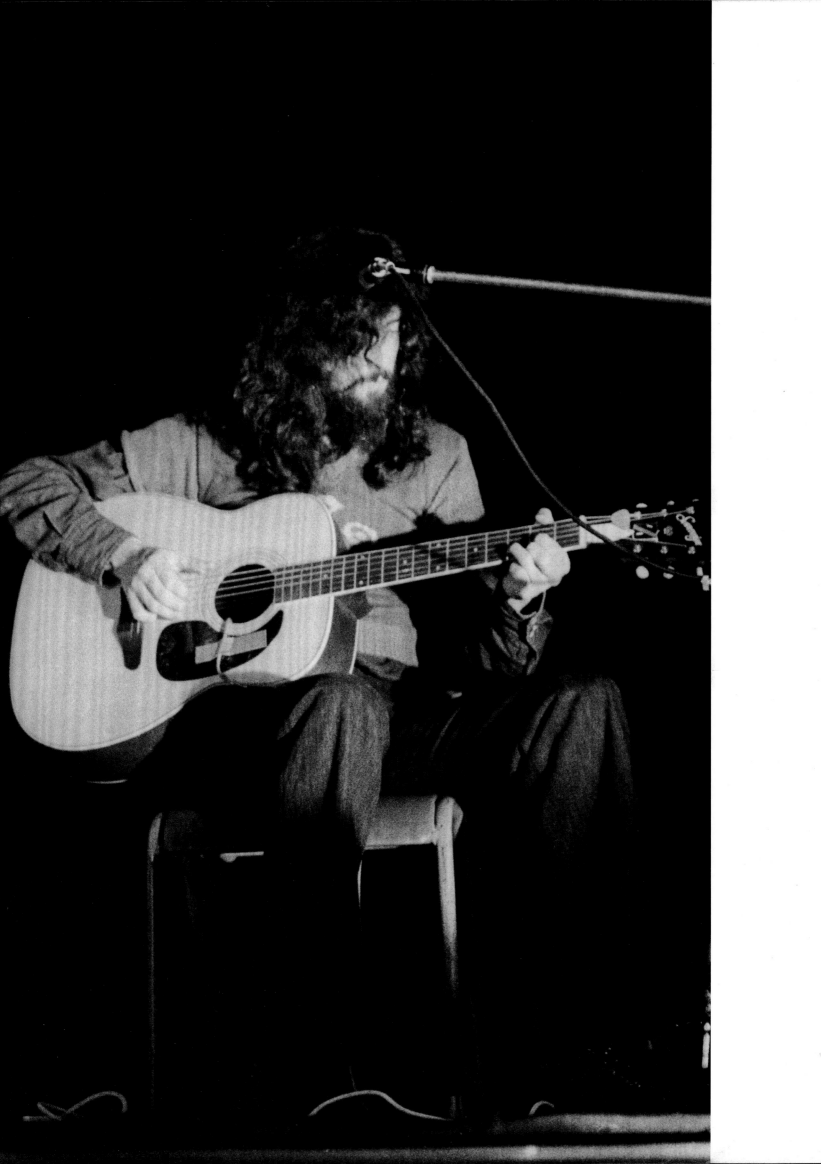

The 'Laird' of Boleskine.
Boleskine House
Loch Ness, UK

THE RELEASE OF *LED ZEPPELIN IV*
NOVEMBER 8 (US)
NOVEMBER 12 (UK)

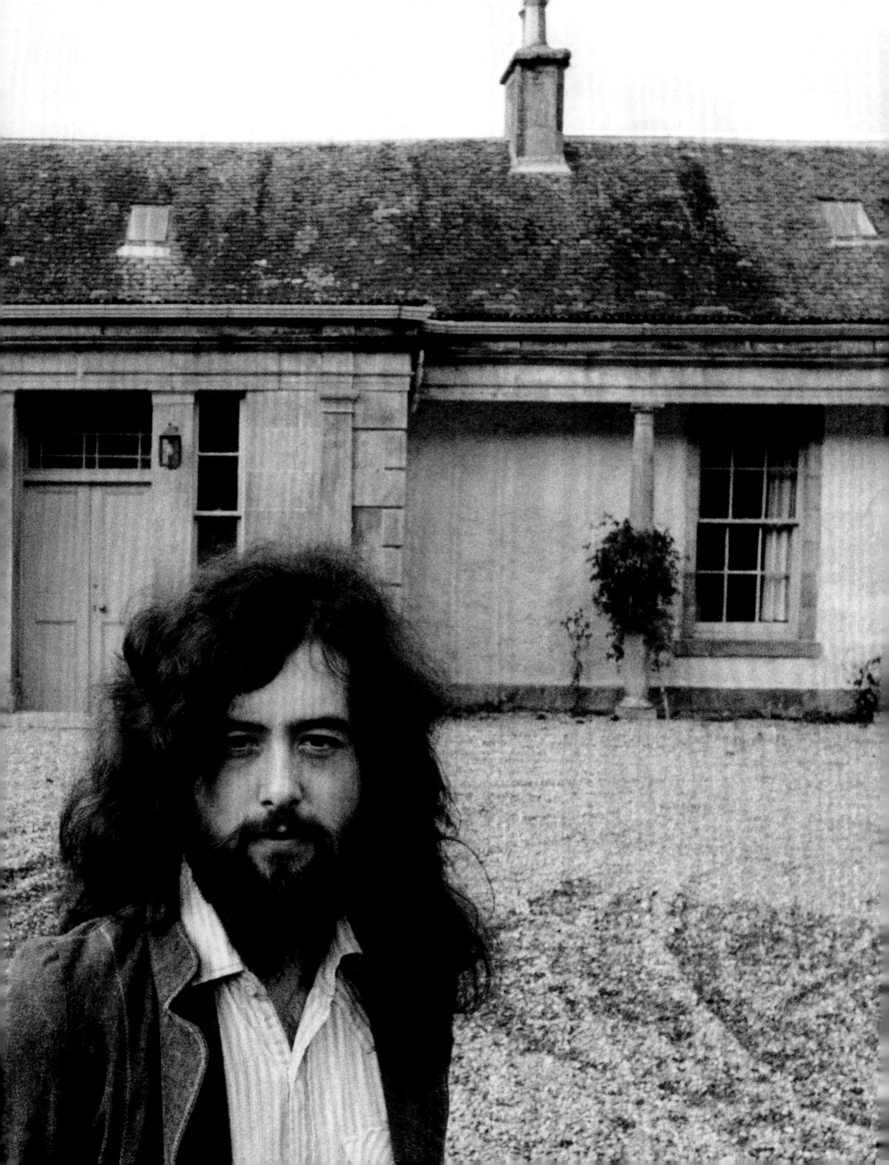

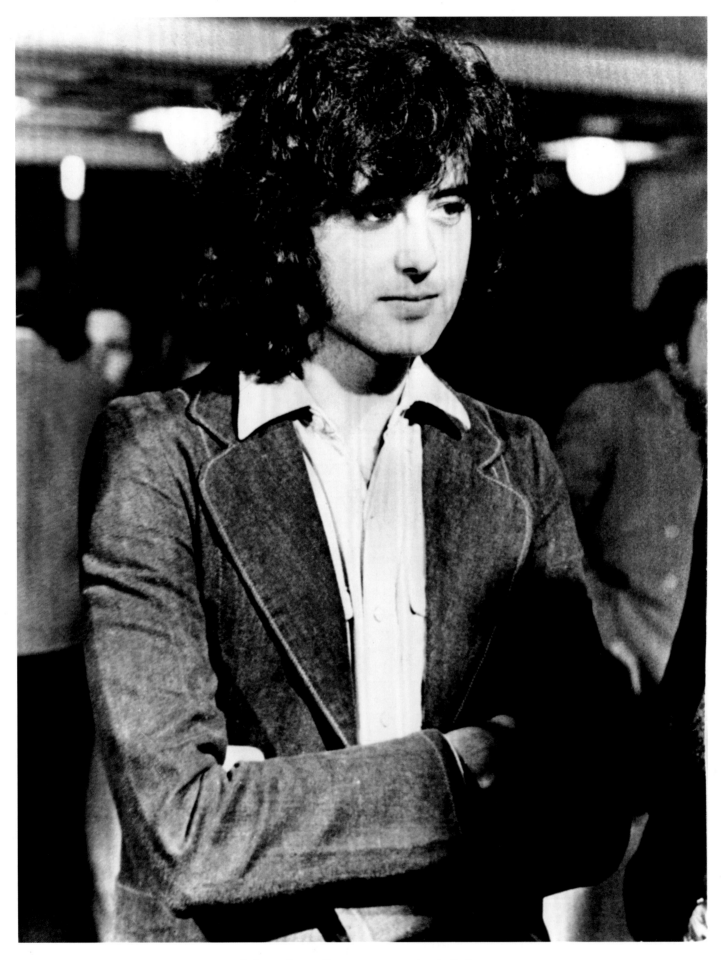

I arrived clean-shaven for a press reception in Sydney;
it took ages for them to work out who I was.

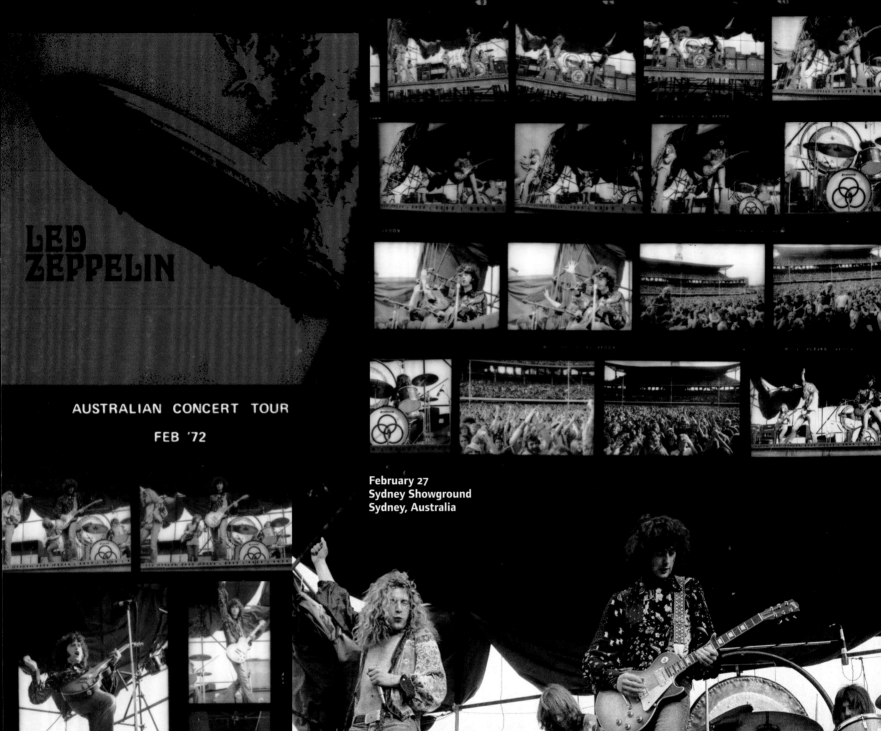

LED ZEPPELIN

AUSTRALIAN CONCERT TOUR

FEB '72

February 27
Sydney Showground
Sydney, Australia

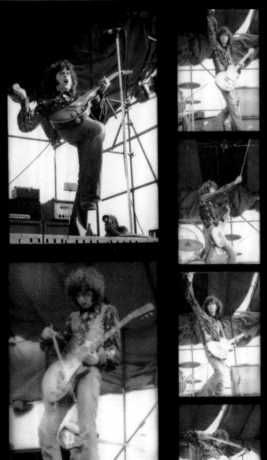

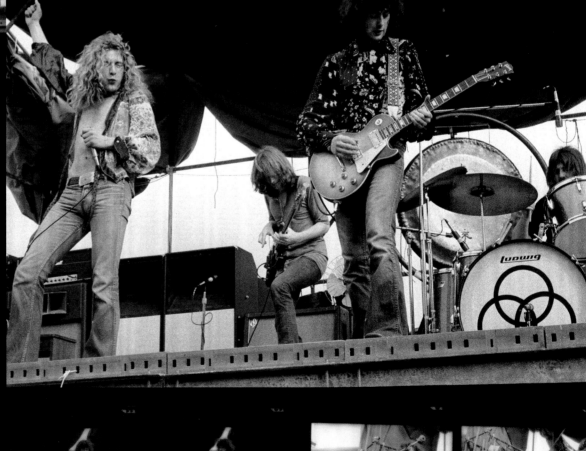

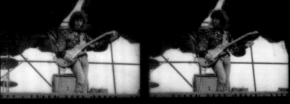

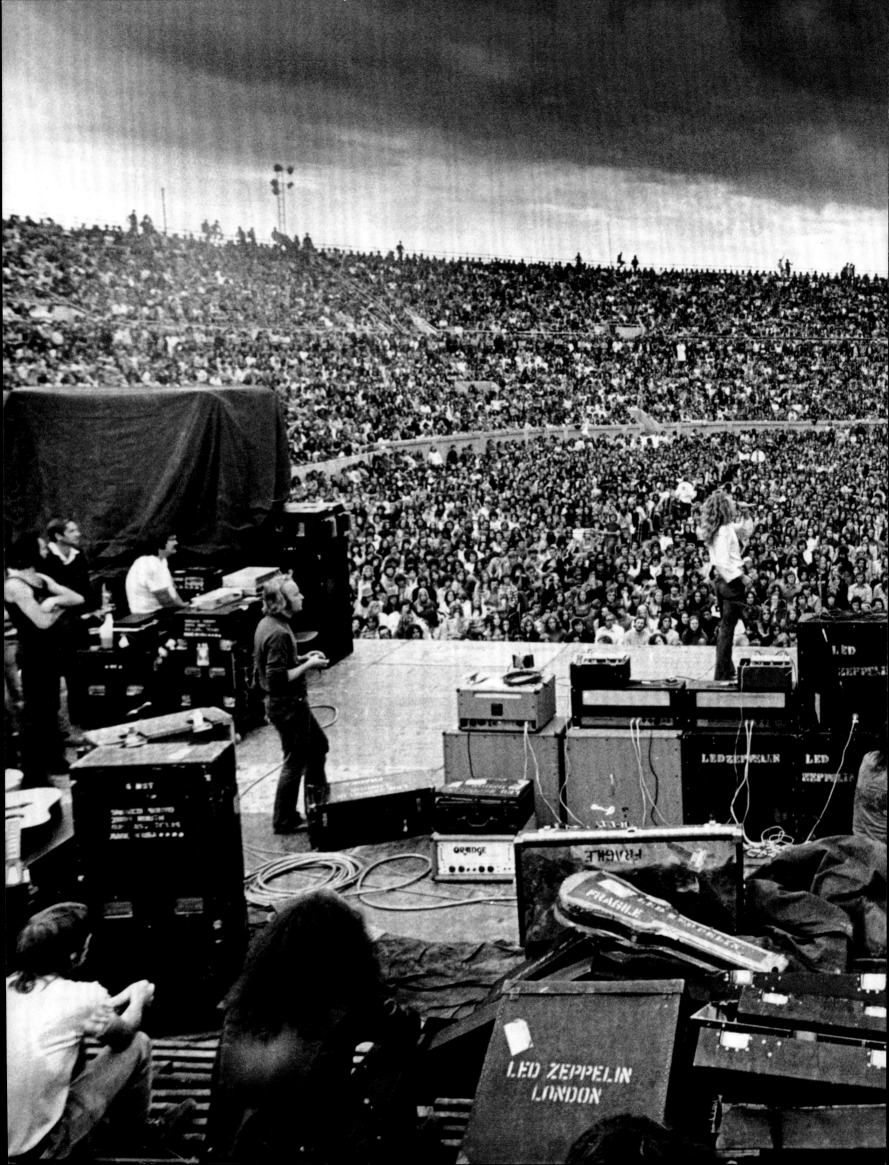

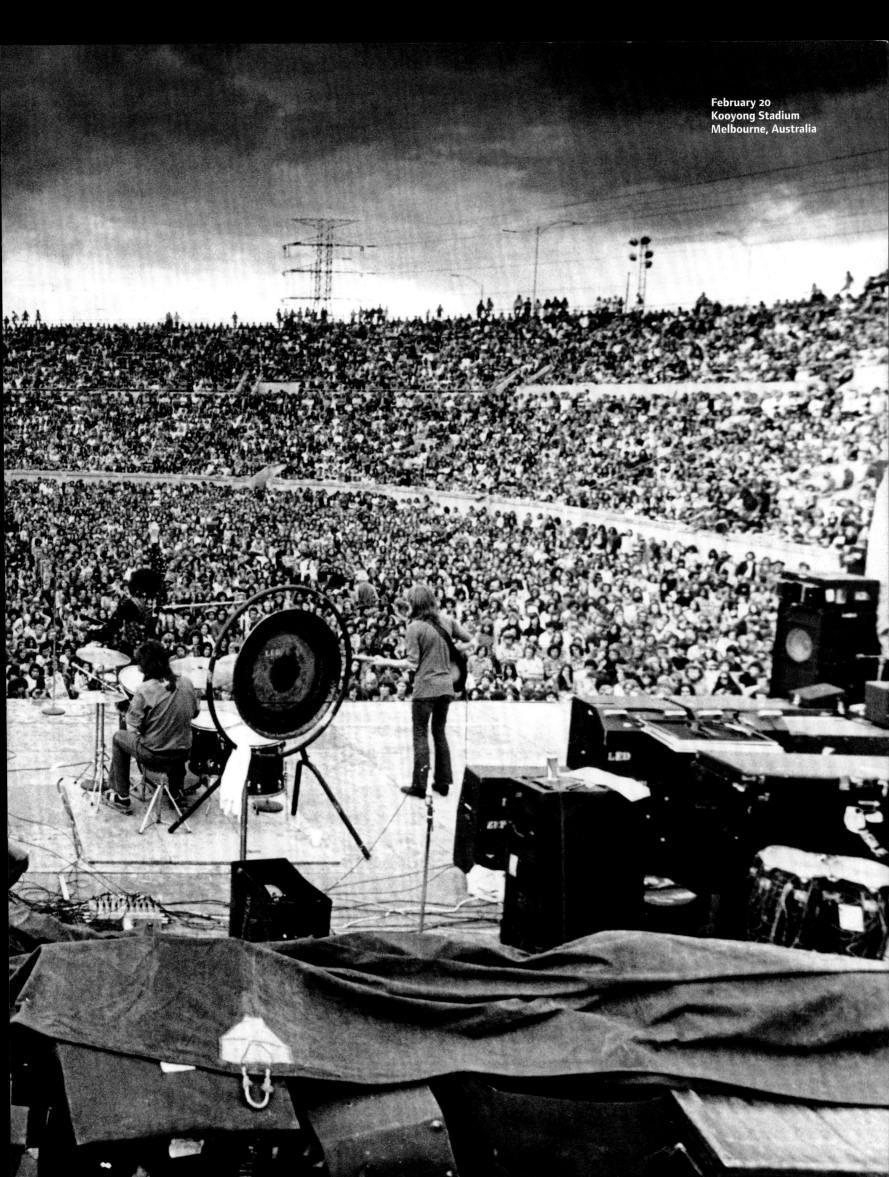

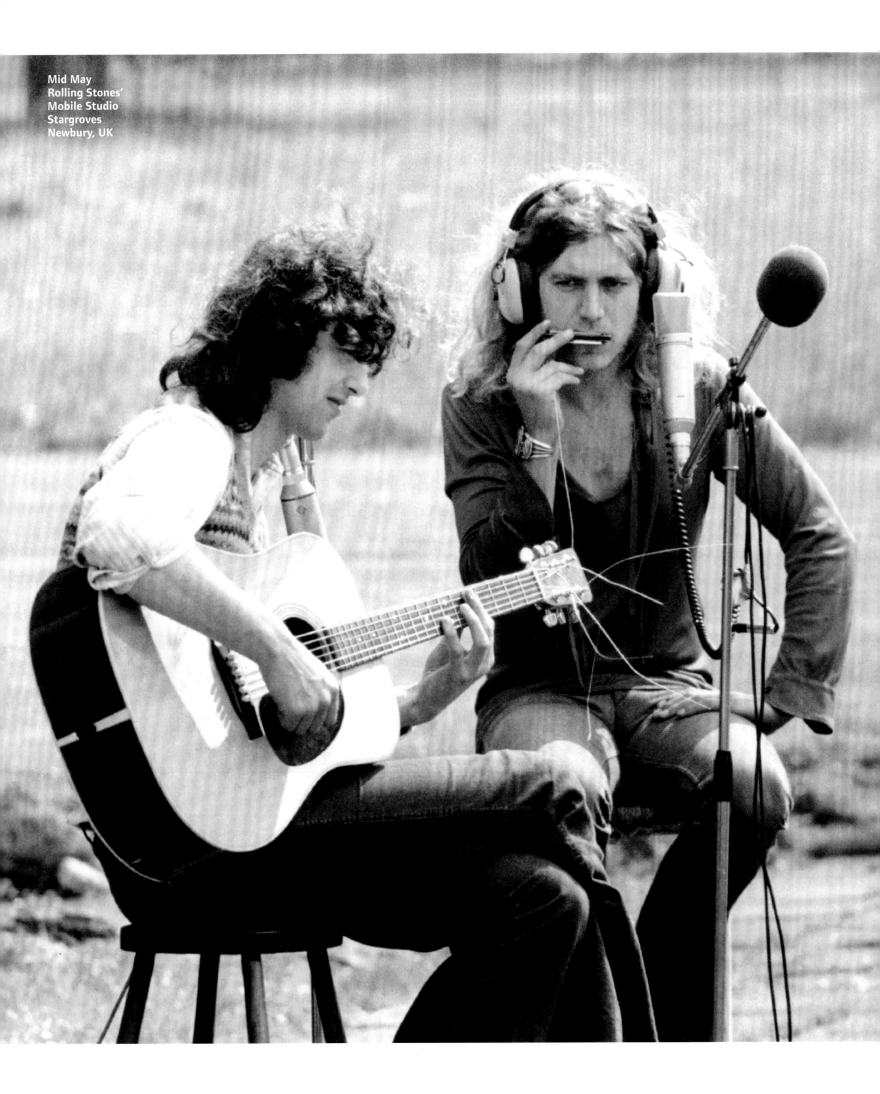

These photographs relate to the recording of 'Black Country Woman'.
As we might have outstayed our welcome at Headley Grange, and armed
with Eddie Kramer and The Rolling Stones' Mobile Studio, the group
began our fifth album, *Houses Of The Holy* at Stargroves – Mick Jagger's
country home. 'The Song Remains The Same,' 'The Rover' and 'D'Yer
Mak'er' were recorded at this location.

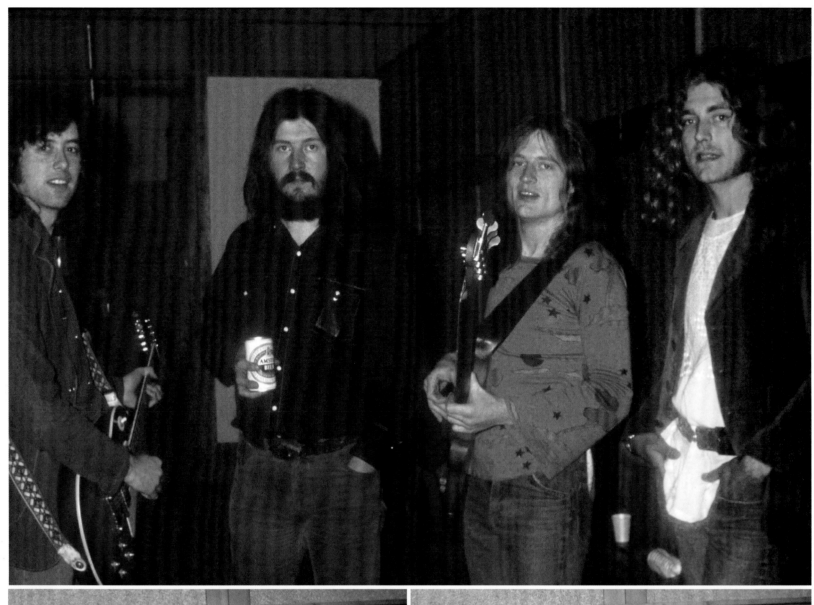

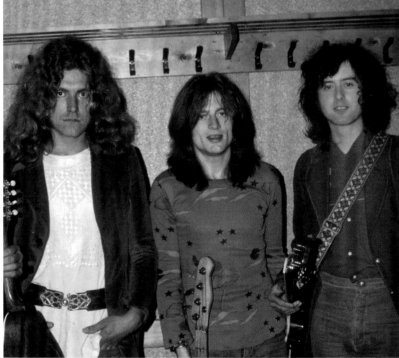

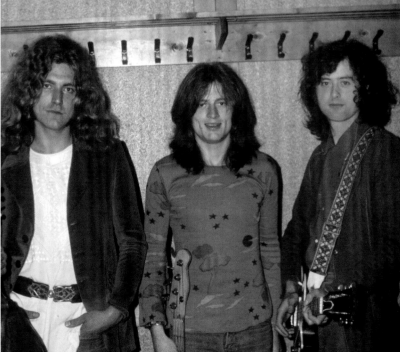

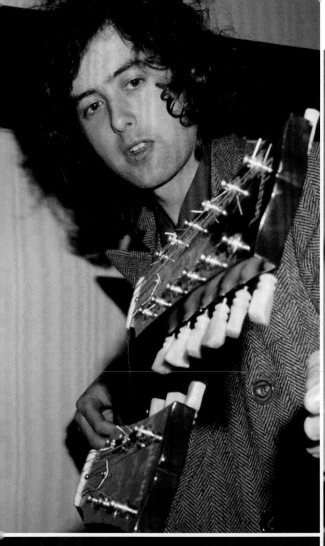

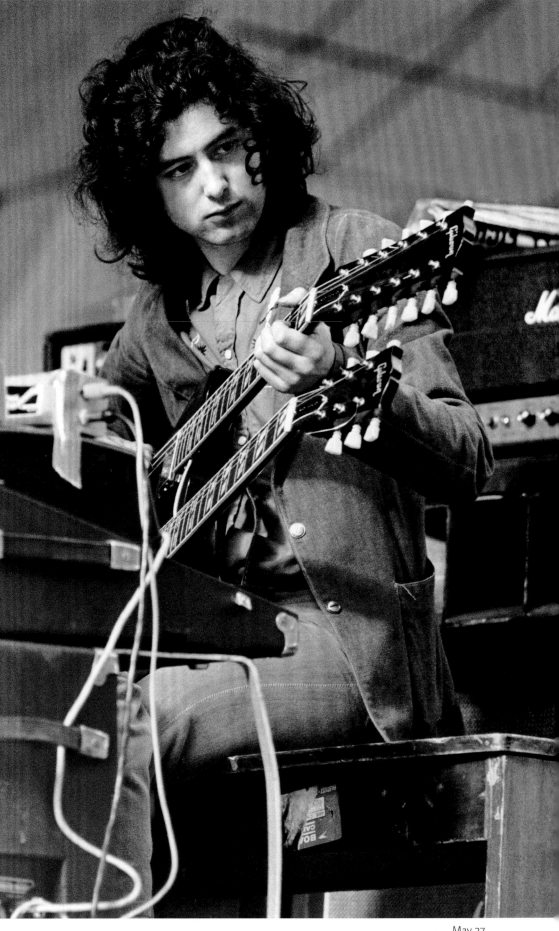

A taste of Europe before the American tour.

May 27
Oude Rai
Amsterdam,
Netherlands

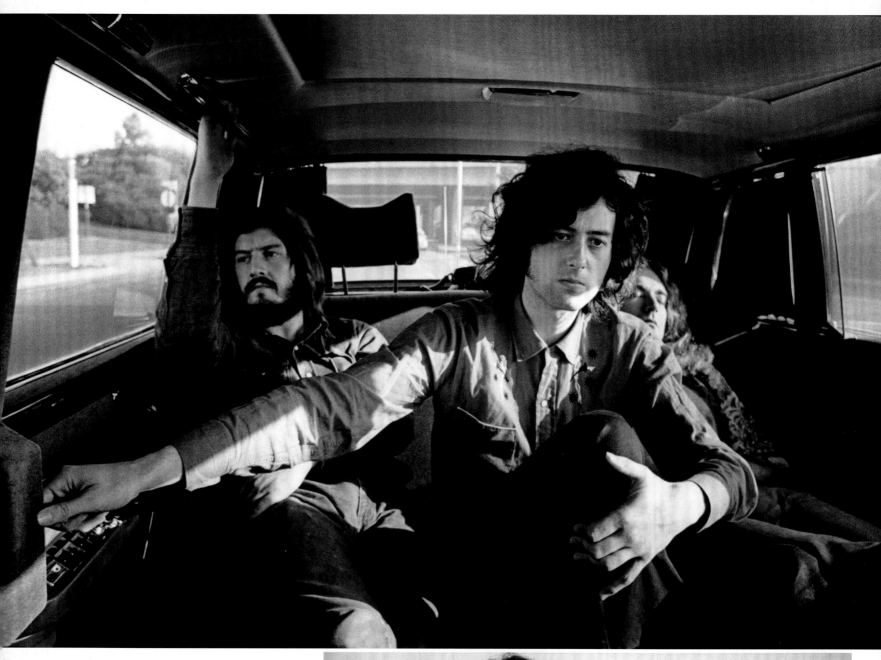

Photographic intrusion in the back of the
limousine, whilst on our way to The Forum.

More photographic intrusion, now backstage
at The Forum.

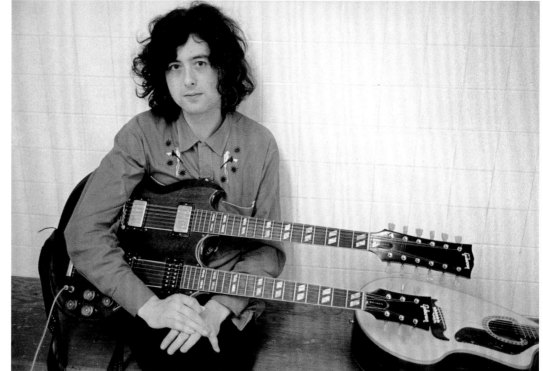

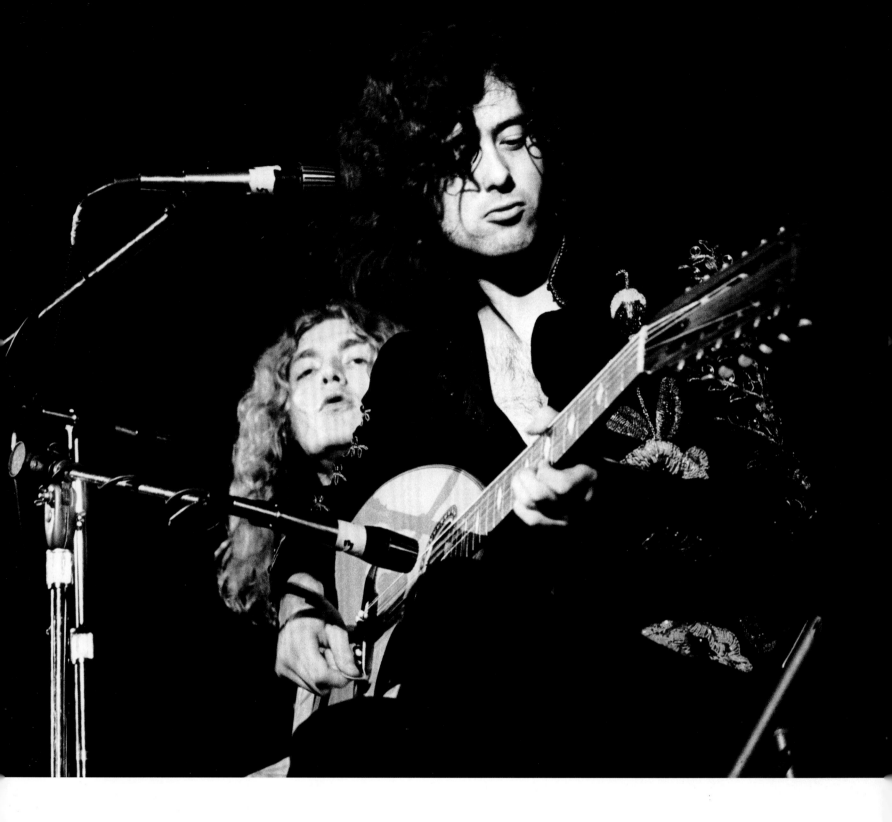

We included 'Tangerine' in the set.

June 25
The Forum
Los Angeles, USA

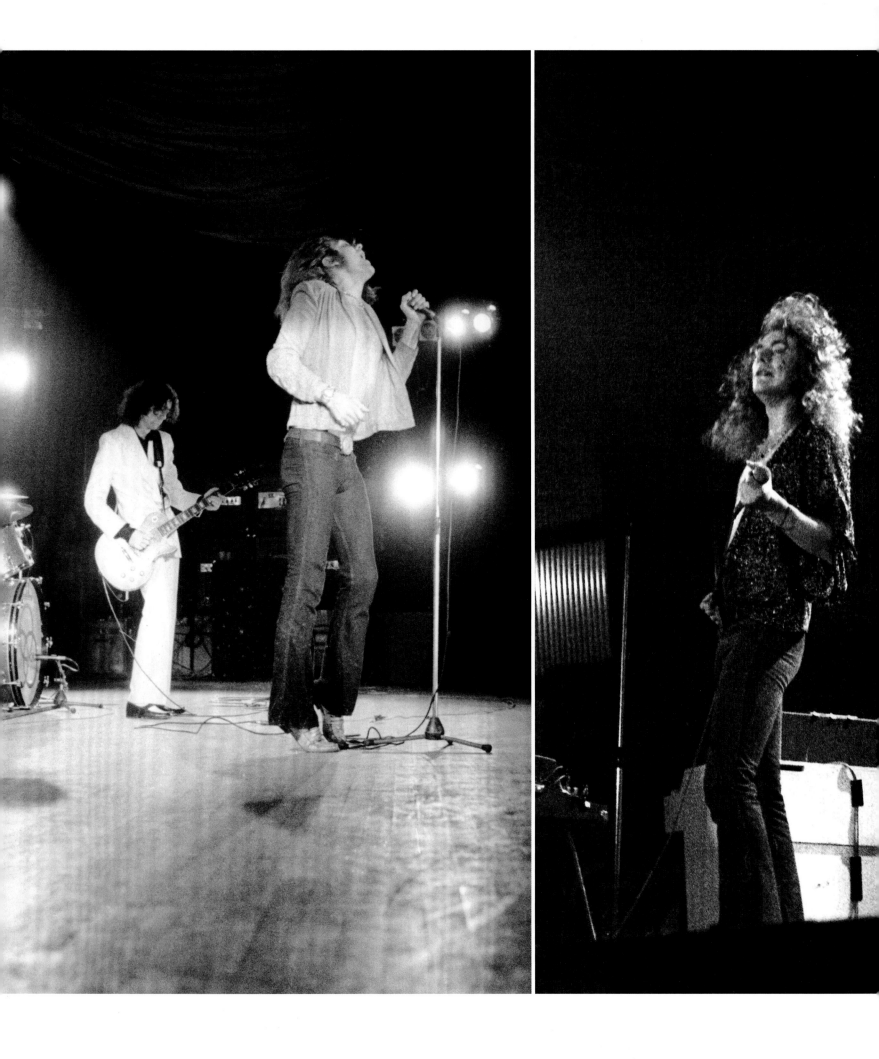

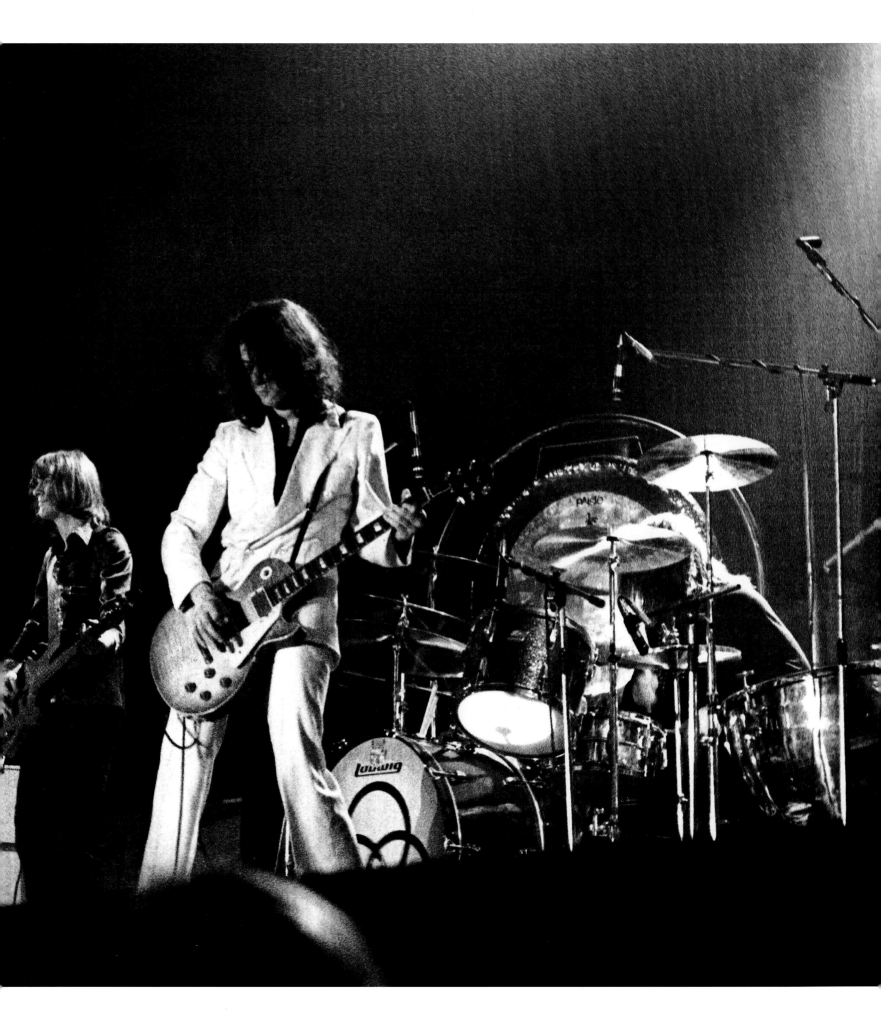

I had this suit made in one of those 24-hour tailors on a visit to Hong Kong.
I was trying for the look of those Fifties electric bluesmen, à la T-Bone Walker.

1972

Start of Australasian tour
February 16: Subiaco Oval, Perth, Australia
February 19: Memorial Drive, Adelaide, Australia
February 20: Kooyong Stadium, Melbourne, Australia
February 25: Western Springs Stadium, Auckland, New Zealand
February 27: Sydney Showground, Sydney, Australia
February 29: Festival Hall, Brisbane, Australia
End of Australasian tour

May 27: Oude Rai, Amsterdam, Netherlands
May 28: Vorst Nationaal, Brussels, Belgium

Start of eighth American tour
June 6: Cobo Hall, Detroit, USA
June 7: Montreal Forum, Montreal, Canada
June 9: Charlotte Coliseum, Charlotte, USA
June 10: Memorial Auditorium, Buffalo, USA
June 11: Civic Center, Baltimore, USA
June 13: Spectrum, Philadelphia, USA
June 14: Nassau Coliseum, Uniondale, USA
June 15: Nassau Coliseum, Uniondale, USA
June 17: Memorial Coliseum, Portland, USA
June 18: Seattle Center Coliseum, Seattle, USA
June 19: Seattle Center Coliseum, Seattle, USA
June 21: Denver Coliseum, Denver, USA
June 22: Swing Auditorium, San Bernardino, USA
June 23: Sports Arena, San Diego, USA
June 25: The Forum, Los Angeles, USA
June 27: Long Beach Arena, Long Beach, USA
June 28: Community Center, Tucson, USA
End of eighth American tour

Start of Japanese tour
October 2: Budokan Hall, Tokyo, Japan
October 3: Budokan Hall, Tokyo, Japan
October 4: Festival Hall, Osaka, Japan
October 5: Kokaido, Nagoya, Japan
October 9: Festival Hall, Osaka, Japan
October 10: Kaikan Hall, Kyoto, Japan
End of Japanese tour

October 28: Montreux Pavilion, Montreux, Switzerland
October 29: Montreux Pavilion, Montreux, Switzerland

Start of fifth UK tour
November 30: City Hall, Newcastle, UK

December 1: City Hall, Newcastle, UK
December 3: Green's Playhouse, Glasgow, UK
December 4: Green's Playhouse, Glasgow, UK
December 7: Hard Rock, Manchester, UK
December 8: Hard Rock, Manchester, UK
December 11: Capitol Theatre, Cardiff, UK
December 12: Capitol Theatre, Cardiff, UK
December 16: Birmingham Odeon, Birmingham, UK
December 17: Birmingham Odeon, Birmingham, UK
December 20: Brighton Dome, Brighton, UK
December 22: Alexandra Palace, London, UK
December 23: Alexandra Palace, London, UK

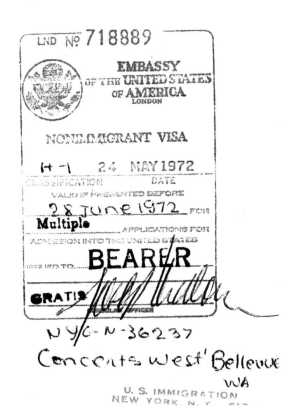

December 11 & 12
Capitol Theatre
Cardiff, UK

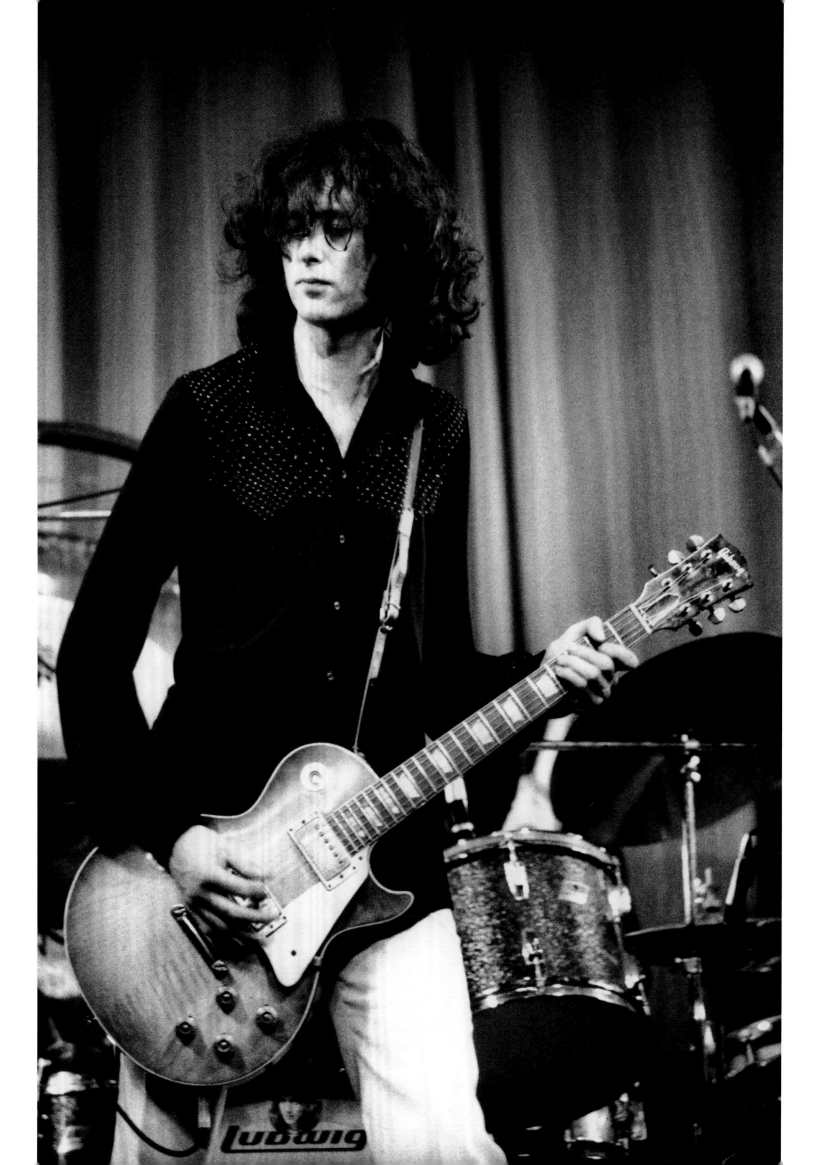

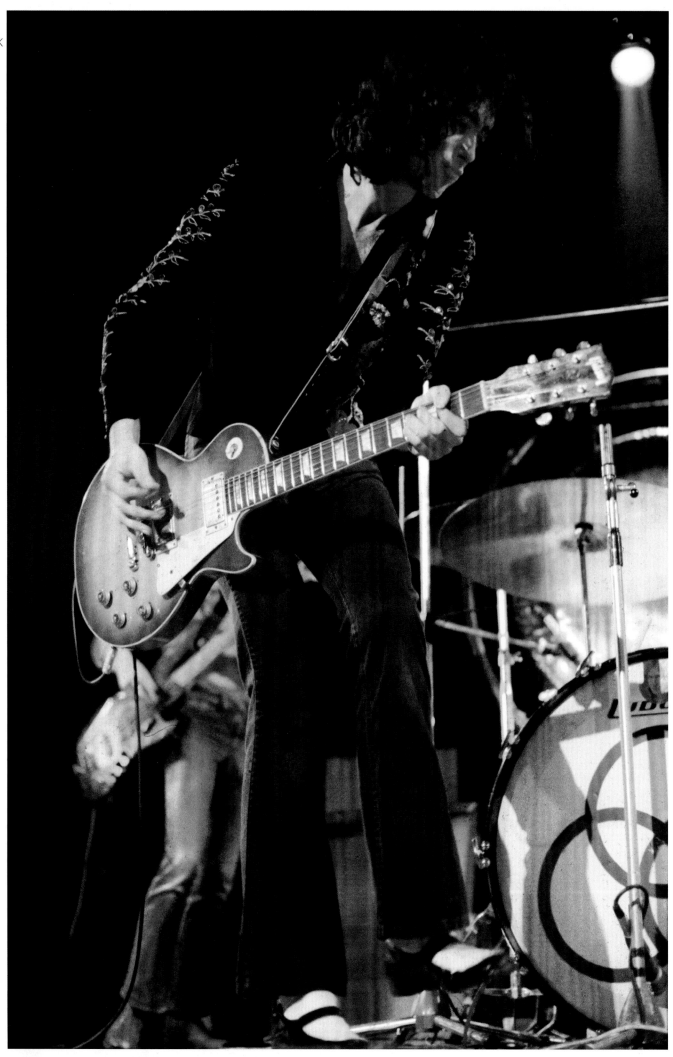

1973

January 2: City Hall, Sheffield, UK
January 7: New Theatre, Oxford, UK
January 14: Liverpool Empire, Liverpool, UK
January 15: Trentham Gardens, Stoke, UK
January 16: King's Hall, Aberystwyth, UK
January 18: St George's Hall, Bradford, UK
January 21: Gaumont Theatre, Southampton, UK
January 22: Southampton University, Southampton, UK
January 25: Aberdeen Music Hall, Aberdeen, UK
January 27: Caird Hall, Dundee, UK
January 28: King's Theatre, Edinburgh, UK
January 30: Guildhall, Preston, UK
End of fifth UK tour

Start of third European tour
March 2: KB Hallen, Copenhagen, Denmark
March 4: Scandinavium Arena, Gothenburg, Sweden
March 6: Kungliga Tennishallen, Stockholm, Sweden
March 7: Kungliga Tennishallen, Stockholm, Sweden
March 14: Messe-Zentrum Halle, Nuremburg, Germany
March 16: Stadthalle, Vienna, Austria
March 17: Olympiahalle, Munich, Germany
March 19: Deutschlandhalle, Berlin, Germany
March 21: Musikhalle, Hamburg, Germany
March 22: Grugahalle, Essen, Germany
March 24: Ortenauhalle, Offenburg, Germany
March 26: Palais de Sports, Lyon, France
March 27: Parc des Expositions, Nancy, France

April 1: Palais des Sports, Paris, France
April 2: Palais des Sports, Paris, France
End of third European tour

Start of ninth American tour
May 4: Fulton County Stadium, Atlanta, USA
May 5: Tampa Stadium, Tampa, USA
May 7: Jacksonville Coliseum, Jacksonville, USA
May 10: Memorial Coliseum, University of Alabama,
Tuscaloosa, USA
May 11: St Louis Arena, St Louis, USA
May 13: Municipal Auditorium, Mobile, USA
May 14: Municipal Auditorium, New Orleans, USA
May 16: Sam Houston Coliseum, Houston, USA
May 18: Memorial Auditorium, Dallas, USA
May 19: Tarrant County Convention Center, Fort Worth, USA
May 22: HemisFair Arena, San Antonio, USA
May 23: University of New Mexico, Albuquerque, USA
May 25: Denver Coliseum, Denver, USA
May 26: Salt Palace, Salt Lake City, USA
May 28: Sports Arena, San Diego, USA
May 31: The Forum, Los Angeles, USA

June 2: Kezar Stadium, San Francisco, USA
June 3: The Forum, Los Angeles, USA
July 6: Chicago Stadium, Chicago, USA
July 7: Chicago Stadium, Chicago, USA
July 8: Market Square Arena, Indianapolis, USA [Unconfirmed]
July 9: Civic Center, St. Paul, USA
July 10: Milwaukee Arena, Milwaukee, USA
July 12: Cobo Hall, Detroit, USA
July 13: Cobo Hall, Detroit, USA
July 15: Memorial Auditorium, Buffalo, USA
July 17: Seattle Center Coliseum, Seattle, USA
July 18: Pacific Coliseum, Vancouver, Canada
July 20: Boston Garden, Boston, USA
July 21: Civic Center, Providence, USA
July 23: Civic Center, Baltimore, USA
July 24: Three Rivers Stadium, Pittsburgh, USA
July 27: Madison Square Garden, New York, USA
July 28: Madison Square Garden, New York, USA
July 29: Madison Square Garden, New York, USA
End of ninth American tour

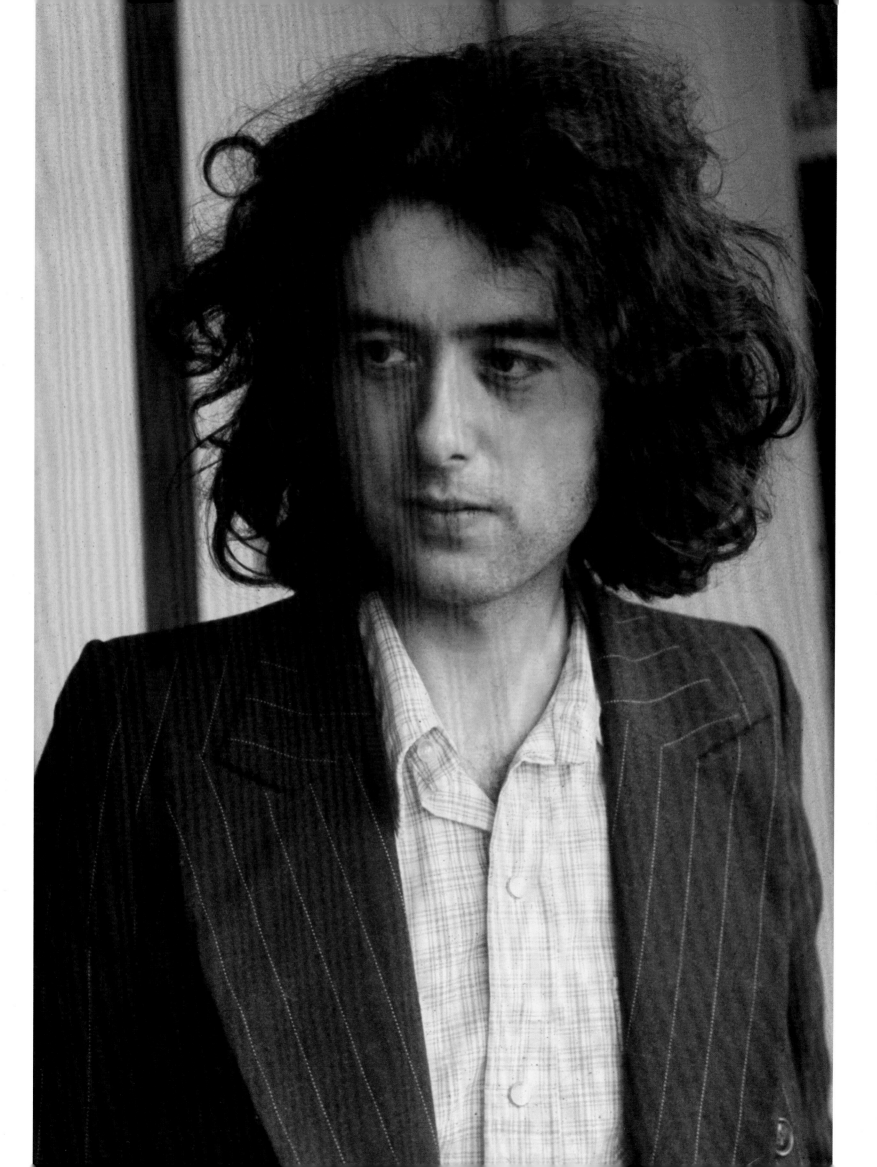

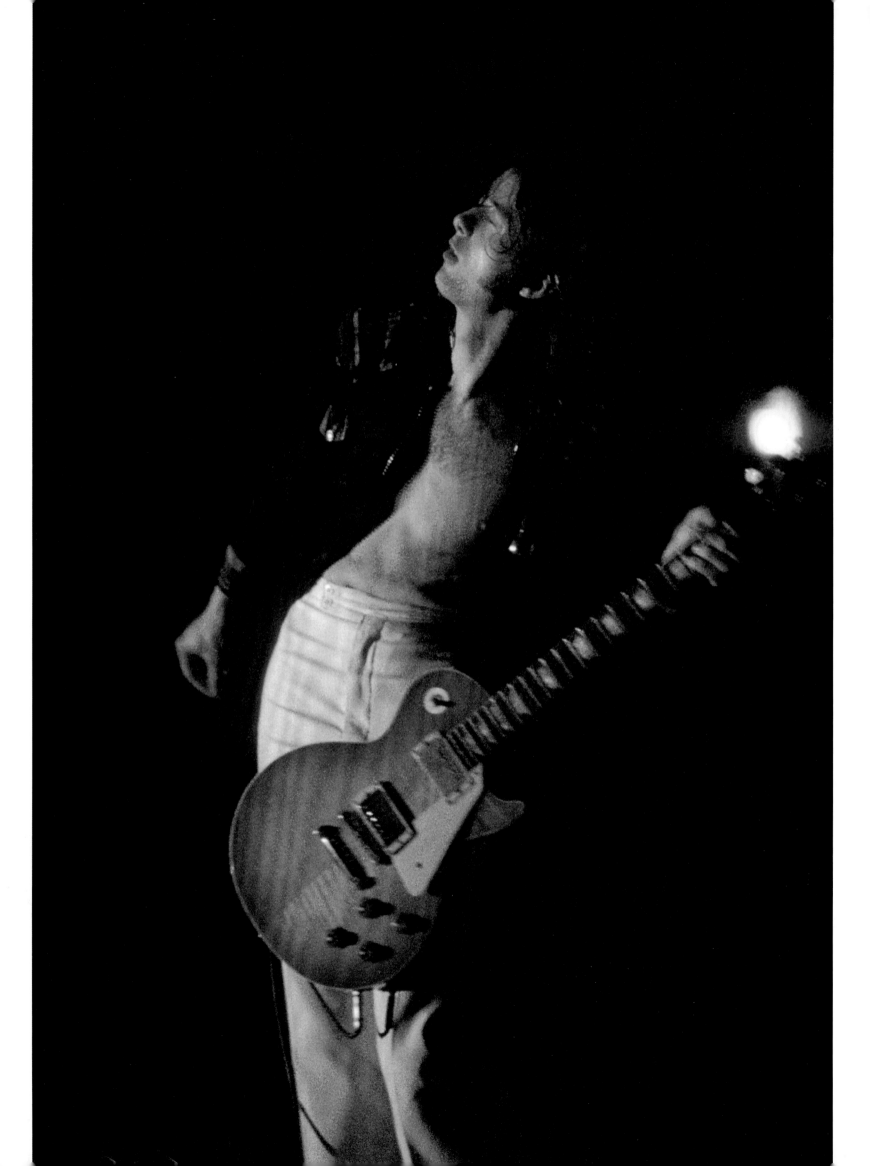

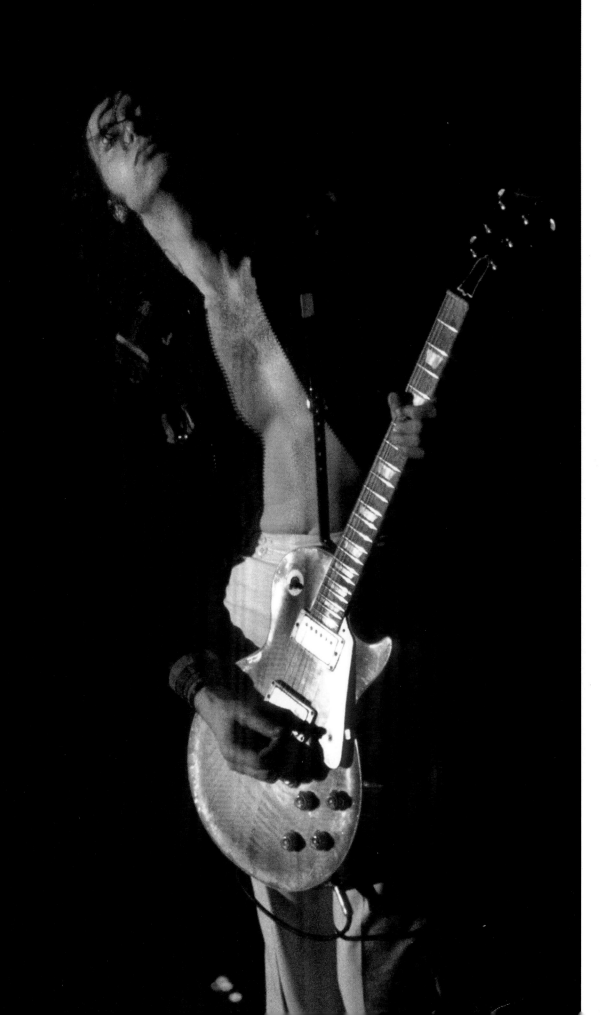

April 1 & 2
Palais des Sports
Paris, France

Last shows of the
European tour

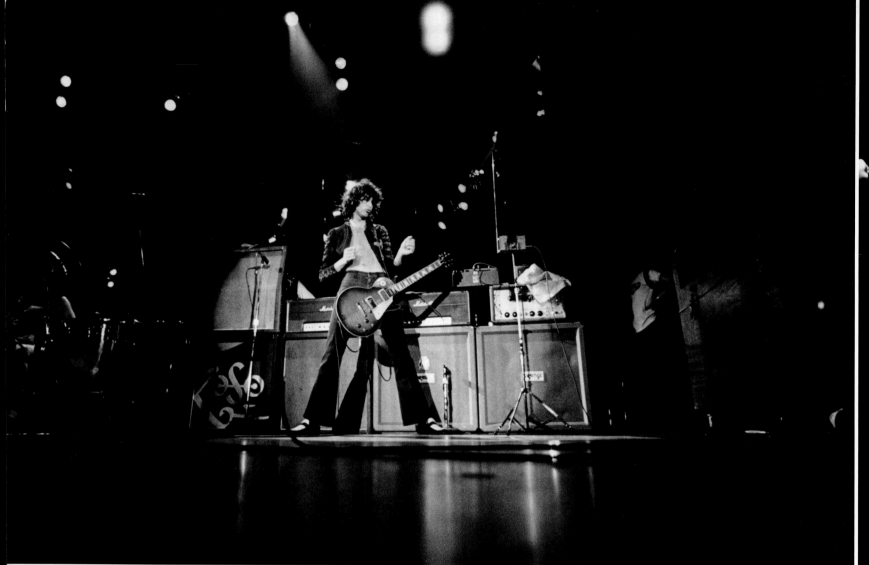

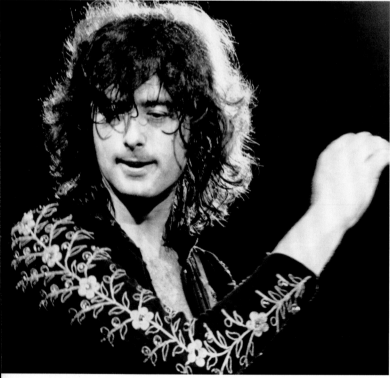

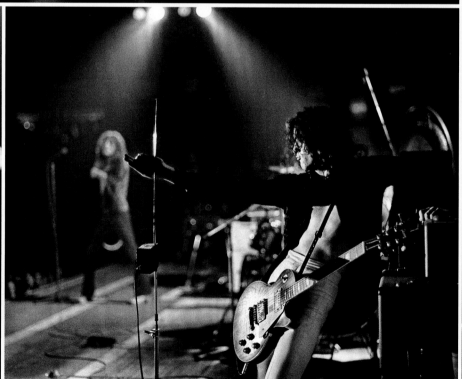

May 22
HemisFair Arena
San Antonio, USA

April 1
Palais de Sport
Paris, France

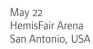

May 22
HemisFair Arena
San Antonio, USA

May 28
Sports Arena
San Diego, USA

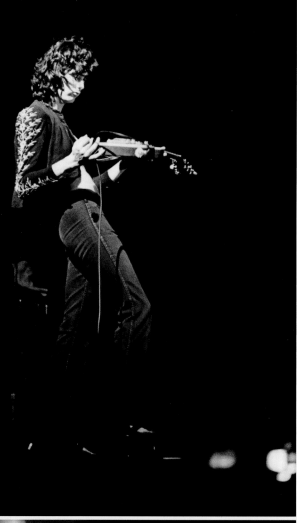

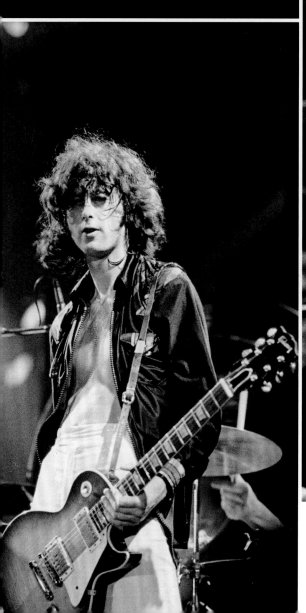

June 2
San Francisco Airport
San Francisco, USA

June 2
Kezar Stadium
San Francisco, USA

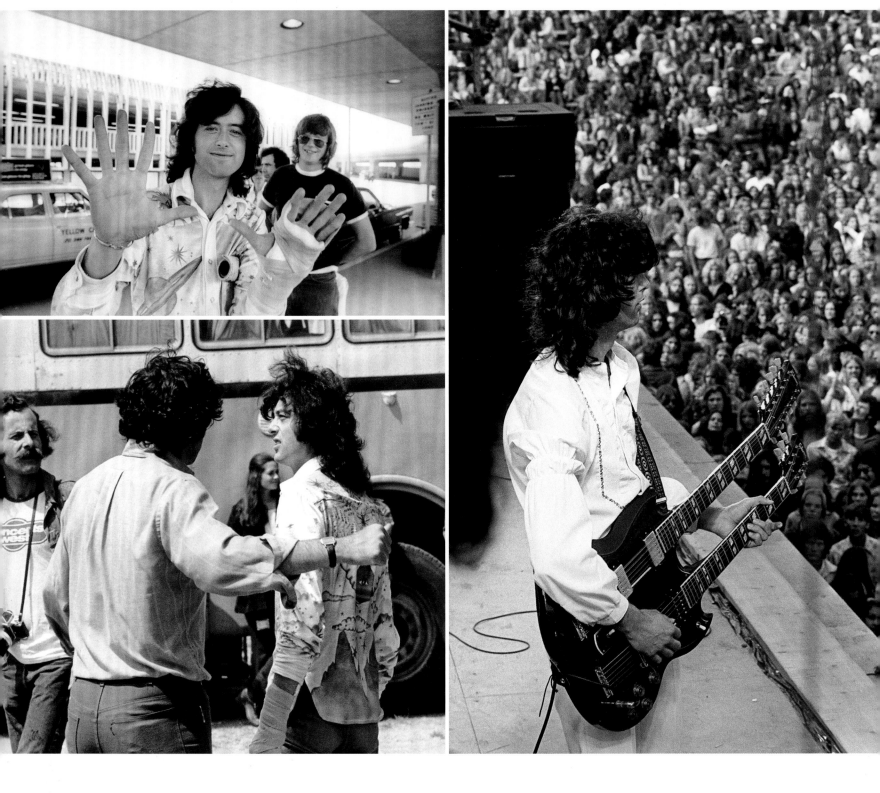

Et tu Brutus?

Somehow I managed to damage my hand in LA, rendering the ring finger on my left hand out of commission. Therefore I had to continue the tour without the use of it by modifying my playing technique. Mercifully it recovered by July, where we were due to record a film of the shows in New York.

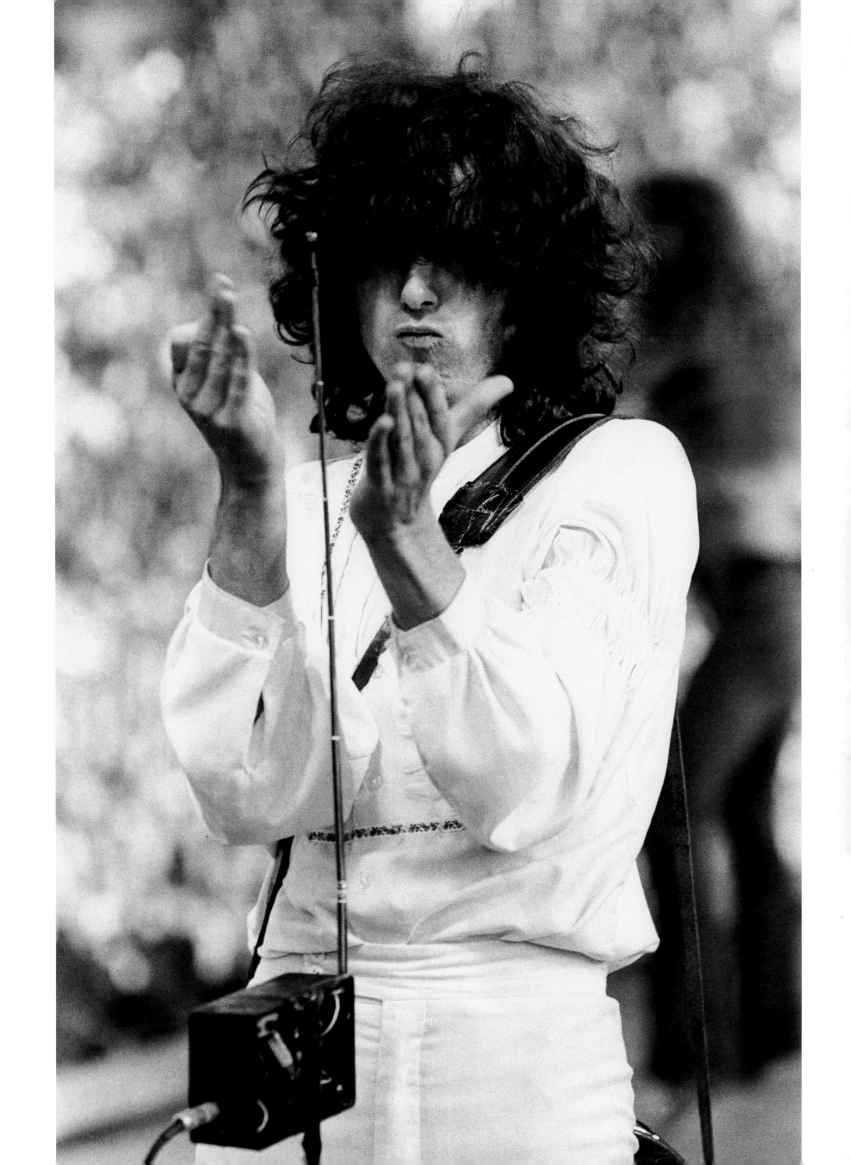

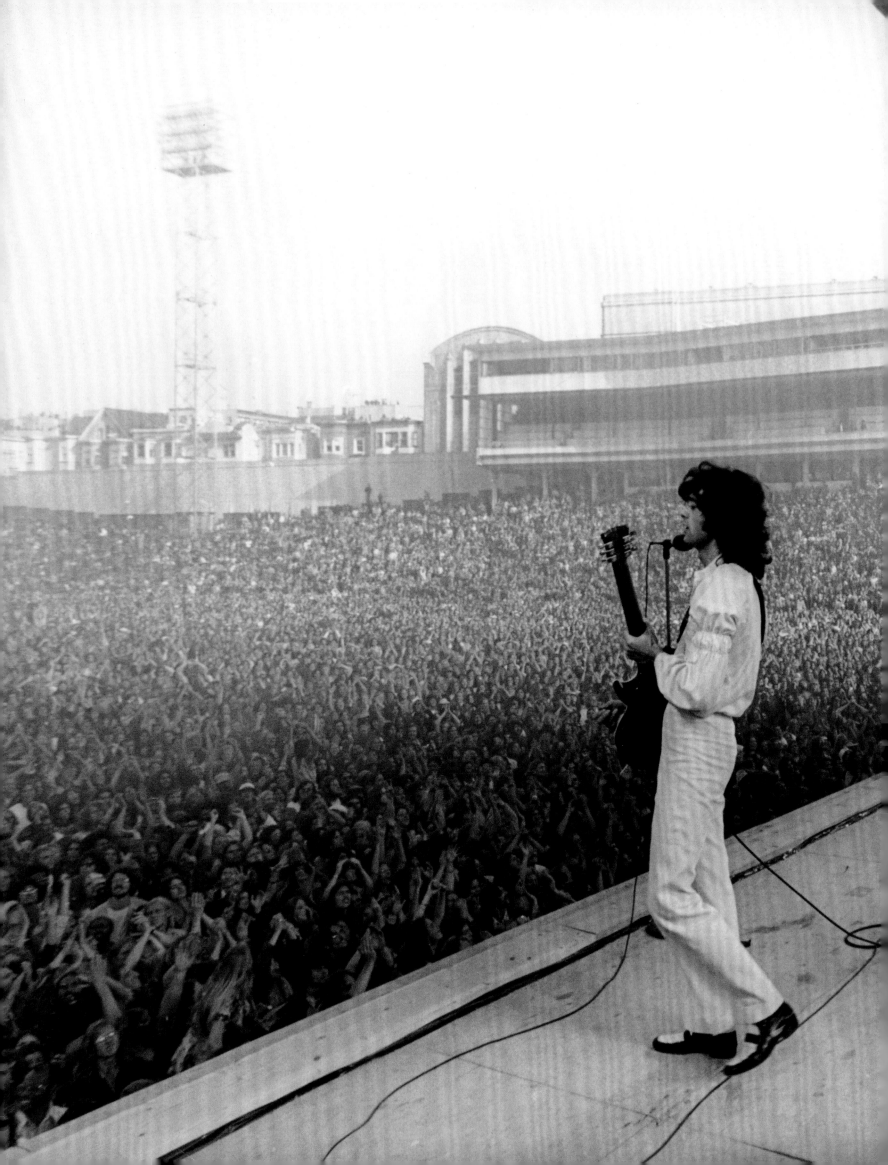

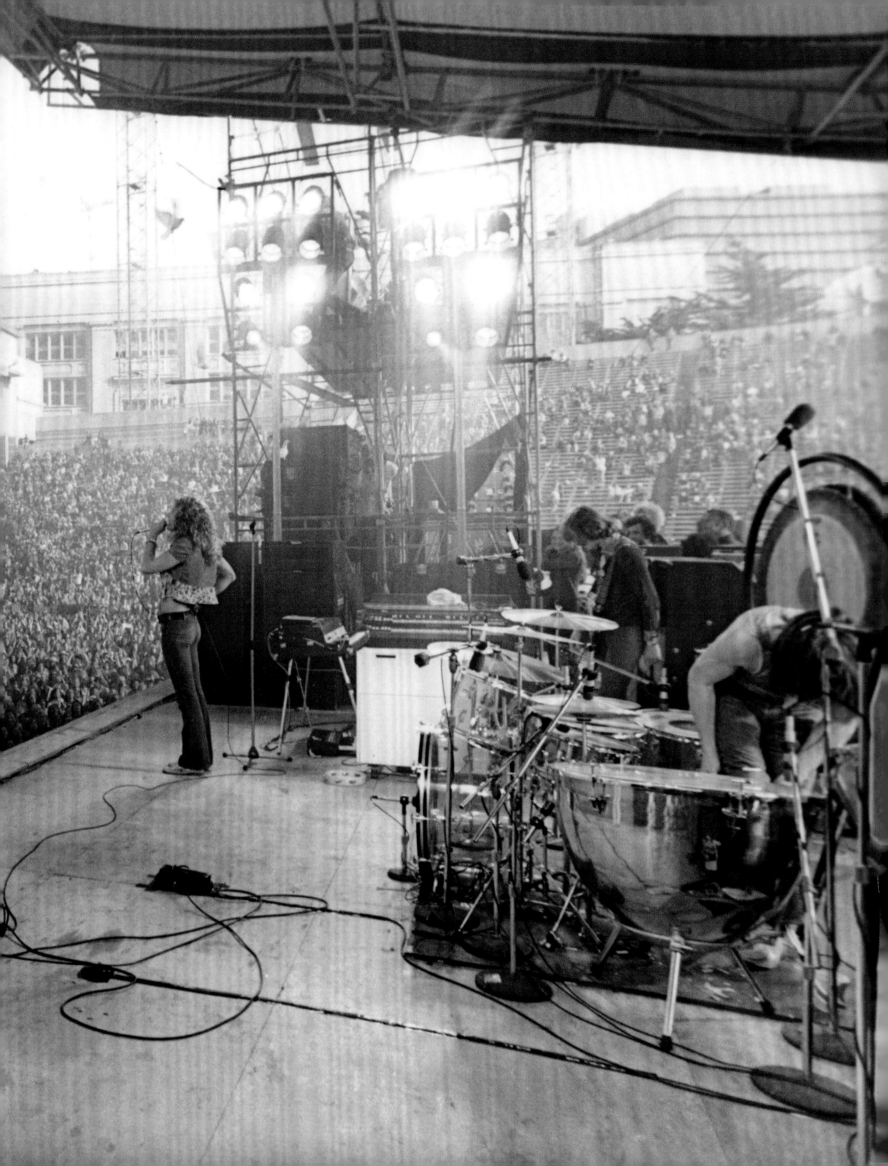

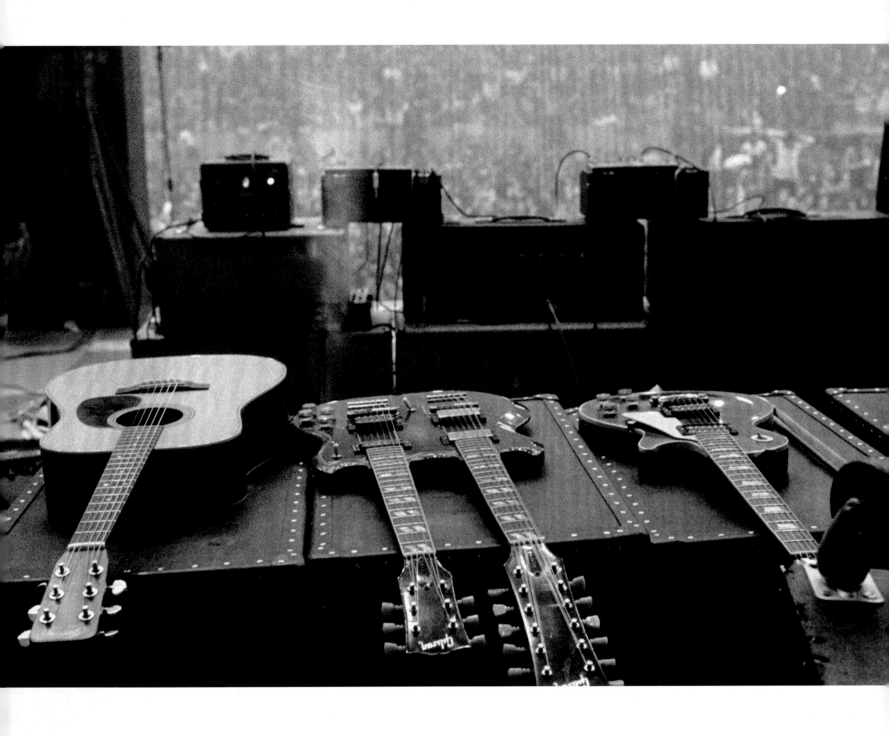

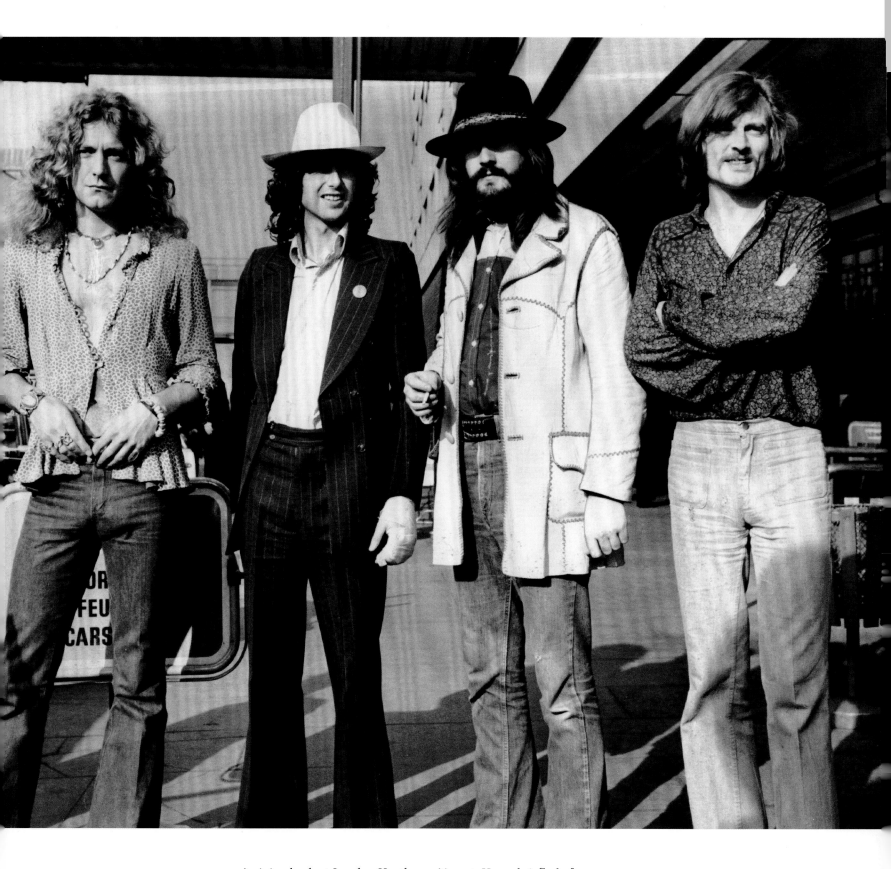

Arriving back at London Heathrow Airport. Home briefly before returning to the States to continue the US tour.

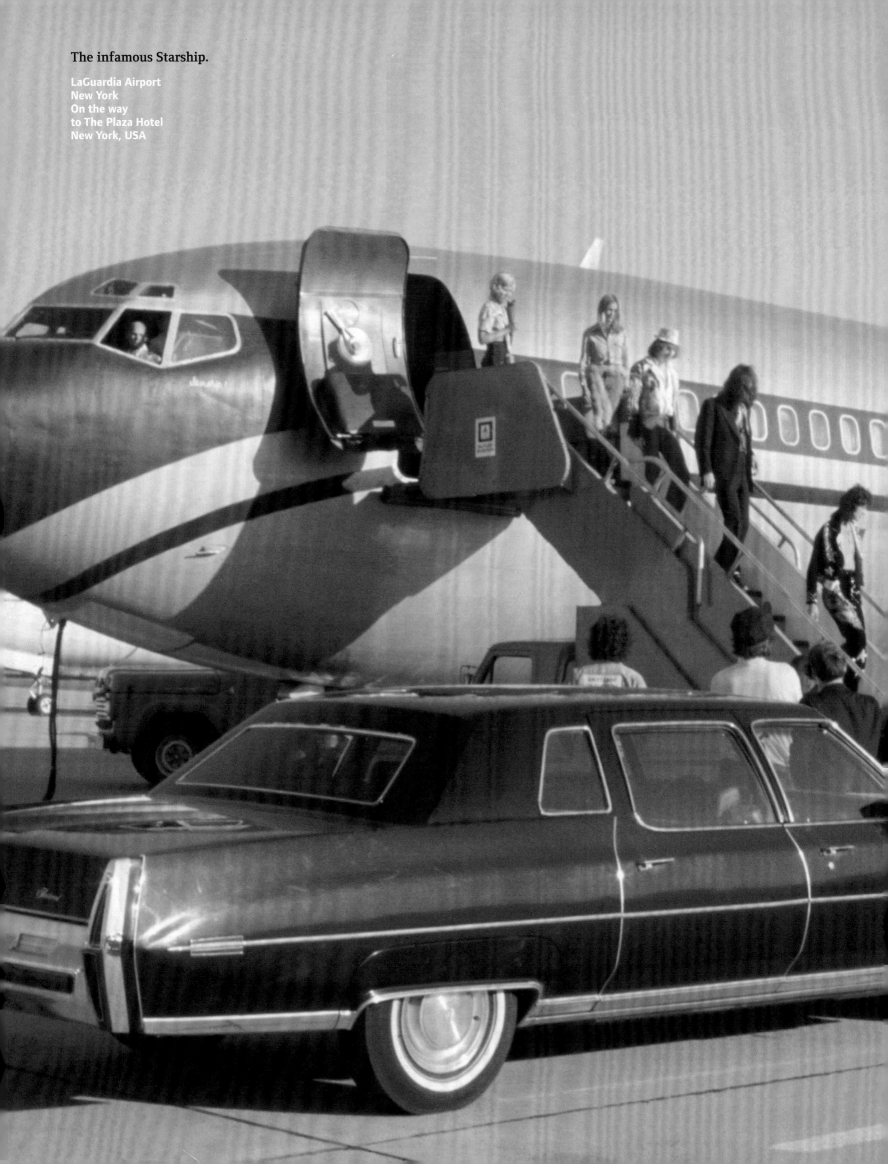

The infamous Starship.

LaGuardia Airport
New York
On the way
to The Plaza Hotel
New York, USA

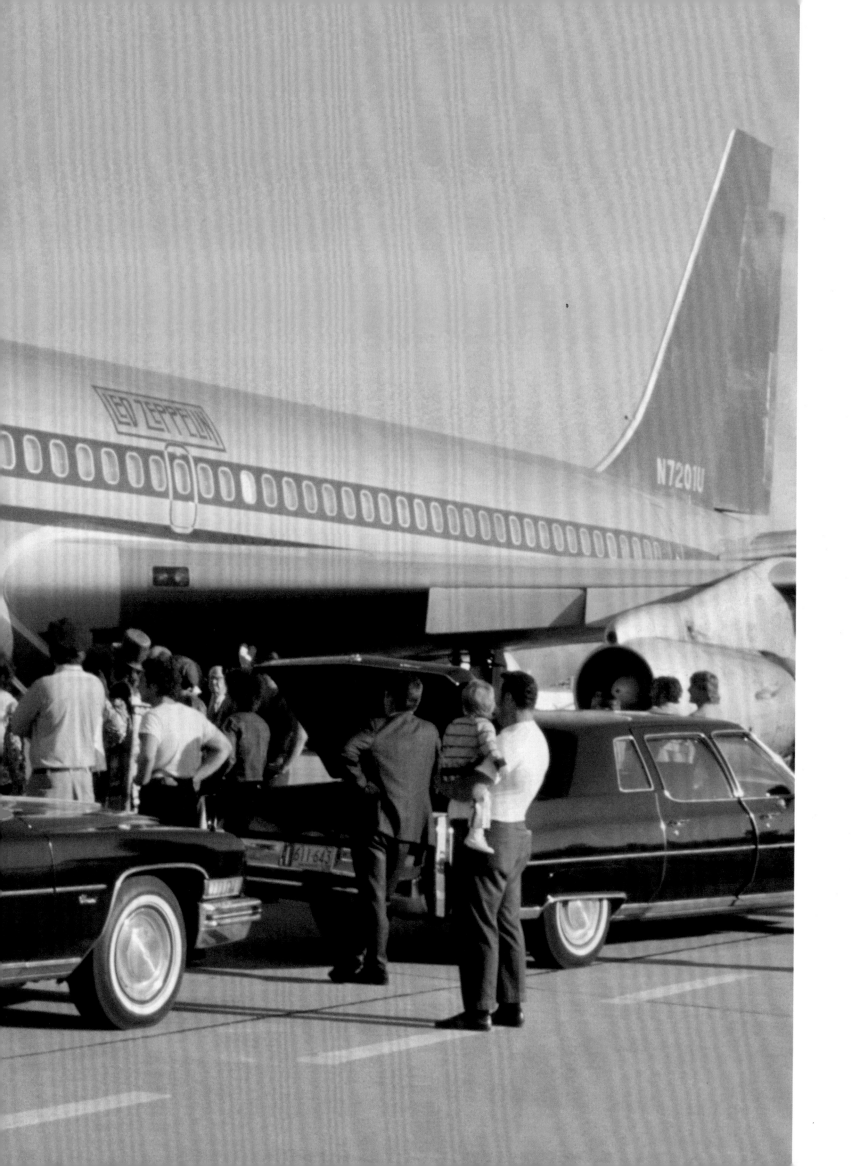

July
The Starship
JFK Airport
New York, USA

July 27-29
Madison Square Garden
New York, USA

Final shows of American Tour

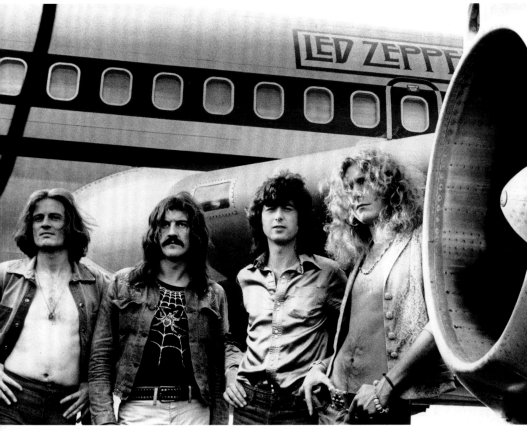

We played three nights at Madison Square Garden that
were filmed and recorded. Here with Eddie Kramer who
was taking care of things in the recording truck.

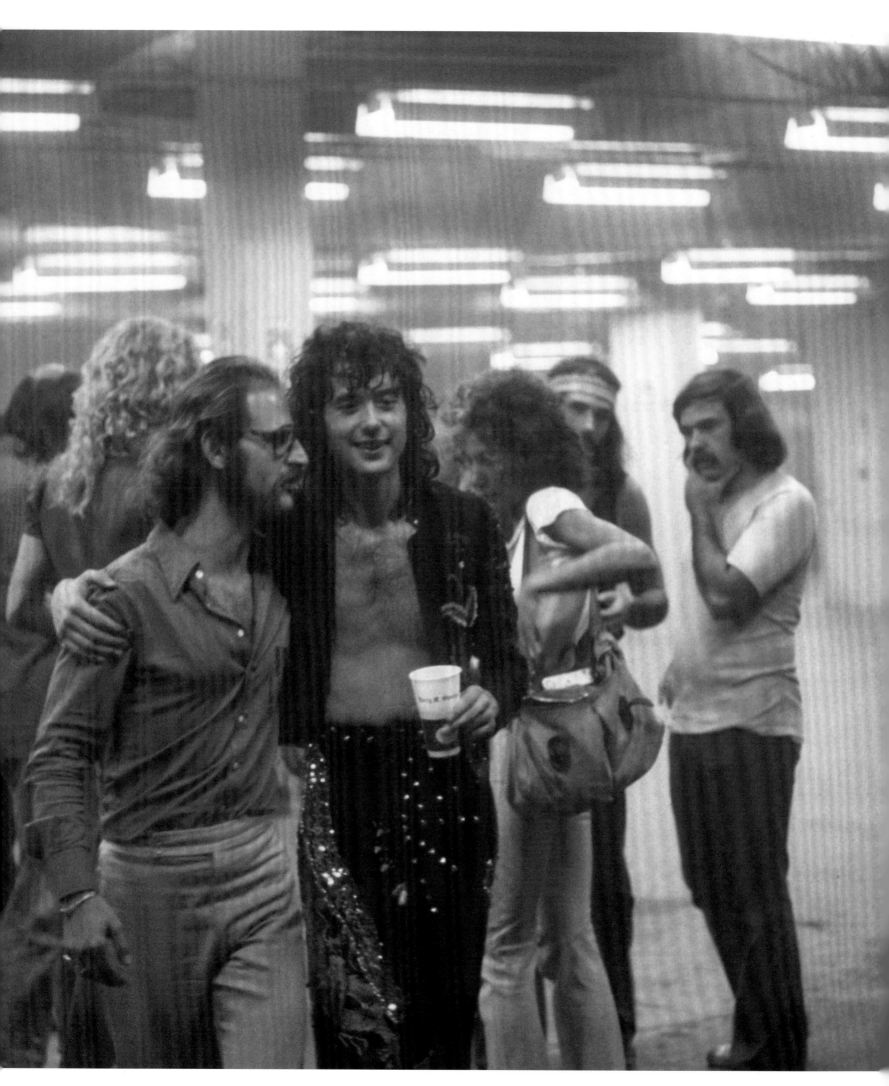

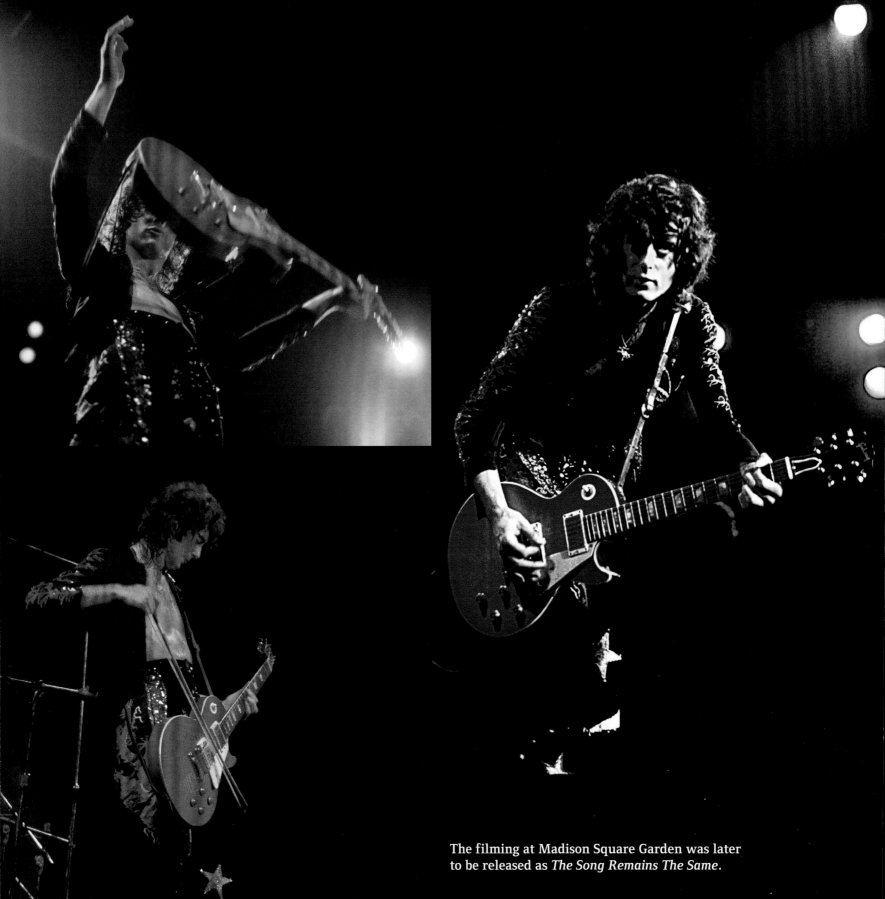

The filming at Madison Square Garden was later to be released as *The Song Remains The Same*.

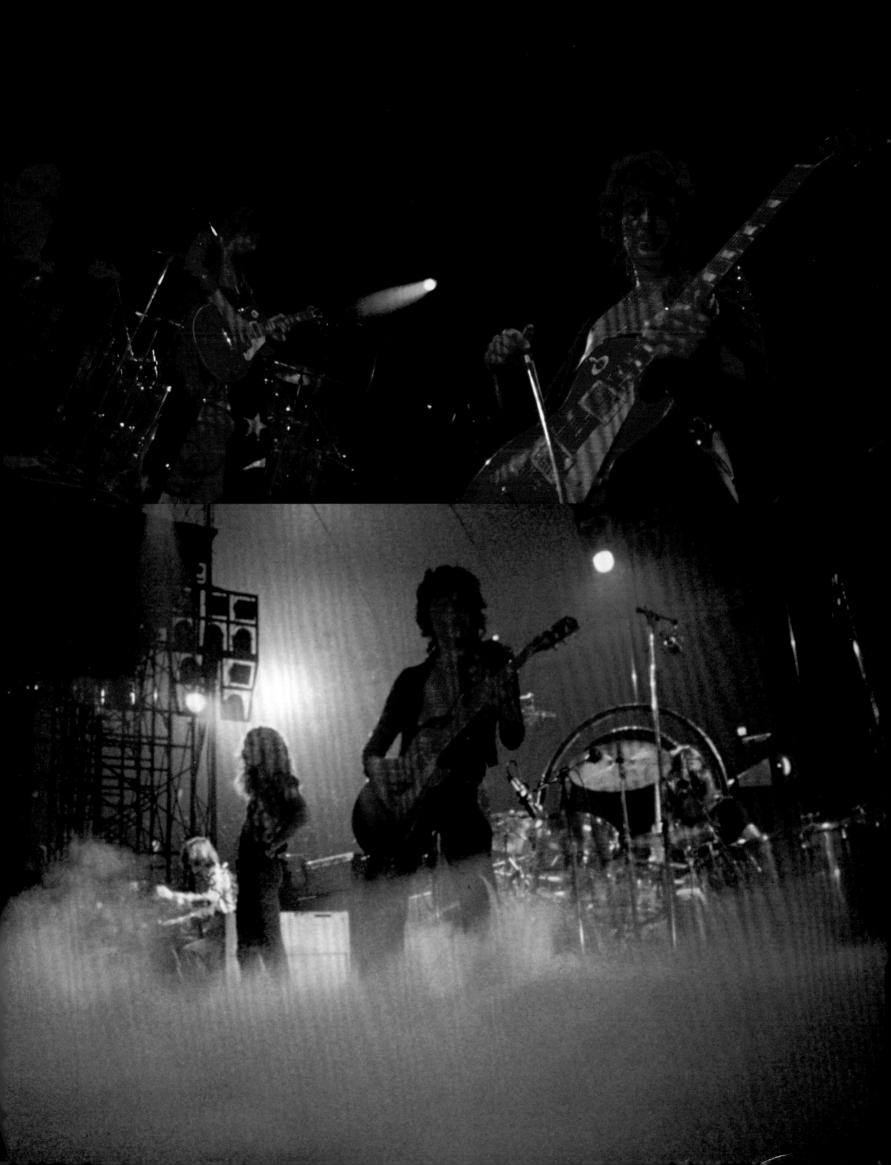

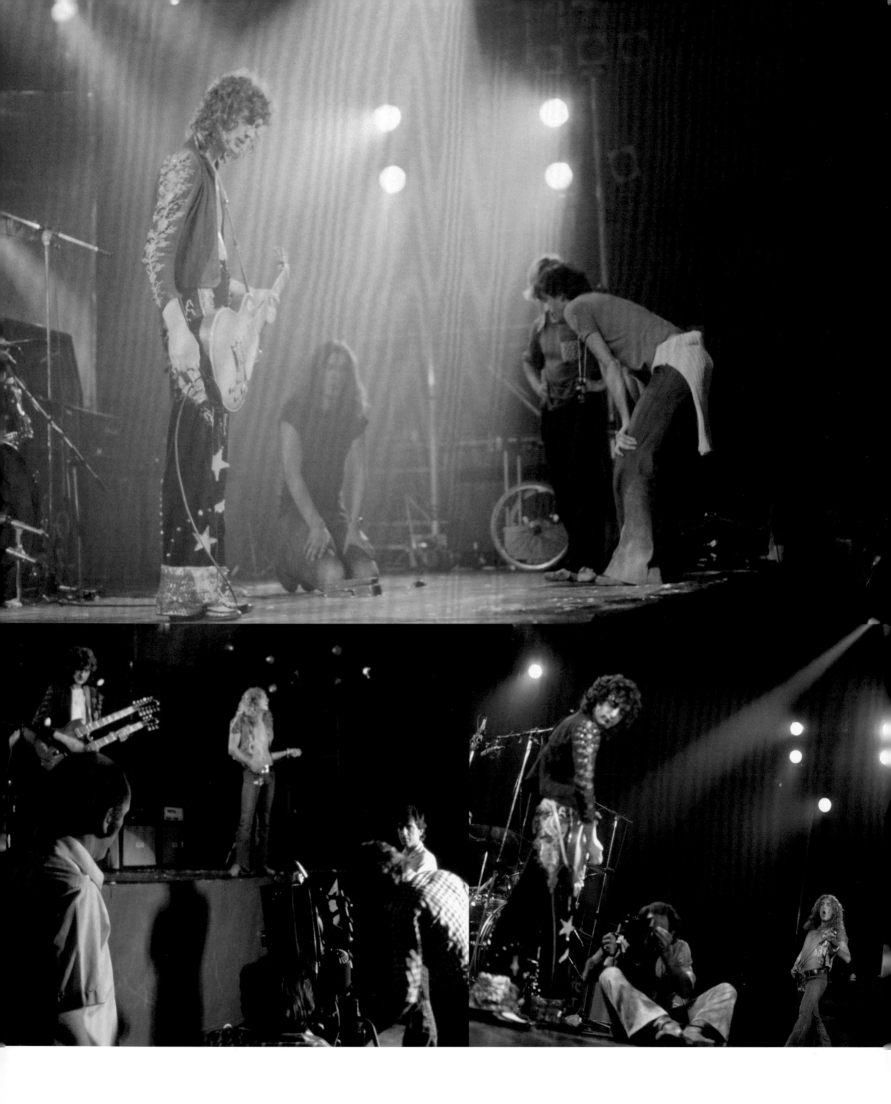

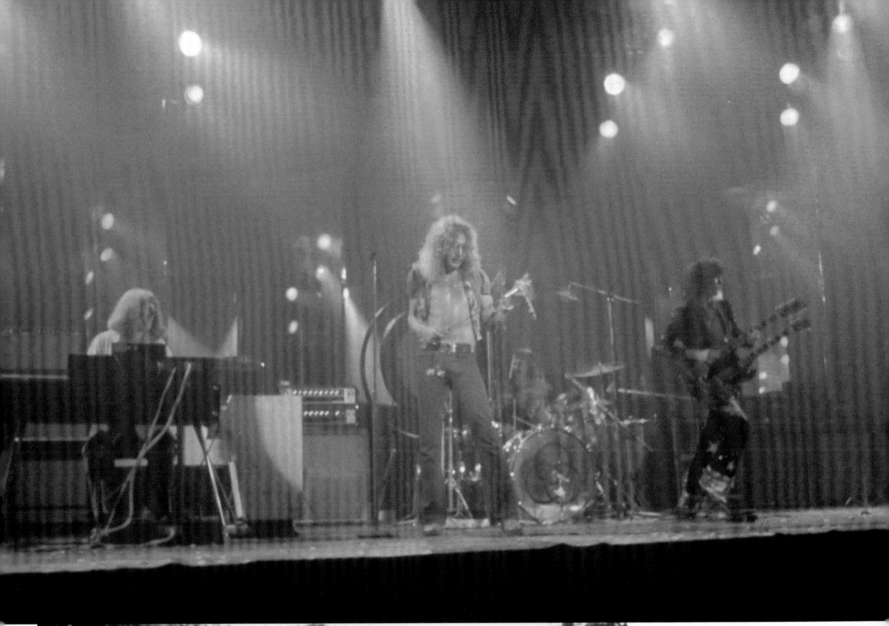

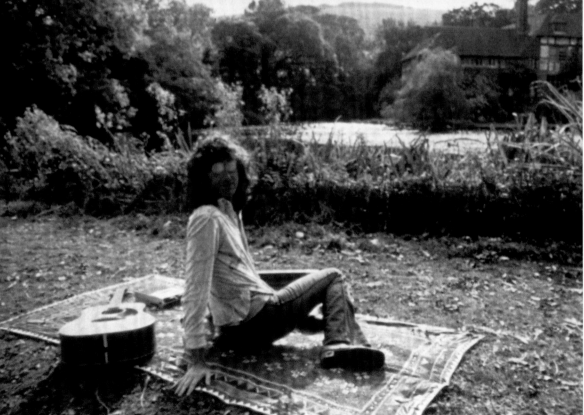

After we reviewed the footage from Madison Square Garden it was necessary to re-shoot certain areas of the show to cover missing elements, mainly the vocals.

This is from a sequence shot at my home in Plumpton to be included in the film.

Plumpton Place
Plumpton
East Sussex, UK

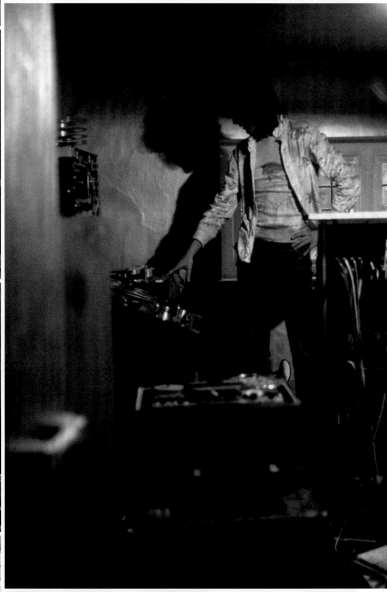
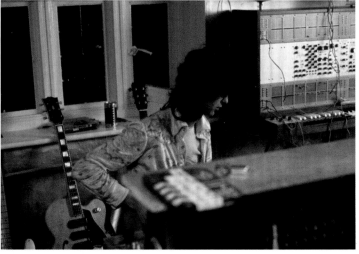

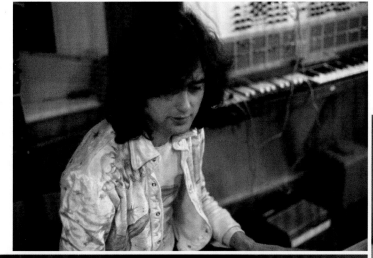

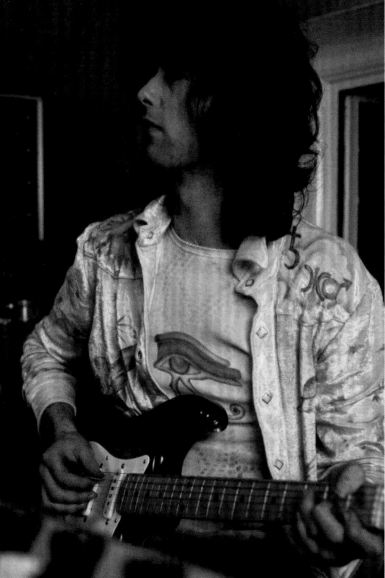

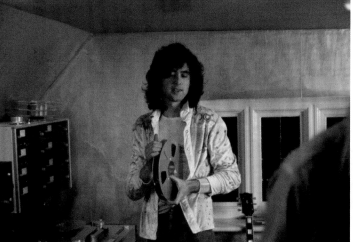

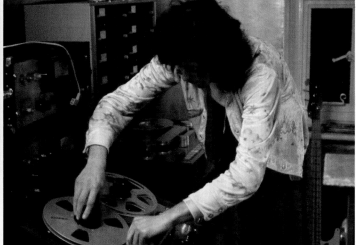

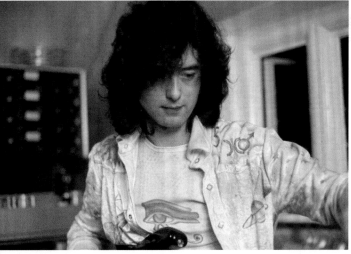

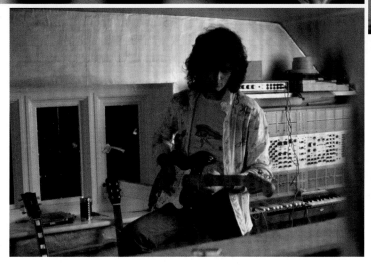

During the filming in England we all experimented with home location shots. I was living at Plumpton at the time and this sequence of photographs outline the perpetual motion of playing, recording, listening, playing back, over-dubbing, double-tracking and finessing etc, when you have a sketch of an idea in progress.

My fantasy sequence for the film, however, was shot on location at Boleskine House in Scotland.

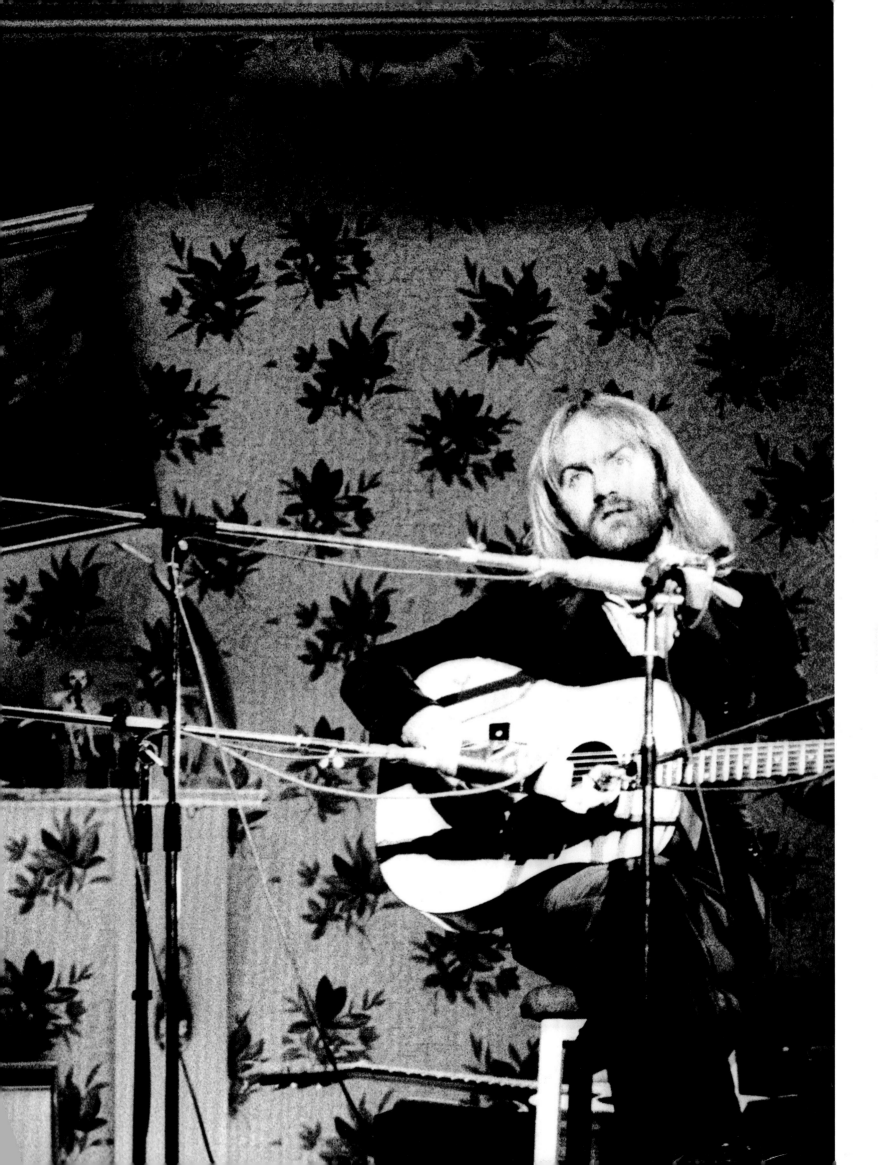

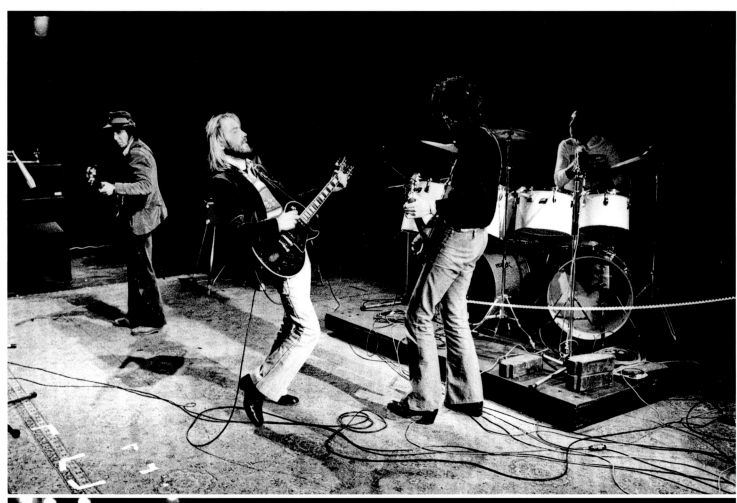

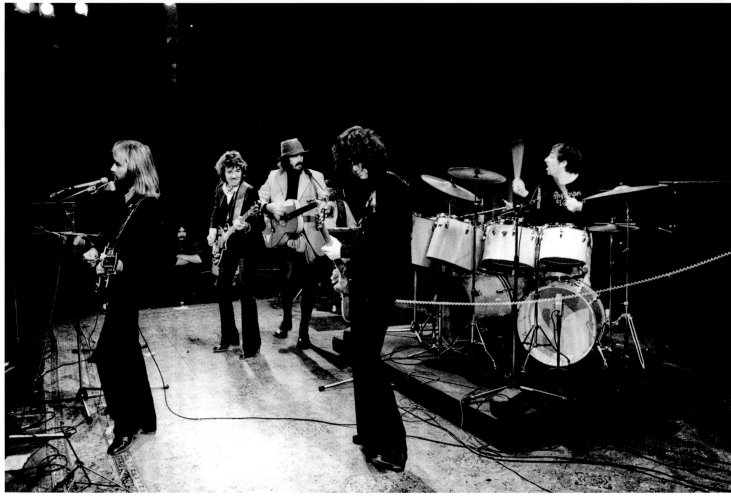

I met Roy the first time Led Zeppelin played the Bath Festival and we became good friends. I had played with Roy on his albums *Stormcock* and *Life Mask*. He had asked me to join him at the Rainbow Theatre in London on 14th February for his Valentine's concert. We did an acoustic set featuring 'Highway Blues' and an electric set with Keith Moon on drums and Ronnie Lane on bass. We played 'Home' and 'MCP Blues'. During the show John Bonham made an unscheduled appearance, miming on acoustic.

Around this time Led Zeppelin returned to Headley Grange with LMS mobile recording studio to record initial tracks that, with material from previous dates and sources, became the epic album *Physical Graffiti*.

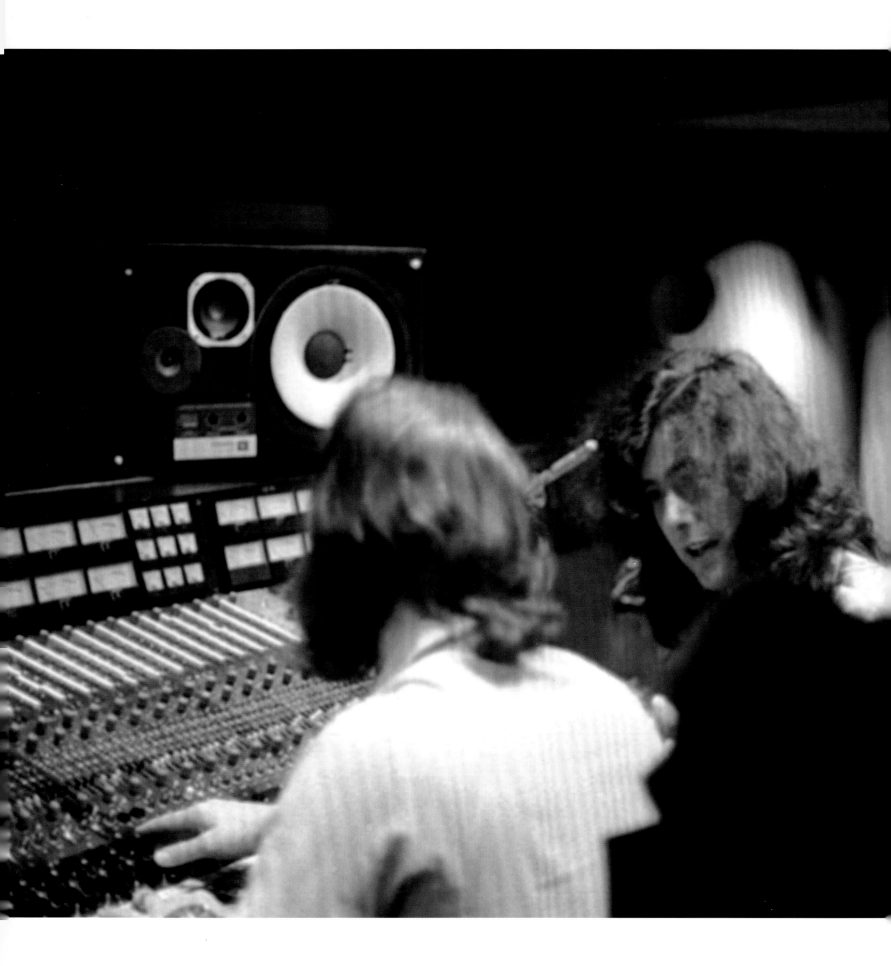

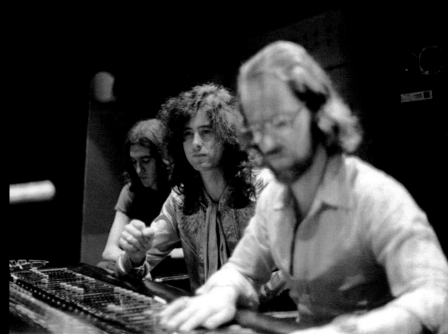

In New York at Electric Ladyland Studios with Eddie Kramer mixing the soundtrack for the film *The Song Remains The Same* in surround sound for cinema release.

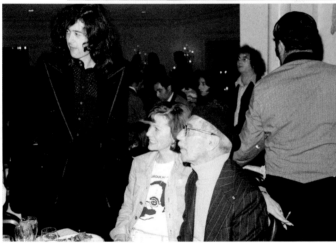

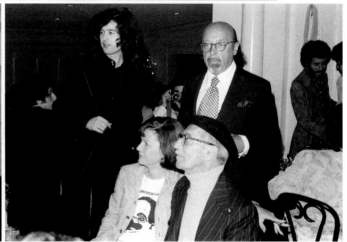

May 10th, at the launch of the Swan Song record label in Los Angeles.
Groucho Marx attended and Gloria Swanson of *Sunset Boulevard* fame
was invited but declined. I was unaware that Ahmet Ertegun, never one
to miss a photo opportunity, popped in and out of the picture as I was
being photographed with Groucho.

Groucho had a cool approach to autographs by tracing around your
hand with the pen to paper and then signing it.

My contribution to sport.

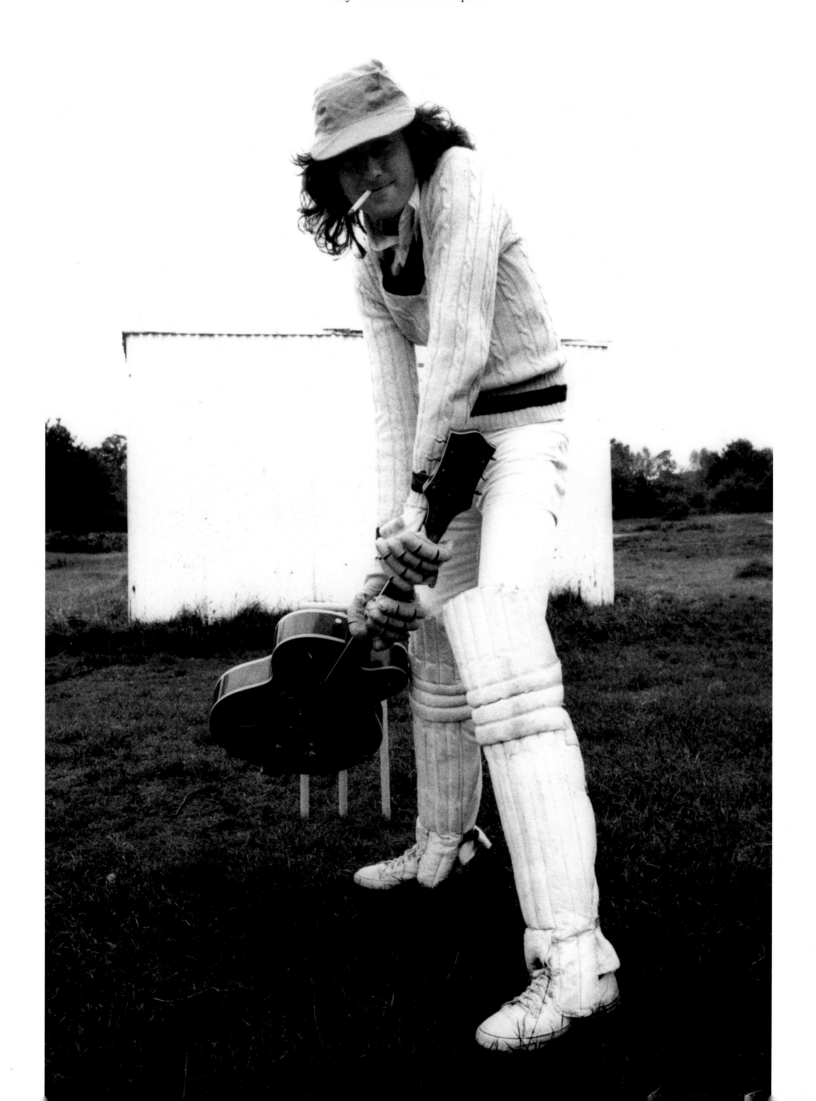

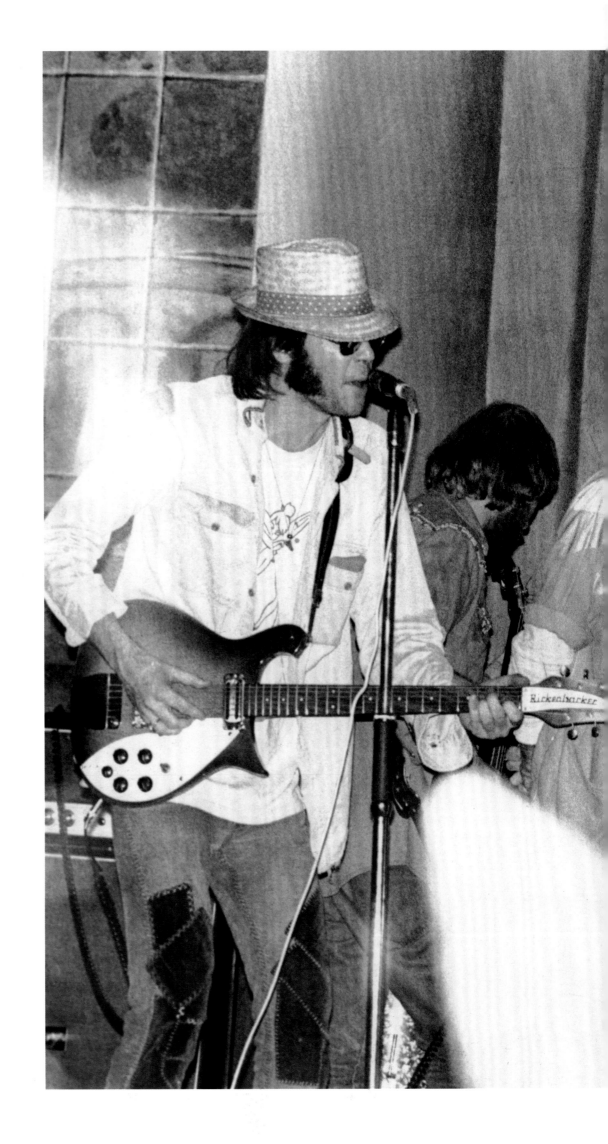

Crosby, Stills, Nash, Young & Page.

September 14
Aftershow party
at Quaglino's Restaurant
London, UK
After CSNY gig at
Wembley Stadium
London, UK

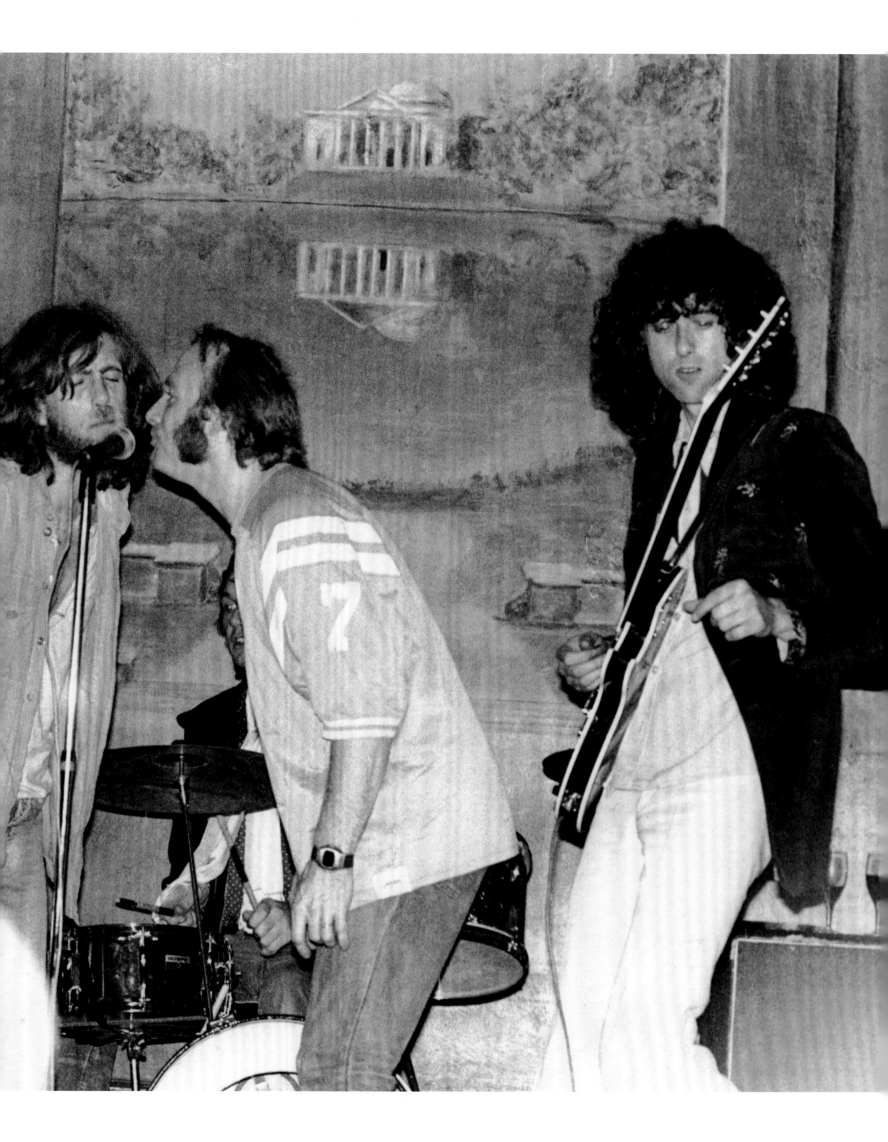

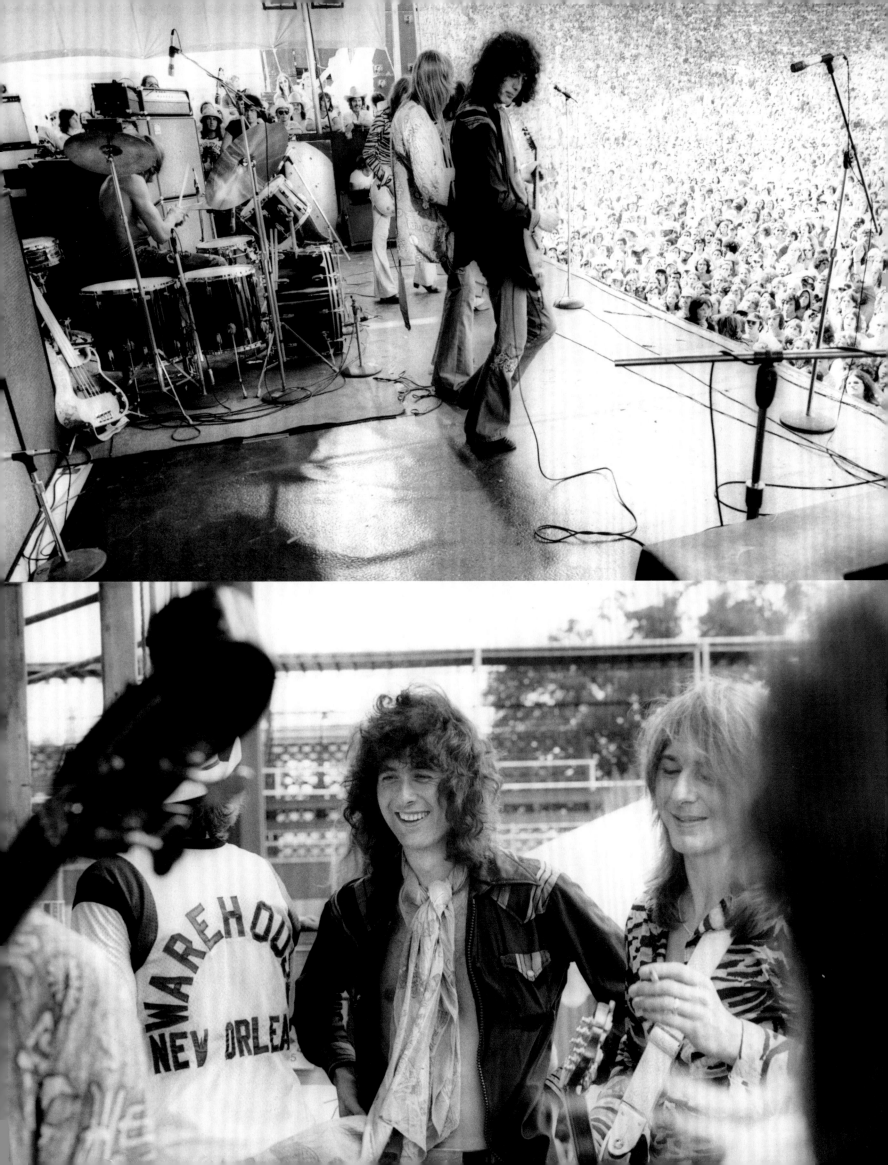

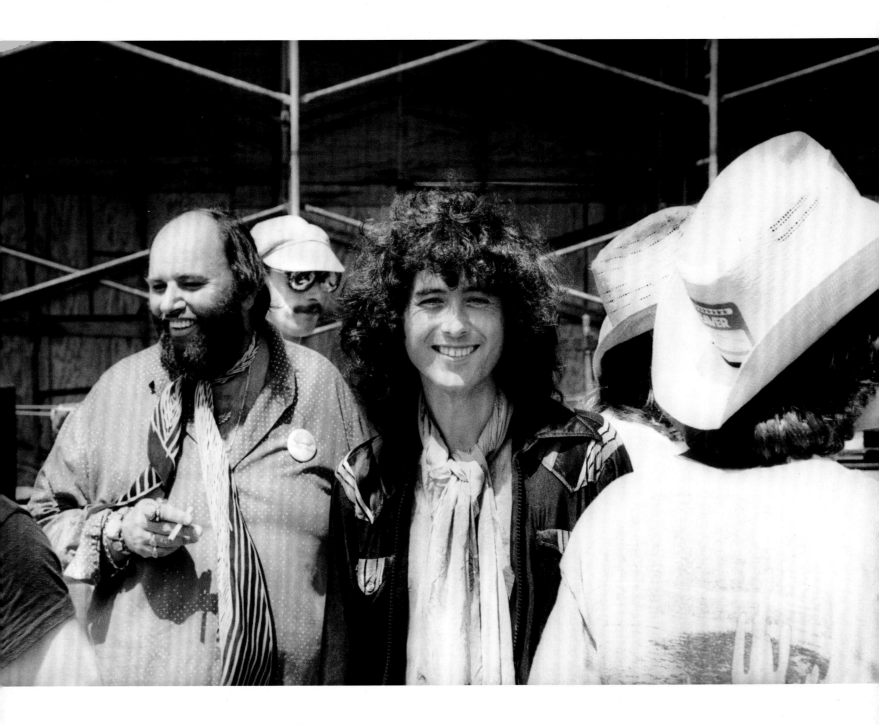

Peter Grant and I attended the Austin Pop Festival to see Bad Company, then a newly signed group and first release on the Swan Song label.

And opposite with Mick Ralphs, guitarist and writer of 'Can't Get Enough' and a good pal.

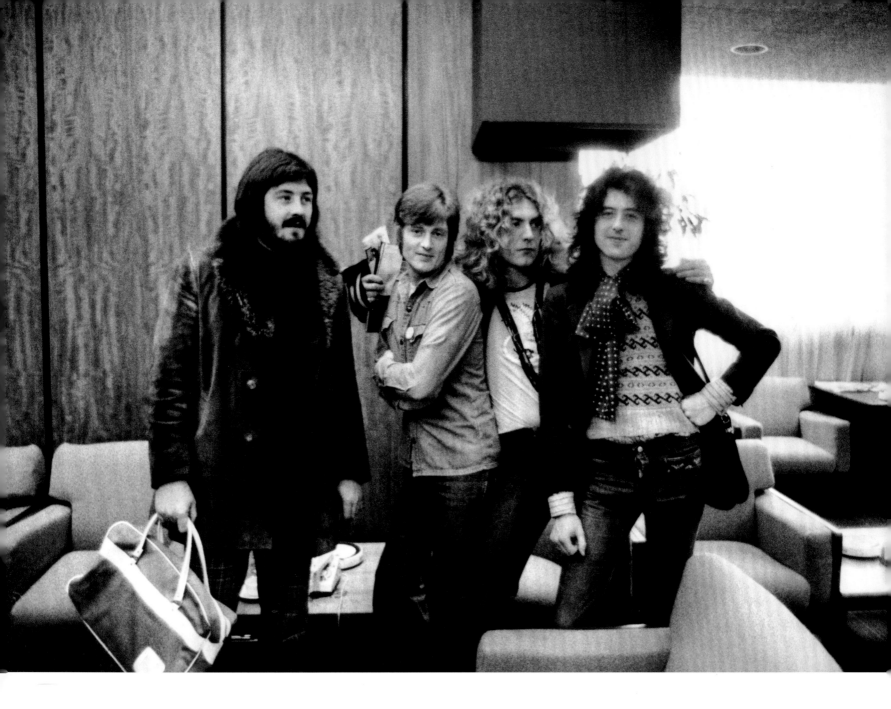

Heathrow Airport
London, UK
On the way to USA
arrival January 16

January 17
Rehearsal
Met Center
Minneapolis, USA

Leaving for America from Heathrow. On arrival we went straight to
Minneapolis for a lengthy and spirited sound-check at the Met Center.

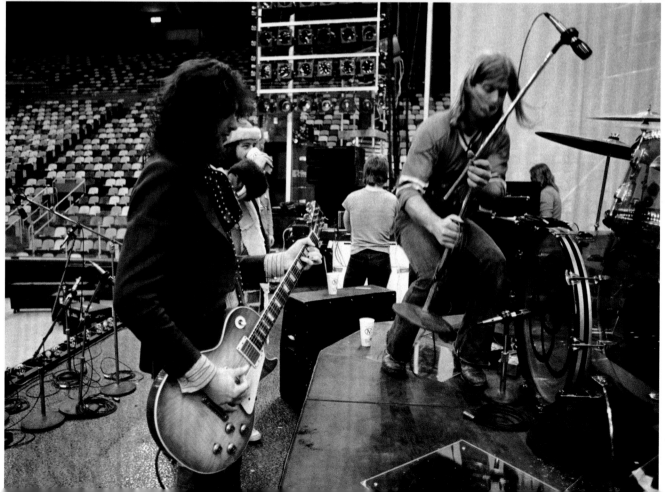

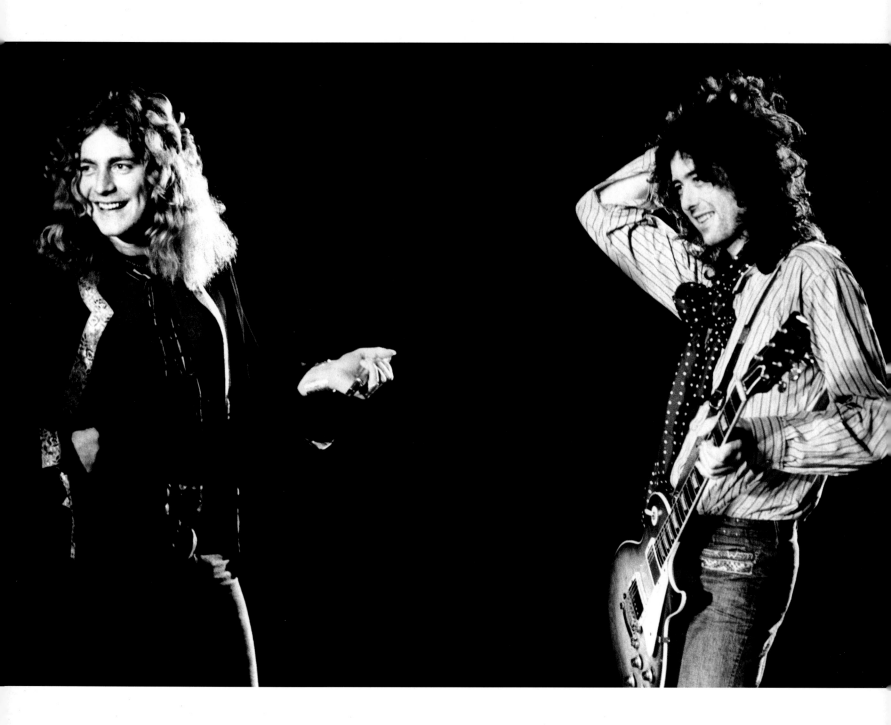

January 17
Rehearsal
Met Center
Minneapolis, USA

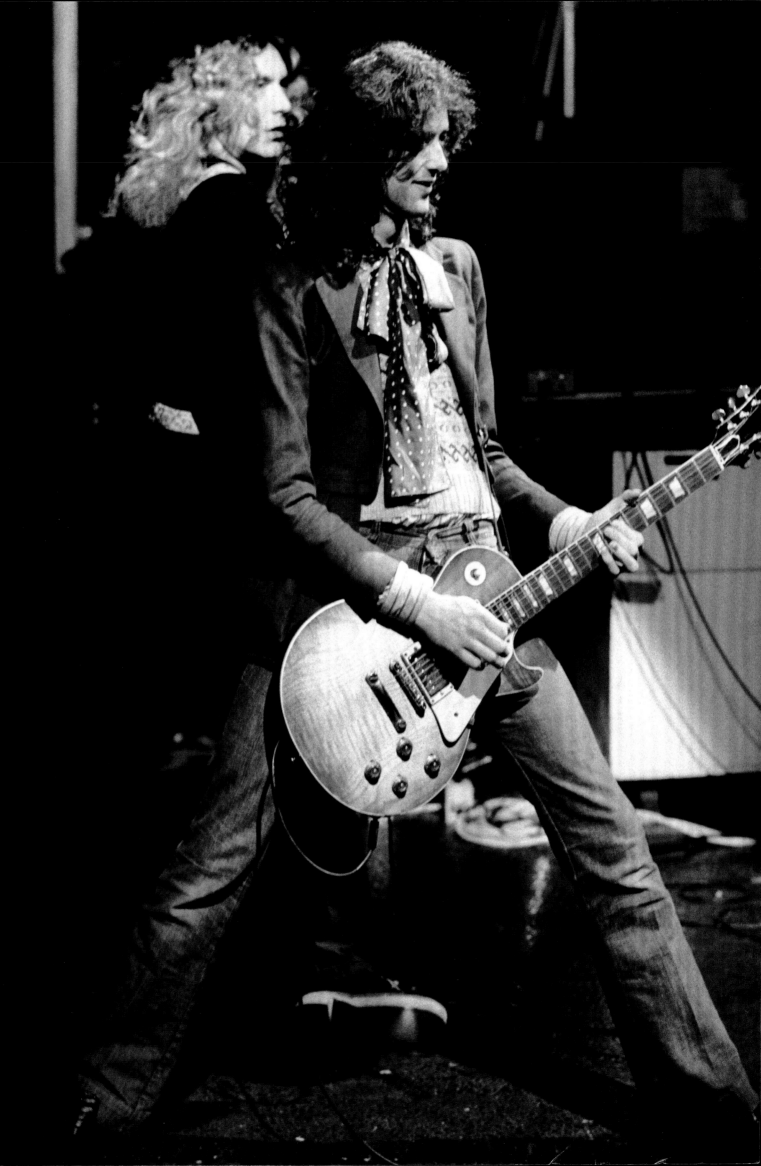

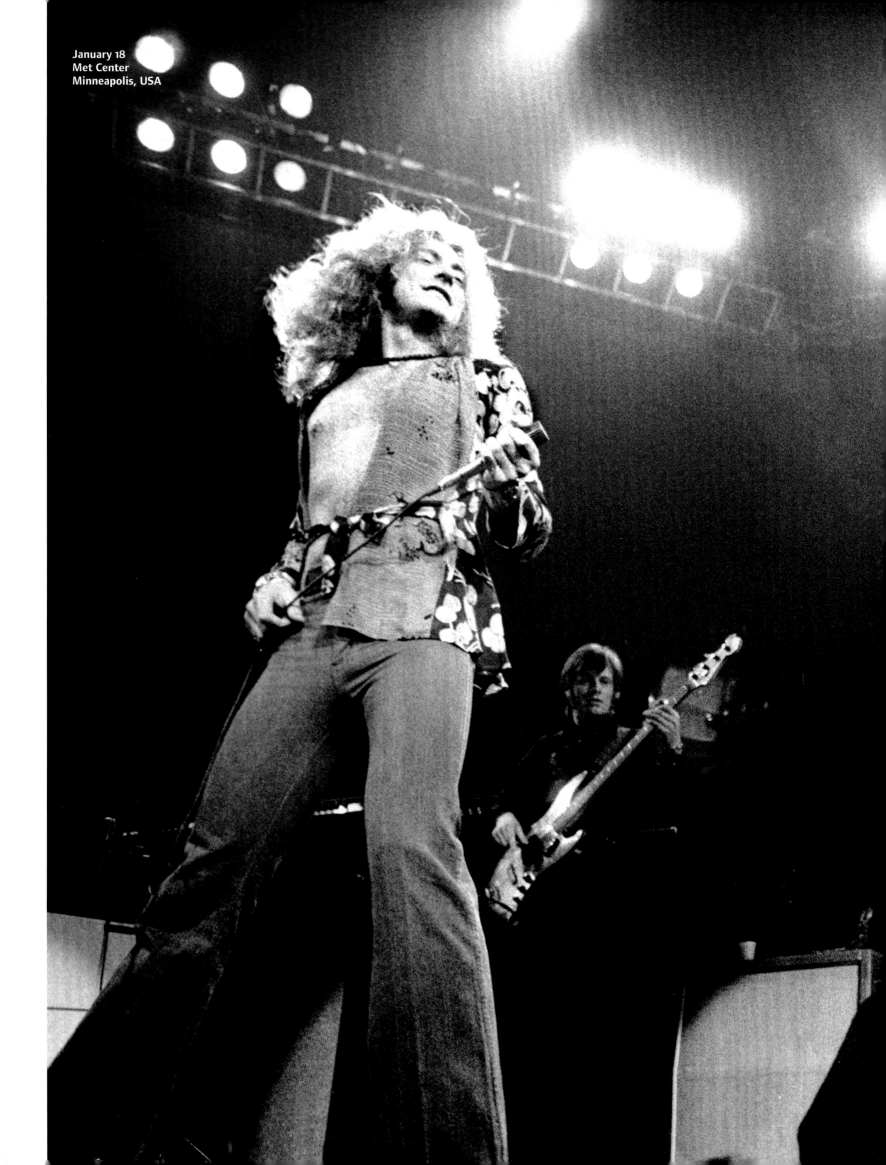

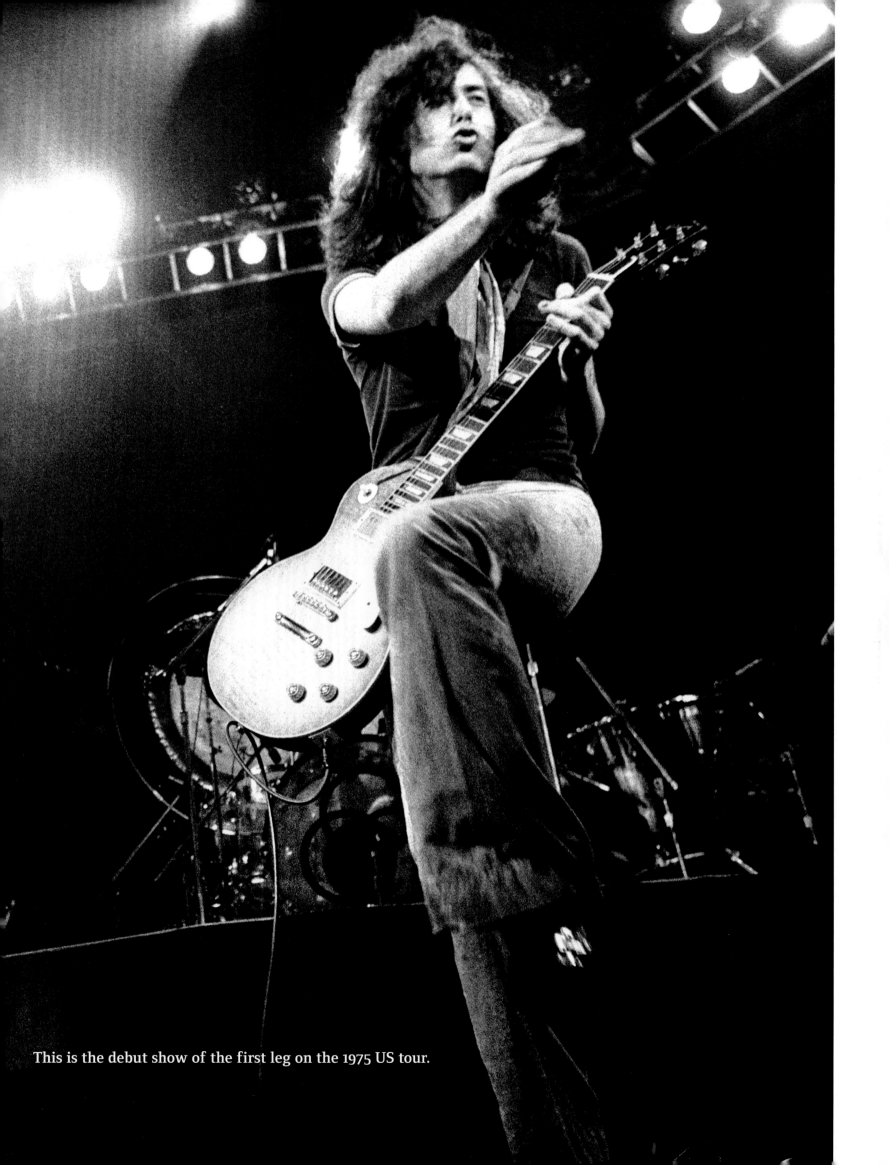

This is the debut show of the first leg on the 1975 US tour.

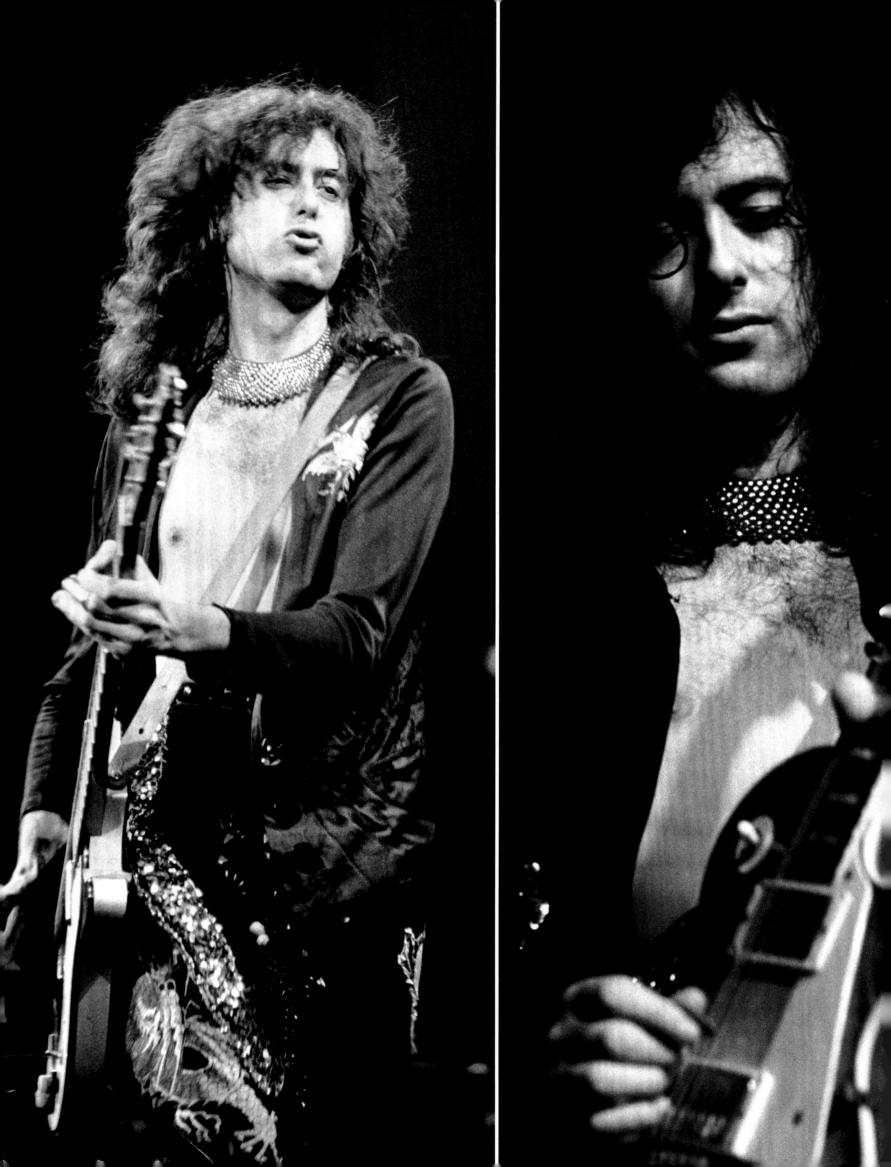

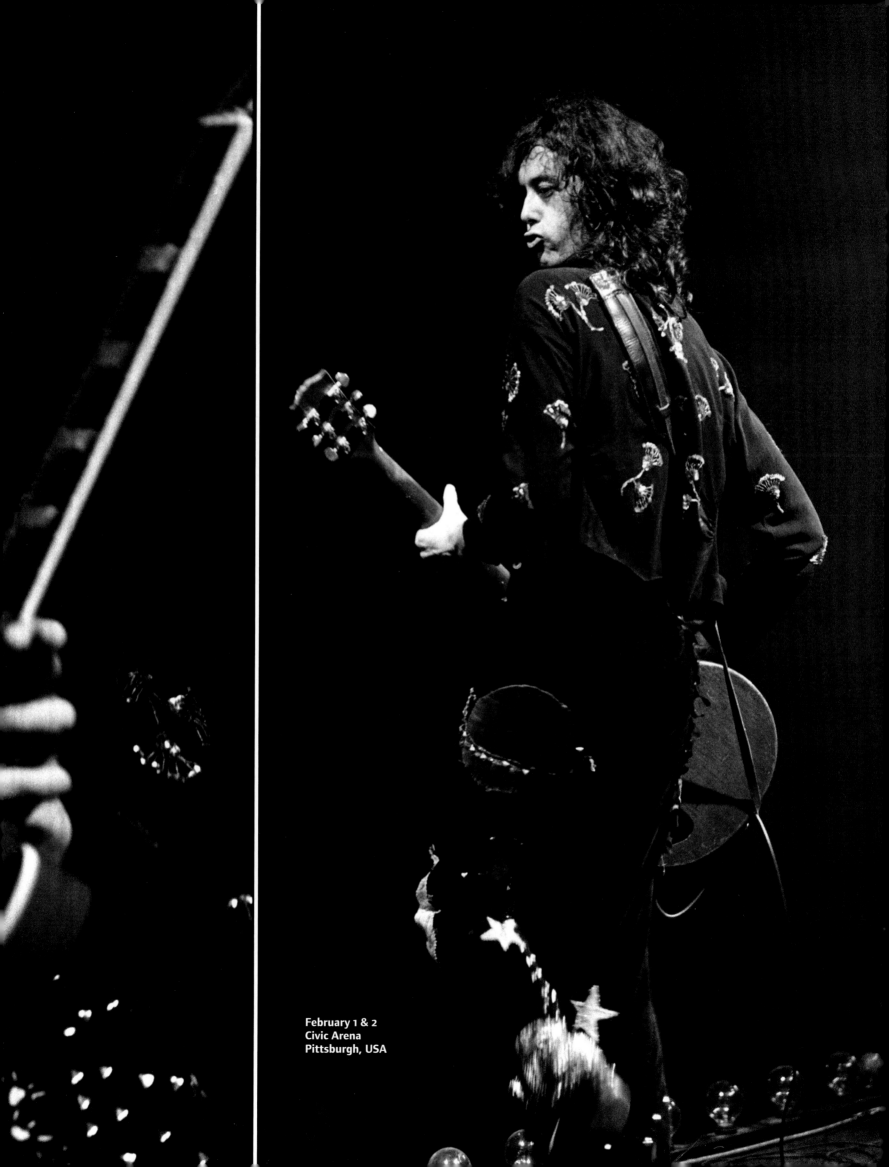

February 1 & 2
Civic Arena
Pittsburgh, USA

ROLLING STONE

ISSUE NO. 182

MARCH 13, 1975

THE STATE OF THE UNION
by George McGovern

DID NIXON LEGALLY WIN THE 1968 ELECTION?
by Eric Redman

THE NEW BOB DYLAN ALBUM:
by Jonathan Cott
by Jon Landau

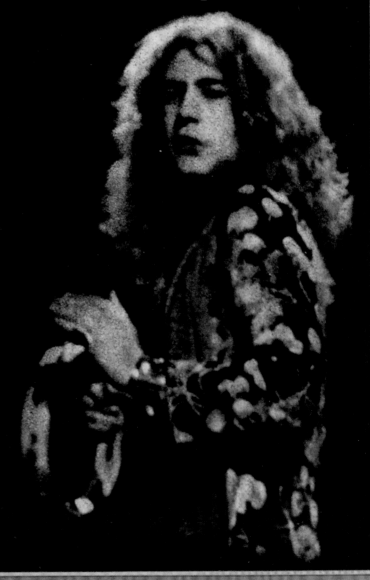

LED ZEPPELIN:
JIMMY PAGE & ROBERT PLANT TALK TO CAMERON CROWE

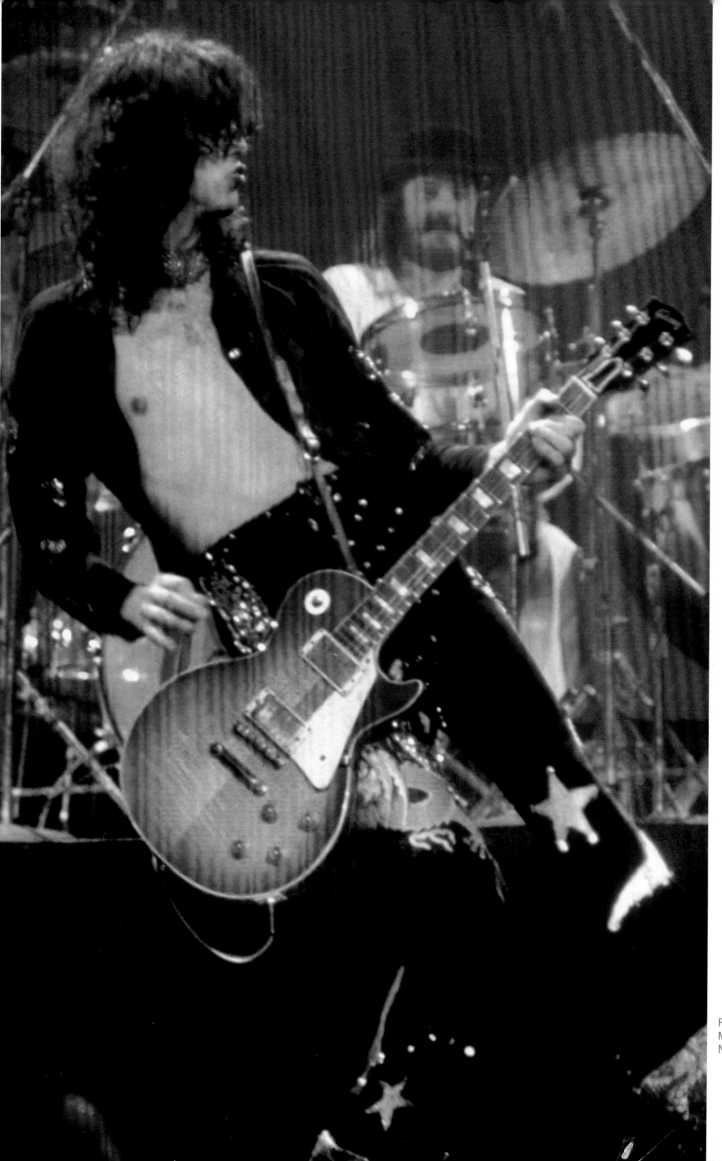

February 3
Madison Square Garden
New York, USA

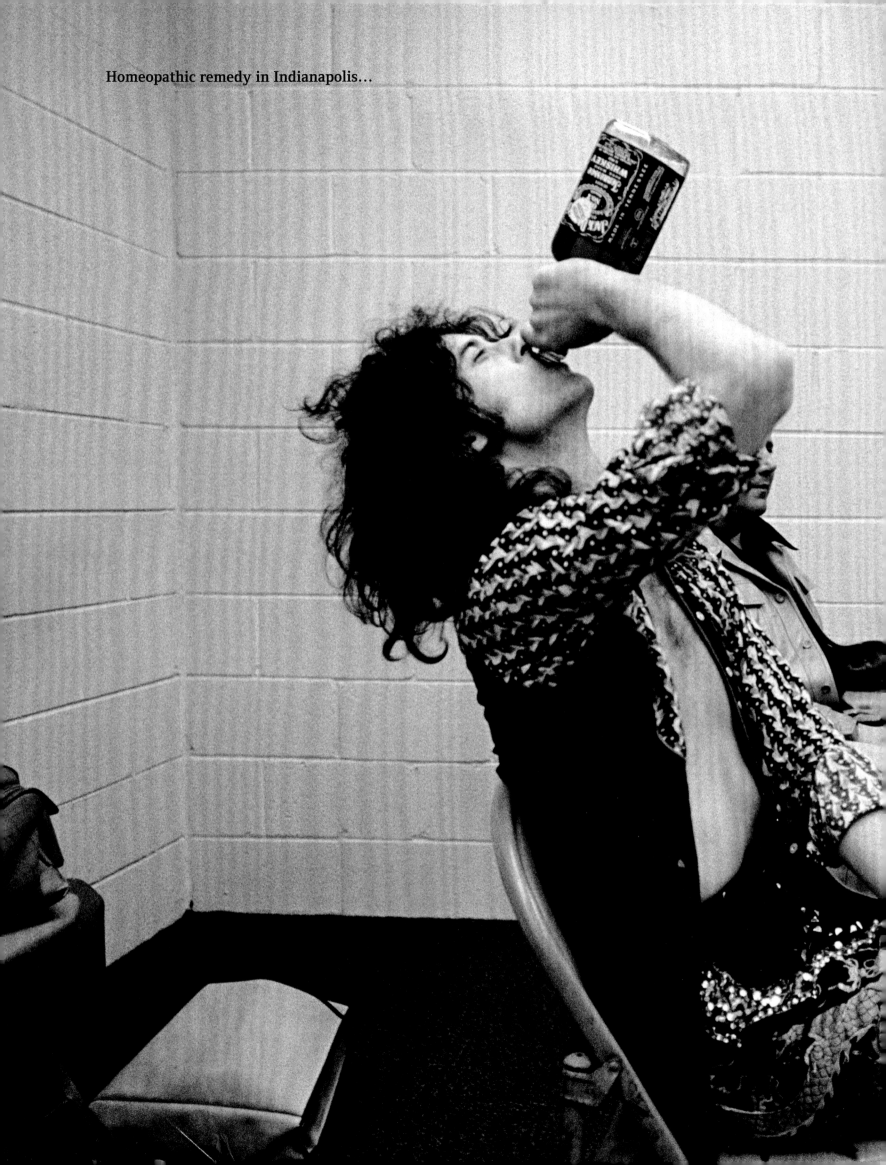

Homeopathic remedy in Indianapolis...

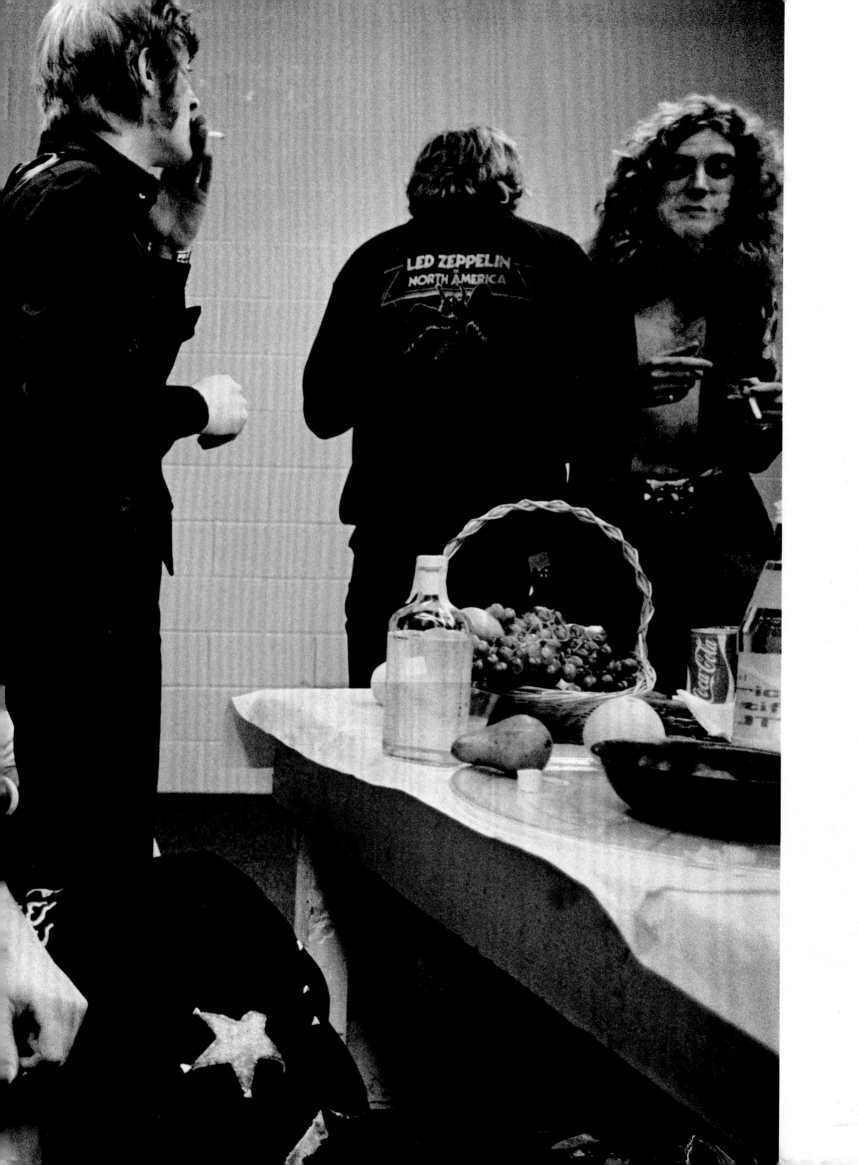

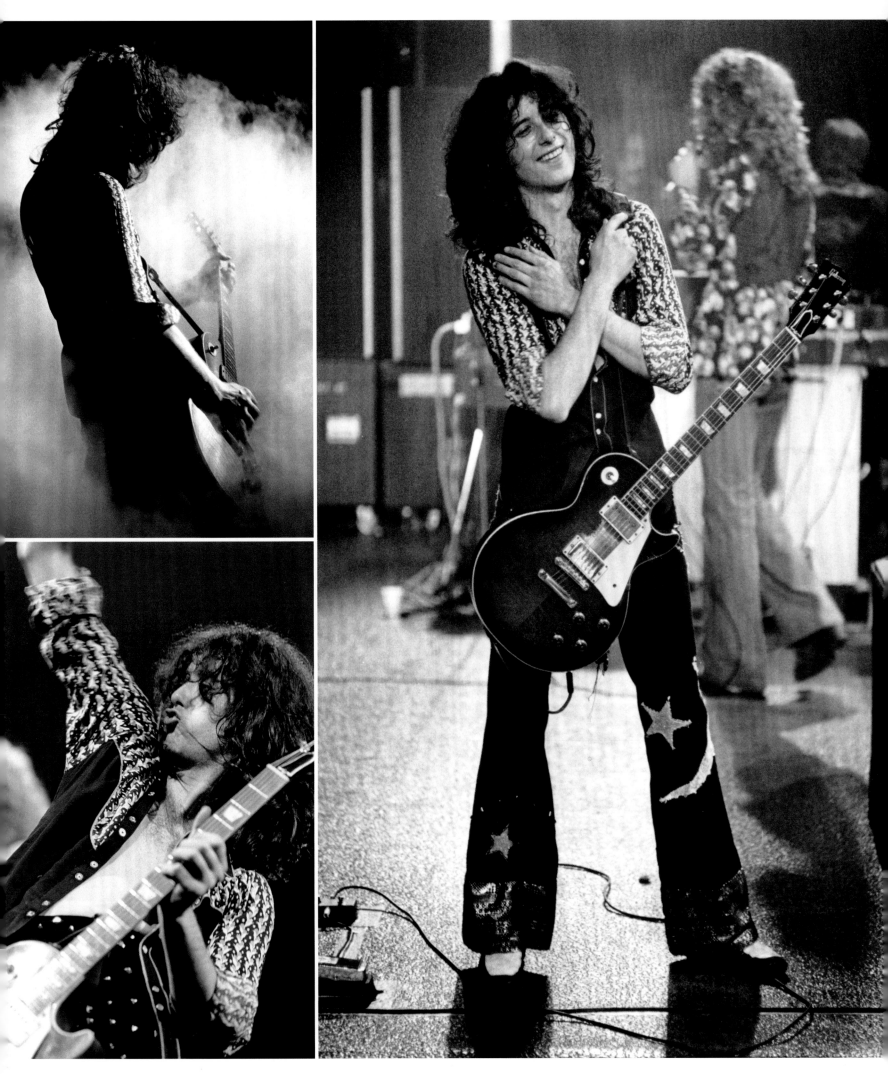

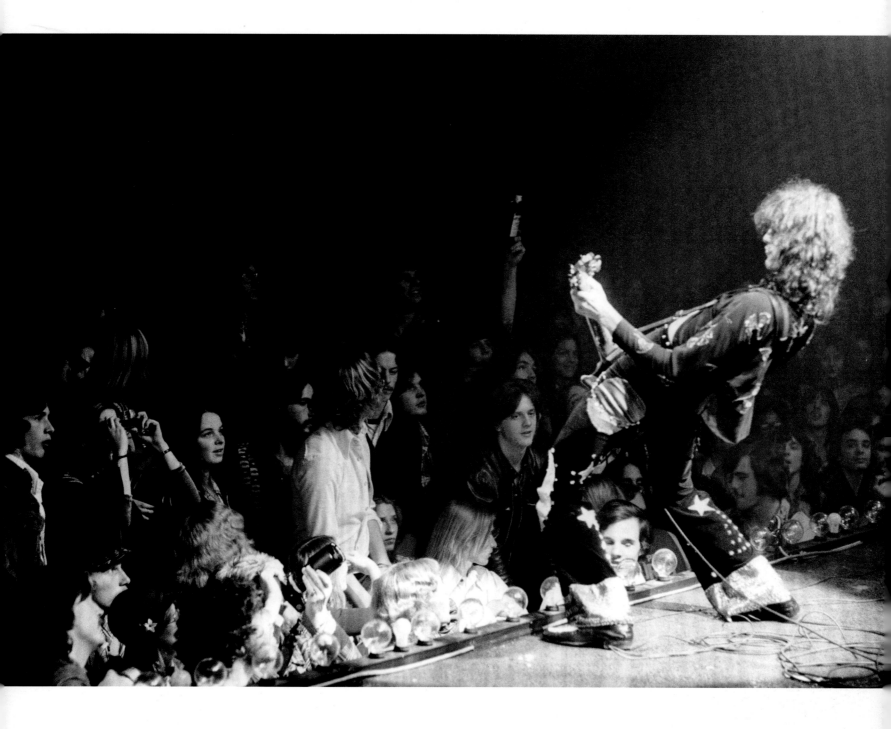

January 25
Market Square Arena
Indianapolis, USA

February 7
Madison Square Garden
New York, USA

Above: January 31
Olympia Stadium
Detroit, USA

Defying gravity…

January 29
Greensboro Coliseum
Greensboro, USA

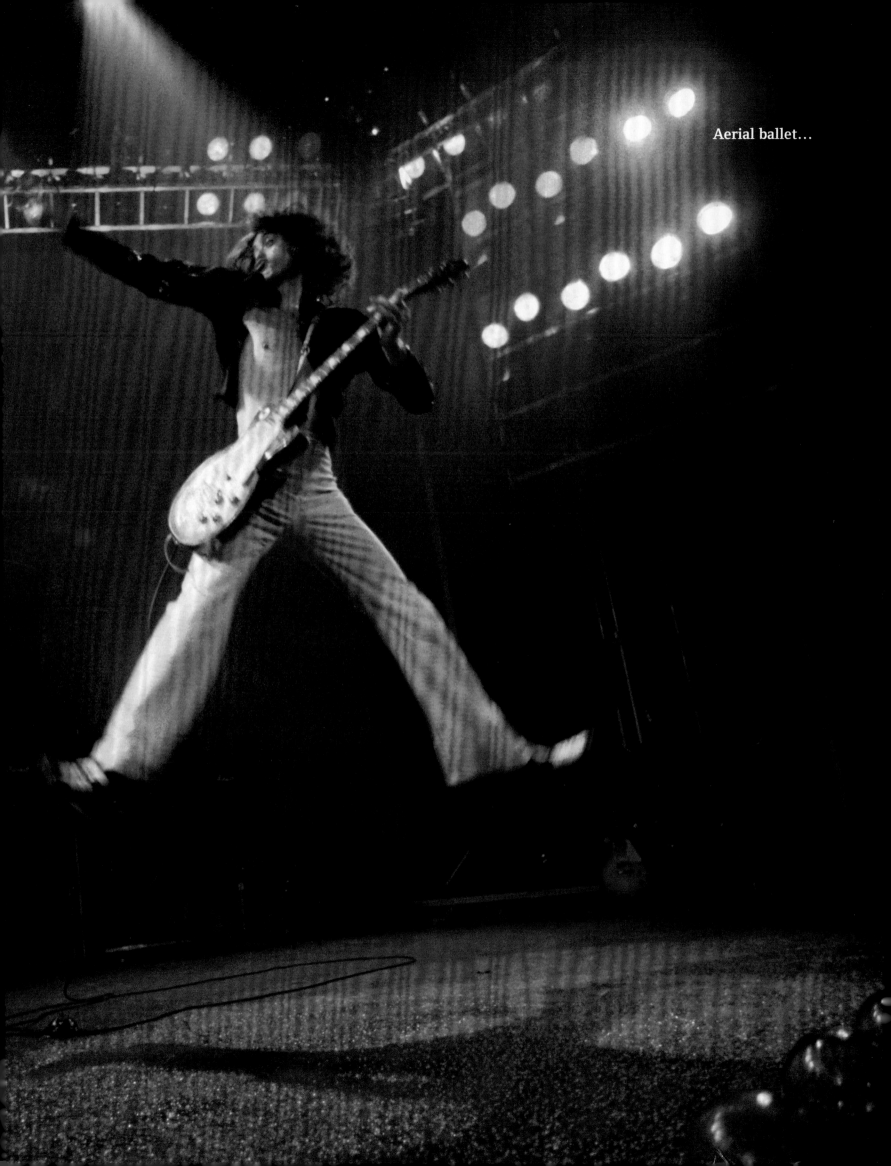

Aerial ballet…

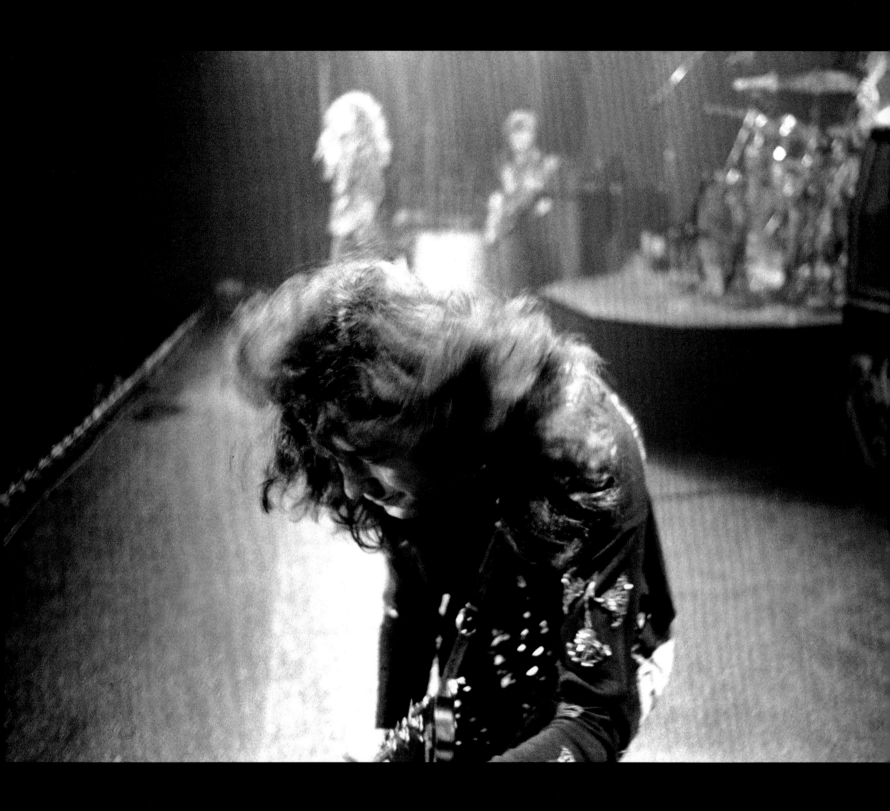

February 4
Nassau Coliseum
Uniondale, USA

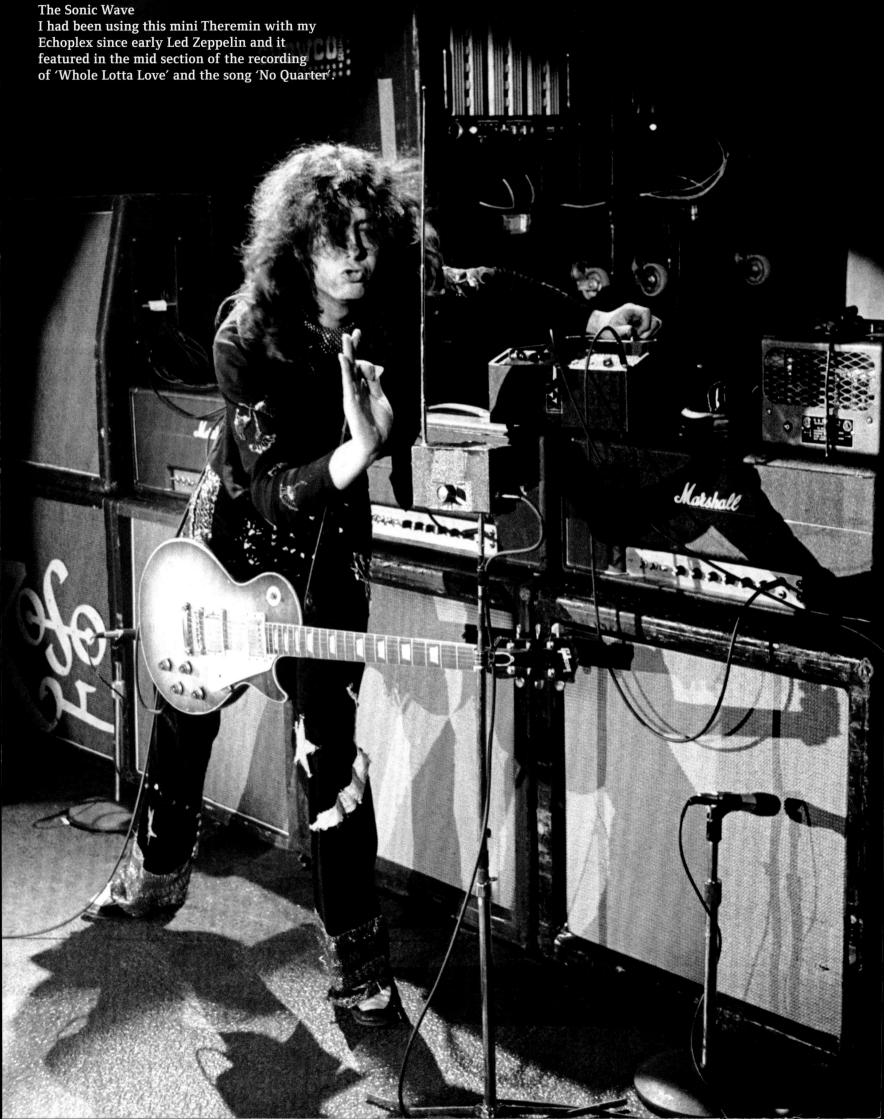

The Sonic Wave
I had been using this mini Theremin with my
Echoplex since early Led Zeppelin and it
featured in the mid section of the recording
of 'Whole Lotta Love' and the song 'No Quarter'.

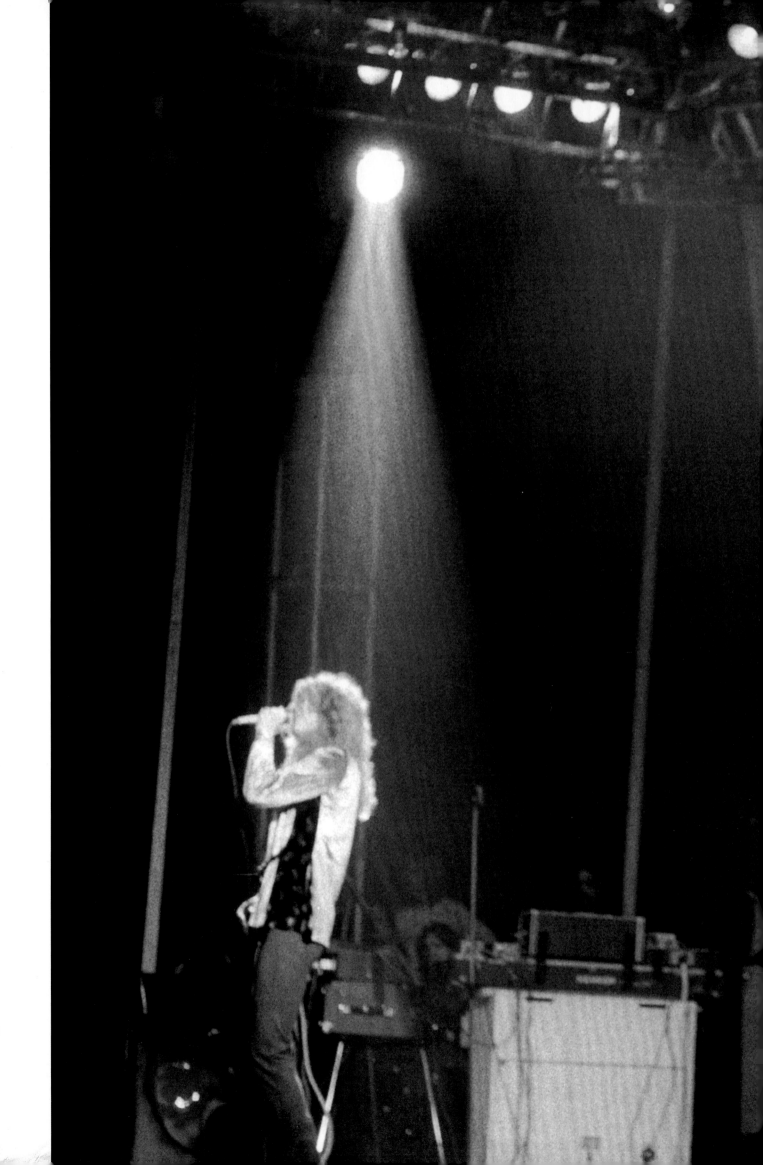

February 4
Nassau Coliseum
Uniondale, USA

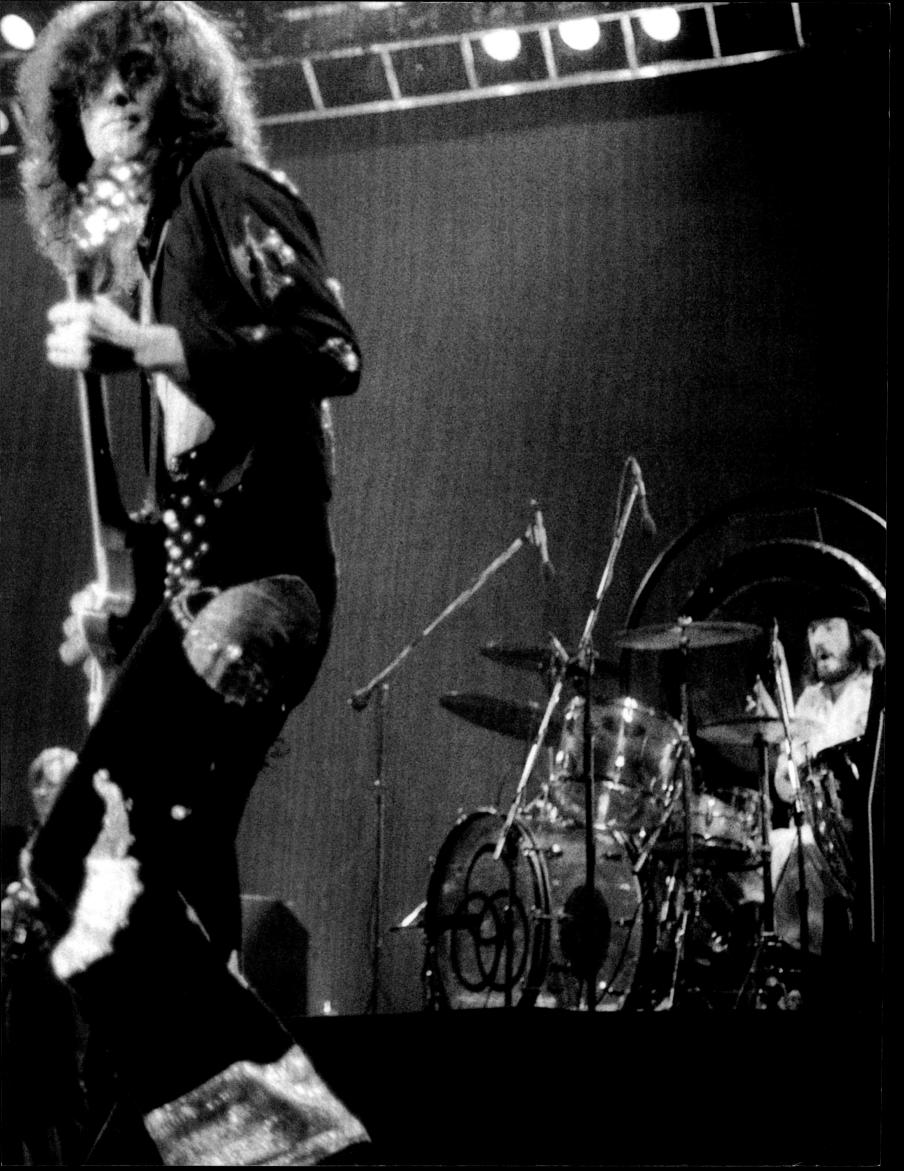

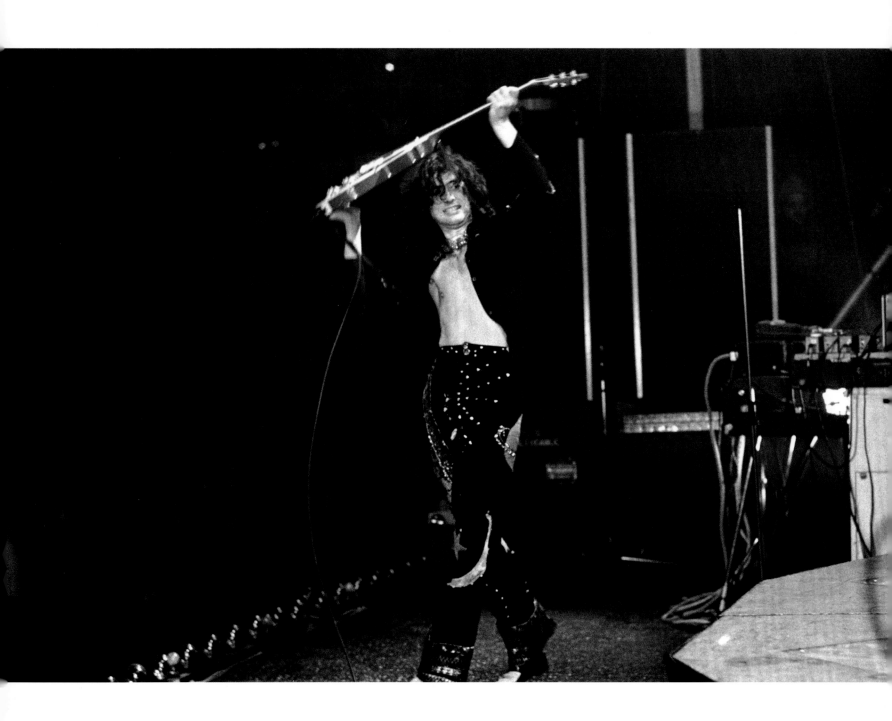

February 1 & 2
Civic Arena
Pittsburgh, USA

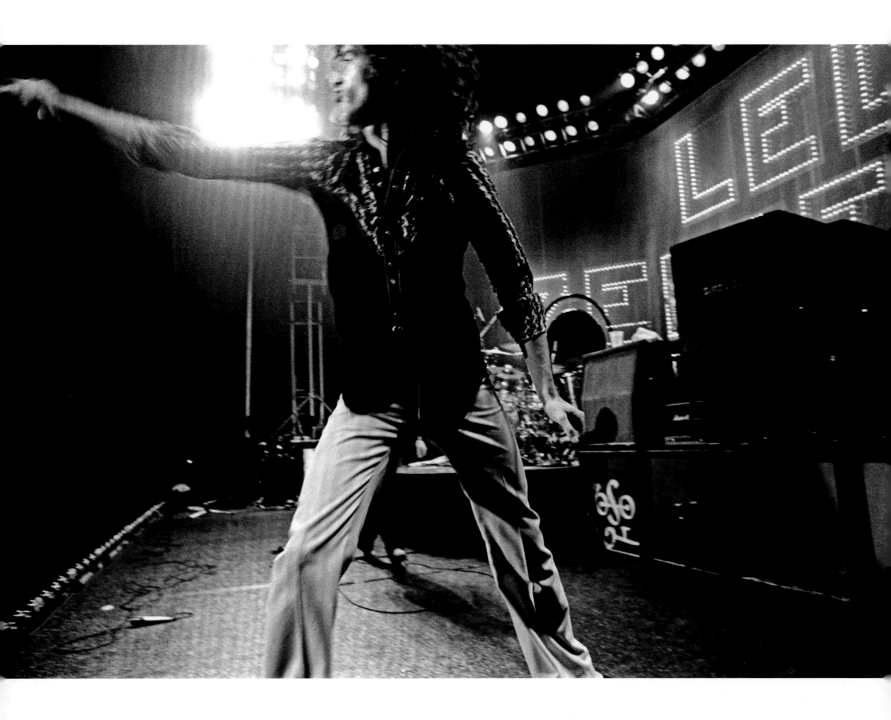

February 13
Nassau Coliseum
Uniondale, USA

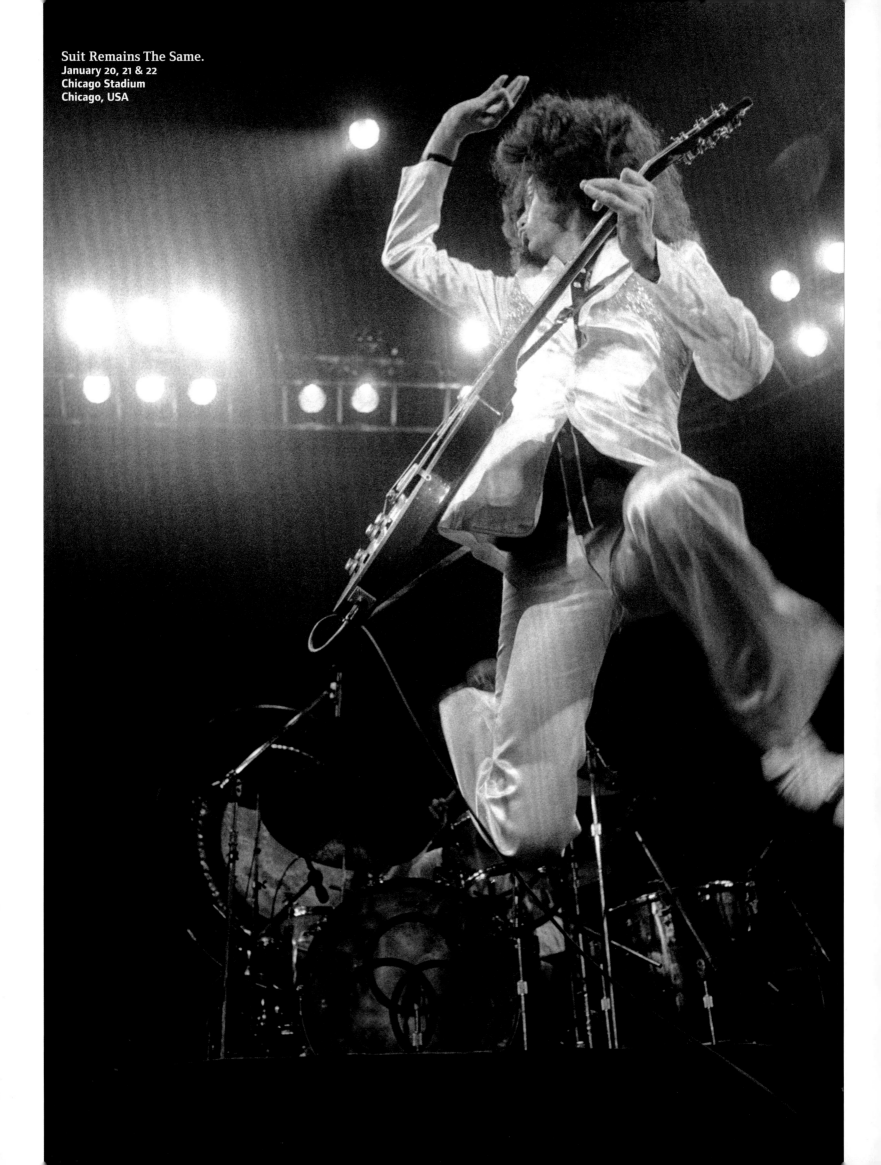

Suit Remains The Same.
January 20, 21 & 22
Chicago Stadium
Chicago, USA

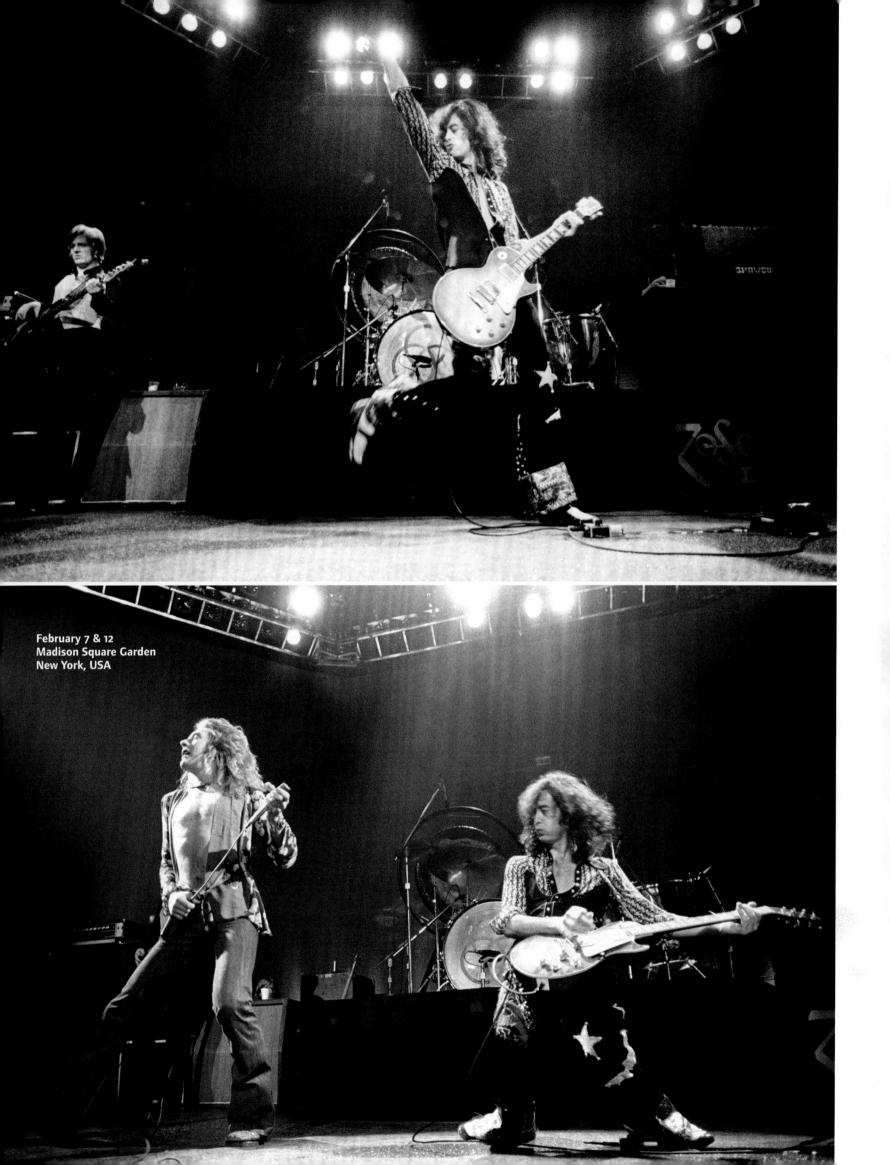

February 7 & 12
Madison Square Garden
New York, USA

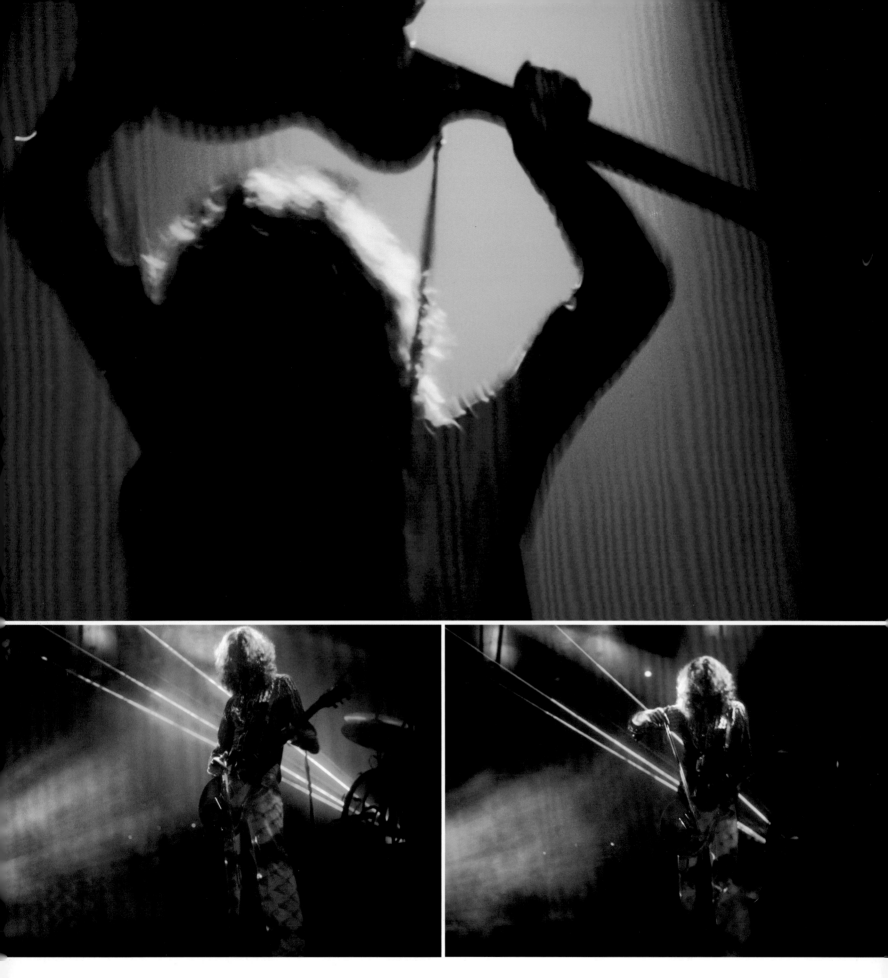

February 7 & 12
Madison Square Garden
New York, USA

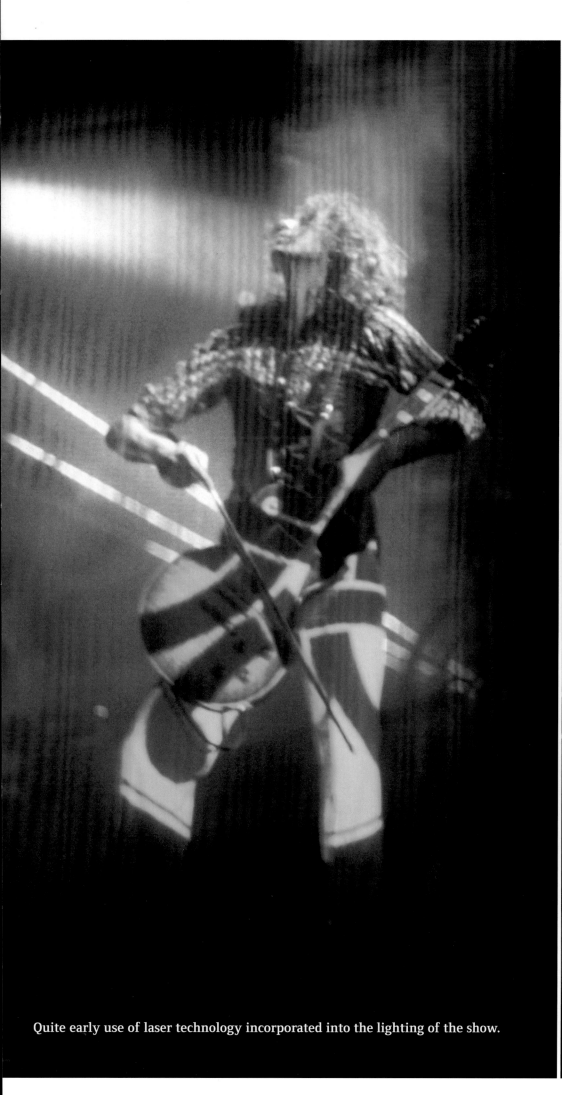

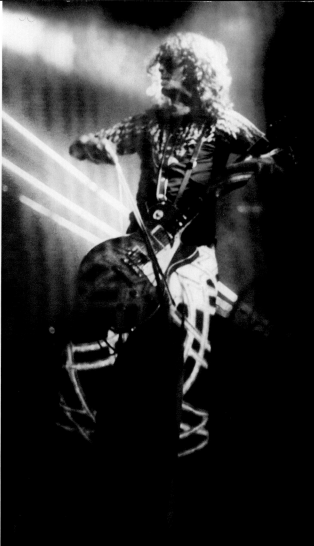

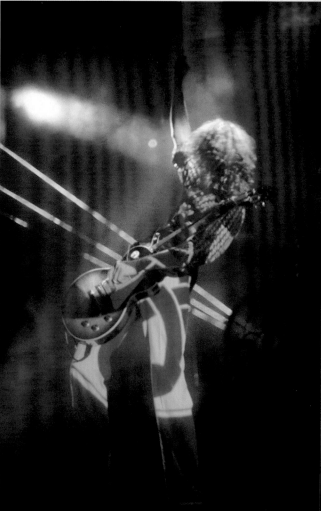

Quite early use of laser technology incorporated into the lighting of the show.

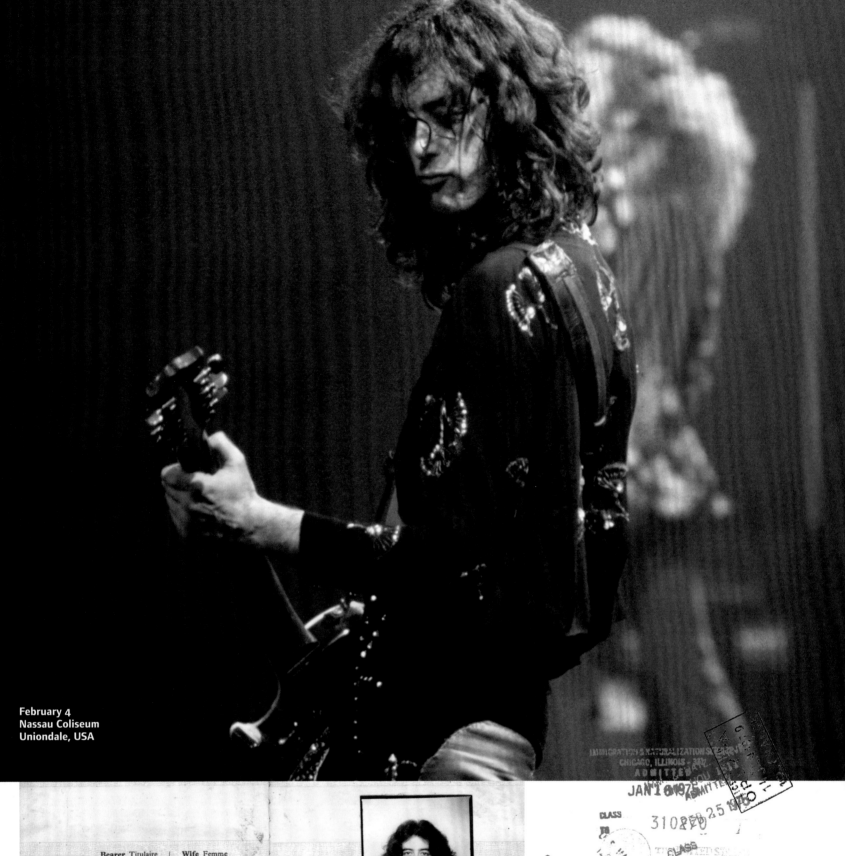

February 4
Nassau Coliseum
Uniondale, USA

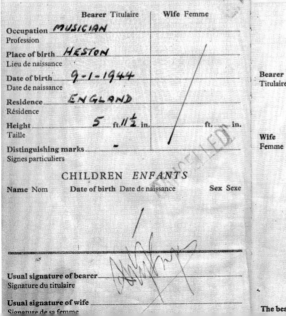

	Bearer Titulaire	Wife Femme
Occupation Profession	MUSICIAN	
Place of birth Lieu de naissance	HESTON	
Date of birth Date de naissance	9-1-1944	
Residence Résidence	ENGLAND	
Height Taille	5 ft. 11½ in.	ft. in.
Distinguishing marks Signes particuliers	-	

CHILDREN *ENFANTS*

Name Nom	Date of birth Date de naissance	Sex Sexe

Usual signature of bearer
Signature du titulaire

Usual signature of wife
Signature de sa femme

Bearer
Titulaire

Wife
Femme

Photo

CANCELLED

The bearer (and wife, if included) should sign opposite on receipt

CLASS
310 FEB 25 1976

H-1
28 MAR. 1975
MULTIPLE

BEARER AND DEPENDENTS
NAMED IN PASSPORT

NYC-N-45711

Swan Song Inc.

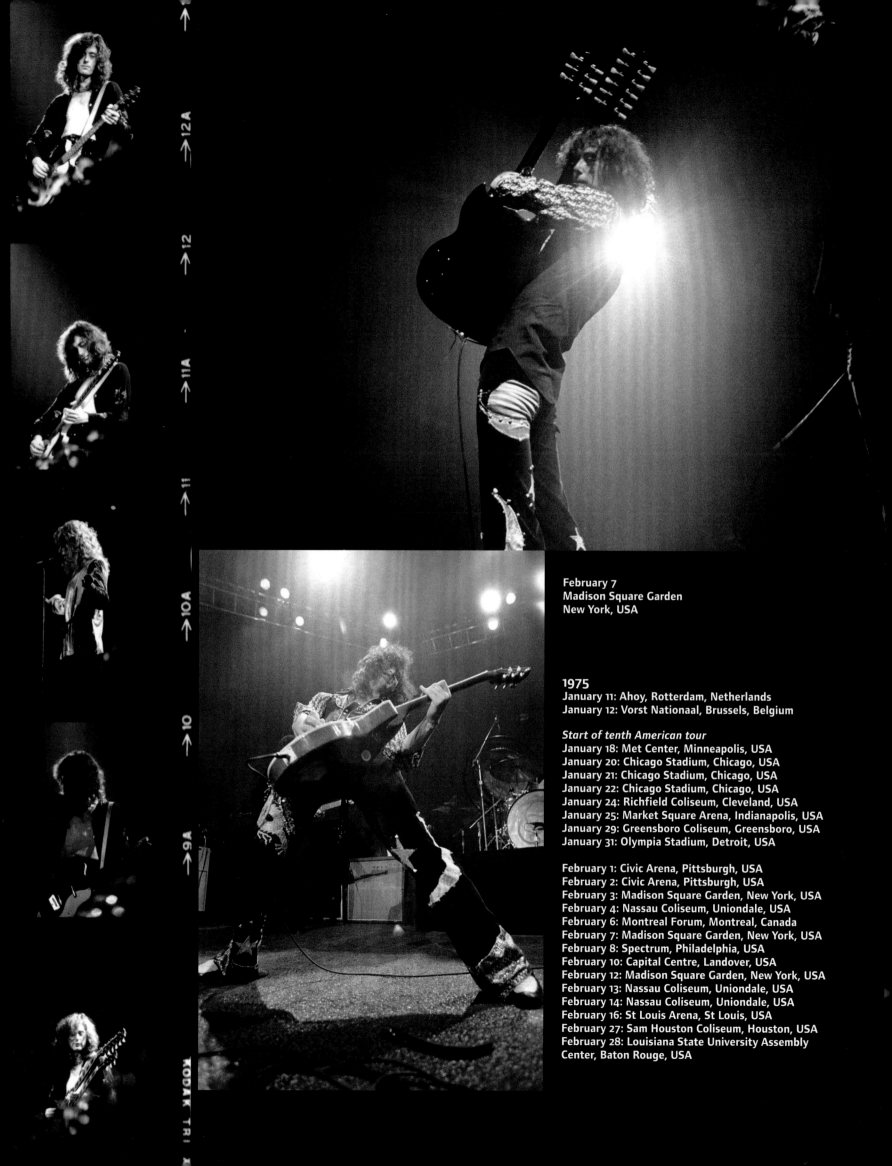

February 7
Madison Square Garden
New York, USA

1975
January 11: Ahoy, Rotterdam, Netherlands
January 12: Vorst Nationaal, Brussels, Belgium

Start of tenth American tour
January 18: Met Center, Minneapolis, USA
January 20: Chicago Stadium, Chicago, USA
January 21: Chicago Stadium, Chicago, USA
January 22: Chicago Stadium, Chicago, USA
January 24: Richfield Coliseum, Cleveland, USA
January 25: Market Square Arena, Indianapolis, USA
January 29: Greensboro Coliseum, Greensboro, USA
January 31: Olympia Stadium, Detroit, USA

February 1: Civic Arena, Pittsburgh, USA
February 2: Civic Arena, Pittsburgh, USA
February 3: Madison Square Garden, New York, USA
February 4: Nassau Coliseum, Uniondale, USA
February 6: Montreal Forum, Montreal, Canada
February 7: Madison Square Garden, New York, USA
February 8: Spectrum, Philadelphia, USA
February 10: Capital Centre, Landover, USA
February 12: Madison Square Garden, New York, USA
February 13: Nassau Coliseum, Uniondale, USA
February 14: Nassau Coliseum, Uniondale, USA
February 16: St Louis Arena, St Louis, USA
February 27: Sam Houston Coliseum, Houston, USA
February 28: Louisiana State University Assembly
Center, Baton Rouge, USA

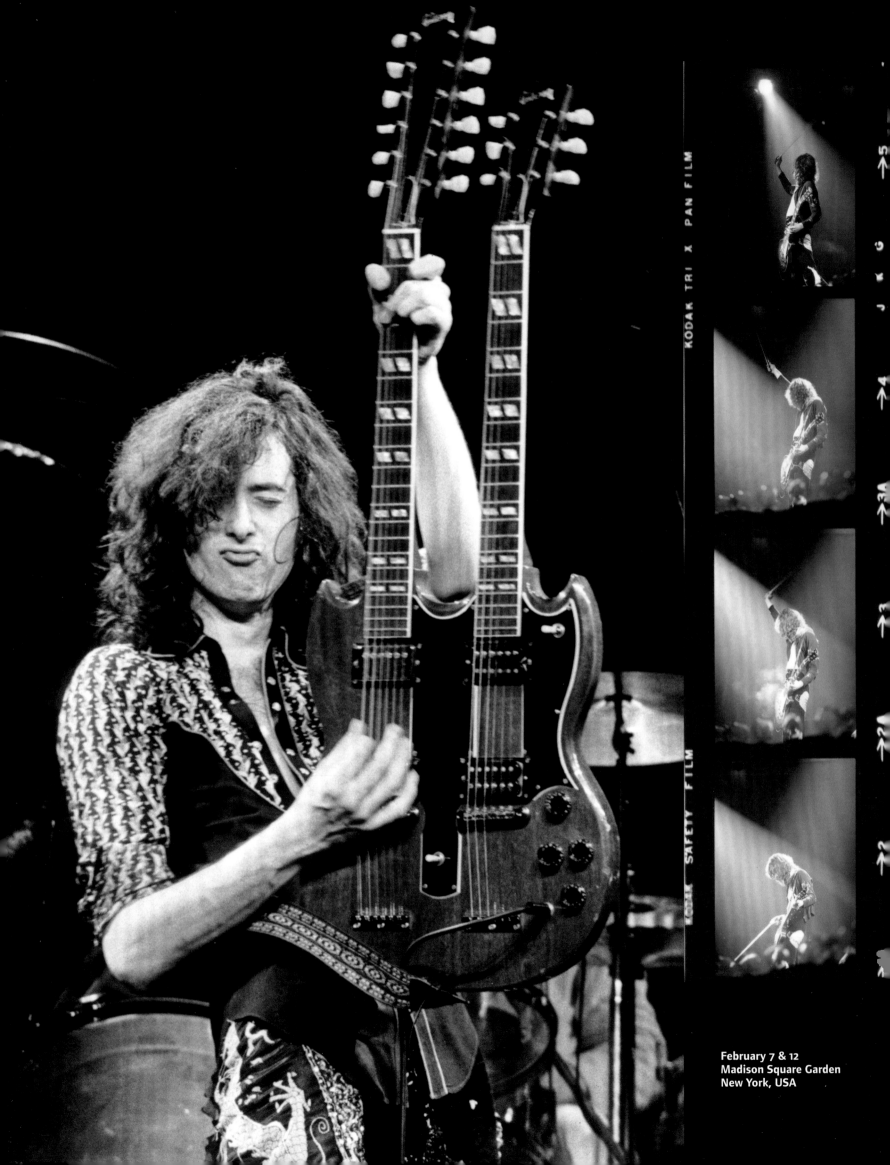

February 7 & 12
Madison Square Garden
New York, USA

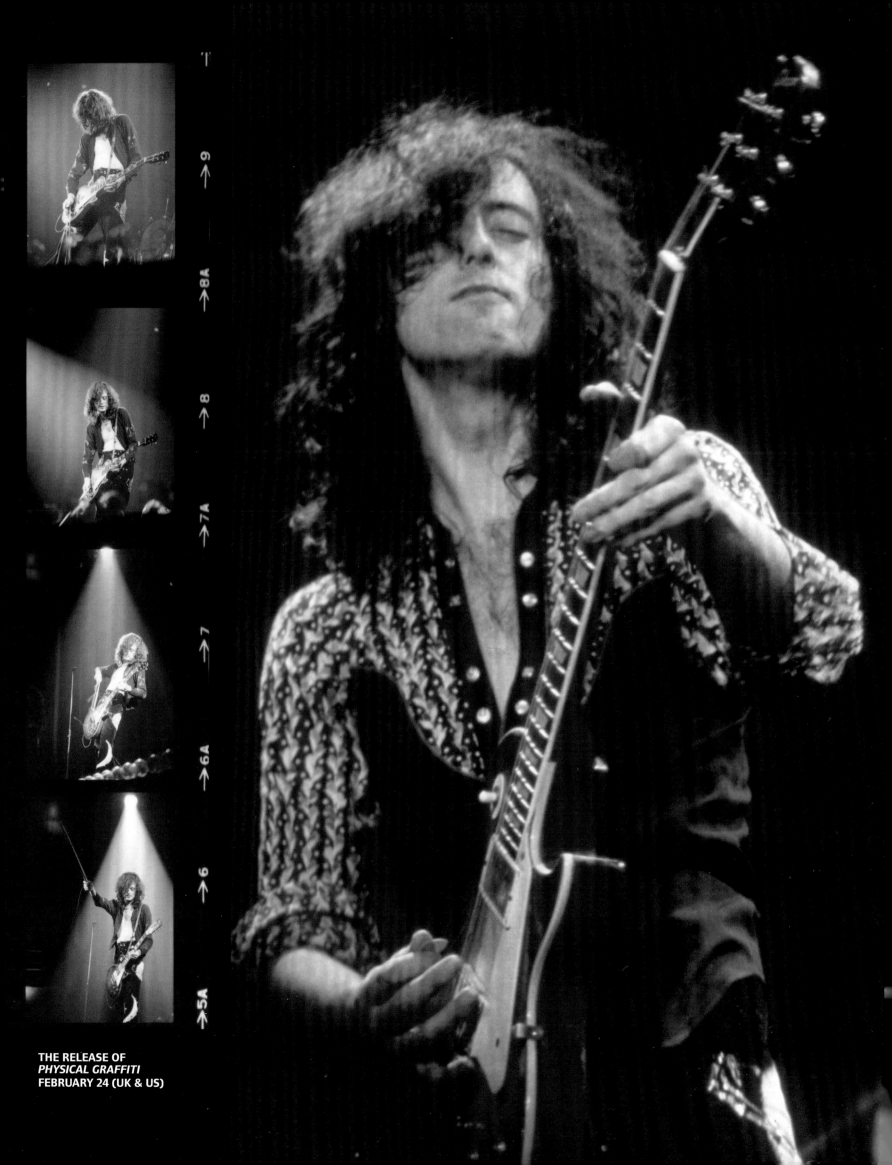

THE RELEASE OF
PHYSICAL GRAFFITI
FEBRUARY 24 (UK & US)

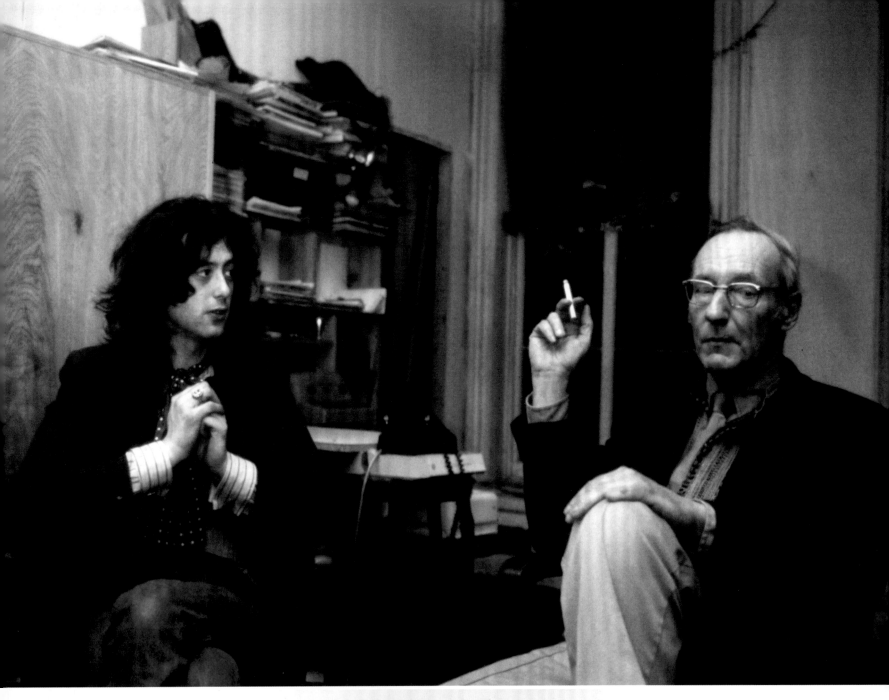

William Burroughs'
apartment
New York, USA

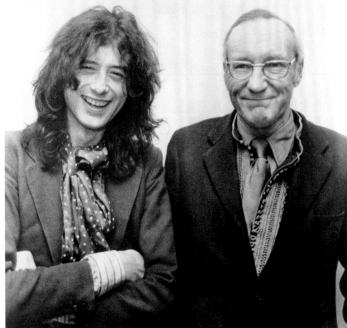

This was a photo shoot during an interview with Burroughs for *Crawdaddy!* where he wrote about rock music, trance music and Morocco.

I turned the conversation to Wilhelm Reich and orgone energy. And it was much to my surprise that William Burroughs had an orgone cabinet there in his home which he would visit on a daily basis.

After the interview we went to Mr Burroughs' local Mexican restaurant where we ate heartily and he introduced me to Dos Equis.

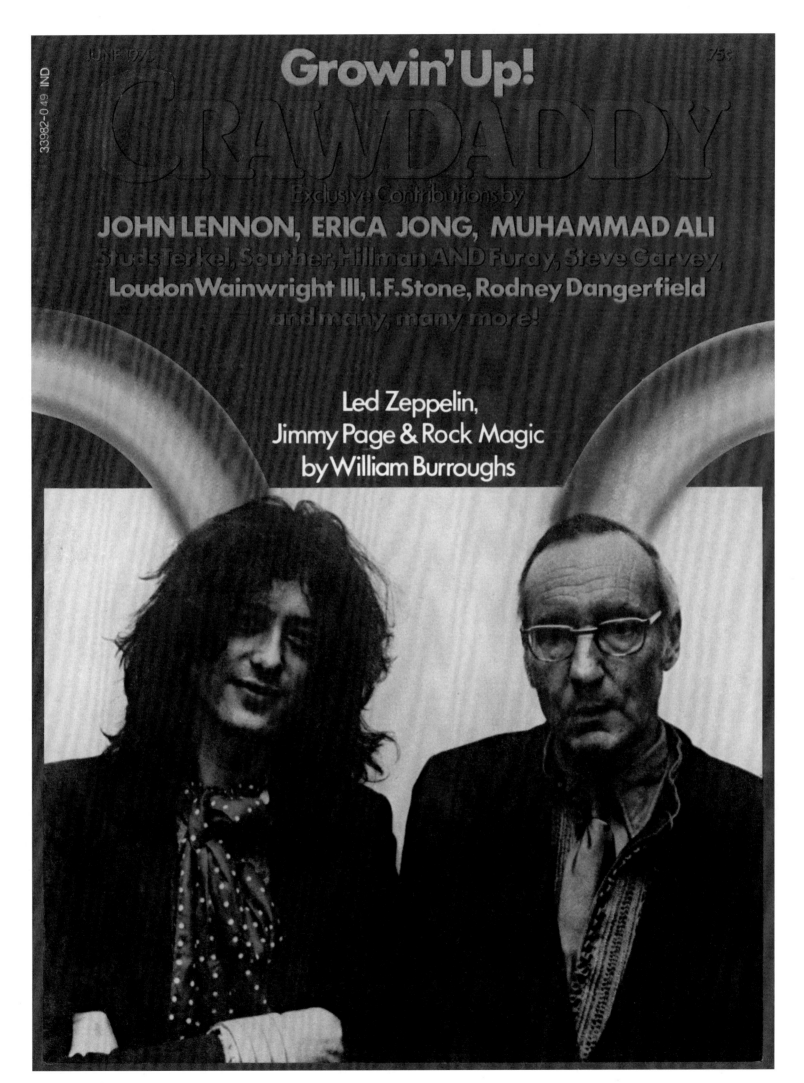

On cover:

JUNE 1975 75¢

Growin' Up!

CRAWDADDY

Exclusive Contributions by

JOHN LENNON, ERICA JONG, MUHAMMAD ALI
Studs Terkel, Souther, Hillman AND Furay, Steve Garvey,
Loudon Wainwright III, I. F. Stone, Rodney Dangerfield
and many, many more!

Led Zeppelin,
Jimmy Page & Rock Magic
by William Burroughs

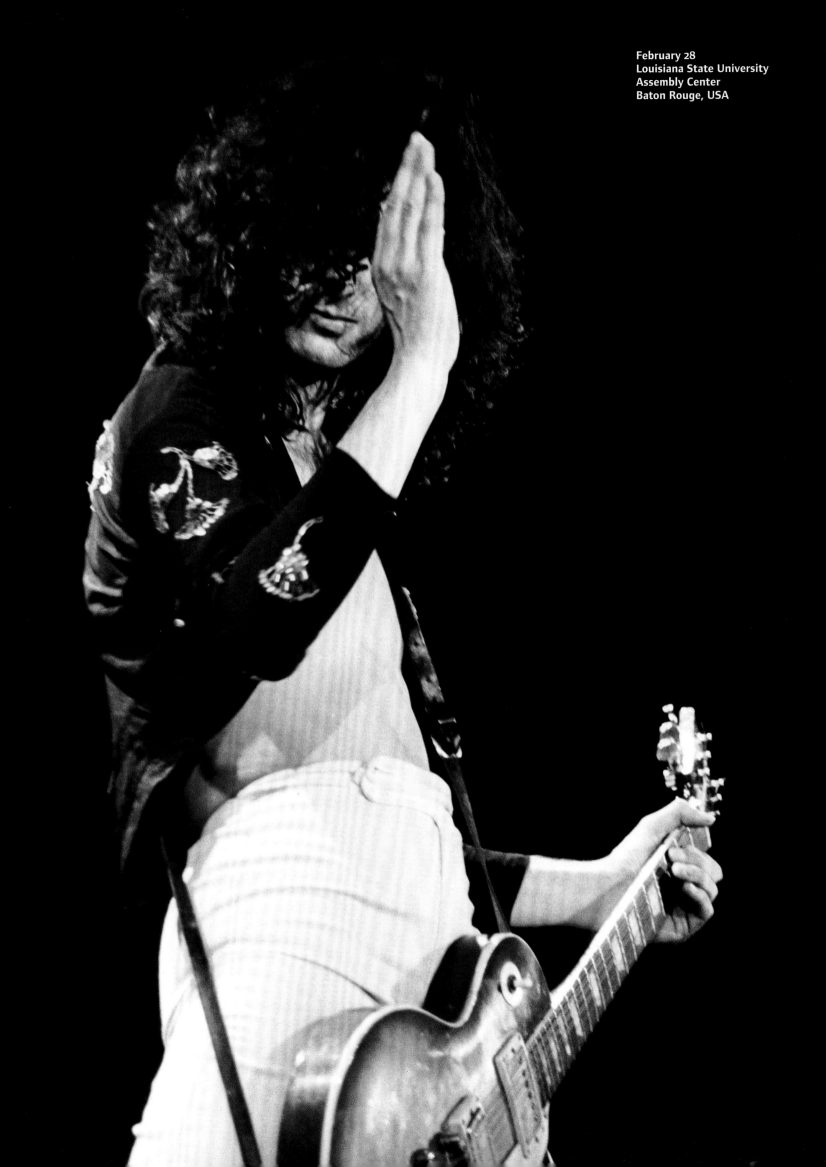

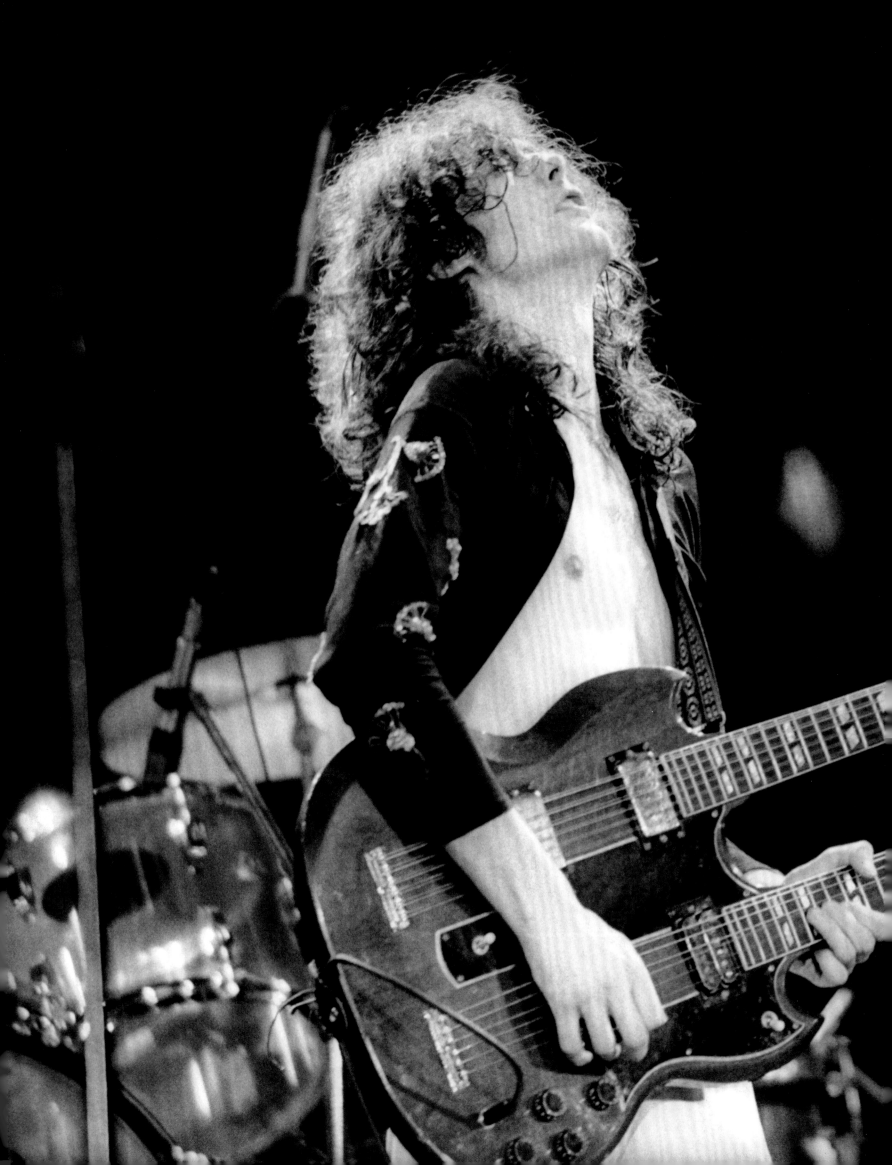

March 24-27
The Forum
Los Angeles, USA

Final shows
of the American tour

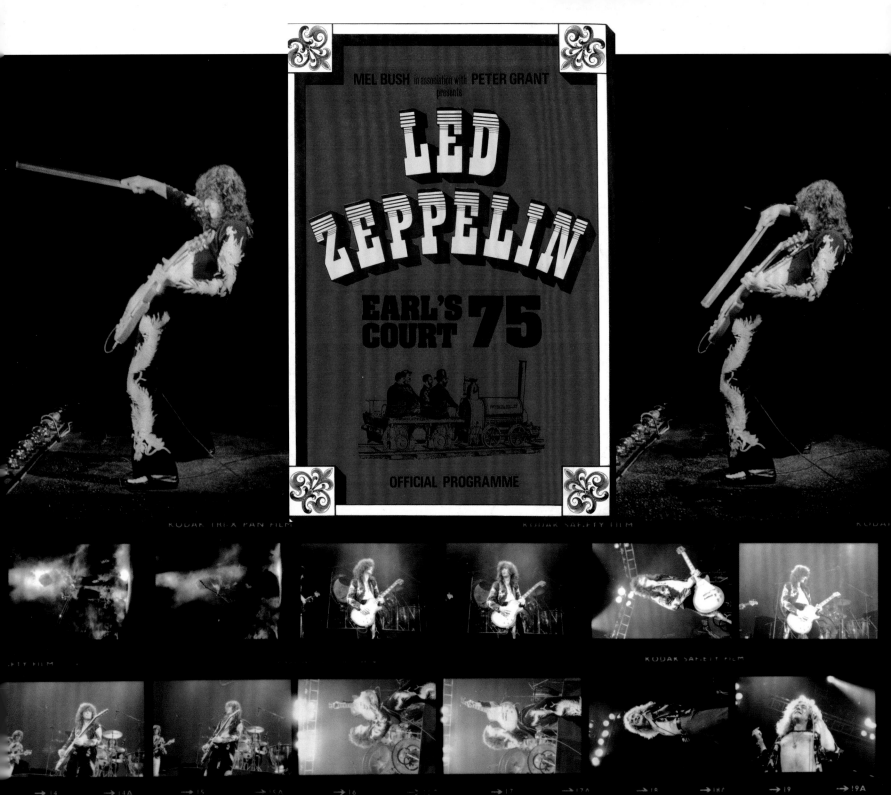

May 17-25
Earls Court Arena
London, UK

For the Earls Court shows we included back screen projection and laser technology. It was the first time that either of these techniques had been incorporated into shows in England.

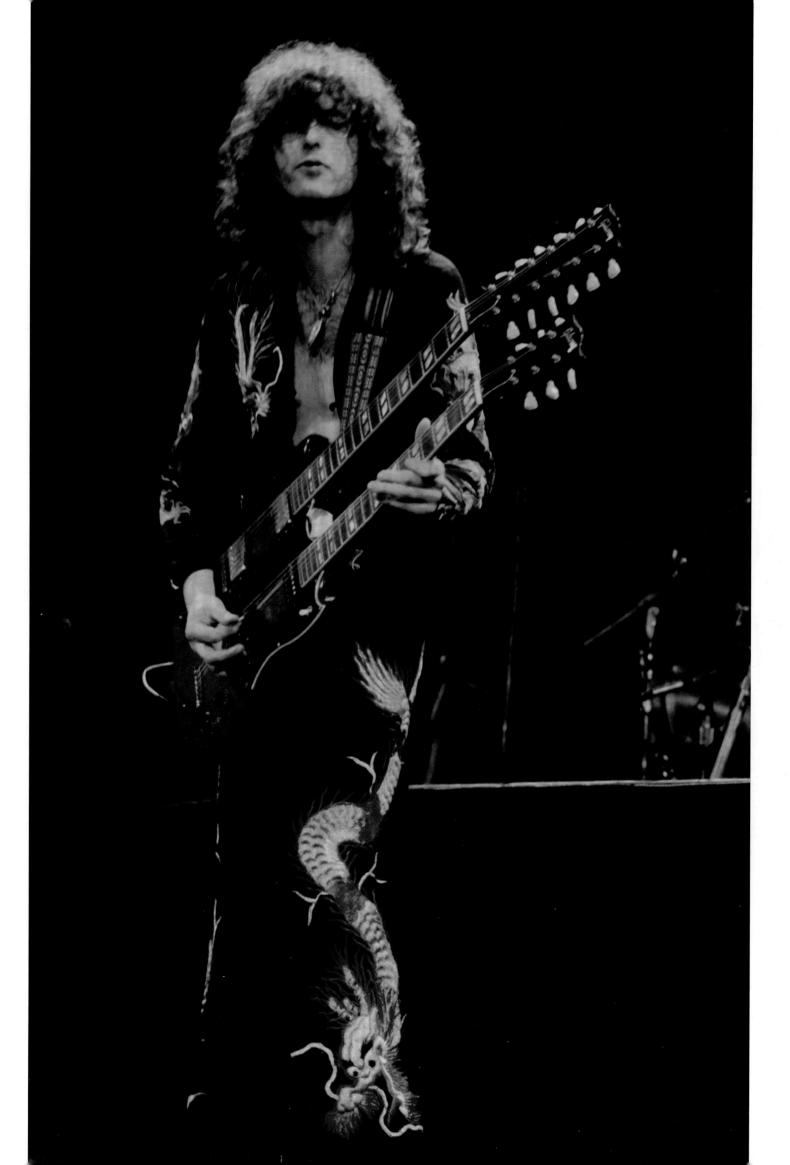

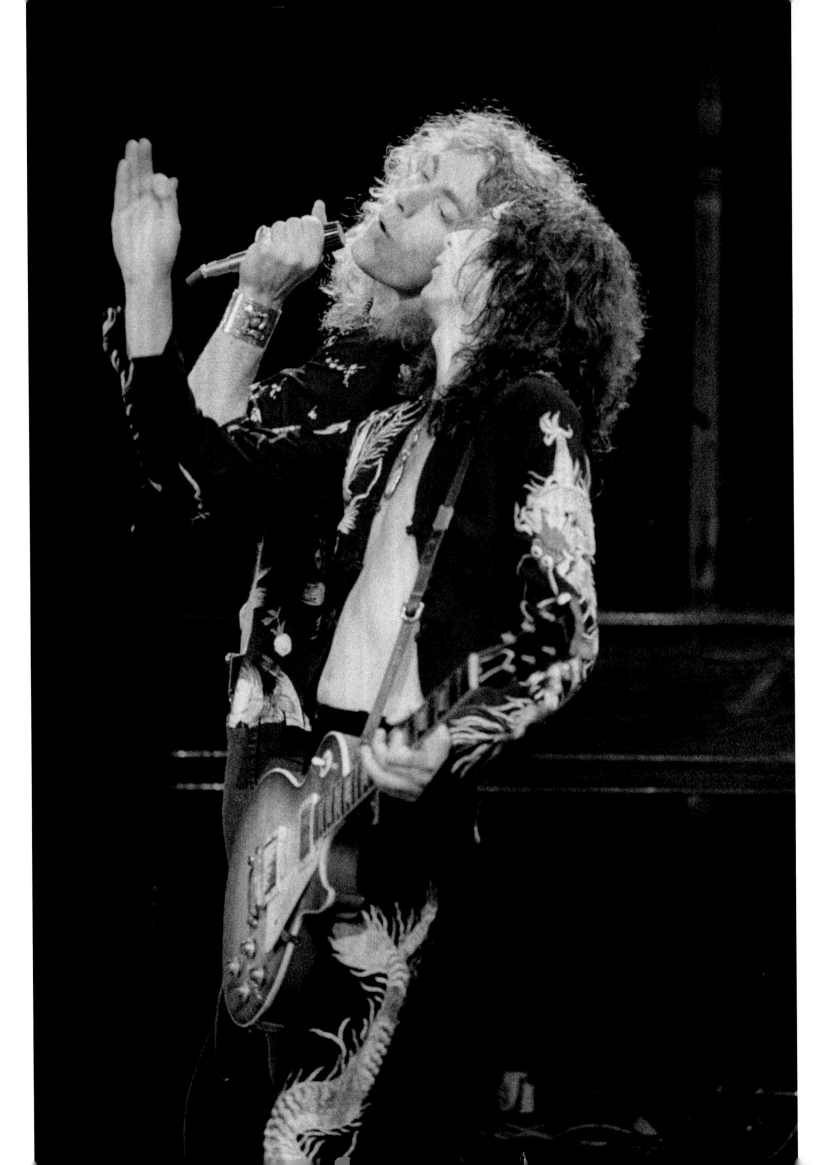

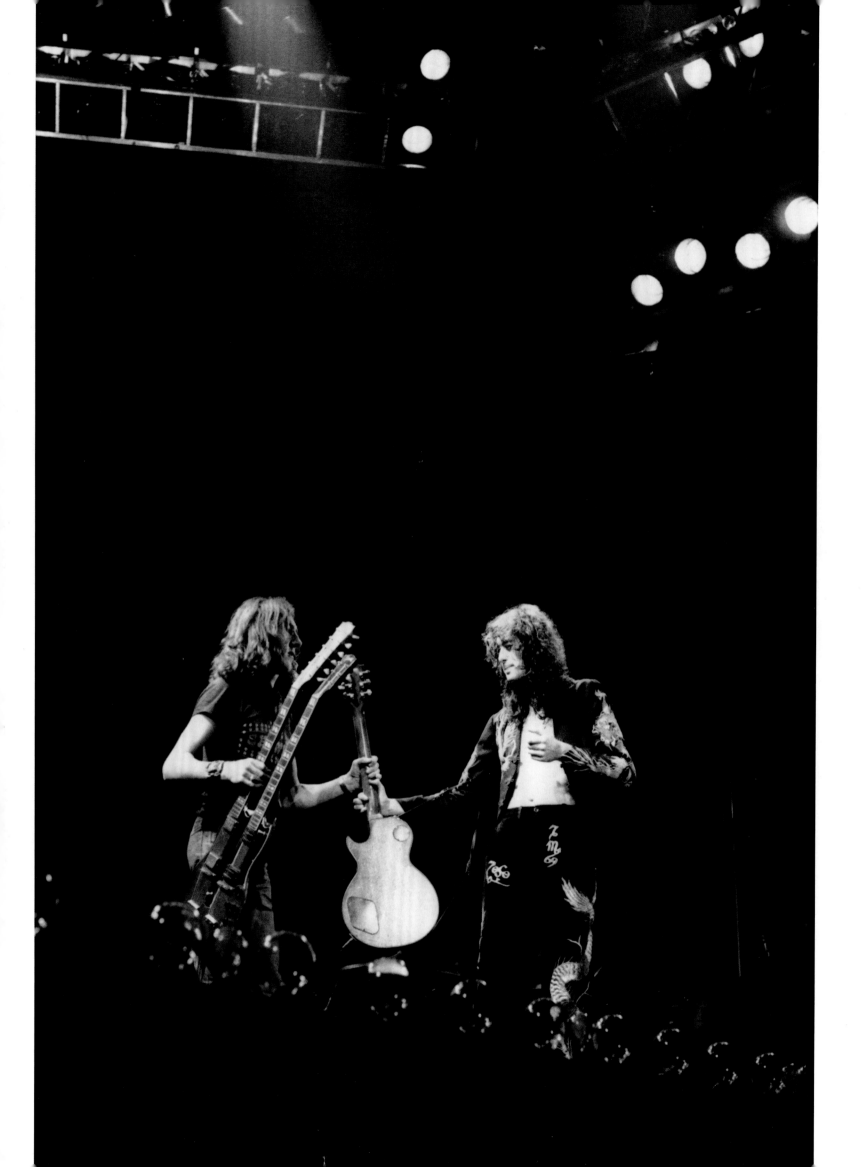

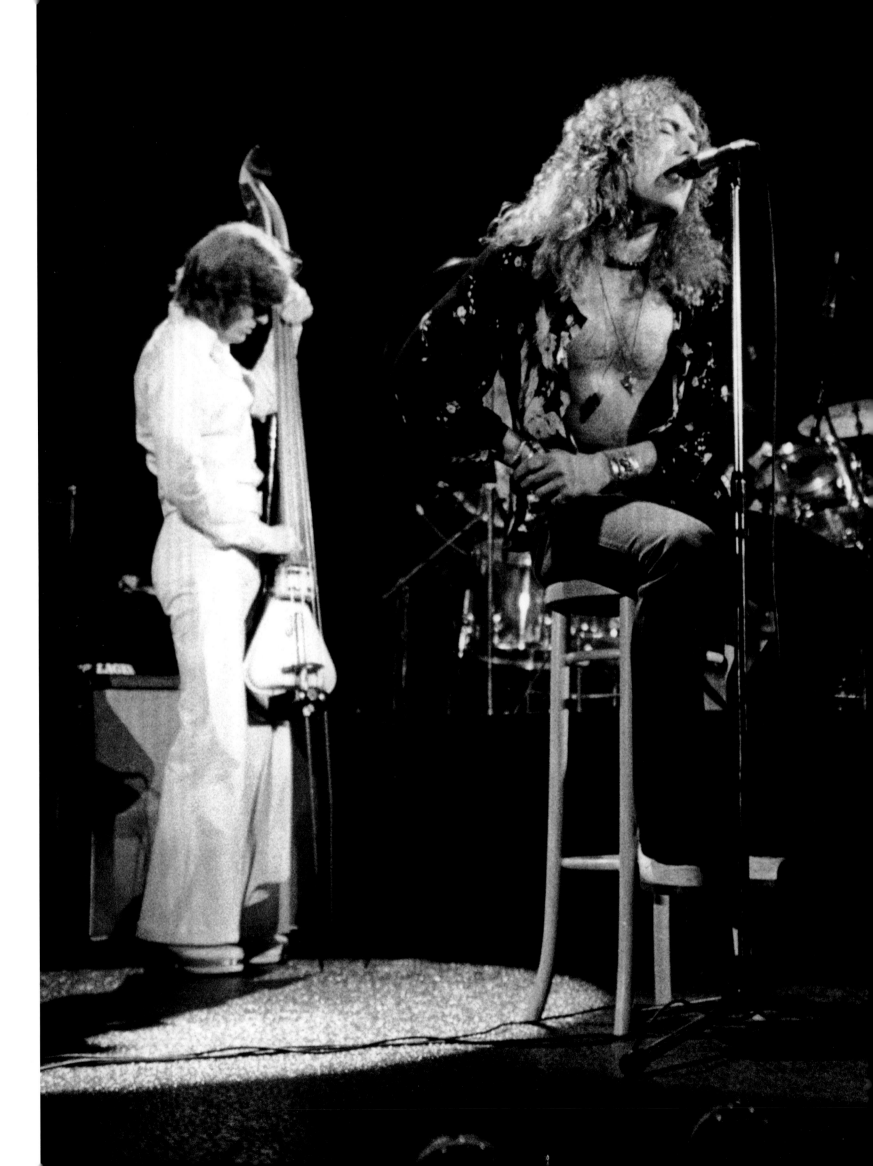

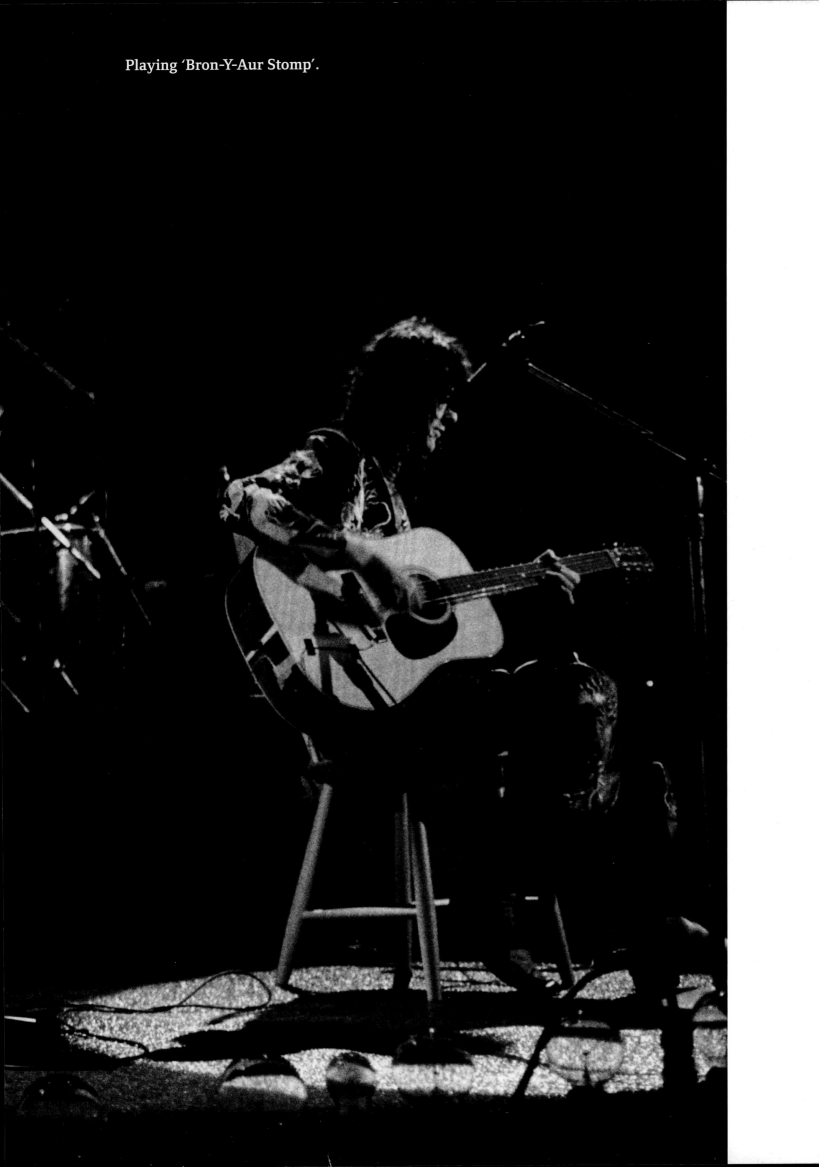

Playing 'Bron-Y-Aur Stomp'.

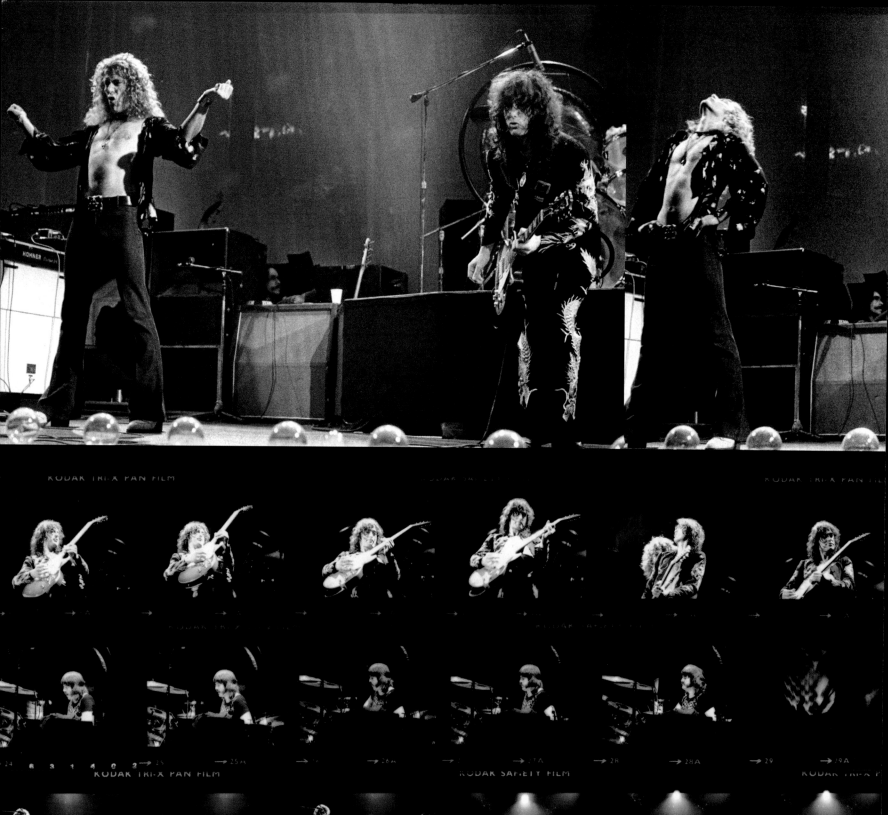

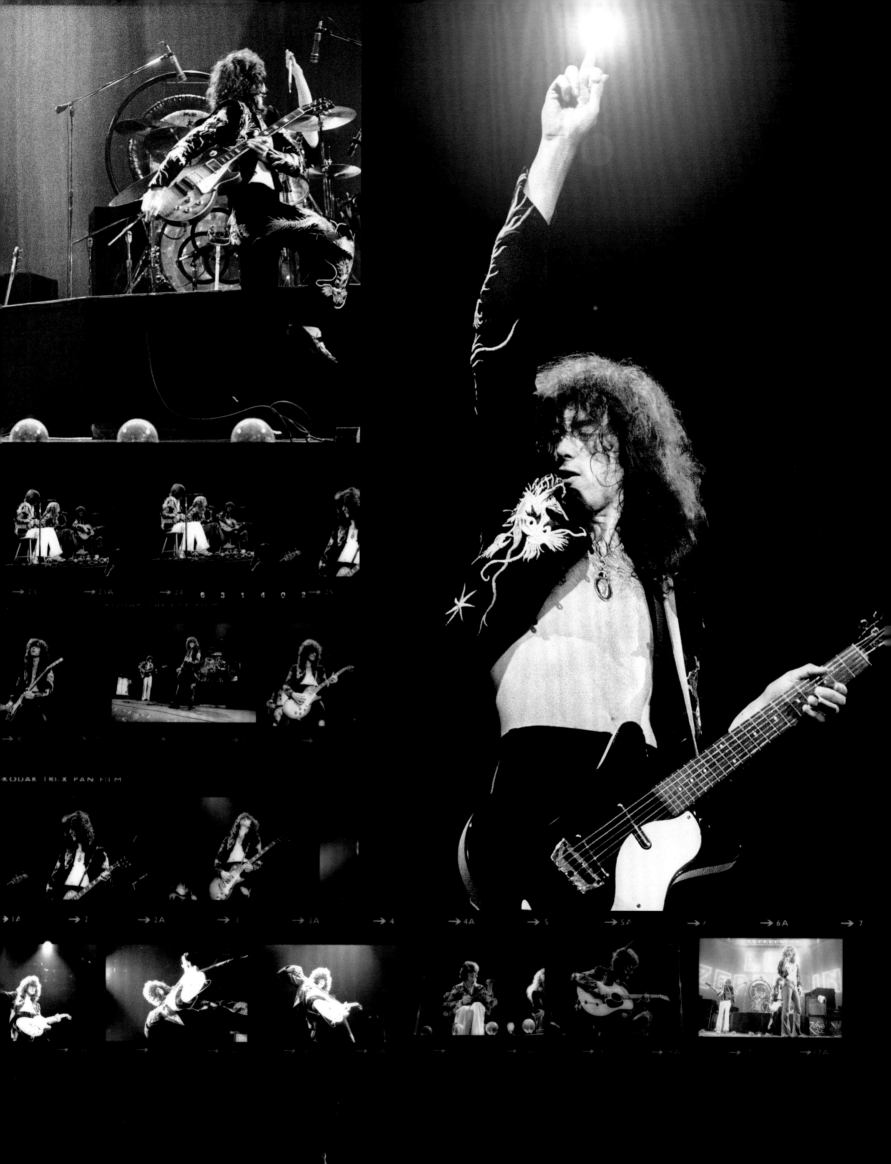

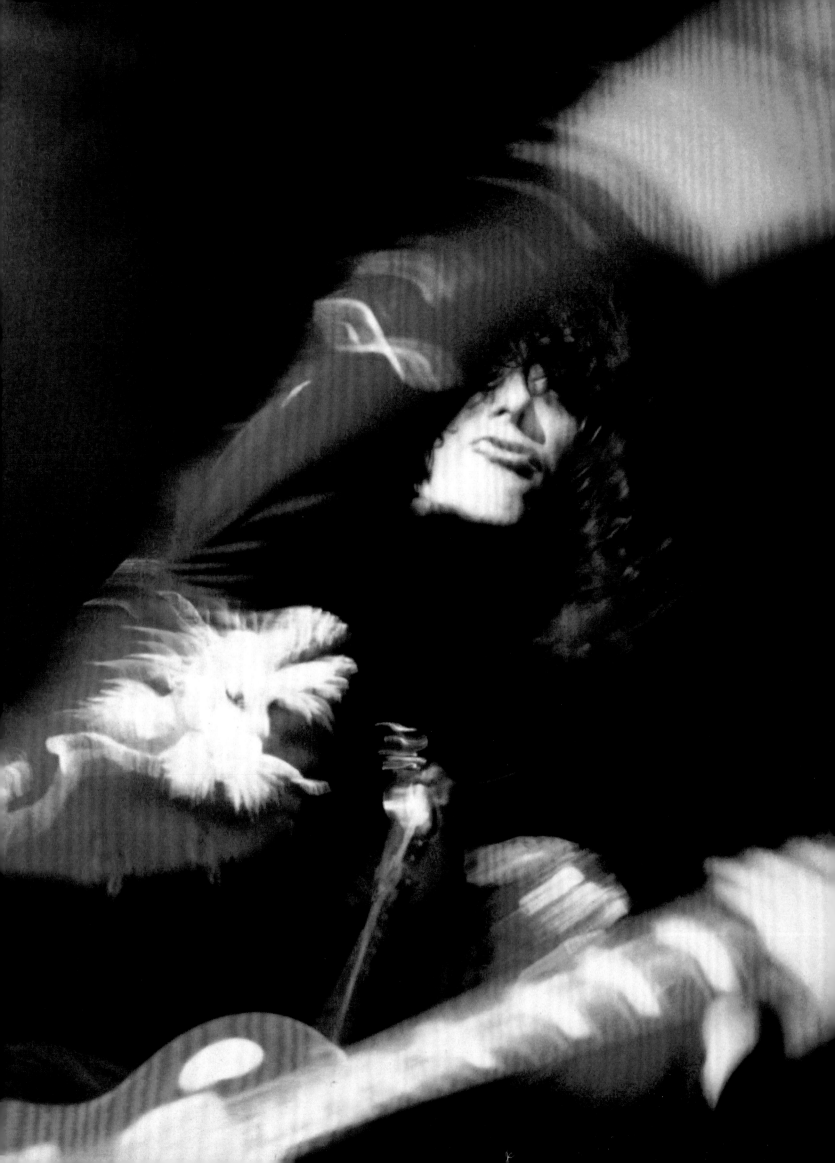

1975

March 3: Tarrant County Convention Center,
Fort Worth, USA
March 4: Convention Center, Dallas, USA
March 5: Convention Center, Dallas, USA
March 10: Sports Arena, San Diego, USA
March 11: Long Beach Arena, Long Beach, USA
March 12: Long Beach Arena, Long Beach, USA
March 14: Sports Arena, San Diego, USA
March 17: Seattle Center Coliseum, Seattle, USA
March 19: Pacific Coliseum, Vancouver, Canada
March 20: Pacific Coliseum, Vancouver, Canada
March 21: Seattle Center Coliseum, Seattle, USA
March 24: The Forum, Los Angeles, USA
March 25: The Forum, Los Angeles, USA
March 27: The Forum, Los Angeles, USA
End of tenth American tour

May 17: Earls Court Arena, London, UK
May 18: Earls Court Arena, London, UK
May 23: Earls Court Arena, London, UK
May 24: Earls Court Arena, London, UK
May 25: Earls Court Arena, London, UK

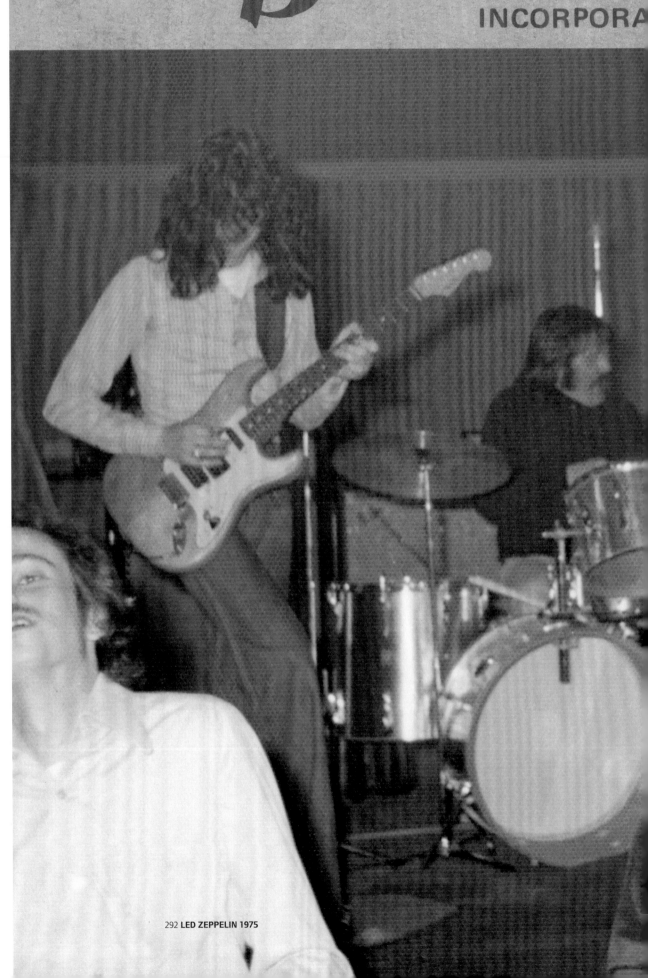

On this occasion we were visiting St Helier in Jersey on business; fortunately we had the light relief of being able to jam one evening in a local club.

SOUVENIR OF *Behan's* WEST PARK INCORPORA

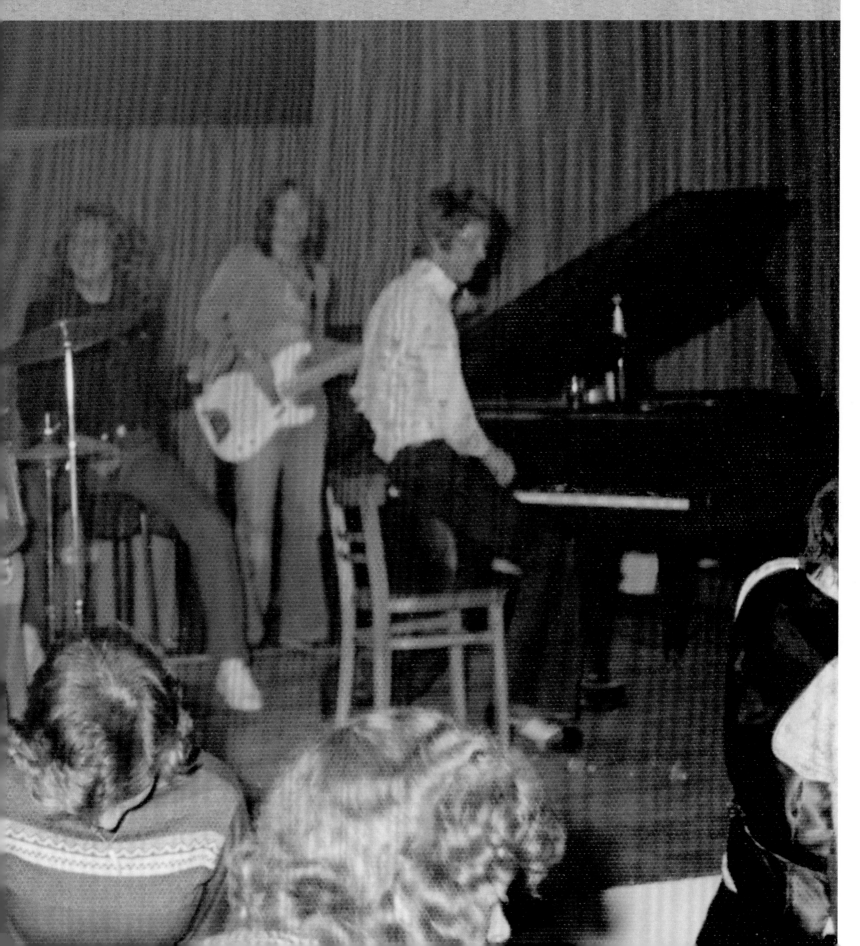

PHOTO BY HOLIDAY PHOTOS

NG "BLIMPERS" DISCOTHEQUE

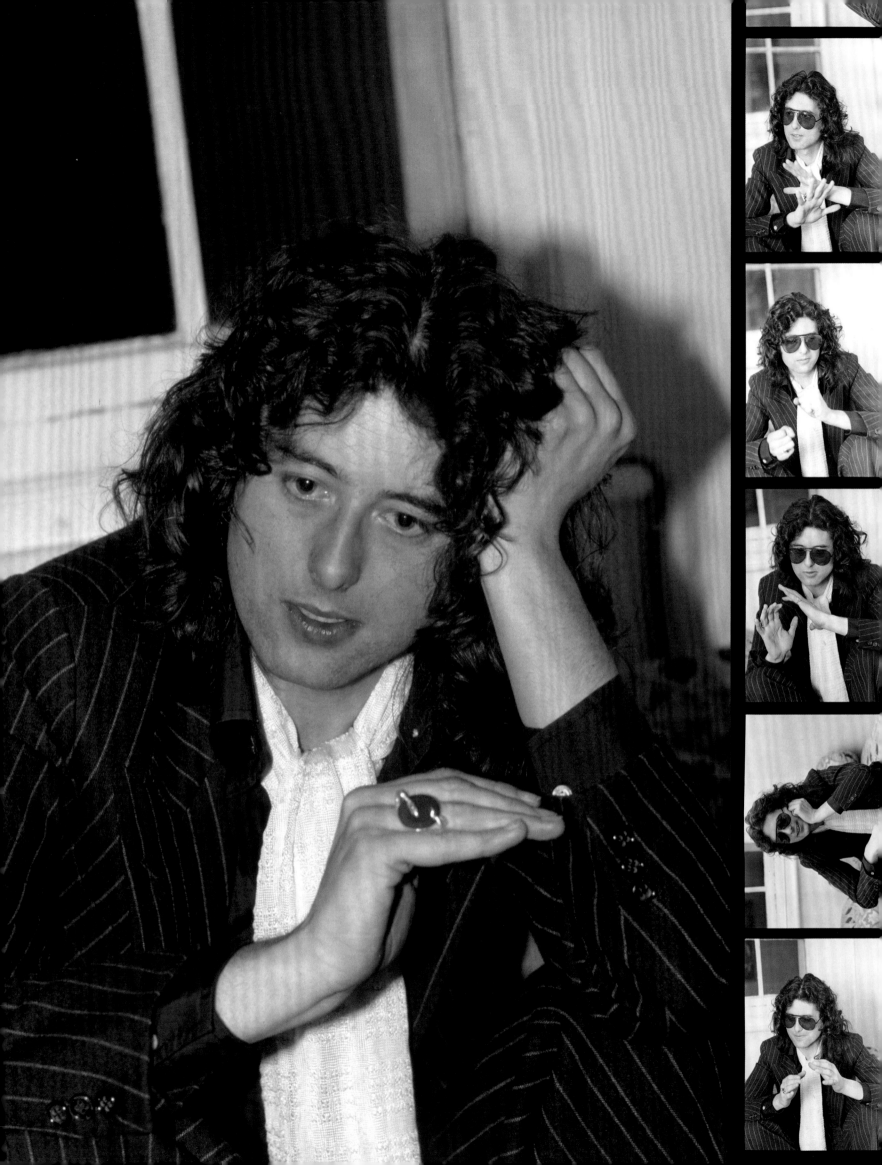

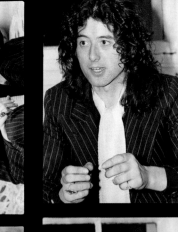
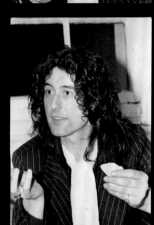
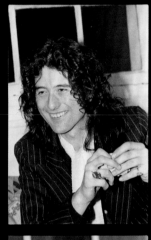
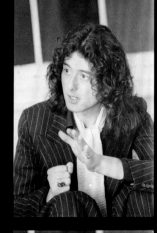
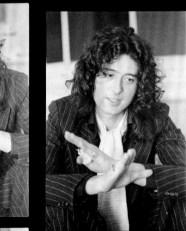
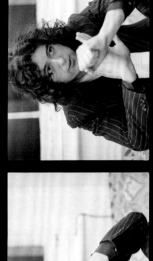
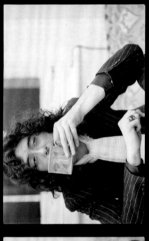
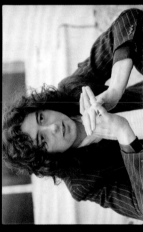
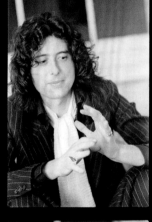
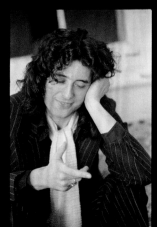

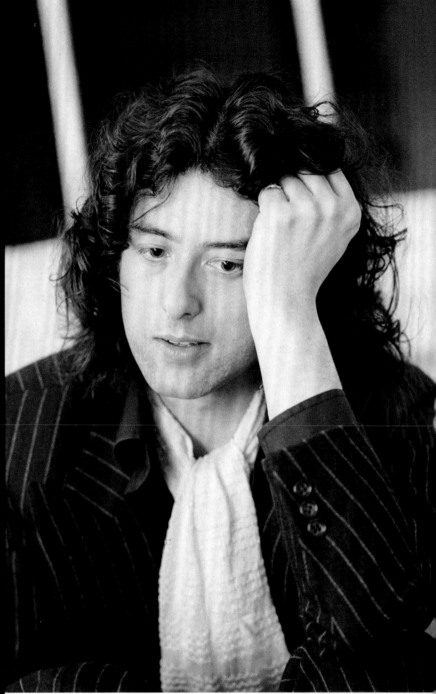

This is a sequence taken in 1976 during an interview promoting *Presence*. That album had been preceded by an intense and unsettling period. Robert had a bad car accident in Rhodes in August and suffered compound fractures to his leg. We began recording mid-November at Musicland Studios in Munich with Keith Harwood engineering. Robert was still in a cast, yet the album – a testament to the intensity of the time – was recorded and mixed in three weeks and two days. It felt like it had been channeled. And these photographs accurately reflect my mood at an emotional time in the band's career.

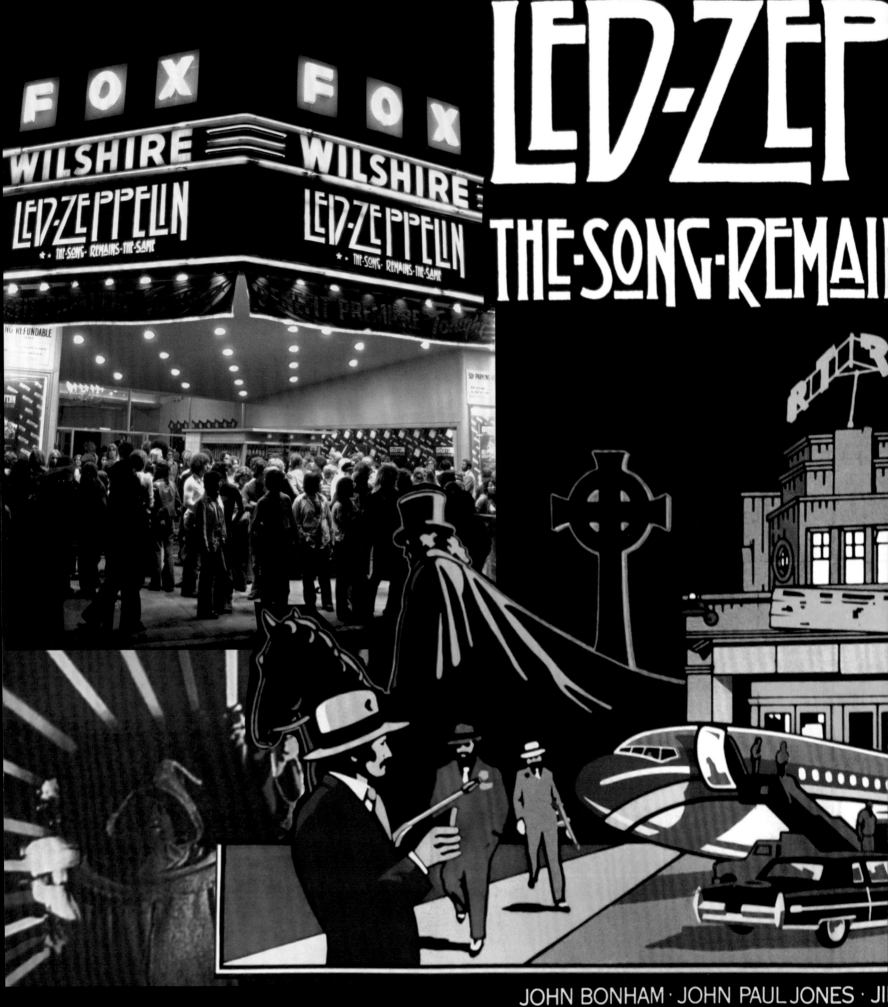

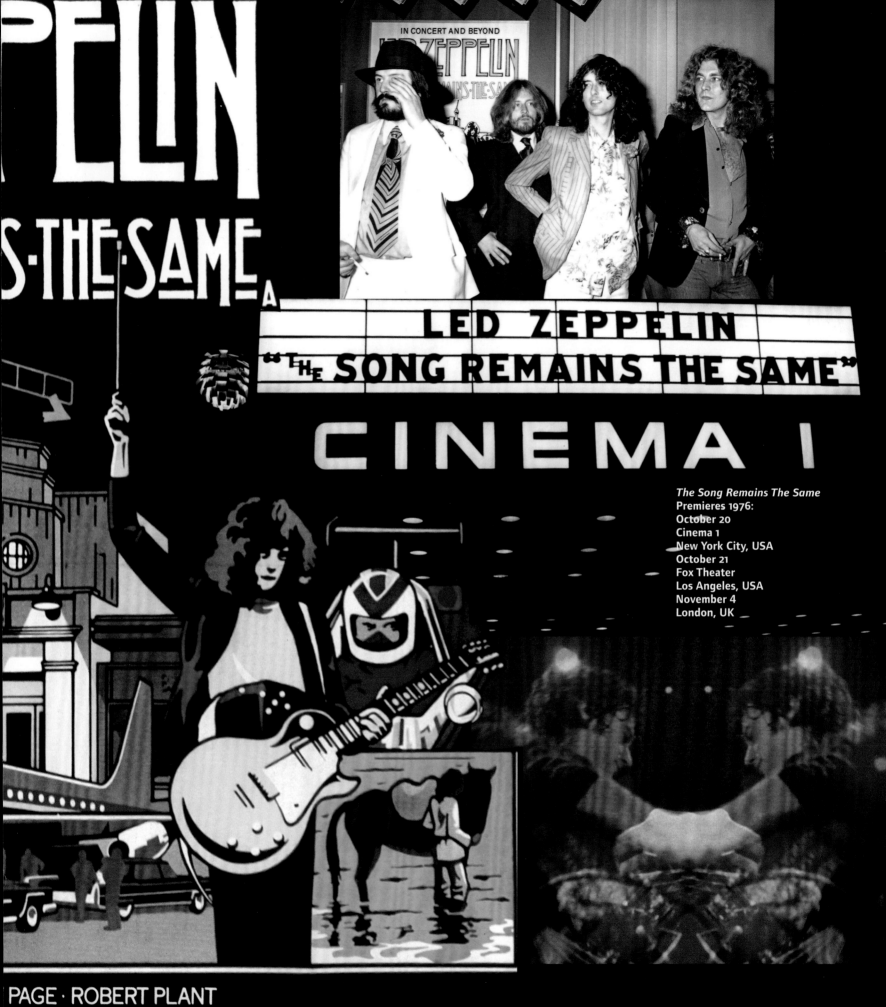

LED ZEPPELIN

"THE SONG REMAINS THE SAME"

CINEMA I

The Song Remains The Same
Premieres 1976:
October 20
Cinema 1
New York City, USA
October 21
Fox Theater
Los Angeles, USA
November 4
London, UK

PAGE · ROBERT PLANT
SQUARE GARDEN

THE RELEASE OF
THE SONG REMAINS THE SAME
SEPTEMBER 28 (UK & US)

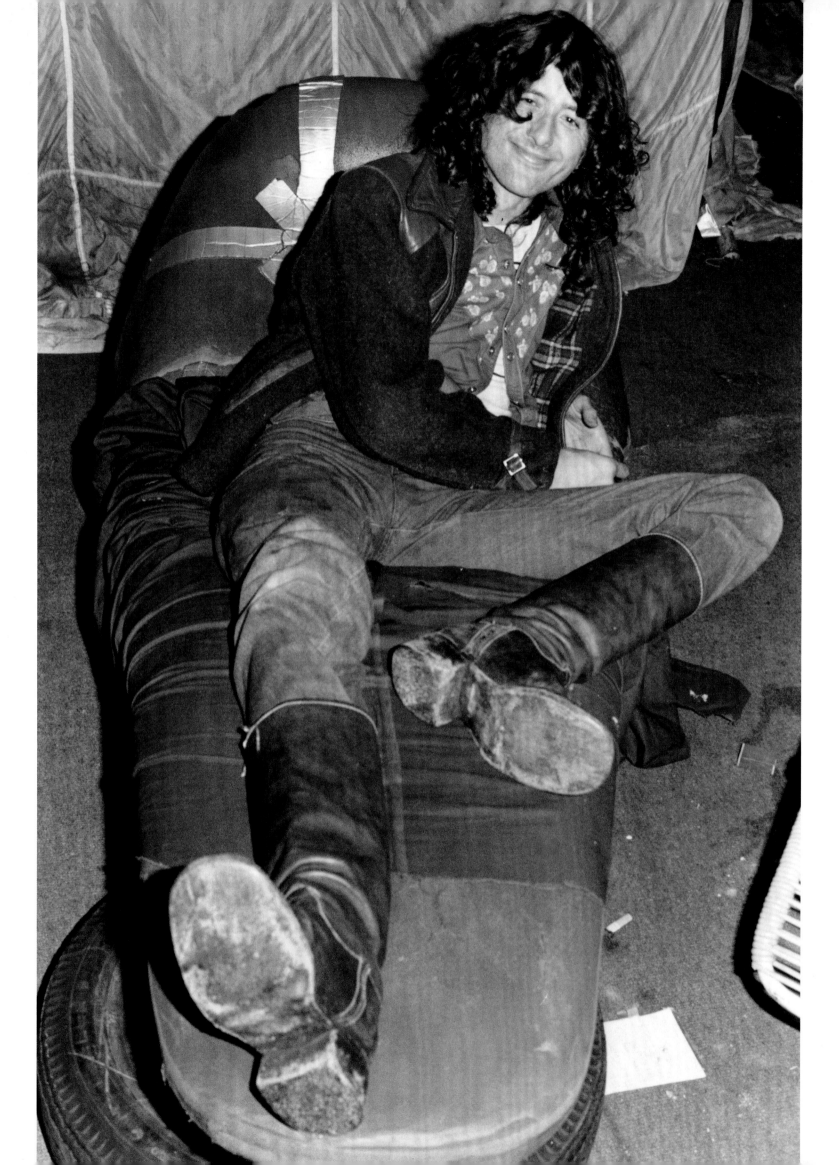

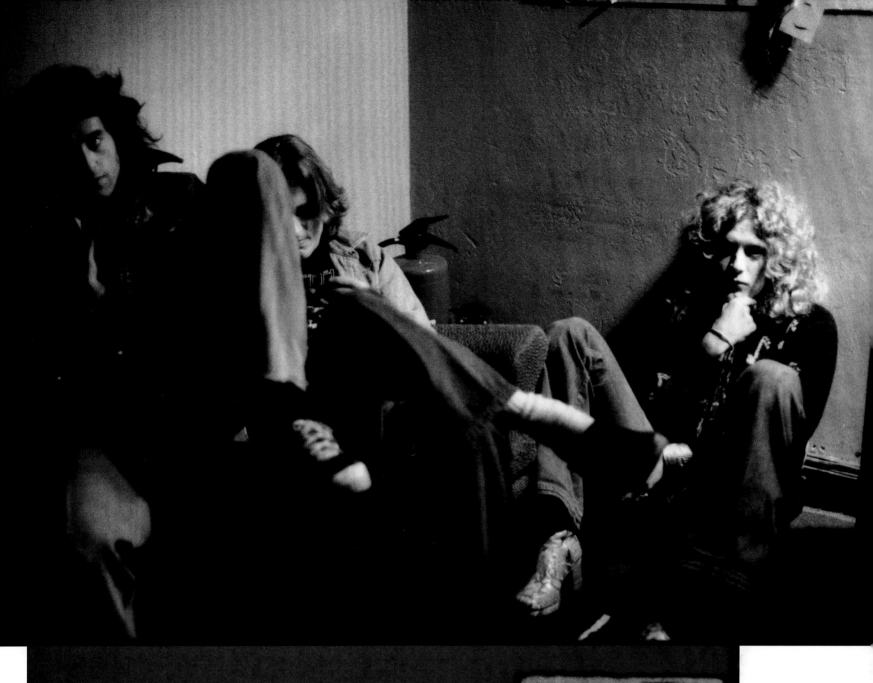

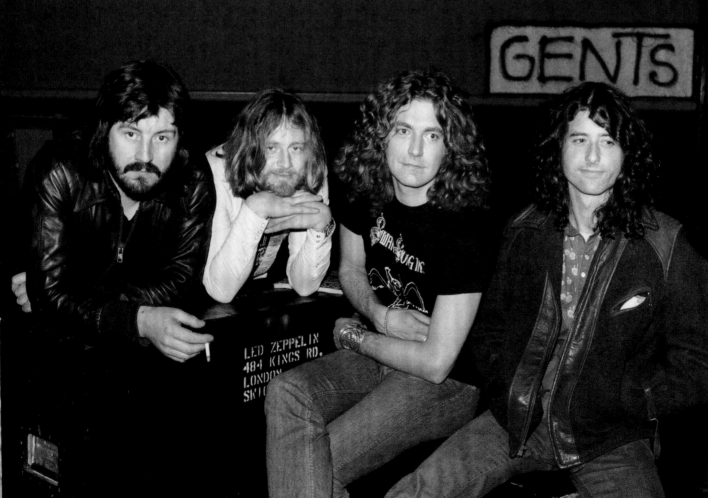

January
Manticore Studios
London, UK

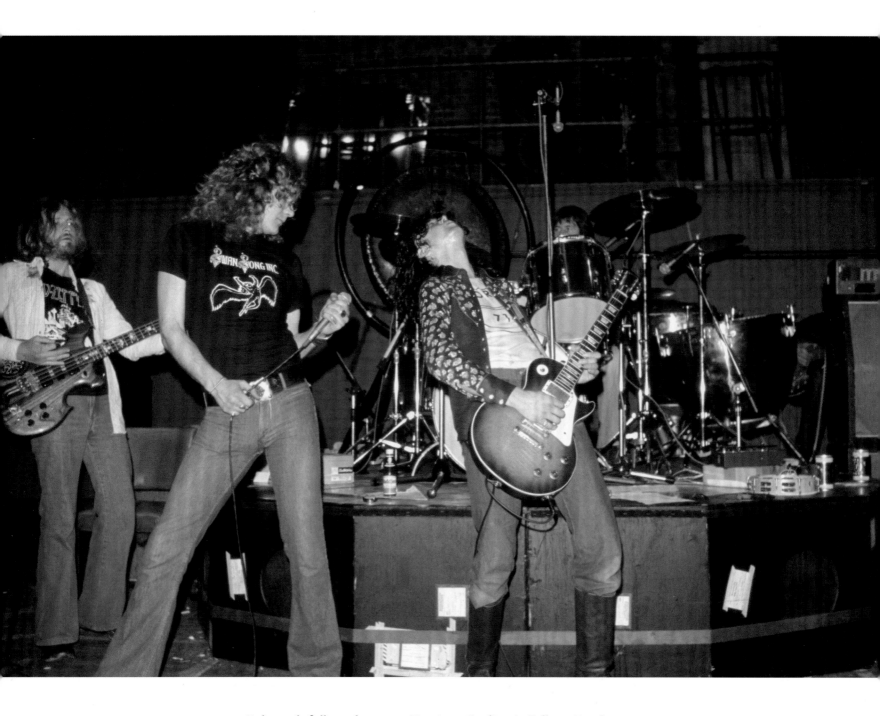

Rehearsals fully underway at Manticore Studios, in Fulham, London,
in preparation for the 1977 US tour.

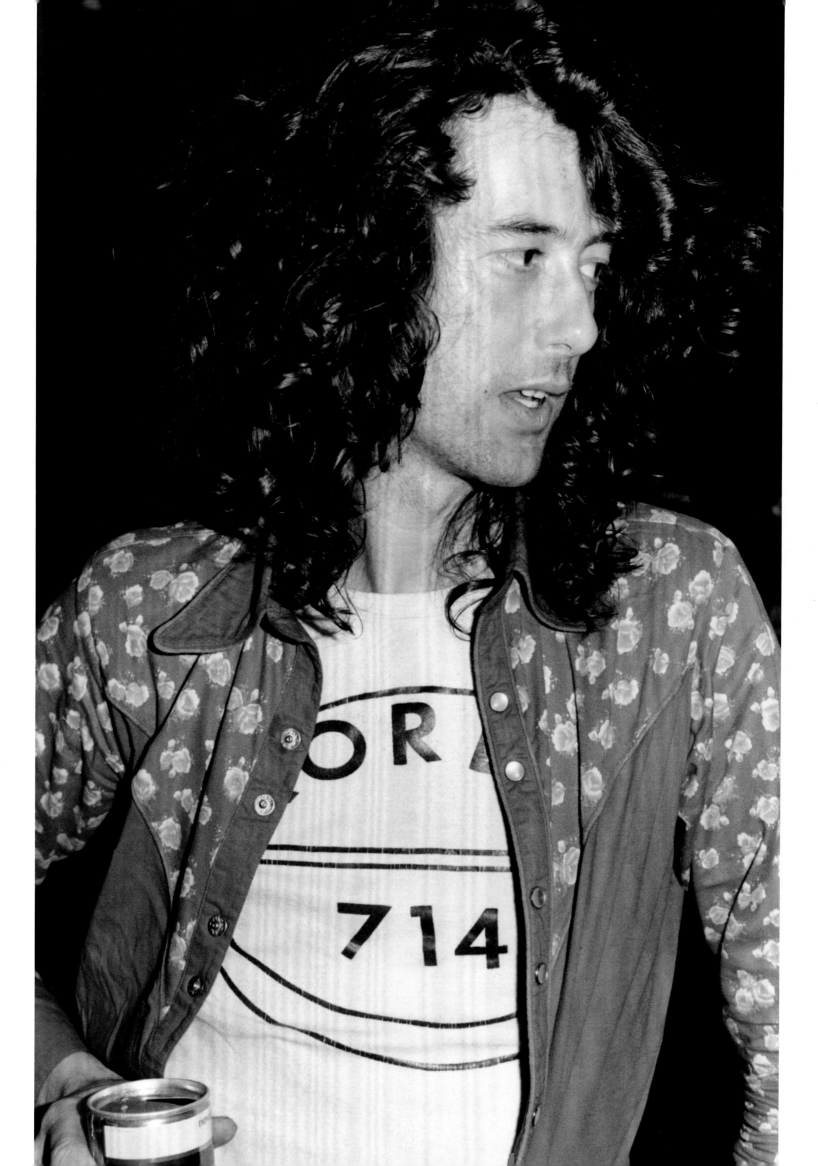

LED-ZEPPELIN

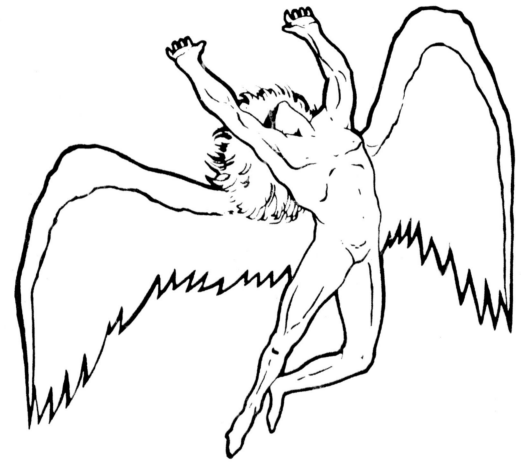

UNITED STATES OF AMERICA 1977

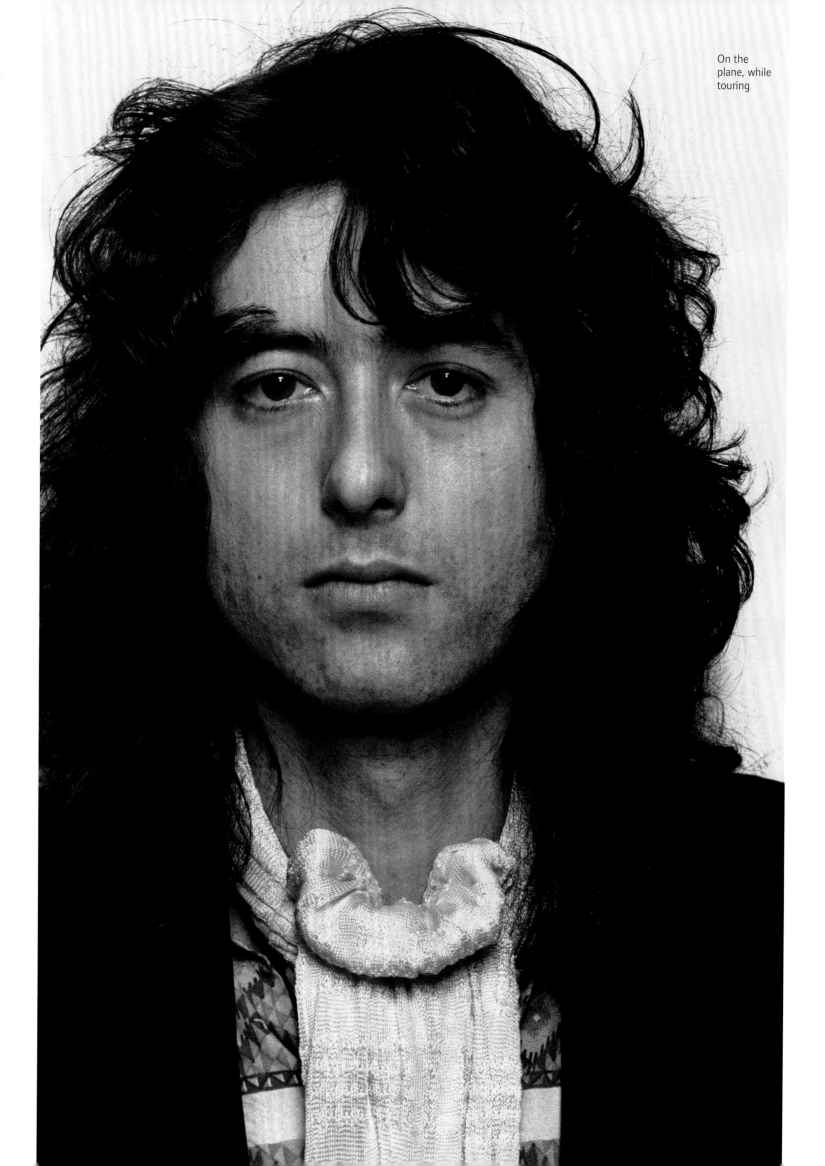

On the
plane, while
touring

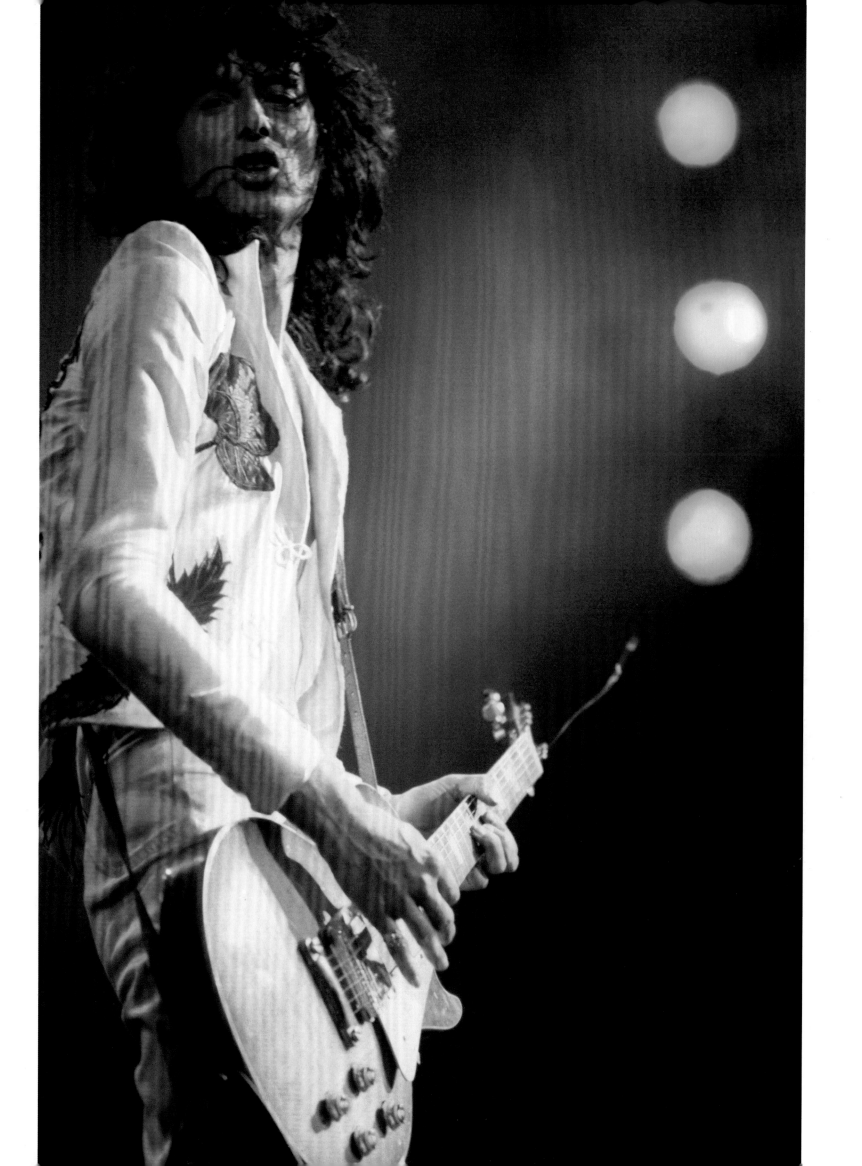

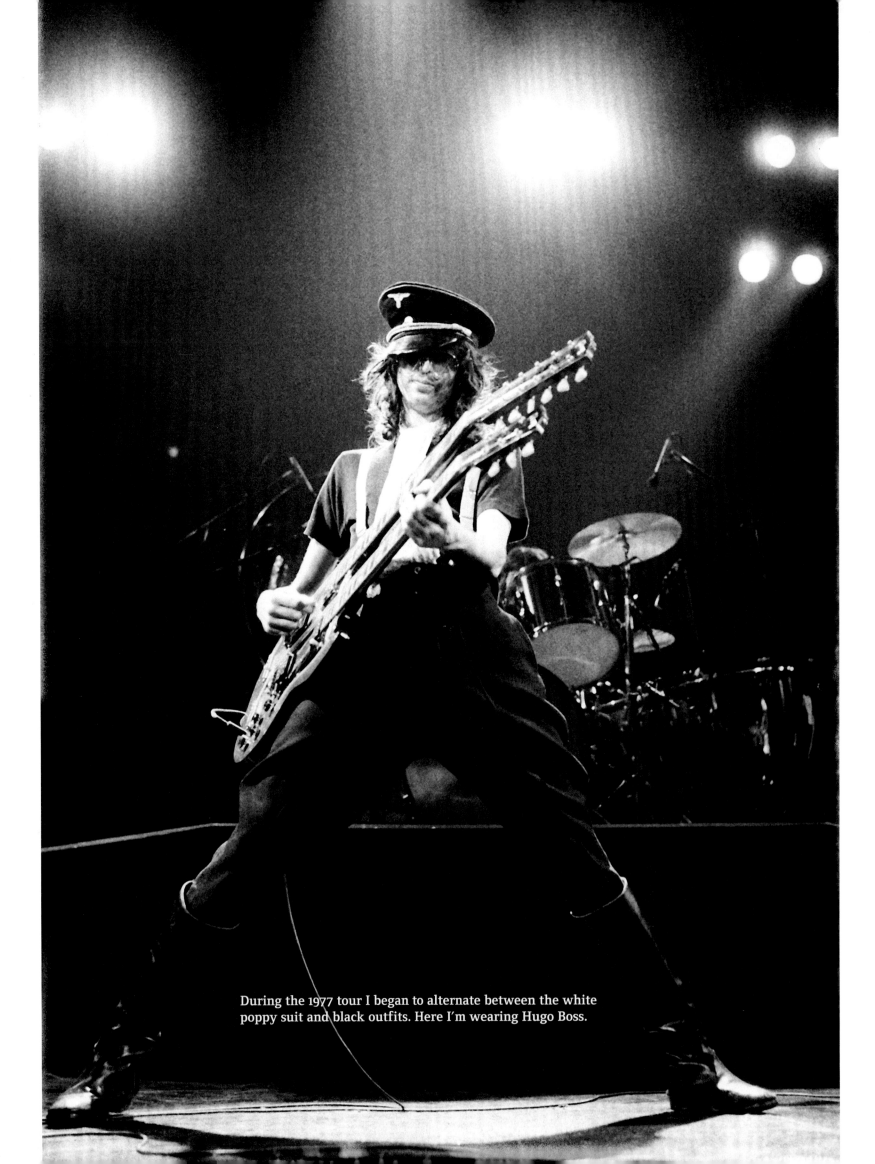

During the 1977 tour I began to alternate between the white poppy suit and black outfits. Here I'm wearing Hugo Boss.

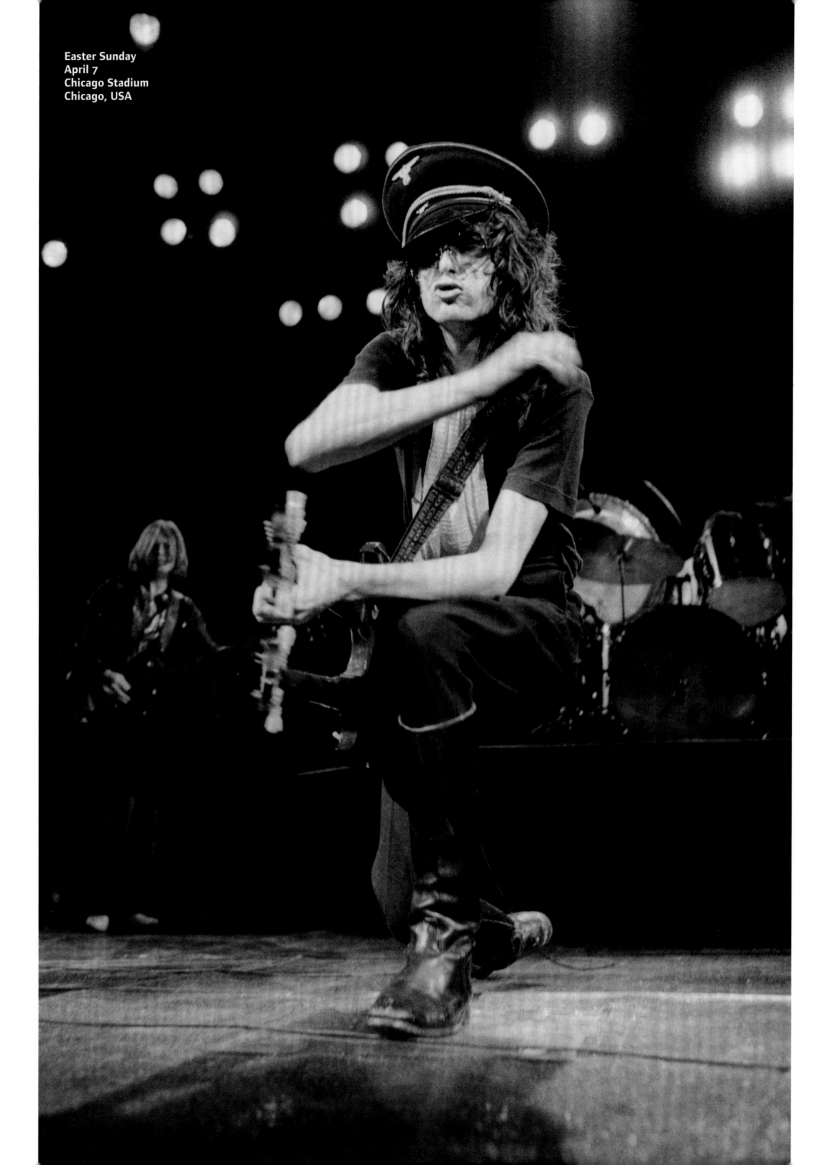

1977

Start of eleventh American tour

April 1: Memorial Auditorium, Dallas, USA
April 3: The Myriad, Oklahoma City, USA
April 6: Chicago Stadium, Chicago, USA
April 7: Chicago Stadium, Chicago, USA
April 9: Chicago Stadium, Chicago, USA
April 10: Chicago Stadium, Chicago, USA
April 12: Met Center, Minneapolis, USA
April 13: Civic Center, St Paul, USA
April 15: St Louis Arena, St Louis, USA
April 17: Market Square Arena, Indianapolis, USA
April 19: Riverfront Coliseum, Cincinnati, USA
April 20: Riverfront Coliseum, Cincinnati, USA
April 23: The Omni, Atlanta, USA
April 25: Freedom Hall, Kentucky Fair & Expo Center, Louisville, USA
April 27: Richfield Coliseum, Cleveland, USA
April 28: Richfield Coliseum, Cleveland, USA
April 30: Pontiac Silverdome, Pontiac, USA

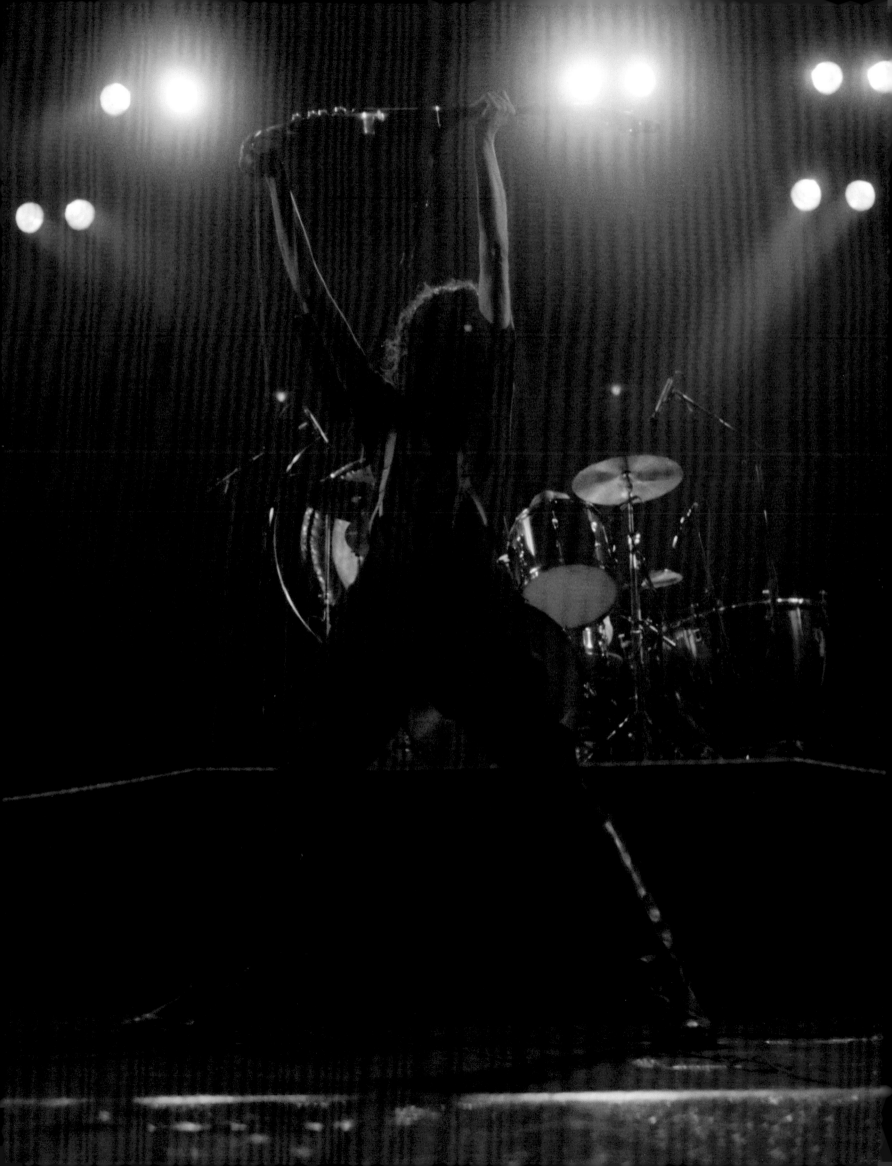

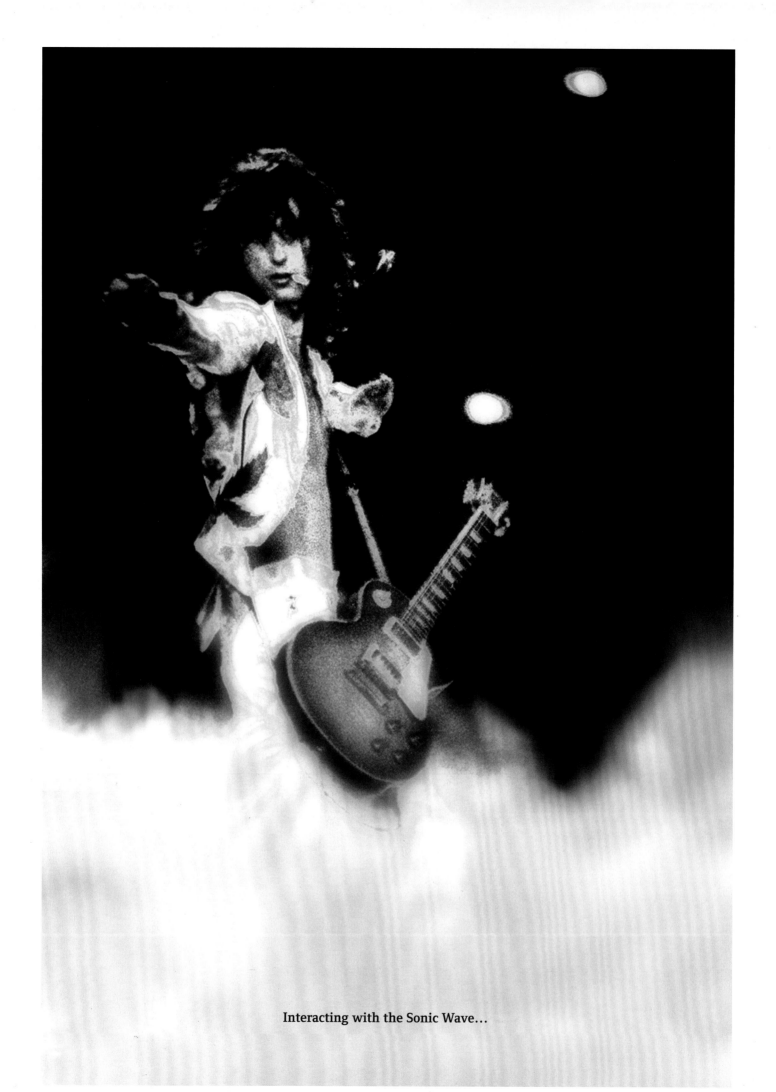

Interacting with the Sonic Wave...

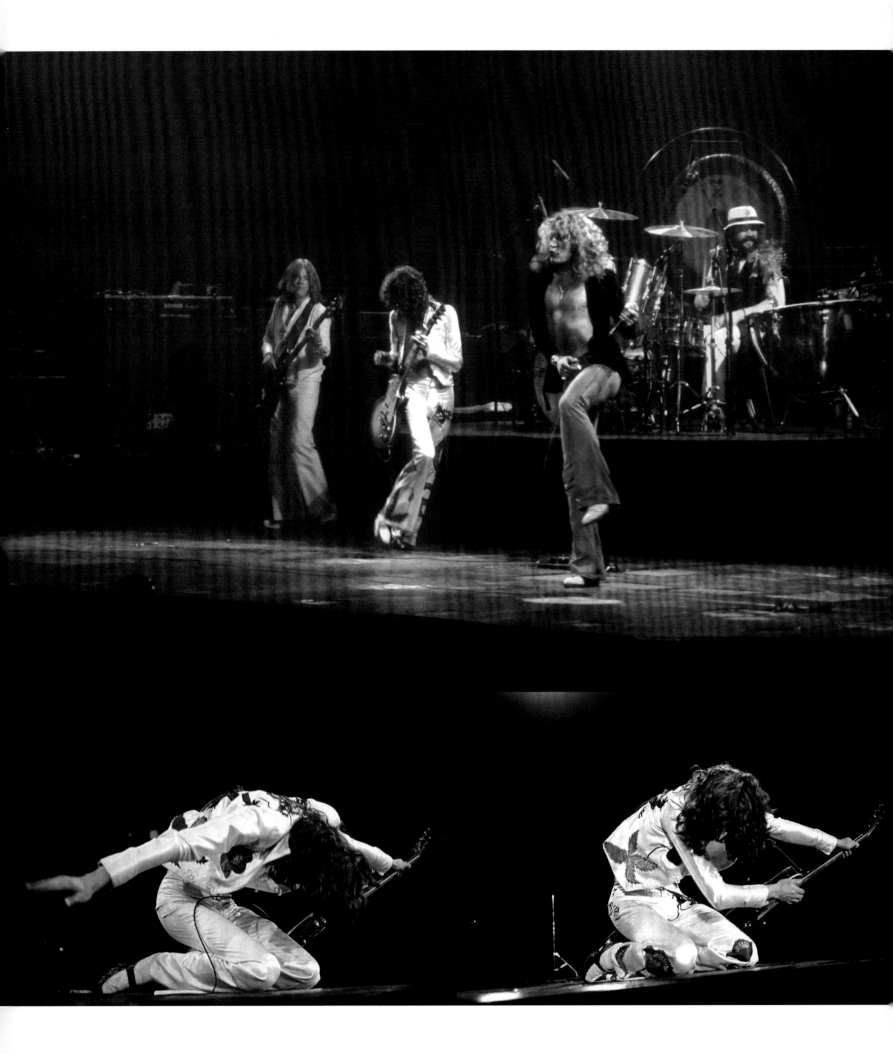

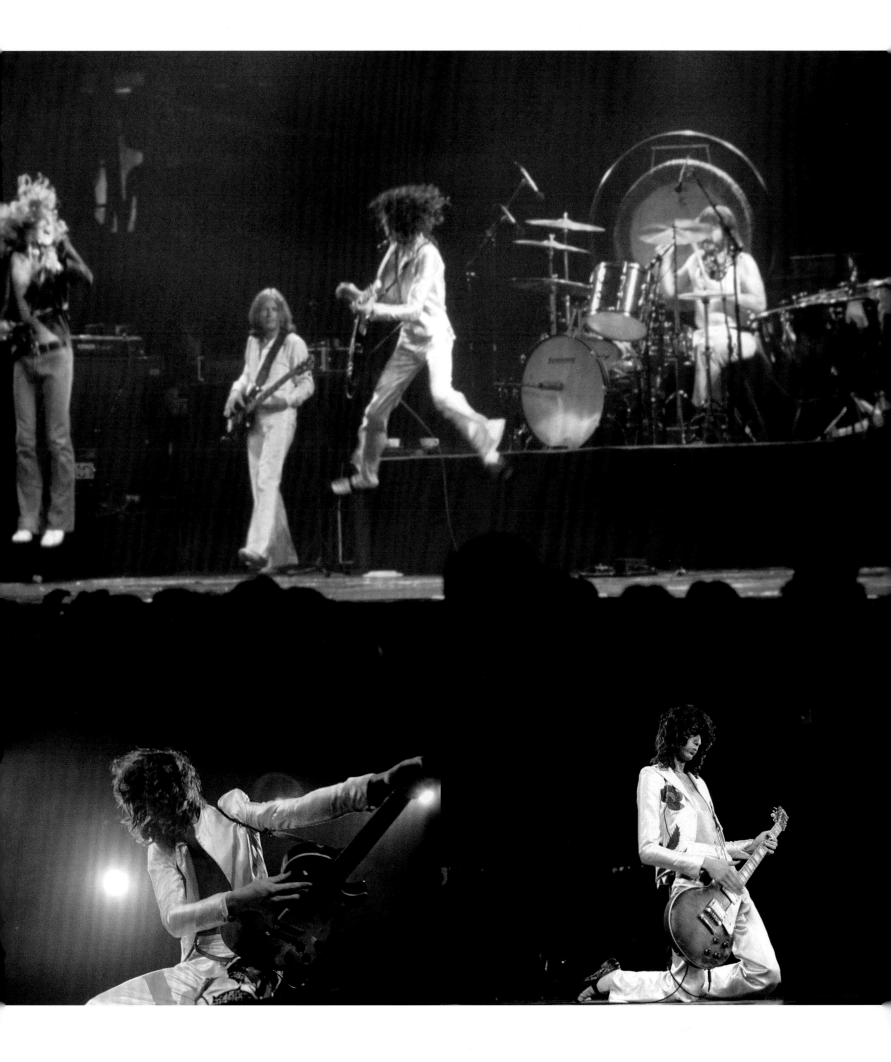

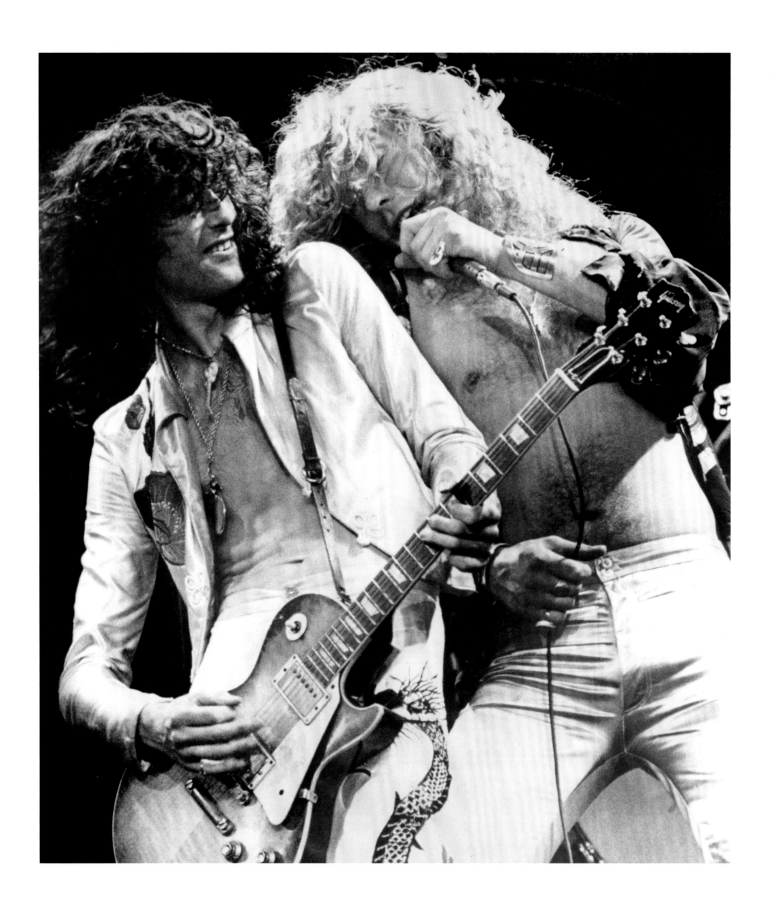

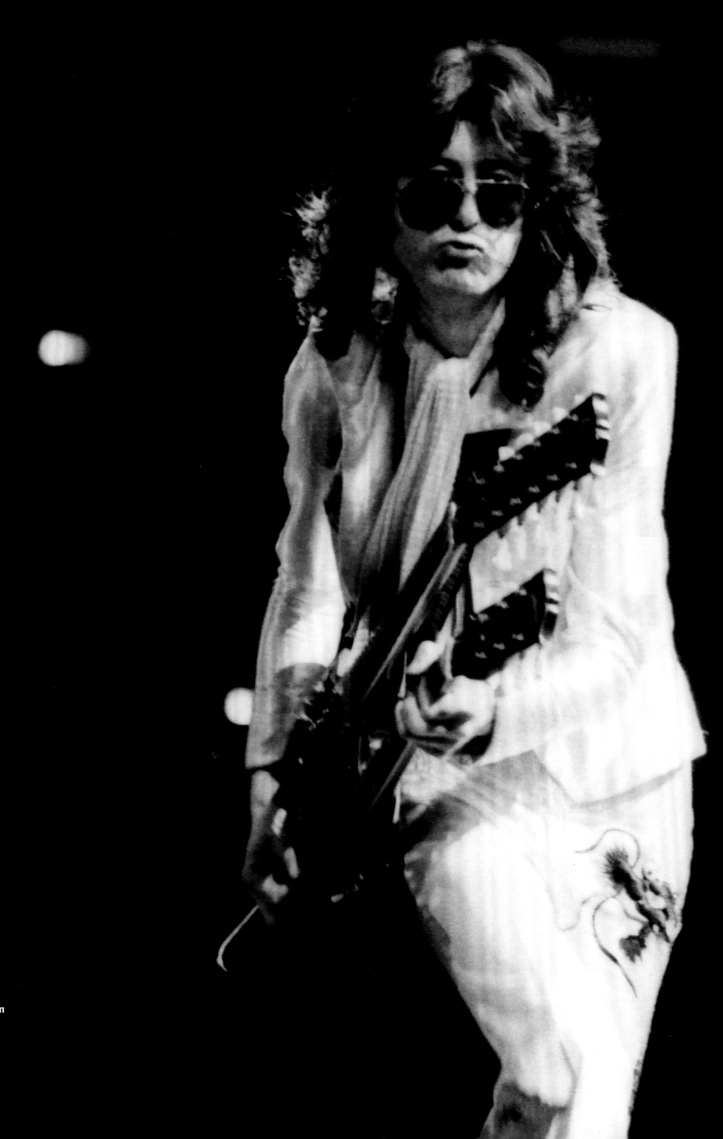

April 27
Richfield Coliseum
Cleveland, USA

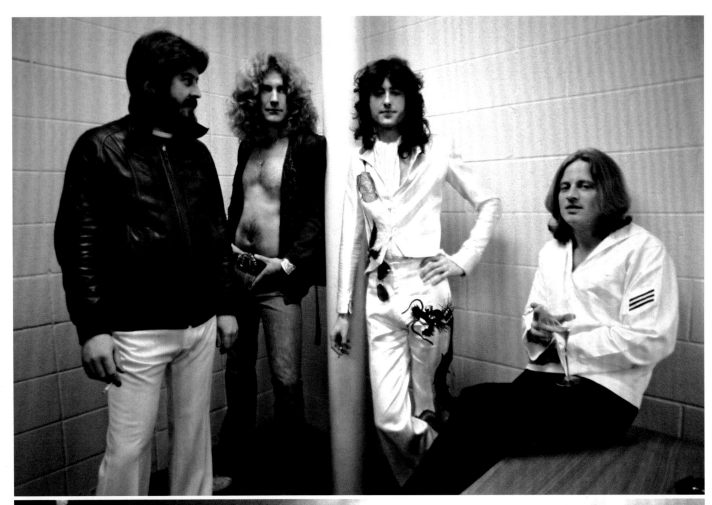

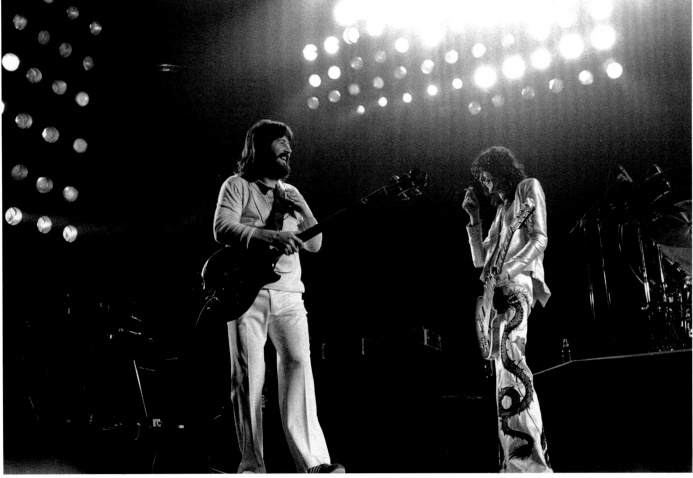

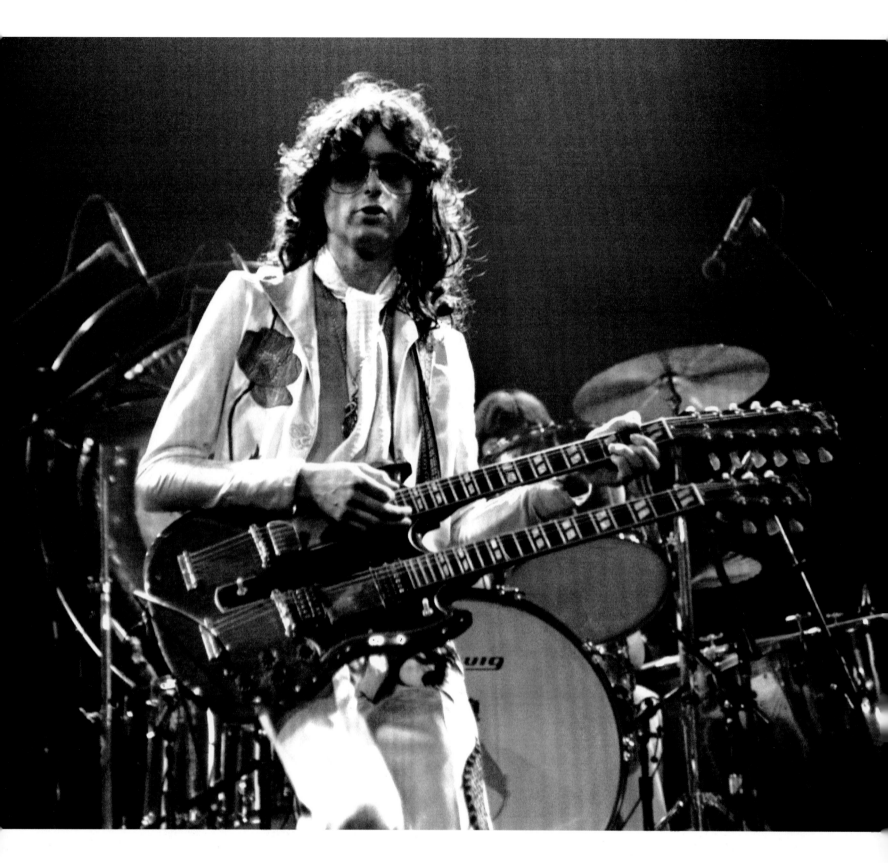

Opposite:
April 30
Pontiac Silverdome
Pontiac, USA

June 10, 11, 13 & 14
Madison Square Garden
New York, USA

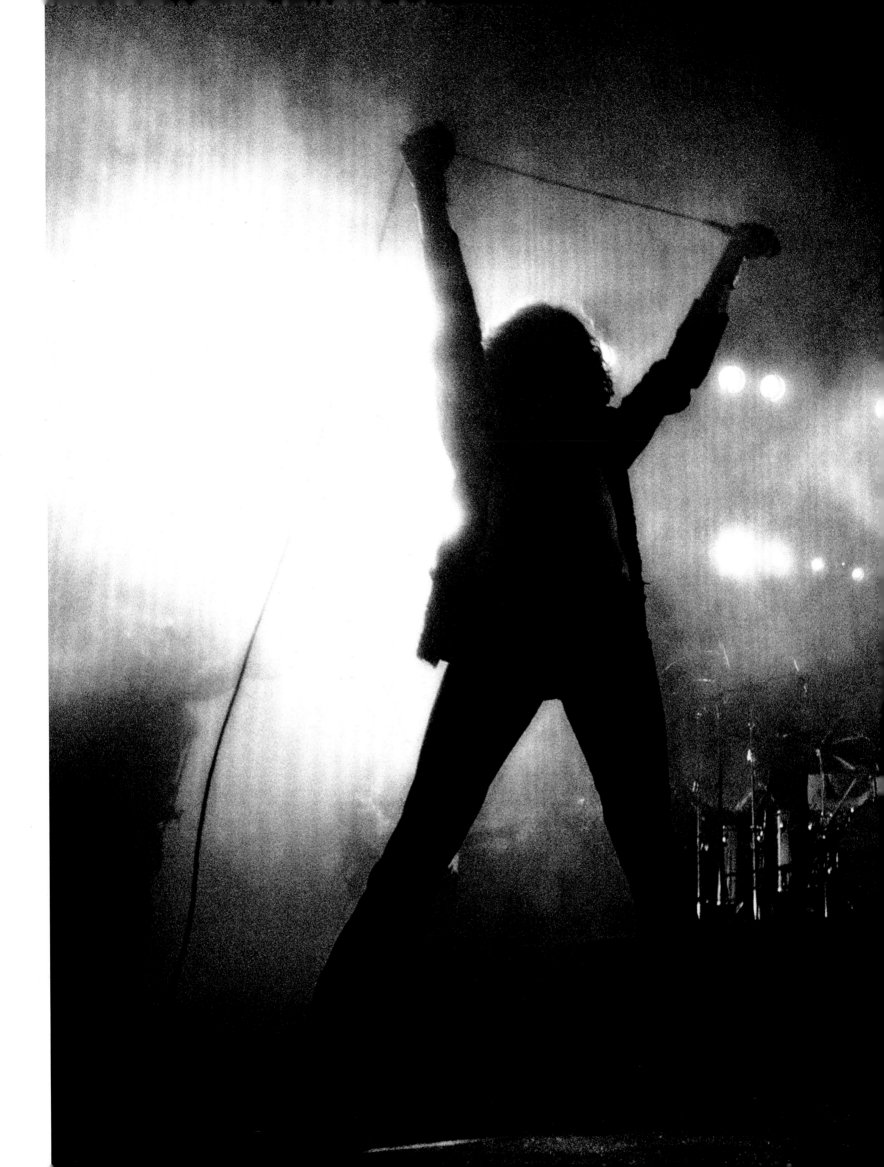

The Pontiac Silverdome was a large inflated structure and you had to walk through an airlock to get to the stage; there were 70,000 people indoors. We had the largest screen that was available at that time for back projection – that was useful in such a gigantic space so the audience at the back could get some idea of what was going on onstage.

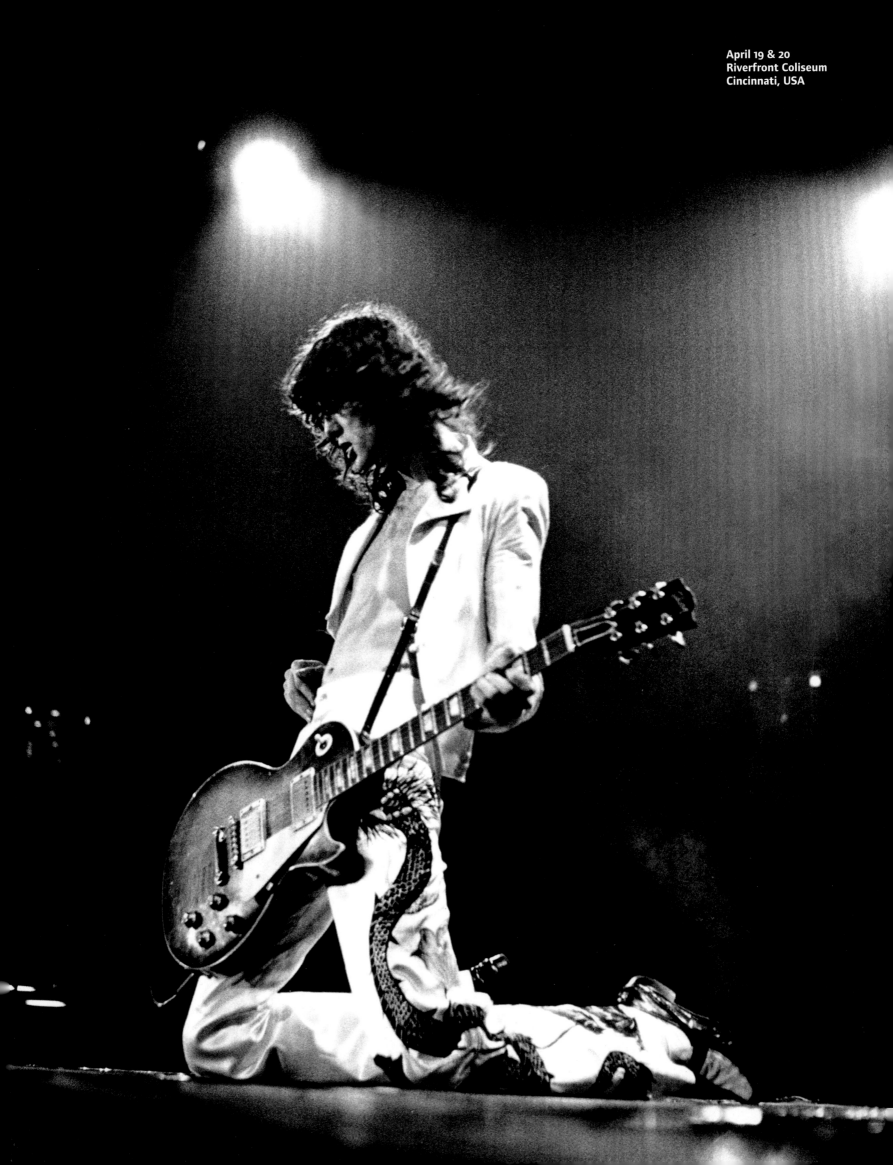

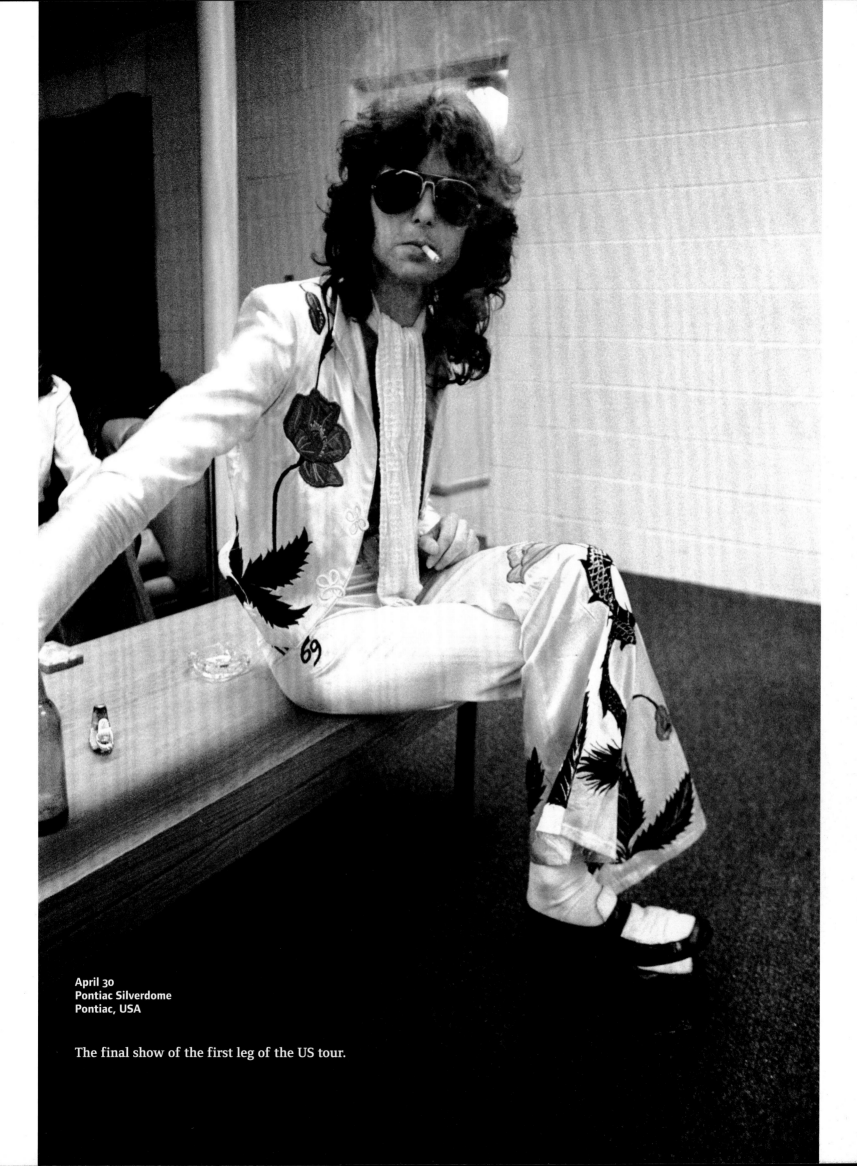

April 30
Pontiac Silverdome
Pontiac, USA

The final show of the first leg of the US tour.

Between the first and second leg of the 1977 tour
I visited and spent time in Egypt.

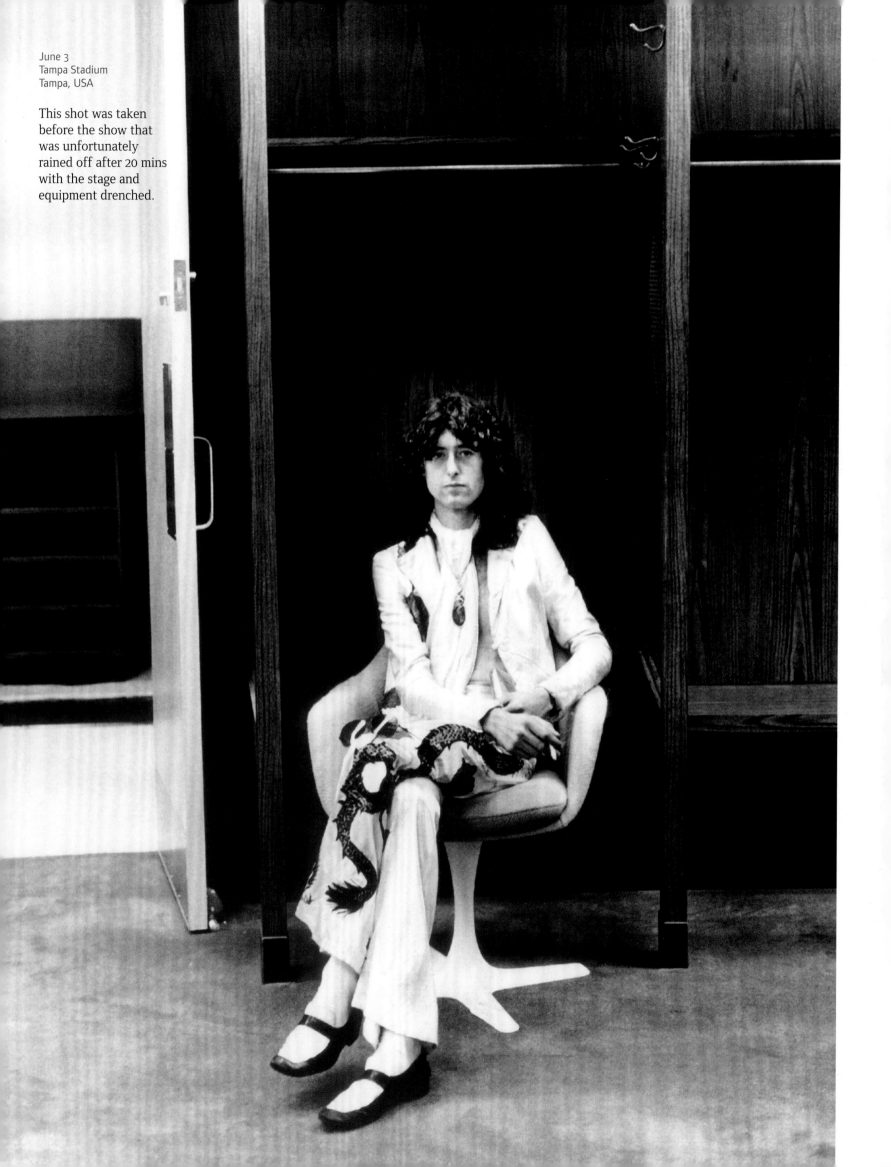

June 3
Tampa Stadium
Tampa, USA

This shot was taken before the show that was unfortunately rained off after 20 mins with the stage and equipment drenched.

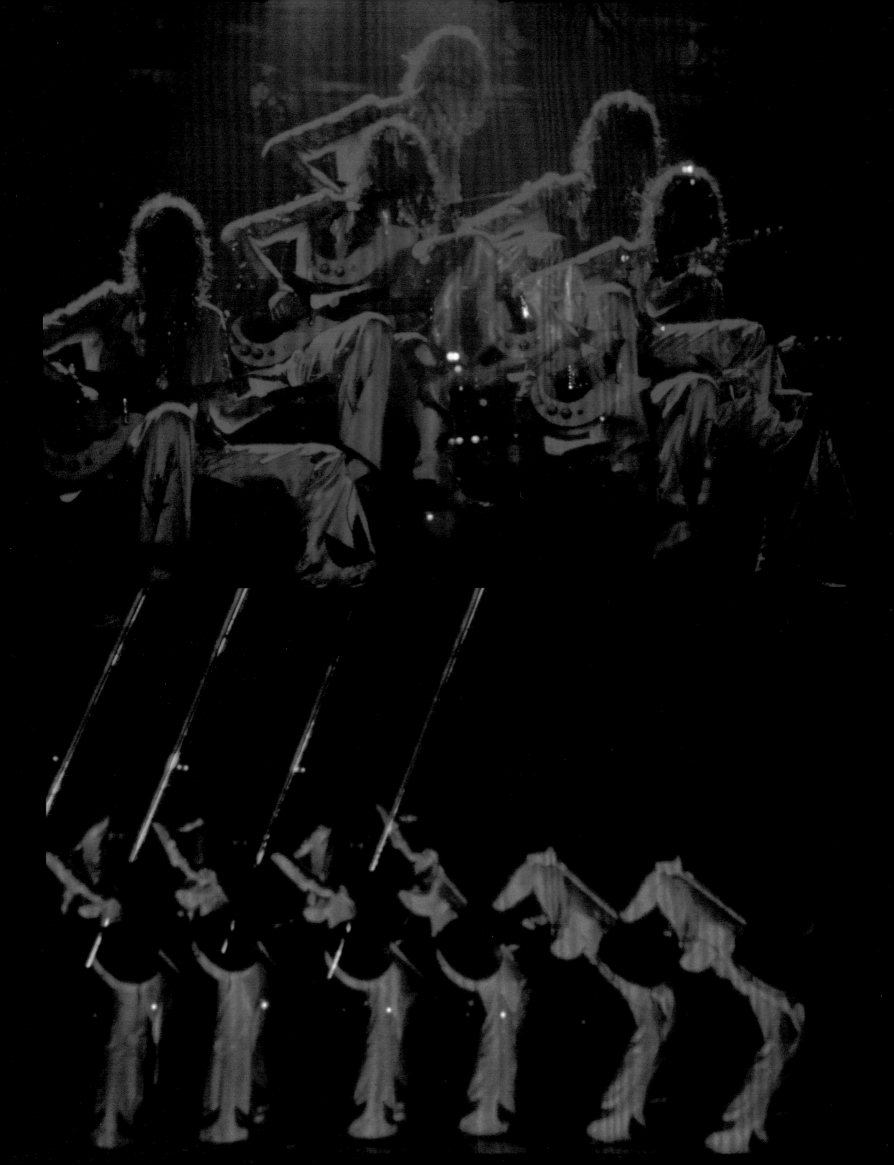

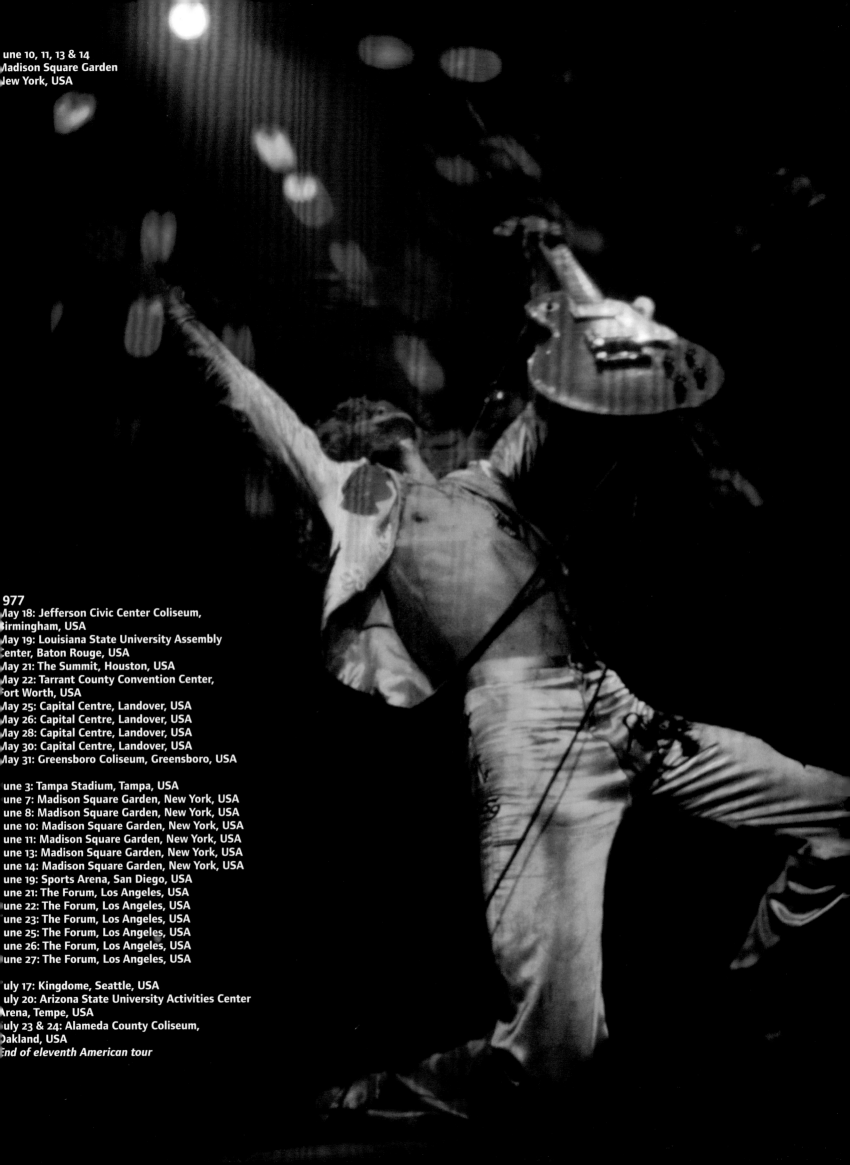

June 10, 11, 13 & 14
Madison Square Garden
New York, USA

1977
May 18: Jefferson Civic Center Coliseum,
Birmingham, USA
May 19: Louisiana State University Assembly
Center, Baton Rouge, USA
May 21: The Summit, Houston, USA
May 22: Tarrant County Convention Center,
Fort Worth, USA
May 25: Capital Centre, Landover, USA
May 26: Capital Centre, Landover, USA
May 28: Capital Centre, Landover, USA
May 30: Capital Centre, Landover, USA
May 31: Greensboro Coliseum, Greensboro, USA

June 3: Tampa Stadium, Tampa, USA
June 7: Madison Square Garden, New York, USA
June 8: Madison Square Garden, New York, USA
June 10: Madison Square Garden, New York, USA
June 11: Madison Square Garden, New York, USA
June 13: Madison Square Garden, New York, USA
June 14: Madison Square Garden, New York, USA
June 19: Sports Arena, San Diego, USA
June 21: The Forum, Los Angeles, USA
June 22: The Forum, Los Angeles, USA
June 23: The Forum, Los Angeles, USA
June 25: The Forum, Los Angeles, USA
June 26: The Forum, Los Angeles, USA
June 27: The Forum, Los Angeles, USA

July 17: Kingdome, Seattle, USA
July 20: Arizona State University Activities Center
Arena, Tempe, USA
July 23 & 24: Alameda County Coliseum,
Oakland, USA
End of eleventh American tour

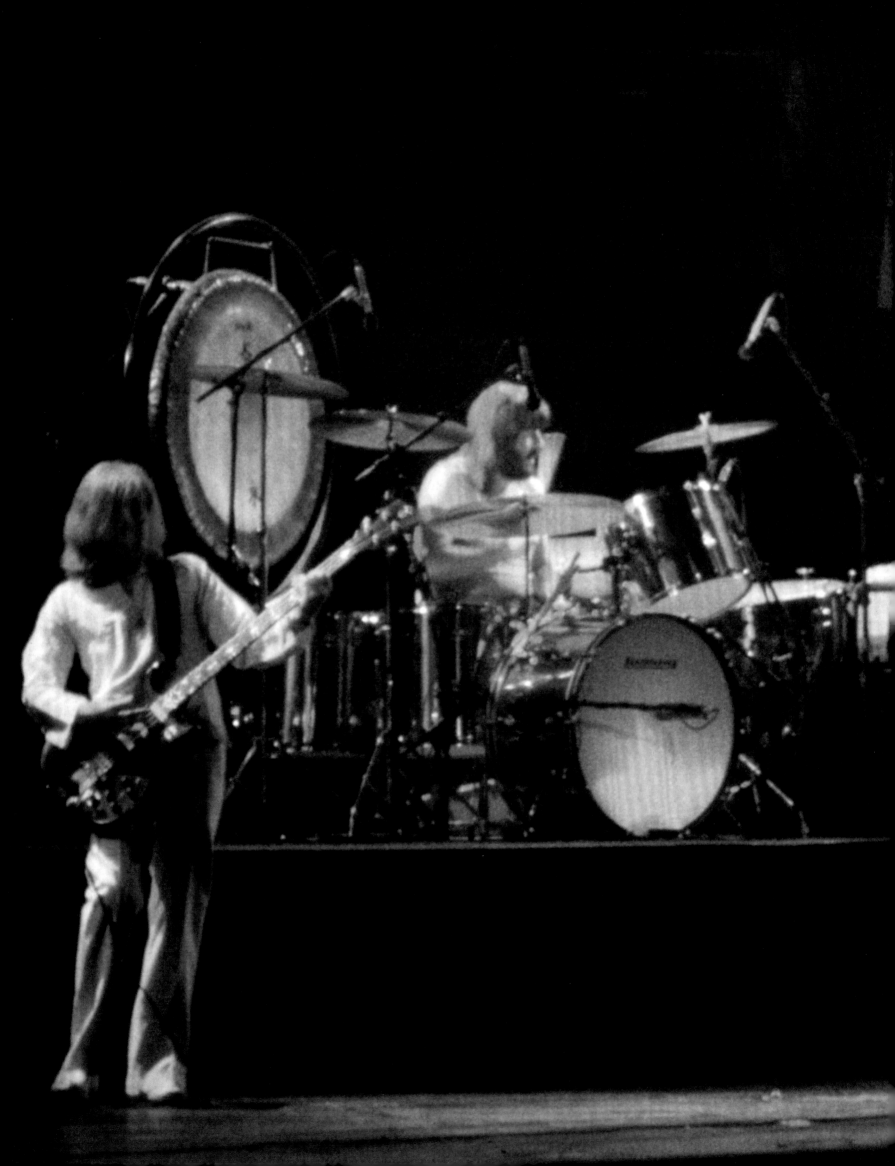

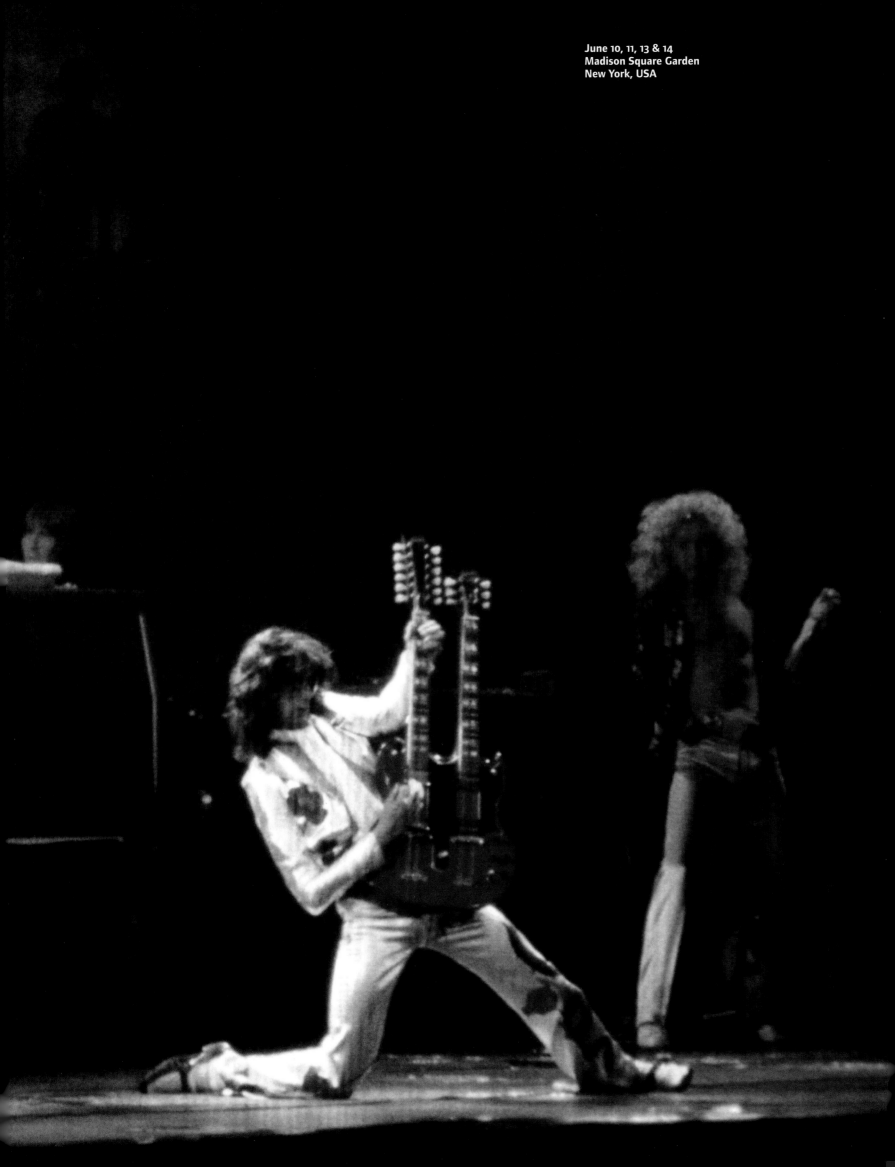

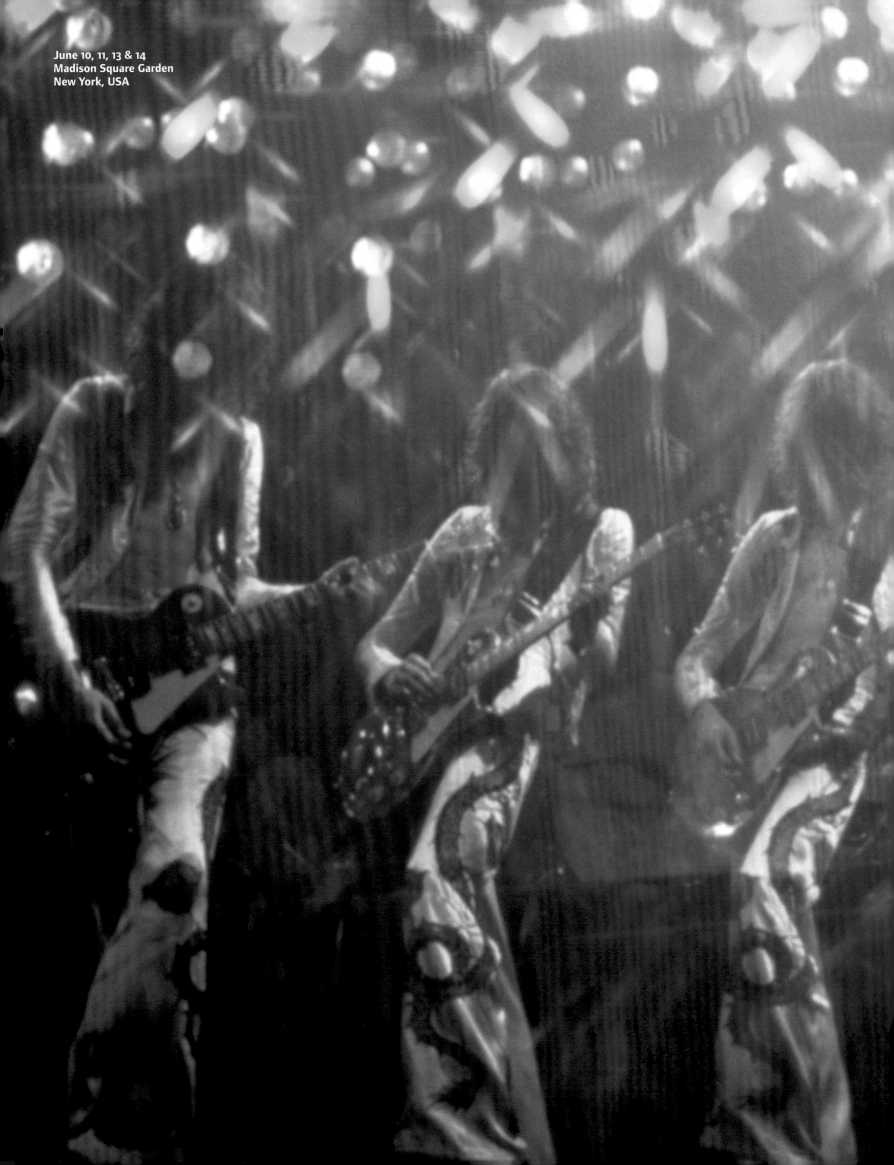

June 10, 11, 13 & 14
Madison Square Garden
New York, USA

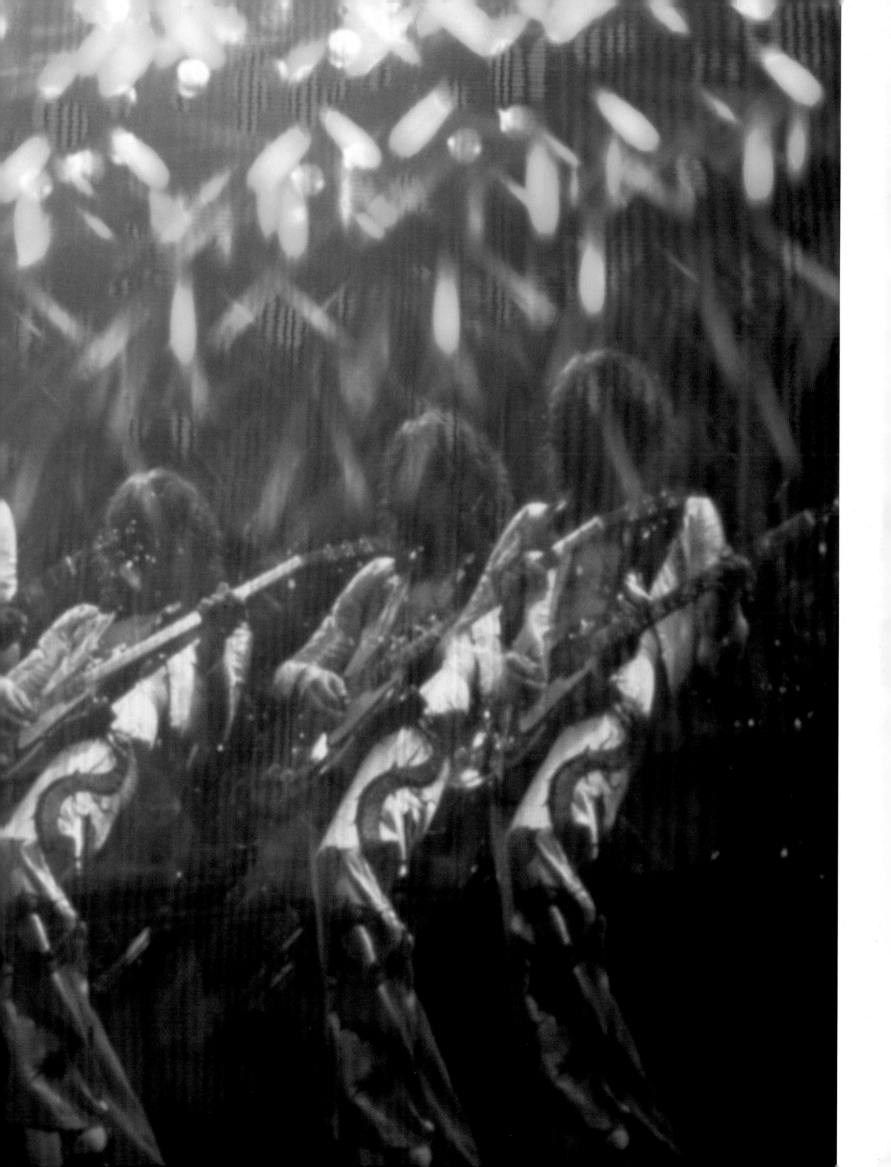

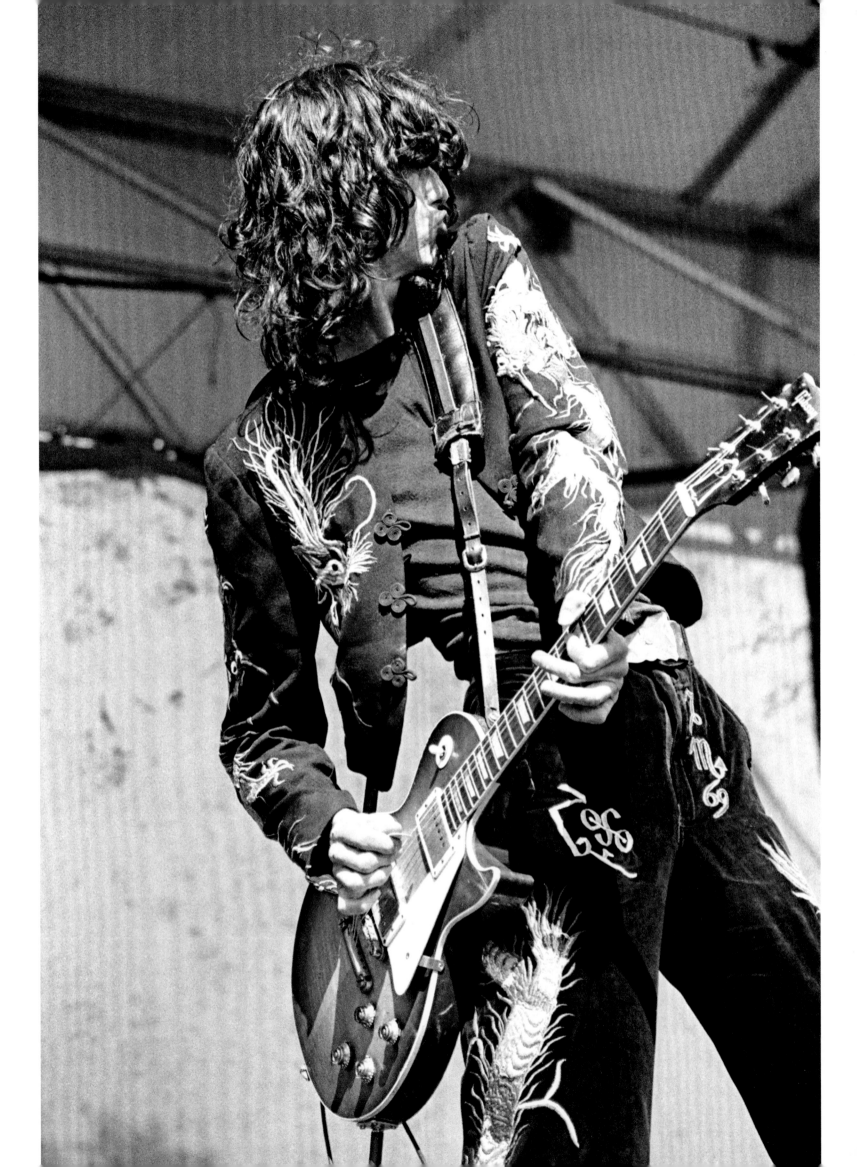

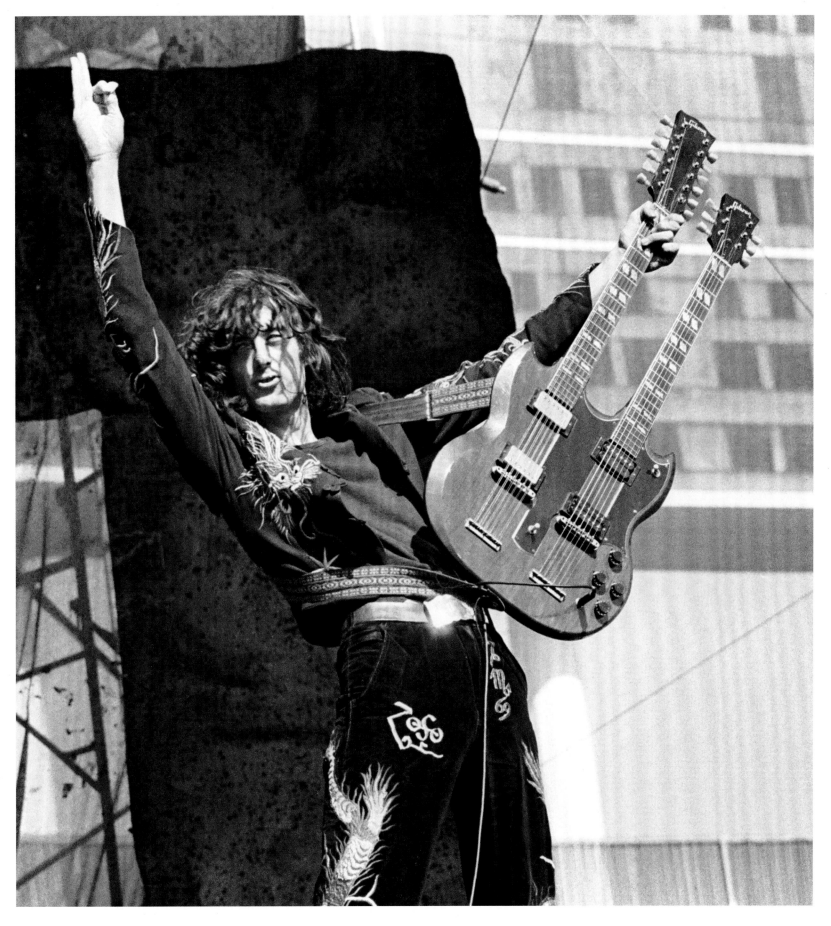

July 23
Alameda
County Coliseum
Oakland, USA

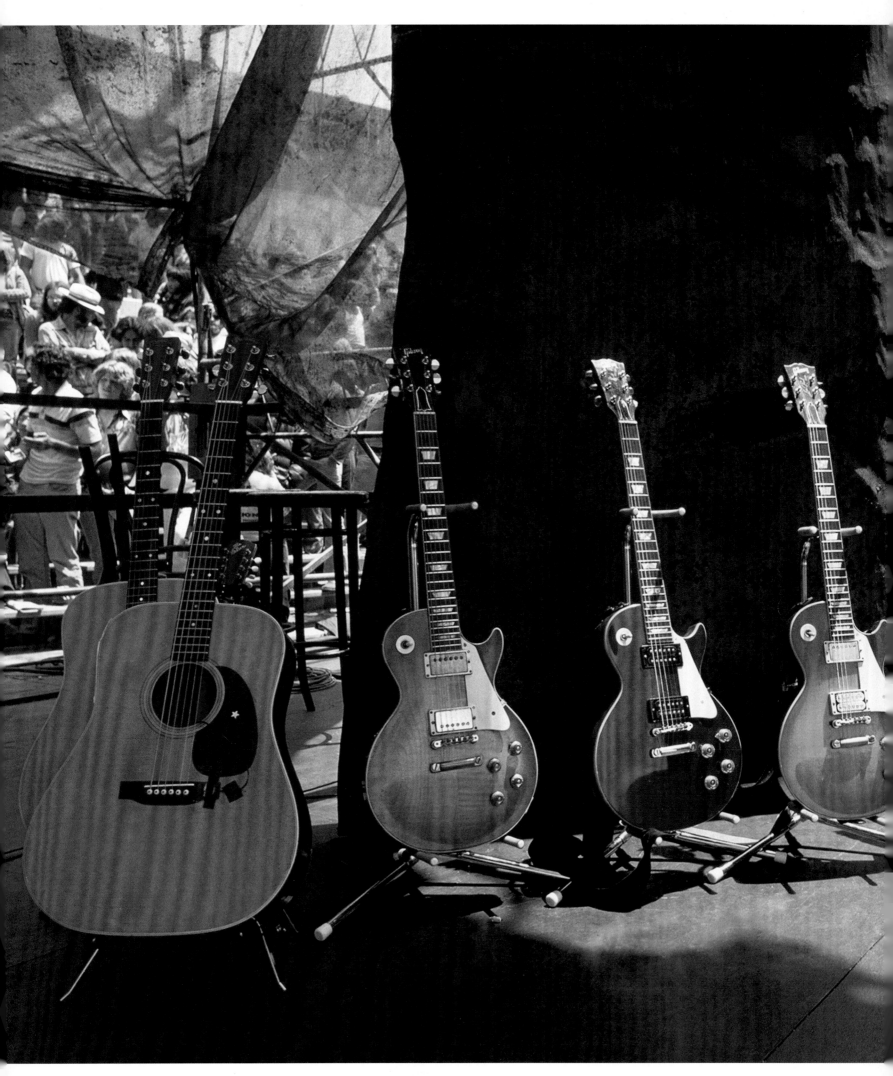

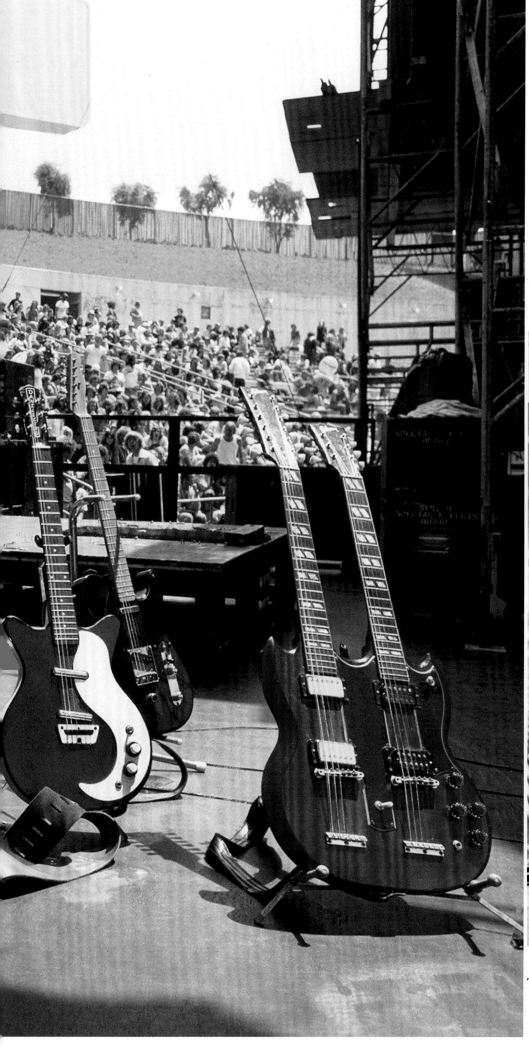

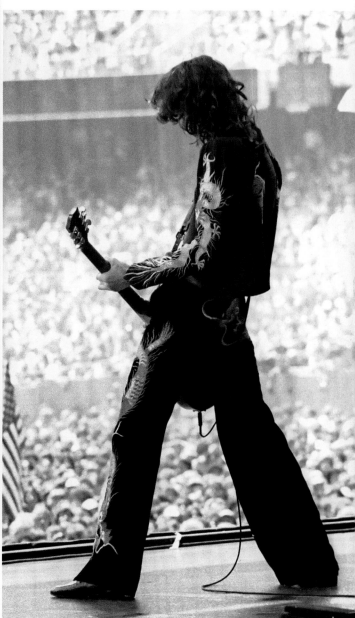

The main artillery of the guitar army.

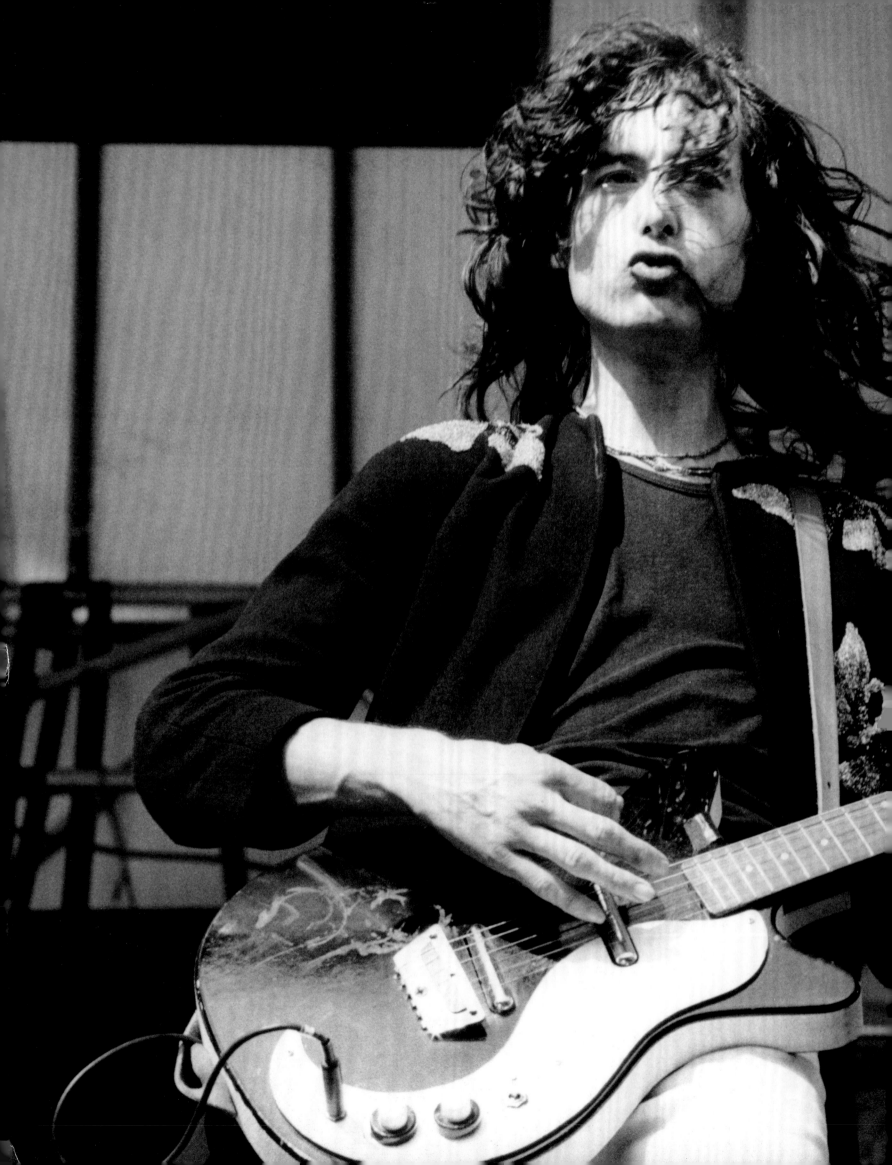

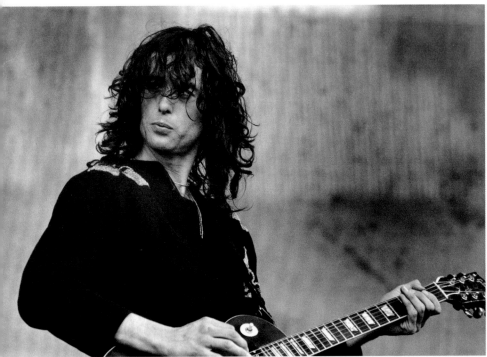

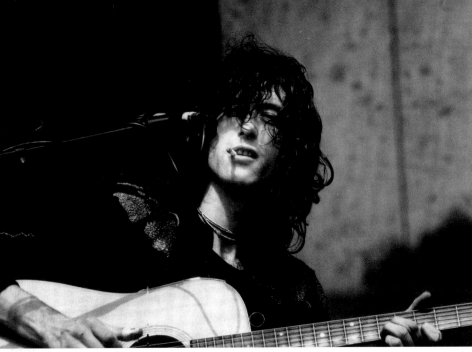

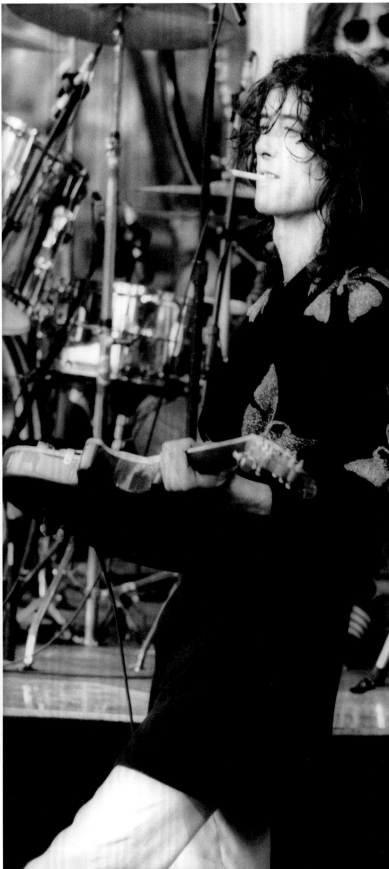

July 24
Alameda
County Coliseum
Oakland, USA

Final shows of US tour

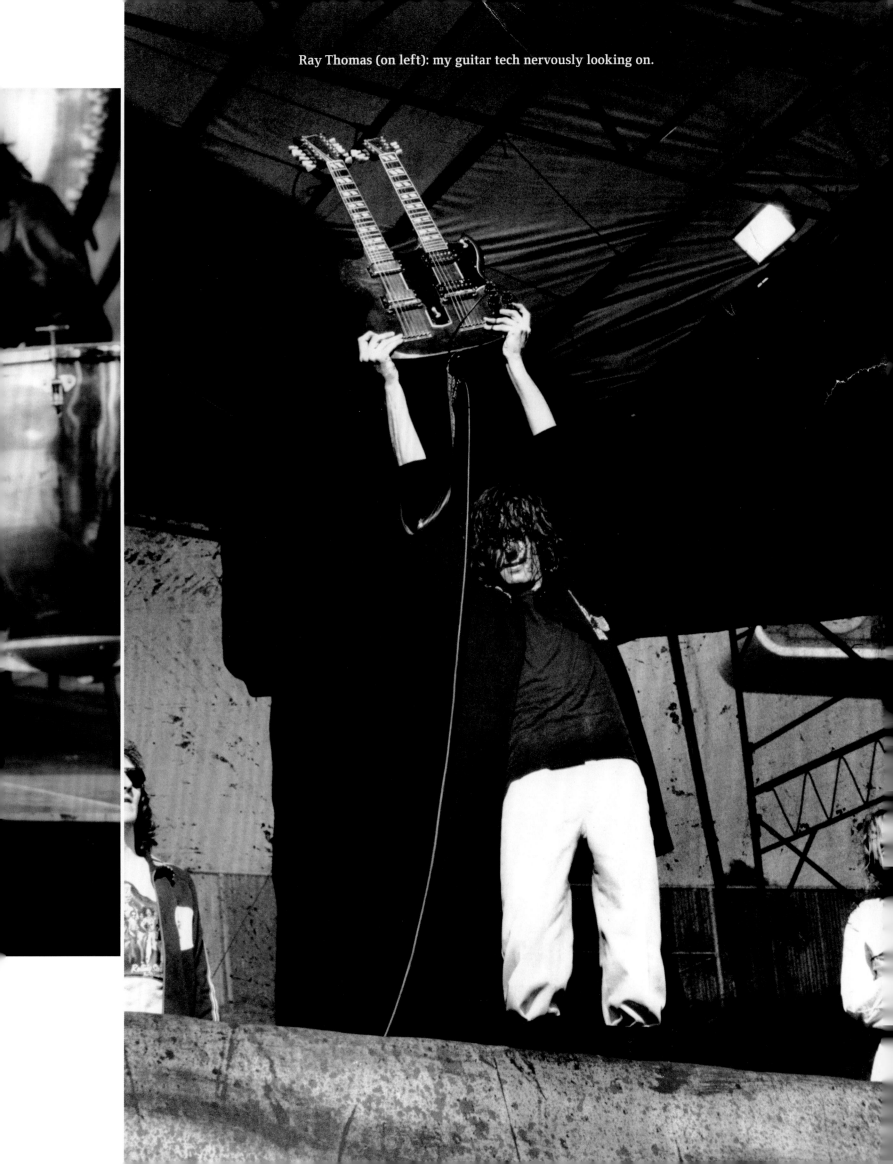

Ray Thomas (on left): my guitar tech nervously looking on.

The herb garden at the Swan Song office...

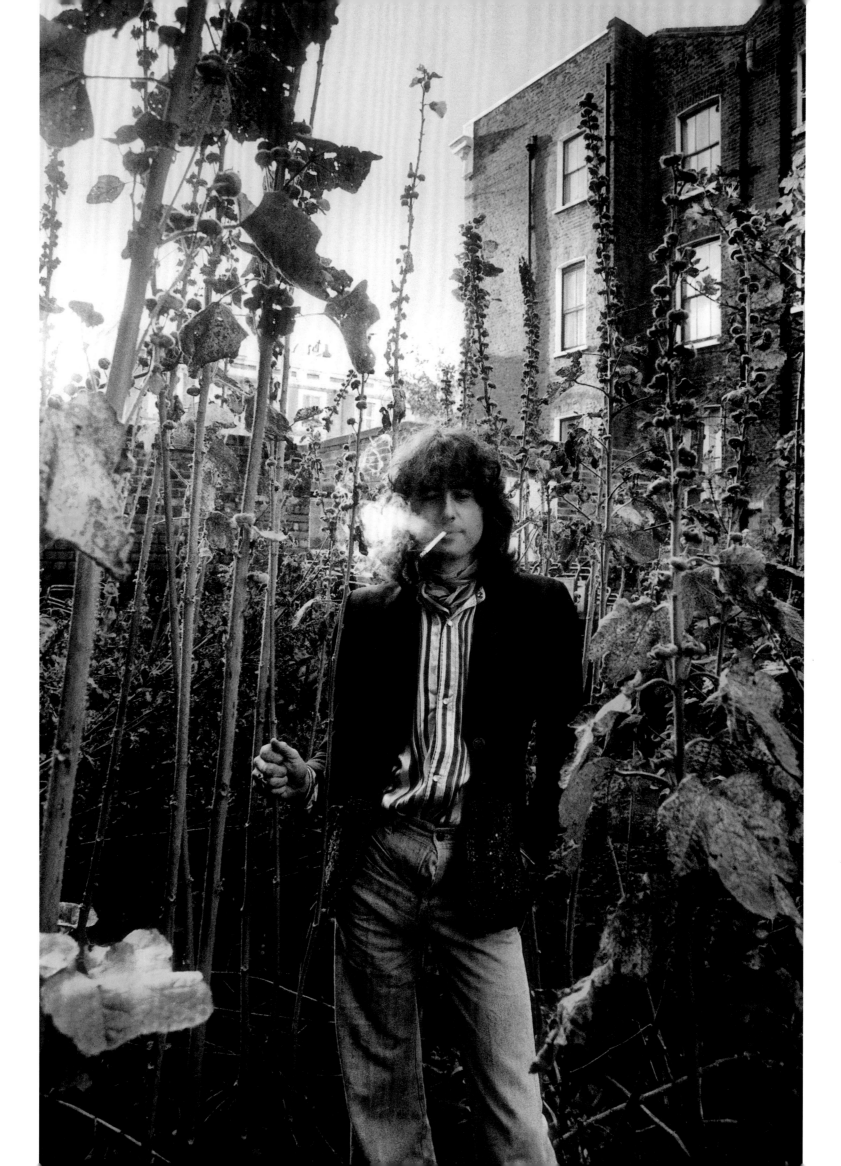

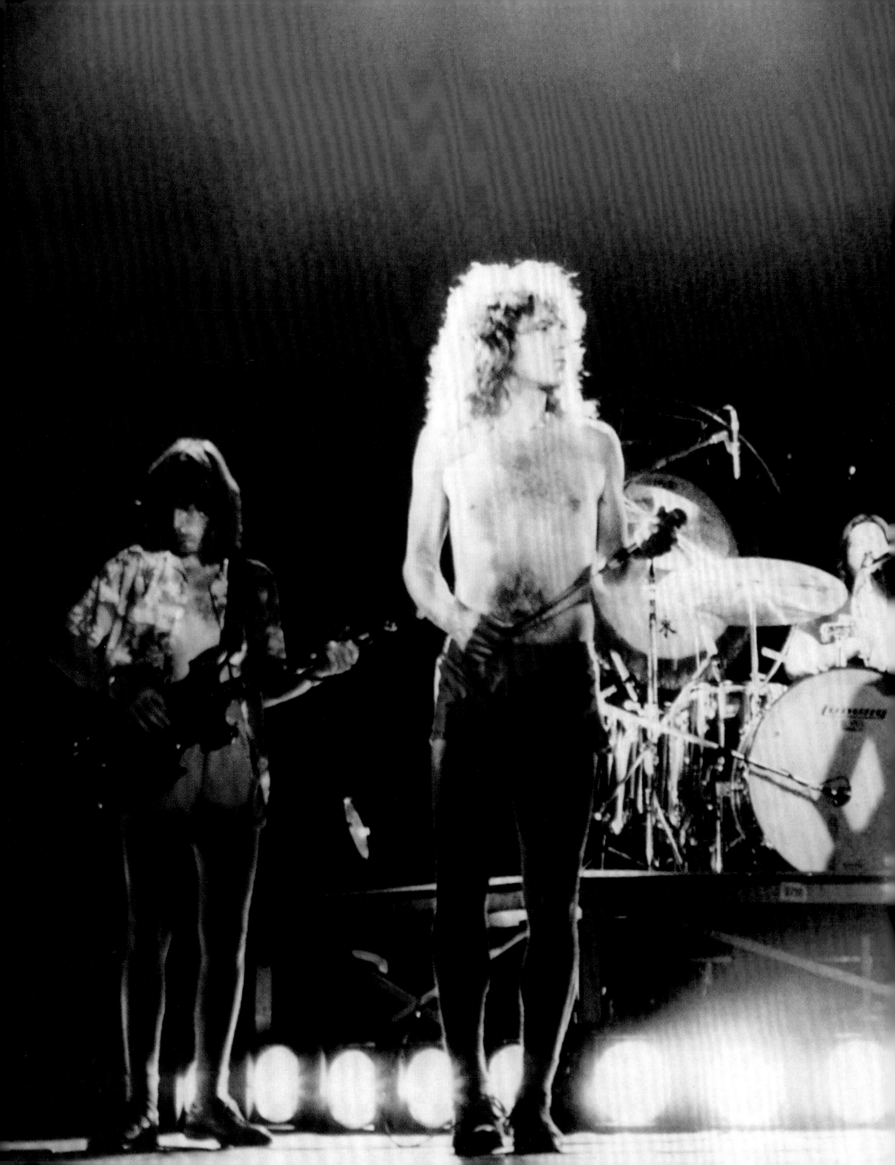

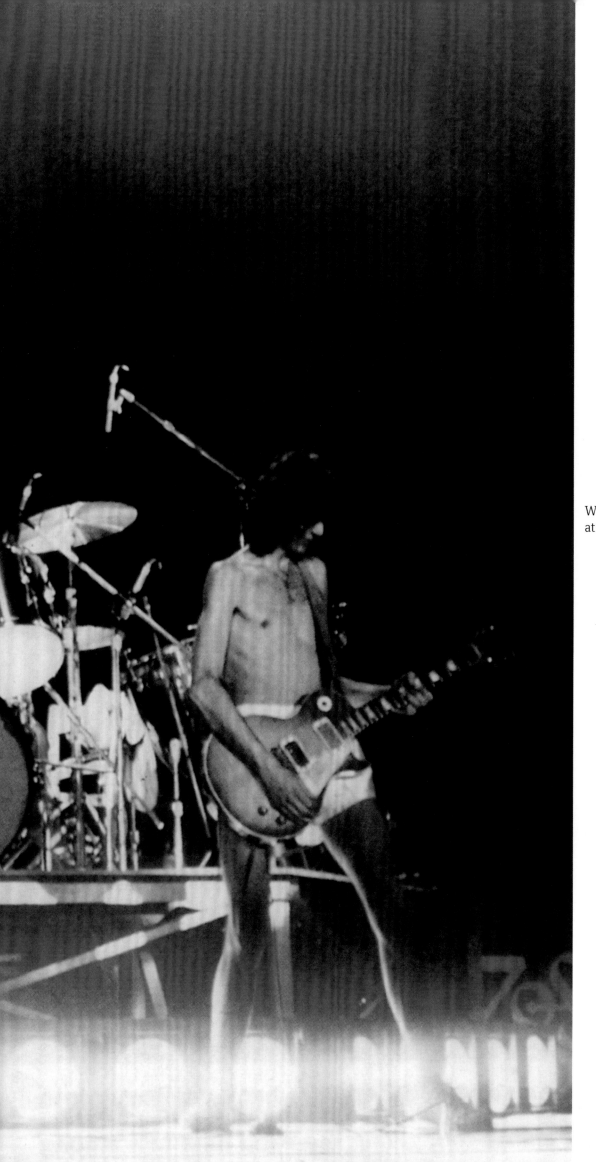

Warming up for Knebworth
at Bray Studios, Berkshire, UK.

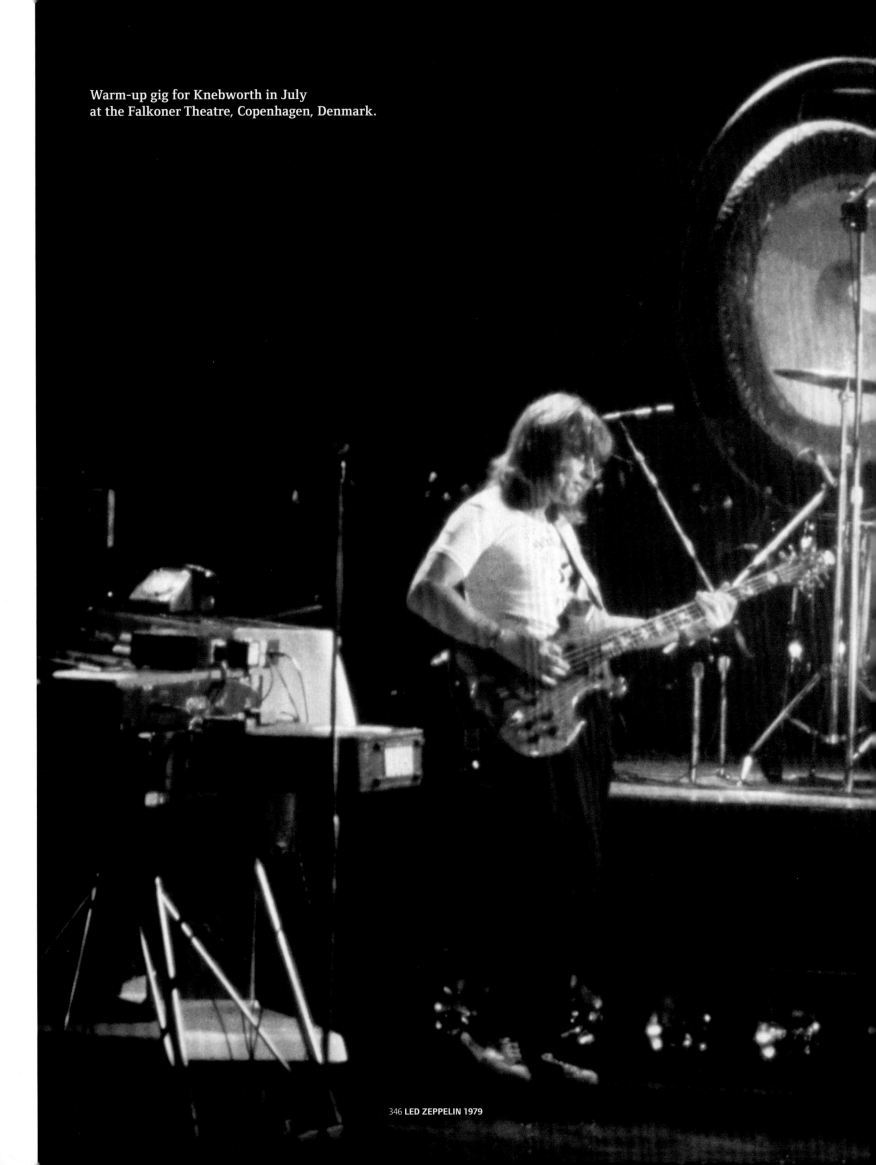

Warm-up gig for Knebworth in July
at the Falkoner Theatre, Copenhagen, Denmark.

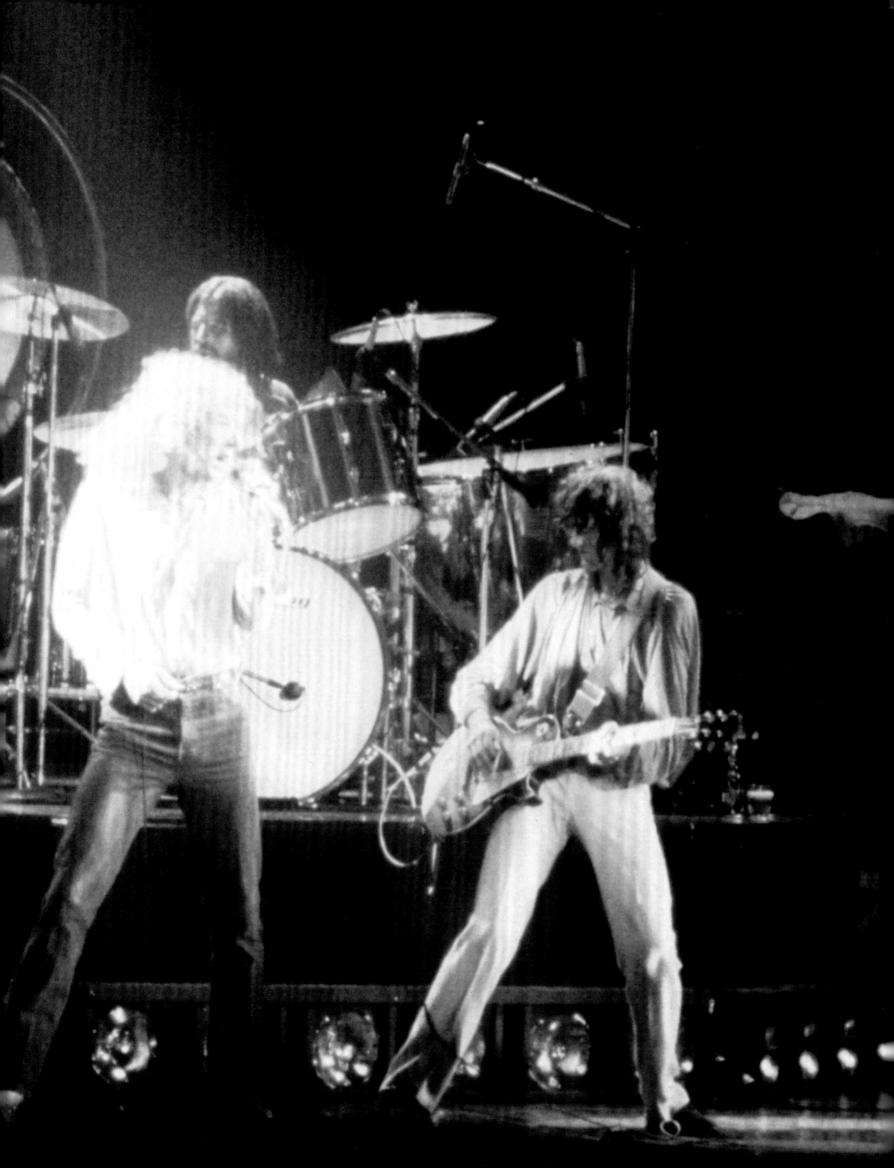

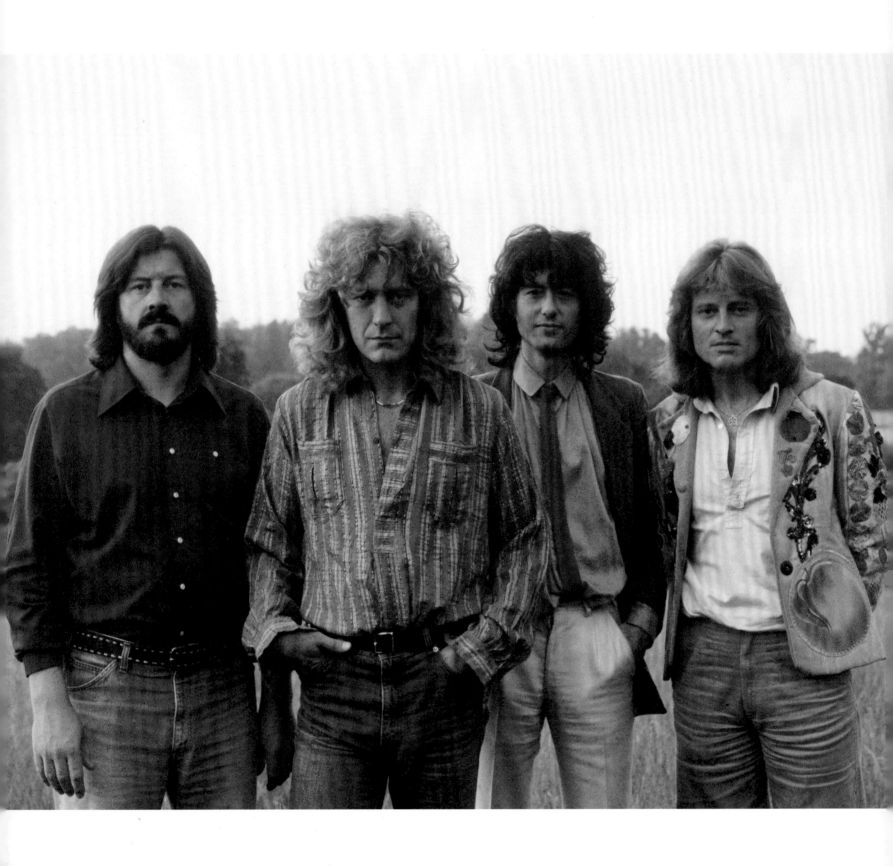

FREDERICK BANNISTER IN ASSOCIATION WITH PETER GRANT
PRESENTS

LED-ZEPPELIN

AT
KNEBWORTH 1979

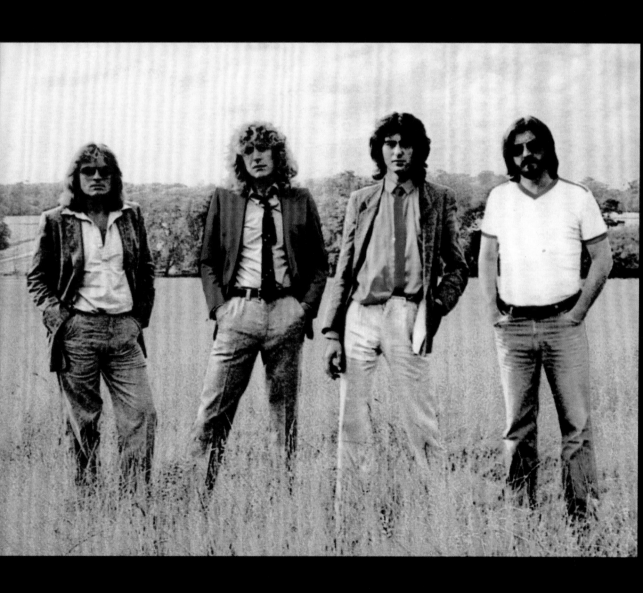

OFFICIAL PROGRAMME 90p

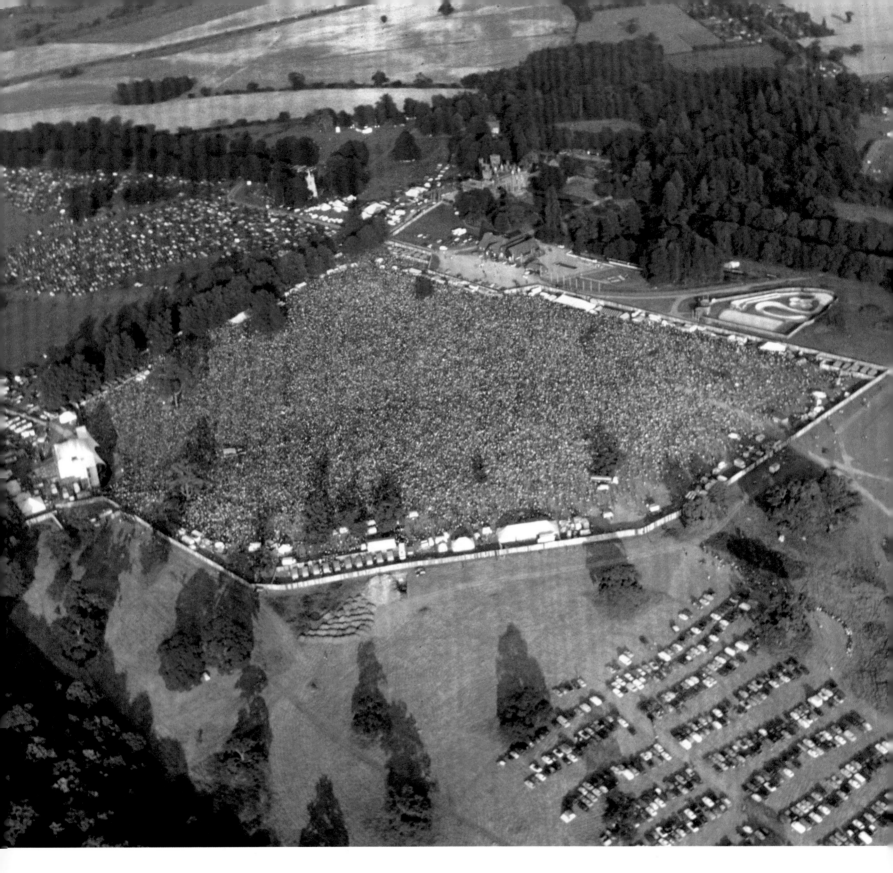

The aerial shot.

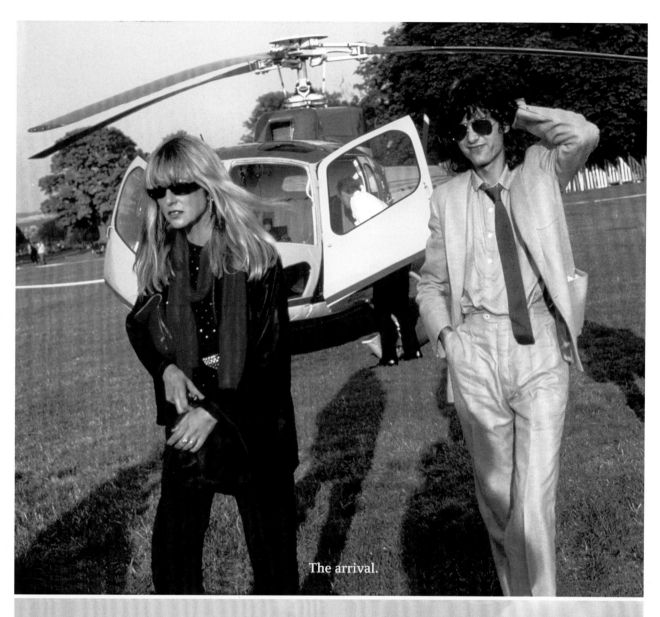

The arrival.

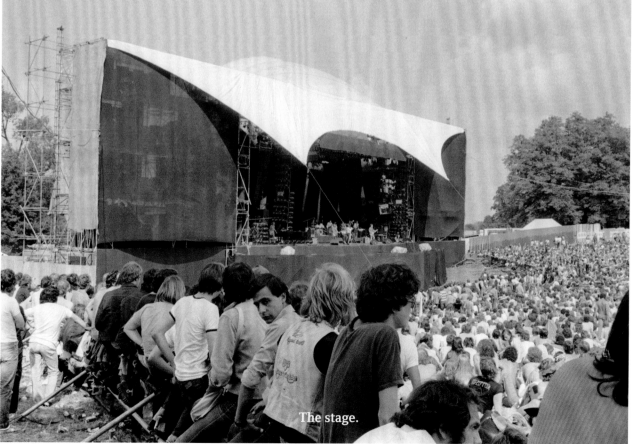

The stage.

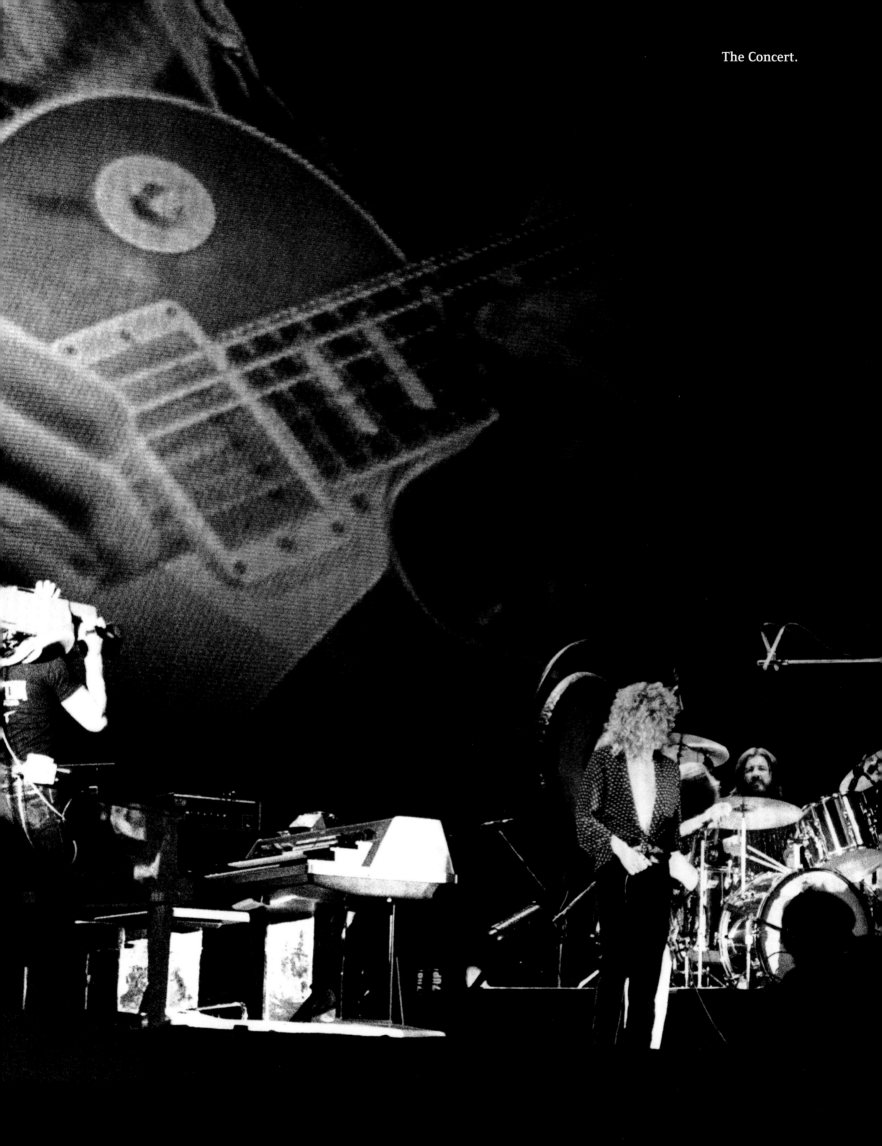

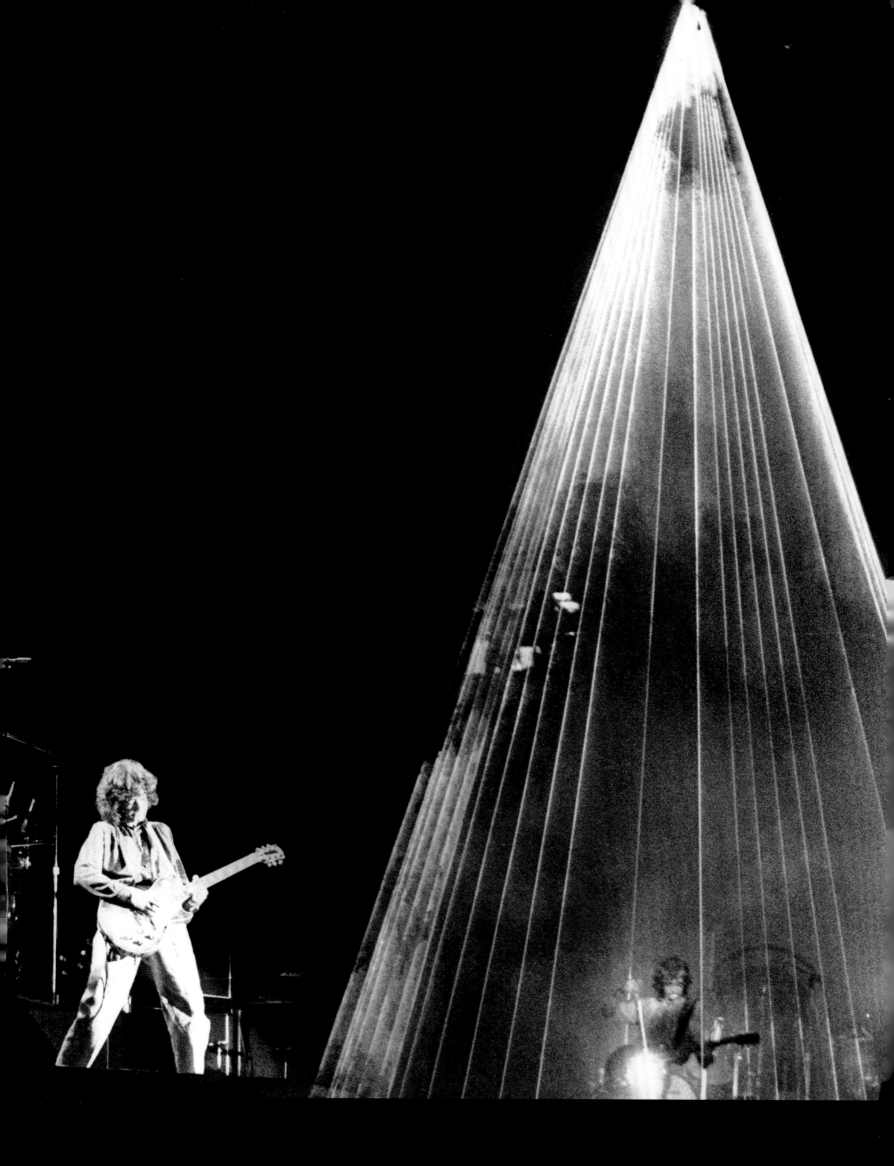

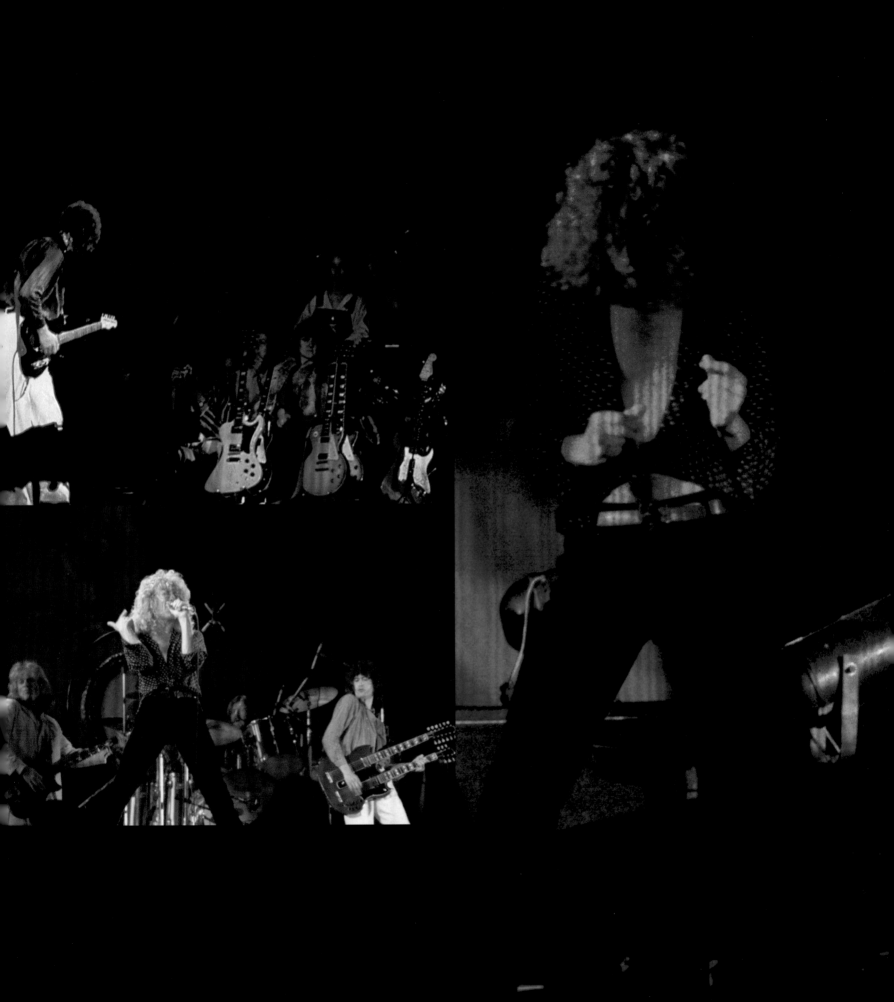

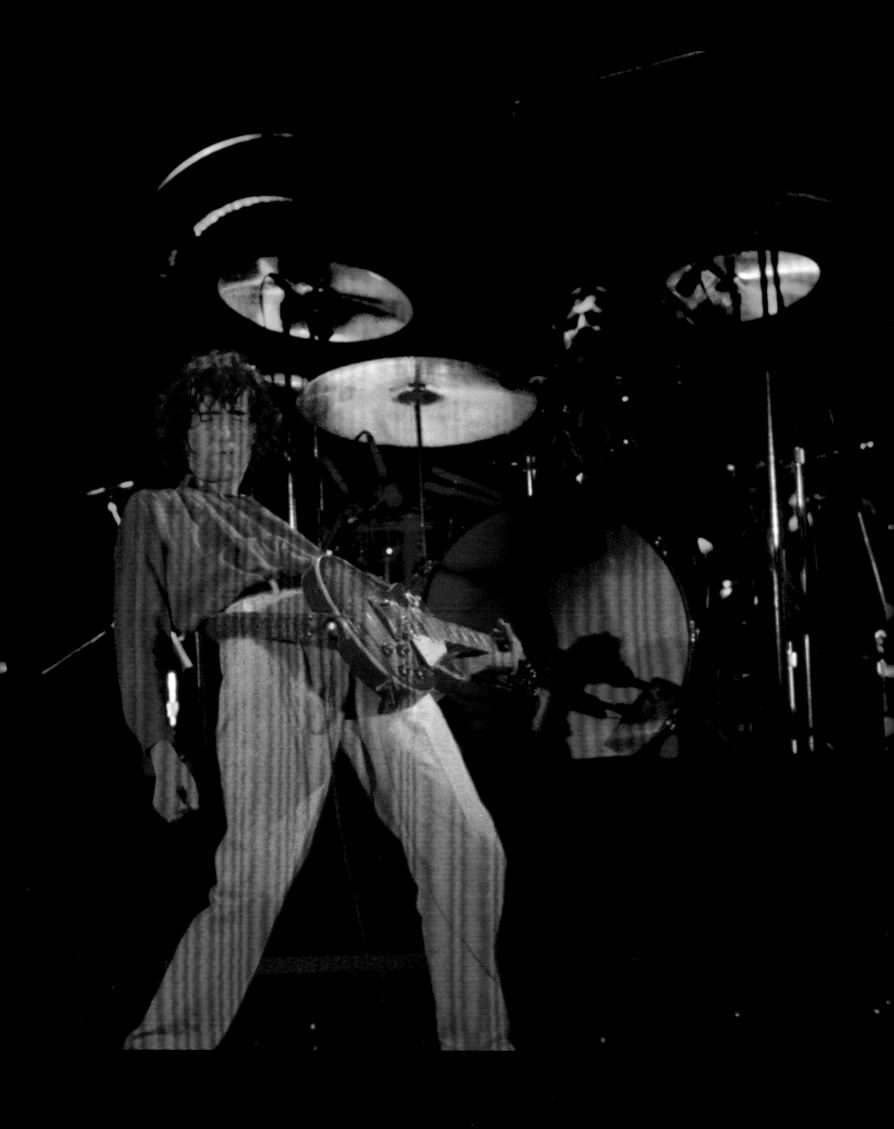

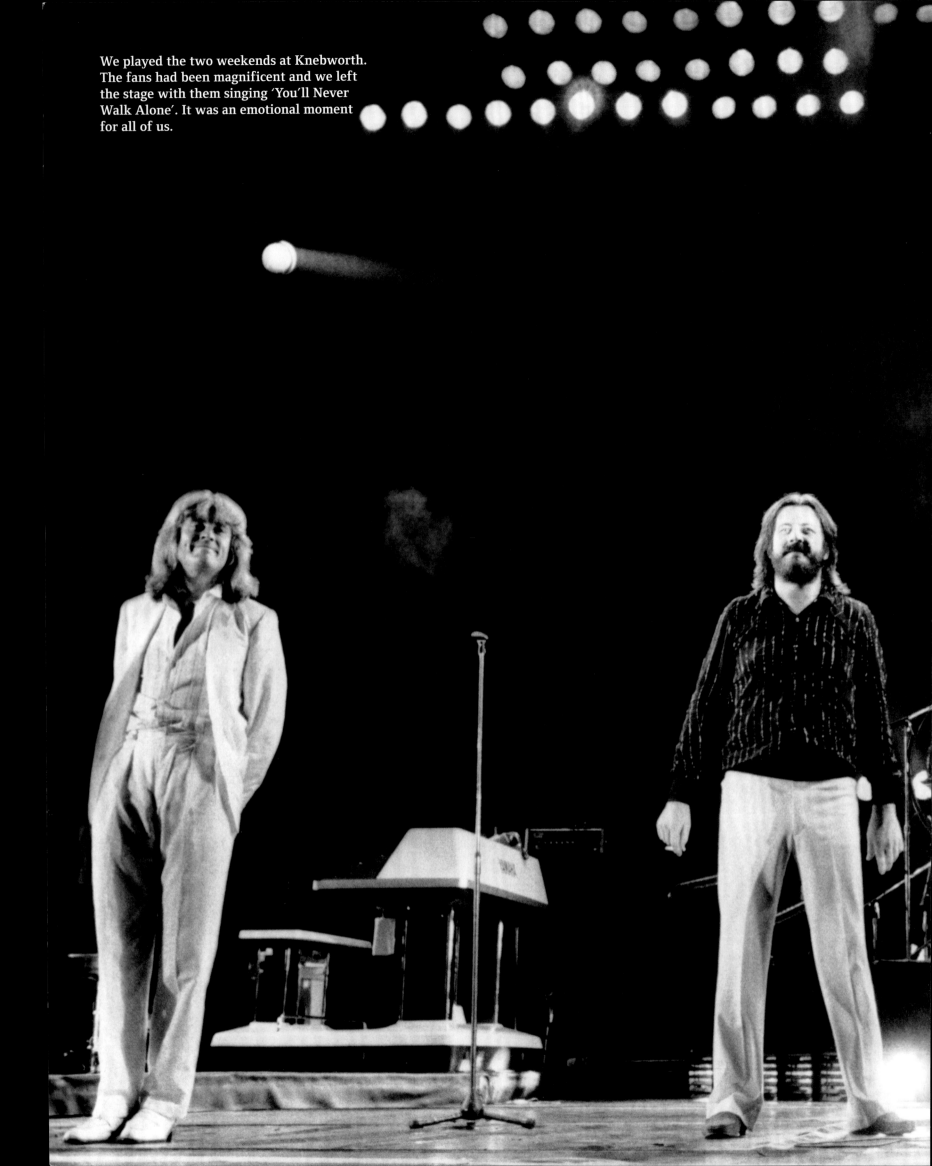

We played the two weekends at Knebworth. The fans had been magnificent and we left the stage with them singing 'You'll Never Walk Alone'. It was an emotional moment for all of us.

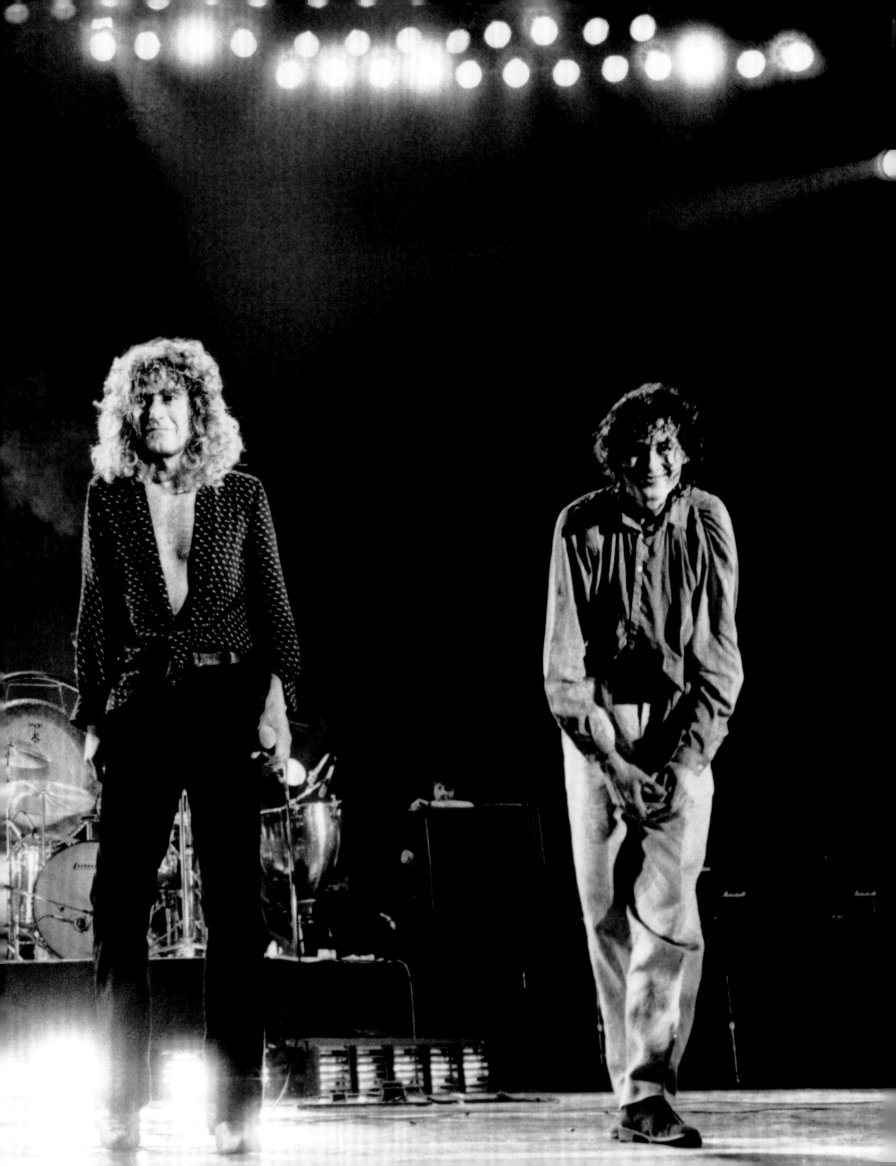

Interviews for *In Through The Out Door* at
Swan Song, the World's End, Chelsea, London.

THE RELEASE OF
IN THROUGH THE OUT DOOR
AUGUST 15 (US)
AUGUST 20 (UK)

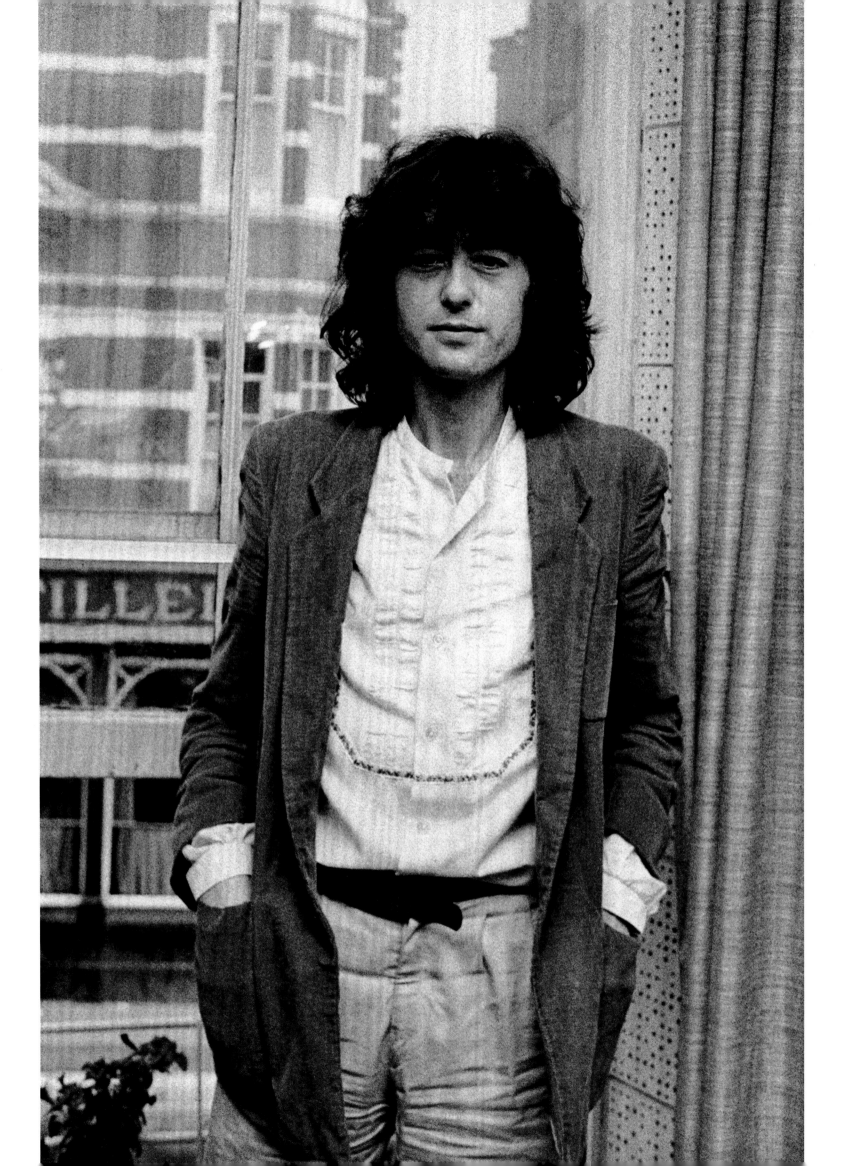

Lippmann+Rau present

›LED ZE
Cc

22.5. Wien	—	Stadthalle
23.5. München	—	Olympiahalle
25.5. Dortmund	—	Westfalenhalle
26.5. Köln	—	Sporthalle
28.5. Bremen	—	Stadthalle
29.5. Berlin	—	Deutschlandhalle
31.5. Mannheim	—	Eisstadion

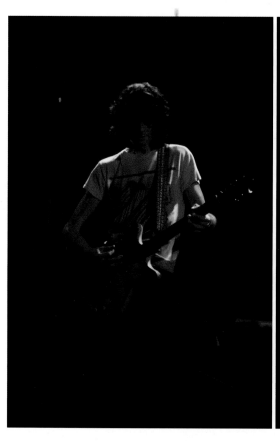
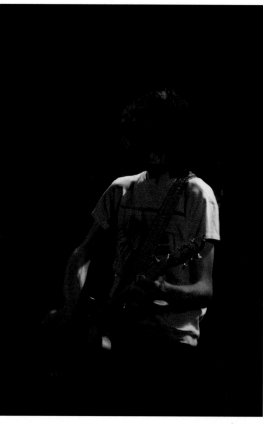
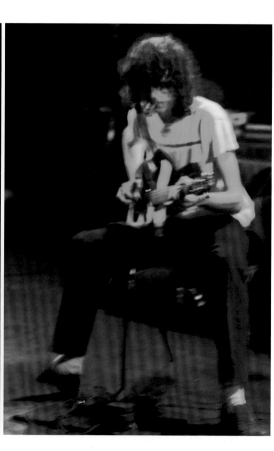

PPELIN‹
ncert 80

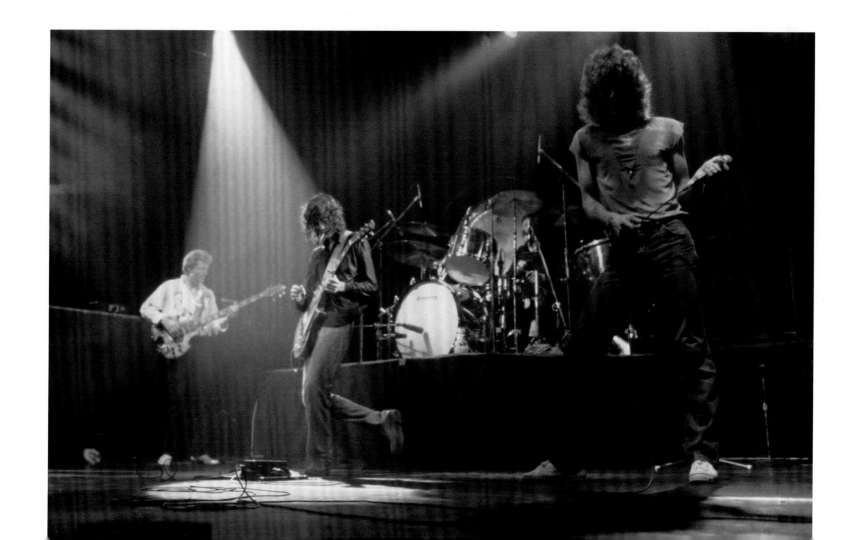

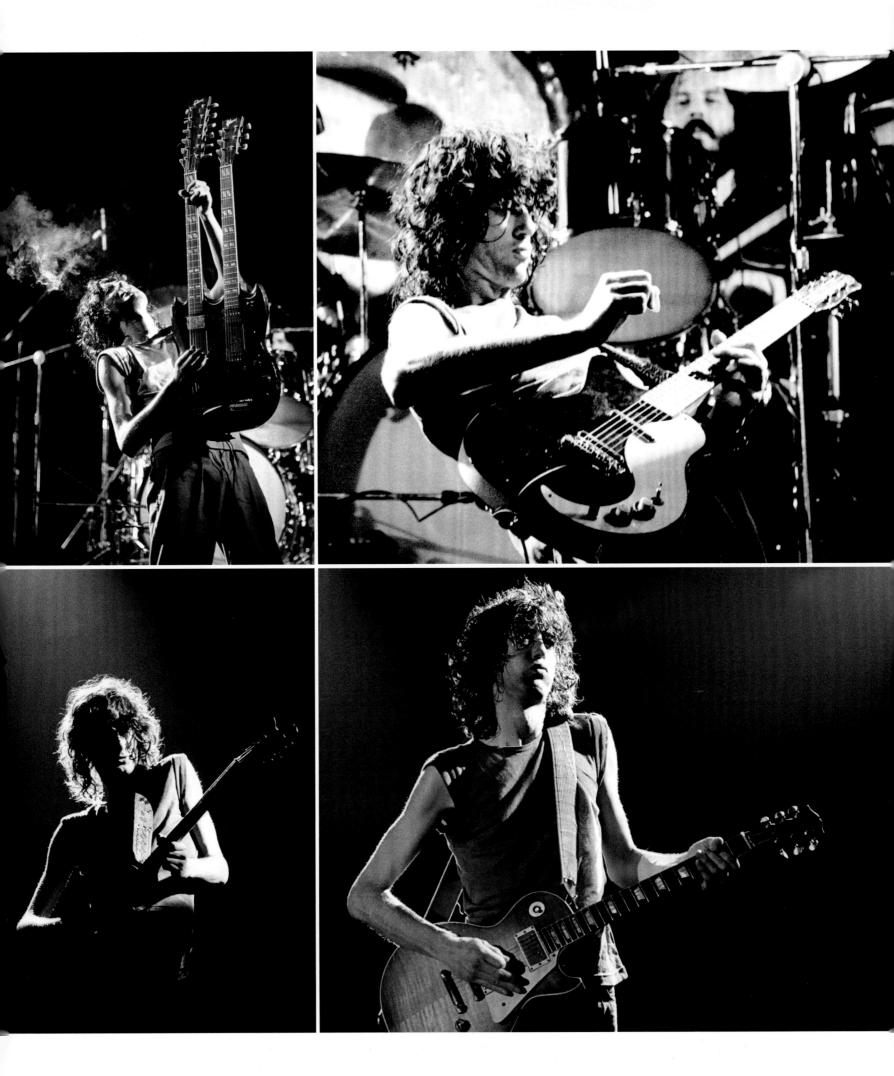

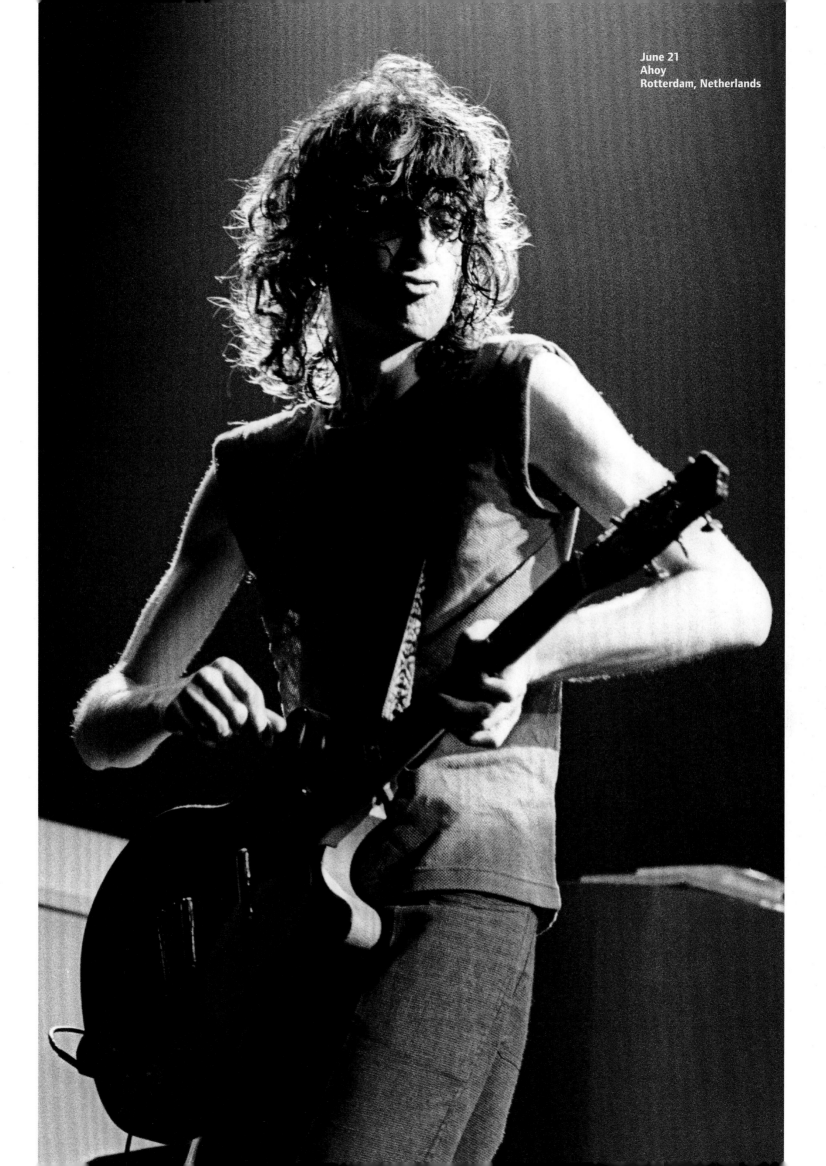

June 21
Ahoy
Rotterdam, Netherlands

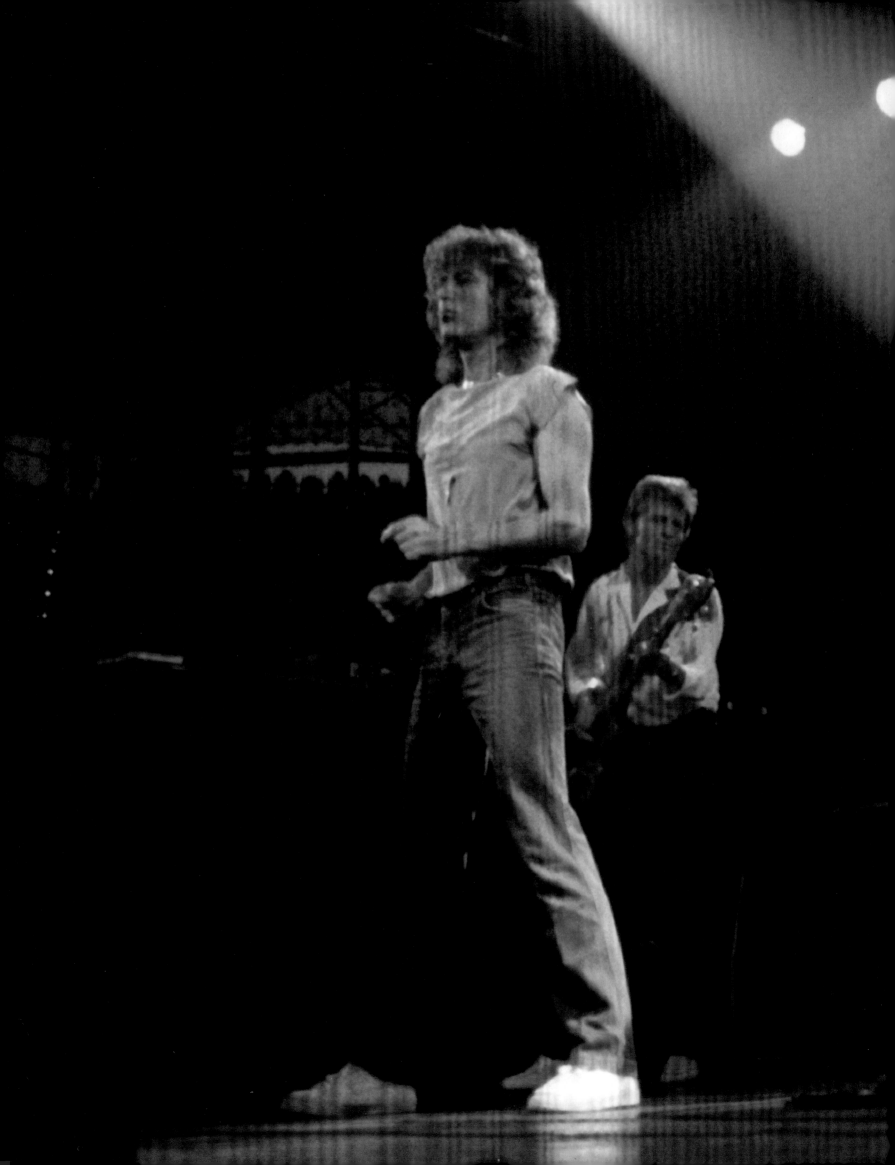

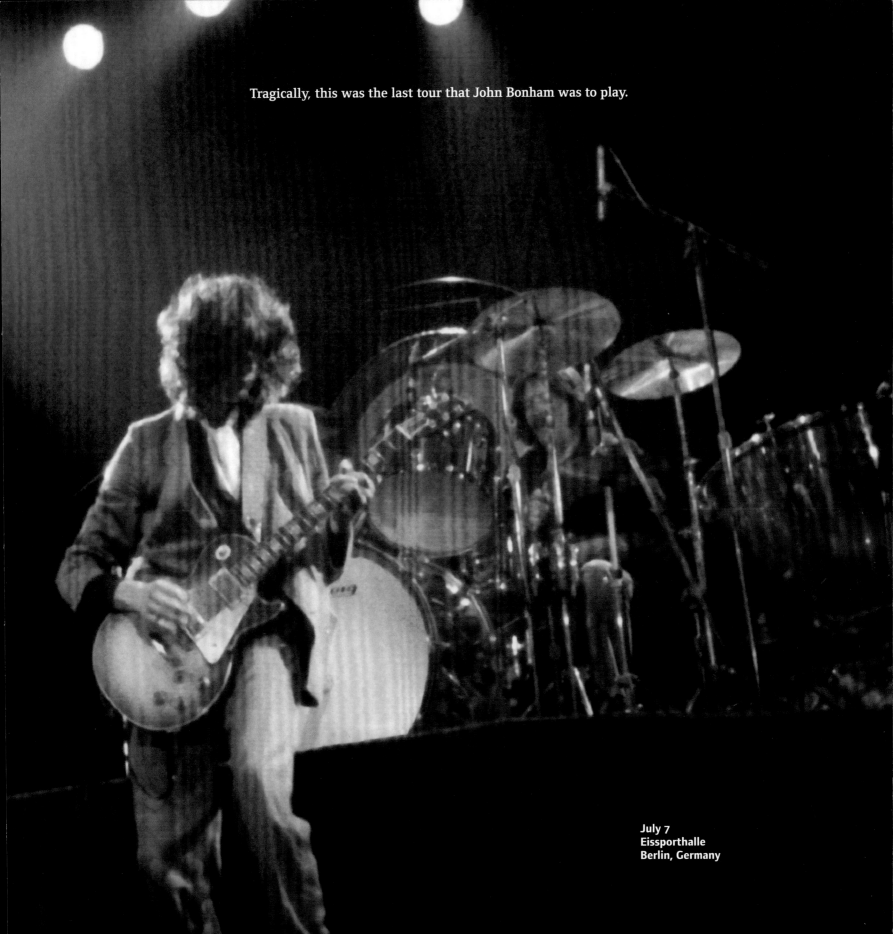

Tragically, this was the last tour that John Bonham was to play.

July 7
Eissporthalle
Berlin, Germany

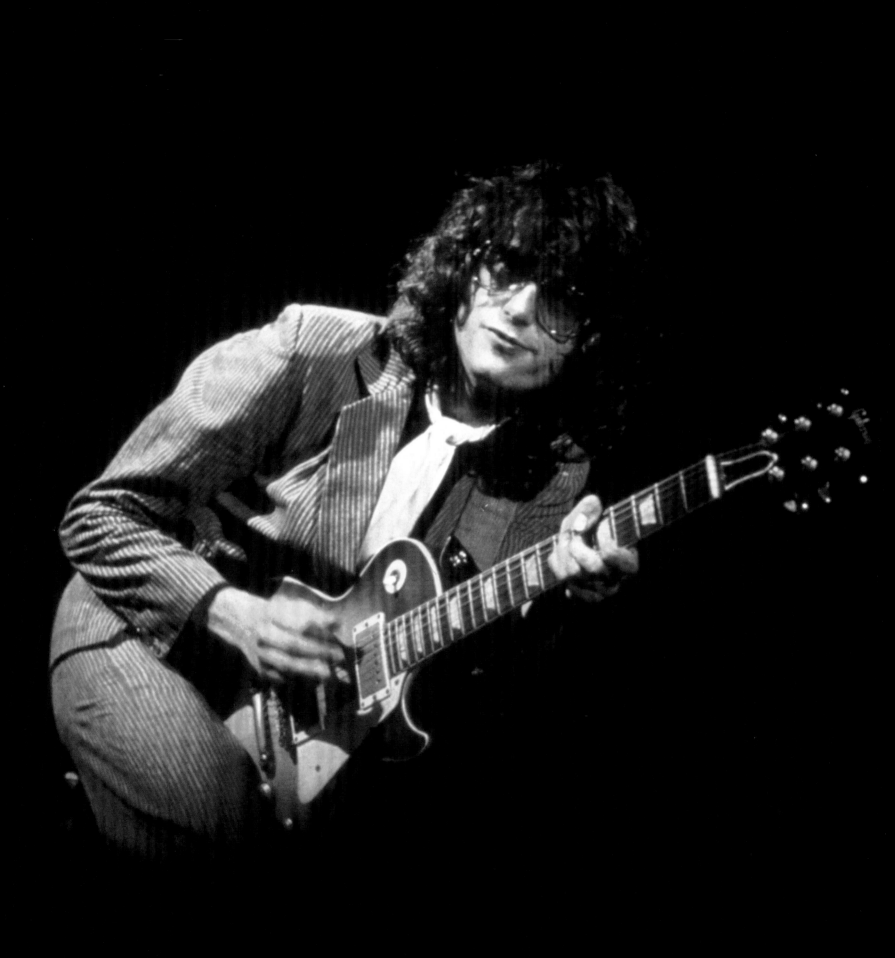

June 20
Vorst Nationaal
Brussels, Belgium

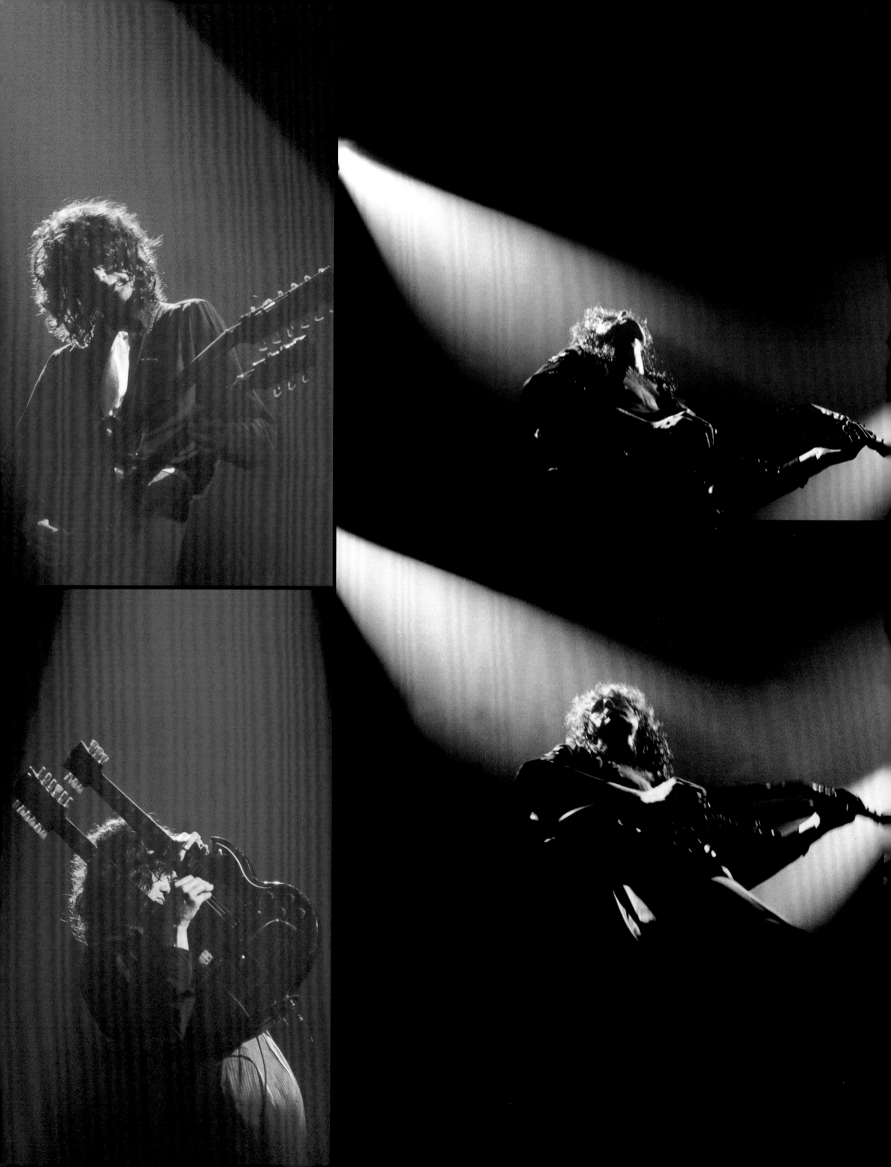

June 20
Vorst Nationaal
Brussels, Belgium

1980
Start of fourth European tour
June 17: Westfalenhalle, Dortmund, Germany
June 18: Sporthalle, Cologne, Germany
June 20: Vorst Nationaal, Brussels, Belgium
June 21: Ahoy, Rotterdam, Netherlands
June 23: Stadthalle, Bremen, Germany
June 24: Messehalle, Hanover, Germany
June 26: Stadthalle, Vienna, Austria
June 27: Messehalle, Nuremburg, Germany
June 29: Hallenstadion, Zurich, Switzerland
June 30: Festhalle, Frankfurt, Germany

July 2: Eisstadion, Mannheim, Germany
July 3: Eisstadion, Mannheim, Germany
July 5: Olympiahalle, Munich, Germany
July 7: Eissporthalle, Berlin, Germany
End of fourth European tour

THE RELEASE OF *CODA*
NOVEMBER 19 (US)
NOVEMBER 22 (UK)

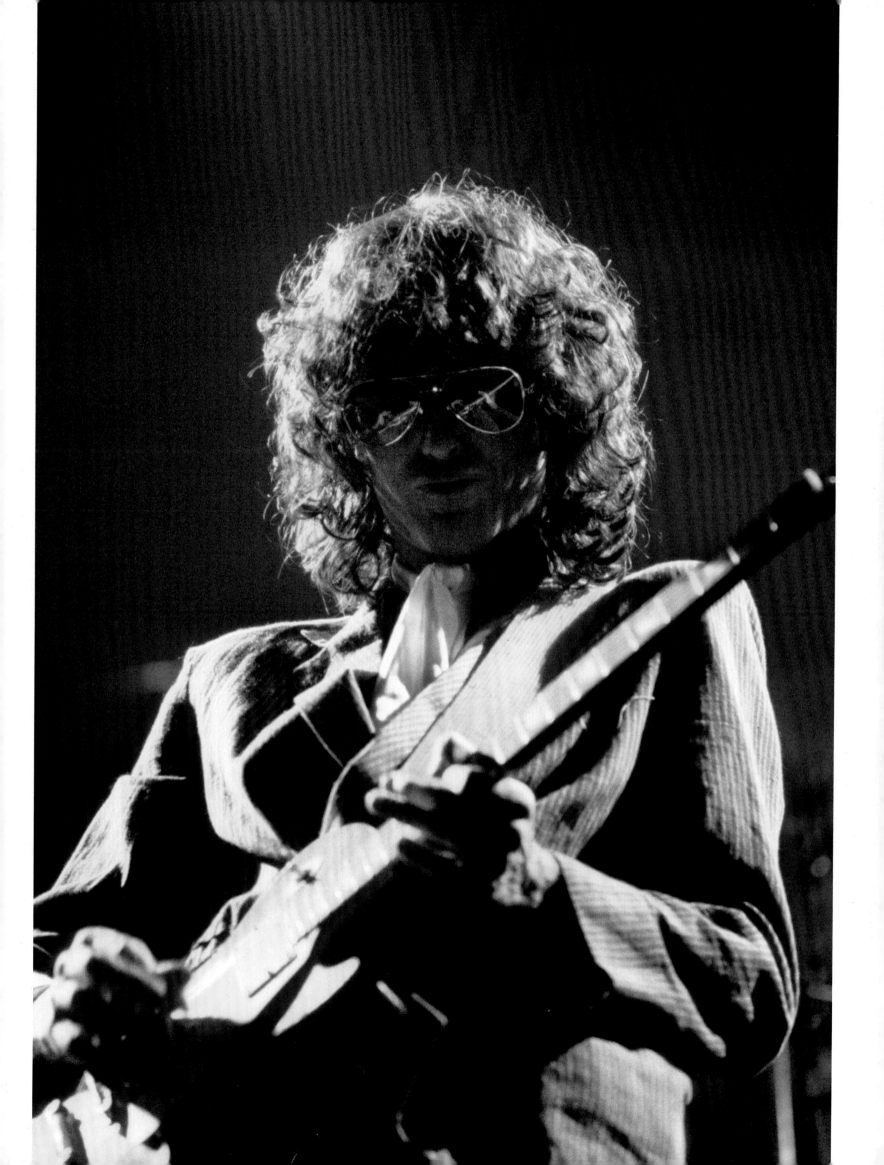

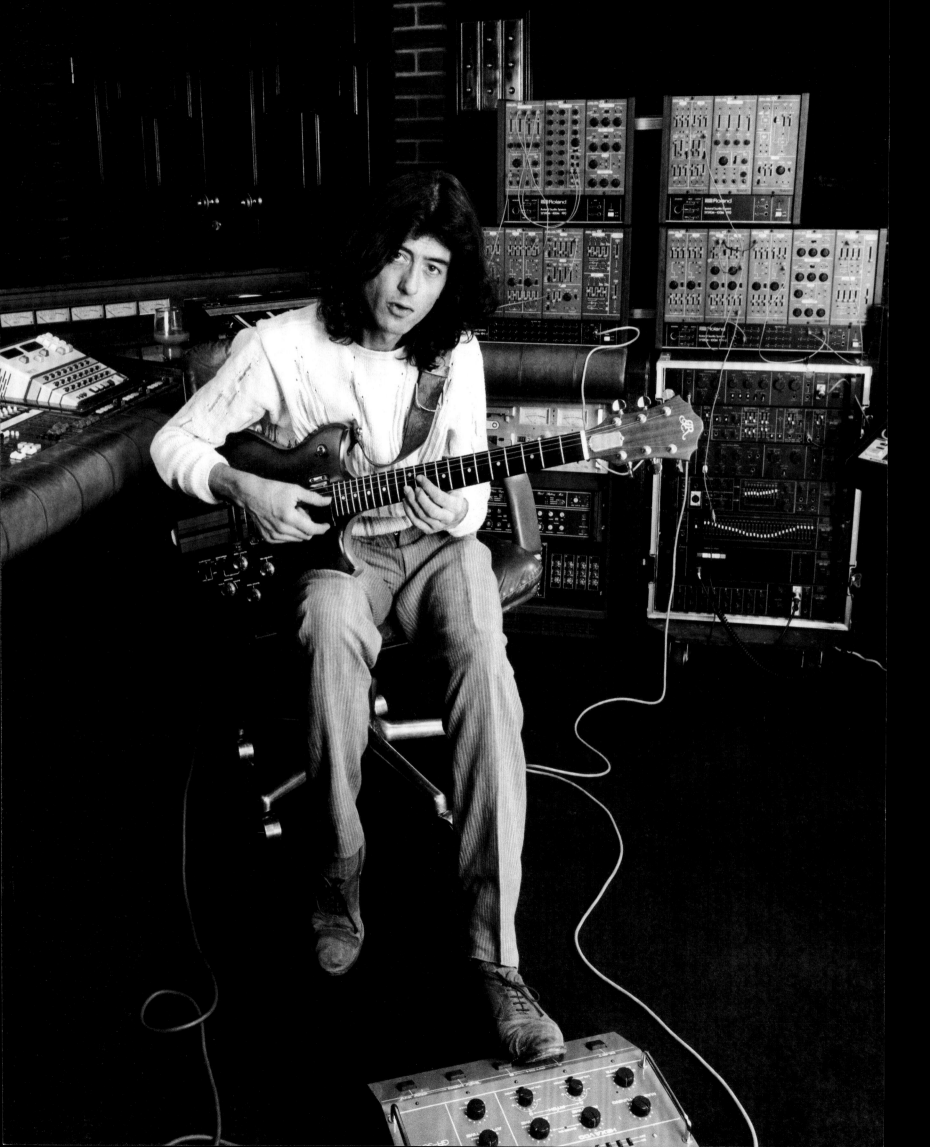

THE ORIGINAL SOUNDTRACK · MUSIC BY JIMMY PAGE

DEATH WISH II

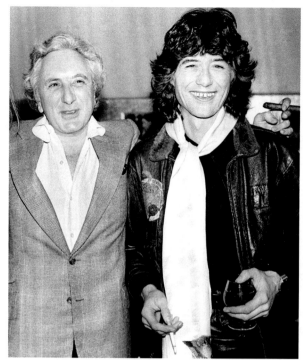

In 1980 Michael Winner invited me to do the soundtrack to *Death Wish II* – 45 minutes of music for a 90-minute film. The recordings took place in my studio, The Sol, on the River Thames at Cookham, Berkshire. The guitar synthesiser in the photograph opposite was the most advanced for its time and I used it extensively on those sessions. Winner later applied the music to *Death Wish III*. Here we are looking very jolly at the *Death Wish II* premiere in 1981.

THE RELEASE OF *DEATH WISH II*
FEBRUARY 15, 1982

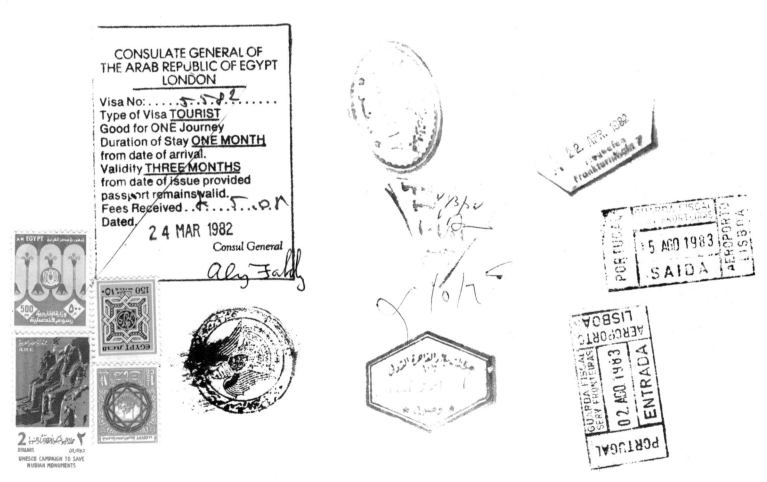

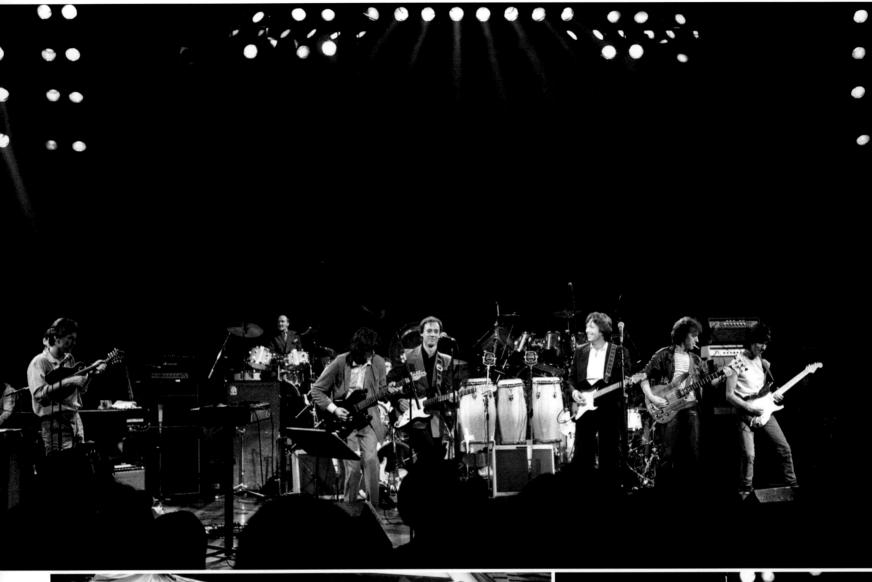

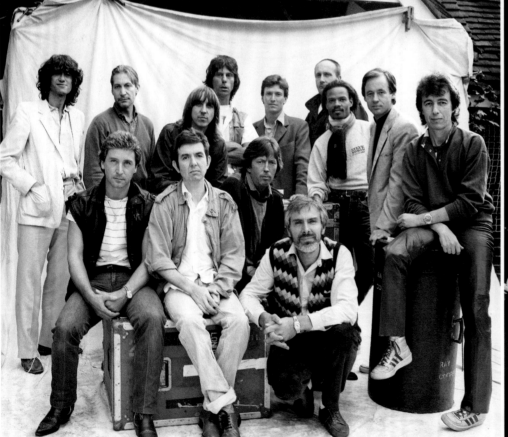

ARMS Concert/Prince's Trust – UK LINE UP
Front row (in photograph left) from left to right:
Kenney Jones – drums
Ronnie Lane – vocals
Eric Clapton – guitar, vocals
James Hooker – keyboards
Back row from left to right:
Jimmy Page – guitar
Charlie Watts – drums
Chris Stainton – keyboards
Jeff Beck – guitar, vocals
Steve Winwood – vocals, keyboards, mandolin
Ray Cooper – drums, percussion
Fernando Saunders – bass
Andy Fairweather Low – guitar, keyboards, vocals
Bill Wyman – bass
Also (not featured in photograph):
James Hooker – keyboards
Tony Hymas – keyboards
Simon Phillips – drums

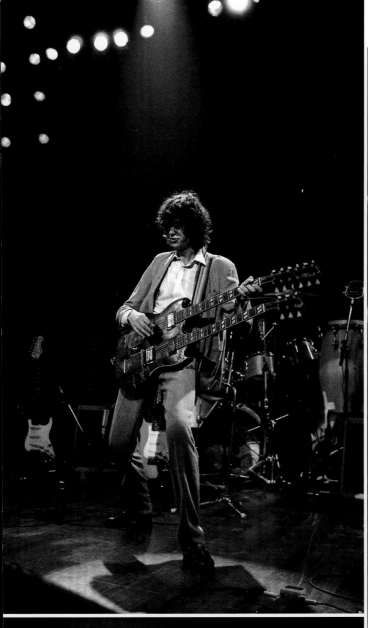

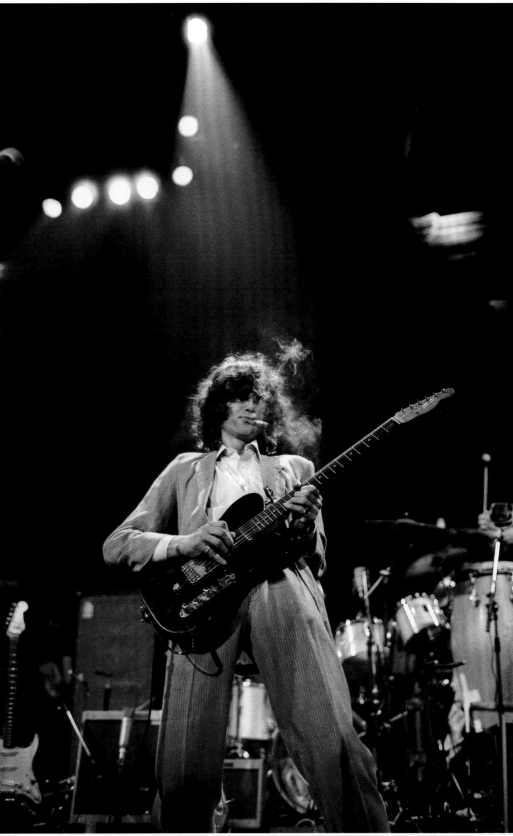

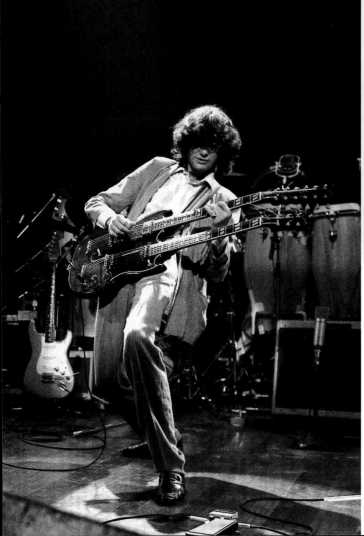

I was at a party at Jeff Beck's when Ian Stewart outlined a project that would involve Jeff, Eric Clapton, myself and others appearing together at The Royal Albert Hall for a charity event named ARMS – Action Research into Multiple Sclerosis – for our dear friend Ronnie Lane who had been suffering from this debilitating illness.

At The Royal Albert Hall Steve Winwood, who was appearing in his own set, helped me out with mine.

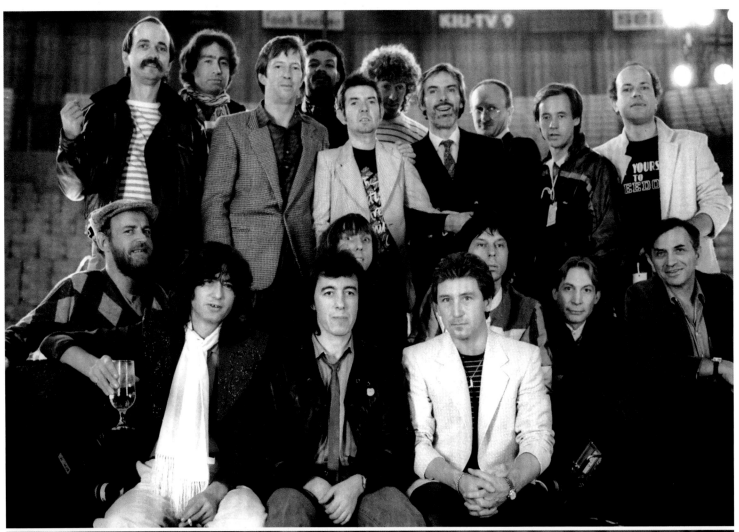

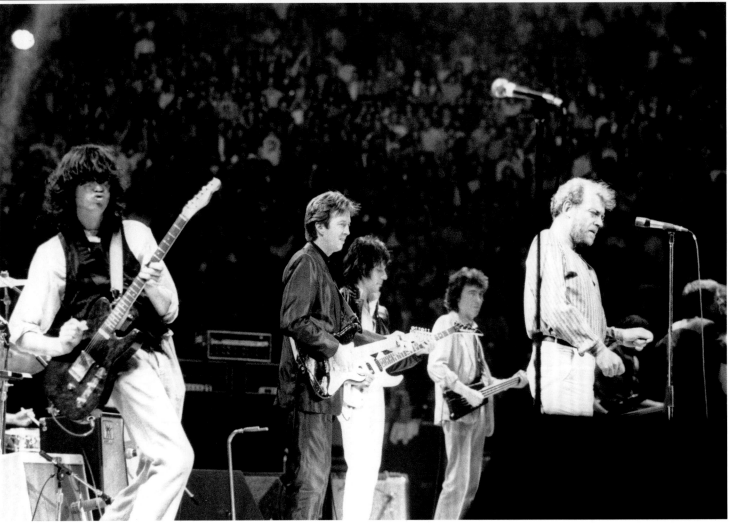

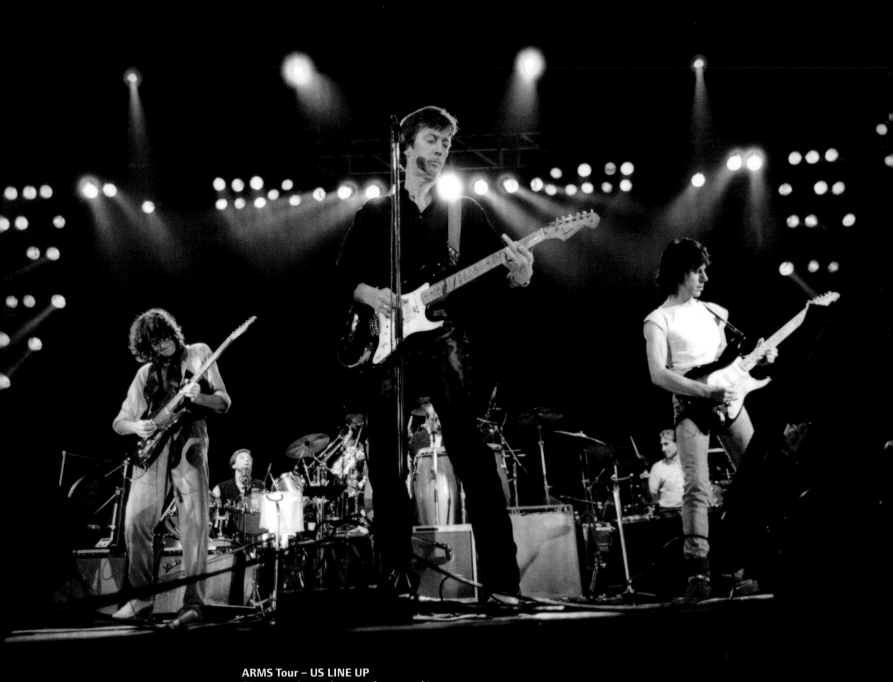

Opposite:
December 8 & 9
Madison Square Garden
New York, USA

ARMS Tour – US LINE UP
Front row (opposite top photograph)
from left to right:
Joe Cocker – vocals
Jimmy Page - guitar
Bill Wyman – bass
Kenney Jones – drums
Second row from left to right:
Chris Stainton – keyboards
Jeff Beck – guitar
Charlie Watts – drums
Bill Graham
Back row from left to right:
Paul Rodgers – vocals, guitar
Eric Clapton – guitar, vocals
Fernando Saunders – bass
Ronnie Lane – vocals
Simon Phillips – drums
James Hooker – keyboards
Ray Cooper – percussion
Andy Fairweather Low – guitar
Jan Hammer – keyboards
Also (not featured in photograph):
Ian Stewart – keyboards

1983
ARMS Concert/Prince's Trust
September 20: Royal Albert Hall, London, UK
September 21: Royal Albert Hall, London, UK

Start of ARMS American tour
November 28: Reunion Arena, Dallas, USA
November 29: Reunion Arena, Dallas, USA

December 1: Cow Palace, San Francisco, USA
December 2: Cow Palace, San Francisco, USA
December 3: Cow Palace, San Francisco, USA
December 5: The Forum, Los Angeles, USA
December 6: The Forum, Los Angeles, USA
December 8: Madison Square Garden, New York, USA
December 9: Madison Square Garden, New York, USA
End of ARMS American tour

December 1, 2 & 3
Cow Palace
San Francisco, USA

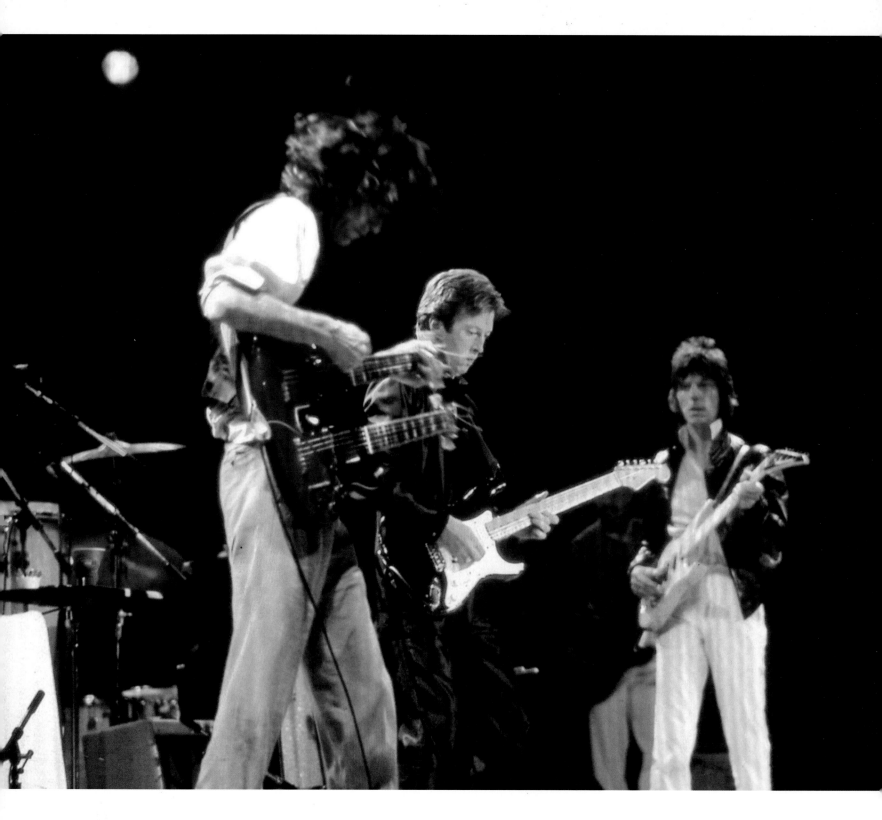

December 8 & 9
Madison Square Garden
New York, USA

Sometime after The Royal Albert Hall there was a plan put forward to take the show to the States but Steve Winwood had other commitments, so I asked Paul Rodgers whether he would like to collaborate. We wrote some new material including, 'Midnight Moonlight' which was featured in our section of the show.

Opposite:
November 28 & 29
Reunion Arena
Dallas, USA

First shows of the
ARMS US tour

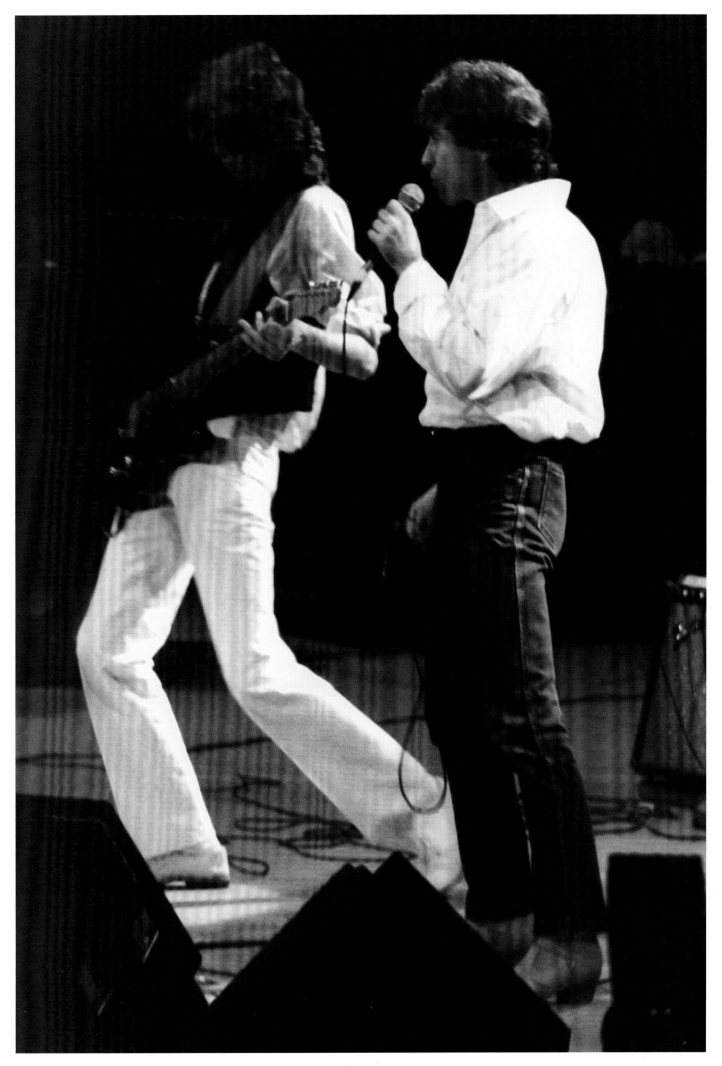

On the plane
Los Angeles, USA

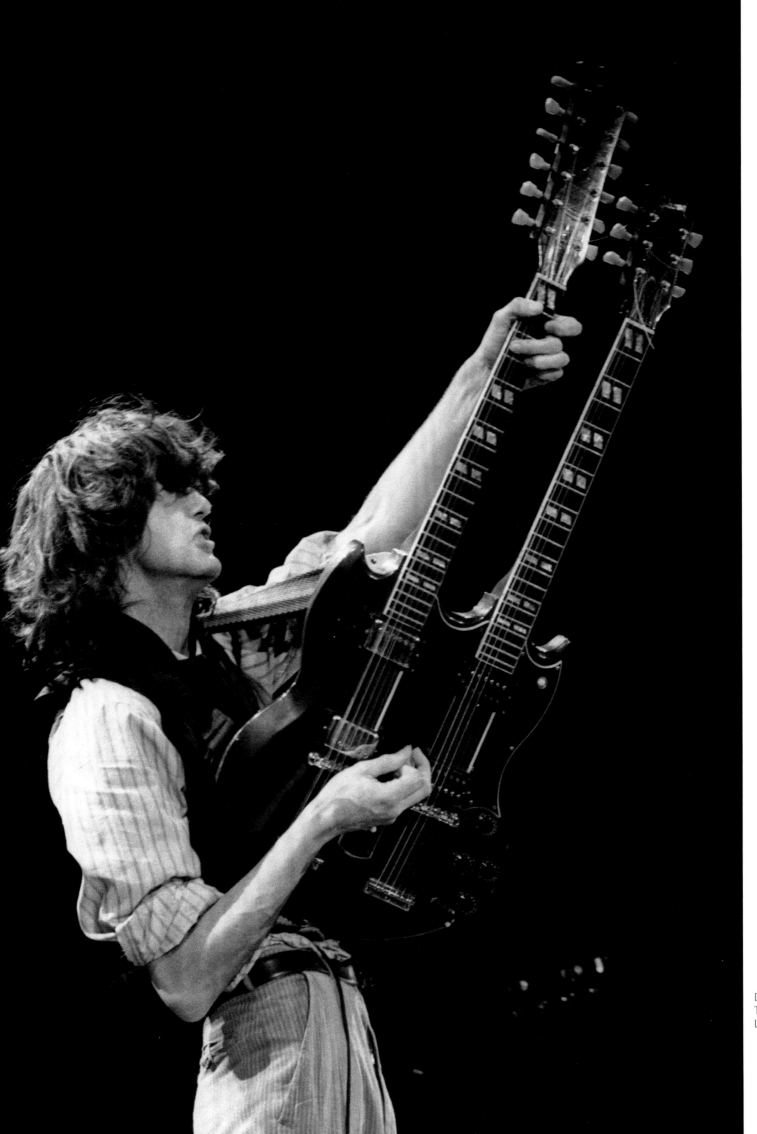

December 5 & 6
The Forum
Los Angeles, USA

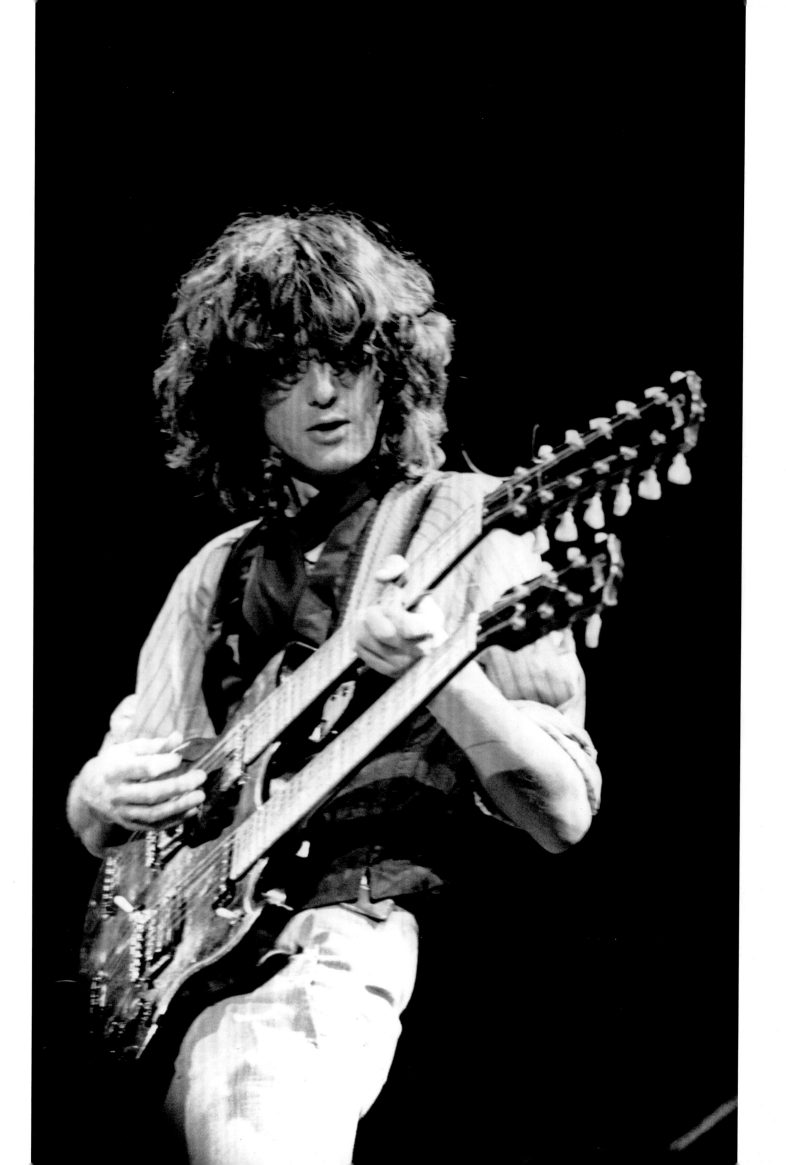

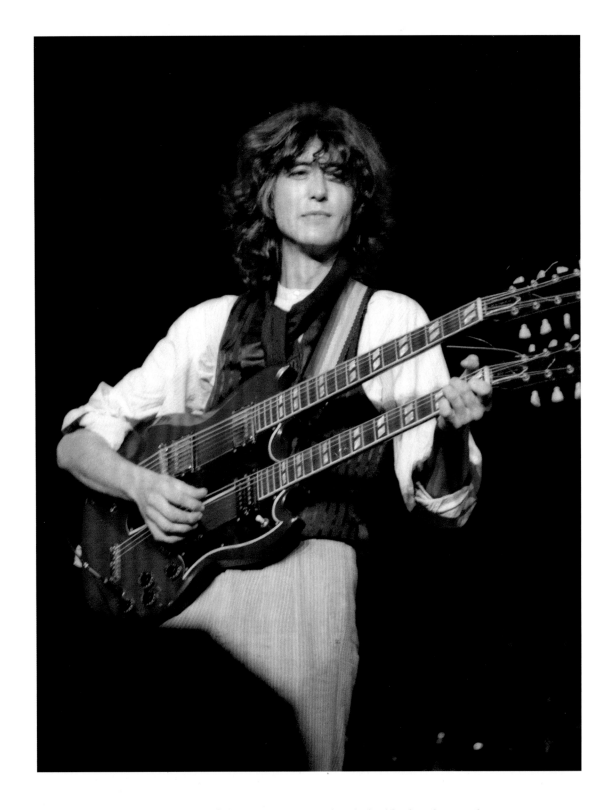

December 8
Madison Square Garden
New York, USA

Last shows of the tour

At the conclusion of the ARMS tour, Paul and I had had such a good time working together that we decided to continue our endeavours and form a band. The band was to become The Firm.

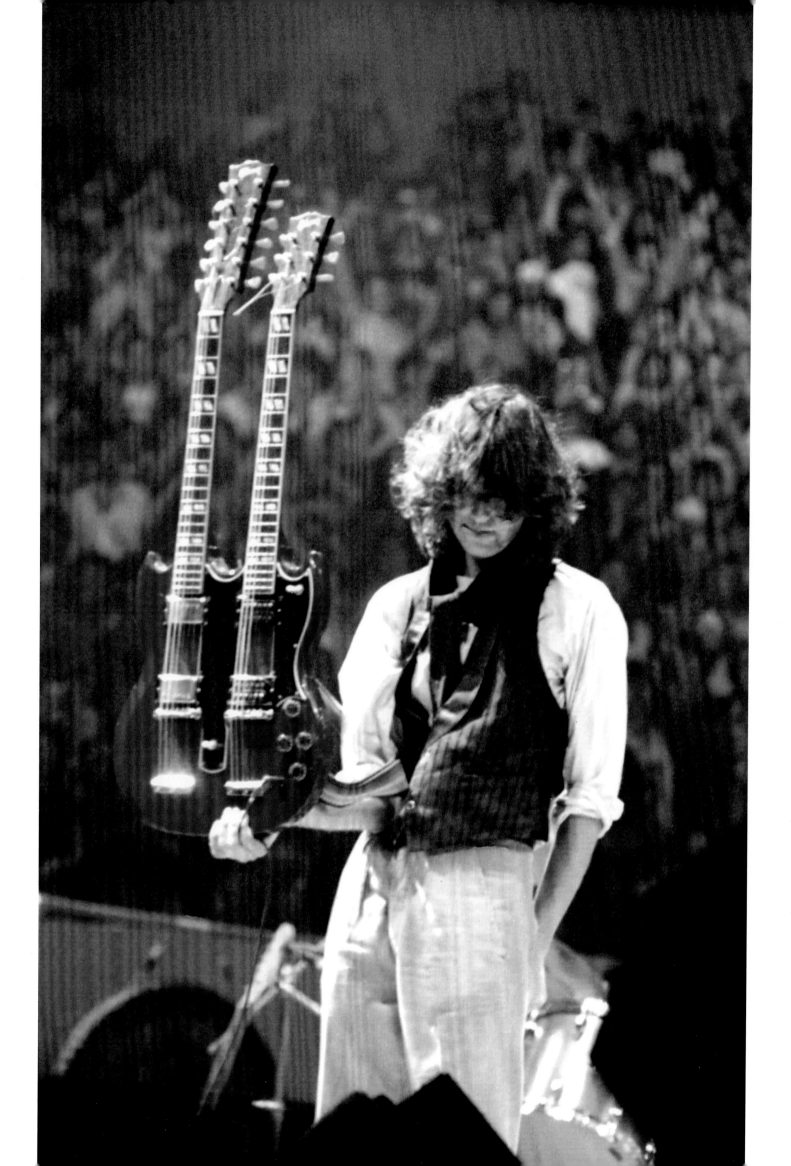

PAUL RODGERS **JIMMY PAGE**

TONY FRANKLIN **CHRIS SLADE**

1984
Start of first European tour
November 29: Gota Lejon, Stockholm, Sweden
November 30: Falkoner Theatre, Copenhagen, Denmark

December 1: Olympen, Lund, Sweden
December 3: Kongresshalle, Frankfurt, Germany
December 4: Pfalzbau, Ludwigshafen, Germany
December 5: Audimax, Hamburg, Germany
December 7: Town Hall, Middlesbrough, UK
December 8: Hammersmith Odeon, London, UK
December 9: Hammersmith Odeon, London, UK
End of first European tour

1985
Start of first American tour
February 28: Reunion Arena, Dallas, USA

March 2: Kansas Coliseum, Wichita, USA
March 7: Mecca Arena, Milwaukee, USA
March 8: Civic Center, Omaha, USA
March 10: McNichols Arena, Denver, USA
March 12: Compton Terrace, Phoenix, USA
March 14: The Forum, Los Angeles, USA
March 15: Coliseum, Oakland, USA
March 16: Pacific Amphitheater, Costa Mesa, USA
March 18: Tingley Coliseum, Albuquerque, USA
March 21: The Summit, Houston, USA
March 23: Frank Erwin Center, Austin, USA
March 24: Lakefront Arena, New Orleans, USA

April 16: Coliseum, Jacksonville, USA
April 18: The Omni, Atlanta, USA
April 19: Freedom Hall, Louisville, USA
April 20: Coliseum, Cleveland, USA
April 22: Market Square Arena, Indianapolis, USA
April 23: Met Center, St Paul, USA
April 24: Rosemont Horizon, Chicago, USA
April 26: Joe Louis Arena, Detroit, USA
April 27: Riverfront Coliseum, Cincinnati, USA
April 29: Madison Square Garden, New York, USA

May 1: Capitol Center, Landover, USA
May 3: Civic Center, Hartford, USA
May 5: Civic Arena, Pittsburgh, USA
May 7: The Centrum, Worcester, USA
May 8: The Centrum, Worcester, USA
May 9: Brendan Byrne Arena, East Rutherford, USA
May 11: The Spectrum, Philadelphia, USA
End of first American tour

Start of UK tour
May 18: NEC, Birmingham, UK
May 20: Playhouse Theatre, Edinburgh, UK
May 22: Wembley Arena, London, UK
End of UK tour

THE RELEASE OF *THE FIRM*
MARCH 2, 1985

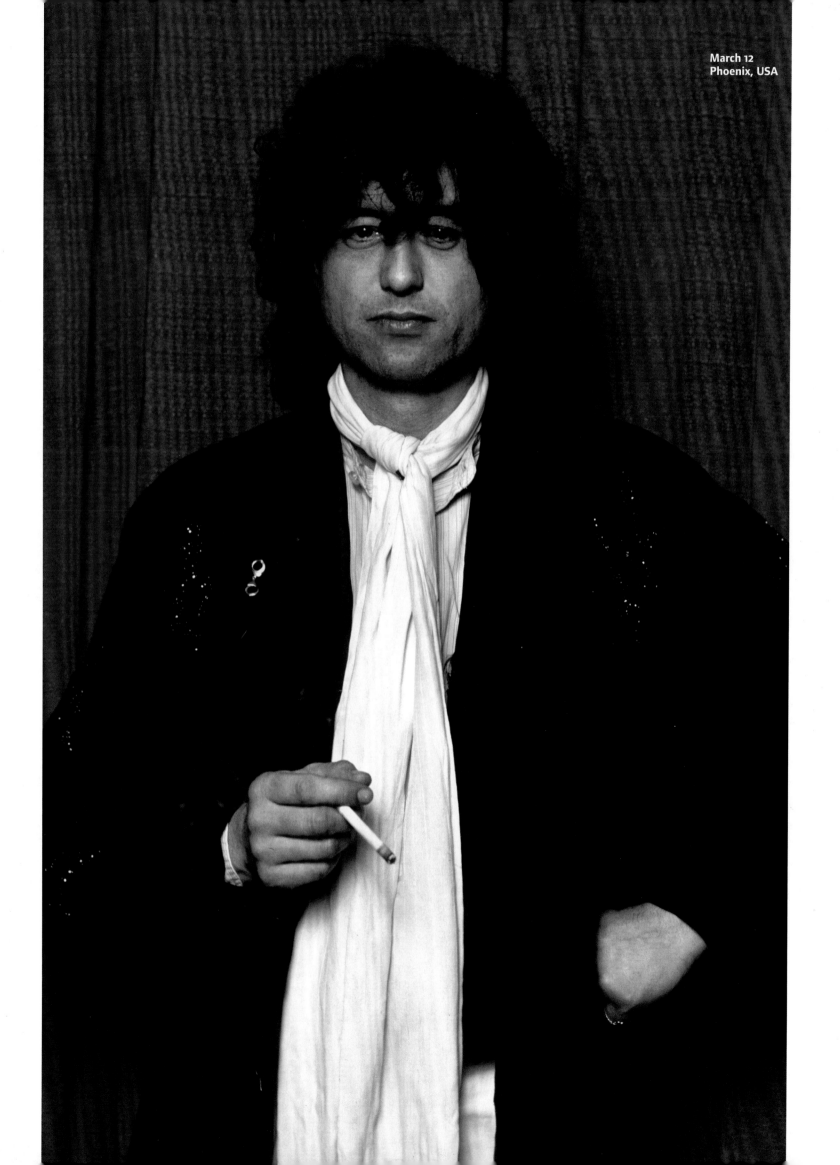

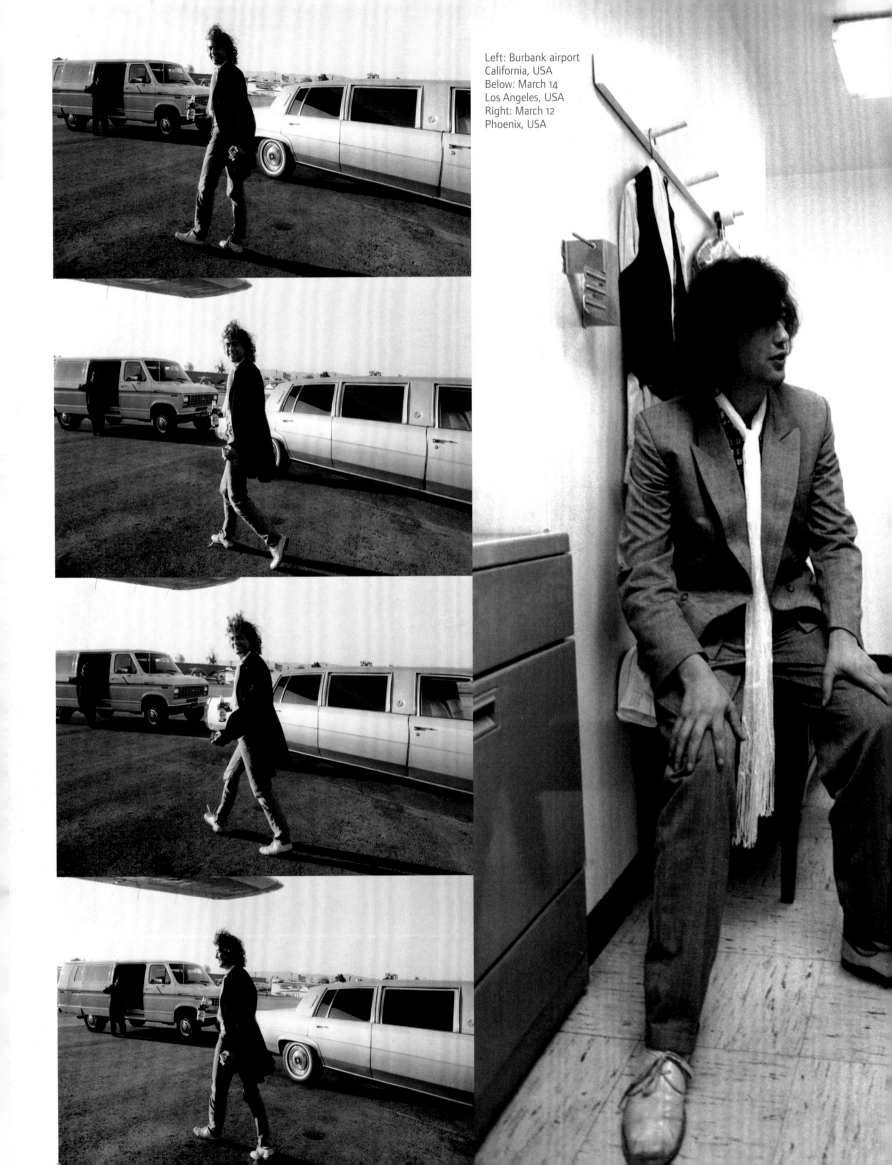

Left: Burbank airport
California, USA
Below: March 14
Los Angeles, USA
Right: March 12
Phoenix, USA

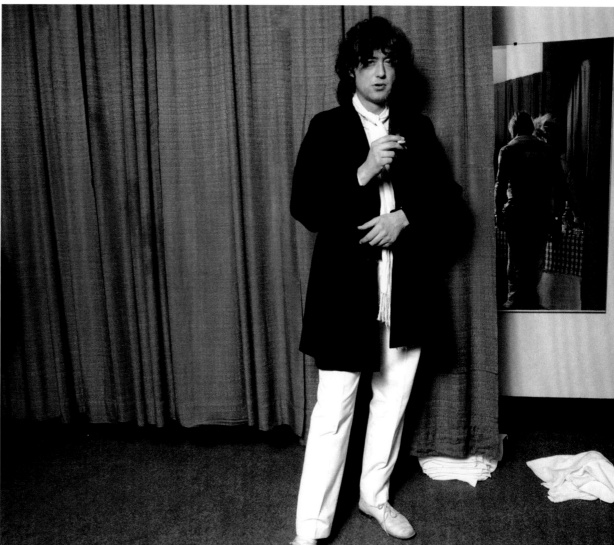

In The Firm Paul and I had written songs together and individually. We set about recording our first album with Chris Slade on drums and Tony Franklin on bass and hair. We recorded 'Radioactive', 'Midnight Moonlight' and 'Closer'.

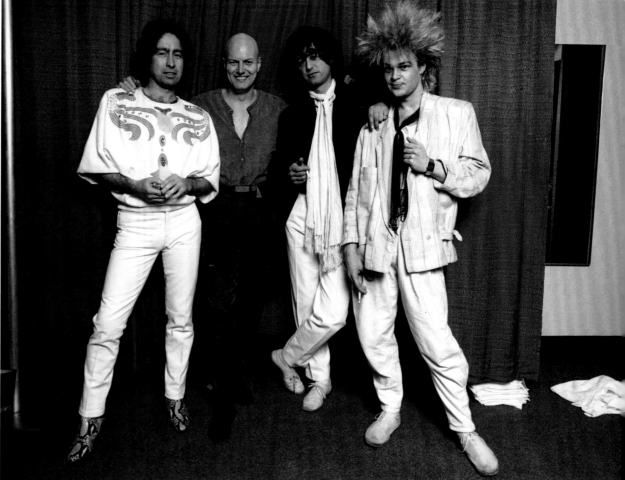

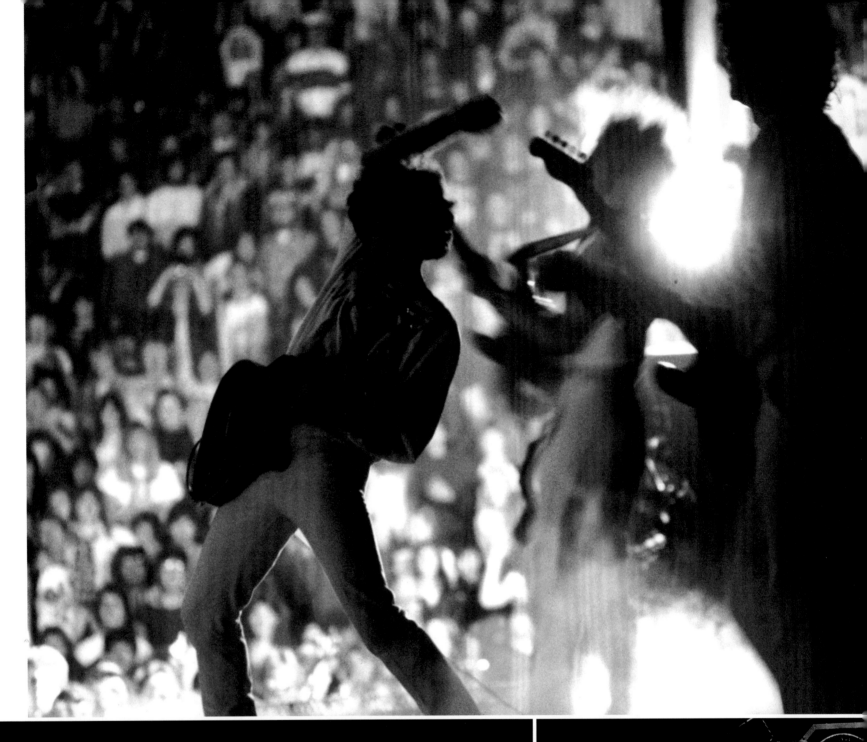

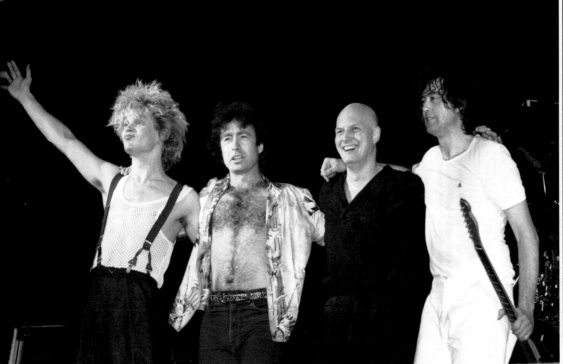

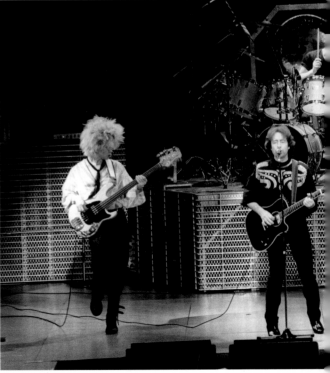

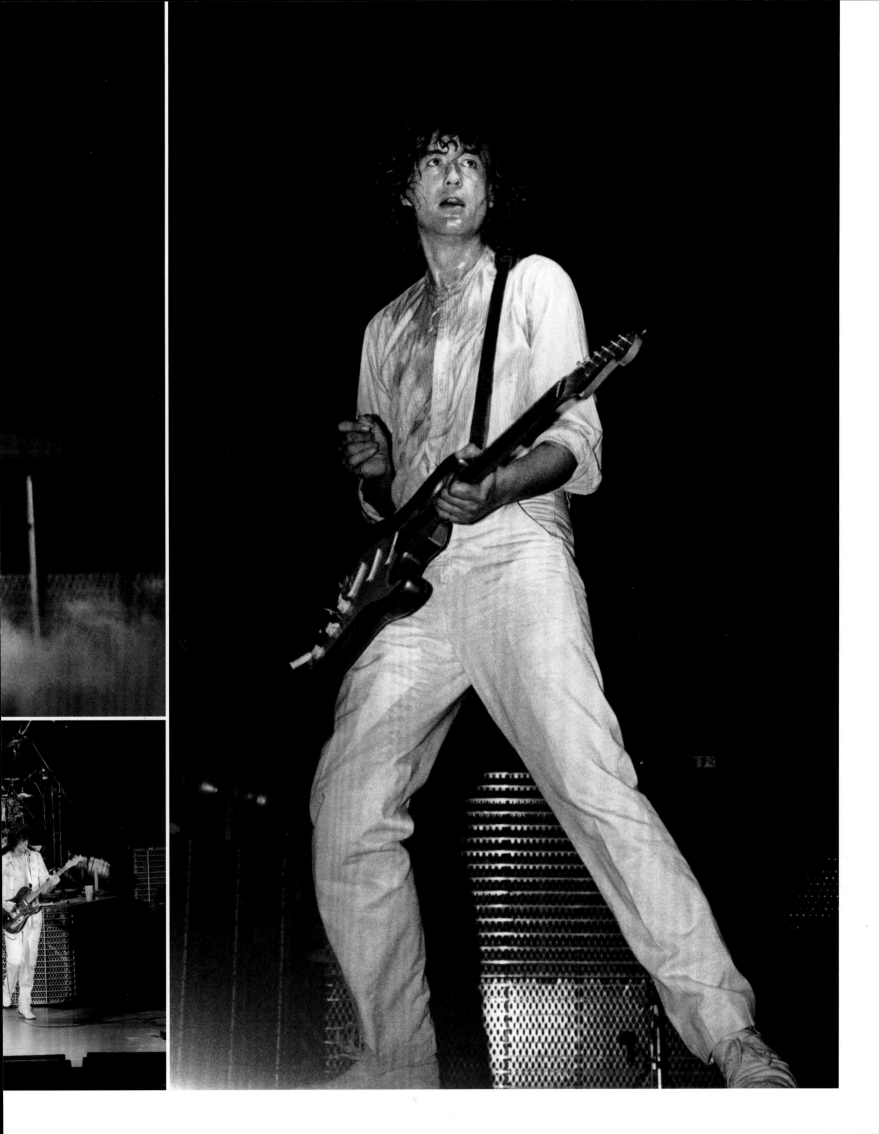

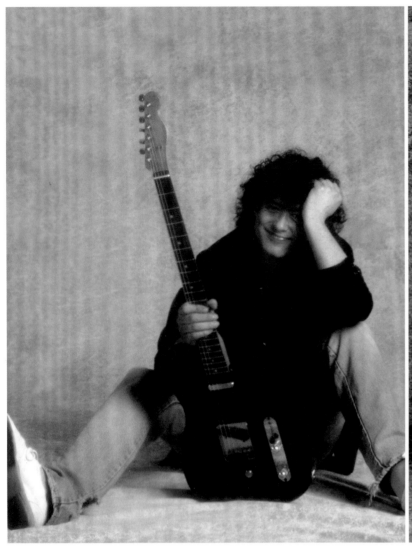

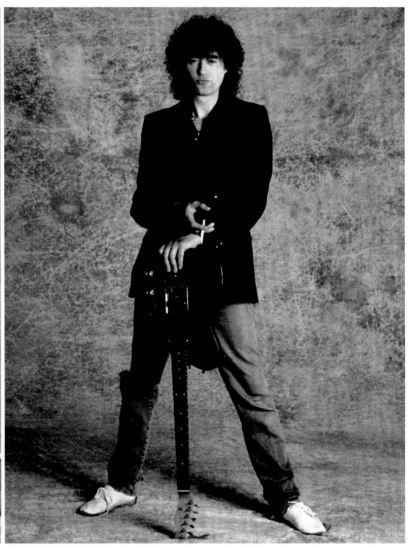

March
Daytona Beach
Florida, USA

During The Firm's tour of the US, *Guitar World* did an issue on me. The accompanying photo shoot featured my Parsons/White Telecaster B-Bender customised for me by Gene Parsons. I used this guitar live with Led Zeppelin on the 1977 tour and on the *In Through The Out Door* sessions, and then later recordings and live shows with The Firm.

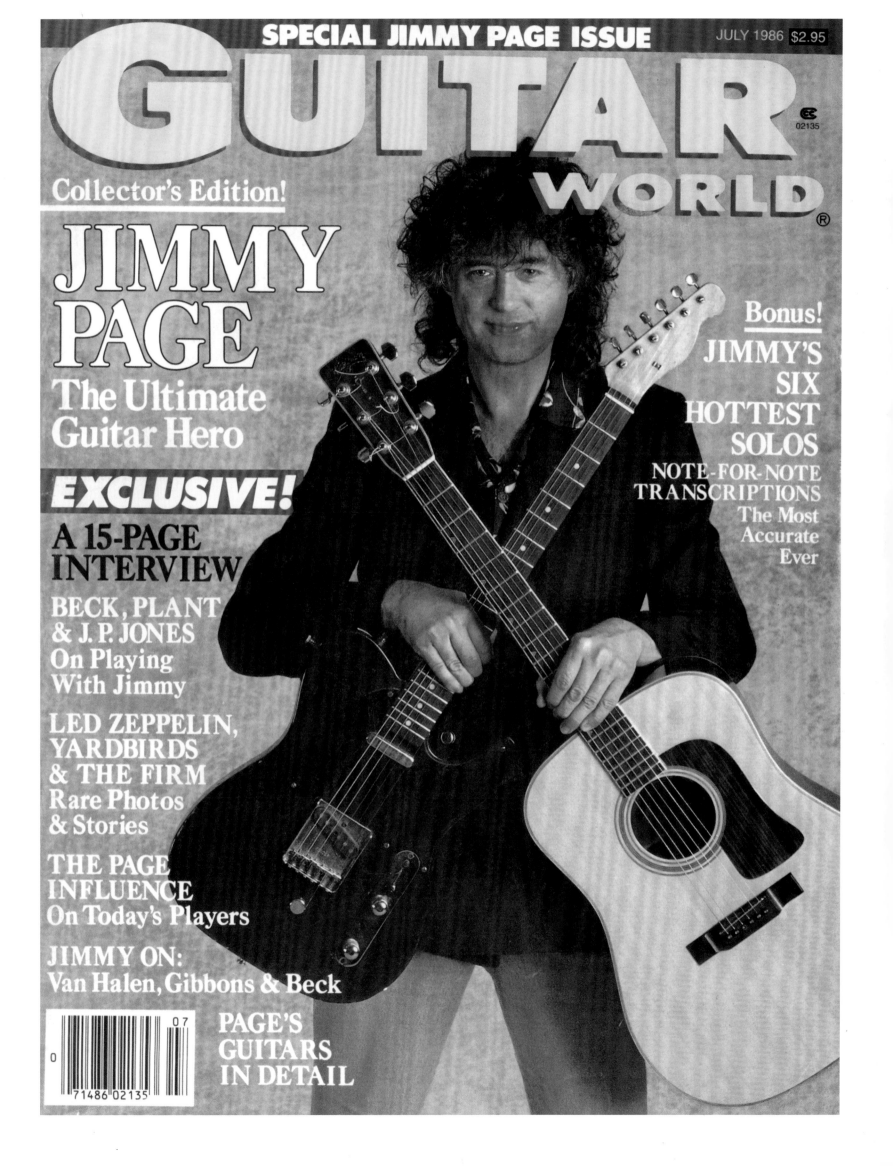

May The Firm be with you.

May 9
Brendan Byrne Arena
East Rutherford, USA

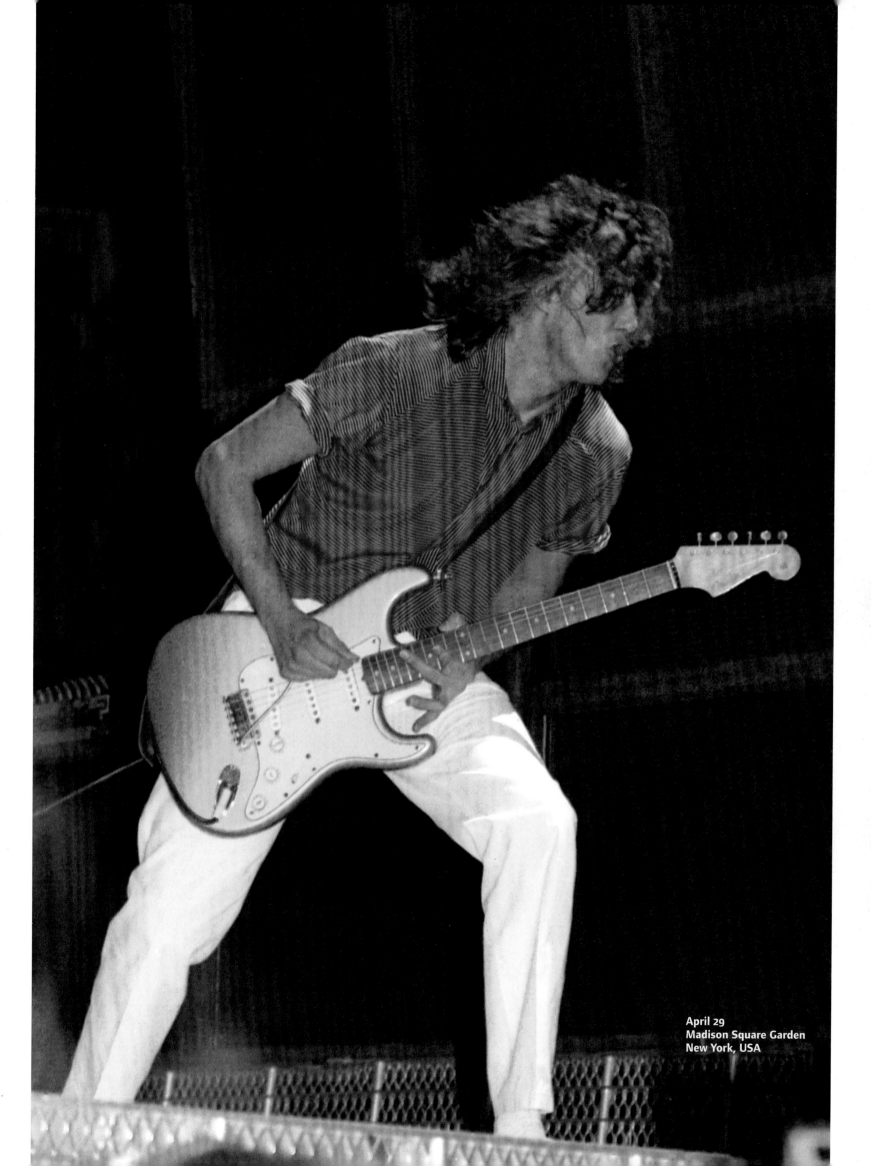

April 29
Madison Square Garden
New York, USA

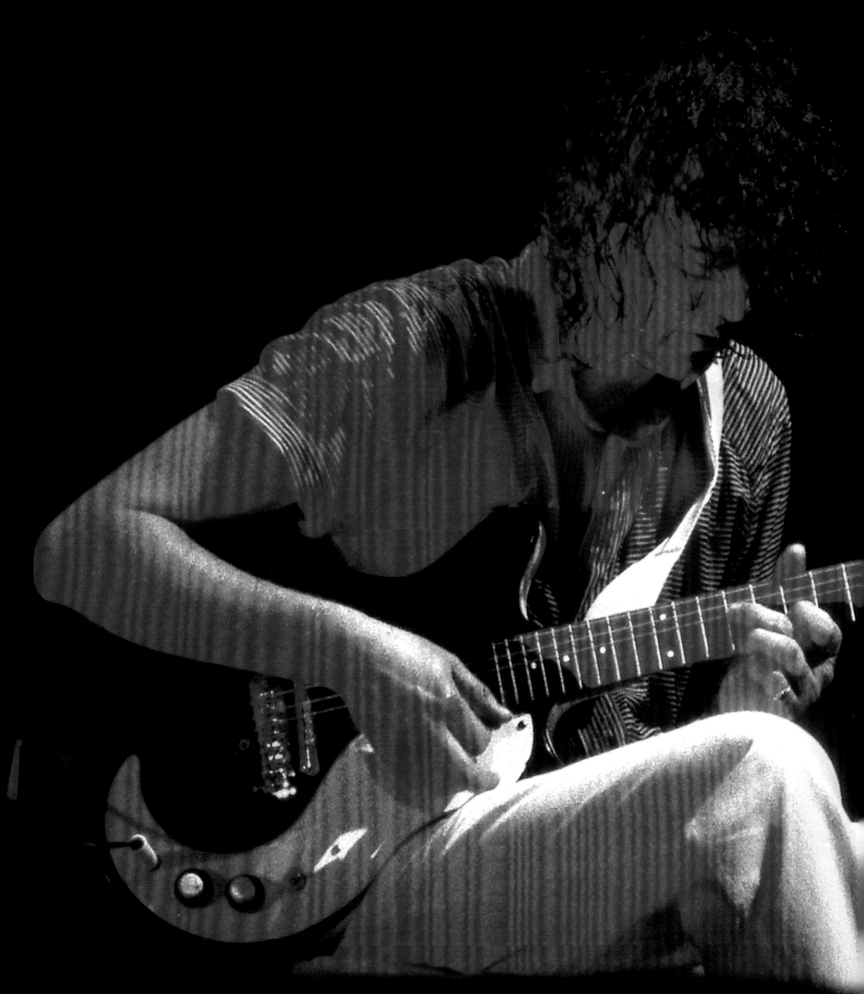

1986

Start of second American tour – Mean Business
March 14: Sun Dome, Tampa, USA
March 15: Sportatorium, Hollywood (FL), USA
March 17: Ocean Center, Daytona Beach, USA
March 19: Capitol Center, Landover, USA
March 21: Civic Center, Providence, USA
March 22: Coliseum, New Haven, USA
March 24: Civic Center, Springfield, USA
March 25: Broome County Arena, Binghamton, USA
March 27: Civic Center, Pittsburgh, USA
March 29: War Memorial Auditorium, Rochester, USA
March 31: The Spectrum, Philadelphia, USA

April 1: The Garden, Boston, USA
April 3: Nassau Coliseum, Uniondale, USA
April 4: Brendan Byrne Arena, East Rutherford, USA
April 23: The Omni, Atlanta, USA
April 25: Lakefront Arena, New Orleans, USA
April 27: Wings Stadium, Kalamazoo, USA
April 29: Elliot Hall, Purdue University, Lafayette, USA
April 30: Champaign, USA

May 2: Joe Louis Arena, Detroit, USA
May 3: Centennial Hall, Toledo, USA
May 5: Met Center, St Paul, USA
May 6: Rosemont Horizon, Chicago, USA
May 9: Hara Arena, Dayton, USA
May 11: Richfield Coliseum, Cleveland, USA
May 13: St Louis, USA
May 14: Kemper Arena, Kansas City, USA
May 15: Civic Center, St Paul, USA
May 16: Civic Center, Oklahoma City, USA
May 17: Reunion Arena, Dallas, USA
May 19: The Summit, Houston, USA
May 22: The Forum, Los Angeles, USA
May 23: Pacific Amphitheater, Costa Mesa, USA
May 25: Concord Pavilion, Concord, USA
May 26: Concord Pavilion, Concord, USA
May 28: Seattle Center Coliseum, Seattle, USA
[Phil Carson joins]
End of second American tour – Mean Business

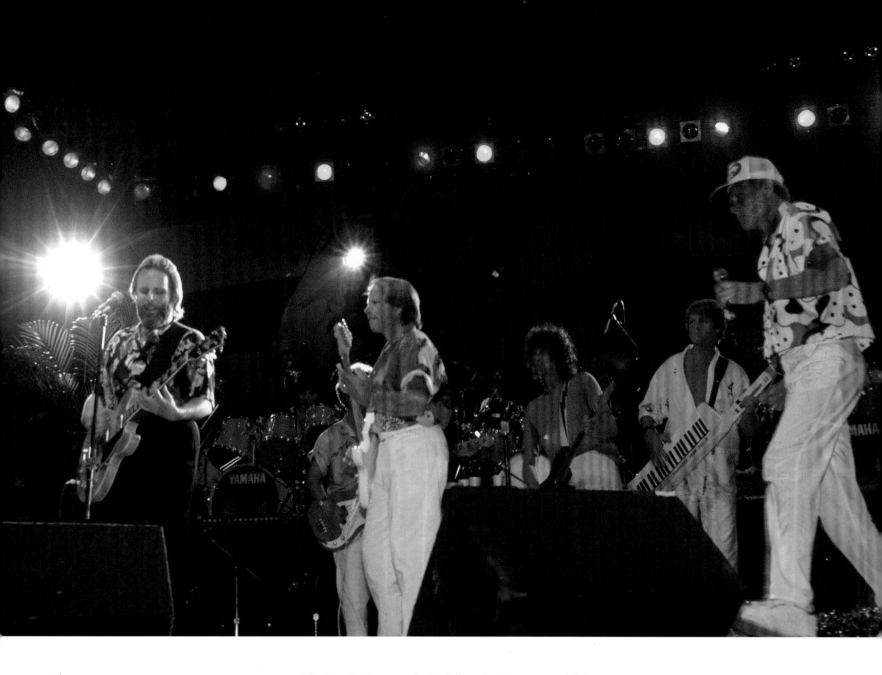

July 4
Ben Franklin Parkway
Art Museum
Philadelphia, USA

National Mall
Washington, DC, USA

The Beach Boys regularly did a 4th July concert. This particular year they performed two and I was invited to play on both.

We travelled by rail between Philadelphia and Washington. Here we are entering into the spirit of the event.

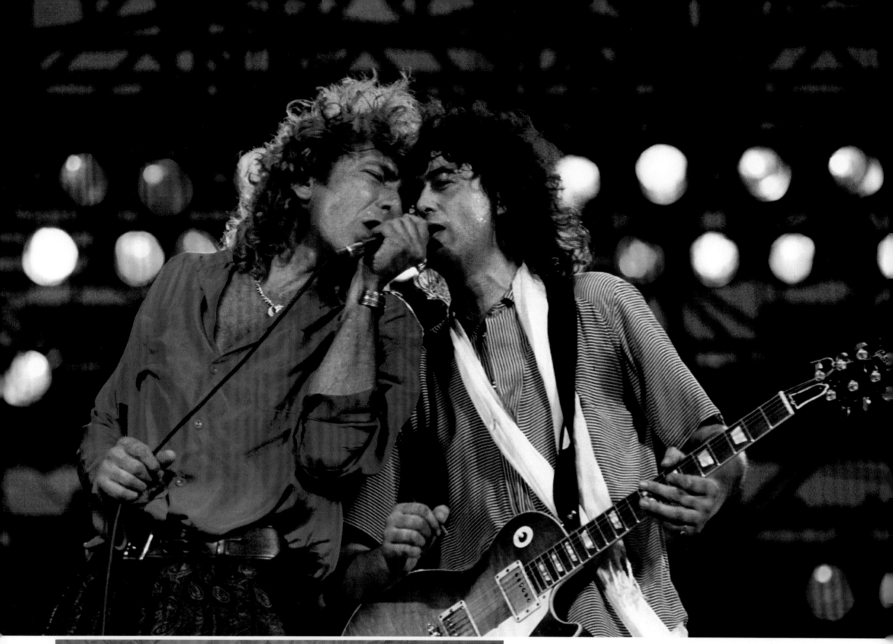

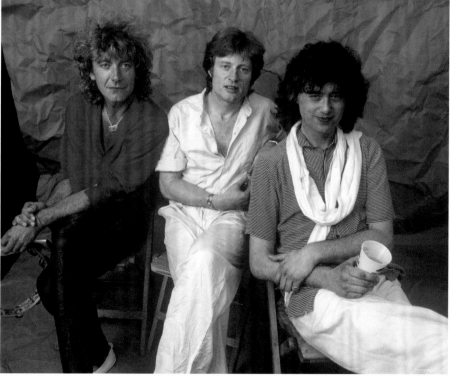

July 13
Live Aid
JFK Stadium
Philadelphia, USA

I returned to Philadelphia to appear at Live Aid with Robert and John Paul Jones. The pictures are better than our performance. We had two hours rehearsal with a stand-in drummer. We came together to be part of the Live Aid ethic, but sometimes it needs a little more than a wing and a prayer.

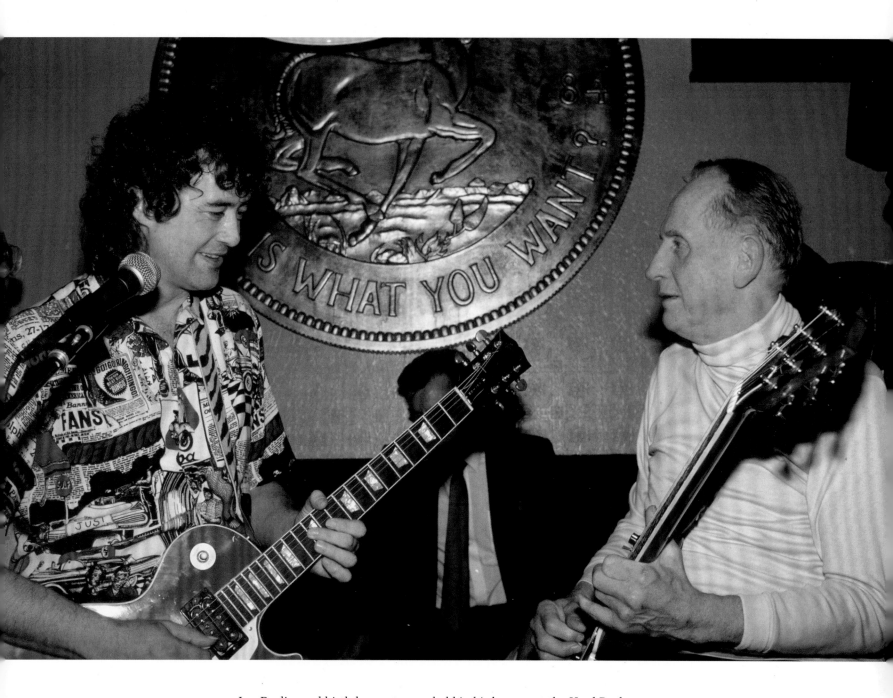

Les Paul's 72nd birthday party was held in his honour at the Hard Rock restaurant in New York. I had a loud graphic shirt to which Les made allusions to signing in order to increase its graphic quality. He had a remarkable sense of humour; we miss him.

JIMMY PAGE
OUTRIDER

Twenty three years after the release of my one and only solo
single I thought it might be fun to do a solo album where
I had the opportunity to include some of my old friends on
the tracks. I had much fun doing the slow-motion photographic
session that accompanied the artwork for the album.

A band was formed around this project including John Miles
on vocals and keyboards, Durban Laverde on bass and Jason
Bonham on drums. I took this on tour playing material from
The Yardbirds, Led Zeppelin, the *Deathwish II* soundtrack,
The Firm and the *Outrider* album.

The reception was strong and reassuring.

THE RELEASE OF *OUTRIDER*
JUNE 19

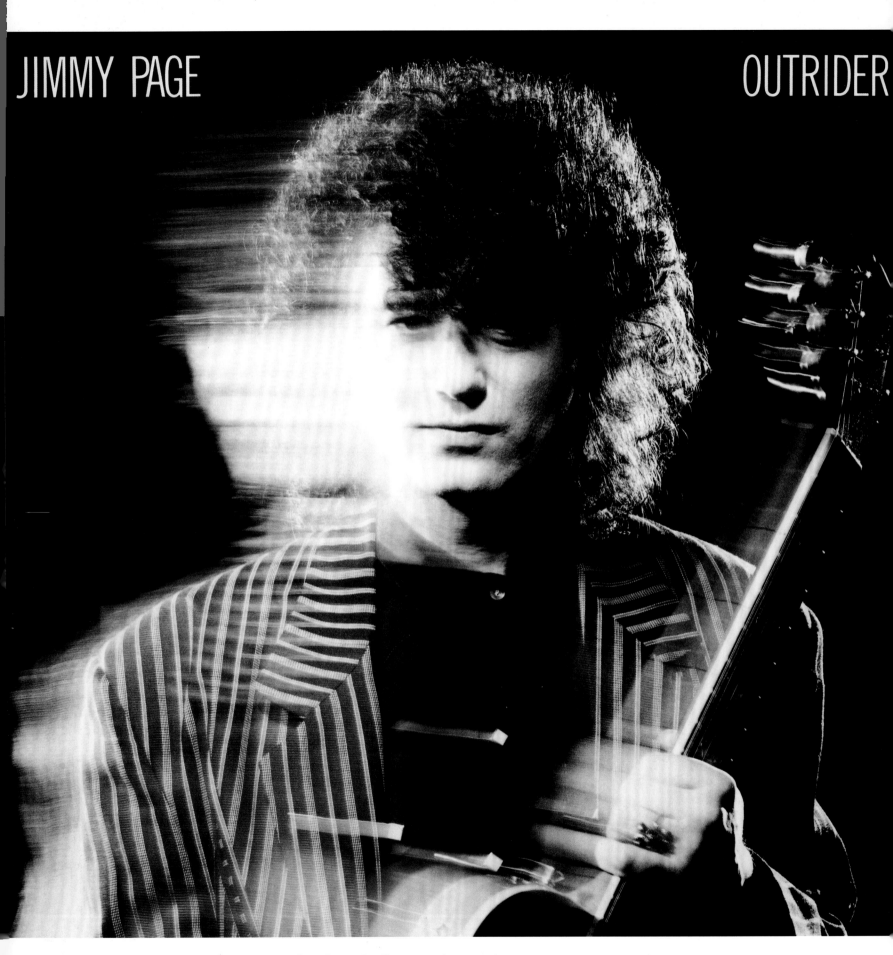

On the artwork of my first solo album *Outrider*, I was keen to capture my connection with the instrument: the movement, energy and flow. Inspired by a photograph by Robert Mapplethorpe, I wanted to take this idea further. These slow motion images encapsulate exactly what I was trying to convey.

JIMMY PAGE OUTRIDER

His First Solo Album
LP · CASSETTE · CD
Produced by Jimmy Page

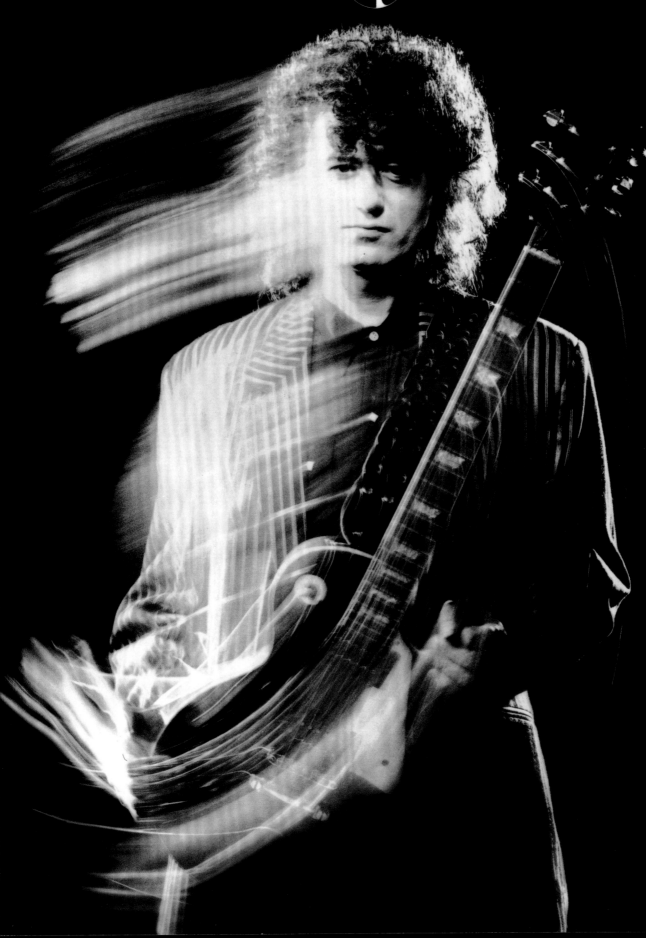

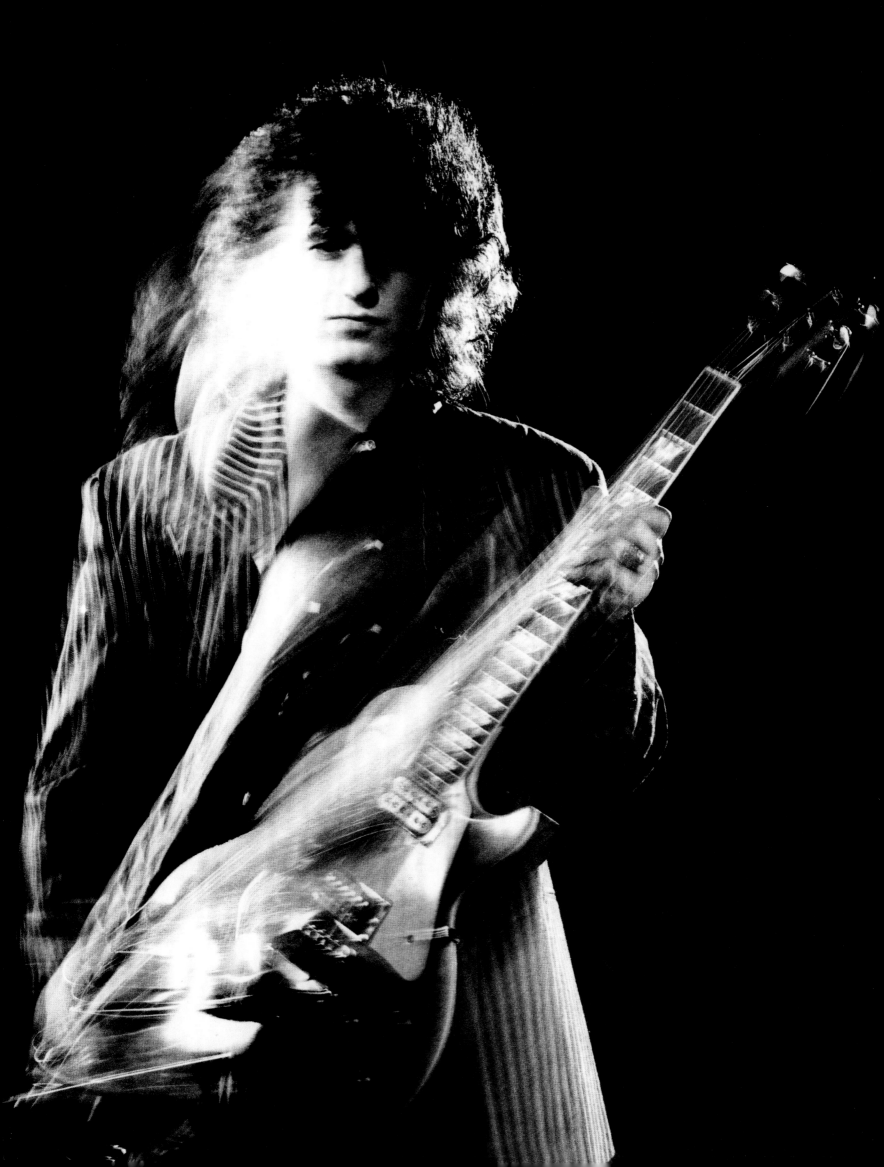

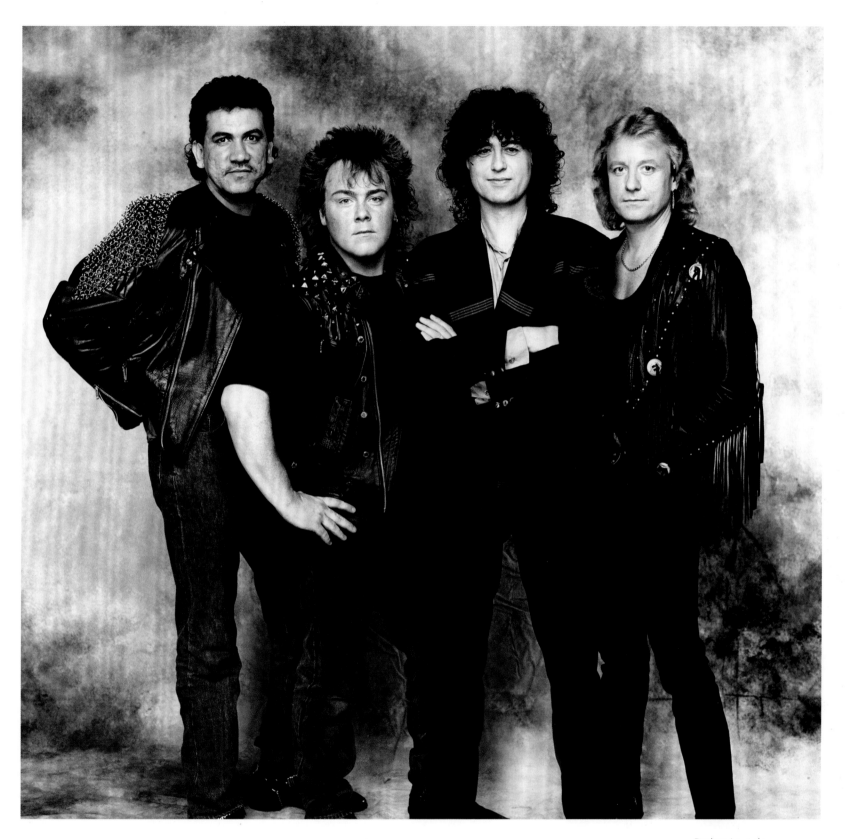

Durban Laverde,
Jason Bonham, Jimmy Page
and John Miles

November 12
The Ritz
New York, USA

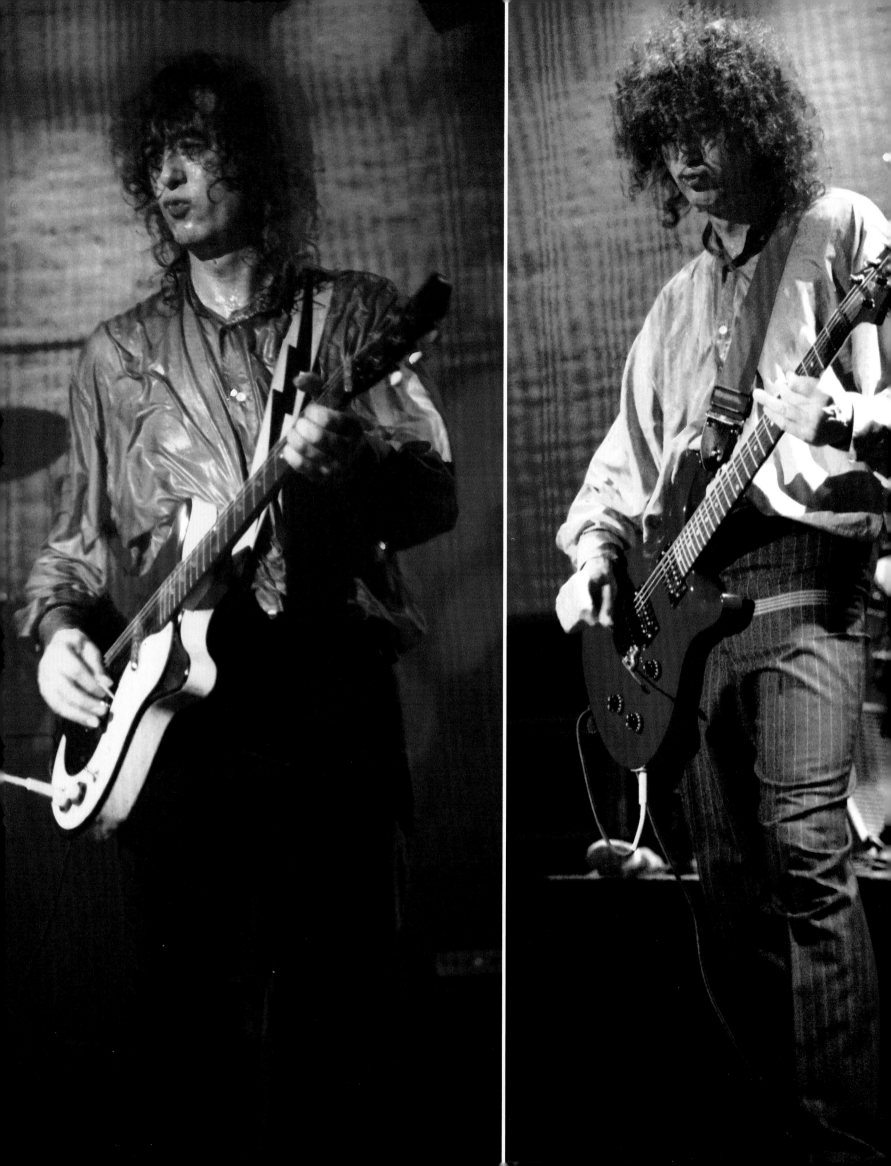

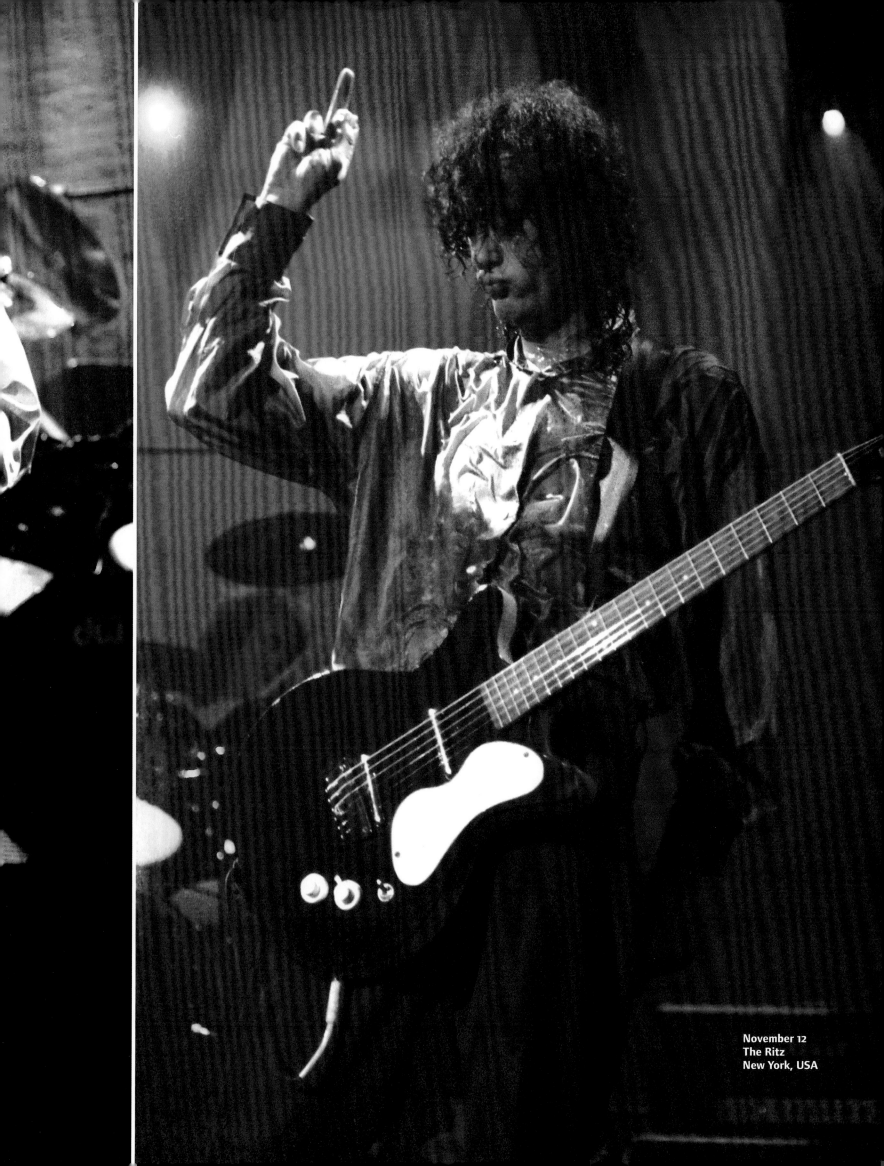

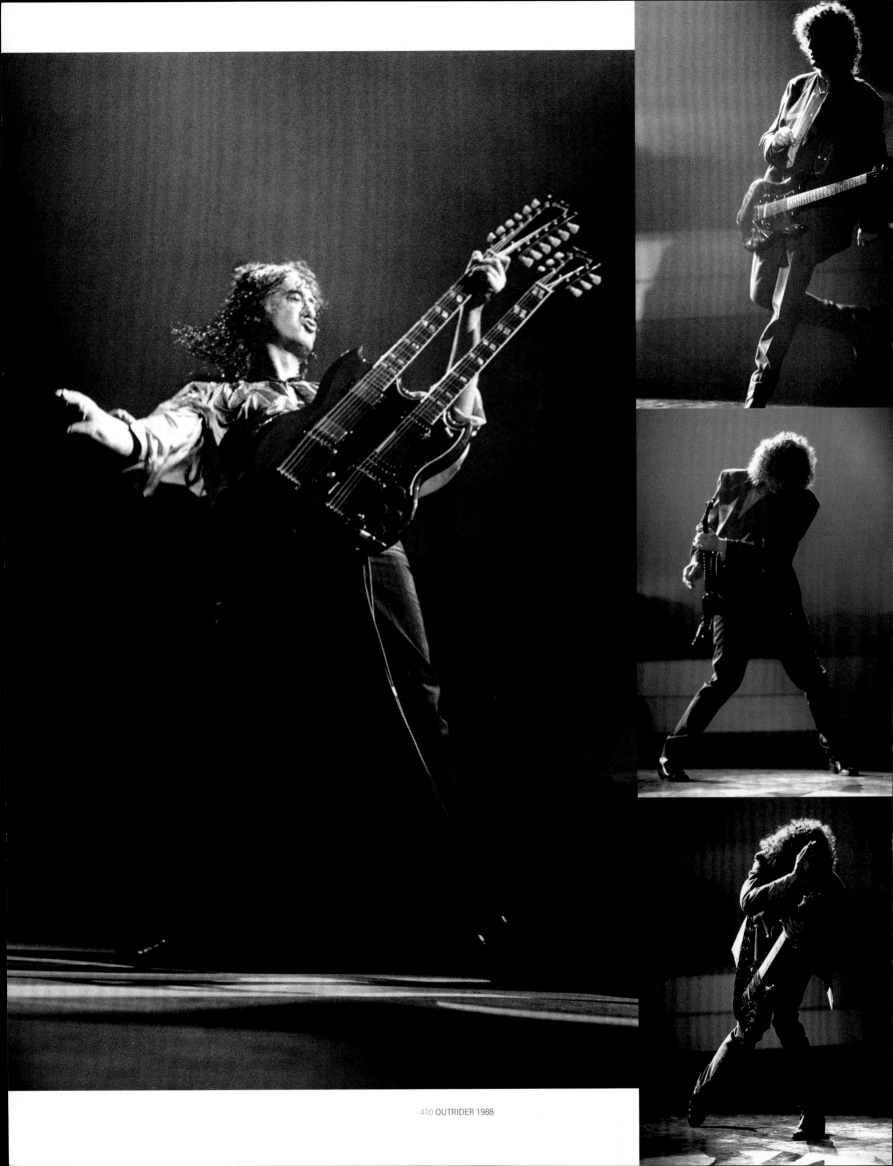

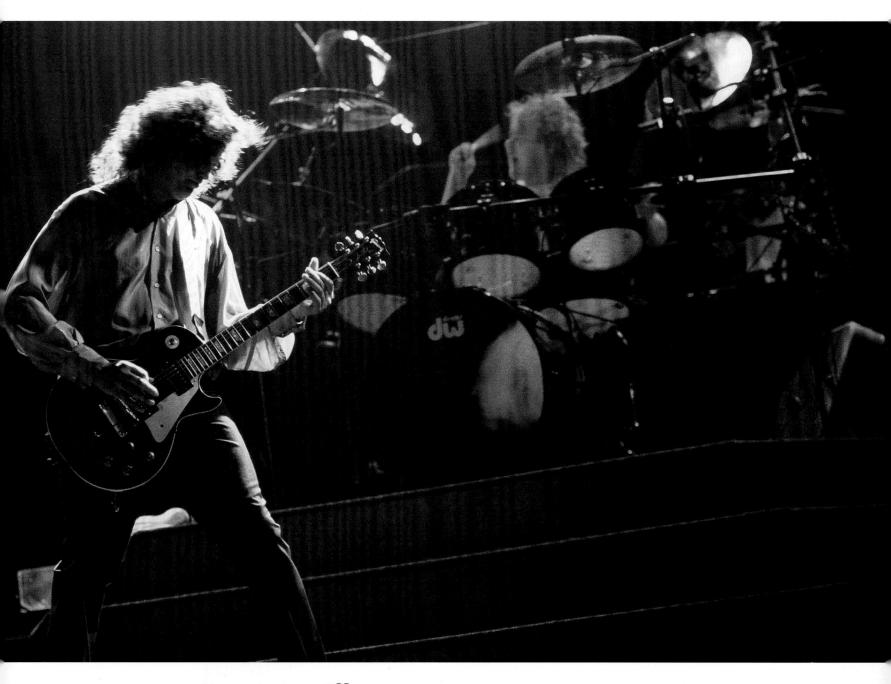

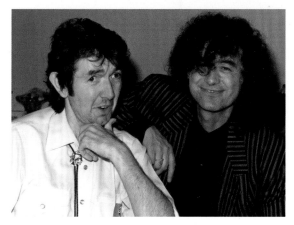

When we played in Texas it gave me a chance to hook up with my old pal, Ronnie Lane.

1988

Start of American tour
September 6: Omni Theatre, Atlanta, USA
September 8: Miami Knight Center, Miami, USA
September 9: USF Sun Dome, Tampa, USA
September 11: The Summit, Houston, USA
September 14: Frank Erwin Center, Austin, USA
September 16: Special Events Center, El Paso, USA
September 17: Mesa Amphitheater, Phoenix, USA
September 23: Starplex Amphitheatre, Dallas, USA
September 24: Municipal Auditorium, New Orleans, USA

October 7: Inglewood Forum, Los Angeles, USA
October 8: SDSU Open Air Amphitheater, San Diego, USA
October 11: Coliseum, Oakland, USA
October 14: Memorial Hall, Kansas City, USA
October 16: Met Center, Minneapolis, USA
October 17: UIC Pavilion, Chicago, USA
October 19: Public Auditorium, Cleveland, USA
October 21: Hara Arena, Dayton, USA
October 22: Joe Louis Arena, Detroit, USA
October 25: War Memorial Auditorium, Rochester, USA
October 26: Brendan Byrne Arena, East Rutherford, USA
October 28: Nassau Coliseum, Uniondale, USA
October 29: The Centrum, Worcester, USA
October 30: The Spectrum, Philadelphia, USA

November 3: Coliseum, New Haven, USA
November 4: Onondaga War Memorial Auditorium, Syracuse, USA
November 5: RPI Fieldhouse, Troy, USA
November 8: Landover, USA
November 9 Pittsburgh, USA
November 11: Civic Center, Portland, USA
November 12: The Ritz, New York, USA
November 13: The Ritz, New York, USA
End of American tour

Start of UK tour
November 21: The Hummingbird, Birmingham, UK
November 23: City Hall, Newcastle, UK
November 24: Hammersmith Odeon, London, UK
November 25: Hammersmith Odeon, London, UK
November 26: The Apollo, Manchester, UK
End of UK tour

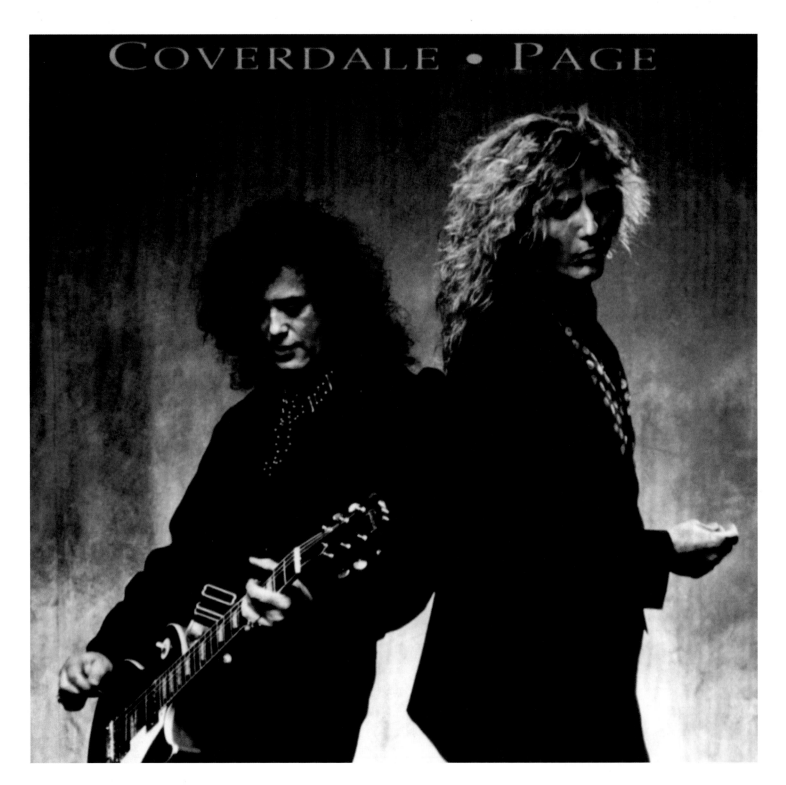

COVERDALE • PAGE

THE RELEASE OF *COVERDALE PAGE*
MARCH 27

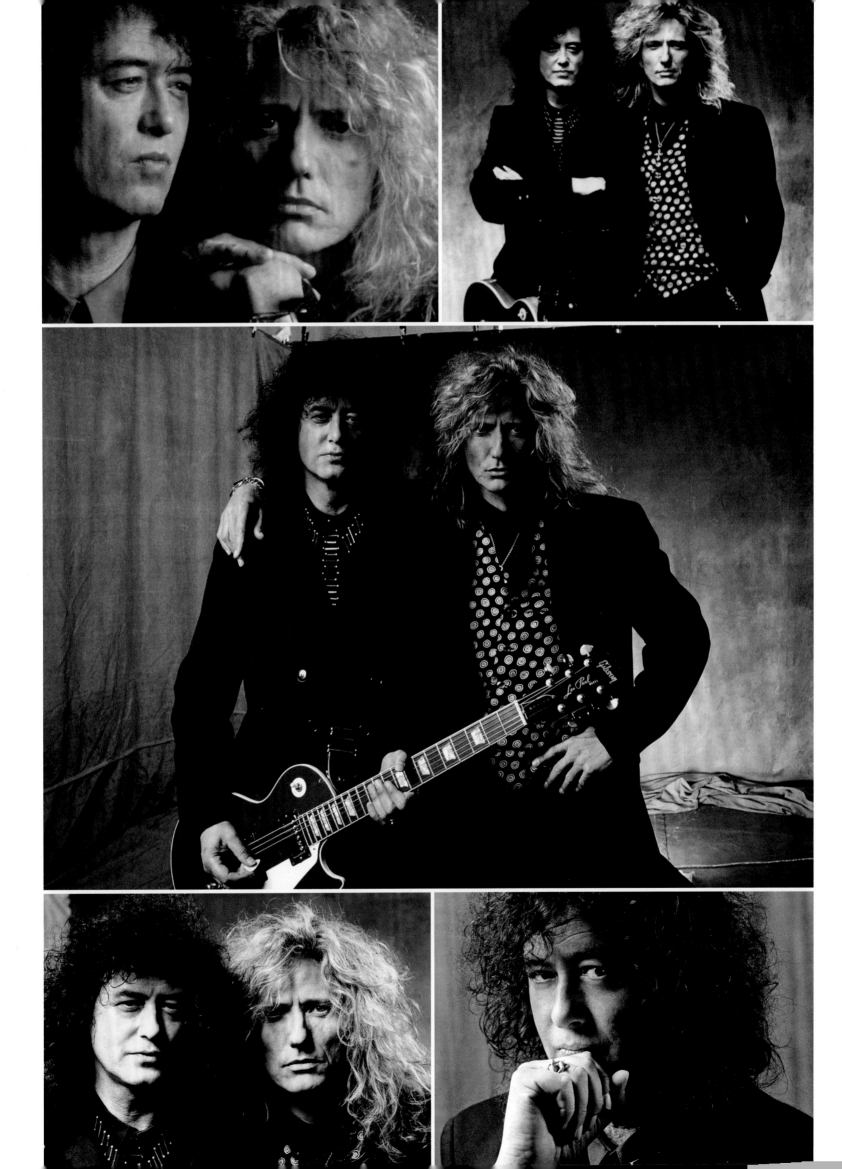

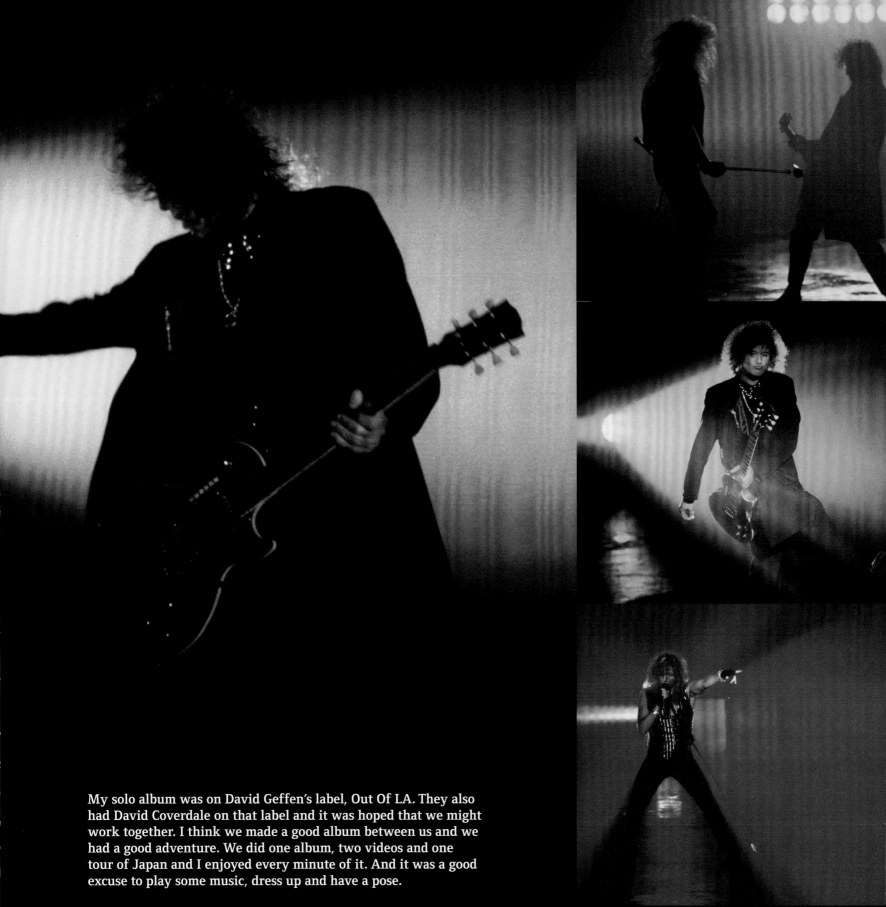

My solo album was on David Geffen's label, Out Of LA. They also had David Coverdale on that label and it was hoped that we might work together. I think we made a good album between us and we had a good adventure. We did one album, two videos and one tour of Japan and I enjoyed every minute of it. And it was a good excuse to play some music, dress up and have a pose.

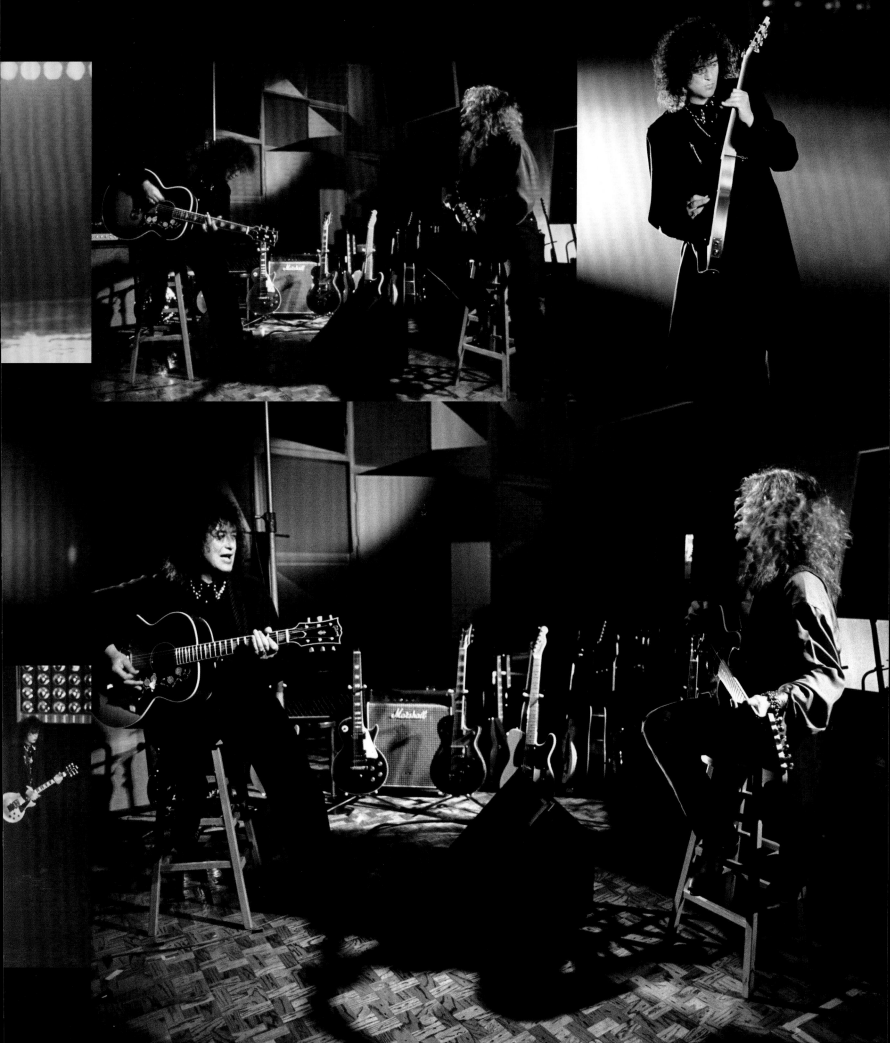

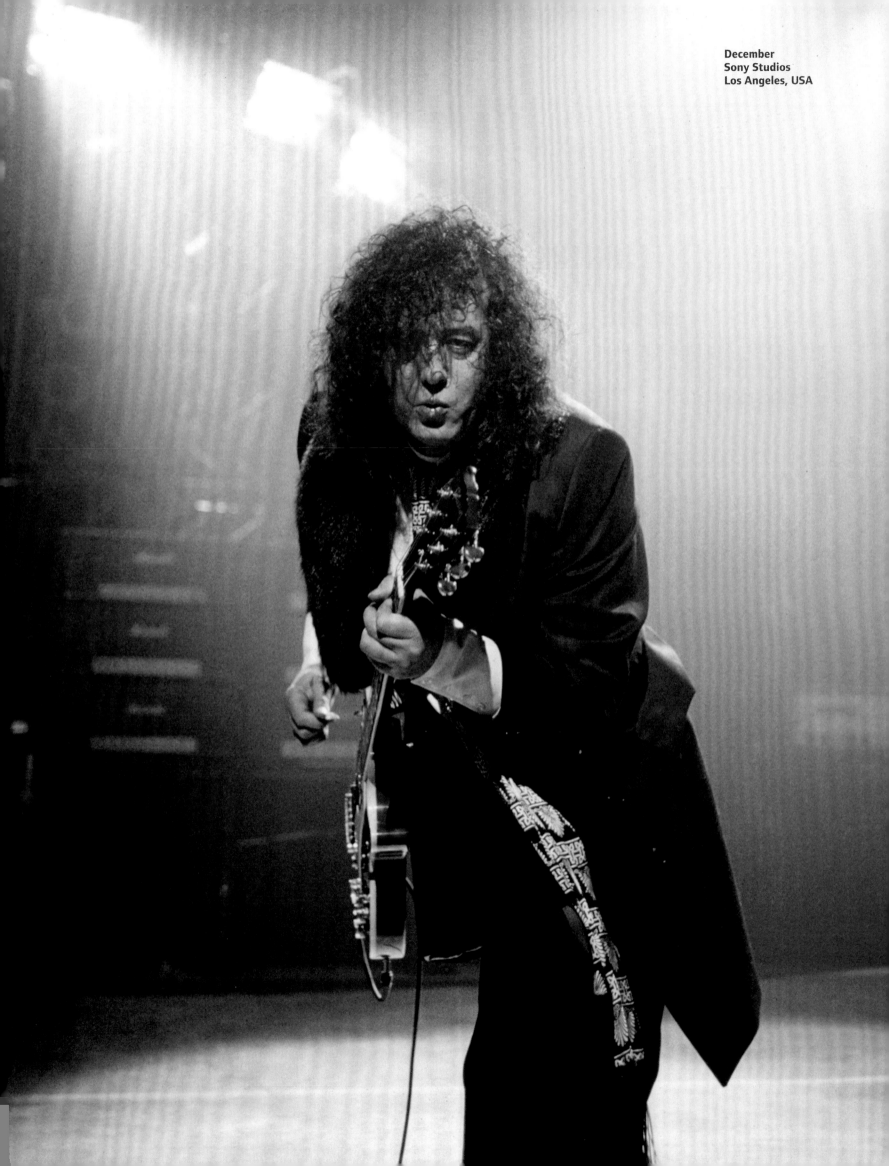

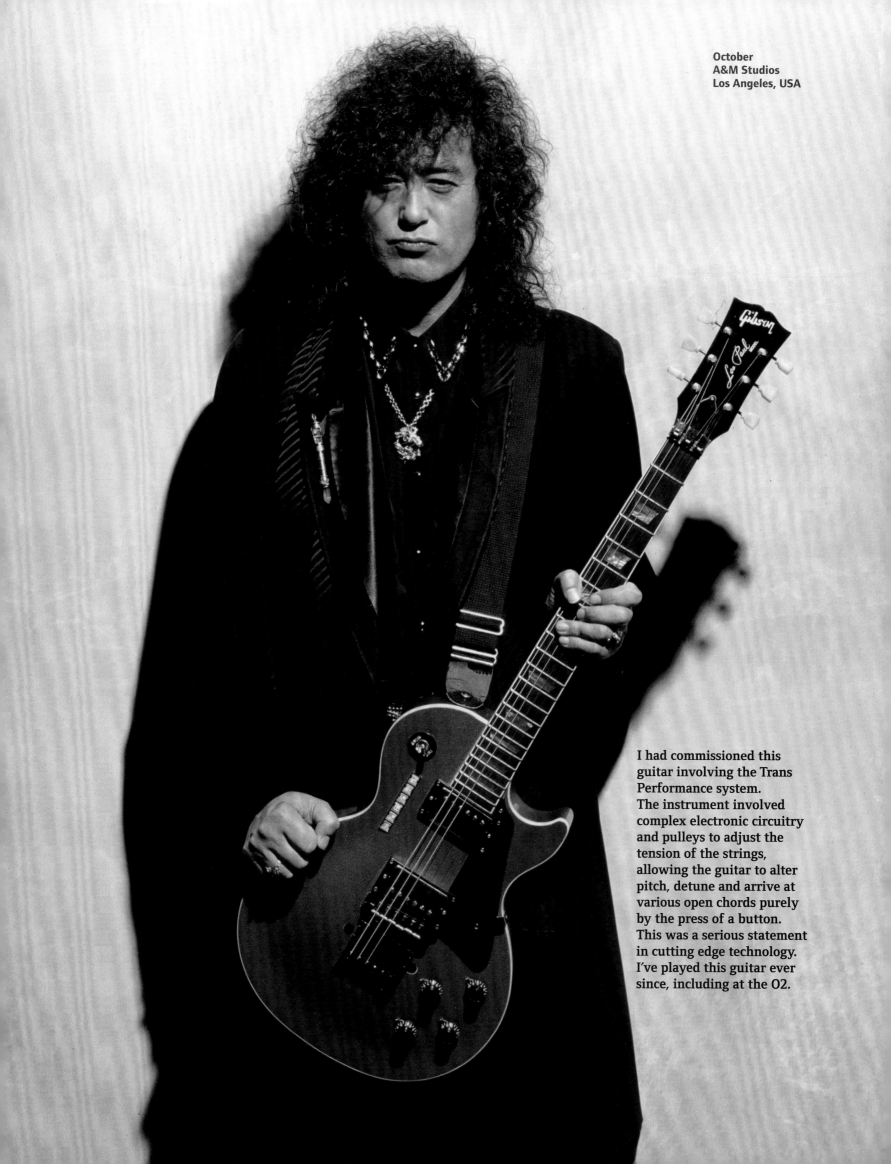

I had commissioned this guitar involving the Trans Performance system. The instrument involved complex electronic circuitry and pulleys to adjust the tension of the strings, allowing the guitar to alter pitch, detune and arrive at various open chords purely by the press of a button. This was a serious statement in cutting edge technology. I've played this guitar ever since, including at the O2.

1993
Start of Japanese tour
December 14: Budokan Hall, Tokyo, Japan
December 15: Budokan Hall, Tokyo, Japan
December 17: Yoyogi Olympic Hall, Tokyo, Japan
December 18: Yoyogi Olympic Pool, Tokyo, Japan
December 20: Castle Hall, Osaka, Japan
December 21: Castle Hall, Osaka, Japan
December 22: Nagoya Gym, Nagoya, Japan
End of Japanese tour

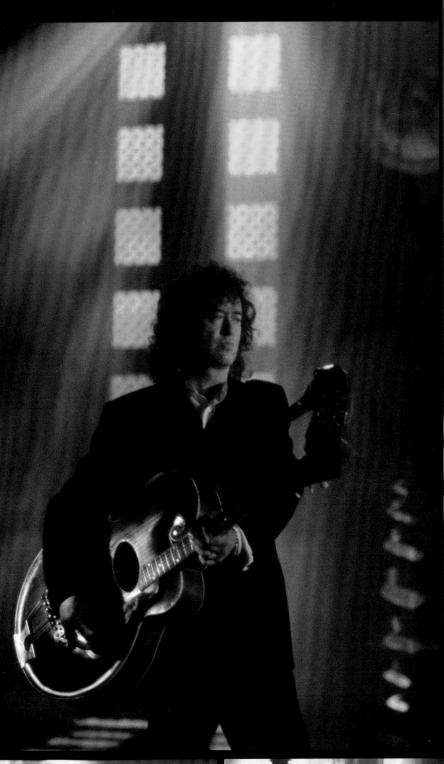

Filming the video for 'Take Me For A Little While' at Shepperton Film Studios with an antique Gibson harp guitar.

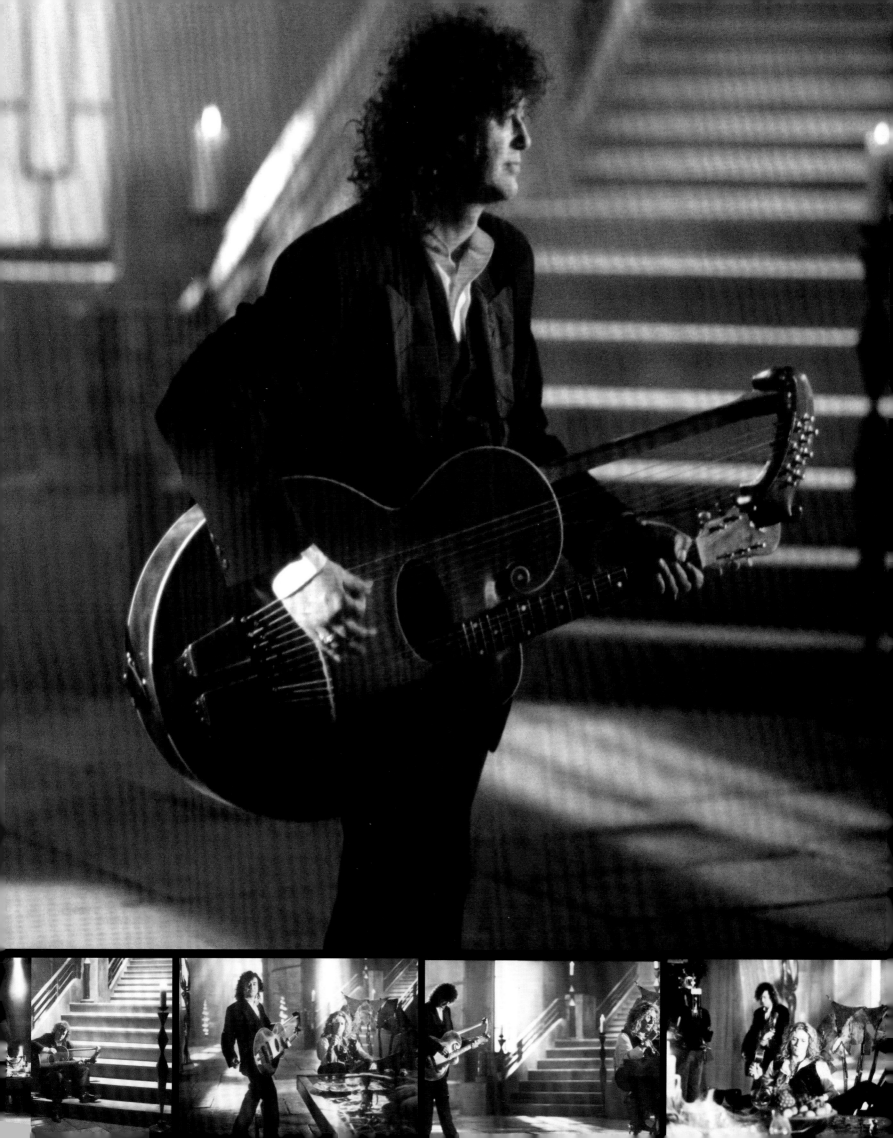

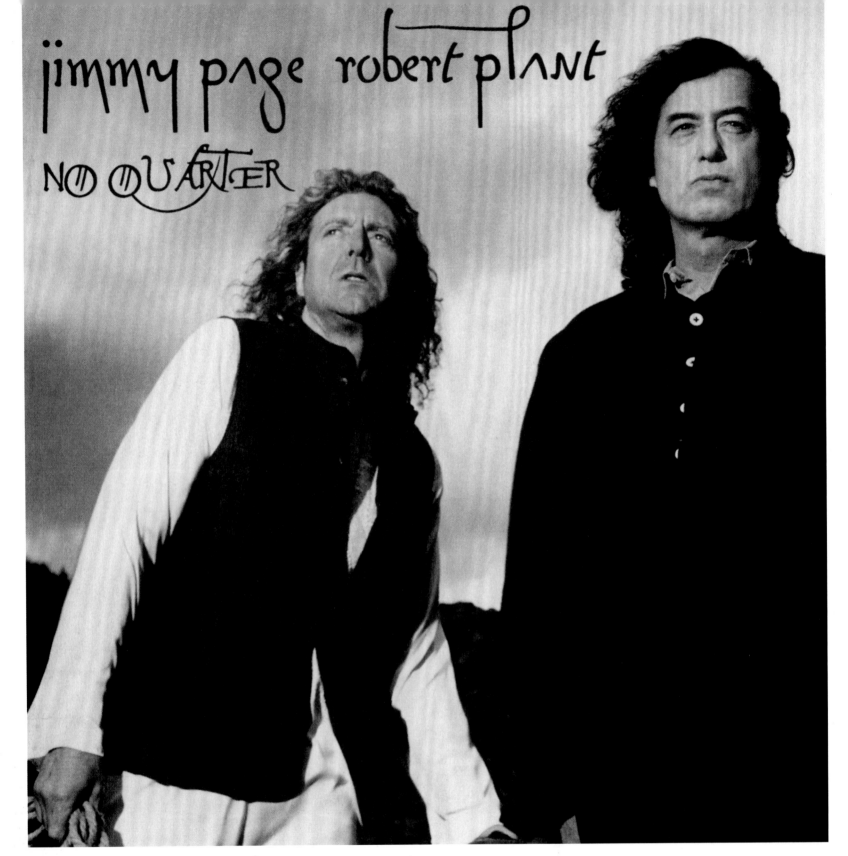

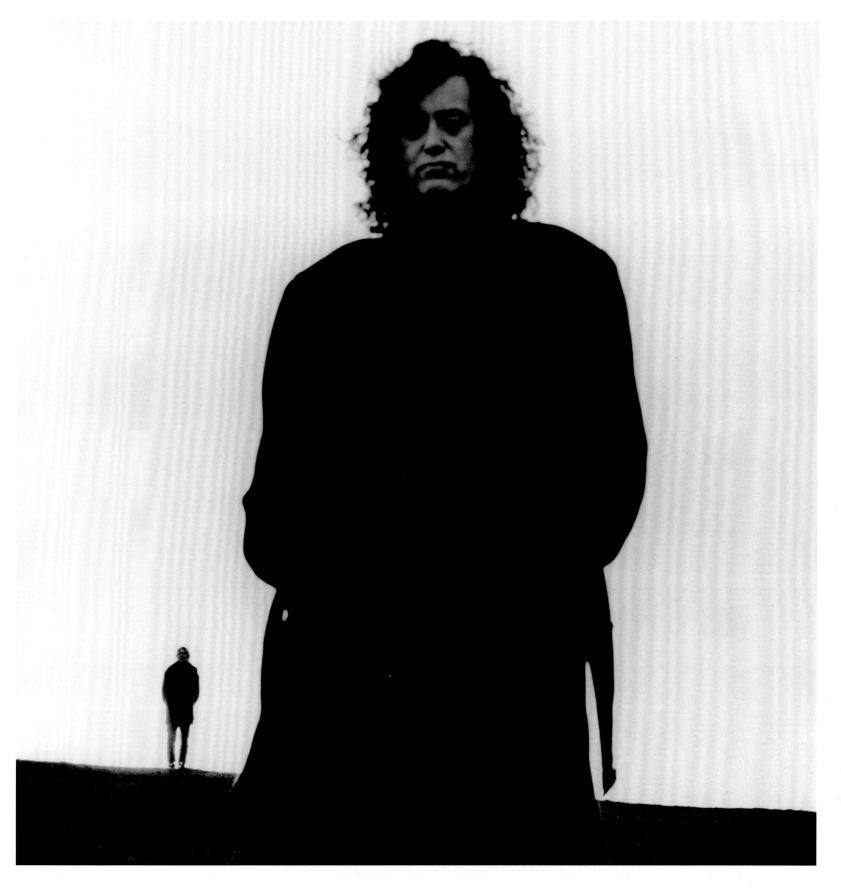

Robert Plant and I embarked upon an ambitious project which was to involve recording in Morocco with ethnic musicians, in the rain at a slate mine in Wales and at London TV Studios with a rhythm section, hurdy gurdy player, a western orchestra, four Egyptian violinists, and four Egyptian percussionists.

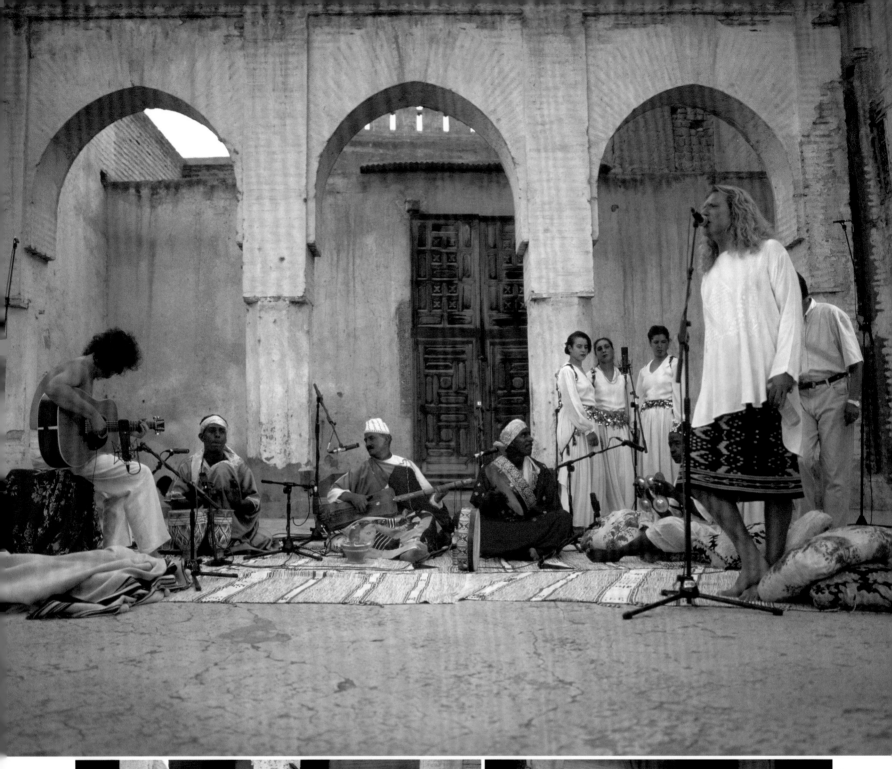

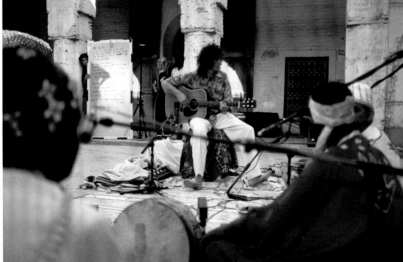

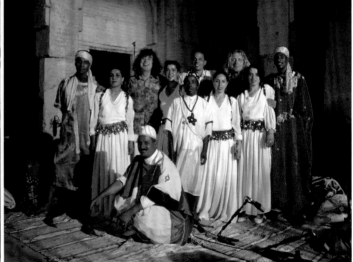

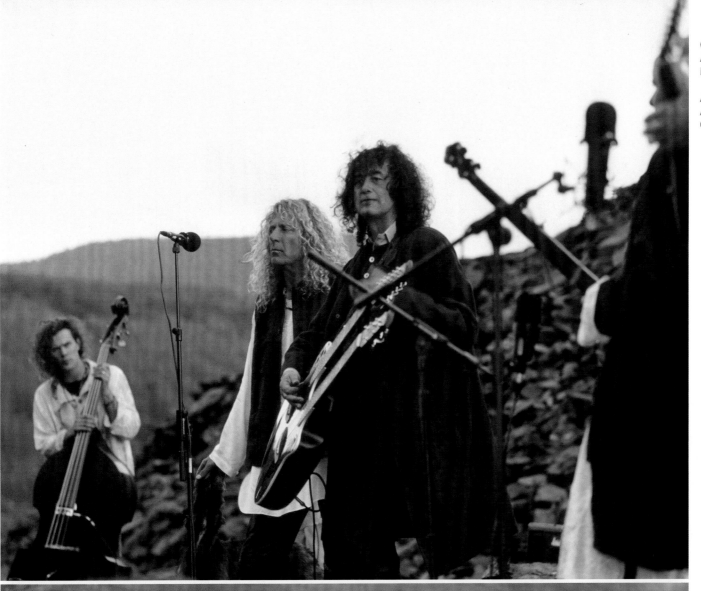

Opposite:
August 9–12
Marrakech, Morocco

August 17
A slate mine
Corris, Wales

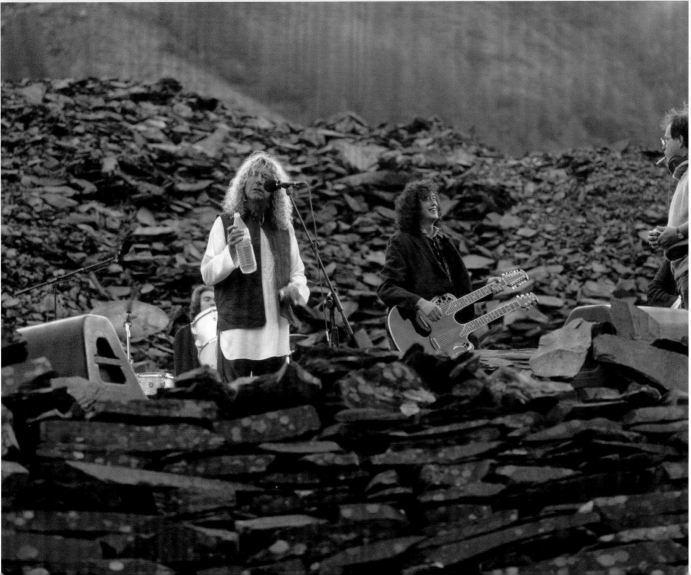

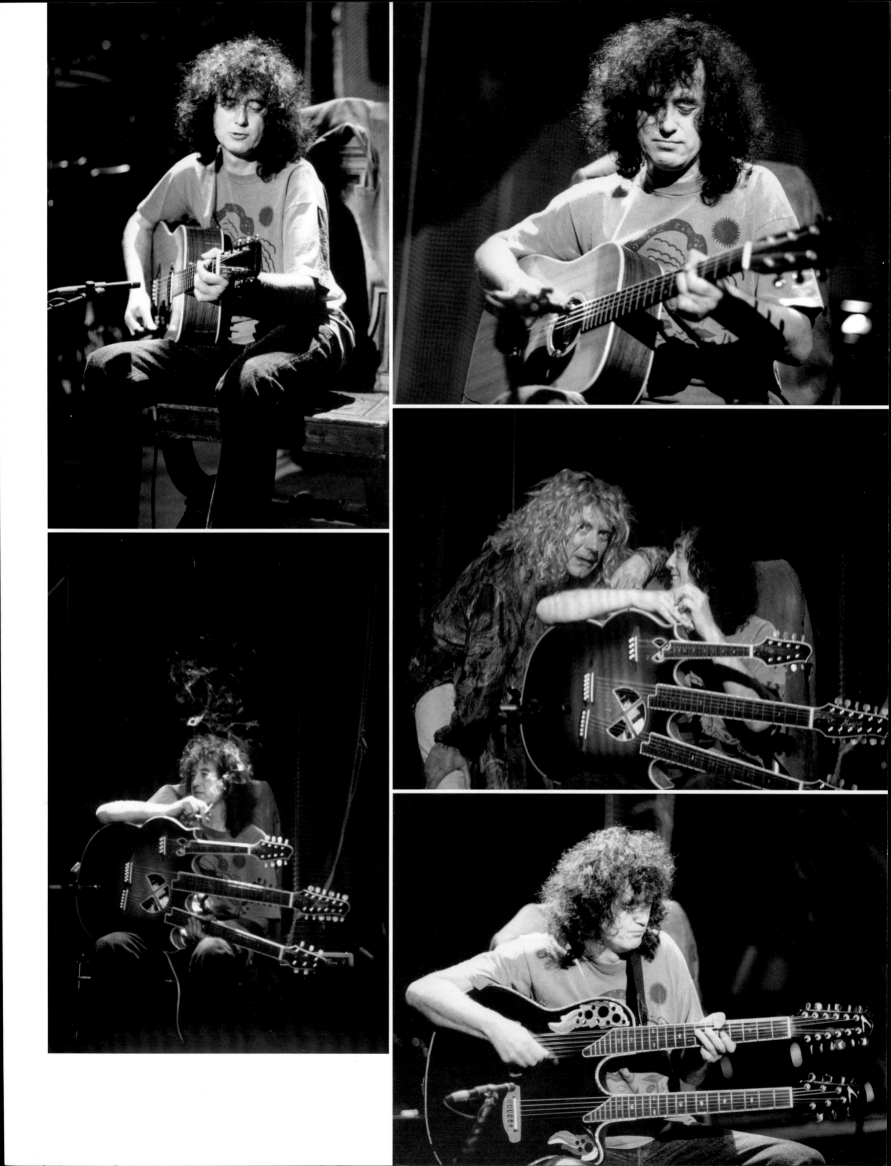

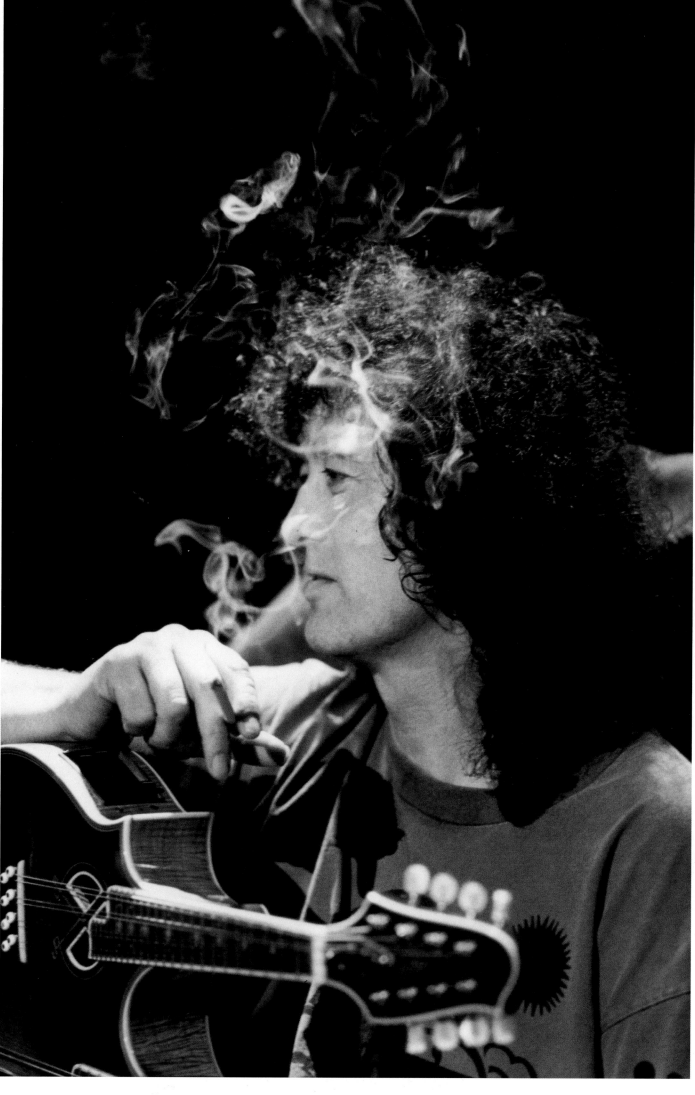

August 24
Rehearsals
Studio 2
London TV Studios
London, UK
For MTV's
Unplugged series

THE RELEASE OF
*NO QUARTER: JIMMY PAGE
& ROBERT PLANT UNLEDDED*
OCTOBER 14

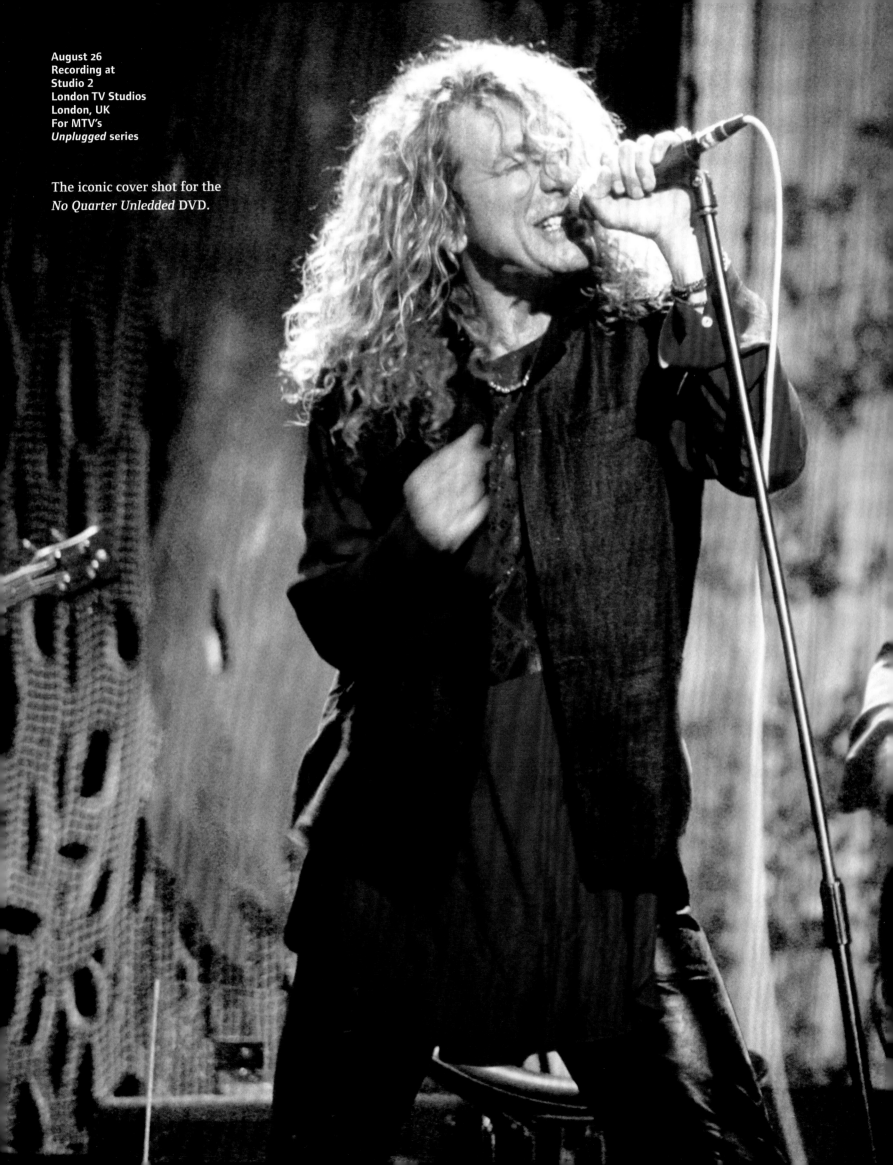

August 26
Recording at
Studio 2
London TV Studios
London, UK
For MTV's
Unplugged series

The iconic cover shot for the
No Quarter Unledded DVD.

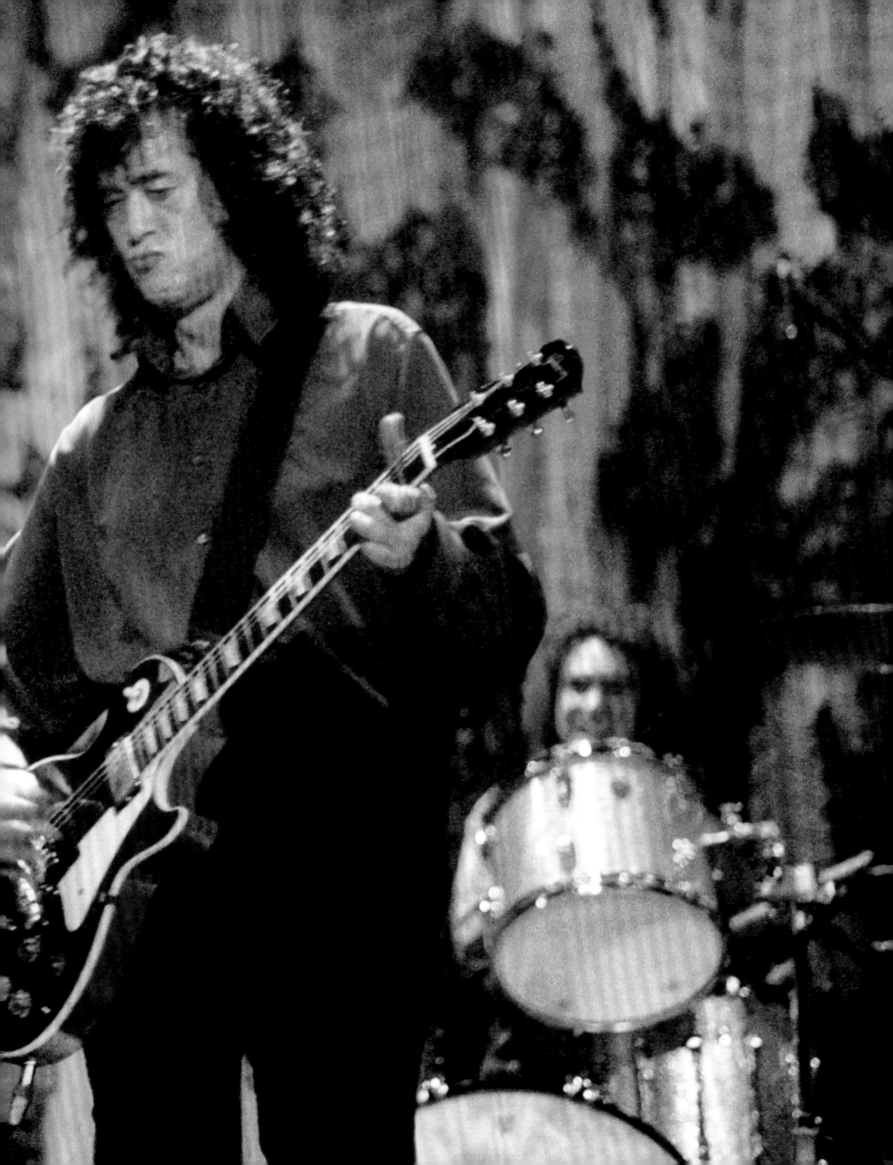

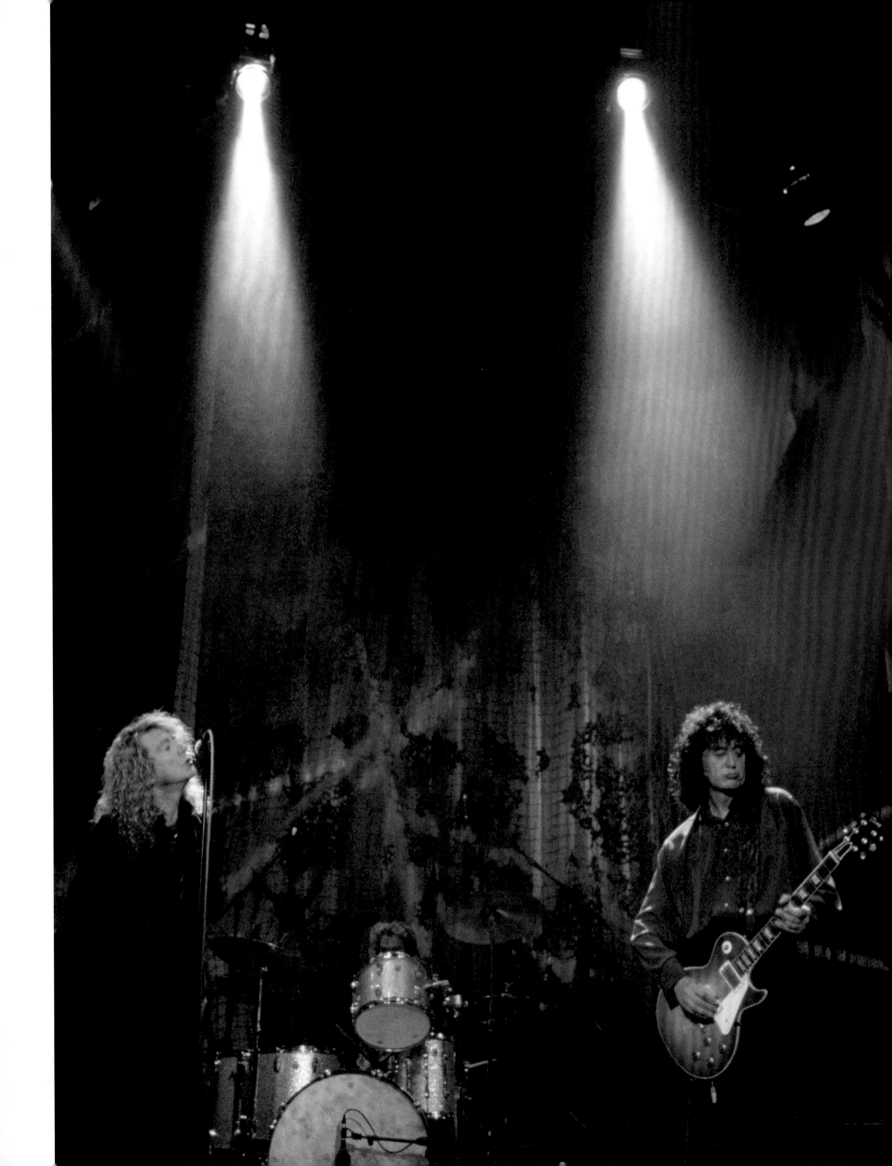

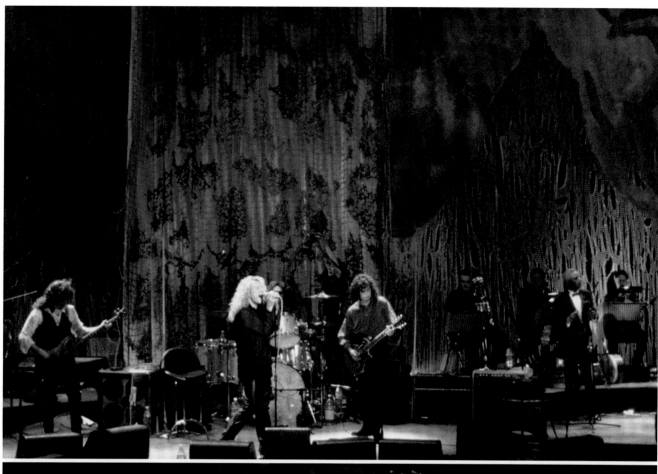

Opposite and left:
August 26
Studio 2
London TV Studios
London, UK

Below:
25 & 26 July
Wembley
London, UK

Final shows of European
leg of *Unledded*
world tour

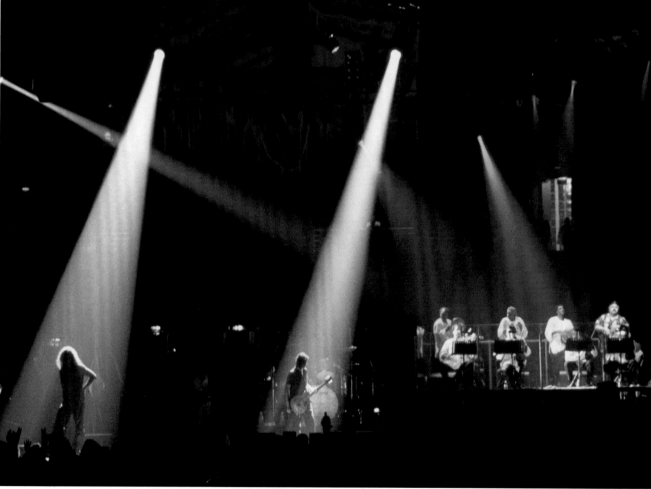

We took this project around the world where it introduced the audience to a
tapestry of musical textures and colours that they had not experienced before.

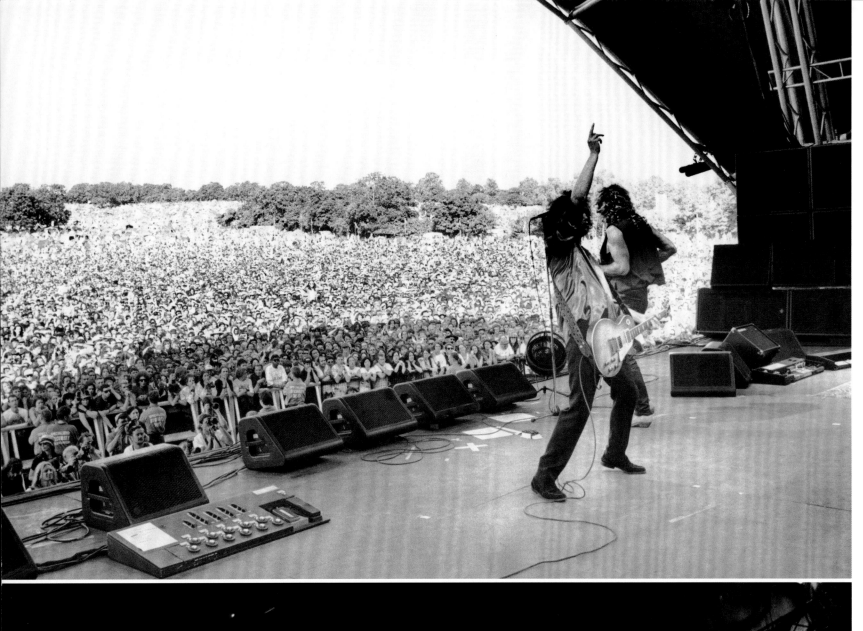

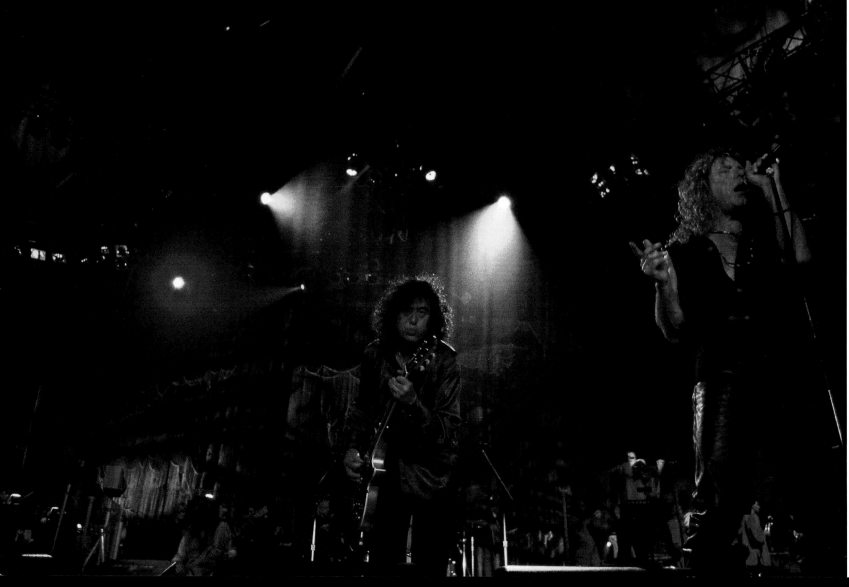

1994

April 17: Alexis Korner Tribute Concert, Buxton, UK

August 9: Marrakech, Morocco
August 10: Place Djemaa el-Fna, Marrakech, Morocco
August 16: Dolgoch, Wales, UK
August 17: Braich-goch Slate Mine, Corris, UK
August 24: Studio 2, London TV Studios, UK
August 25: Studio 2, London TV Studios, UK
August 26: Studio 2, London TV Studios, UK

November 8: *Later with Jools Holland*, BBC TV Centre, London, UK
November 10: The News Station, TV Asahi, Japan
November 16: 3MMM FM, Sydney, Australia
November 17: *Denton* TV Show, Australia

1995

Start of first American leg of Unledded world tour
February 6: Pensacola Civic Arena, Pensacola, Florida
February 28: The Omni, Atlanta, USA

March 1: The Omni, Atlanta, USA
March 3: Thompson-Boling Arena, Knoxville, USA
March 4: Pyramid Arena, Memphis, USA
March 6: Miami Arena, Miami, USA
March 7: Orlando Complex, Orlando, USA
March 10: Lakefront Arena, New Orleans, USA
March 11: Lakefront Arena, New Orleans, USA
March 13: Frank Erwin Center, Austin, USA
March 14: Summit, Houston, USA
March 17: Barton Coliseum, Little Rock, USA
March 18: Reunion Arena, Dallas, USA
March 20: Rupp Arena, Lexington, USA
March 22: US Air Arena, Washington, USA
March 23: US Air Arena, Washington, USA
March 25: Civic Arena, Pittsburgh, USA
March 27: Skydome, Toronto, Canada
March 28: Gund Arena, Cleveland, USA
March 31: Palace of Auburn Hills, Detroit, USA

April 1: Palace of Auburn Hills, Detroit, USA
April 3: The Spectrum, Philadelphia, USA
April 4: The Spectrum, Philadelphia, USA
April 6: Meadowlands, East Rutherford, USA
April 7: Meadowlands, East Rutherford, USA
April 9: Boston Gardens, Boston, USA
April 10: Boston Gardens, Boston, USA
April 25: Riverside Coliseum, Cincinnati, USA
April 26: Market Square Arena, Indianapolis, USA
April 28: Rosemont Horizon, Chicago, USA
April 29: Rosemont Horizon, Chicago, USA

May 1: Bradley Center, Milwaukee, USA
May 2: Target Center, Minneapolis, USA
May 5: Kemper Arena, Kansas City, USA
May 6: Kiel Center, St Louis, USA
May 8: McNichols Arena, Denver, USA
May 10: America West Arena, Phoenix, USA
May 12: MGM Grand, Las Vegas, USA
May 13: Sports Arena, San Diego, USA
May 16: The Forum, Los Angeles, USA
May 17: The Forum, Los Angeles, USA
May 19: Coliseum, Oakland, USA
May 20: Arena, San Jose, USA
May 23: Coliseum, Portland, USA
May 25: Tacoma Dome, Tacoma, USA
May 26: PNE, Vancouver, Canada
May 27: The Gorge Amphitheatre, George, USA
End of first US leg

Start of European leg of Unledded world tour
June 6: Palais Omnisports de Paris Bercy, Paris, France
June 7: Halle Tony Garnier, Lyon, France
June 9: Dome, Marseilles, France
June 10: Sonoria Festival, Milan, Italy
June 12: Palais des Sports, Toulouse, France
June 15: Ahoy, Rotterdam, Netherlands
June 16: Forest National, Brussels, Belgium
June 18: Lueneberg Festival, Germany
June 24: Wegberg Festival, Schwalmstadt, Germany
June 25: Glastonbury Festival, Glastonbury, England
June 28: Naval Museum, Stockholm, Sweden
June 29: Roskilde Festival, Denmark

July 1: Olympic Stadium, Munich, Germany
July 2: Munich Festival, Munich, Germany
July 5: Sports Palace, Madrid, Spain
July 6: Sports Palace, Barcelona, Spain
July 8: Out In The Green, Switzerland
July 9: Belfort Festival, France
July 12: Glasgow SECC, UK
July 13: Sheffield Arena, Sheffield, UK
July 15: Coliseum, St Austell, UK
July 16: Arts Centre, Poole, UK
July 19: The Point, Dublin, Ireland
July 20: The Point, Dublin, Ireland
July 22: Birmingham NEC, Birmingham, UK
July 23: Birmingham NEC, Birmingham, UK
July 25: Wembley Arena, London, UK
July 26: Wembley Arena, London, UK
End of European leg of Unledded world tour

Start of second American leg of Unledded world tour
September 23: Palacio de los Deportes, Mexico City, Mexico
September 24: Palacio de los Deportes, Mexico City, Mexico
September 27: Pan Am Center, Las Cruces, USA
September 29: Tingley Coliseum, Albuquerque, USA
September 30: Fiddlers Green, Denver, USA

October 2: Irvine Meadows, Irvine, USA
October 3: Irvine Meadows, Irvine, USA
October 6: Cal Expo Amphitheatre, Sacramento, USA
October 7: Shoreline Amphitheatre, Mountain View, USA
October 9: BSU Pavilion, Boise, USA
October 10: Delta Center, Salt Lake City, USA
October 12: Hilton Coliseum, Ames, USA
October 13: United Center, Chicago, USA
October 15: Palace of Auburn Hills, Detroit, USA
October 16: Gund Arena, Cleveland, USA
October 18: The Forum, Montreal, Canada
October 19: Memorial Auditorium, Buffalo, USA
October 21: Civic Center, Hartford, USA
October 23: The Fleet Center, Boston, USA
October 24: The Spectrum, Philadelphia, USA
October 26: Madison Square Garden, New York, USA
October 27: Madison Square Garden, New York, USA

1996

January 20: Pacaembu Stadium, Sao Paulo, Brazil
January 23: Estadio Sausalito, Viña del Mar, Chile
January 25: Buenos Aires, Argentina
January 27: Apoteose Square, Rio, Brazil
End of second American leg of Unledded world tour

Start of Japanese leg of Unledded world tour
February 5: Budokan Hall, Tokyo, Japan
February 6: Budokan Hall, Tokyo, Japan
February 8: Budokan Hall, Tokyo, Japan
February 9: Budokan Hall, Tokyo, Japan
February 12: Budokan Hall, Tokyo, Japan
February 13: Tokyo, Japan
February 15: Castle Hall, Osaka, Japan
February 17: Century Hall, Nagoya, Japan
February 19: Castle Hall, Osaka, Japan
February 20: Marine Messe, Fukuoka, Japan
End of Japanese leg of Unledded world tour

Start of Australian leg of Unledded world tour
February 24: Sydney Entertainment Centre, Sydney, Australia
February 25: Sydney Entertainment Centre, Sydney, Australia
February 27: Brisbane, Australia
February 29: Melbourne, Australia

March 1: Flinders Park, Melbourne, Australia
End of Australian leg of Unledded world tour

June 25
Glastonbury Festival
Glastonbury, UK

February 6
Pensacola Civic Arena
Pensacola, Florida

March 18
Reunion Arena
Dallas, USA

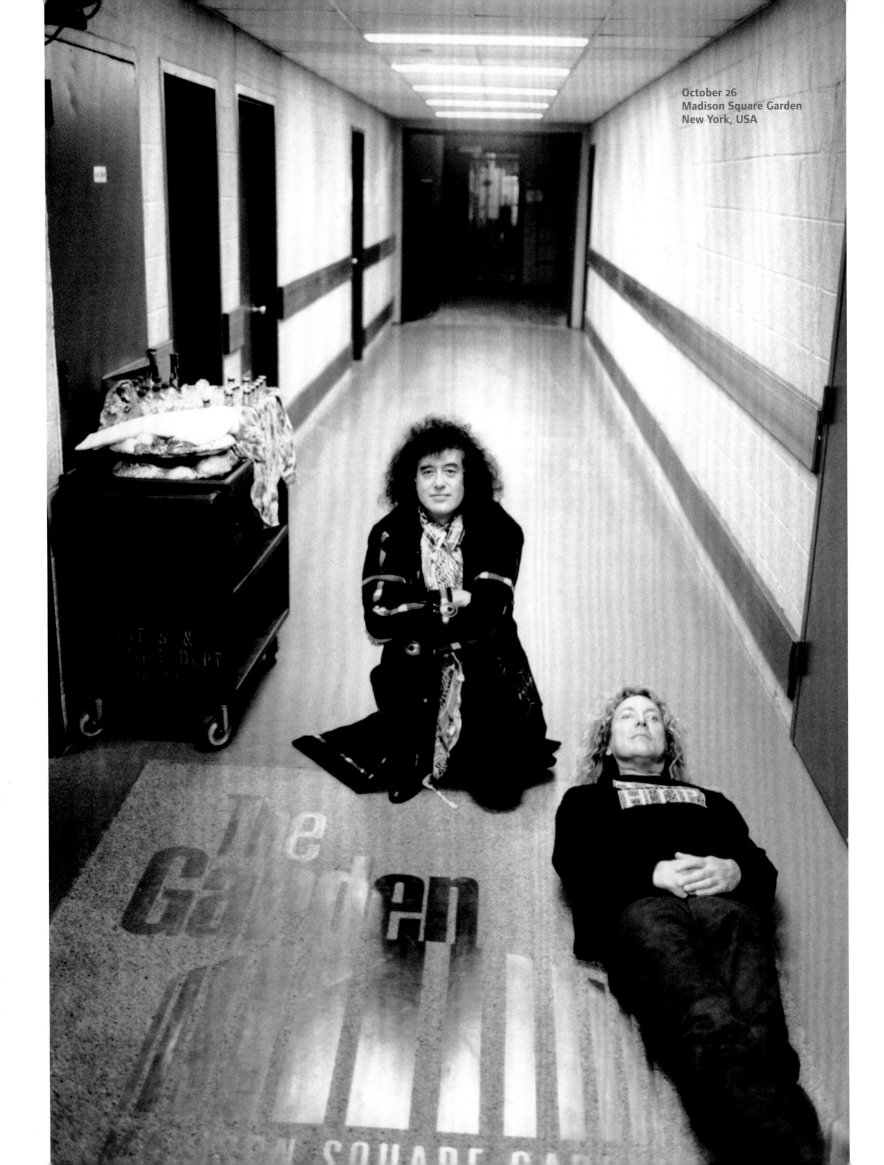

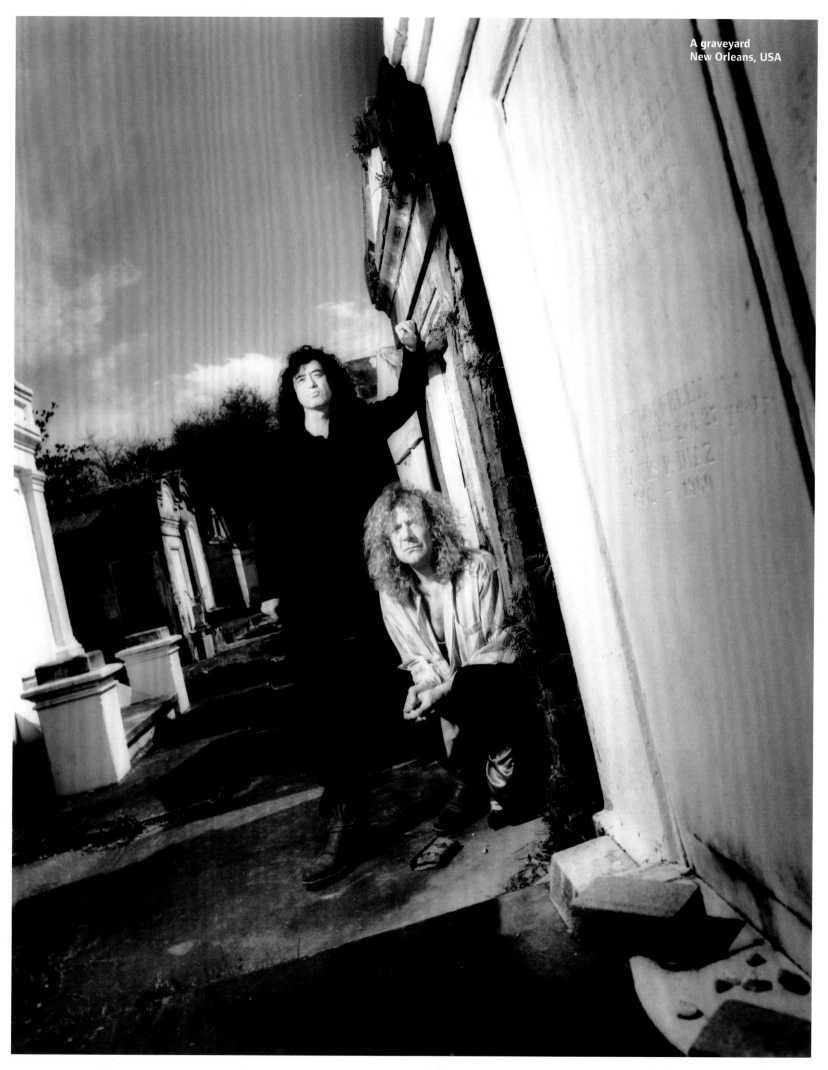

A graveyard
New Orleans, USA

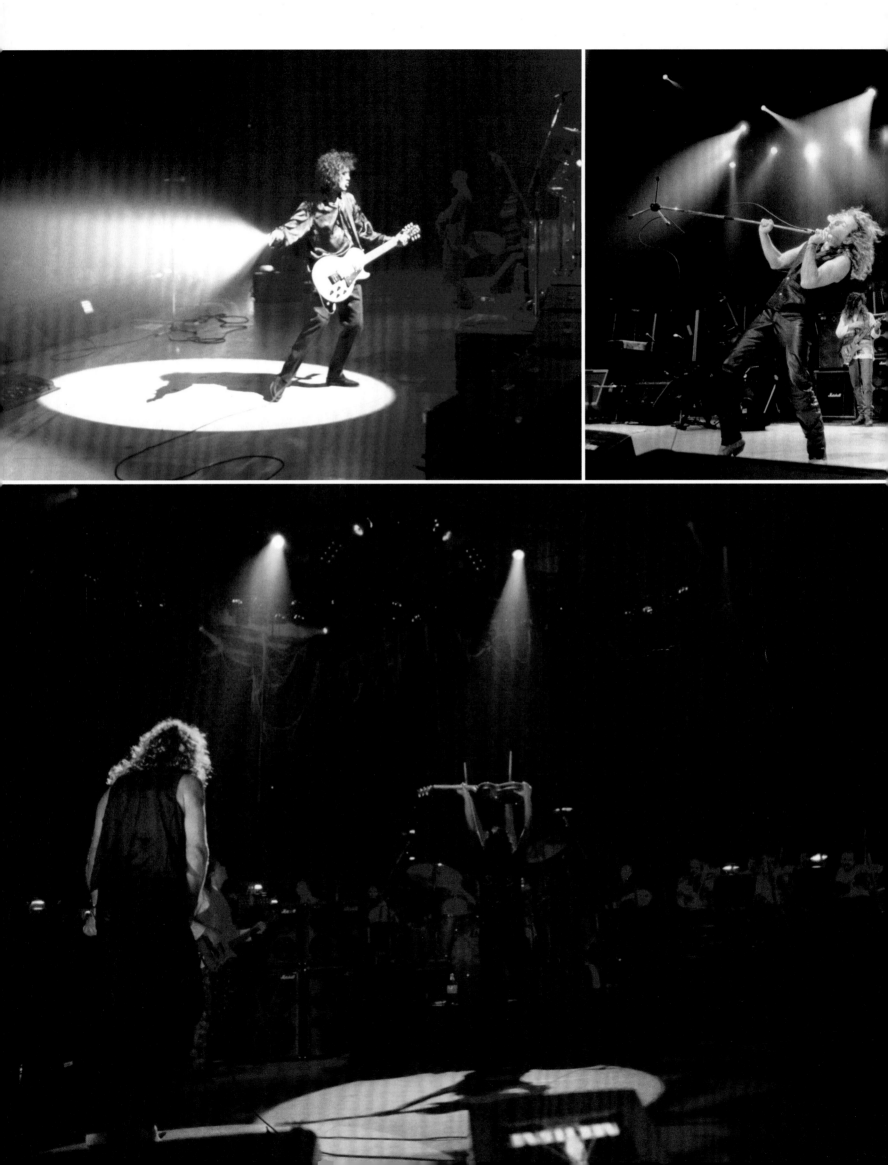

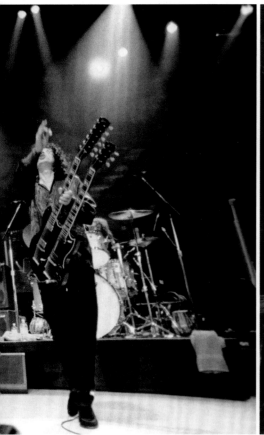

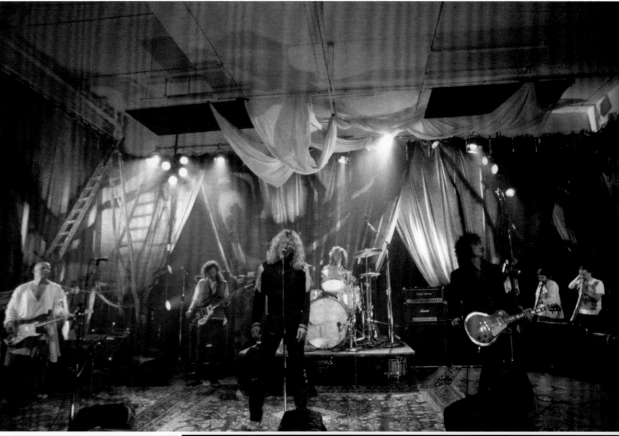

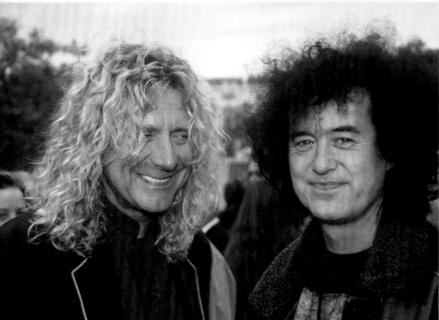

Opposite:
March 18
Reunion Arena
Dallas, USA

Top left:
February 28
The Omni
Atlanta, USA

Top right:
January 30
American Music Awards
complete with didgeridoos
ABC channel, USA

Bottom left:
Hyde Park
London, UK

Bottom right:
March 18
Reunion Arena
Dallas, USA

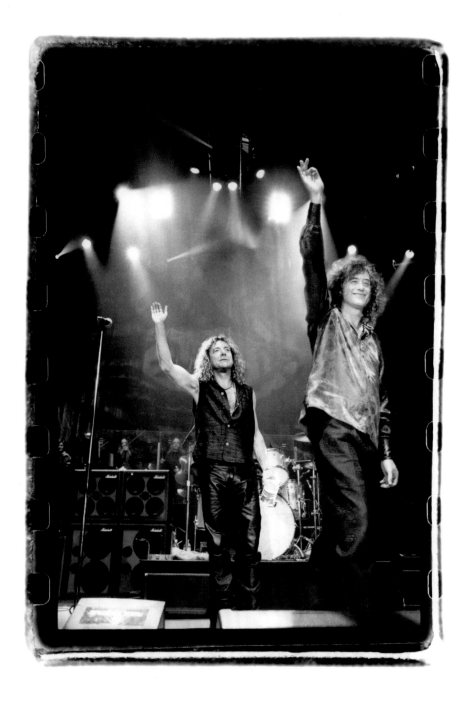

The *Unledded* world tour gave us the opportunity to present our music, involving a western orchestra and an Egyptian string and percussion ensemble, throughout the world. In fact, the last leg of the tour was referred to as 'Down, Up, Round, Down Under and Up Again'. I think that sums it up. It was an extraordinary and heroic spectacle made possible by the collective passion of all those involved in those memorable concerts.

After the conclusion of the tour we made an album entitled *Walking Into Clarksdale*, which featured the Grammy Award-winning song 'Most High'. The album was quite minimalist after the full textures of the *No Quarter* project. Robert was later to re-record, 'Please Read The Letter' on his album with Alison Krauss.

With Michael Lee and Charlie Jones we managed to return to that classic interaction of drums, bass, vocals and guitar.

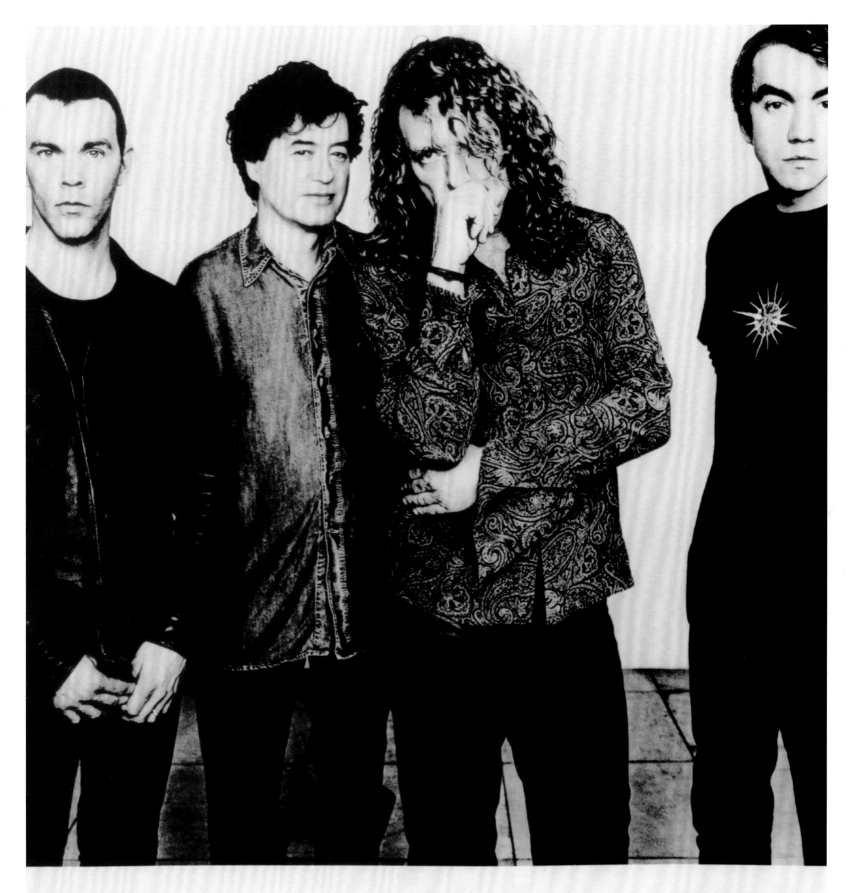

CHARLIE JONES

MICHAEL LEE

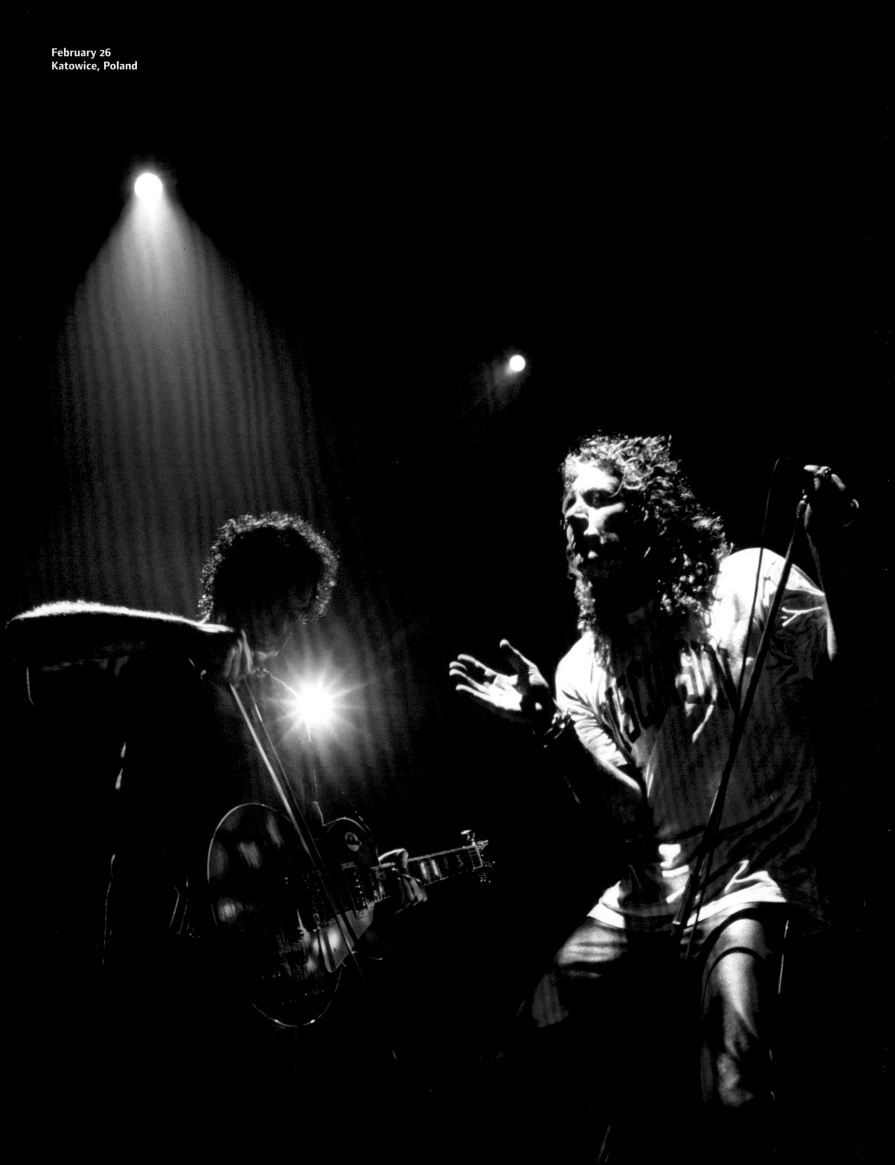

February 26
Katowice, Poland

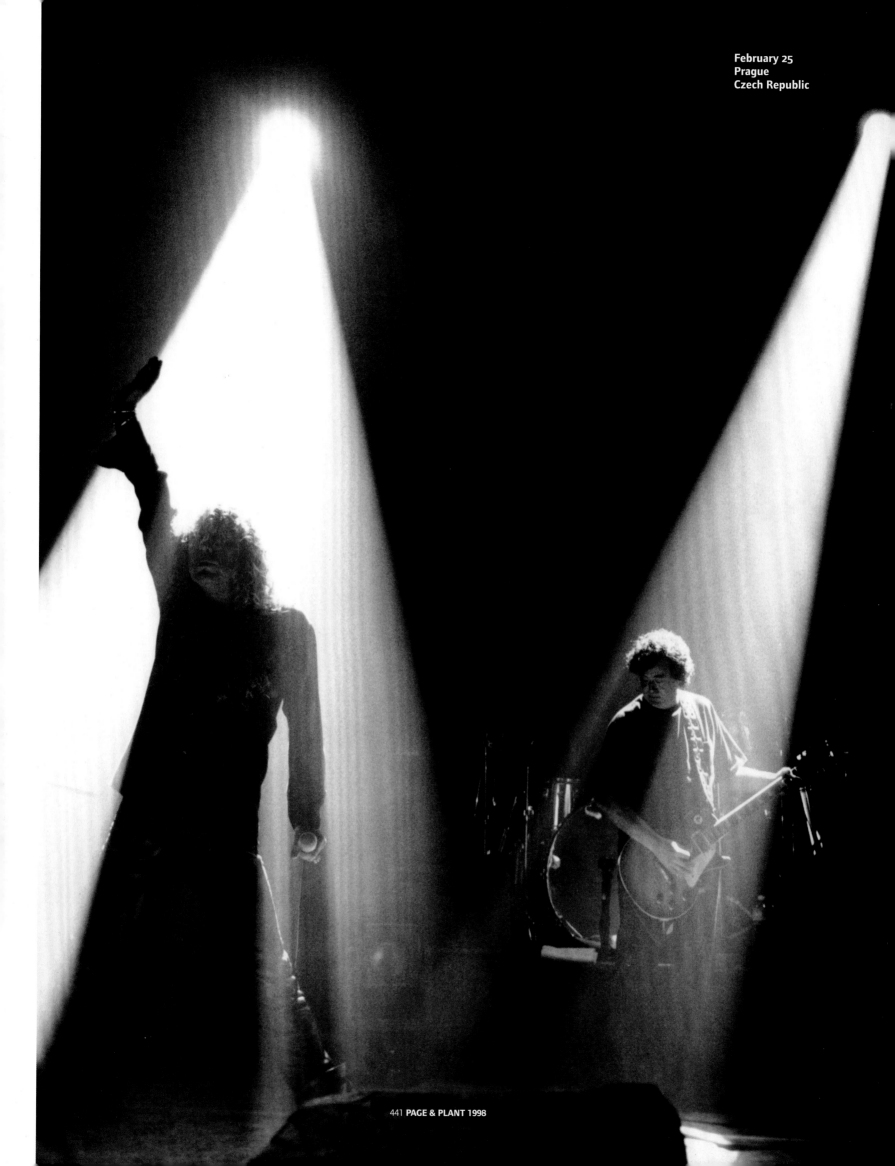

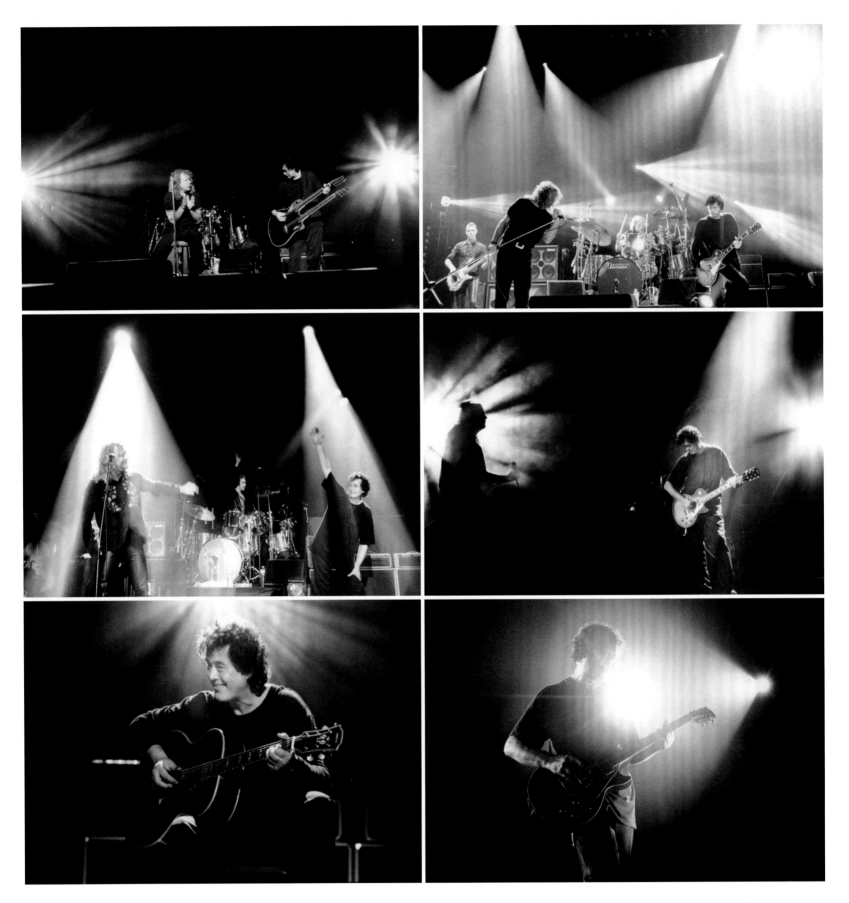

February & March
On tour in Europe

Opposite top:
March 25
Shepherd's Bush
Empire
London, UK

Opposite bottom:
University of London
Union, London, UK

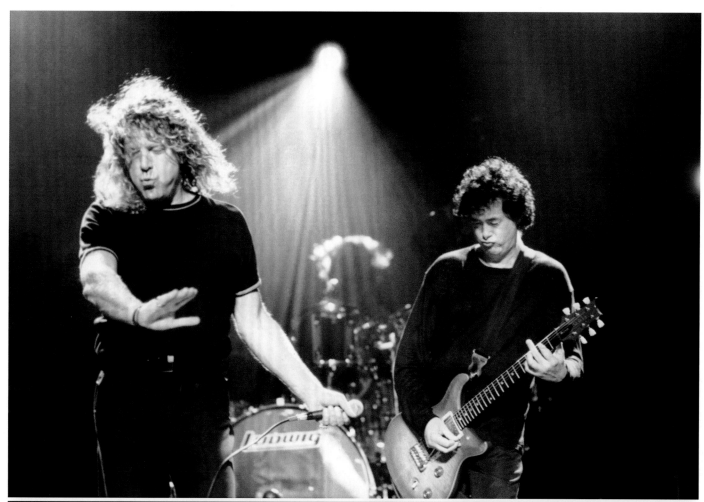

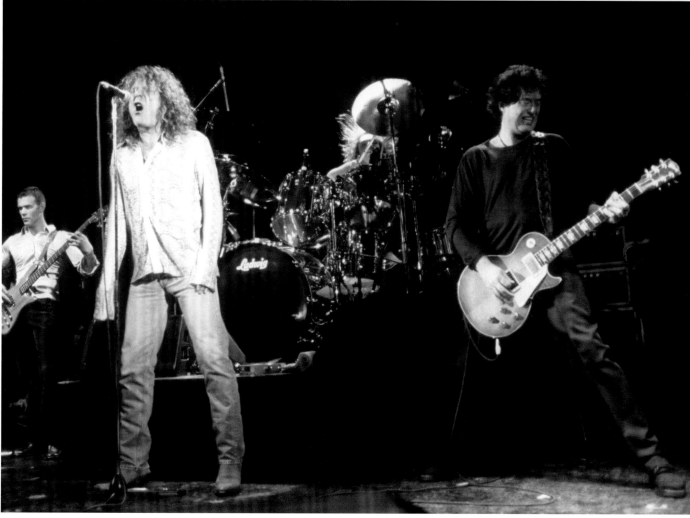

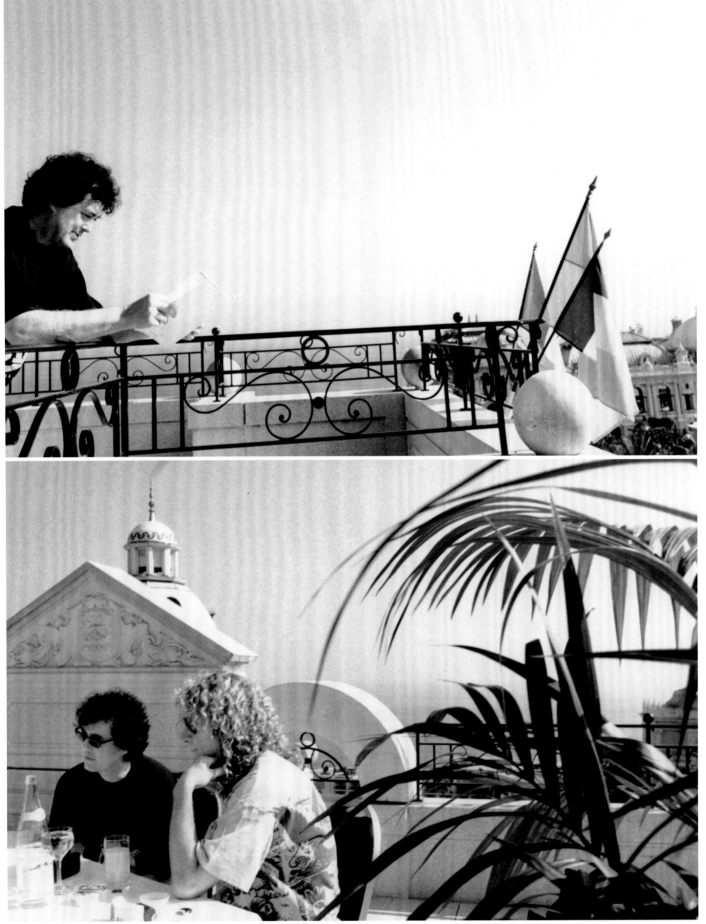

THE RELEASE OF
WALKING INTO
CLARKSDALE
APRIL 21

March 5
Istanbul, Turkey

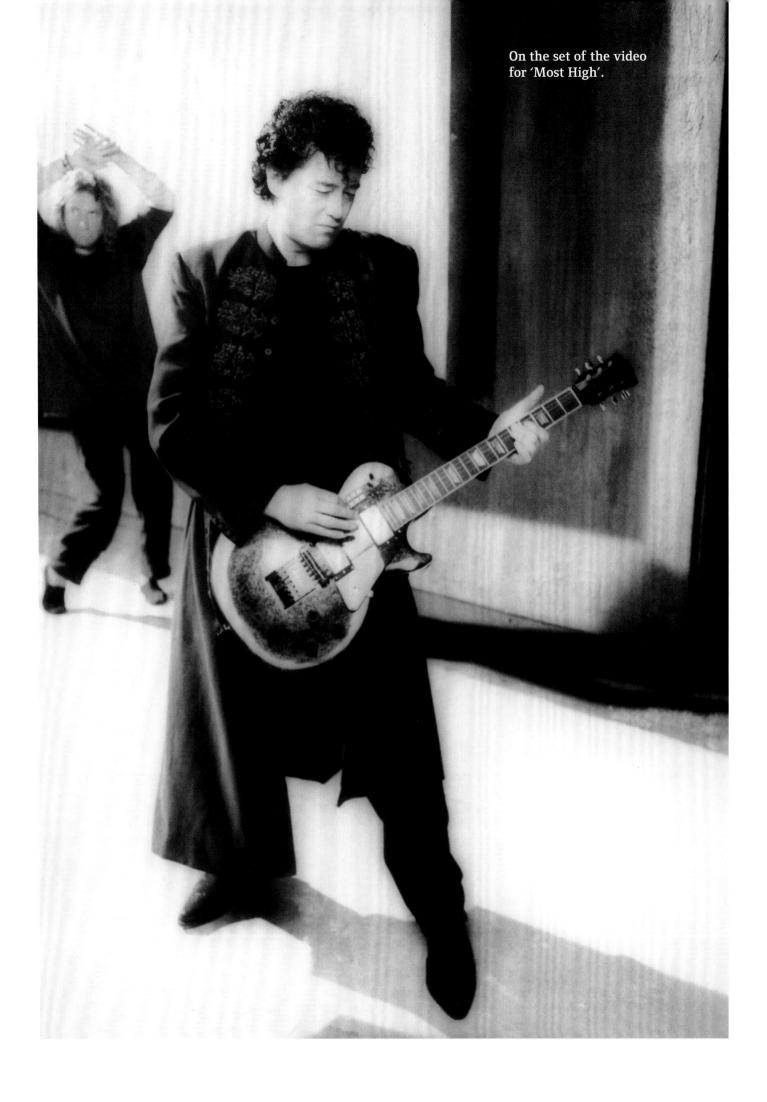

On the set of the video for 'Most High'.

1998

Start of first European leg of Walking Into Everywhere tour
February 21: Dom Sportova, Zagreb, Croatia
February 23: Budapest, Hungary
February 25: Prague, Czech Republic
February 26: Katowice, Poland

March 1: Bucharest, Romania
March 5: Istanbul, Turkey
March 6: Istanbul, Turkey

March 25: Shepherd's Bush Empire, London, UK
End of first European leg

March 26: *Top Of The Pops*, BBC TV
Elstree Studios, UK
March 27: *TFI Friday*, Channel 4 TV
Riverside Studios, UK
March 30: La Cigale, Paris, France
March 31: Canal-1 TV, France

May 5: BBC TV Studios, London, UK

Start of first American leg of Walking Into Everywhere tour
May 19: Pensacola Civic Center, Pensacola, USA
May 20: Ice Palace, Tampa, USA
May 22: Civic Center, Miami, USA
May 23: Coliseum, Jacksonville, USA
May 26: Coliseum, Charlotte, USA
May 27: North Charleston Coliseum, Charleston, USA
May 29: Lakewood Amphitheater, Atlanta, USA
May 30: Tupelo Coliseum, Tupelo, USA

June 1: Civic Center, Birmingham, USA
June 2: Coliseum, Nashville, USA
June 4: Myriad, Oklahoma City, USA
June 6: Kemper Arena, Kansas City, USA
June 7: Kiel Center, St Louis, USA
June 9: Market Square Arena, Indianapolis, USA
June 10: Bradley Center, Milwaukee, USA
June 12: Target, Minneapolis, USA
June 13: Fargodome, Fargo, USA
June 15: United Center, Chicago, USA
June 16: United Center, Chicago, USA
June 26: Palace of Auburn Hills, Detroit, USA
June 27: Palace of Auburn Hills, Detroit, USA
June 29: Van Andel Arena, Grand Rapids, USA

July 1: Civic Arena, Pittsburgh, USA
July 3: Gund Arena, Cleveland, USA
July 4: Molson Amphitheater Toronto, Ontario, Canada
July 7: MCI Center, Washington, USA
July 8: Virginia Beach Amphitheater, Virginia Beach, USA
July 10: CoreStates Arena, Philadelphia, USA
July 11: Pepsi Arena, Albany, USA
July 13: Fleet Center, Boston, USA
July 16: Madison Square Garden, New York, USA
July 18: Continental Airlines Arena, East Rutherford, USA
July 19: Jones Beach Theater, Wantagh, USA
End of first American leg

August 6: Dromquinna Hotel, County Kerry, Ireland
August 21: Vaduz, Liechtenstein
August 23: Bizarre Festival, Cologne, Germany
August 26: The Point, Dublin, Ireland
August 28: Reading Festival, Reading, UK

Start of second American leg
September 5: General Motors Place, Vancouver, Canada
September 6: The Gorge Amphitheatre, Washington, USA
September 8: The Rose Garden, Portland, USA
September 11: Concord Pavilion, Concord, USA
September 12: Shoreline Amphitheatre,
Mountain View, USA
September 15: E Center, West Valley,
Salt Lake City, USA
September 16: Red Rocks Amphitheatre, Morrison, USA
September 18: Irvine Meadows Amphitheatre, USA
September 19: Hollywood Bowl, USA
September 21: Cox Arena, San Diego, USA
September 23: MGM Grand Garden Arena,
Las Vegas, USA
September 24: America West Arena, Phoenix, USA
September 26: Alamo Dome, San Antonio, USA
September 27: Reunion Arena, Dallas, USA
September 30: Cynthia Woods Mitchell Pavilion,
Houston, USA

October 1: UNO Lakefront, New Orleans, USA
October 2: Pyramid Arena, Memphis, USA
End of second American leg

Start of second European leg
October 30: SECC, Glasgow, UK

November 2: SECC, Glasgow, UK
November 3: Manchester Evening News Arena,
Manchester, UK
November 5: Wembley Arena, London, UK
November 6: Wembley Arena, London, UK
November 9: Liberte, Rennes, France
November 10: Bercy, Paris, France
November 12: Zagreb, Croatia
November 13: Stadthalle, Vienna, Austria
November 16: Messehalle, Erfurt, Germany
November 17: Sports Hall, Prague, Czech Republic
November 19: Forum, Milan, Italy
November 20: Hallenstadion, Zurich, Switzerland
November 23: Olympiahalle, Munich, Germany
November 25: Zenith, Montpellier, France
November 26: Patinoire, Bordeaux, France
November 28: Zenith, Toulon, France
November 29: Halle Tony Garnier, Lyon, France

December 1: Exhibition Hall, Flanders Expo,
Gent, Belgium
December 2: Oberhausen Arena, Germany
December 3: Festhalle, Frankfurt, Germany
December 10: Palais Omnisports, Paris, France
End of Walking Into Everywhere tour

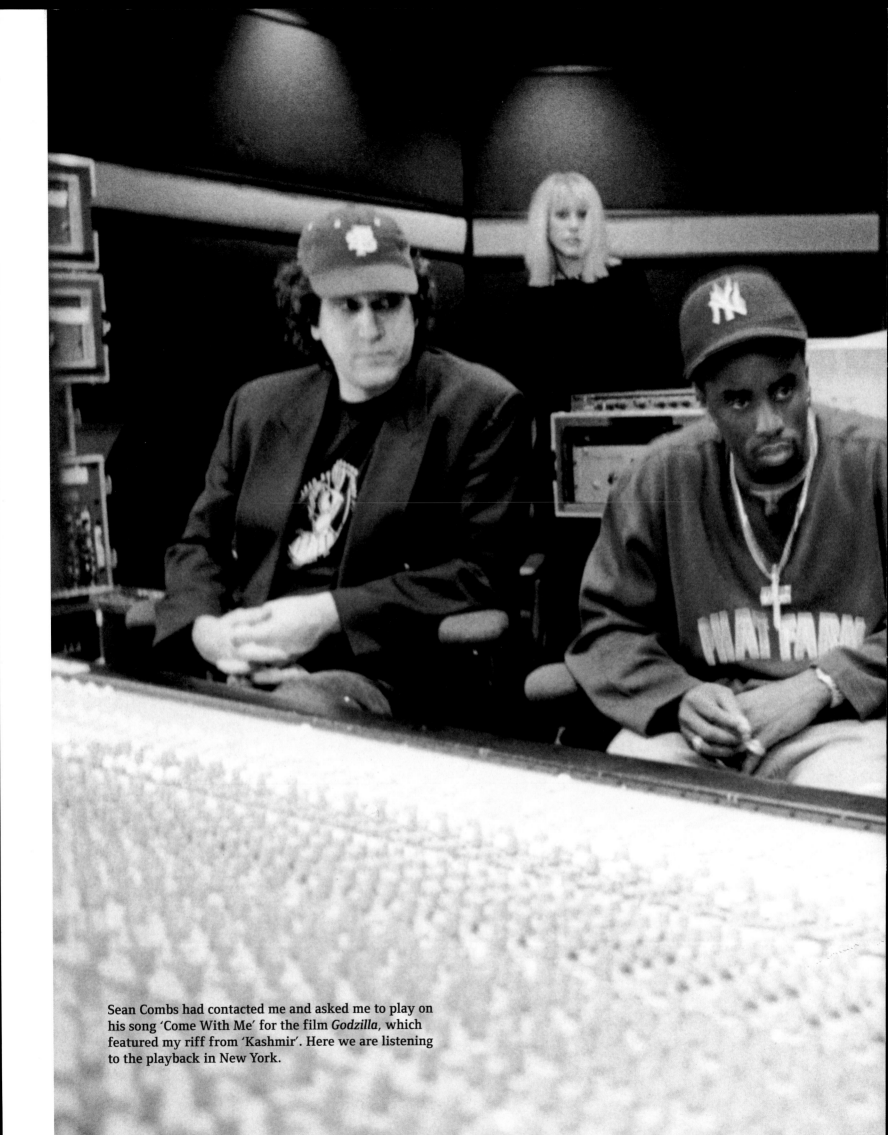

Sean Combs had contacted me and asked me to play on his song 'Come With Me' for the film *Godzilla*, which featured my riff from 'Kashmir'. Here we are listening to the playback in New York.

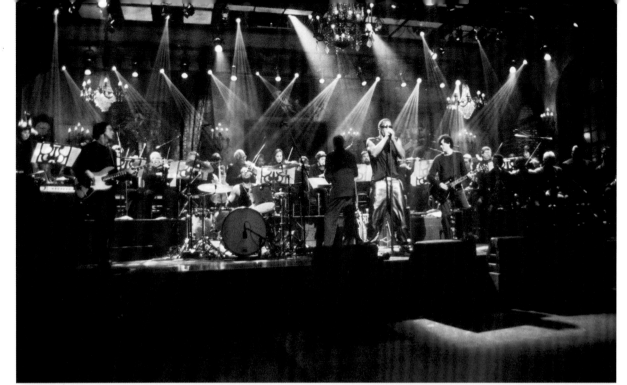

May 9
Saturday Night Live
with Puff Daddy
NBC Studios
New York, USA

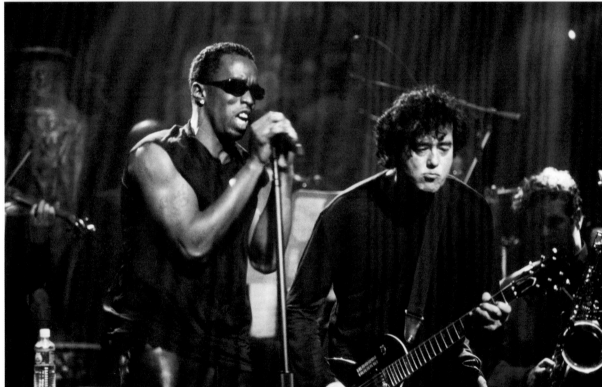

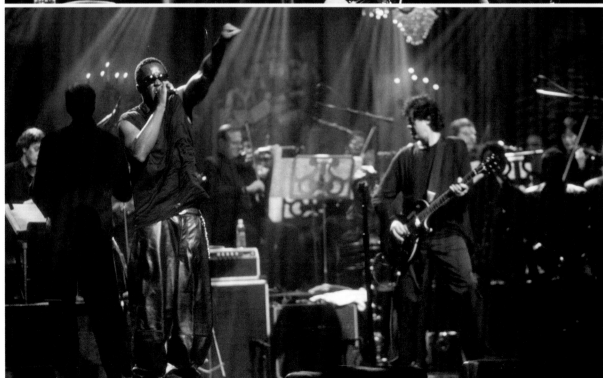

THE RELEASE OF
'COME WITH ME', JULY 21

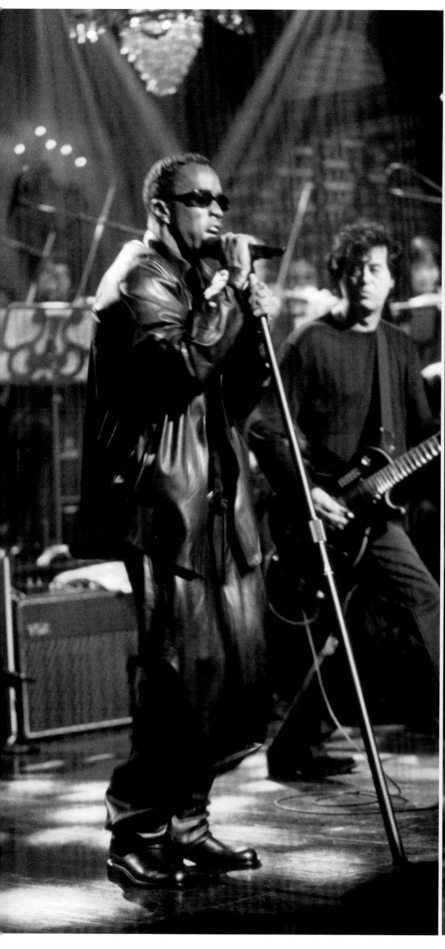
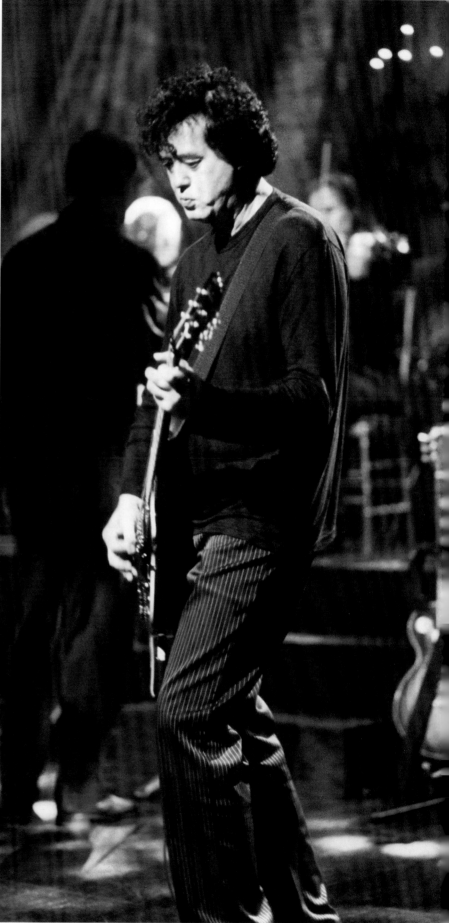

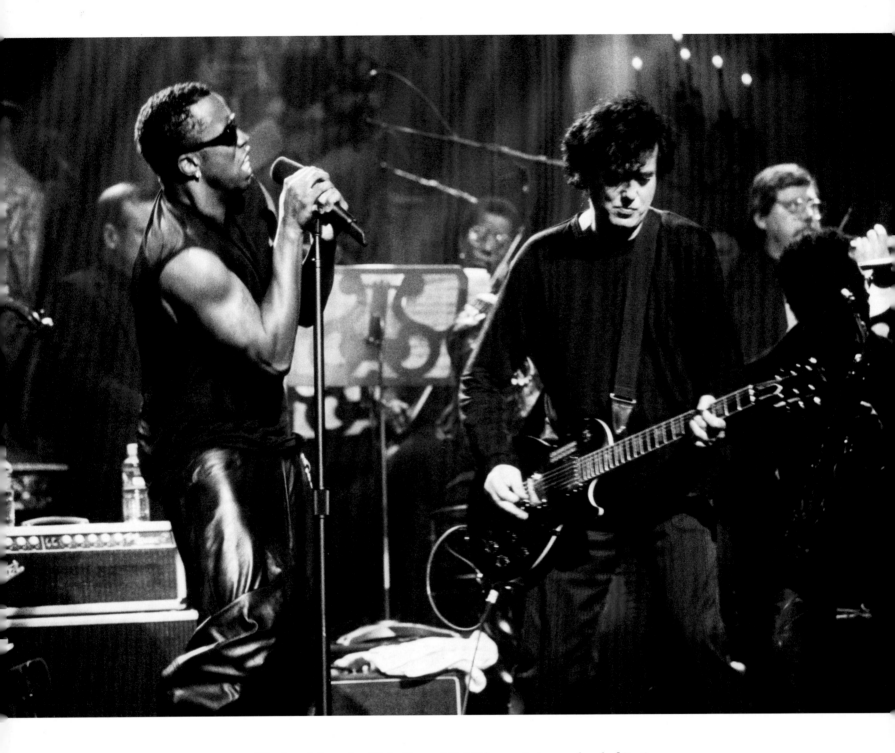

May 9
Saturday Night Live
NBC Studios
New York, USA

We played *Saturday Night Live* and NetAid, a project way ahead of its time.
I have nothing but respect for this man, his energy and imagination.

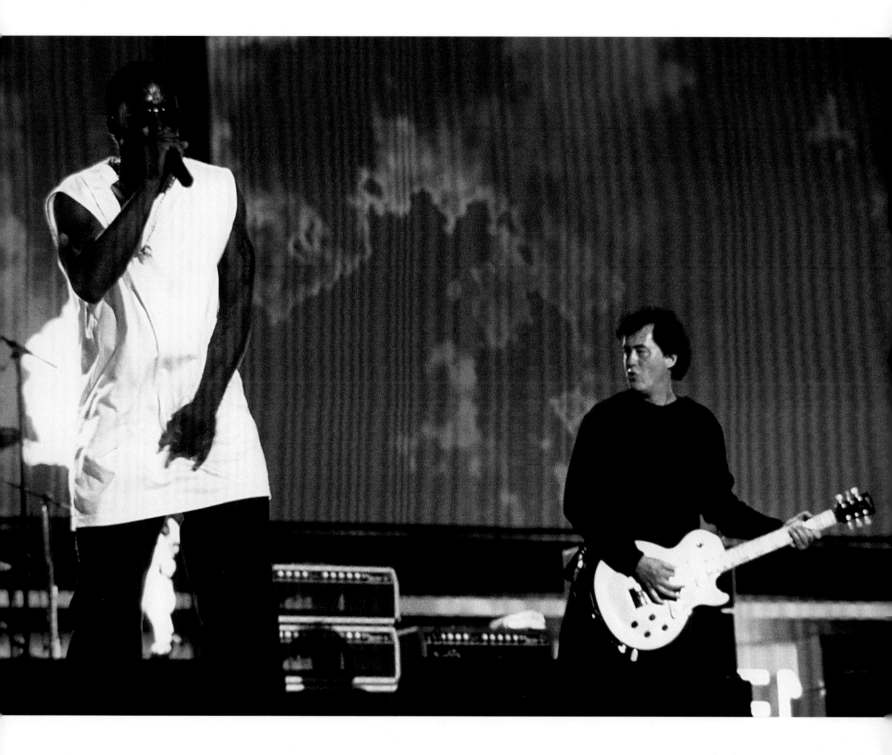

October 9
NetAid
Giants Stadium
New York, USA

1999
July 27: Café de Paris, London, UK

Start of first American tour
October 9: Brendan Byrne Arena, East Rutherford, USA
October 12: Roseland Theater New York, USA
October 13: Roseland Theater New York, USA
October 14: Roseland Theater New York, USA
October 16: The Centrum, Worcester, USA
October 18: The Greek Theater, Los Angeles, USA
October 19: The Greek Theater, Los Angeles, USA
End of first American tour

2000
Start of second American tour
June 24: New World Music Theatre, Chicago, USA
June 26: Palace of Auburn Hills, Detroit, USA
June 28: Star Lake Amphitheater, Pittsburgh, USA
June 29: Marcus Amphitheater, Milwaukee, USA
June 30: PNC Bank Arts Center, Holmdel, USA

July 2: Tweeter Center, Mansfield, USA
July 4: Alltel Pavilion, Raleigh, USA
July 6: Nissan Pavilion, Bristow, USA
July 8: E Center, Camden, USA
July 10: Jones Beach Amphitheatre, Wantaugh, USA
July 11: *Conan O'Brien* TV Show, New York, USA

August 12: Mesa Del Sol, Albuquerque, USA
August 14: *The Tonight Show,* NBC Studios, Burbank, USA
End of second American tour

In 1999 the Robinson brothers, Chris and
Rich, played with me at a Warchild
Charity Function at the Café de Paris in
London. It was a superb night.

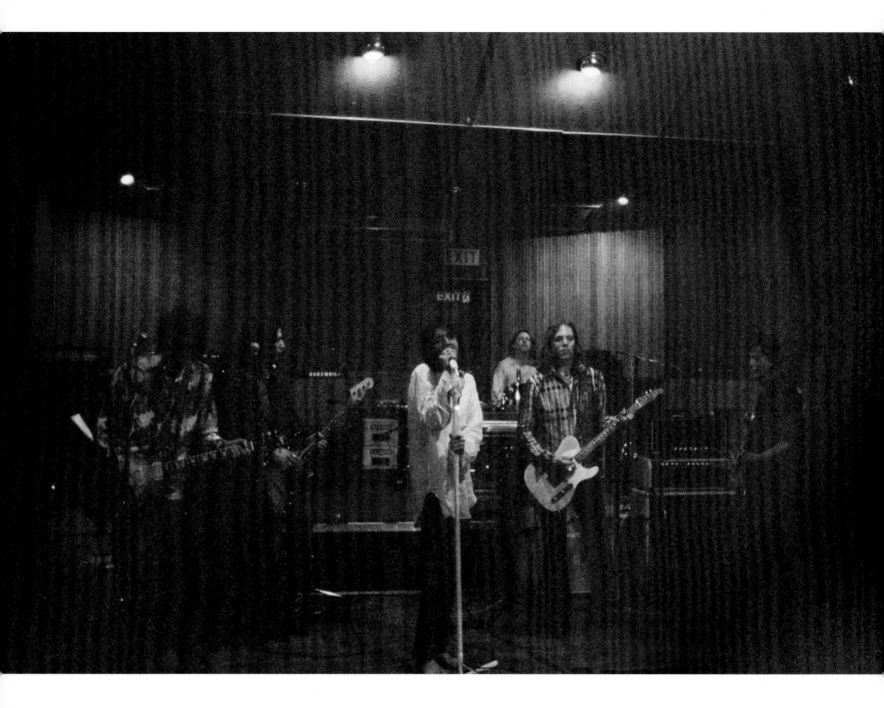

Rehearsals at
Nomis Studios
London, UK

A month or two later, it was suggested that we reciprocate in the US and so I played seven shows with the Black Crowes. On the West Coast we played The Greek Theater in LA; the show was recorded and an album was later released.

It gave me a chance to play their material and my material with a really good band. The chemistry was electric and Chris dazzling.

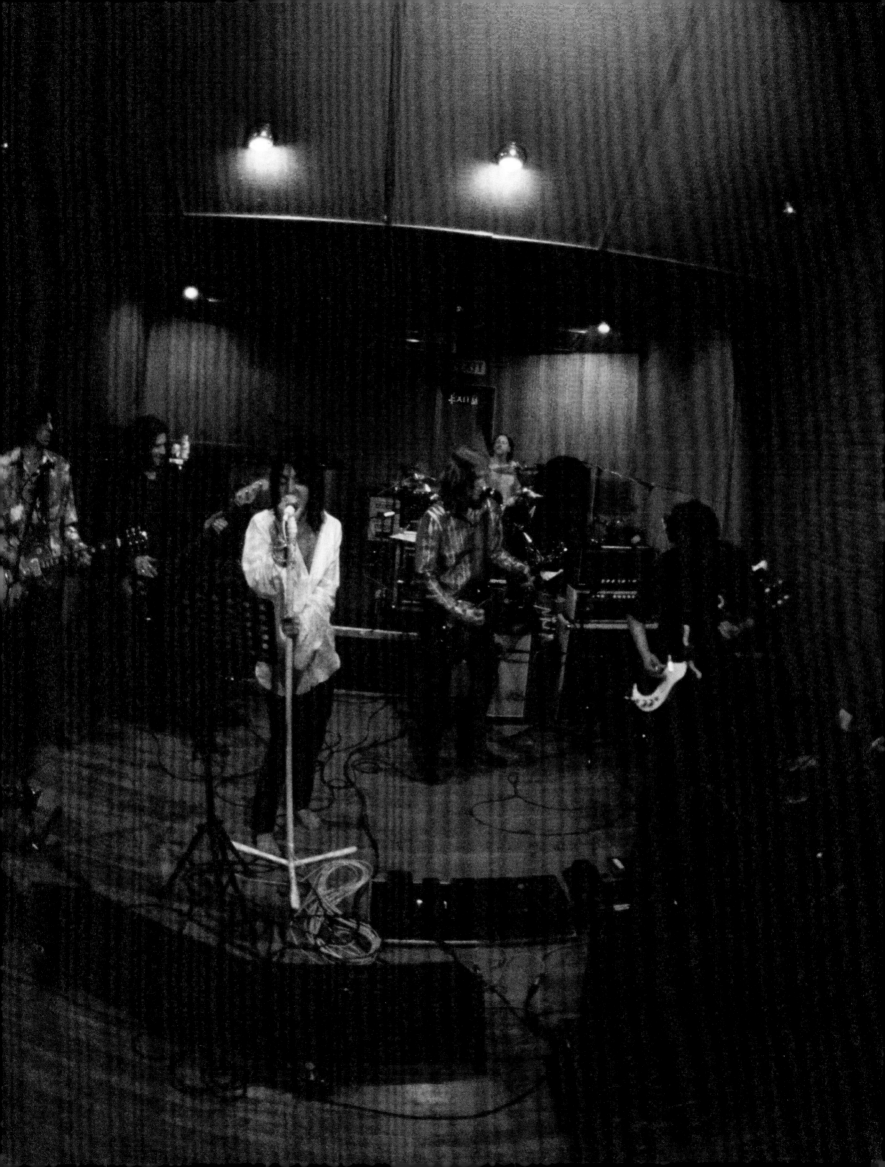

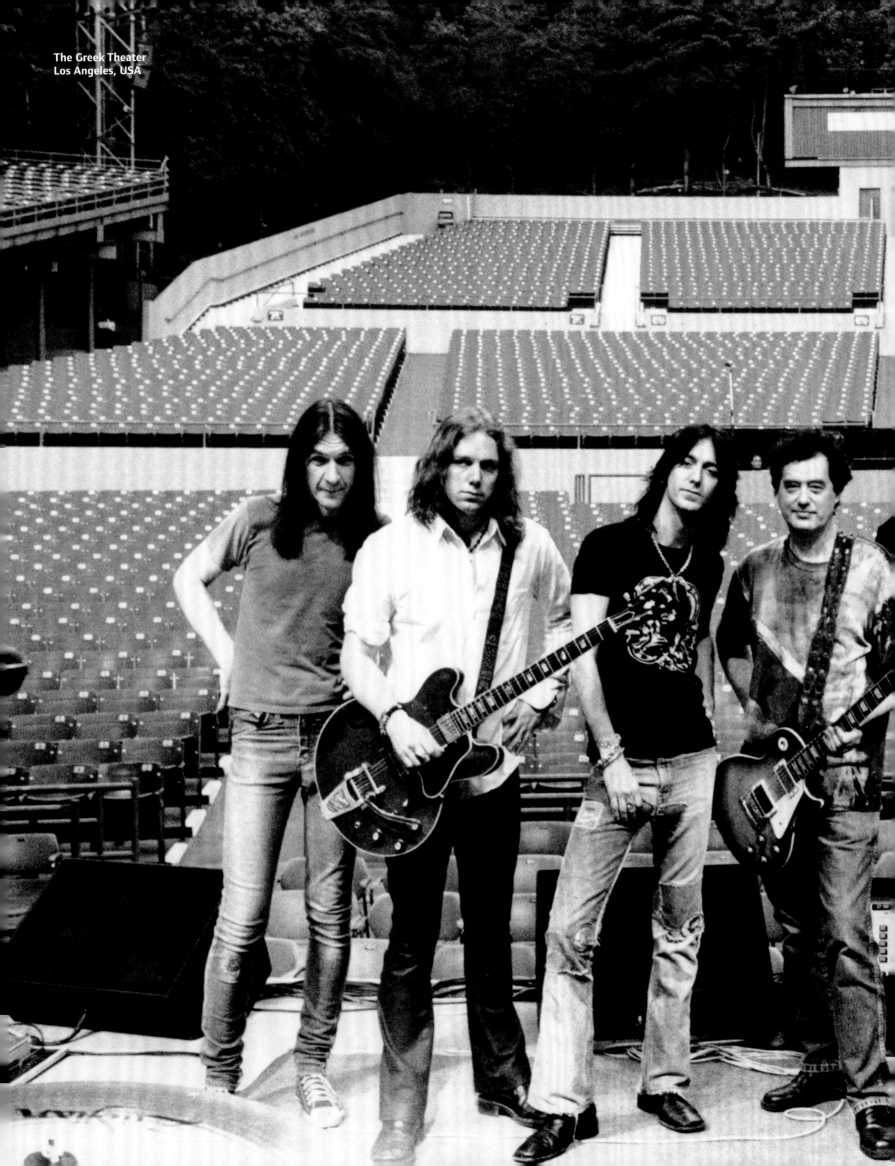

The Greek Theater
Los Angeles, USA

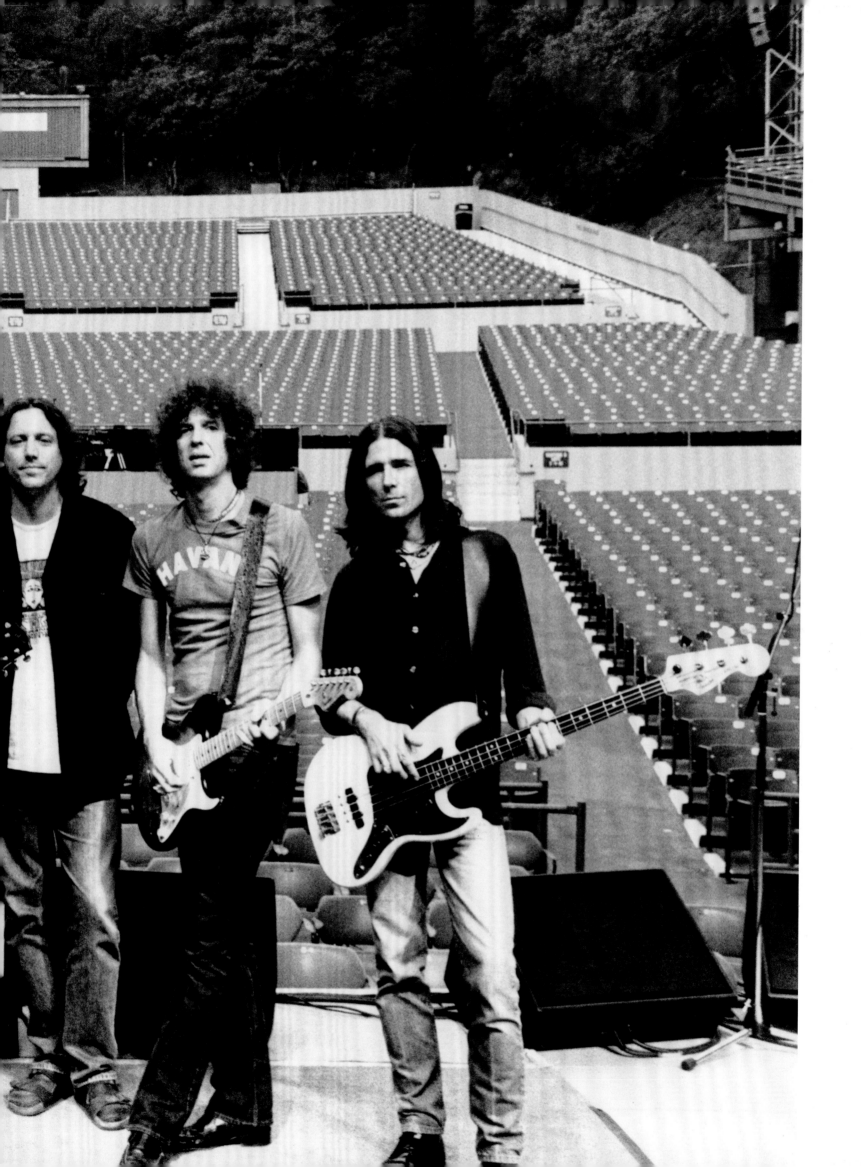

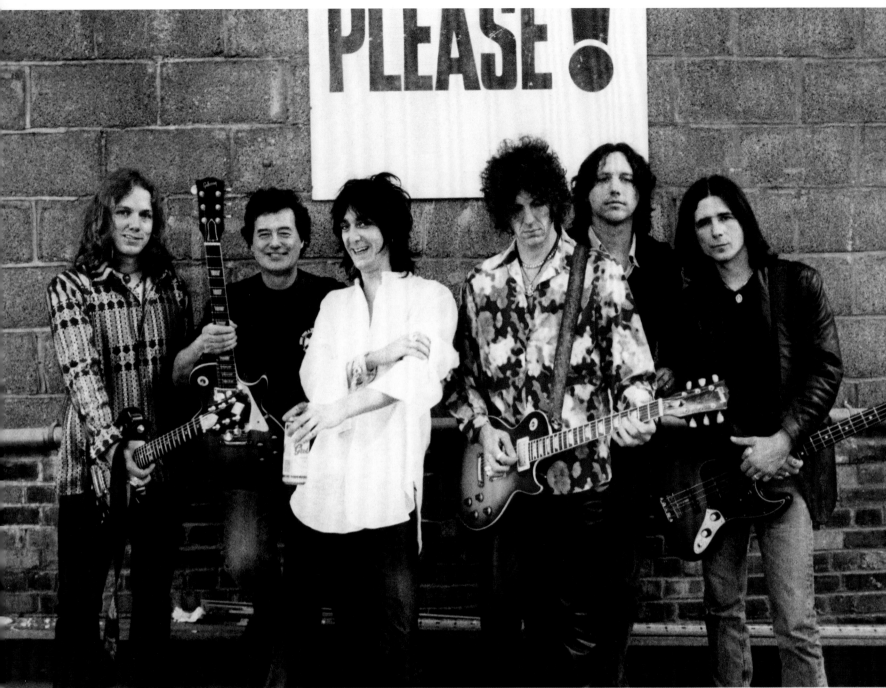

Rehearsals at
Nomis Studios
London, UK

Opposite:
October 18 & 19
The Greek Theater
Los Angeles, USA

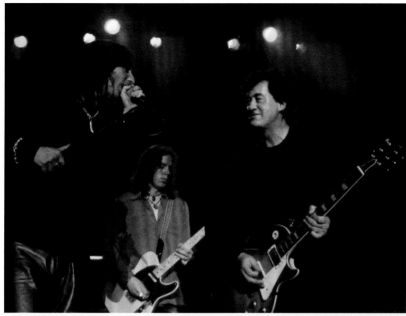
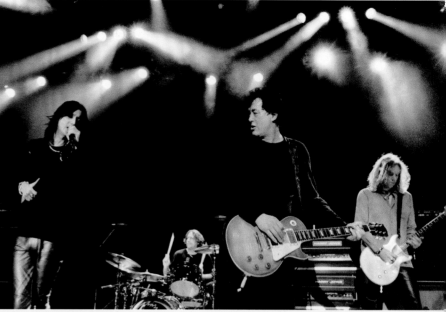
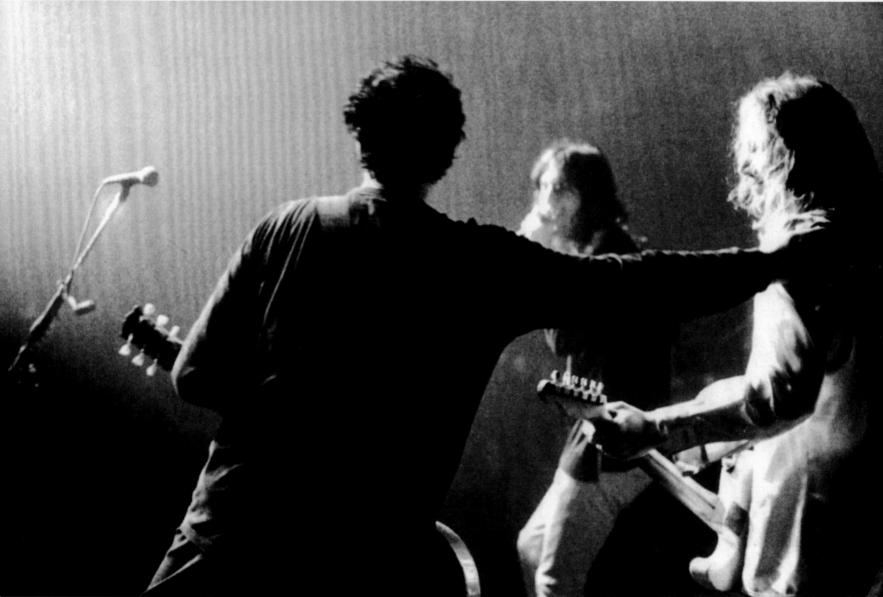

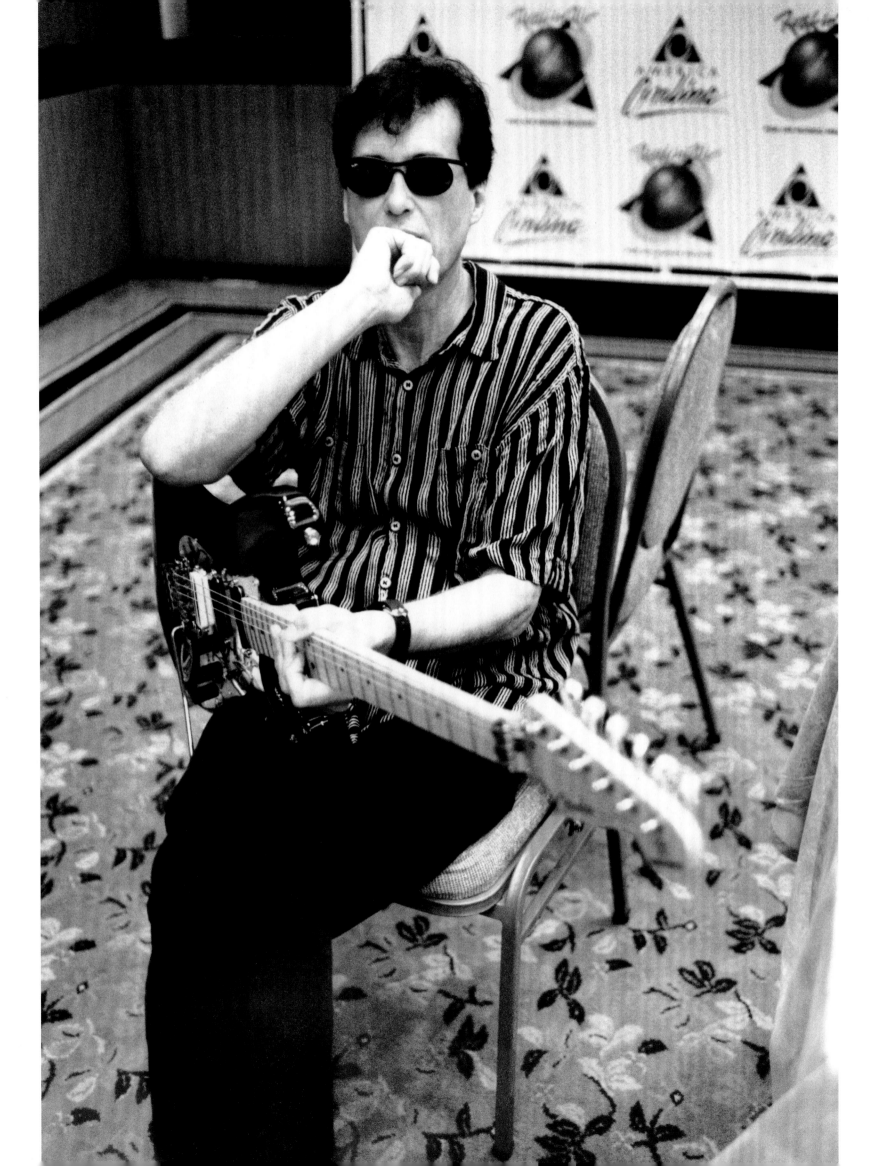

Here in 2001 at the Rock In Rio festival in Brazil.
Iron Maiden headlined that night.

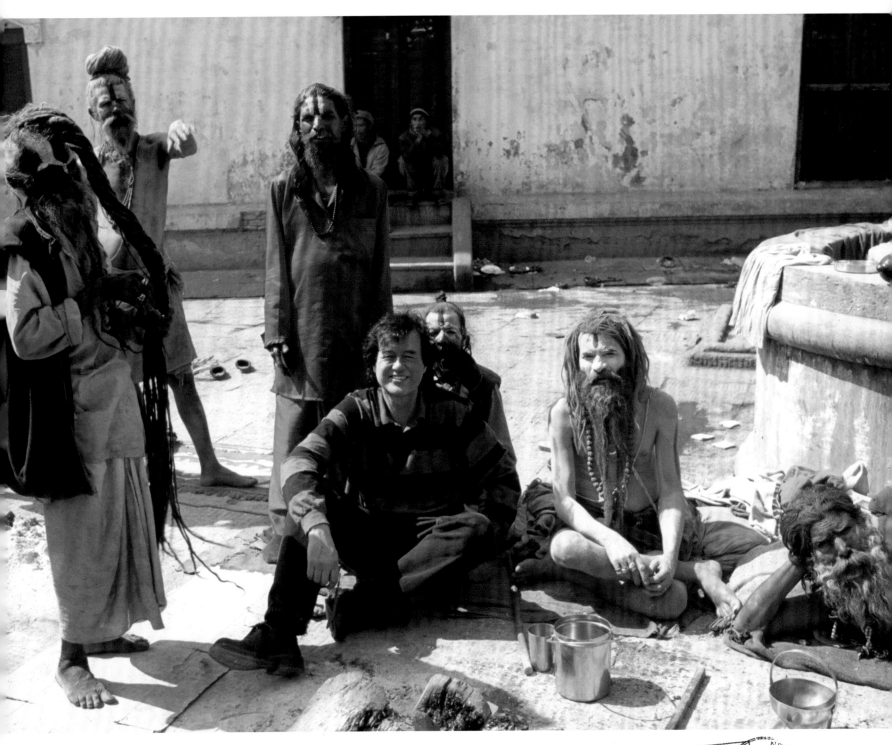

In Kathmandu, Nepal, auditioning vocalists.

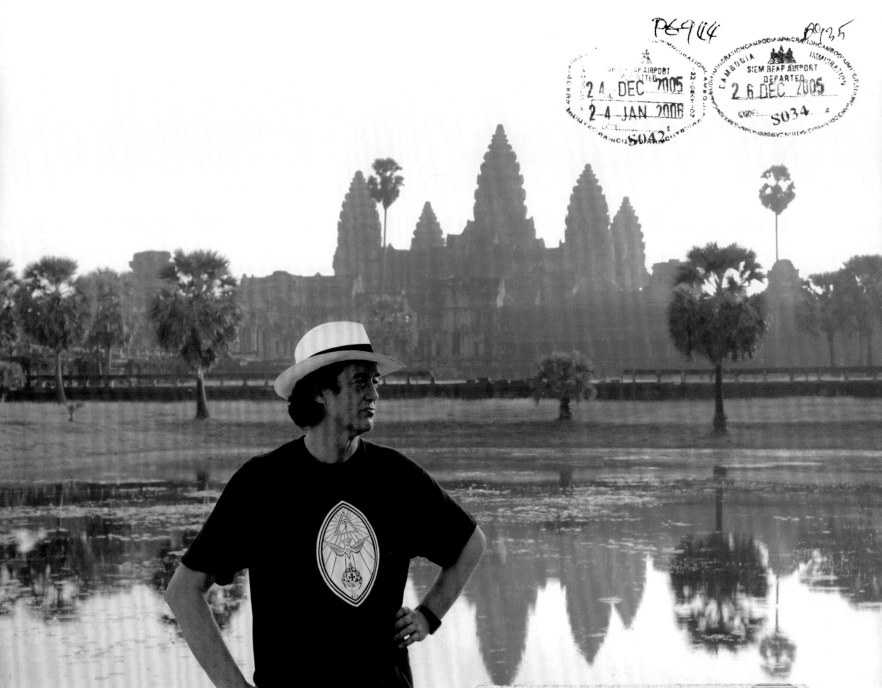

On Christmas Day, in the shadow of the magnificent Angkor Wat in Cambodia.

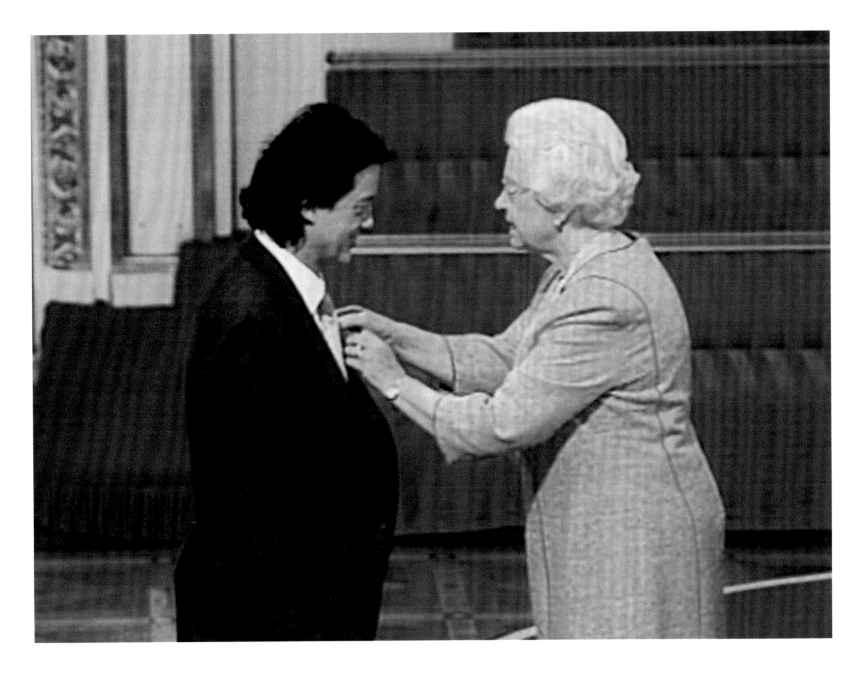

This picture is from CCTV footage taken inside the palace

I was awarded the OBE by Her Majesty The Queen at Buckingham Palace.

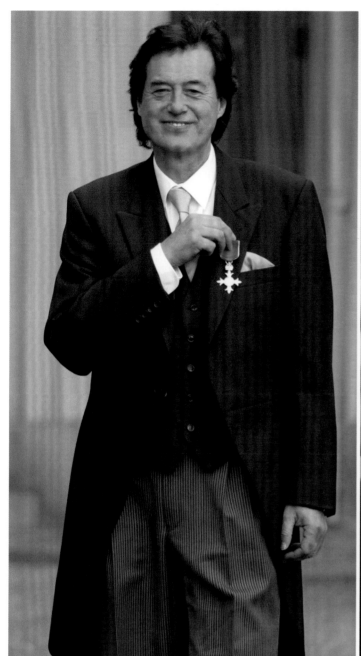
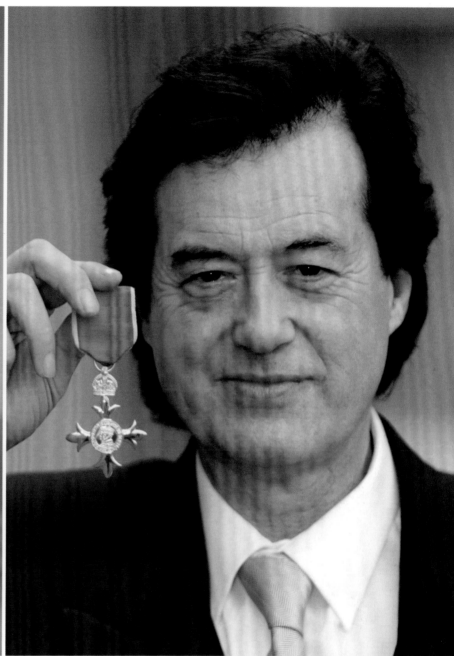

December 14
Buckingham Palace
London, UK

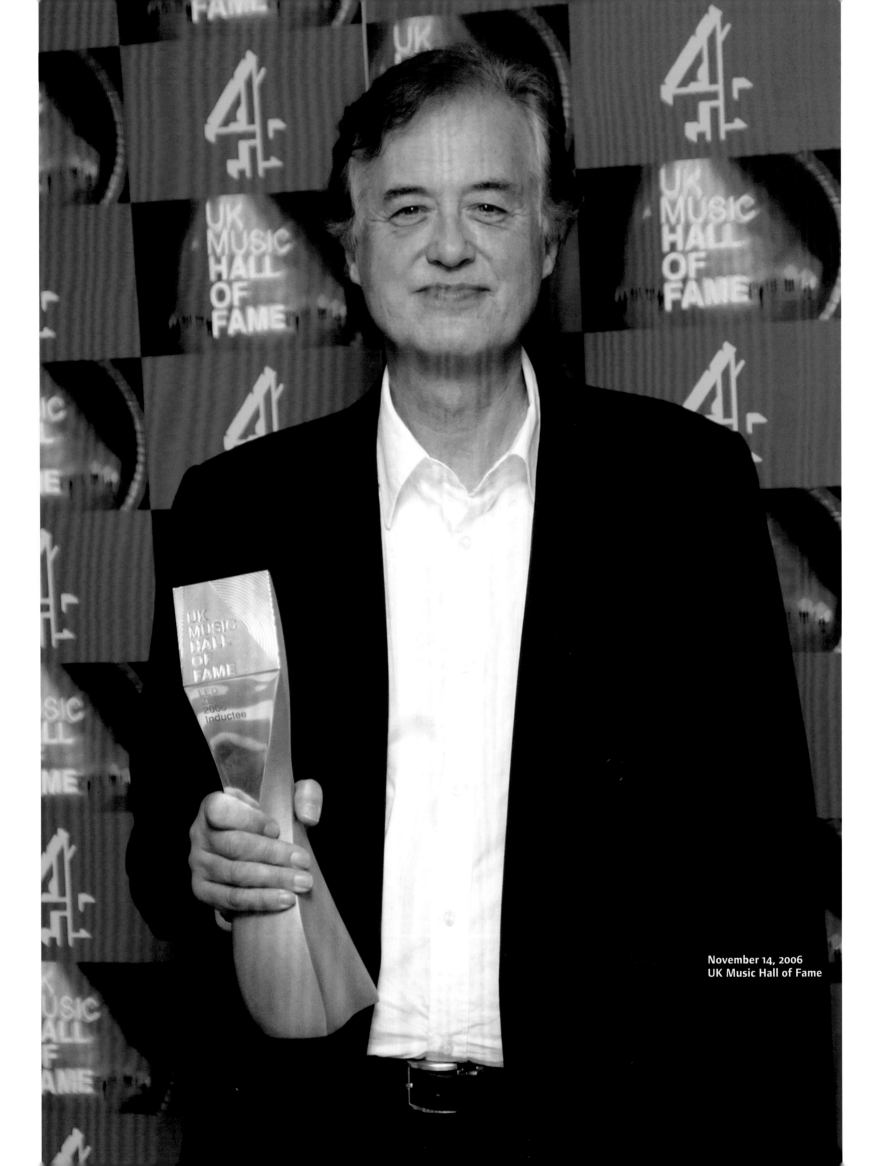

November 14, 2006
UK Music Hall of Fame

471 JIMMY PAGE 2007

The Fender Stratocaster played on 'Ten Years Gone'.

I asked Gibson to make this Custom Shop ES-350, a guitar I closely associated with Chuck Berry. I was to use this later at the O2 and on *It Might Get Loud*.

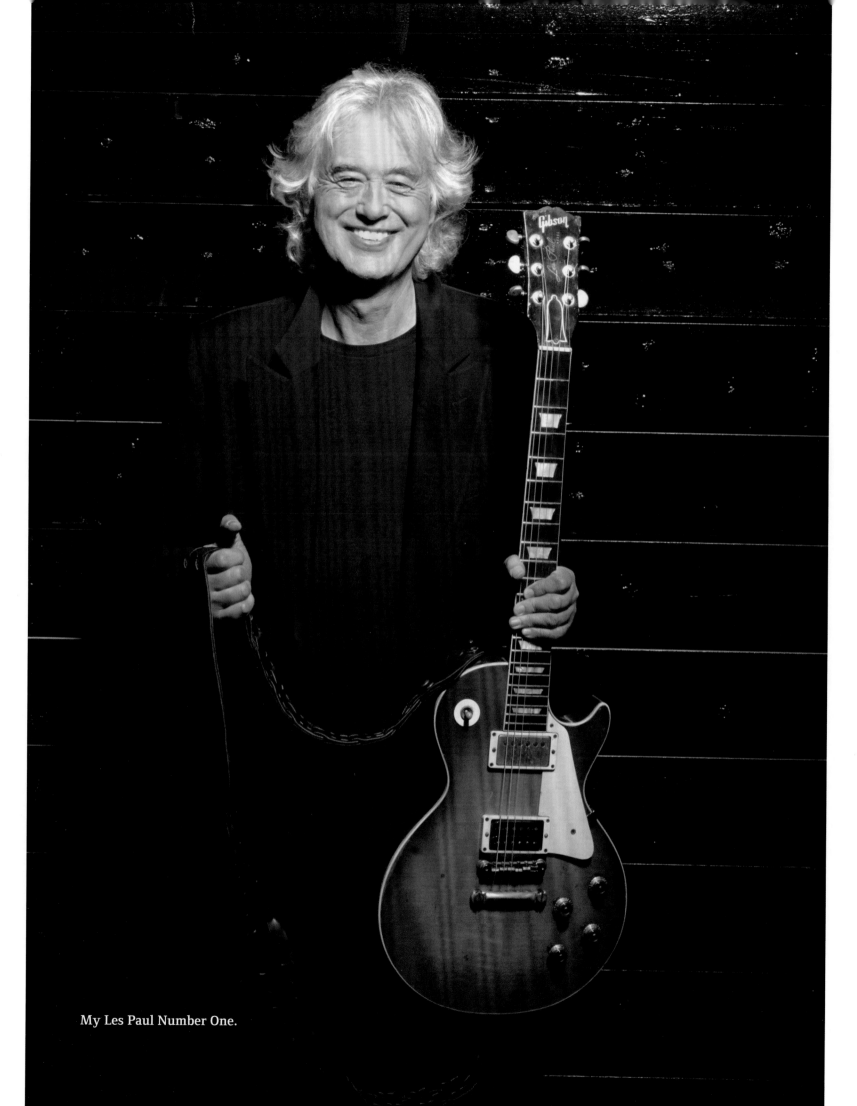

My Les Paul Number One.

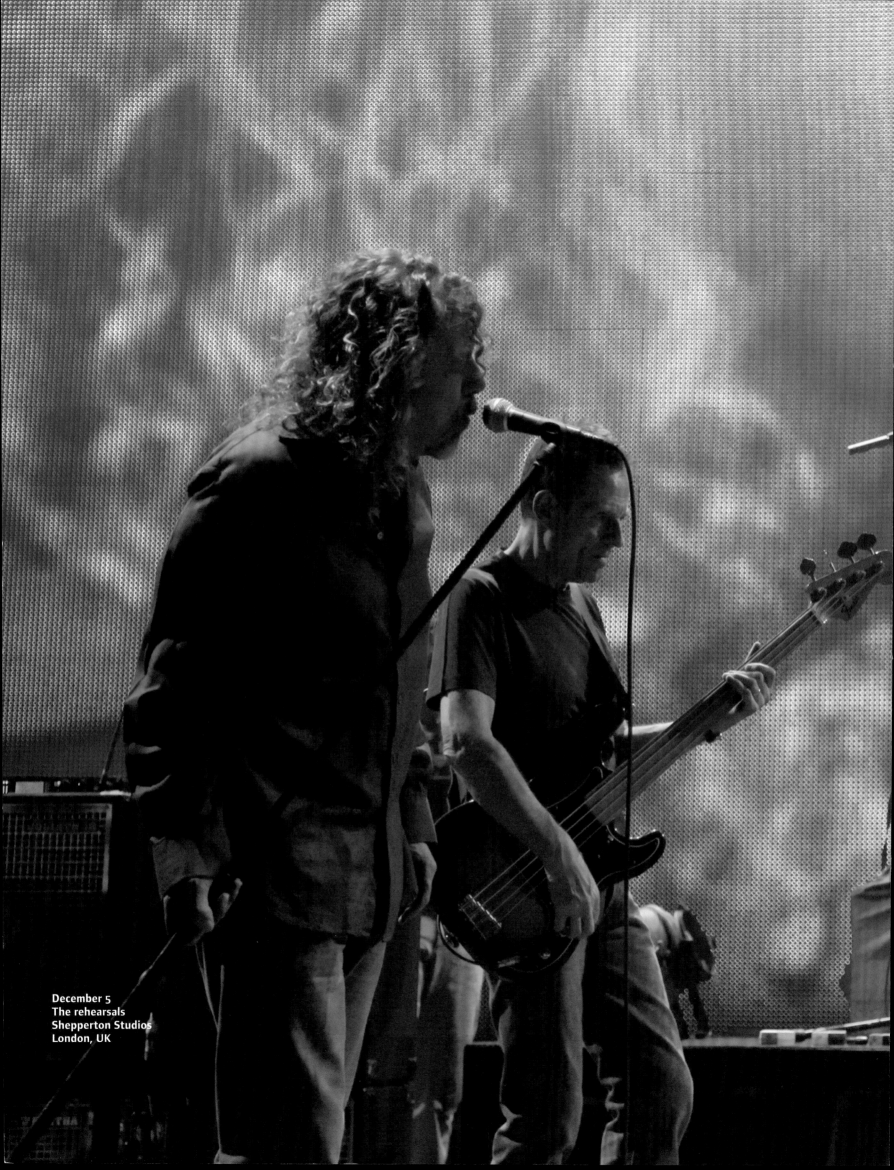

December 5
The rehearsals
Shepperton Studios
London, UK

Without further ado, it's the O2.
The fun up to the run up…

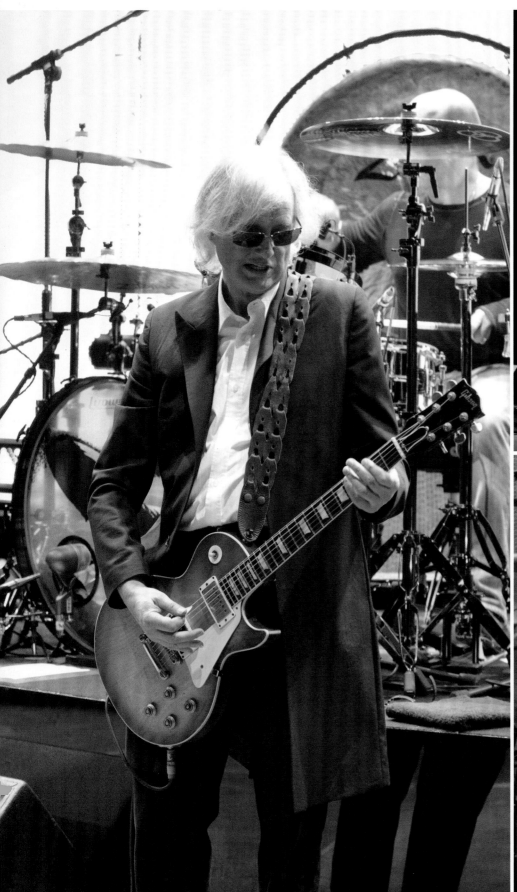

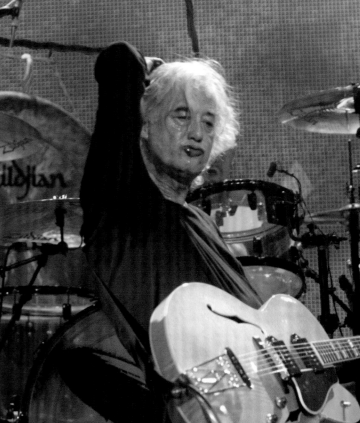

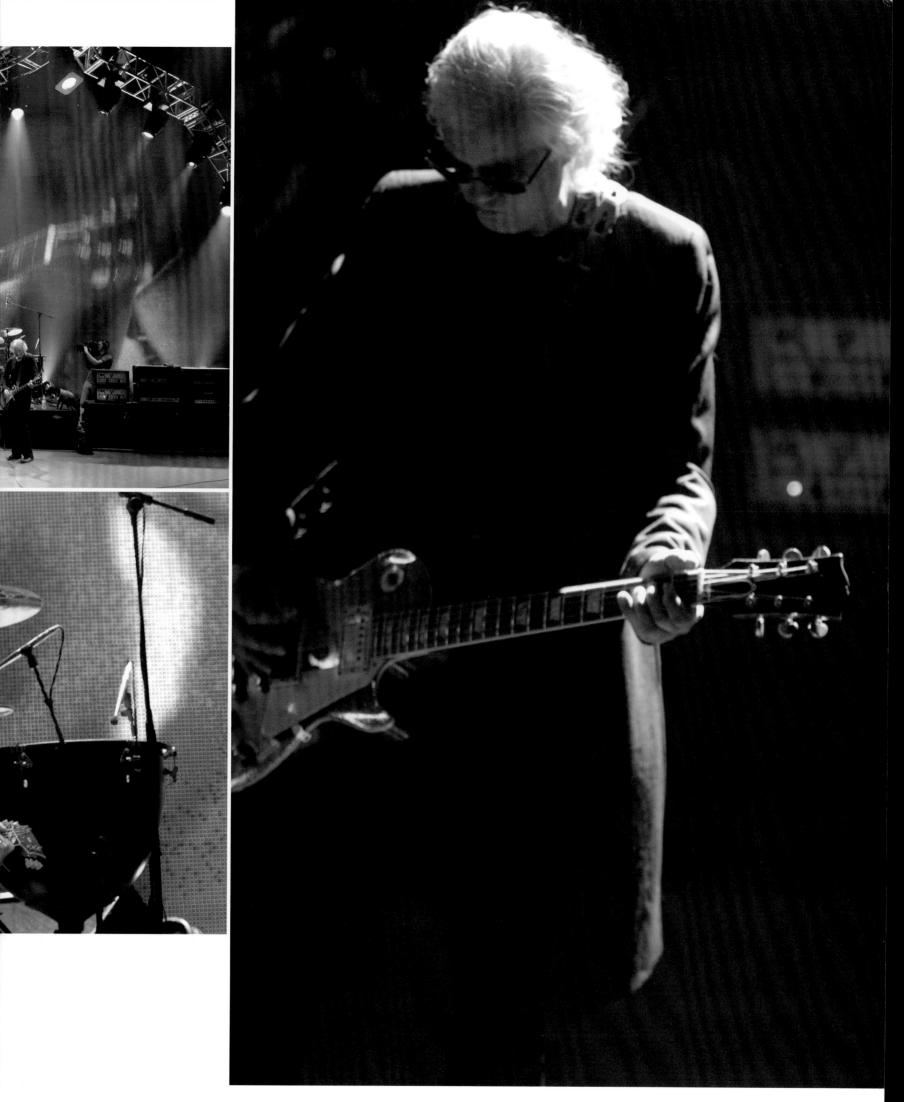

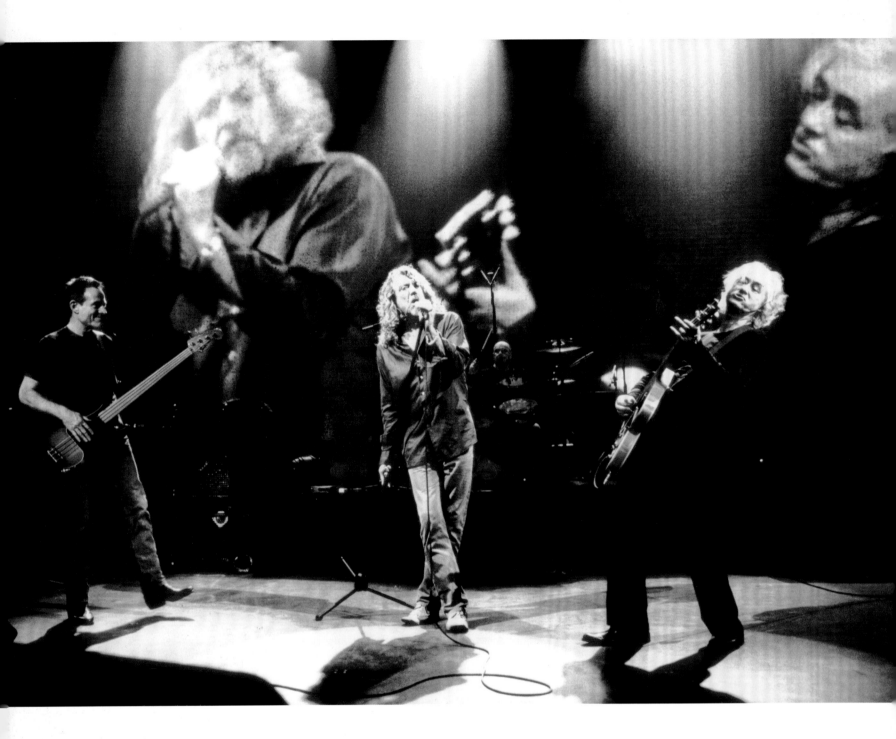

In full flight at Shepperton.

THE RELEASE OF *MOTHERSHIP*
12 NOVEMBER (UK)
13 NOVEMBER (US)

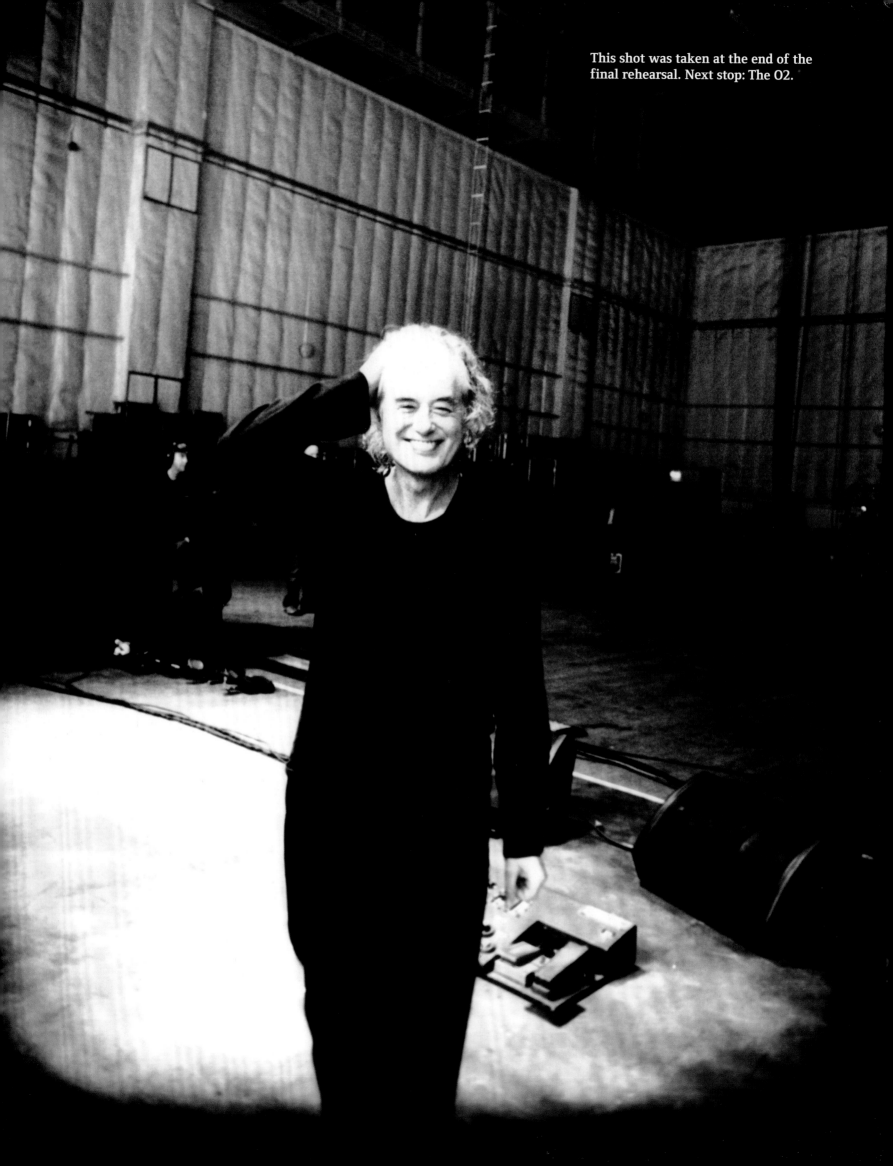

This shot was taken at the end of the final rehearsal. Next stop: The O2.

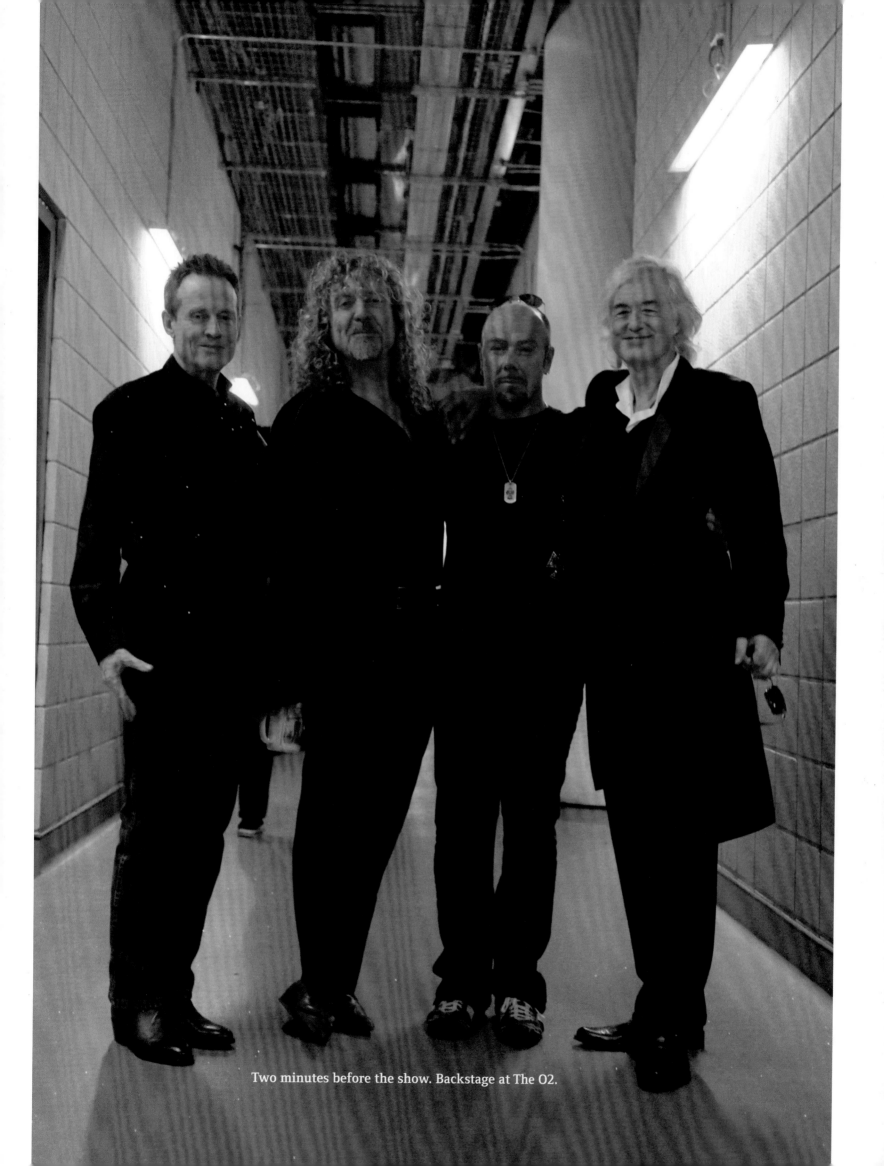

Two minutes before the show. Backstage at The O2.

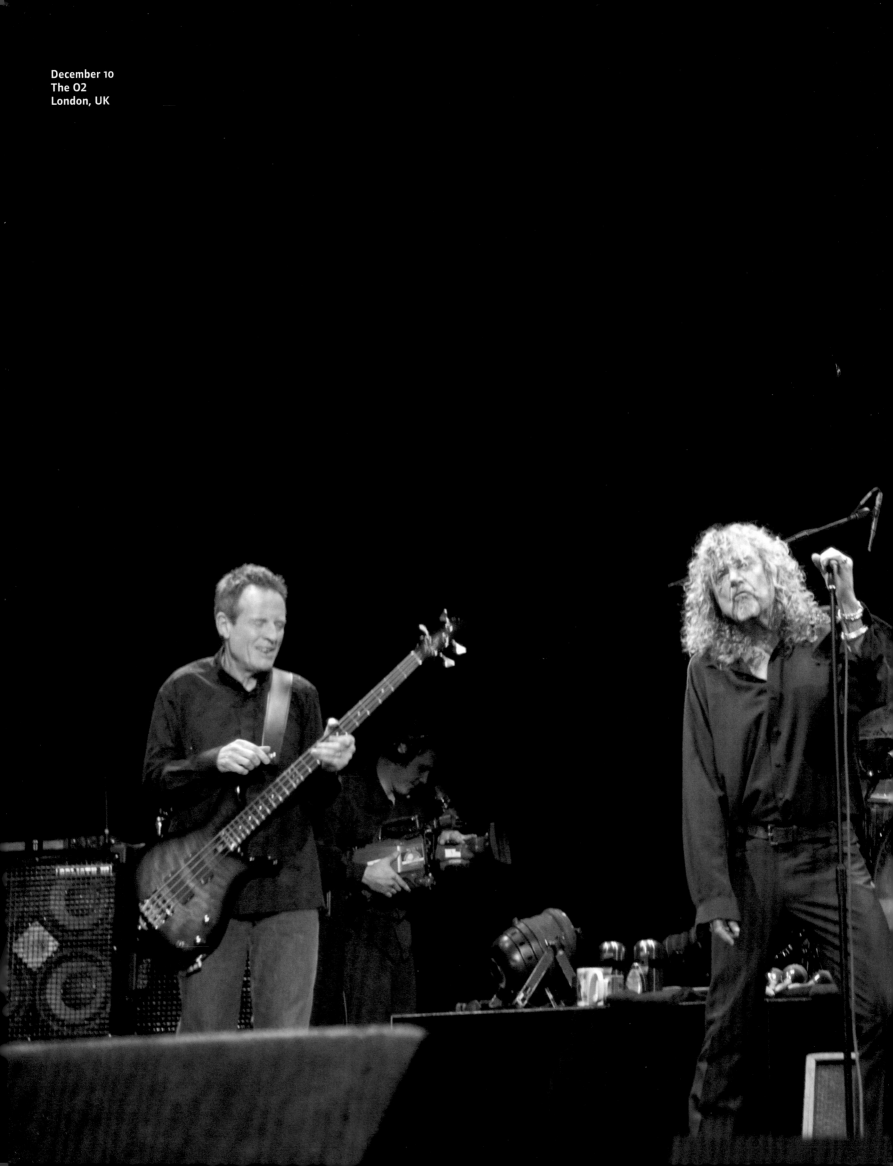

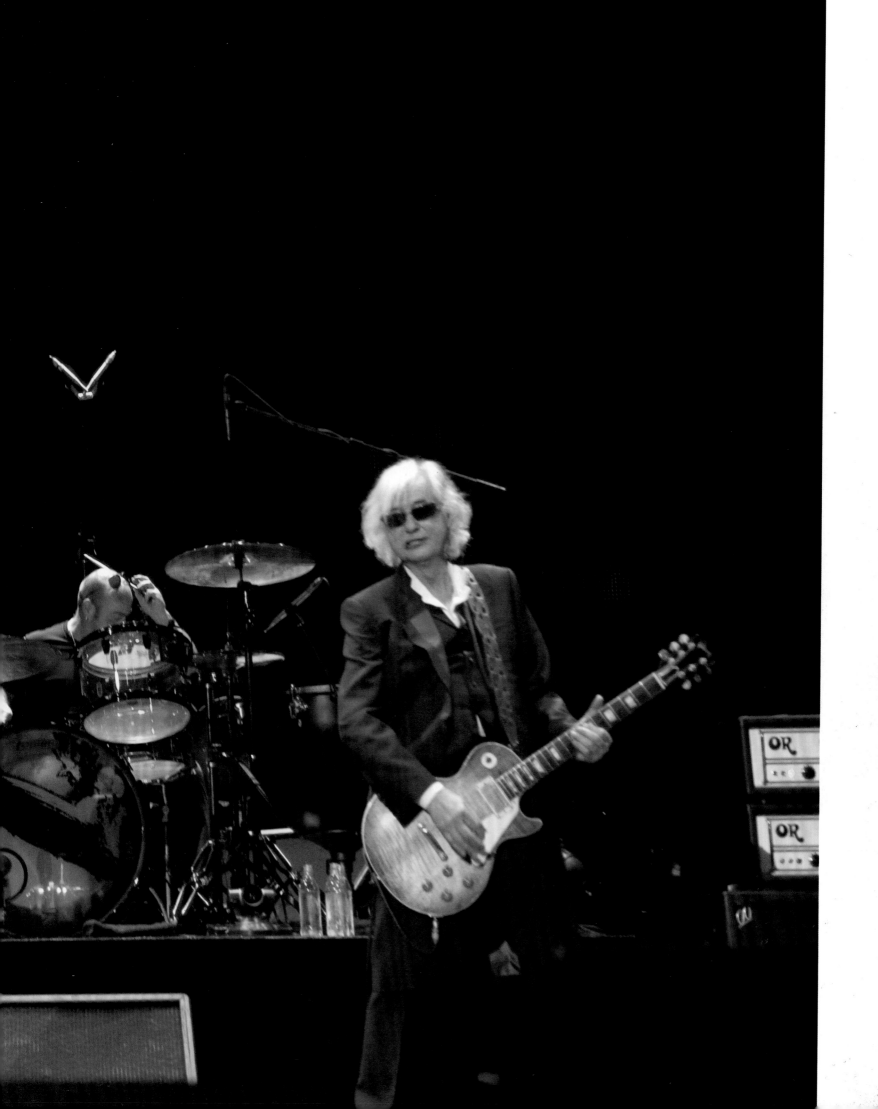

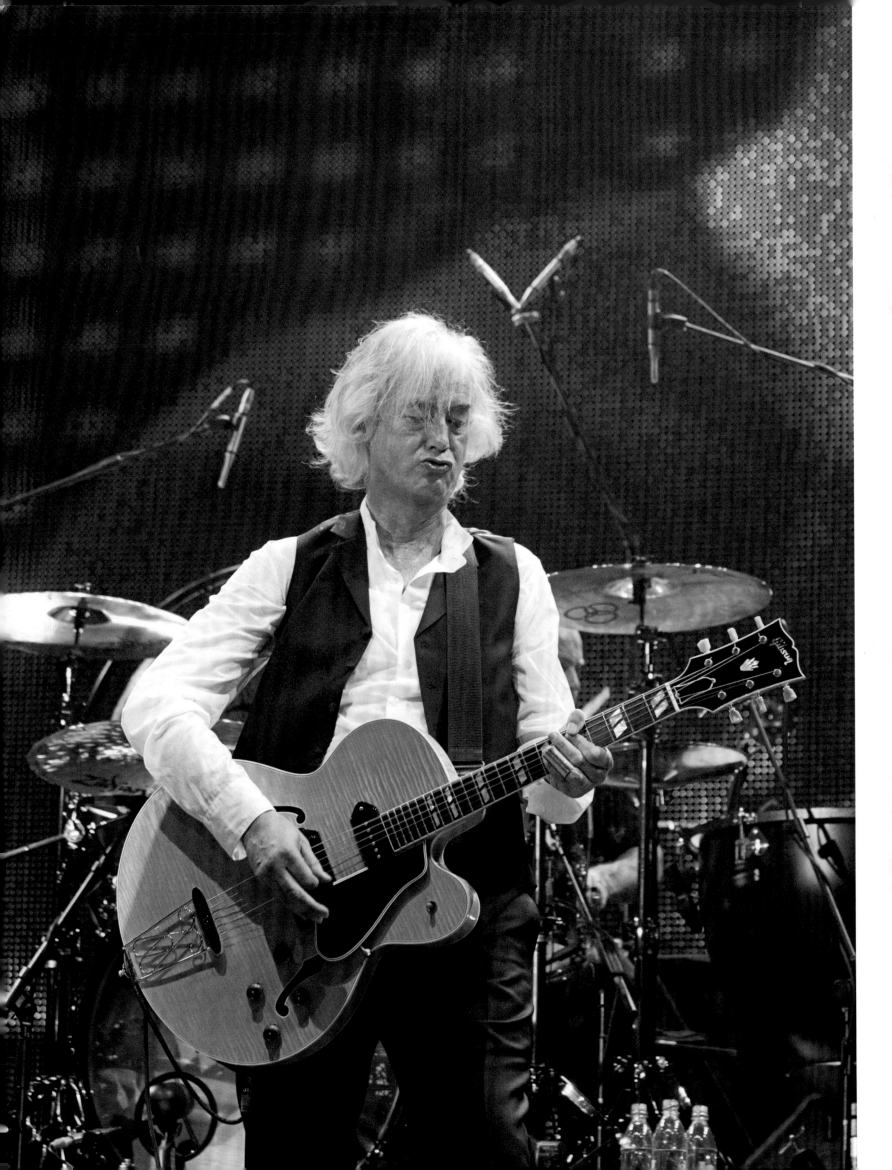

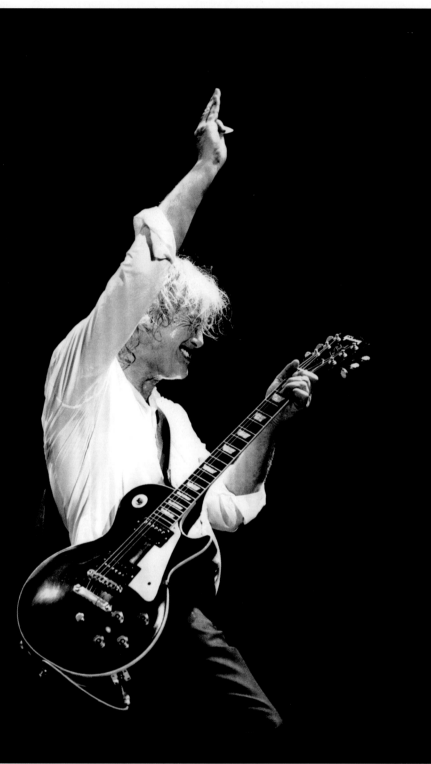
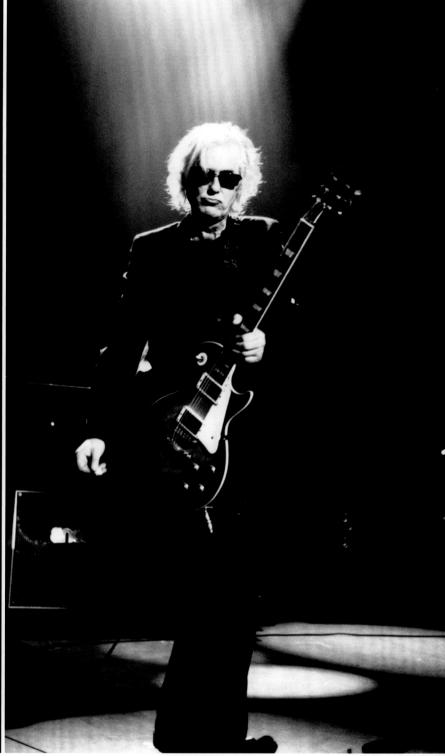

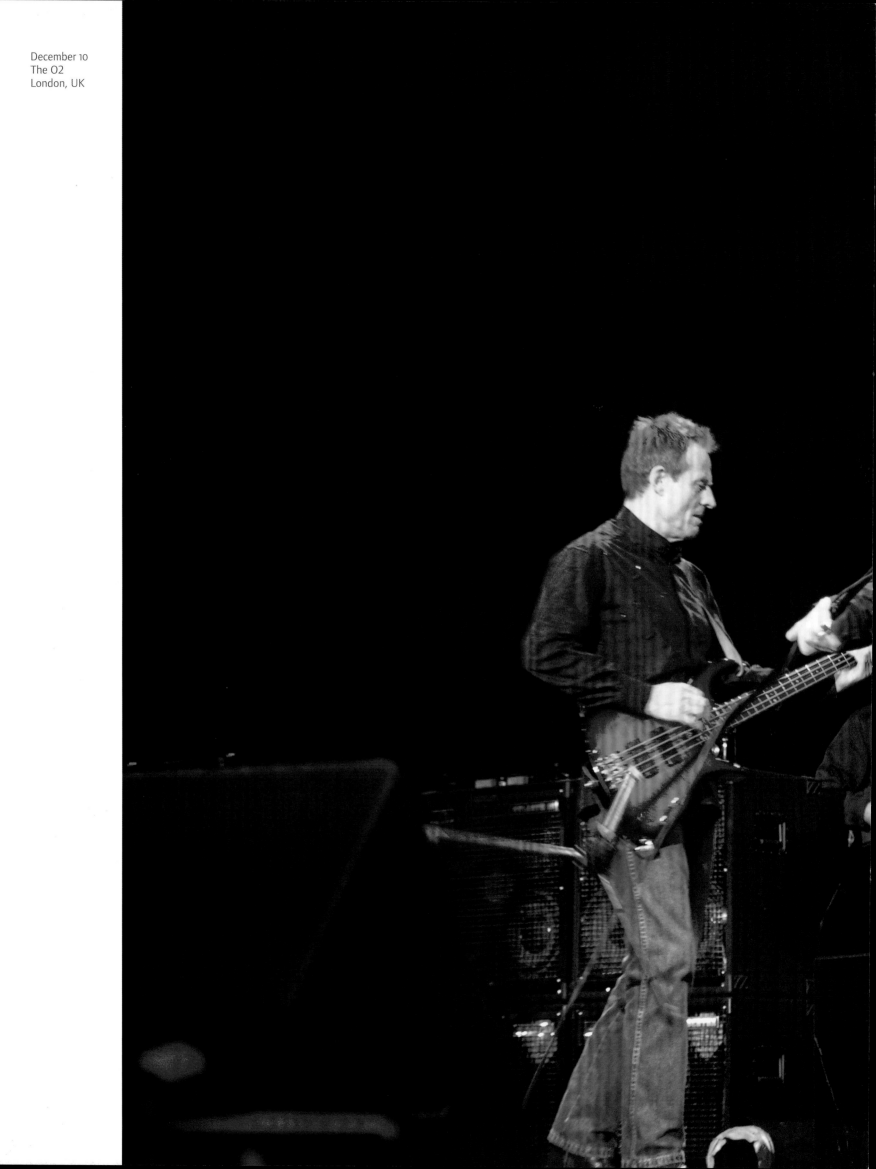

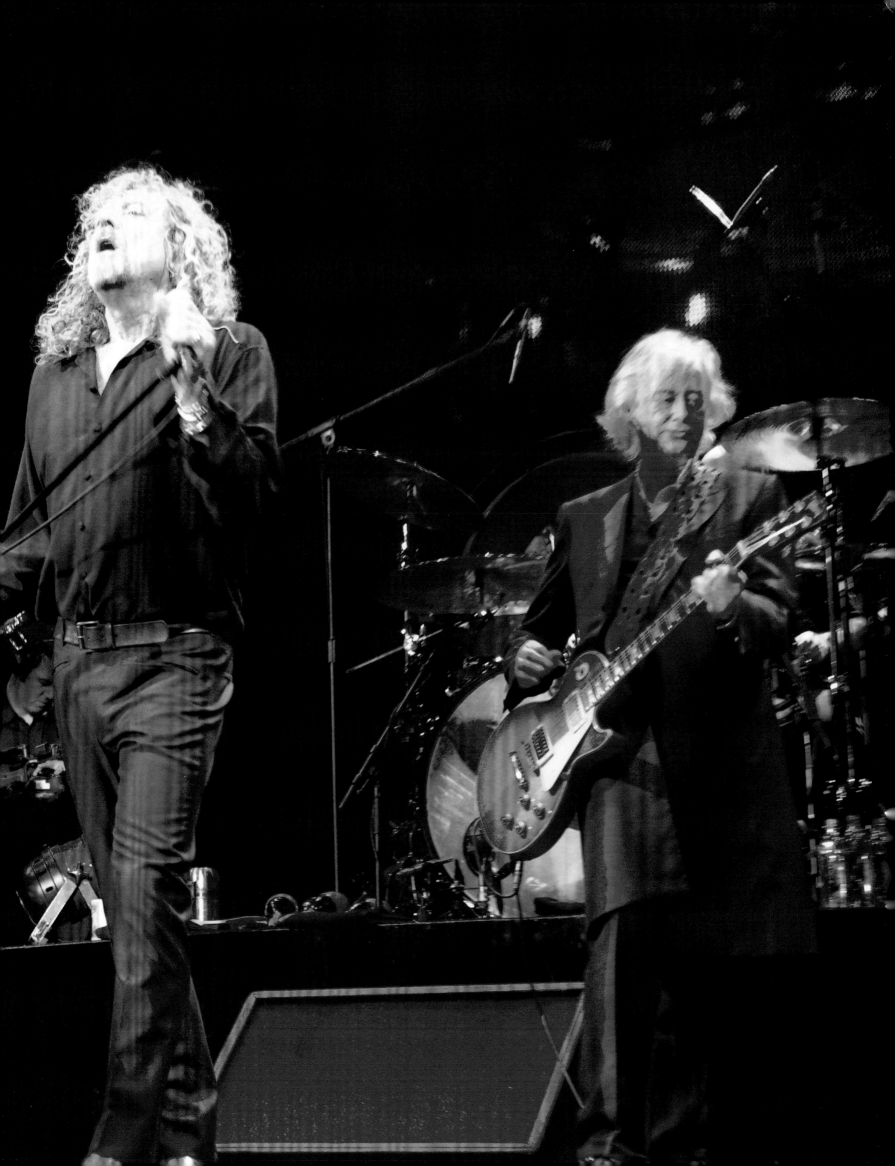

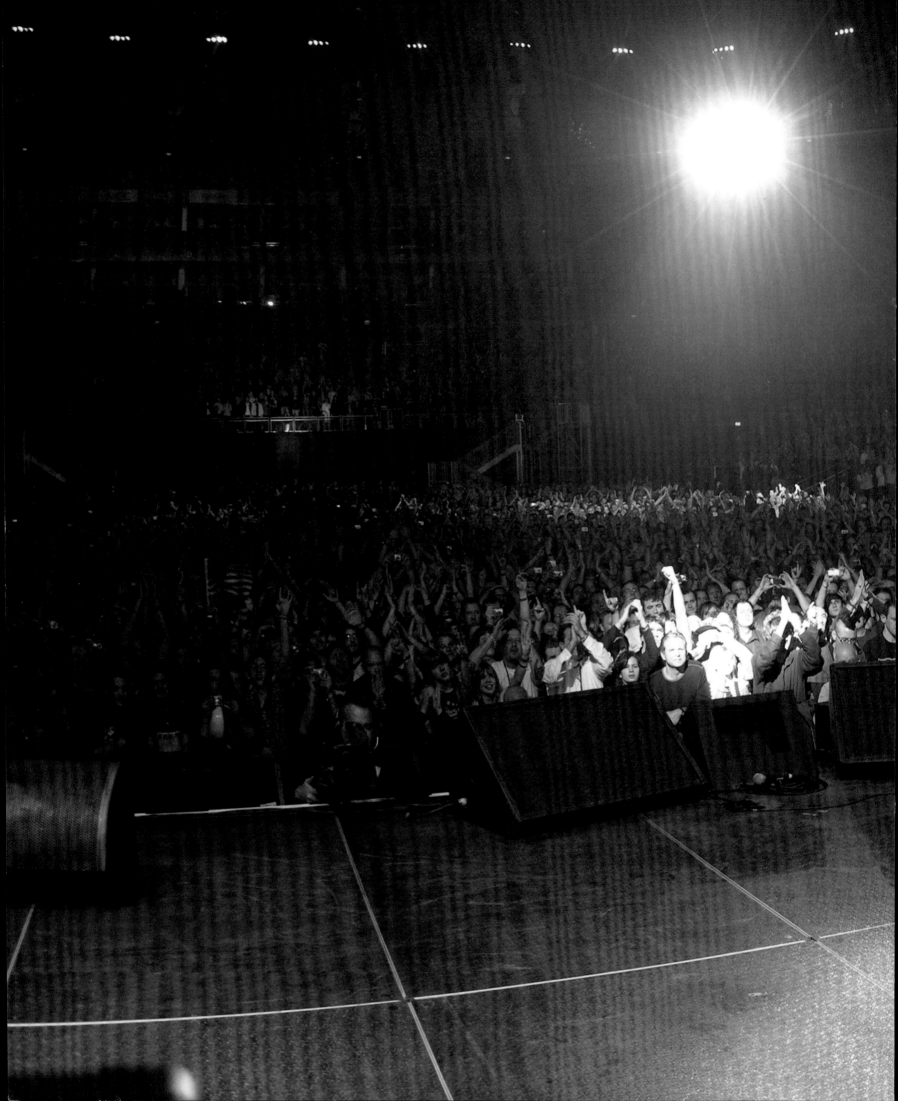

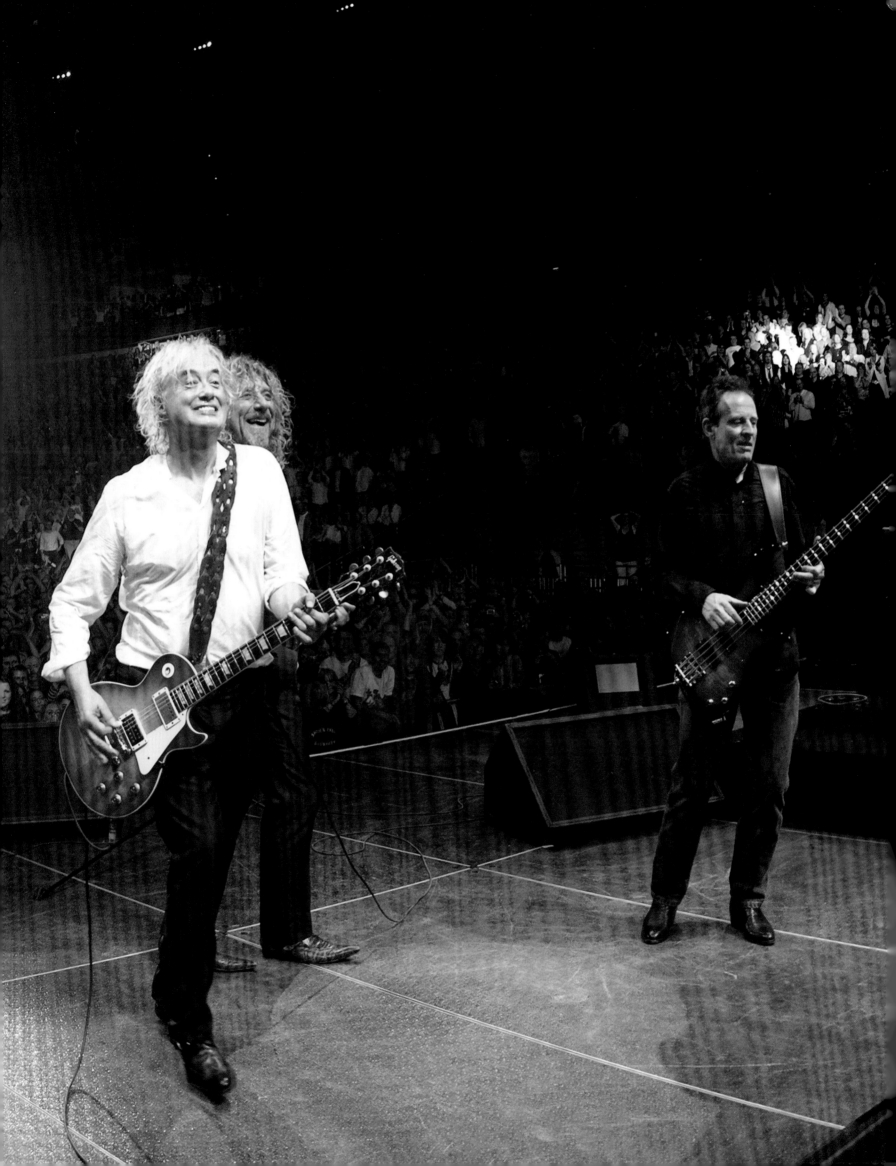

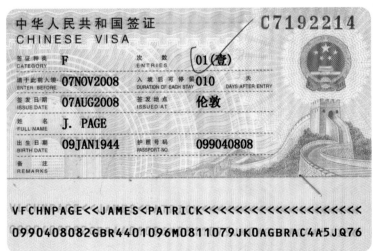

In 2008 I was contacted to give permission for 'Whole Lotta Love' to be used in the closing ceremony of the Beijing Olympics and the hand-over to London as the next host city.

Naturally I agreed, but the following call outlined what they really had in mind which was to use the full length of the song with me playing it and Leona Lewis singing.

This was termed 'Project X' by me and without doubt will be one of the high points of my career. With the wondrous talent of Miss Leona Lewis, viewed by over 250 million people worldwide I'm told that it was the most watched guitar solo in TV history and with David Beckham kicking a ball into the audience – on this level of the WAH factor, it doesn't come much better!

August 23
Beijing National Stadium
Beijing, China

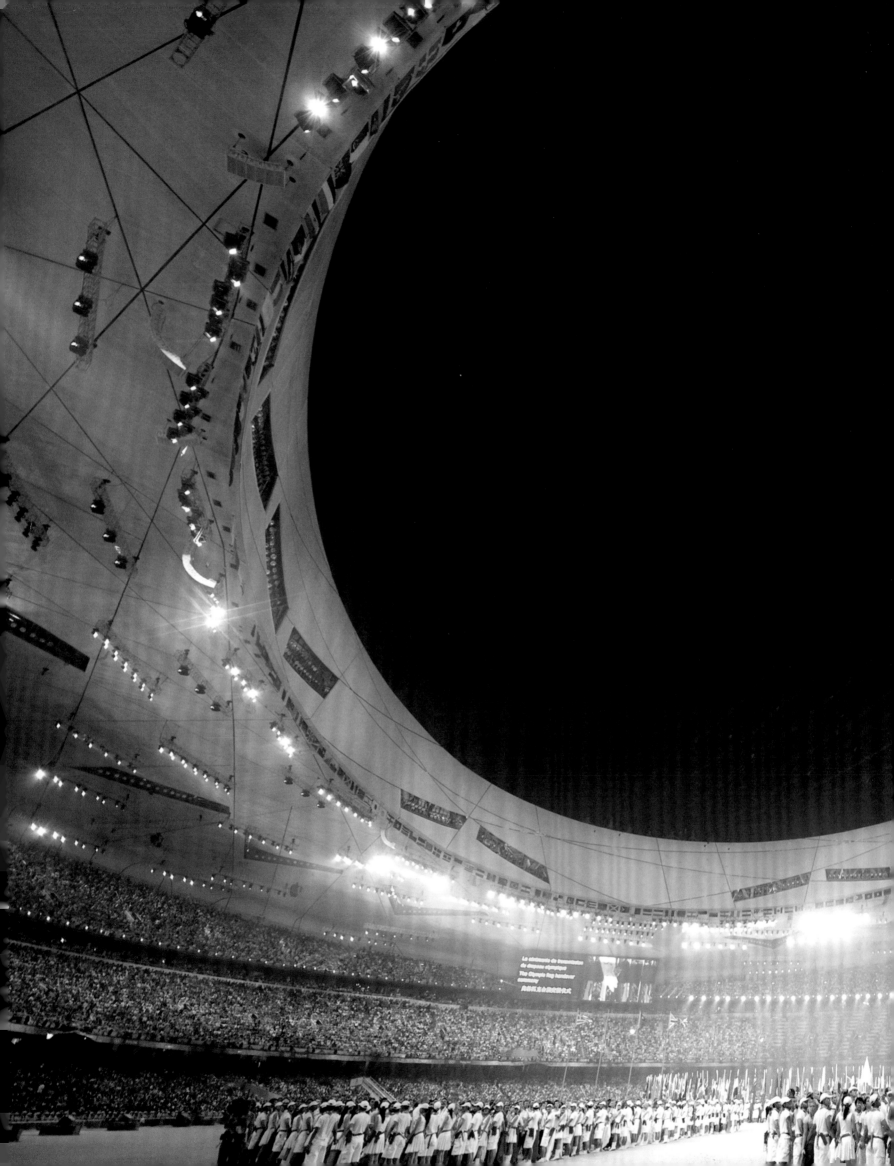

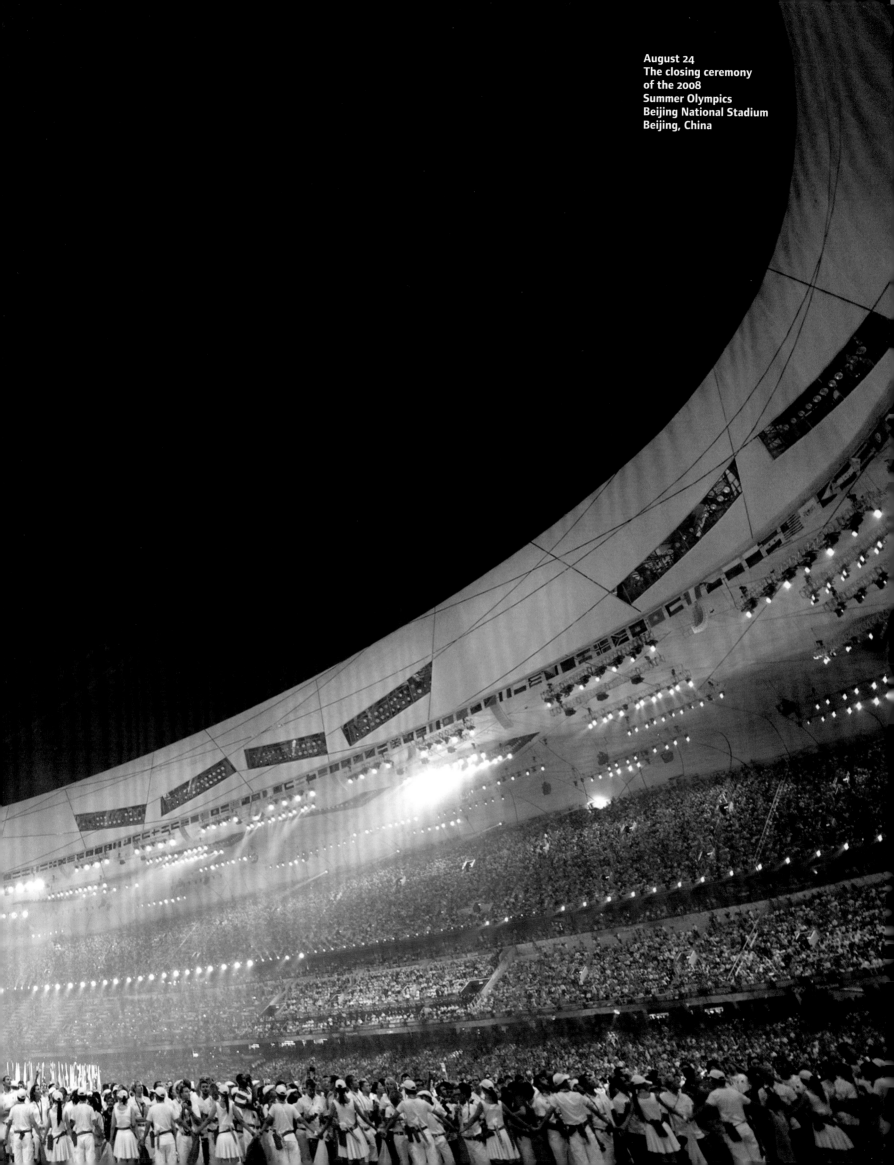

August 24
The closing ceremony
of the 2008
Summer Olympics
Beijing National Stadium
Beijing, China

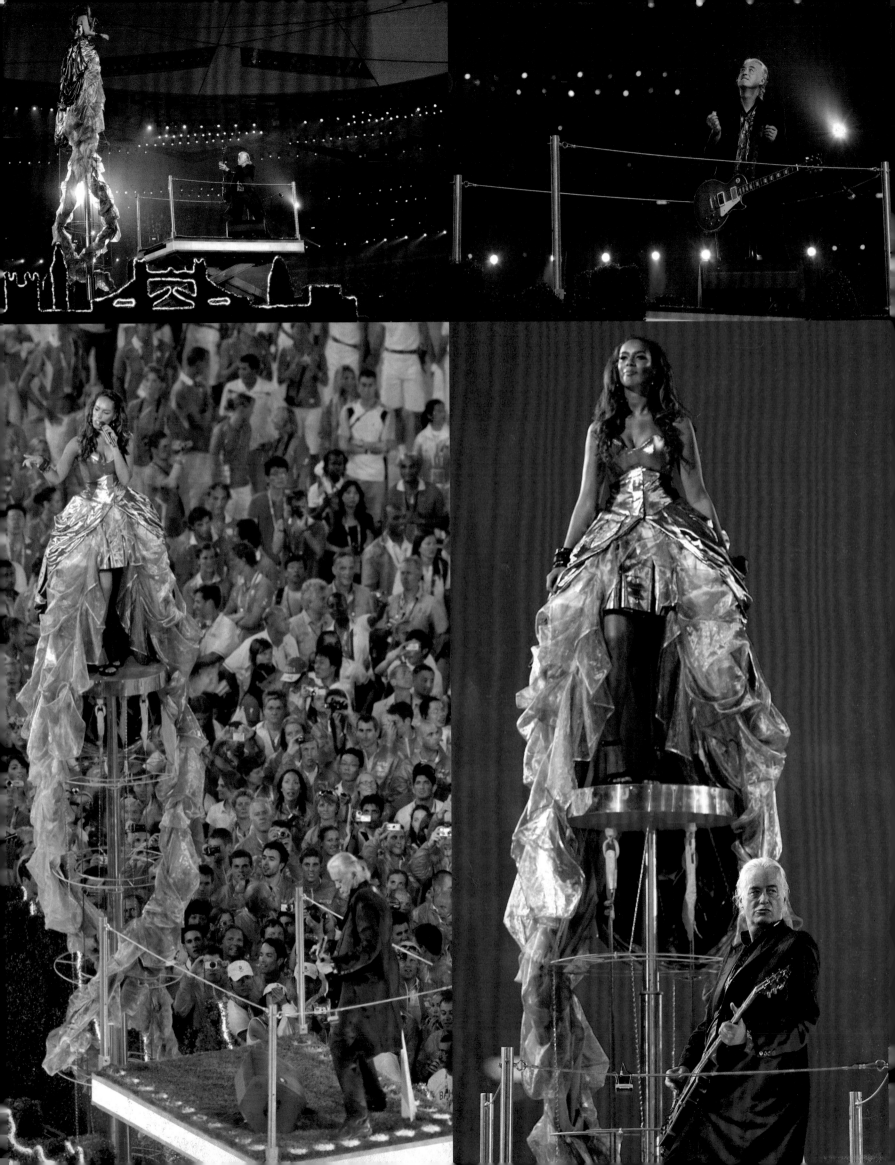

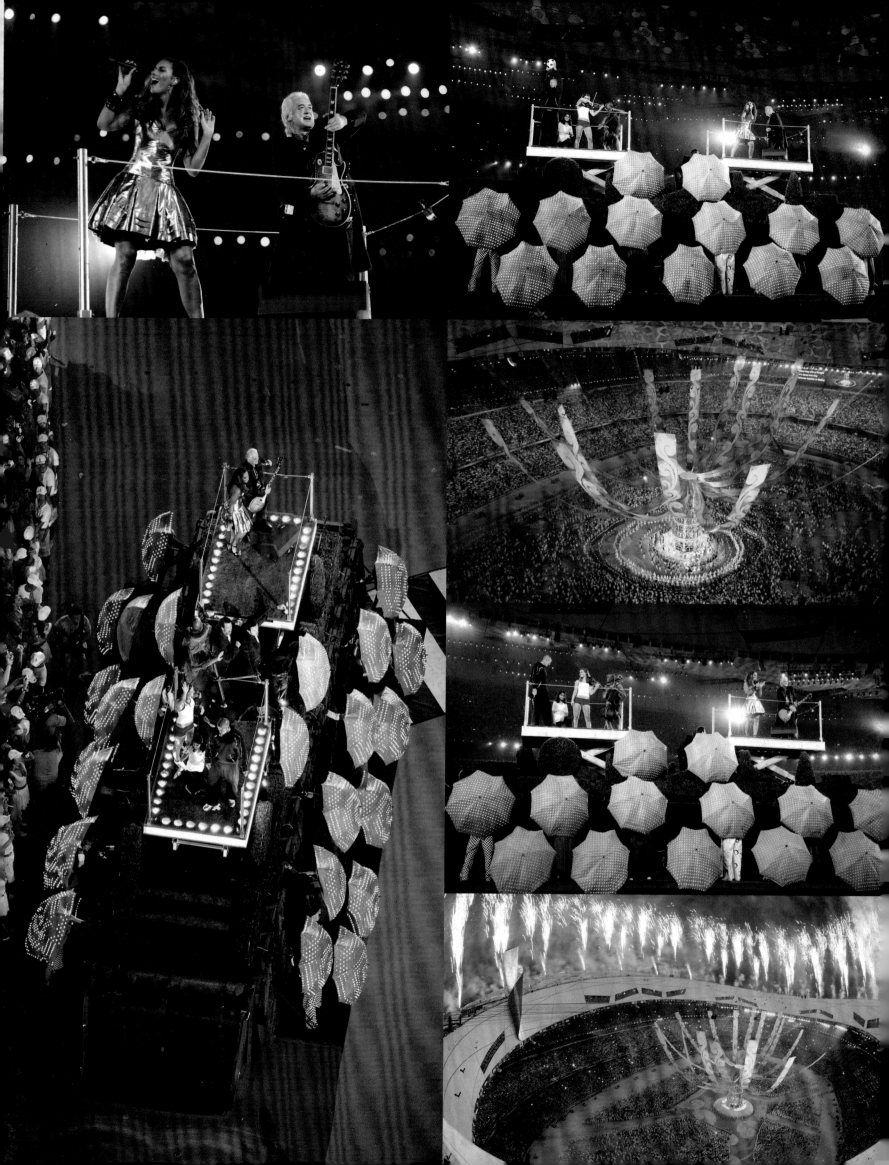

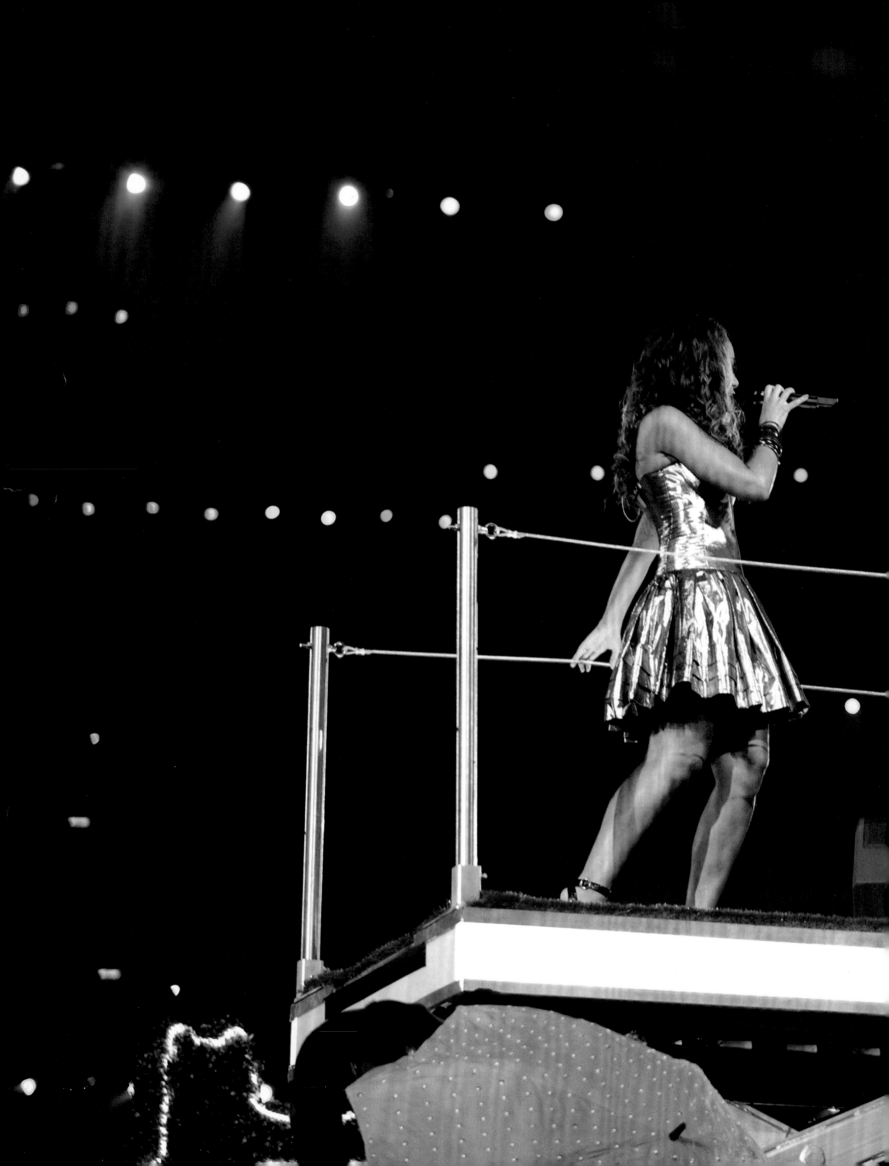

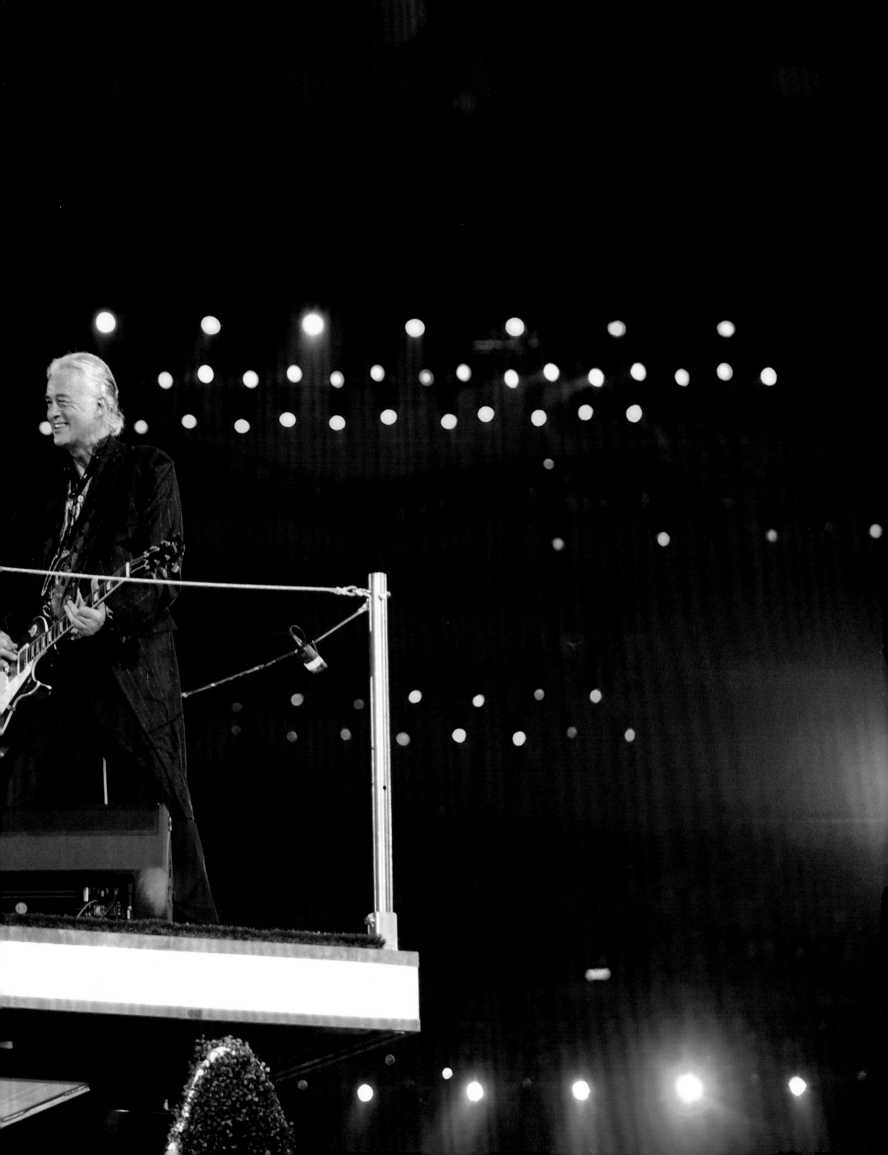

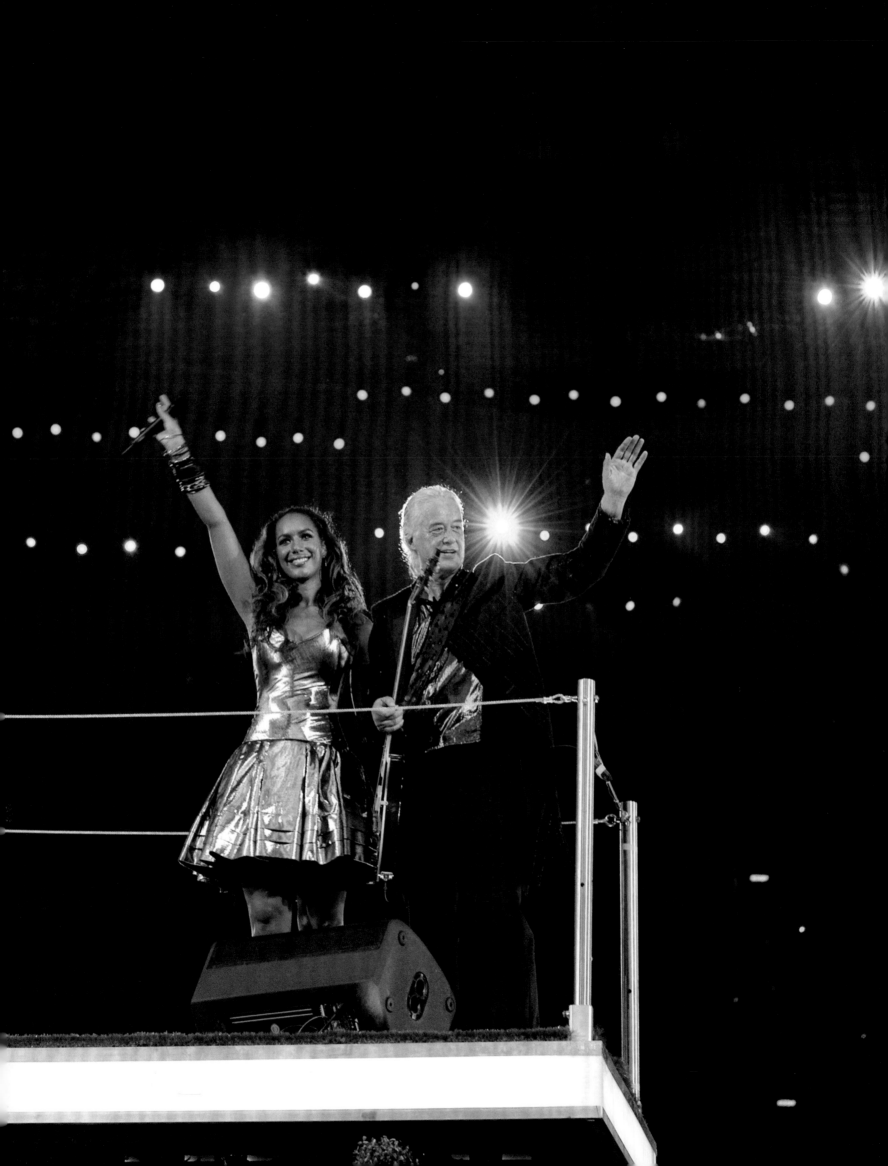

Forty years after our first show as Led Zeppelin at the University of Surrey, I was awarded an honorary Doctorate by the university which was bestowed on me at Guildford Cathedral.

June 20
Guildford Cathedral
Guildford, UK

The University of Surrey confer the honorary degree of Doctor of the University to Jimmy Page, for services to the music industry

THE EDGE JIMMY PAGE JACK WHITE

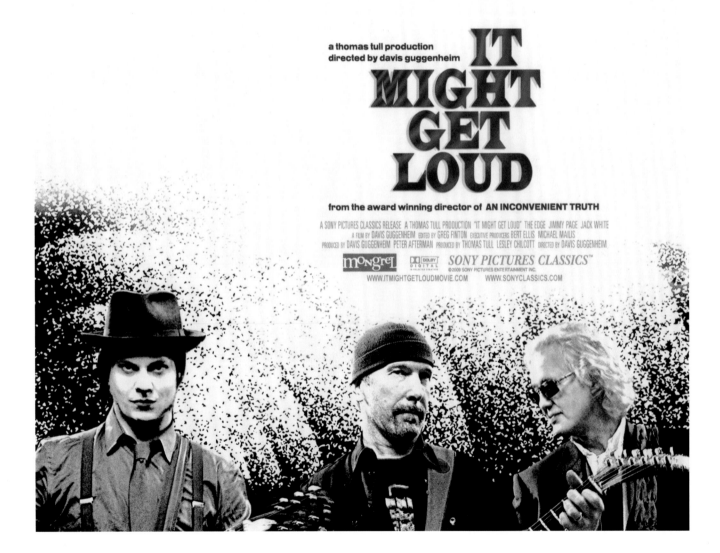

Davis Guggenheim had approached me to do a documentary about the guitar and its eccentricities, with The Edge and Jack White. We filmed the 'Summit' at Warner Bros Studios on 23rd January 2008. Davis had a unique idea in that the cast members did not meet up (or confer notes) until they hit the Summit. The whole project was intriguing.

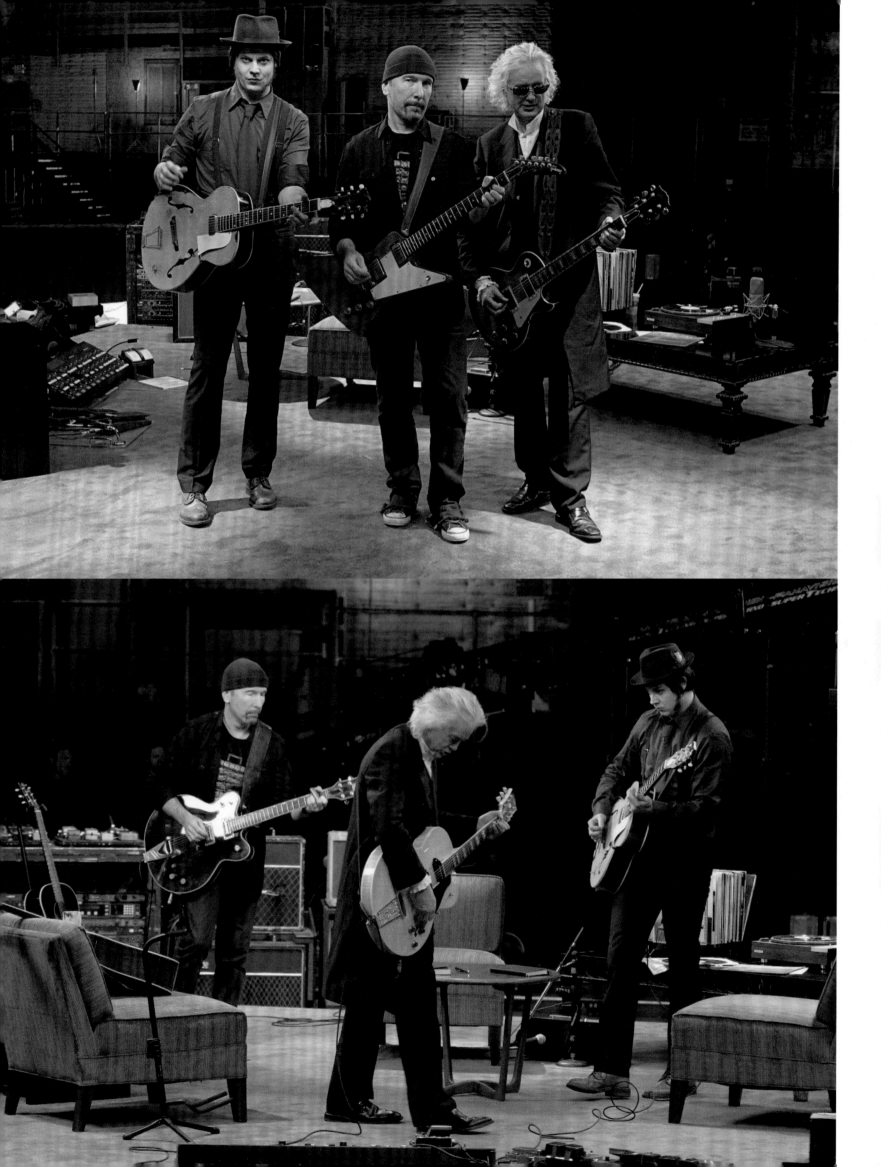

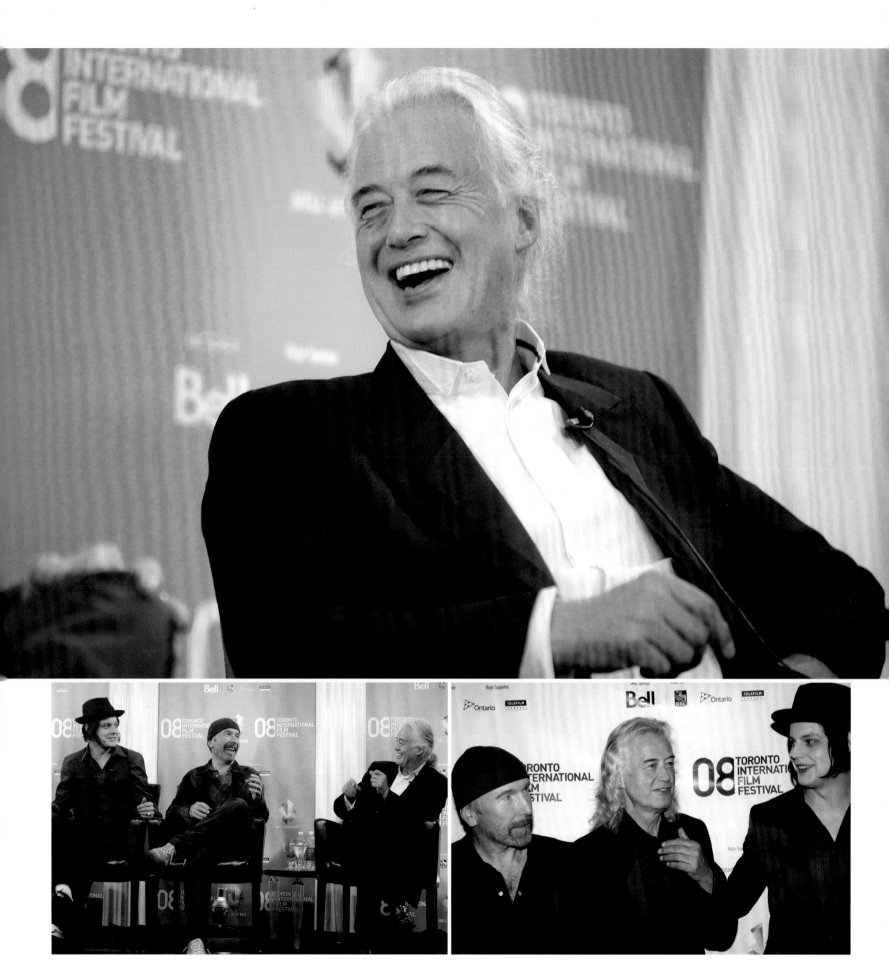

The film made its debut at the Toronto International Film Festival.
You can see the infectious humour and team spirit alive and well.

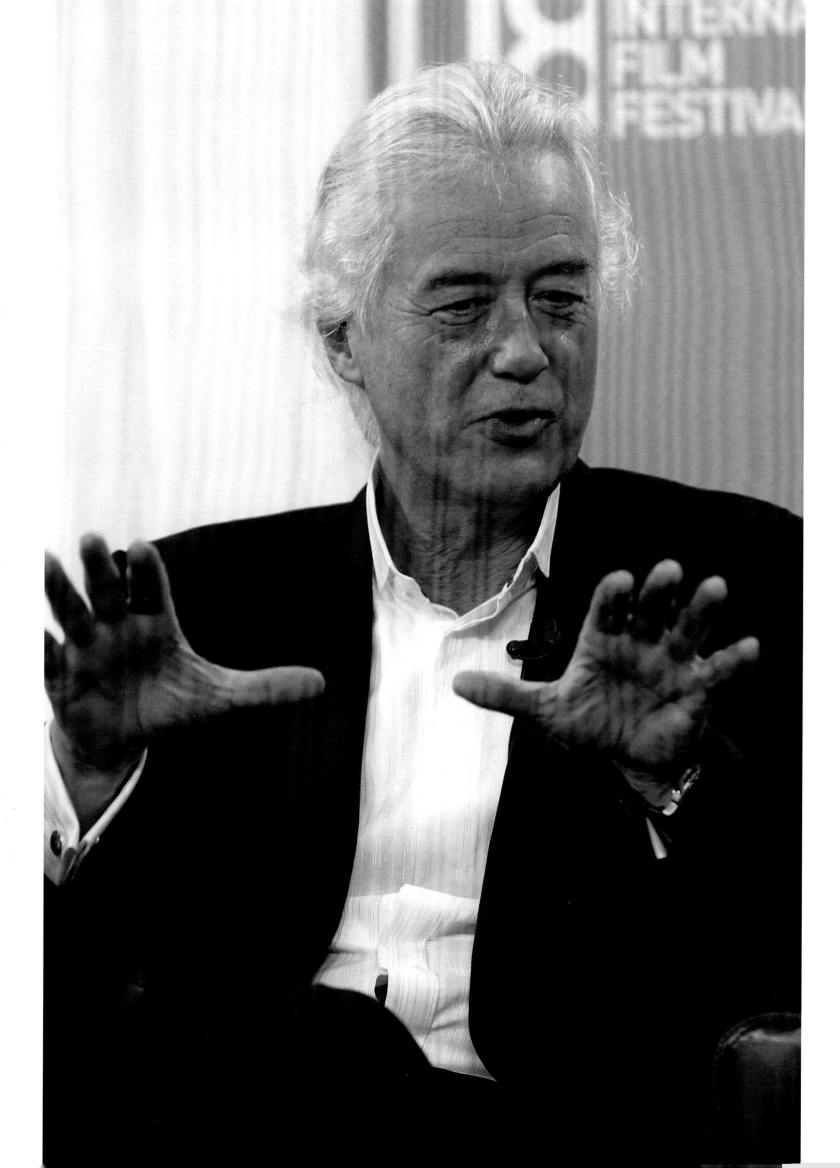

December 2
The White House
Washington, USA

At the 35th Annual
Kennedy Center Honors,
Led Zeppelin are
recognised by President
Barack Obama for their
lifetime contributions to
American culture through
the performing arts

In December 2012, Led Zeppelin were honoured at the Kennedy Center
with the Kennedy Award, a truly remarkable occasion, and meetings
with President Bill Clinton, Secretary of State Hillary Clinton, President
Barack Obama and First Lady Michelle Obama. President Obama told me
they had listened to Led Zeppelin music whilst they were at college.
They hosted the most incredible concert of many surprises. Thank you
again for your hospitality, President Obama.

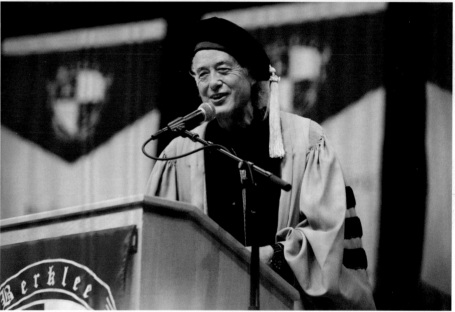

In May 2014, I received an Honorary Doctorate for Music at the prestigious Berklee College of Music in Boston. From the age of 12, American music had a profound effect on me, and I fully understand the significance of this award. There had been a concert where one could marvel at the incredibly high standard of musicianship of Berklee College and its students.

May 10
Berklee College of Music
Agganis Arena
Boston University
Boston, USA

Berklee College of Music confer the Honorary Doctorate for Music to Jimmy Page

It might get louder…

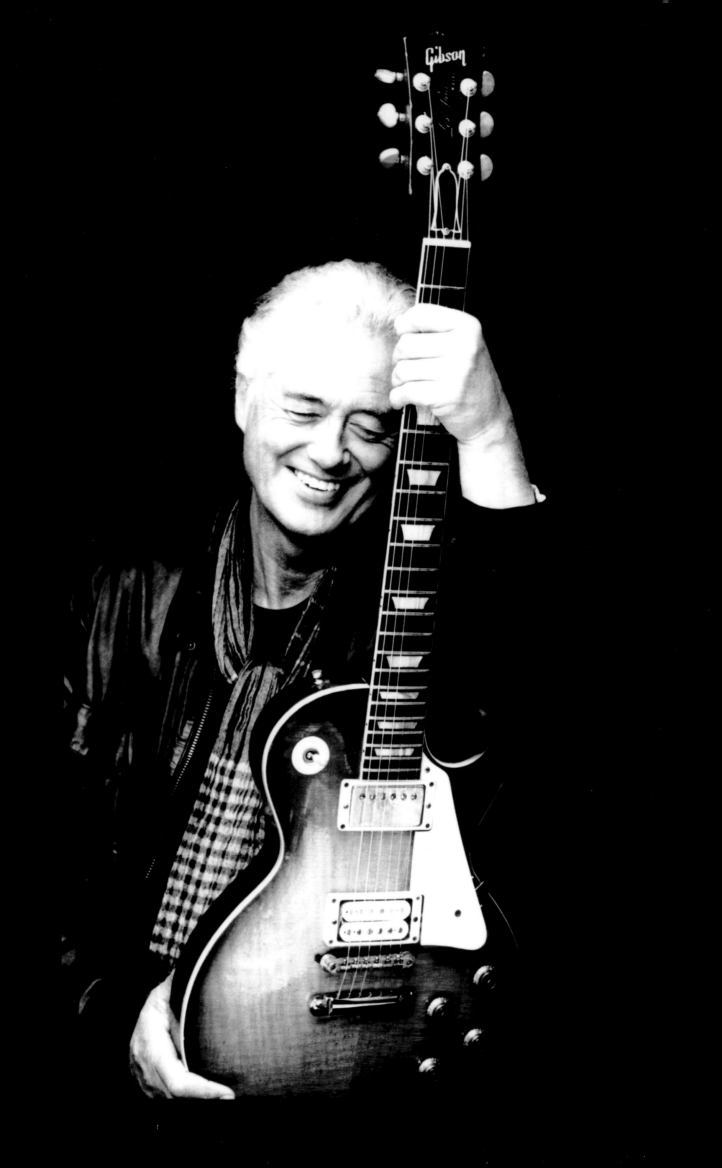

Epilogue

I set out to create a photographic autobiography. I wanted the images to illustrate the journey of my musical career, beginning as a teenager and continuing throughout my life.

This book originally appeared as a signed limited edition. I am pleased to make it available now to a wider audience.

Jimmy Page, April 2014

Publishers' Note

This limited edition is testament to Jimmy Page's vision of a 'photographic autobiography'. Jimmy has been an inspiring and thoroughly dedicated author throughout the creative process of putting this huge book together, allowing us to spend his time for months on end: sifting through thousands of prints to accomplish the final selection, arranging the content into its narrative sequence and annotating and reviewing the design with him to arrive at the finished book. We are truly honoured to have worked alongside him to produce this unique publication.

The photographs in this book are produced from a variety of sources. As well as images by some of the world's finest photographers, there is artwork recovered from such ephemera as long-lost prints, fliers, posters, magazines and record covers. We have done our best to restore them and include them here for historic interest.

All reasonable effort has been made to identify and contact the copyright holders of the images and artwork printed in this publication. Any omissions are inadvertent.